"This is truly pioneering work, capturing the birth of an art form, or rather the birth of an interconnected series of art forms that seem to have infinite potential. The traditional forms of narrative are treated with their due respect but the ground rules for a whole new world of entertainment, education, and self-expression are laid out here with clarity and insight. This heavily revised and up-to-date edition is a lifesaver for those us who have to cross the gulf between linear and non-linear, passive and interactive, approaches to entertainment, and a useful handbook for those who have already made the jump and want to use these wonderful tools more effectively."

—Christopher Vogler, Screenwriter and Author of The Writer's Journey

"Carolyn Miller's Digital Storytelling, Second Edition is an excellent survey of the field, covering the varied and diverse techniques, delivery platforms, and historical roots of a wide range of software titles. Not content with merely mentioning a few recent American games, Miller touches on important milestones from the past and key titles from around the world. While particularly impressive in its breadth and scope, the book also focuses in on specifics by featuring many interesting interviews and quotes from some of the leaders in the digital storytelling, as well as pioneers of emerging fields like Alternate Reality Games and Serious Games. Students, developers, and aficionados of interactive stories will all find something interesting here."

—Noah Falstein, President of The Inspiracy

"Digital Storytelling makes the reader aware of the breadth and potential of this emerging field. Whether you are a student, a researcher, an artist, a technologist, or just a curious reader, Carolyn Handler Miller's book will give you a tremendous insight into this fascinating and important area."

—Ed Angel, Director, Art, Research, Technology and Science Laboratory (ARTS Lab), University of New Mexico

"A thorough and highly readable discussion of the wonderful diversity of digital storytelling. Carolyn Handler Miller explores not only the familiar territory of video games and virtual reality, but also the emerging new fields of transmedia entertainment, serious games, smart toys, interactive cinema, and many more. Recommended."

—Ernest Adams, game design consultant and author of Fundamentals of Game Design

Digital Storytelling

A Creator's Guide to Interactive Entertainment

Second Edition

Carolyn Handler Miller

Cover images courtesy istockphoto.com

"Subconscious" @ Andy Held; "Happy Robot" @ Mark Evans; "Control Pad"

© Michal Rozanski; "Hi-Tech PDA mobile phone" © Matjaz Boncina; "Mouse Globe"

© Andrew Johnson; "Man holding mobile phone,laptop in background" © Manuela Krause

Other illustrations courtesy istockphoto.com

"Temple Wall Detail" © Jan Rihak; "Computer Gaming" © Quavondo Nguyen; "Study on Computer" © Bulent Ince; "Back to School" © Lisa Thornberg; Global Communication © Alex Slobodkin; "World Search" © Amanda Rohde; "Binary Code Abstract" © Emrah Turudu; "Human body of a Vitruvian man with skeleton for study"; "Togetherness" © Lise Gagne; "Puzzle Concepts" © Onur Döngel; "Remote" © Jente Kasprowski; Action Clapboard; "Electric Tunnel Vertical" © Frank Ramspott; "Blue CD"

© Dan Eckert; "Ticket Machine User" © Gary Martin; "Perfect businesswoman typing"; "Sun and Life"

Publisher: Elinor Actipis

Acquisitions Editor: Georgia Kennedy

Publishing Services Manager: George Morrison Senior Project Manager: Dawnmarie Simpson

Editorial Assistant: David Bowers Marketing Manager: Rebecca Pease Designer: Dennis Schaefer Cover Designer: Alan Studholme

Focal Press is an imprint of Elsevier 30 Corporate Drive, Suite 400, Burlington, MA 01803, USA Linacre House, Jordan Hill, Oxford OX2 8DP, UK

Copyright © 2008, Elsevier, Inc. All rights reserved.

No part of this publication may be reproduced, stored in a retrieval system, or transmitted in any form or by any means, electronic, mechanical, photocopying, recording, or otherwise, without the prior written permission of the publisher.

Permissions may be sought directly from Elsevier's Science & Technology Rights Department in Oxford, UK: phone: (+44) 1865 843830, fax: (+44) 1865 853333, E-mail: permissions@elsevier.com. You may also complete your request online via the Elsevier homepage (http://elsevier.com), by selecting "Support & Contact" then "Copyright and Permission" and then "Obtaining Permissions."

Recognizing the importance of preserving what has been written, Elsevier prints its books on acid-free paper whenever possible.

Library of Congress Cataloging-in-Publication Data

Miller, Carolyn Handler.

Digital storytelling: a creator's guide to interactive entertainment / Carolyn Handler Miller. – 2nd ed. p. cm.

Includes index.

ISBN-13: 978-0-240-80959-5 (pbk.: alk. paper) 1. Interactive multimedia. 2. Storytelling–Data processing. I. Title.

2007048519

QA76.76.I59M55 2008 006.7-dc22

British Library Cataloguing-in-Publication Data A catalogue record for this book is available from the British Library.

ISBN: 978-0-240-80959-5

For information on all Focal Press publications visit our website at www.books.elsevier.com

08 09 10 11 5 4 3 2 1

Printed in the United States of America.

Working together to grow libraries in developing countries

www.elsevier.com | www.bookaid.org | www.sabre.org

ELSEVIER BOOKAID Sabre Foundation

For my husband, Terry Borst, who is a living definition of the word helpmate, and in memory of my father, Marvin Handler, who could turn even the driest of law cases into a compelling story.

VII

Contents

FOR	EWORDIX
PRE	FACEXI
ACKI	NOWLEDGMENTSXV
PA	RT1 • New Technologies, New Creative Opportunities
1.	Storytelling, Old and New3
2.	Backwater to Mainstream: The Growth of Digital Entertainment21
3.	Moving Toward Convergence 41
PA	RT 2 • Creating Story-Rich Projects
4.	Interactivity and Its Effects53
5.	Old Tools/New Tools69
6.	Characters, Dialogue, and Emotions
7.	Structure in Digital Storytelling
8.	Tackling Projects for Children
9.	Using a Transmedia Approach149
10.	Creating a Work of Digital Storytelling: The Development Process165
PA	RT3 • Harnessing Digital Storytelling for Pragmatic Goals
11.	Using Digital Storytelling to Teach and Train
12.	Using Digital Storytelling for Promotion, Advertising,
	and Other Business Purposes211
13.	Using Digital Storytelling to Inform227
PA	RT 4 • Media and Models: Under the Hood
14.	Video Games
15.	The Internet257
16.	Massively Multiplayer Online Games (MMOGs)269
17.	Alternate Reality Games (ARGs)287
18.	Interactive Television (iTV)303

CONTENTS

19.	Smart Toys and Lifelike Robots	319
20.	Mobile Devices	335
	Interactive Cinema (iCinema)	
22.	Immersive Environments	363
23.	DVDs	383
24.	Electronic Kiosks	393
PART 5 • Career Considerations		
PA	R15 • Career Considerations	
	Working as a Digital Storyteller	411
25.		
25. 26.	Working as a Digital Storyteller Creating Your Own Showcase	425
25. 26.	Working as a Digital Storyteller	425
25. 26. CON	Working as a Digital Storyteller Creating Your Own Showcase	425
25. 26. CON	Working as a Digital Storyteller Creating Your Own Showcase	425 437 439
25. 26. CON GLO ADD	Working as a Digital Storyteller Creating Your Own Showcase	425 437 439 461

Foreword

By Sue Thomas

I've been working with writing and computers for over 20 years, and all that time I've been trying to figure out what this new technology really means. I've watched the computer evolve from a glorified typewriter to an incredible portal for the imagination in which writing is both multimodal and interactive. Through the lens of computers and the Web I have seen text take second place to image, sound, and video. I have seen writers and readers begin to view themselves not as isolated individuals but as members of a connected collaborative community. For 10 years I led such a group, the trAce Online Writing Community, which at its peak around the turn of the millennium had around 5,000 members in over 30 countries across the world.

Today, when I give talks about new media I like to include a clip from an old movie about even older movies—Singin in the Rain. Gene Kelly and Jean Hagen play a couple of romantic idols from the silent movies who find themselves under pressure to adapt to new media—in their case, sound. This 1952 film is set in the late 1920s just after the unexpected success of the first talkie *The Jazz Singer*. As readers will know, many silent film stars were left with ruined careers by the coming of the talkie. In Singin in the Rain, Hagen plays Lina Lamont, a beautiful and famous silent movie star whose voice, unfortunately, in no way matches her looks. Kelly is Don Lockwood, her onscreen romantic partner. Lockwood has a better voice but is still quite clueless about how to behave on a sound stage. The performers and crew muddle along with their hapless director as they try to adapt to the terrifying multimedia future, which has raced up on them like a giant wave and threatens to engulf everything in its path. In fact, the technical challenges of the talkies were enormous for everyone—actors, producers, and the crews, not to mention the audience itself, who at first did not really understand how to appreciate movies with sound. And of course that wasn't the beginning. Only a couple of decades earlier there had been no such thing as a movie audience anyway. In fact, there have always been new media and new skills to learn. But the stories we tell with them remain universal. For example, no matter which technology we use to recreate it, the story of Romeo and Juliet forever remains a tale of two star-crossed lovers.

But there does still seem to be something extra-different about the electronic age. All new technologies challenge popular prejudices, but in recent years fast-moving developments in digital entertainment media have forced audiences, authors, and industries to revise their opinions about what defines taste, value, skills, production, and distribution. The entire financial model upon which publishing and media industries have based their practice is being overturned,

and the ways in which artists and writers create work, and in which audiences consume it, are undergoing radical changes.

In short, we are having to learn to read and write all over again, and this has exposed a new kind of literacy—transliteracy. Transliteracy is not new—indeed it reaches back to the very beginning of culture—but it has only been identified as a working concept since the Internet allowed humans to communicate in ways that seem to be entirely novel. To be transliterate means to be able to read, write, and interact across a range of platforms, tools, and media from signing and orality through handwriting, print, TV, radio, and film, to digital social networks. The word is derived from the verb "to transliterate," meaning to write or print a letter or word using the closest corresponding letters of a different alphabet or language. Transliteracy extends the act of transliteration and applies it to the increasingly wide range of communication platforms and tools at our disposal. From early signing and orality through handwriting, print, TV, and film, to networked digital media, the concept of transliteracy calls for a change of perspective away from the battles over print versus digital and a move instead toward a unifying ecology not just of media but of all literacies relevant to reading, writing, interaction, and culture, both past and present. It is an opportunity to cross some very obstructive divides.

That's why this book is so important. It is not just an invaluable store of knowledge about the history of communication from the earliest days to the present, but it can also be read as a manual of transliteracy. The digital can be a daunting arena—so many unfamiliar concepts and words, so many skills to learn. Whether you are a producer, a writer, a teacher, or a consumer of digital storytelling, this volume will build your confidence, bring you up to date and, most importantly, introduce you to the drama and pleasure of enjoying stories in ways that are both entirely different from anything you have known before whilst at the same time feeling extraordinarily familiar. Carolyn Handler Miller's approach is informative and inspiring. I am indebted to a mutual friend, the artist Jack Ox, for introducing me to Carolyn via email when I was looking for guest lecturers for De Montfort University's online Master's degree in Creative Writing and New Media. Holding our classes in cyberspace means we can avail ourselves of the best teachers around the world, and it was our very good fortune that Carolyn agreed to work with our students. To date, though, our paths have never crossed in physical space. I very much hope that they do, and soon.

In 2004, Ken Goldstein ended his Foreword to the first edition of this important book with "we are still at the beginning." Well, it's almost 2008 and I think it's fair to say that we are still "still at the beginning." But what a fascinating, challenging, and mind-moving beginning it is turning out to be! May it go on and on.

Sue Thomas
Professor of New Media
De Montfort University, Leicester, England, October 2007
http://www.hum.dmu.ac.uk/~sthomas/

Preface

THE RAPIDLY CHANGING WORLD OF DIGITAL STORYTELLING

As the second edition of *Digital Storytelling: A Creator's Guide to Interactive Entertainment*, this book reflects how swiftly the arena of digital storytelling is growing and changing and how much still remains in flux. Even the way the term "digital storytelling" is defined is undergoing change. In fact, the online encyclopedia Wikipedia notes that "the definition of digital storytelling is still the subject of much debate," and calls it an "emerging term."

Some individuals and organizations consider digital storytelling to be a technique for relating personal, real-life stories—a form of first-person journalism, illustrated by various types of visual material. Others see it as an educational tool to teach multimedia literacy and narrative skills to schoolchildren and to excite them about learning. Still others, myself included, define the term digital storytelling in a broader, less specialized way and consider it to be the use of interactive digital technology to tell immersive and participatory stories. These stories can be works of fiction or nonfiction, and they can be geared for a general audience or for specialized groups. Furthermore, such stories can be intended solely for entertainment or can be utilized for pragmatic purposes, such as education, training, promotion, or information. But even when designed to serve pragmatic goals, works of digital storytelling always have elements of narrative and always offer some degree of entertainment.

This, then, is the perspective from which this edition of *Digital Storytelling* is written, and it is unchanged from the first edition. Very little else about the first and second editions have remained the same, however. In writing a new edition for a book, it is customary to revise or change about 20% of the content and leave about 80% unchanged. But for this book, the rapid pace of development in digital storytelling has caused this ratio to be turned on its head. Approximately 80% of the content is entirely new or substantially revised, while only about 20% is unchanged.

THE CONTENTS OF THIS EDITION

While the second edition includes many of the same topics as the first edition, though updated by new material, it includes a great many areas that did not even exist or were not yet perceived as forms of digital storytelling while the first edition was being written. It also includes discussions of how digital storytelling fits into the larger world of entertainment. Major new sections focus on

- · serious games;
- virtual worlds:
- · user-generated content;
- casual games;
- robots, androids, and animatronic characters;
- fulldome:
- · mixed or augmented reality;
- the impact of digital distribution on Hollywood entertainment.

In addition, this edition contains an entirely new section called *Harnessing Digital Storytelling for Pragmatic Goals*. This section includes chapters on using digital storytelling for teaching and training; for promotion, advertising, and other business purposes; and for information-based projects. Furthermore, this book includes a full chapter on the thriving arena of alternate reality gaming and a chapter on transmedia storytelling. And it greatly expands the chapters on character development, structure, mobile entertainment, and immersive environments.

THE ORGANIZATION OF THIS EDITION

This book is organized into five sections, each with a different function.

- PART ONE: NEW TECHNOLOGIES, NEW CREATIVE OPPORTUNITIES
 puts digital storytelling into a historic context, covers the development
 of digital media and the most recent developments in the field, and discusses the implications of convergence.
- PART TWO: CREATING STORY-RICH PROJECTS investigates some of the major concepts and tools of digital storytelling. It also examines transmedia storytelling and interactive entertainment for children. In addition, it gives a step-by-step description of the development process of a new media project.
- PART THREE: HARNESSING DIGITAL STORYTELLING FOR PRAGMATIC GOALS investigates how digital storytelling can be used effectively for teaching and training; advertising, promoting, and other business purposes; and as a vehicle for information.
- PART FOUR: MEDIA AND MODELS: UNDER THE HOOD is organized into chapters devoted to different types of digital storytelling (video games, the Internet, Massively Multiplayer Online Games, and so on) and deconstructs a number of new media projects, many of them seminal works of digital storytelling.
- PART FIVE: CAREER CONSIDERATIONS examines the career issues of being a digital storyteller and discusses how to go about creating one's own showcase.

Each chapter in the first four parts concludes with a feature called "Idea-Generating Exercises." These exercises are designed to put you, the reader, in the driver's seat and give you the chance to work with the concepts laid out in the chapter you just read.

Some of these exercises are modeled on ones I've used successfully with my students. Others are self-imposed mental workouts I've employed to stimulate my own creative juices. Still others were suggested to me by the subject matter of the chapters in which they are found as a tool to probe the material more deeply. At the end of the chapters in Part Five, the section on career issues, I have given some practical tips and suggestions instead of offering a set of ideagenerating exercises.

SOURCES AND PERSPECTIVE

As with the first edition, the material in this book is drawn from a number of sources: interviews; conferences that I have attended; information provided by industry groups, print and electronic publications; and material provided by content developers. In addition, researching this book called for many hours spent playing games, studying interactive movies and iTV shows, visiting websites, and interacting with smart toys—hardly an onerous task, and one that deepened my understanding of interactive entertainment.

Great pains have been taken to include an international cross section of examples of digital storytelling. The projects described in the book include works produced in North America, Europe, Asia, Australia, and Africa. Inevitably, however, this book is weighted toward projects made in the United States and Western Europe, since these are the parts of the world that I know best.

The projects described here include some of the most popular new media projects ever developed, as well as experimental works known only to a small circle of people. Some of these projects never even made it into production while others, though produced, failed to obtain commercial success. All of them, however, whether well-known or obscure, illustrate valuable concepts and offer important lessons to be learned.

I have inevitably brought my own experiences and perspective to this subject, and it is that of a writer and an active participant in the creative side of this field, not as an academic or as an expert on the technological aspects of digital storytelling. My primary goal is to investigate this field from a creator's point of view and to attempt to deconstruct the basic creative elements of an effective work of digital storytelling. I have approached this task both in a genre-agnostic way and in a genre-specific way.

My professional involvement in digital storytelling includes work as a writer, writer-content designer, or consultant on over 40 interactive projects. Some were designed for pure entertainment while others were made for more pragmatic purposes. They span many different types of interactive media and include a great variety of genres, including video games; Massively Multiplayer Online Games (MMOGs); interactive storybooks; webisodes and other types of content for the Internet; electronic kiosks; smart toys; and transmedia productions.

ADDITIONAL RESOURCES

As you are reading this book, I hope you will regard these pages as a starting place and continue to look around you for other good examples of digital story-telling. New projects are being launched at a dizzying pace. When you find one that intrigues you, analyze it closely and deconstruct it, referring to the concepts of interactive storytelling laid out in this book.

You can also find a large collection of additional material on the companion website that Focal Press and I have built for this book. It includes a great deal of material that could not be contained in this edition because of space limitations. In addition, it contains convenient links to online examples of digital storytelling and additional resources. The URL is: http://books.elsevier.com/companions/9780240809595, and I hope you will visit it.

You can also find updates on the field of digital storytelling on my own website, www.CarolynMiller.com. And if you have a question about something in this book or have an interesting project you would like to bring to my attention, please feel free to drop me a line at Carolyn@CarolynMiller.com.

XIV

Acknowledgments

The second edition of this book would not be what it is, and would not even have seen the light of day, without the help of a great many people. I owe them all a very heartfelt thank you.

I would first like to acknowledge the individuals who allowed me to conduct in-depth interviews of them about their innovative work in digital storytelling. They generously shared their ideas with me and put up with my seemingly endless stream of emails with follow-up questions. They include Bill Klein, Hue Walker, Mike Goslin, Elaine Raybourn, Richie Solomon, and Dave Szulborksi. Talking to them about their work, and gaining insights into their creative processes, was one of the great joys of writing this book.

I would also like to thank my technical advisor, Greg Roach, who carefully reviewed every word of the manuscript. He not only helped me stay on a straight path when it came to tricky technical matters, but he also brightened my workday with wonderful notes on nontechnical subjects—everything from Egyptian mystery plays to pithy quotes from George Bernard Shaw. He was an amazing and invaluable resource.

In addition, I would like to acknowledge the help of the individuals who reviewed my proposal for this second edition, mythologist Pamela Jaye Smith (http://www.mythworks.com) and game scholar Joris Dormans (http://www.jorisdormans.nl/home.php). Their feedback and suggestions were immensely helpful and played a meaningful role in shaping the development of this book.

My two editors at Focal Press, Georgia Kennedy and Dawnmarie Simpson, also deserve a special thank you. They have been a pleasure to work with and have made the process of writing this edition as light a burden as possible. I'd also like to thank my literary agent, Susan Crawford, for continuing to offer such warm support and assistance.

There are two special groups that I would also like to acknowledge: my students at the University of New Mexico and the individuals who attended my seminars and talks during the past few years. Their questions, comments, and occasional expressions of bafflement helped me articulate my concepts more clearly and dig more deeply into a number of areas. And it was a tremendously gratifying experience to kindle their interest in this new form of storytelling; it served to reconfirm my own fascination with it, and it reenergized me whenever I felt my spirits flagging.

ACKNOWLEDGMENTS

Finally, I would like to thank my husband, Terry, who was never too tired to act as a sounding board and supported me every step of the way. And, just to complete the acknowledgments on the domestic front, our cat, Willie, also deserves a word of thanks for sitting by my feet as I worked, keeping me company when it seemed as if everyone else in the world was fast asleep.

PART 1 New Technologies, New Creative Opportunities

Storytelling, Old and New

In what ways is digital storytelling like traditional forms of storytelling, and in what ways is it quite unique?

What ancient human activities can be thought of as the precursors of digital storytelling, and what can we learn from them?

What are the similarities between athletic games and digital storytelling, and why are they important?

What ideas can we find in classic literature, movies, and theatrical works that may have influenced digital storytelling?

STORYTELLING: AN ANCIENT HUMAN ACTIVITY

Storytelling is a magical and powerful craft. Not only can it transport the audience on a thrilling journey into an imaginary world, but it can also reveal the dark secrets of human behavior or inspire the audience with the desire to do noble deeds. Storytelling can also be pressed into service for other human goals: to teach and train the young, for example, or to convey important information. Although digital storytelling is humankind's newest way to enjoy narrative entertainment, it is part of this same great tradition.

Digital storytelling is narrative entertainment that reaches its audience via digital technology and media. One of its unique hallmarks is *interactivity*: backand-forth communications between the audience and the narrative material. Digital storytelling is a vast field. It includes video games, entertainment content for the Internet, and even intelligent toy systems and electronic kiosks—at least 11 major and very different areas in all. On the vast timetable of human achievements, this type of storytelling is a mere infant, only coming into being in the mid-twentieth century with the development of computer technology. As to be expected with something so young, it is still growing and evolving. Each new development in digital media—broadband, wireless signals, DVDs, virtual reality—sees a corresponding development in digital storytelling.

The biggest difference between traditional types of narratives and digital story-telling is that the content of traditional narratives is in an *analog* form, whereas the content in digital storytelling comes to us in a *digitized* form. Digital data is made up of distinct, separate bits: the zeroes and ones that feed our computers. Analog information, on the other hand, is continuous and unbroken. The oldest stories were conveyed by the human voice and actors; later, narratives were printed on paper; more recently, they were recorded on audiotape, film, or videotape. All these older forms are analogue.

To distinguish between these older forms of content and the computerized forms, people coined the term "new media." New media content includes the words and images we see on our computer screens, streaming audio and video, and material that comes to us on DVDs, CD-ROMs, video game consoles, and mobile phones. All of these forms are digital. The difference between analogue and digital can easily be seen by comparing an analog clock to a digital clock. An analog clock displays time in a smooth sweep around the dial, while a digital clock displays time in specific numerical increments of hours, minutes, and seconds.

Digital information can be stored easily, accessed quickly, and transferred among a great variety of devices. It can also be readily reassembled in an almost infinite number of ways, and thus it becomes a viable form of content for interactivity. The digitizing of content is what makes digital storytelling possible.

Yet, as new as digital storytelling is, it is part of a human tradition that stretches back to preliterate times. Furthermore, it has much in common with other forms of narrative: theatrical performances, novels, movies, and so on. (A narrative is simply an account of events that are interesting or exciting in some way; the word is

often used interchangeably with "story.") In essence, all stories have the same basic components. They portray characters caught up in a dramatic situation, depicting events from the inception of the drama to its conclusion. "Story," of course, does not necessarily mean a work of fiction, something that is makebelieve. Descriptions of things that happen in real life can be stories, too, as long as they are narrated in a dramatic manner and contain characters. Newspapers and TV news shows are major vehicles for nonfiction stories. And documentaries, which are long-form explorations of true events, are also stories.

Scientists believe that storytelling can be traced back to sometime in the Pleistocene age (1.8 million to about 11,000 years ago) and was developed as a critical survival tool. Manuel Molles, Professor Emeritus of Biology at the University of New Mexico, theorizes that storytelling was used to communicate important information about the environment, behavior of wildlife, and availability of food (from his paper *An Ecological Synthesis: Something Old, Something New*, delivered at a 2005 ecology conference in Barcelona).

HUMANS HARDWIRED TO TELL STORIES?

Dr. Daniel Povinelli, a psychologist from the University of Louisiana, has made some interesting observations about the origins of storytelling. Dr. Povinelli, who studies the differences between the intellect of humans and apes, believes that our species has an inborn impulse to connect the past, present, and future, and in doing so, to construct narratives. As reported in the *Los Angeles Times* (June 2, 2002), Dr. Povinelli believes that this ability gives humans a unique advantage. For example, it enables us to foresee future events based on what has happened in the past; it gives us the ability to strategize; and it helps us understand our fellow human beings and behave in a way that is advantageous to us.

INTERACTIVITY AND STORYTELLING

One of the things that distinguishes digital storytelling from classical storytelling is that members of the audience can become active players in the narrative and can even have a direct impact on it. Surprising as it may seem, however, interactive narrative experiences like this existed long before the invention of computers.

Some professionals in interactive media hypothesize that the earliest forms of interactive storytelling took place around the campfires of prehistoric peoples. I can remember this theory being enthusiastically touted back in the early 1990s, when the creative community in Hollywood was first becoming excited about the potential of interactive media. At almost every conference I attended at the time, at least one speaker would allude to these long ago campfire scenes. The prehistoric storyteller, according to this theory, would have a general idea of the tale he planned to tell but not a fixed plot. Instead, he would shape and mold the story according to the reactions of those gathered around him.

This model evokes an inviting image of a warm, crackling fire and comfortable conviviality. It was no doubt a reassuring scenario to attendees of these first interactive media conferences, many of whom were intimidated by computers and the concept of interactive media. But to me, this model never sounded particularly convincing. For one thing, how could anyone really know what took place around those smoky old campfires? And even if it were true that ancient storytellers constructed their tales to fit the interests of their listeners, how much actual control or participation in the story could these campfire audiences have had? At best, it would have been an extremely weak form of interactivity.

But no matter what one thinks of this campfire model, it is unquestionably true that a form of interactive stories—a far more profound and participatory form—dates back to extremely ancient times. According to the renowned scholar Joseph Campbell (1904–1987), one of the earliest forms of story was the myth, and storytellers did not merely recite these old tales. Instead, the entire community would reenact them in the form of religious rituals.

PARTICIPATORY DRAMAS

These ancient reenactments of myths were a form of participatory drama. Campbell and other scholars in the field have observed that the myths acted out by a community generally contained deep psychological underpinnings and that one of their most common themes was death and rebirth. Campbell noted that participants who took part in myth-based rituals often found the experience so intense that they would undergo a catharsis, a profound sense of emotional relief. (The word catharsis comes from the Greek *katharsis* and means purgation, or purification.)

In agrarian communities, these rituals would often commemorate the death of the earth (winter) and its joyous rebirth (spring). One such ritual, well known to scholars of Greek drama, was called the Festival of Dionysus. Celebrated twice annually throughout ancient Greece, these festivals were a ritual retelling of the myth of Dionysus, the Greek god of wine and fertility. (See Figure 1.1.) They not only depicted important events in the deity's life, but they were also closely connected to the cycle of seasons, particularly the death and rebirth of the grapevine, a plant closely associated with Dionysus.

While some details of the Dionysian rituals have been lost over time, a fair amount is still known about them. They involved singing and dancing and the playing of musical instruments. The male participants would dress as satyrs, drunken creatures who were half man and half goat (the goat being one of the animal forms associated with the god), while the women would play the part of maenads, the god's frenzied female attendants. In some Greek communities, the festival included a particularly bloodthirsty element—the participants would take a live bull (symbolizing another animal form of the god) and tear it apart with their teeth.

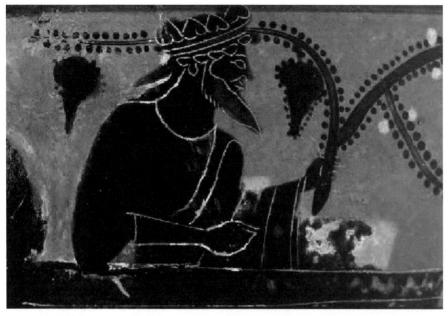

Figure 1.1 The Greek god Dionysus, pictured on this ancient vase (ca. 500 BC), was honored in intense ritual ceremonies that were an early form of interactive storytelling. Note the grapevine and clusters of grapes in the decoration: Dionysus was closely associated with grape cultivation and wine. Photograph by Maria Daniels, courtesy of University Museums, University of Mississippi.

Ultimately, these festivals evolved into a more sedate ceremony, the performance of songs called *dithyrambs* that were dedicated to Dionysus. These choral performances in turn evolved into classic Greek drama, both tragedy and comedy, which continued to retain the influence of the early rites. The word "tragedy," in fact, comes from the Greek word *tragoidia*, which means "goat song."

MYTHOLOGICAL SYMBOLISM AND DIGITAL STORYTELLING

The Greeks were by no means the only ancient community to reenact its myths in dramatic performances. The ancient Egyptians also held religious rituals based on their mythology. Over time, they evolved into staged performances, with actors playing the role of various gods. These early forms of drama actually predated Greek theatre. Campbell asserts that the reenactment of myths was a common element of all preliterate societies. Even today, in regions where old traditions have not been erased by modern influences, isolated societies continue to perform ceremonies that are rich in mythological symbolism.

One such group is the Dogon people of Mali, West Africa, who live in clay dwellings tucked into the steep cliffs of the Bandiagara Escarpment, not far from the Sahara desert. Because this region is so remote and relatively inaccessible, the Dogon have managed to preserve their ancient traditions and spiritual practices to this day. Many of the Dogon's beliefs are reenacted in elaborate dance ceremonies, during which participants don masks and full body costumes. Unlike dancers in Western culture, where troupes are made up

of a select few talented individuals who perform for an audience of nonparticipants, in Dogon society, every member of the community takes part in the dances put on by their clan.

One of the most dramatic of these ceremonies is the Sigui dance, which takes place just once every 60 years. It contains many of the elements that Joseph Campbell noted as being customary in important ritualistic ceremonies, such as a representation of death and a rebirth. In this case, the Sigui dance symbolizes the passing of the older generation and the rebirth of the Dogon people.

Although the actual ceremony is performed at such great intervals, every so often a version of it will be presented to visitors who make the difficult trek to the Dogon's cliff dwellings. Some years ago, I had the great privilege of witnessing the Sigui dance. It was an extraordinary sight to see the costumed dancers appear, as if from nowhere, and make their way into the center of the village where we waited. A number of them danced on stilts, making them as tall as giants and all the more impressive.

Each dancer plays a highly symbolic and specific role. Their masks and costumes represent important animals, ancestors, and spirit figures in their belief system. (See Figure 1.2.) In the eyes of the community, the dancers are more than mere human beings; each is an *avatar* for a mythological being or spirit—the embodiment or incarnation of an entity who is not actually present.

Odd though it may seem, the rituals performed by the Dogons and ancient Greeks have a great deal in common with modern day digital storytelling. After all, they involve the use of avatars; they are a form of role-play; participants interact with each other and work toward accomplishing a particular goal; and they play out scenes that have life and death significance. To me, these ritual reenactments are a far more intriguing model of interactivity than that of the old campfire stories.

FAMILIAR RITUALS AND DIGITAL STORYTELLING

Closer to home, and to our own lives, we can examine our own holidays and traditional religious practices and discover other surprising similarities to digital storytelling. These celebrations are often forms of participatory drama and contain items of important symbolic or mystical value, just as works of digital storytelling do. And in some cases, they are also *multisensory*. In other words, they involve the senses in a variety of ways.

The Jewish holiday of Passover is a particularly good example of this. Passover commemorates the exodus of Jews from Egypt and their liberation from the slavery imposed on them by the pharaoh. The traditional way to observe Passover is at a ceremonial meal called the Seder, where the dramatic story of exodus is recounted and recreated by the symbolic foods that are part of the ritual.

For example, one eats a flat unleavened bread called *matzo*, which recalls the bread hurriedly made during the exodus, when the escaping Jews had no time

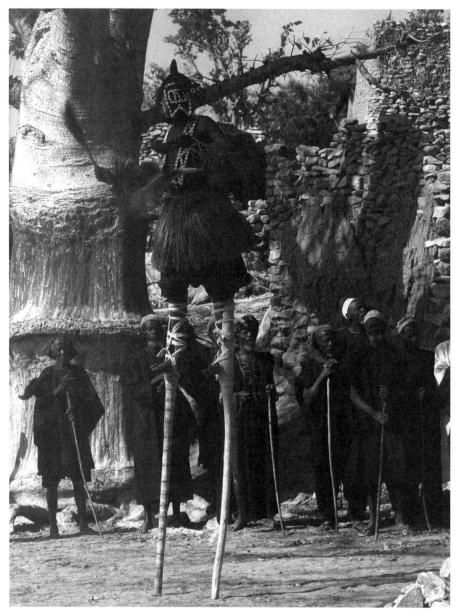

Figure 1.2 This Dogon dancer on stilts represents a female tingetange, or waterbird. Dogon dancers don masks and costumes to portray mythological beings or spiritual figures in much the same way as game players control avatars to play character roles in digital dramas. Photograph courtesy of Stephenie Hollyman.

to let their bread rise. One also eats a bitter herb called *maror* (customarily horseradish), which symbolizes the bitterness of slavery, together with *charoset*, a sweet chopped mixture of apples, nuts, and spices, which represents the mortar the Jews used to build the pyramids and also hints at the sweetness of freedom to come. These are among the many symbolic foods eaten during the ritual. And in addition to the foods consumed, a traditional Seder includes

another sensory element: the participants recline on pillows instead of sitting upright in chairs. This is a reminder of another aspect of the exodus story (through body position and the softness of the cushions): Once the Jews were liberated, they were free to eat like noble families, in a reclining position.

Many forms of digital storytelling are multisensory in this way, involving tactile feedback, aromas, motion, and other stimuli. The addition of multisensory components adds to the immersiveness and emotional power of works of digital storytelling.

HALLOWEEN AND DIGITAL STORYTELLING

Our yearly celebration of Halloween is just one of many Western holidays that bears some surprising similarities to digital storytelling. This holiday originated as a Celtic celebration called *Samhain*, and it marked the end of summer and the beginning of the dark half of the year. It was considered a time when the spirits of the dead might return and interact with those who were still living. Again, we have the recurring theme of death and rebirth found in so many other rituals. And though we might not be aware of what the holiday symbolized to ancient Celts, Halloween still retains reminders of death (skulls, skeletons, gravestones) and of the supernatural (ghosts, witches on broomsticks, zombies).

One of the most alluring aspects of Halloween is, of course, the opportunity to wear a costume. Just as in works of digital storytelling, we can take on a new role and "be" something we are not in real life. Halloween also gives us a chance to transition into a world that is quite different from our ordinary reality, a world filled with magic and the supernatural and spooky reminders of the afterlife. This ability to get a taste of another reality is something else we can do, thanks to digital storytelling.

RITES OF PASSAGE AND DIGITAL STORYTELLING

Joseph Campbell, the scholar who did the groundbreaking work on mythology, also noted that traditional myth-based rituals frequently reflected major life passages, such as a coming-of-age for young boys and girls. According to Campbell, the ceremonies held for boys typically required them to undergo a terrifying ordeal, during which they would "die" as a child and be reborn as an adult. Girls also went through coming-of-age ceremonies, he found, though they tended to be less traumatic.

Campbell discovered that cultures all over the world and across all cultures told myths about this universal coming-of-age experience, a type of mythology he analyzed in 1949 in his seminal work, *The Hero with a Thousand Faces*. This genre of myth is often referred to as the *hero's journey*. As we will see in Chapter 5, its core elements and recurring characters have been incorporated into many popular movies and, most importantly for us, the hero's journey has also served as a model for innumerable works of digital storytelling, particularly video games.

GAMES AND DIGITAL STORYTELLING

We can look back at a very different type of human activity and find another important precursor to digital storytelling: the playing of games. As we will see later in this book, many works of digital storytelling are either full-fledged games or include gamelike elements. And like rituals, games date back to ancient times and once served important functions.

The earliest games were developed not for idle amusement but for serious purposes: to prepare young men for the hunt and for warfare. By taking part in games, the youths would strengthen their bodies and develop athletic skills like running and throwing. By playing with teammates, they would also learn how to coordinate maneuvers and how to strategize. Over time, these athletic games evolved into formal competitions. Undoubtedly, the best known of these ancient sporting events are the Greek Olympic games. We can trace the Olympic games back to 776 BC, and we know they continued to be held for more than 1000 years.

Athletic competitions were also held in ancient Rome, India, and Egypt. In many old societies, these competitions served a religious function as well as being a form of popular entertainment. In Greece, for example, the games were dedicated to the god Zeus, and the athletic part of the program was preceded by sacred religious rites.

Religion and sporting games were even more intricately mixed in the part of the world that is now Mexico and Central America. The Olmecs, Mayans, and other peoples throughout Mesoamerica played a ball game somewhat like basketball. We now know this game had great spiritual and symbolic significance to them, and it was a central ritual in their culture. The game served as a conduit to the gods they believed dwelt beneath the earth and was a way of communicating with divine powers.

The game was played by two competing teams in an outdoor court marked by a set of high parallel walls. The players had to keep the ball in the air and could use any part of their body to do this except for their hands. As in a modern ball game, the two teams vied to lob the ball into a specific target to make a goal, in this case the target was a high stone ring. However, unlike modern ball games, once a goal was scored, the game ended, and so did the life of at least one of the players. Scholars still are debating whether this fate fell to the captain of the winning team or the losing team. They do agree, however, that the leader of one of the teams was ritually executed by decapitation and that this action was meant as a religious sacrifice to please their gods. Visitors to the excavated ball court at Chichén Itzá, in Mexico's Yucatán Peninsula, can still see a stone relief depicting the decapitation ceremony. (See Figure 1.3.)

Over 1500 years ago, all the way across the ocean in Asia, players faced each other in another athletic competition with deep spiritual significance. In this case, the country was Japan and the game was sumo. Sumo is closely tied to Japan's Shinto religion, and it symbolizes a legendary bout between two gods, a contest upon which the fate of the Japanese people rested. The Japanese emperor

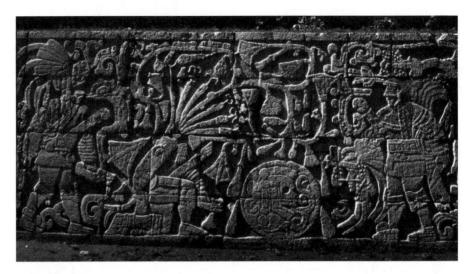

Figure 1.3

This carving at Chichén Itzá of a Mayan postgame decapitation ritual illustrates that games can play a deadly serious role in the spiritual life of a culture, and they can carry a deep symbolic meaning. The circle in the carving represents the ball, and the figure inside the ball is the skull of the decapitated player. Photograph courtesy of E. Michael Whittington, Mint Museum of Art, Charlotte, North Carolina.

himself is believed to be a descendent of the victor. As different as sumo and the Mesoamerican ball games are, they both illustrate that games can have intensely meaningful significance. The same can be true for the games found in works of digital storytelling, where game and narrative can be closely interconnected, and where the players can be enormously invested in achieving a positive outcome.

ANCIENT GAMES AND DIGITAL STORYTELLING

The sporting competitions that have come down to us from ancient times were inherently dramatic. Two opponents or two teams were pitted against each other, each attempting to achieve a victorious outcome for their side and to defeat their opponents. These old games contained many of the key elements that continue to be hallmarks of today's athletic games. Furthermore, they are also the distinguishing characteristics of the gameplay found in many works of digital storytelling. Sporting competitions as well as many works of digital storytelling are

- · dramatic and exciting;
- · full of action;
- · intensely competitive;
- · demanding of one's skills, either physical or mental;
- regulated by specific rules;
- · clearly structured, with an established way of beginning and ending;
- played to achieve a clear-cut goal; in other words, to succeed at winning, and to avoid losing.

Board Games and Digital Storytelling

Athletic competitions are not the only type of game that has come to us from ancient times and that have strong similarities to many works of digital storytelling.

Board games dating back to 2700 BC have been found in the temples of the Egyptian pharaohs. They were also highly popular in ancient China, Japan, and Korea, and the people of India played chess and card games thousands of years ago. According to mythologist Pamela Jaye Smith of MYTHWORKS, some board games were used in ancient and premodern times to train players in strategy and diplomatic skills. She cites chess as a prime example of this, saying they called for "the need to analyze the other player's move, to think three, four or more moves down the line, to recognize feint, and to know when and how to make sacrifices." The ancient Chinese board game of go is another game that demands strategic skills.

Another type of game, distantly related to board games, are tabletop war games. The earliest forms of such games were war game simulations developed in the eighteenth and nineteenth centuries. These games were used to train officers in strategy, and they were typically played on tabletops with miniature soldiers made of metal. (See Figure 1.4.) In the latter part of the twentieth century, games like these, married to elements of improvisational theatre, morphed into computerized role-playing games.

Many board games involve a mixture of skill and luck, and the element of chance is one of the things that makes them particularly enjoyable. The draw of a wild card or the throw of the dice can dramatically change one's fortunes, Also, many

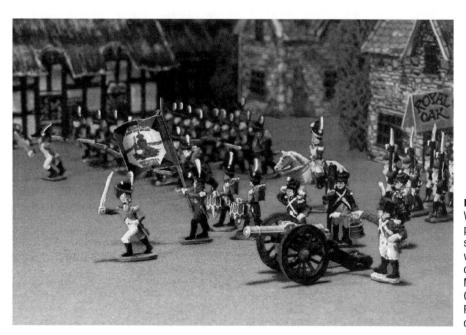

Figure 1.4 War game simulations played with miniature soldiers like these were the precursors of today's Massively Multiplayer Online Games (MMOGs). Photograph courtesy of Lloyd Pentacost.

people are attracted to board games primarily because of the social interactions that are a major part of the experience. And although board games can be competitive, they offer a safer, less stressful playing environment than athletic games. And these are all features that attract players to works of digital storytelling as well.

Children's Games and the "Fun Factor"

In addition to the structured games played by adults, children in every era and every culture have played games of all sorts. Many of them are more free-flowing and less formalized than adult games. Children's pastimes range from "quest" games, like hide-and-seek, to games that are more social in nature, like jump rope, to games of skill, like jacks. Children also enjoy make-believe activities like fantasy role-play. Two old favorites, for example, are cowboys and Indians and cops and robbers.

Even adults engage in fantasy role-playing activities, as evidenced by the popular Renaissance Faires, which are elaborate reconstructions of Elizabethan England, complete with jousting, a royal court, and someone playing the part of Queen Elizabeth I. Many attendees come to these faires dressed in period costumes and attempt to speak in Elizabethan English.

Fantasy role-play activities are not strictly games because they are not competitive in nature. They also don't follow a fixed set of rules or have a clear-cut end goal. But though they differ from more formalized games, the two pursuits have an important element in common: Both activities are experienced as "play." In other words, people engage in these activities for pleasure, and they perceive them as fun.

The expectation of having fun is one of the primary reasons that both adults and children have traditionally engaged in games and other play activities. This continues to be true in contemporary society, even when the playing is done on game consoles or computers instead of on a ball field or in a school yard. The importance of this fun factor was underscored in a survey that was conducted a few years ago by the Entertainment Software Association, a professional organization for publishers of interactive games. In the survey, game players were asked to name their top reason for playing games. Over 85% said they play games because they are fun.

NONLINEAR FICTION BEFORE THE COMPUTER

Traditional entertainment, especially material that is story based, is almost always *linear*. In other words, one event follows another in a logical, fixed, and progressive sequence. The structural path is a single straight line. Interactive works, on the other hand, are always *nonlinear*. Plot points do not necessarily follow each other in fixed sequence, and even when interactive works do include a central storyline, players or users can weave a varied path through the material, interacting with it in a highly fluid manner.

Storytelling, Old and New CHAPTER 1

Nevertheless, a few innovative individuals working in long-established media—printed fiction, the theatre, and more recently in motion pictures—have attempted to break free of the restrictions of linearity and have experimented with other ways of presenting story-based material.

One of the first was Laurence Sterne, author of the novel *The Life and Opinions of Tristram Shandy, Gentleman*. The nine-volume work was published between 1759 and 1766, not long after the first English novels were introduced to the public. In *Tristram Shandy*, Sterne employs a variety of unconventional ways of presenting the narrative flow, starting down one story path only to suddenly switch over to an entirely different one, and then a short while later turning down still another path. He also played with the sequence of chapters, taking chapters that had allegedly been misplaced and inserting them seemingly at random into the text. Sterne asserted that such unexpected narrative digressions were the "sunshine" of a novel and gave a book life.

Several mid-twentieth century authors also experimented with nonlinear narrative. William Burroughs caused something of a sensation when he introduced his "cut up" works, in which he took text that he had cut into fragments and reassembled it in a different order. He believed that these rearrangements enabled new meanings to emerge. His technique was akin to the making of collages in the art world—works composed of bits of assorted materials.

As for the brilliant modern author James Joyce, many now consider his novels to be a precursor of *digital hypertext*, where words are linked to other related "assets," such as photographs, sounds, video, or other text. The user who takes advantage of these links is rewarded by a deeper experience than would have been possible by following a simple linear thread. Joyce, particularly in his sweeping novels *Ulysses* and *Finnegan's Wake*, used a similar technique of associations, allusions, word pictures, and auditory simulations, though all on paper and within the covers of his novels. Entire websites are now devoted to the topic of the hypertext aspects of Joyce's work.

Joyce died in 1941, long before the development of modern computers, but contemporary writers are now using digital technology to compose short stories and novels utilizing hypertext. Their works are available online, and electronic books are published by several companies. Most prominent among them is Eastgate, an evangelist for serious works of hypertext.

But dropping back for a moment to books that are printed the old-fashioned way, on paper, another example of interactive narrative should be mentioned: a series of books introduced in 1979. Going under the general heading of *Choose Your Own Adventure*, and primarily written for the children's market, these unusual books actually presented a form of interactive fiction. At various points in the novel, the narrative would pause and the reader would be offered a number of different ways to advance the story, along with the page number where each option could be found. Many of these books offered dozens of alternate endings. Do these novels sound a little like works of digital storytelling with

branching story lines? Well, not surprisingly, this type of structure has been used in many interactive narratives, as we will see.

NONLINEAR DRAMA IN THEATRE AND MOTION PICTURES

Writers and directors of plays and motion pictures have also experimented with nonlinear methods of telling stories. The Italian playwright Luigi Pirandello (1867–1936) wrote a number of plays that probed the line between reality and fiction. His plays deliberately broke the *fourth wall*, the invisible boundary that separates the audience from the characters on stage and divides reality (the audience side) from fiction (the characters' side). In his play *Six Characters in Search of an Author*, Pirandello breached the wall by having actors in an uncompleted play talk and refer to themselves as if they were real people. They fretted about the need to find a playwright to "complete" their plot lines, or lives. Pirandello won the Nobel Prize in literature in 1934 for his groundbreaking work, and his dramas influenced a number of other playwrights, including Samuel Beckett and Edward Albee.

Pirandello's boldness at smashing the fourth wall is also echoed in Woody Allen's film, *The Purple Rose of Cairo*. In this picture, Mia Farrow plays the part of a woebegone filmgoer with a passionate crush on a character in a movie (played by Jeff Daniels). Much to her astonishment and delight, her film hero speaks to her as she sits in the audience watching the movie, and he even steps out of the screen and into her life.

This breaking of the fourth wall, while relatively unusual in the theatre and in movies, is a common occurrence in interactive media. Video game characters address us directly and invite us into their cyber worlds; fictional characters in Web-based stories and games send us emails and faxes and even engage in instant messaging with us; smart toys joke with us and remember our birth-days. This tunneling through of the fourth wall intimately connects us with a fictional universe in a way that is far more personal than was ever possible in older media.

Another revolutionary technique that first appeared in theatre and films, and was later employed more fully in interactive entertainment, is the use of multiple pathways or points of view. The play *Tamara*, written by John Krizanc, utilized a multiple pathway structure, and it created quite a stir in Los Angeles in the 1990s. Instead of being performed in a theatre, *Tamara* was staged in a large mansion, and multiple scenes were performed simultaneously in various rooms. Members of the audience had to choose which scenes to watch (which they did by following characters from room to room); it was impossible to view everything that was going on during a single performance.

Tamara had a direct influence on the producers of the CD-i (Compact Discinteractive) mystery game Voyeur. Like the play, the game also made use of

multiple pathways. It, too, was set in a mansion with many rooms, and simultaneous action occurred throughout the mansion. But as a player, you could look through only one window of the mansion at a time (much like a member of the *Tamara* audience, who could only observe the action in a single room at a time). To successfully play the game, you had to select a sequence of windows to peer through that would give you sufficient clues to solve the mystery.

Writers and directors of feature films have also experimented with narrative perspective. One notable example is the Japanese film *Rashomon*, made in 1950 by the renowned director–screenwriter Akira Kurosawa. *Rashomon* is the story of a woman's rape and a man's murder, but what made the film so striking was not its core story but Kurosawa's use of multiple points of view. The story is told in flashback by four different characters, each of whom was a witness to the crimes, but each giving a different version of what really happened. In the end, we are not told which is the "correct" version; we are left to puzzle out which person's perspective is the most plausible. Kurosawa's concept of offering multiple points of view has been borrowed by a number of works of interactive cinema, as we will see later in the book.

The American film director Robert Altman often uses another narrative approach, that of multiple overlapping and interconnecting storylines. *Nashville* and *Gosford Park* are two of his films that do this. A viewer watching them has the impression of multiple events occurring simultaneously and sometimes wishes for the freedom offered by interactive media to jump from one storyline to another.

THE SPECIAL CHARACTERISTICS OF DIGITAL STORYTELLING

As we can see from the various examples we've examined here, ranging from ancient rituals to twentieth century films, many of the techniques that are characteristic of today's digital storytelling can actually be found in far earlier forms of storytelling and other human activities. Yet, thanks to computer technology, we can incorporate these techniques into interactive stories in a much more fluid and dynamic fashion to give us quite a new way to experience narrative.

Let's now take a look at the special characteristics of digital storytelling to see what makes it unique as a form of narrative. Some of these characteristics have already been mentioned, and some will be discussed later in the book.

Works of digital storytelling are always

- types of narratives: they involve a series of connected dramatic events that serve to tell a story;
- works that contain characters, including types of characters found only in digital media: characters controlled by the user or by the computer, and synthetic characters with the appearance of *artificial intelligence* (*AI*);

PART 1 New Technologies, New Creative Opportunities

- interactive: the user controls, or impacts, aspects of the story;
- nonlinear: events or scenes do not occur in a fixed order; characters are not encountered at fixed points;
- deeply immersive: they pull the user into the story;
- participatory: the user participates in the story;
- navigable: users can make their own path through the story or through a virtual environment.

Works of digital storytelling often

- break the fourth wall: the user can communicate with the characters; the fictional characters behave as if they are real people;
- blur fiction and reality;
- include a system of rewards and penalties;
- use an enormous narrative canvas, tying together multiple media to tell a single story;
- may be multisensory;
- attempt to incorporate some form of artificial intelligence (AI);
- allow users to create and control avatars;
- offer a shared community experience;
- manipulate time and space (contracting or expanding time; allowing users to travel enormous virtual distances);
- put users through a series of challenges and tests (modeled on rites of passage and the hero's journey);
- offer opportunities to change points of view, either seeing the story from the vantage point of different characters or by changing the visual point of view;
- · include overt and nonovert gaming elements such as
 - clear cut objectives: to score points or to win;
 - high stakes;
 - governed by a clear set of rules;
 - demanding high skill level;
 - played within a defined space;
 - elements of risk;
 - set within a specific time frame;
 - requiring the use of strategy;
 - calling for team play;
 - requiring the overcoming of obstacles and dealing with opponents;
 - requiring players to wear elaborate uniforms that alter their appearance;
- include elements of play such as
 - experienced as pleasurable, as fun, rather than as work;
 - very loosely structured; no formalized set of rules;
 - involves a degree of chance or the unexpected;
 - offers opportunities for interactions with other people (social experiences);
 - may be set in a fantasy environment or call for fantasy role-play.

CLASSIC STORYTELLING AND DIGITAL STORYTELLING: IMPORTANT DIFFERENCES

While digital storytelling shares many characteristics with other forms of narratives, such as plays, novels, movies, and news stories, there are important differences as well.

Traditional Stories

- Are preconstructed; story elements cannot be changed
- Have a linear plot; they are usually told in linear fashion
- · Author/writer is sole creator
- · Are experienced passively
- · Have one unchangeable ending

Works Of Digital Storytelling

- Are malleable; they are not fixed in advance
- · Are nonlinear, nonchronological
- The user cocreates the story
- Are experienced actively
- · Different outcomes are possible

CONCLUSION

As we have seen, two extremely old forms of social interaction—rituals and games—were two of the major precursors to digital storytelling. Despite the obvious differences between the activities that have come down to us from ancient times and today's computerized narratives, rituals and games help to define some of the critical components of this new form of storytelling.

Namely, they are interactive; they are participatory; they facilitate role-play; they are dramatic; and they are deeply immersive. In addition, the type of myth known as the hero's journey has served as a direct model for works of digital storytelling. But there is another significant aspect of rituals and games that has not yet become part of most works of digital storytelling: These ancient human activities aroused intense emotions in those who participated in them. Ancient rituals were capable of producing a powerful feeling of catharsis, or emotional release, in the participants, and communities that played ancient games felt a profound sense of being connected to the divine. In fact, this ability to elicit strong emotions is a characteristic of all classic narratives. The emotional potential of digital storytelling, however, is still largely untapped, waiting for a Shakespeare or a Sophocles of this new form of narrative to take it to a higher level.

IDEA-GENERATING EXERCISES

- **1.** What traditional ritual have you participated in, or are aware of, that reminds you in some way of an interactive narrative? What is it about this ritual that you think is like a work of digital storytelling?
- **2.** Think of a time when you wore a costume or engaged in some form of role-play that did not make use of electronic technology. Describe the experience and how it made you feel. How do you think it was similar

- to or different from the role-playing that occurs in works of digital storytelling?
- **3.** Take a fictional character from a movie, TV show, or novel and list some ways that hypertext could be used to give a fuller picture of this individual
- **4.** Can you think of any work of traditional entertainment (poem, short story, novel, play, movie, TV show, etc.) that breaks the fourth wall? Describe how the fourth wall is broken in this work. Could the fourth wall be broken in a similar way in an interactive work? Why or why not?

Backwater to Mainstream: The Growth of Digital Entertainment

How did international conflicts spur the development of modern computers and the Internet?

What challenges do people face when creating content for a new medium?

Who was a more likely candidate to invent the first computer game: a physicist working with an oscilloscope or a teenage kid fooling around on a PC?

What effect is digital media having on traditional forms of entertainment like movies and TV?

AN EXTREMELY RECENT BEGINNING

The development of the modern computer gave birth to a brand new form of narrative: digital storytelling. Sometimes it is difficult to keep in mind that even the oldest types of digital storytelling are quite recent innovations, especially when compared to traditional entertainment media, like the theatre, movies, or even television. For instance, the first rudimentary video game wasn't even created until the late 1950s, and two more decades passed before the first form of interactive storytelling for the Internet was developed. Most other types of digital storytelling are much more recent innovations. Thus, we are talking about a major new form of narrative that is barely half a century old.

While today's children have never known a world without computers or digital entertainment, the same is not true for middle-aged adults. Individuals who were born before the 1960s grew up, went to college, and got their first jobs before computers ever became widely available. As for today's senior citizens, a great number of them have never even used a computer and frankly aren't eager to try. Almost certainly, though, they have taken advantage of computerized technology embedded in familiar devices, from microwaves to ATM machines to home security systems.

A BRIEF HISTORY OF THE COMPUTER

While computers are newcomers to our world, only having been introduced in the middle of the twentieth century, the conceptual roots of computer technology date back to antiquity. Historians of information technology often point to the use of the abacus, the world's oldest calculating tool, as being the computer's original starting place. They believe that the Chinese, the Babylonians, and the Egyptians used various forms of the abacus as long ago as 3000 BC. It was the first implement in human history to be employed for mathematical computations.

Thousands of years later, in the late nineteenth century, humans moved one step closer to modern computer technology. In 1890, Herman Hollerith and James Powers invented a machine that could perform computations using punch card technology. Their machine was designed to speed up computations for the U.S. Census Bureau.

Punch card machines like this became the computing workhorses of the business and scientific world for half a century. The outbreak of World War II, however, hastened the development of the modern computer, when machines were urgently needed that could swiftly perform complex calculations. Several competing versions were developed. While there is some debate over which machine was the world's first all electronic computer, the majority of historians believe the honor should go to the ENIAC (Electronic Numeric Integrator and Computer). This electronic wonder was completed in 1946 at the University of Pennsylvania. It could perform calculations about 1000 times faster than the previous generation of computers. (See Figure 2.1.)

Despite the ENIAC's great speed, however, it did have some drawbacks. It was a cumbersome and bulky machine, weighing 30 tons, taking up 1800 square feet

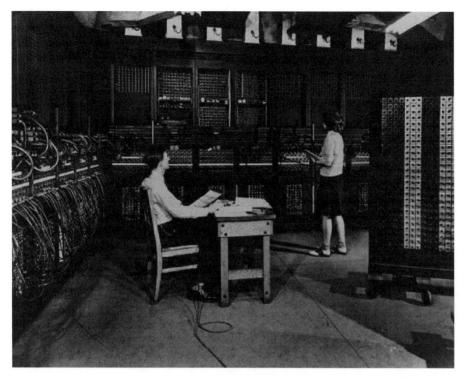

Figure 2.1
The ENIAC, completed in 1946, is regarded as the world's first high-speed electronic computer, but it was a hulking piece of equipment by today's standards.
Photograph courtesy of IBM Corporate Archives.

of floor space, and drawing upon 18,000 vacuum tubes to operate. Furthermore, though it was efficient at performing the tasks it had been designed to do, it could not be easily reprogrammed.

During the three decades following the building of the ENIAC, computer technology progressed in a series of rapid steps, resulting in computers that were smaller and faster, had more memory, and were capable of performing more functions. Concepts such as computer-controlled robots and artificial intelligence (AI) were also being articulated and refined. By the 1970s, computer technology developed to the point where the essential elements could be shrunk down in size to a tiny microchip, meaning that a great number of devices could be computer enhanced. As computer hardware became smaller and less expensive, personal computers (PCs) became widely available to the general public, and the use of computers accelerated rapidly through the 1970s and 1980s. It wasn't long before computer technology permeated everything from children's toys to supermarket scanners to household telephones.

THE BIRTH OF THE INTERNET

As important as the invention of the computer is, another technological achievement also played a critical role in the development of digital storytelling: the birth of the Internet. The basic concept that underlies the Internet—that of connecting computers together to allow them to send information back and

forth even though they are geographically distant from one another—was first sketched out by researchers in the 1960s. This was the time of the cold war, and such a system, it was believed, would help facilitate the work of military personnel and scientists who were working on defense projects at widely scattered institutions. The idea took concrete shape in 1969 when the U.S. Department of Defense commissioned and launched the Advanced Research Project Agency Net, generally known as ARPANET.

Although originally designed to transmit scientific and military data, people with access to ARPANET quickly discovered they could also use it as a communications medium, and thus electronic mail (email) was born. And in 1978 there was an even more important discovery from the point of view of digital storytelling: Some students in England realized that electronic networks could be harnessed as a medium of entertainment, inventing the world's first text-based role-playing adventure game for it. The game was a MUD (Multi-User Dungeon or Multi-User Domain or Multi-User Dimension), the forerunner of today's enormously popular Massively Multiplayer Online Games (MMOGs).

In 1982, Vint Cerf and Bob Kahn designed a new protocol for ARPANET. A protocol is a format for transmitting data between two devices, and theirs was called TCP/IP, or Transmission Control Protocol/Internet Protocol. Without it, the Internet could not have grown into the immense international mass-communication system it has become. The creation of TCP/IP is so significant that it can be regarded as the birth of the Internet.

In 1990, the Department of Defense decommissioned ARPANET, leaving the Internet in its place. And by now, the word "cyberspace" was frequently being sprinkled into sophisticated conversations. William Gibson first coined the word in 1984 in his sci-fi novel, Neuromancer, using it to refer to the nonphysical world created by computer communications. The rapid acceptance of the word "cyberspace" into popular vocabulary was just one indication of how thoroughly electronic communications had managed to permeate everyday life.

Just one year after ARPANET was decommissioned, the World Wide Web was born, created by Englishman Tim Berners-Lee. Berners-Lee recognized the need for a simple and universal way of disseminating information over the Internet, and in his efforts to design such a system, he developed the critical ingredients of the Web, including URLs, HTML, and HTTP. This paved the way for new forms of storytelling and games on the Internet. The Internet's popularity has continued to zoom upward all over the globe, reaching a total of 747 million users in 2007.

THE FIRST VIDEO GAMES

Just as the first online game was devised long before the Internet was an established medium, the first video games were created years before personal computers became commonplace. They emerged during the era when computer technology was still very much the domain of research scientists, professors, and a handful of graduate students.

THE WORLD'S FIRST VIDEO GAME

Credit for devising the first video game usually goes to a physicist named Willy Higinbotham, who created his game in 1958 while working at the Brookhaven National Laboratory in Upton, New York. His creation, *Tennis for Two*, was, as its name suggests, an interactive ball game, and two opponents would square off to play it. In an account written over 20 years later and posted on a U.S. Department of Energy website (www. osti.gov), Higinbotham modestly explained that he had invented the game to have something interesting to put on display for his lab's annual visitor's day event. The game was controlled by knobs and buttons and ran on an analog computer. The graphics were displayed on a primitive-looking oscilloscope, a device normally used for producing visual displays of electrical signals. It was hardly the sort of machine one would associate with computer games. Nonetheless, the game was a great success. Higinbotham's achievement is a vivid illustration of human ingenuity when it comes to using the tools at hand.

A game called *Spacewar*, although not the first video game ever created, was the most direct antecedent of today's commercial video games. *Spacewar* was created in the early 1960s by an MIT student named Steve Russell. Russell, working with a team of fellow students, designed the game on a mainframe computer. The two-player game featured a duel between two primitive-looking spaceships, one shaped like a needle and the other like a wedge. It quickly caught the attention of students at other universities and was destined to be the inspiration of the world's first arcade game, though that was still some 10 years off.

In the meantime, work was going forward on the world's first home *console games*. The idea for making a home console game belongs to Ralph Baer, who came up with the revolutionary idea of playing interactive games on a TV screen way back in 1951. At the time, he was employed by a television company called Loral, and nobody would take his idea seriously. It took him almost 20 years before he found a company that would license his concept for a console, but finally, in 1970, Magnavox stepped up to the plate. The console, called the Magnavox Odyssey, was released in 1972, along with 12 games. The console demonstrated the feasibility of home video games and paved the way for further developments in this area.

At just about the same time as the console's release, things were moving forward in the development of arcade games. Nolan Bushnell and Ted Dabney, the future founders of Atari, created an arcade version of *Spacewar*, the game that had been made at MIT, and released it in 1971. Their game, *Computer Space*, was the first arcade game ever, but it was a failure, reportedly because people found it too hard to play. Dabney lost faith in the computer game business and he and Bushnell parted company. Bushnell, however, was undaunted. He went on to produce an arcade game called *Pong*, an interactive version

of ping-pong, complete with a ponging sound when the ball hit the paddle. Released in 1972, the game became a huge success. In 1975, Atari released a home console version of the game, and it too was a hit.

Pong helped generate an enormous wave of excitement about video games. A flurry of arcade games followed on its heels, and video arcade parlors seemed to spring up on every corner. By 1981, less than 10 years after *Pong* was released, over 1.5 million coin-operated arcade games were in operation in the United States, generating millions of dollars.

During the ensuing decades, home console games similarly took off. Competing brands of consoles, with ever more advanced features, waged war on each other. Games designed to take advantage of the new features came on the market in steady numbers. Of course, console games and arcade games were not the only form of interactive gaming in town. Video games for desktop computers, both for the PC and Mac, were also being produced. These games were snapped up by gamers who were eager for exciting new products.

THE DEVELOPMENT OF OTHER IMPORTANT INTERACTIVE PLATFORMS

Not counting the great variety of video game consoles, four other significant platforms were introduced during the 20 years between the late 1970s and the late 1990s. All of these technologies—laser discs, CD-ROMs, CD-is, and DVDs—were used as vehicles for interactive narratives, some more successfully than others.

Laser Discs

Laser discs, also called video discs, were invented by Philips Electronics and made available to the public in the late 1970s. The format offered outstandingly clear audio and video and was easy to use. Consumers primarily used laser discs for watching movies, while its interactive capabilities were more thoroughly utilized in educational and corporate settings.

The laser disc's potential as a vehicle for pure interactive fun came into full bloom in the arcade game *Dragon's Lair*, released in 1983. The game not only fully exploited the capabilities of laser disc technology but also broke important new ground for video games. Unlike the primitive graphics of other games up until then, *Dragon's Lair* contained 22 minutes of vivid animation. It also had a far more developed storyline than the typical "point and shoot" arcade offerings. As a player, you had the heady experience of "becoming" the hero of the story, the knight Dirk the Daring, and as Dirk, you had a dangerous mission to fulfill: to rescue Princess Daphne from a castle full of monsters. The game was an entertainment phenomenon unlike anything seen to date. So many people wanted to play it that arcade machines actually broke down from overuse.

CD-ROMs

CD-ROMs (for Compact Disc-Read Only Memory) were introduced to the public in 1985, a joint effort of Philips and Sony, with prototypes dating back to 1983. These little discs could store a massive amount of digital data—text, audio, video, and animation—which could then be read by a personal computer. Prior to this, storage media for computer games—floppy discs and hard discs—were far more restrictive in terms of capacity and allowed for extremely limited use of moving graphics and audio.

In the early 1990s, the software industry began to perceive the value of the CD-ROM format for games and edutainment (a blend of education and entertainment). Suddenly, these discs became the hot platform of the day, a boom period that lasted about five years. Myst and The Seventh Guest were two extremely popular games that were introduced on CD-ROMs, both debuting in the early 1990s. It also proved to be an enormously successful format for children's educational games, including hits like the Carmen Sandiego and Putt-Putt series, Freddie Fish, MathBlaster, The Oregon Trail, and the JumpStart line.

The success of the CD-ROM as a platform for games was largely due to its ability to combine story elements with audio and moving visuals (both video and animation). Even professionals in Hollywood started to pay attention. intrigued with its possibilities, and hoping, as one entrepreneur put it back then, "to strike gold in cyberspace."

Unfortunately, CD-ROMs went through a major downturn in the second half of the 1990s, caused in part by the newest competitor on the block, the Internet. Financial shake-ups, mergers, and downsizing within the software industry put the squeeze on the production of new titles, and many promising companies went out of business. Despite this painful shake-up, however, CD-ROMs have remained a major platform for delivering games, education, and even corporate training, along with DVDs and the Internet.

CD-is

The CD-i (Compact Disc-interactive) system was developed jointly by Philips and Sony and was introduced by Philips in 1991. Termed a "multimedia" system, it was intended to handle all types of interactive genres, and it was the first interactive technology geared for a mass audience. The CD-i discs were played on special devices designed for the purpose and connected to a TV set or color monitor. The system offered high quality audio and video and was extremely easy to use.

Although CD-ROMs were already out on the market at the time CD-is came along, the new platform helped spur significant creative advances in interactive entertainment, in part because Philips was committed to developing attractive titles to play on its new system. Among them was Voyeur, a widely heralded interactive movie-game hybrid.

DVDs

DVD technology was introduced to the public in 1997, developed by a consortium of 10 corporations. This group, made up of major electronics firms, computer companies, and entertainment studios, opted to pool their resources and work collaboratively, rather than to come out with competing products, a practice that had led to the demise of prior consumer electronics products. In a few short years, the DVD became the most swiftly adopted consumer electronics platform of all time.

The initials DVD once stood for "Digital Video Disc," but because the format could do so much more than store video, the name was changed to Digital Versatile Disc. The second name never caught on, however, and now the initials themselves are the name of the technology.

DVD technology is extremely robust and versatile. The quality of the audio and video is excellent, and it has a far greater storage capacity than either CD-ROMs or laser discs. While primarily used to play movies or compilations of television shows, it is also used as a platform for original material, including interactive dramas and documentaries. (For more on DVDs, please see Chapter 23.)

Less Familiar Forms of Interactive Entertainment

As we will see in future chapters of this book, a number of other important technologies and devices are employed for digital storytelling, and new ones are introduced on a frequent basis. Some platforms for interactive narrative are extremely familiar to the general public and are highly popular—such as video game consoles and the Internet—while others, such as interactive television, have been slower to catch on. We will be exploring both the highly popular forms and the less familiar forms throughout this book.

THE EVOLUTION OF CONTENT FOR A NEW MEDIUM

As we have seen, digital storytelling is an extremely new form of narrative, and it has only had a very brief period of time to develop. The first years of any new medium are apt to be a rocky time, marked by much trial and error. The initial experiments in a new field don't always succeed, and significant achievements are sometimes ignored or even ridiculed when first introduced.

THE EARLY DAYS OF A NEW MEDIUM

The very first works produced for a new medium are sometimes referred to as *incunabula*, which comes from the Latin word for cradle or swaddling clothes, and thus means something still in its infancy. The term was first applied to the earliest printed books, those made before 1501. But now the term is used more broadly to apply to the early forms of any new medium, including works made for various types of digital technology.

When creating a work for a brand new medium, it is extremely difficult to see its potential. People in this position must go through a steep learning curve to discover its unique properties and determine how they can be used for narrative purposes. To make things even more challenging, a new technology often has certain limitations, and these must be understood and ways must be found to cope with them. Creating works for a new medium is thus a process of discovery and a great test of the imagination.

Typically, projects created for a new medium go through an evolution, with three major steps:

- **1.** The first step is almost always *repurposing*, which is the porting over materials or models from older media or models, often with almost no change. For instance, many early movies were just filmed stage plays, while in digital media, the first DVDs just contained movies and compilations of TV shows, and many of the first CD-ROMs were digital versions of already existing encyclopedias.
- **2.** The middle step is often the adaptation approach, or a spin-off. In other words, an established property, like a novel, is modified somewhat for a new medium, like a movie. Producers of TV series have been taking this approach with the Internet by creating *webisodes* (serialized stories for the Web) and *mobisodes* (serialized stories for the mobile devices) based on successful TV shows.
- **3.** The final and most sophisticated step is the creation of totally original content that makes good use of what the new medium has to offer and does not imitate older forms. For example, the three-camera situation comedy is a unique genre that takes full advantage of the medium of television. The same can be said of the MMOG, which takes full advantage of the opportunities offered by the Internet.

Developing works for digital media has presented challenges never faced before by the creative community. For example, how could you tell a story using interactivity and a nonlinear structure? And how would the user be made aware of the interactivity and know how to use it?

THE PROFOUND IMPACT OF DIGITAL MEDIA

Since the days when it was first called ARPANET, the Internet has matured as a major medium of distribution. A critical mass of users now has broadband connectivity, making it possible to receive and send large quantities of audio and video. Users can download and watch episodes of TV series on their computers and even watch entire feature length movies, not to mention the wealth of shorter pieces of video and animation that are so abundant on the Internet. Broadband has also helped to turn the Internet into a robust vehicle for original content of all types, including new genres of games, new forms of drama, and new types of journalism. Broadband has also made it possible to create

PART 1 New Technologies, New Creative Opportunities

whole new types of social communities, such as virtual worlds, social networking sites, and video file sharing sites.

The maturing of the Internet is just one reason for this digital revolution. Another important factor is the creation of new digital devices that make it possible to watch and listen to programming no matter where you are. Apple has been an important innovator in this area. It built the iTunes website, which allowed users to download music for a small fee, and also created the iPod, a conveniently portable and stylish piece of playback equipment for listening to your downloaded music and other kinds of audio programming. Then, in 2005, Apple introduced the video iPod, enabling users to download video as well as audio content from the Internet.

When Apple released the video iPod, it also announced that it would make episodes of hit television shows available on its iTunes website for a small fee. Within the first year, it sold 45 million TV shows. In addition, the iPod can be used to watch full-length movies and play simple video games. It can also be used to watch or listen to *podcasts* (Internet audio and video broadcasts that can be watched online or downloaded to mobile devices). The iPod is probably the best-known portable media device, but sophisticated cell phones and other types of mobile devices can also be used to enjoy all kinds of audio and video content, as can many types of video game consoles.

Another device that has played a role in the digital revolution is the personal video recorder (PVR), also known as the digital video recorder (DVR). This type of device, of which TiVo is the best known, allows TV viewers to select and record TV programs and play them back whenever they wish. Viewers also have the option of fast forwarding through the commercials, a feature that many appreciate. And viewers who own a piece of equipment called the Slingbox can even send recorded programming to their computers, no matter where their computers happen to be. Let's say, for example, your TiVo is in your apartment in Manhattan, but you are on a business trip to Paris. With a Slingbox, you could forward your TV favorite show to your laptop in your Paris hotel room.

TiVos, PVRs, iPods, and other digital devices have freed television viewers from the tyranny of the television schedule. As one media analyst put it, "Appointment-based television is dead." Perhaps this is an overstatement, but there's no question that developments in recent years—including the development of the Internet as major new medium, new forms of digital distribution, and the enormous popularity of video games and other kinds of digital entertainment—are having a profound impact on the Hollywood entertainment establishment. This digital revolution is also having a number of other ramifications. For example, it is impacting how and where advertising dollars are spent, and it is profoundly changing the world of journalism. It is also bringing about innovations in the way students are taught and how employees are trained. And, most relevant to this book, it is sparking the creation of exciting new forms of storytelling.

Changes in the Consumption of Entertainment

From the debut of the world's first commercial video game, *Pong*, in 1972 to the present day explosion of digital content, the popularity of digital entertainment has grown at a steady and impressive rate. Not only are more people consuming digital entertainment, but they are also spending more hours enjoying it. As a result, the audiences for traditional forms of entertainment have shrunk. We are now at the point where digital content can no longer be considered a maverick outsider because it has become an accepted part of the mainstream entertainment world.

Young people, in particular, are enormous fans of digital entertainment and everything digital. (See Figure 2.2.) They text message each other on their cell phones, *instant message* (IM) each other and watch streaming video on the Internet, listen to music on their iPods, and play games on their game consoles. A 2007 study released by JupiterResearch reported that people between the ages of 18 and 24 spend twice as much time online as they do watching television.

Older people are also spending more time on pursuits typically considered the domain of teenaged boys. According to statistics released in 2007 by the Entertainment Software Association (ESA), the average age of gamers has risen to 33, and a full 25% of players are over 50. Furthermore, girls and women now make up 38% of the gamer population.

Figure 2.2
Young people are great fans of all types of digital media, and as their use of interactive platforms increases, the time they spend consuming television and movies declines.

Digital media is having a major impact on broadcast television, which is slowly being overshadowed by the penetration of broadband Internet access. According to *The Hollywood Reporter*, for example, more homes in the United States have broadband access than subscribe to HBO.

While once there were only two entertainment screens that mattered—TV screens and movie screens—there is now a powerful "third screen" to contend with. This so-called third screen is really composed of multiple types of screens, a mixture of game consoles, computer monitors, and other digital devices.

The Impact on Hollywood

Television networks and movie studios are by no means unaware of the digital revolution, and the most forward-looking of them are taking steps to minimize the negative impact and to even take advantage of it as much as possible. They clearly want to avoid being blindsided the way the music industry was in the late 1990s with illegal file sharing. Until the courts put an end to it, people were able to download songs for free, using Napster's file sharing services. This online piracy caused the recording industry to suffer tremendous financial losses, and now that video can easily be downloaded from the Internet, Hollywood is taking steps to avoid a similar debacle.

Thus, following Apple's lead, a number of film studios and TV networks have been making their movies and TV shows readily available for legal downloads for a small fee. Some are also adapting an innovative *multiplatforming* strategy. With multiplatforming, not only do they create entertainment content for their two traditional screens—movie theatres and TV sets—but they also create auxiliary content for the third screen. When the same narrative storyline is developed across several forms of media, one of which is an interactive medium, it is known as *transmedia entertainment*.

Content created for a multiple media approach may take the form of dramatic material such as webisodes and faux blogs (blogs that are written in the voice of fictional characters, much like diaries). They may also use digital media to involve viewers in a mystery that's part of the plot of a TV show, giving them clues on websites and other venues so they can help solve it. Or sometimes, especially with television shows, the producers will find ways to involve the viewers while the show is being broadcast. For example, viewers may use their cell phones or laptops to participate in contests or polls, vote a contestant off a reality show, or voice an opinion.

The multiplatforming and transmedia approach to content is being used across the spectrum of television programming, including sitcoms, reality shows, dramas, news shows and documentaries. These strategies serve multiple purposes. They

 make the shows more attractive to younger viewers—the demographic that is particularly fond of interactive entertainment;

- keep viewers interested in a show and involved with it even when it is not on the air, in the days between its regular weekly broadcast, and during the summer hiatus;
- · attract new viewers to a show;
- take advantage of new revenue streams offered by *video on demand* (VOD), the Internet, and mobile devices.

These techniques are equally important in the feature film arena, although here digital platforms are primarily used for promotional purposes. We will be exploring the multiplatforming and transmedia approach to storytelling, and the kinds of interactive content that grow out of it, throughout this book, with Chapters 9 and 17 specifically devoted to this topic.

Despite various efforts to embrace the digital revolution, it is clear that traditional Hollywood entertainment is taking a hit from the third screen. Not only is television viewing down, but movie attendance is also being impacted. According to *The New York Times* (December 11, 2005), people are getting pickier about the types of films they go to. The big event movies remain popular, as do the specialized low-budget genre pictures, but the films that are middle-of-the-road, with midlevel budgets, are doing poorly. It indicates that while people may be willing to spend money to go to films they really want to see, they'd rather stay home and watch a DVD or play a video game than go to movies that don't sound particularly appealing.

THE IMPACT ON HOLLYWOOD'S TALENT POOL

The popularity of digital media is also rocking the boat with Hollywood professionals. Writers, actors, and directors are demanding that they be paid fairly when their work is downloaded from the Internet or when they contribute to a new form of content like a webisode. The long-established compensation system for top talent was created well before the digital revolution and doesn't cover these situations. Not surprisingly, payment issues have grown contentious. As of this writing they have already led to a major strike by the Writers Guild of America, the union that represents Hollywood writers. Digital technology is raising some unexpected concerns, as well. For example, actors worry that their voices and images may be digitized and used in productions without their consent, meaning that they could lose jobs to a virtual version of themselves.

How Advertisers Are Responding

People inside the world of the Hollywood entertainment business are not the only ones grappling with the sea changes created by the explosion of digital media. These changes are also creating upheavals for the advertising industry. In the past, television commercials were a favored way of promoting products, and advertisers spent a staggering amount of money on them—approximately \$250 billion in 2005 alone. But they are becoming far less willing to

make such an investment under the present circumstances. Not only is television viewing down, but people are also downloading commercial-free shows from the Internet, fast-forwarding through commercials on their PVRs, and viewing commercial-free television programming on DVDs. Another major medium for advertising—the daily newspaper—is also becoming less attractive to advertisers. Circulation numbers are plummeting almost everywhere, and readership is especially low with young people, who prefer to get their news online or through their mobile devices.

Thus, advertisers are shifting their ad dollars to other areas. An ever-larger portion is going to the Internet. In 2007, online advertising rose 34% above the previous year, reaching a total of almost \$17 billion. Advertisers are also investing in product placement in video games. In a car racing game, for example, the track might be plastered with billboards promoting a particular product, or in a sports game, the athletes may be wearing shirts emblazoned with the name of a clothing line. In 2006, \$80 million was spent on in-game advertising.

Even the way advertising is done on broadcast TV is changing somewhat. There are more *infomercials*—full-length shows that promote a particular product—and more sponsored programs, which are entertainment shows that are fully funded by a single advertiser, in other words, shows that are "brought to you" by a particular product. And the kind of product placement found in games is also on the rise in television and movies.

In addition, advertisers are devising new forms of digital narratives and games to promote products, which is of particular interest to those of us involved in digital storytelling. For example, they are putting money into *advergaming*—a form of casual gaming that integrates a product into the game and is often set in a narrative frame. They are also producing webisodes and elaborate multiplatform games that subtly or not so subtly make a particular product shine. We will be exploring these new types of content throughout this book.

The Impact of Digital Media on the Economy

Along with shifts in the way that advertising dollars are being spent, the digital revolution is impacting other areas of the economy, often in quite positive ways. For example, video games are an extremely healthy growth industry. Worldwide, games earned an impressive \$31.6 billion in 2006, a figure that was expected to rise to \$37.7 billion by the end of 2007, according to *The Hollywood Reporter* (June 21, 2007). And, according to the gaming industry, video games now gross more money than ticket sales for feature films.

In 2006, the Entertainment Software Association released a report focusing on the economic impact of video games, *Video Games: Serious Business for America's Economy.* According to the report, games were responsible for creating 144,000 full-time jobs. Many of these jobs are high paying; recent college graduates employed by game companies earn significantly more money than the average college graduate. In addition, the report noted that software developed for games is being applied to other endeavors. For example, gaming software had been

adapted by the real estate market and the travel industry, which uses it for virtual online tours. Video game techniques have been successfully incorporated into educational and training games used by schools, corporations, and the military.

The Impact on Journalism and How We Receive Information

The digital revolution has both hurt and helped the field of journalism, and it has profoundly impacted the way information is disseminated. While newspaper circulation is down, as is the viewership of television newscasts, we have a whole universe of new sources of information and journalism, thanks to digital media. On the Internet, we can receive up-to-the-minute news stories, complete with audio and video, and we also get information from blogs, interactive informational websites, online news magazines, and podcasts. And via our mobile devices, we can receive news bulletins, check stock prices, get weather reports, and keep tabs on sports events.

To get an idea of how important these digital news sources have become, one need look no further than the 2008 campaign for the presidency of the United States, which as of this writing is still ongoing. Candidates for this high stakes election have made intensive use of digital media. They've announced their candidacy on YouTube, set up websites, written blogs, and created profiles for Facebook and MySpace. They, or their advisors, are obviously aware of the power of digital media, and their use of it carries a subtext, as well. Candidates who make use of digital media are proclaiming: "I'm with it; I'm plugged in to modern times; I'm not some old fuddy duddy dinosaur."

WHAT THE DIGITAL REVOLUTION MEANS FOR CONTENT

As we have seen, digital technology has had a colossal impact on content, giving us many new forms of entertainment and new ways to receive information. In recent years, it has also given us a powerful new vehicle for content delivery—broadband Internet service. Broadband has helped to turn the Internet into a robust vehicle for original storytelling of all types, including new genres of games like Massively Multiplayer Online Games (MMOGs), Alternate Reality Games (ARGs), and episodic mystery games. It has spawned new forms of drama, as we have already noted, such as webisodes and fictional blogs, and new types of storytelling for children.

In addition, broadband has facilitated the development of sites dominated by user-generated content, such as virtual worlds and video sharing sites. Furthermore, digital technology is providing creative individuals in the fine arts with new ways to express themselves.

Types of User-Generated Content

Unlike other types of digital entertainment, the material found on sites that support user-generated content is largely created by the users themselves. Such websites are enormously popular and are one of the fastest growing areas of the Internet. These online destinations can roughly be divided into four general genres: virtual worlds; sites featuring users' profiles; sites featuring users' videos and animations; and sites featuring fan fiction. In addition to these, there is another important type of user-generated content, Machinima, that is not primarily an online form.

VIRTUAL WORLDS

Virtual worlds are online environments where users control their own avatars and interact with each other. These worlds may have richly detailed landscapes to explore, buildings that can be entered, and vehicles that can be operated, much like a MMOG. However, these virtual worlds are not really games, even though they may have some gamelike attributes. Instead, they serve as virtual community centers, where people can get together and socialize and, if they wish, conduct business.

Second Life is the most successful of these virtual worlds. By mid-2007, it had almost eight million "residents," as users are called. Second Life is a complex environment, offering different types of experiences to different residents, much like real life. It is a thriving center of commerce, for instance, where residents can buy and sell real estate, crafts, and other goods. People who like to party can fill their social calendar with all kinds of lively events. But Second Life can also be a place of higher learning. Real universities, including Harvard and Pepperdine, conduct classes there. In addition, real corporations hold shareholder meetings there, and politicians set up campaign headquarters there. It can also be a romantic destination. Residents have met in Second Life, fallen in love, and gotten married in real life.

VIRTUAL WORLDS FOR THE KIDS

While Second Life is intended for grown-ups, children need not feel left out of the chance to enjoy virtual worlds. Software developers have created a host of virtual worlds just for them. For example, capitalizing on the popular craze for penguins, New Horizon Interactive created a virtual world called Club Penguin in 2005 for children aged 6 to 14. Kids get to control their own penguin avatars and play in a wintery-white virtual world. Another site called WeeWorld lets small children control avatars, called WeeMees, play games, and send messages to each other. Even the famous Barbie (otherwise known as Barbie Doll) has joined this rush to create virtual worlds. She has developed a site for girls, BarbieGirls, where girls create their own Barbie girl avatars.

SOCIAL NETWORKING SITES

Social networking sites primarily feature users' profiles, making them quite different from virtual worlds. Two of the most popular of these social sites are MySpace and Facebook. Along with personal profiles, they contain photos, videos and users' blogs. Although these two sites have somewhat different features, they both are designed to facilitate socializing. They are two of the most frequently visited sites on the Internet.

VIDEO SHARING SITES

Some websites primarily serve as online spaces where users can share their own creative works, primarily videos and animation. YouTube is the best known and most successful of these. Created in 2005, it has become an enormously popular place for people to upload their own videos and view videos made by others. While much of the content is made by nonprofessionals, it also hosts slickly made commercial material. And, as noted earlier, politicians sometimes use YouTube to try to woo prospective voters.

FAN FICTION

Fan fiction, also known as *fanfic*, is a type of narrative that is based on a printed or produced story or drama, but it is written by fans instead of by the original author. Works of fan fiction may continue the plot that was established in the original story, may focus on a particular character, or may use the general setting as a springboard for a new work of fiction. This genre of writing began long before the advent of digital media. Some experts believe it dates back to the seventeenth century, beginning with sequels of the novel *Don Quixote* that were not written by Cervantes himself but by his admirers. Since then, other popular novels have been used as launching pads for fan fiction. In the twentieth century, until the birth of the Internet, this type of writing primarily revolved around the science fiction TV series *Star Trek*. With the Internet, however, fan fiction has found a welcoming home and a wider audience. Sites for this type of user-generated content abound, with fans creating stories for everything from Harry Potter novels to Japanese anime.

MACHINIMA

Machinima, a term that combines the words "machine" and "cinema," is a form of filmmaking that borrows technology, scenery, and characters from video games but creates original stories with them. Though it is a form of user-generated content, it is not, as noted, an Internet-based form, though works of Machinima can be found on the Web.

The best known Machinima production is *Red vs Blue*, a multiepisode tongue-incheek science fiction story about futuristic soldiers who have strange encounters in a place called Blood Gulch. Works of Machinima are often humorous, possibly because the characters, borrowed as they are from video games, are not capable of deep expression. Film connoisseurs are beginning to regard Machinima as a genuine and innovative form of filmmaking. A group of these films were shown at Lincoln Center in New York City, where they were described as "absurdist sketch comedy." Machinima has even found a foothold in the documentary film community, where it has been used to recreate historic battle scenes.

Thus, as demonstrated by these very different types of user-generated content, digital tools can give "regular people" the opportunity to do things that may be difficult to do outside of cyberspace—the opportunity to socialize, express themselves, be creative, and share their creations.

Digital Technology and the Arts

It should be stressed that amateurs are not the only ones to use digital tools. Professionals in the fine arts are also using them. Although they are, for the most part, outside of the scope of this book, innovative works using computer technology are being made in the fields of visual arts, music, performing arts, poetry, fiction, and creative nonfiction. For lack of a better term, these works are often labeled as "new media art."

In some cases, these works can be found in mainstream environments. Just as one example, in 2007 the London Philharmonic performed a virtual reality version of Igor Stravinsky's ballet *Le Sacre du Printemps* at the newly refurbished Royal Festival Hall in London. Using Stravinsky's music as a springboard, media artist and composer Klaus Obermaier designed a piece in which dancer Julia Mach interacted with the music and the three-dimensional images projected onto the stage. Members of the audience watched the performance wearing 3-D glasses.

In the area of visual arts, several major museums, such as the Metropolitan Museum and Whitney Museum in New York City, contain new media art works in their collections, and in some cases museums have held exhibits that heavily feature such works. For instance, the Museum of Contemporary Art in Los Angeles held an exhibition in 2005 called *Visual Art*, which contained a number of new media art pieces. The exhibit explored the relationship between color, sound, and abstraction.

For the most part, however, artists who work in new media are still struggling to find an audience, and most of them support themselves by teaching at universities. This is also the case of writers who work in digital literature. This type of writing is sometimes called *hyperliterature*, a catchall phrase that includes hypertext, digital poetry, nonlinear literature, electronic literature, and cyberliterature. Several websites specialize in this kind of writing, including the Hyperliterature Exchange and Eastgate, a company that publishes hypertext. In addition, the Electronic Literature Organization promotes the creation of electronic literature. A particularly lovely example of this kind of work is the hyperliterature version of the Wallace Stevens poem "Thirteen Ways of Looking at a Blackbird," which was recreated as short Flash animation pieces by British artist–writer Edward Picot.

Unfortunately, there is not sufficient room in this book to delve deeply into the realm of fine arts. However, we will be exploring a number of works that fall into the category of fine arts, particularly in the fields of interactive cinema and immersive environments.

A GLOBAL PERSPECTIVE

Although many of the developments mentioned in this chapter, as well as many of the statistics cited, refer specifically to the United States, it is important to keep in mind that digital entertainment is popular throughout the world and that software production centers are also scattered worldwide.

The United States does not have the same stranglehold on digital media as it does on the television and motion picture industry, and it even lags behind other developed countries in some forms of digital technology, such as highspeed Internet access. Countries from India to South Africa to Australia are creating innovative content for digital media and devices, with especially strong production centers in Japan, South Korea, Germany, Great Britain, and Canada.

Furthermore, some forms of digital technology and entertainment are better established outside of the United States than within its borders. Cell phones and content for them are tremendously successful in Japan; video games flourish in Korea; interactive television is well established in Great Britain; and Scandinavian countries lead the way in innovative transmedia games.

CONCLUSION

Clearly, digital storytelling is no longer the niche activity it was several decades ago. While once barely known outside of a few research labs and academic institutions, it can now boast of a worldwide presence and a consumer base numbering in the millions. It can be enjoyed in homes, schools, offices, and via wireless devices virtually anywhere. Furthermore, it is also no longer just the domain of teenage boys. Its appeal has broadened to include a much wider spectrum of the population, in terms of age, gender, and interest groups. It is powerful and universal enough to become a serious contender for the public's leisure time dollars and leisure time hours, and it is muscular enough to cause consternation in Hollywood.

A striking number of the breakthroughs that have paved the way for digital storytelling have come from unlikely places, such as military organizations and the laboratories of scientists. Thus, we should not be surprised if future advances also come from outside the ranks of the usual suppliers of entertainment content.

Various studies have documented the enthusiasm young people have for interactive media. This demographic group has been pushing interactive entertainment forward much like makers of snowmen roll a ball of snow, causing it to expand in size. Almost inevitably, as members of this segment of the population grow older, they will continue to expect their entertainment to be interactive. But will the same kinds of interactive programming continue to appeal to them as they move through the various stages of life? And how can emerging technologies best be utilized to build new and engaging forms of interactive entertainment that will appeal to large groups of users? These are just two of the questions that creators in this field will need to address in coming years.

IDEA-GENERATING EXERCISES

1. Try to imagine yourself going through a normal day but as if the calendar had been set back 50 years, before computers became commonplace. What familiar devices would no longer be available to you? What everyday

- tasks would you no longer be able to perform or would have to be performed in a quite different way?
- **2.** Imagine for a moment that you had just been given the assignment of creating a work of entertainment for a brand new interactive platform, one that had never been used for an entertainment purpose before. What kinds of questions would you want to get answers to before you would begin? What steps do you think would be helpful to take as you embarked on such a project?
- **3.** Most children and teenagers in developed countries are major consumers of interactive entertainment, but what kinds of interactive projects do you think could be developed for them as they move into adulthood, middle age, and beyond? What factors would need to be considered when developing content for this group as they mature?
- **4.** Analyze a website that facilitates social networking or the sharing of user-generated material, if possible, not one described in this chapter. What demographic group is this site primarily geared for? What about the site should make it attractive to its target demographic? What are its primary features? Is there anything about this site that you think could be improved upon?

Moving Toward Convergence

Within the new media arena, we've heard a great deal of talk—some say hype—about convergence. But what do people actually mean by the term?

Where are we today in terms of convergence? Have there been any success stories so far?

Why should people who create interactive entertainment be aware of developments in convergence? How is convergence related to digital storytelling at all?

CONVERGENCE: AN ONGOING DEBATE

The topic of convergence has sparked many a debate within the world of interactive technology. For years, people in media have been awaiting the coming of convergence as eagerly as the people in ancient days awaited the Messiah. Nevertheless, industry professionals have argued back and forth about what "convergence" really meant and when we might see it and if we would recognize it if it ever did arrive. And as time went on, some doubters even began to suggest that convergence was an unrealistic expectation, an empty buzzword that had lost all useful meaning. More recently, though, hope has been renewed, and some now contend that convergence is actually here, right in our midst, an overlooked but significant reality, and they assert that ever more exciting forms of convergence are on the way.

But why all this disagreement about a word that in essence means a coming together of different elements, a blending of two or more entities into one seamless whole? And why has its arrival or nonarrival been the subject of so much dispute? What does it matter whether convergence within interactive technologies ever takes place?

CONVERGENCE AND DIGITAL MEDIA

First of all, let's try to pinpoint what convergence means in the context of interactive technology. Unfortunately, this is no easy task—even experts in media have trouble pinning down a fixed definition of the concept.

If anyone should have a clear grasp of what convergence means, it should be Gary Arlen. Arlen is president of the media research and consulting firm Arlen Communications, and he is an acknowledged expert in the convergence of interactive media and telecommunications. Yet during two recent telephone interviews, he struggled to come up with a precise and universal description, saying there is no one "right" way to define the term. The reason for this, he explained, is that we are in the early stages of a business that is still defining itself as it goes, and furthermore, the term has been used in multiple technologies, where it is given different meanings.

"I've given up trying to define it," he admitted. "I think it's kind of like Scotch tape. It will define itself by the way it is used." Nevertheless, Arlen was able to lay out a lucid description of what the term means within the hardware and software worlds, the arenas most central to the interests of interactive entertainment. "The hardware and software people see convergence as the technology of voice, video, and data delivery coming together through a single package," he said.

For many within these industries, the idea of convergence is built in large part on the widespread availability and consumer adaptation of broadband highspeed access to images and other data via various delivery systems. Broadband is considered to be a critical element because it makes feasible such things as

- interactive TV:
- VOD (video on demand—a system that lets viewers select video content to watch from the Internet or from digital cable or satellite systems);

- streaming audio and video (listening and watching audio and video in real time, without delay, as it is being downloaded);
- the receiving of moving images over wireless devices.

The melding together of voice, video, and data in a single device or network promises to have a powerful synergistic effect. Thus, it is easy to see why convergence is such an attractive idea. It would make possible an exciting array of new electronic products and services and offer potentially lucrative commercial opportunities to those in the business of making and selling hardware and software for consumer use. And, to creators of entertainment, it promises to offer new types of entertainment experiences that would mean a greatly expanded marketplace for interactive programming.

However, convergence also has a potential negative side. When different technologies are bundled together, the devices that are built to utilize them can be clumsy and complicated to use, and they can be highly susceptible to malfunctions or design flaws. They may not work as smoothly and efficiently as devices built for a single purpose, and consumers may either be reluctant to try them or become quickly disenchanted with them.

THE DIGITIZING OF CONTENT

In order for convergence to be possible, the content must be available in digital form. This is a significant requirement. Until fairly recently, critical visual and audio elements have been available only in analog form. But the digitizing of content is so important to the merging of technology and media that some people even refer to convergence as "digital media integration."

The digitizing of content is particularly critical when it comes to video. Once video is digitized, its audio and visual elements can be compressed into tiny units of data, making it feasible to send and receive and usable by digital devices. It can also be easily accessed and readily reassembled in an almost infinite number of ways.

THE FOUR COMPONENTS OF CONVERGENCE

Convergence might be regarded as a four-part formula, a compound that requires four elements, or types of ingredients, to work. They are

- 1. a communication delivery system (via satellite, cellular, dial-up, cable, Wi-Fi, Bluetooth, or some other means);
- 2. hardware (such as a TV set, game console, wireless device, or computer);
- 3. digitized content (data such as text, audio, graphics, video, or animation);
- 4. computerized technology (to access, manipulate, and interact with the content).

CONVERGENCE ON THE CORPORATE LEVEL

The dazzling promise of convergence has tempted a number of companies to impetuously plunge into the convergence waters, anticipating that this coming together of interactive media and technologies will result in significant strategic gains and profits. Unfortunately for some of these companies, their headfirst dive proved to be premature at best, and it resulted in heavy losses, giving convergence a bad name.

One of the most infamous of these corporate ventures was the merger of AOL and Time Warner in 2000. Things went sour in just two years. The stock of the newly merged enterprise plummeted, and shareholders lost an estimated \$200 billion. Entertainment mogul David Geffen might have had this unfortunate union in mind when he quipped that convergence "is the most expensive word in history," a quote captured by Gary Arlen in an article he wrote for *Multichannel News* (August 12, 2002).

CONVERGENCE IN DEVICES

Corporate fiascos aside, convergence has been far more successful when it comes to multiple media, multiple use devices. There are two major categories of such devices: game consoles and cell phones. The latest generation of game consoles can connect to the Internet, play CDs and DVDs, and support multiplayer gameplay as well. As for many of today's mobile phones, they cannot only be used to make calls and send text messages, but they can also connect to the Internet and can be used to take photos and videos—images that can be posted online immediately. They usually also come with built-in games and can access additional games and other entertainment content from the Internet.

Nokia has even developed a convergent device, the Nokia N-Gage, that is both a cell phone and a handheld game console, thus converging media and capabilities that had never before been available on a single device. (See Figure 3.1.) In addition to its main duties as a phone and game console, this little piece of hardware also connects to the Internet and functions as a digital music player and an FM radio. Nokia introduced the N-Gage in 2003 to great fanfare, but unfortunately, it had some serious design flaws. As noted earlier, creating convergent devices can be a risky proposition, and in the case of the N-Gage, consumers found that it looked somewhat ridiculous when held up to the ear as a phone, dubbing it "taco phone" and "elephant ear." It had other drawbacks as well, including problems with the keypad and difficulties with swapping games in and out. To Nokia's credit, the company paid attention to the complaints and redesigned the N-Gage. It now seems to be doing quite well.

In 2007, another innovative convergent device made a big splash—Apple's iPhone. Among its main features, it functions as a cell phone, an iPod, and a video player; it connects to the Web and has email service. In addition, it works as a camera, a calendar, and a calculator. And this is just a partial list of what it can do. The iPhone caused a sensation when it was introduced, and people lined up for days for a chance to buy one. "This is cyberspace in your pocket!"

Figure 3.1
A first generation
Nokia N-Gage, a
convergent device that
combines a mobile
phone and handheld
game player. In
addition, it connects
to the Internet and
also functions as a
radio and digital music
player. Image Courtesy
of Nokia.

exclaimed one enthusiastic Silicon Valley consultant, Paul Saffo (as quoted in the Los Angles Times, January 10, 2007).

The iPhone, the Nokia N-Gage, and sophisticated game consoles like the PSP (PlayStation Portable) now available are living, breathing proof that convergence is not only possible but has actually arrived.

Convergence and Television

Interactive television (iTV) and video on demand (VOD) have been two of the most widely anticipated manifestations of convergence, and to a limited degree, they are already available to us. VOD can be accessed through various digital cable and satellite TV services and downloaded from the Internet, and we can watch video on a variety of handheld devices. Streaming video is also common online, although not everyone would agree that streaming video is actually VOD. In any case, as broadband access spreads to more homes, we will almost certainly find an increased amount of VOD available to us there.

As for iTV, it is already fairly well established in the United Kingdom and in several countries. In the United States, single-screen iTV, the kind they have in the United Kingdom, is only available on a limited basis. With single-screen iTV, the programming is broadcast right to your television set and is controlled by a remote control device. In the United States, single-screen interactivity is just offered by a few satellite and cable services, and an upgraded set-top box is needed to access it.

However, dual-screen iTV is available to anyone who has a computer, online access, and a TV set, and it is the most common form of iTV in the United States. With dual-screen interactivity, a website and a TV show are synchronized

with each other, and the interactive elements are controlled through one's computer. But only a small number of TV shows offer a synchronized online component, and at best this is a jerry-rigged form of convergence.

It is anybody's guess when single-screen iTV will become more widely available in the United States and in other parts of the world. And nobody is betting on what kinds of interactive programming will catch on with consumers, either, although VOD is already an extremely popular service wherever it is available. (For more on iTV, please see Chapter 18.)

CONVERGENCE AND DIGITAL STORYTELLING

There is a close connection between advancements in digital convergence on one hand and advancements in digital storytelling on the other. Creators of new media are quick to take note of significant advances in technology and experiment with ways to incorporate them into entertainment experiences.

For example, when dual-screen television became a workable reality, several forward-looking companies jumped at the chance to make new types of interactive dramas, reality shows, and documentaries for this new type of television. In a similar fashion, when global positioning systems (GPS) were embedded in sophisticated cell phones in Europe, a Swedish company devised a way to use this new technology for urban adventure role-playing games.

SMART DOLLS, CONVERGENCE, AND DIGITAL STORYTELLING

Surprising though it might be, smart dolls (lifelike dolls embedded with microprocessing chips) are some of the most advanced forms of convergent devices on the market. Toy inventors are always on the lookout for new technologies they can use to make their dolls seem more alive, more interactive, and more able to take a central role in an interactive story experience. Smart dolls incorporate nanotechnology and voice recognition systems; they have built-in clocks and calendars; they can connect to the Internet; and they have sensors that let the doll know what outfit she's wearing and that can detect motion, touch, and light conditions.

Sometimes it is users themselves who discover new or enhanced storytelling potential in a convergent device. For example, the Microsoft Xbox game console has an accessory device called the Xbox Communicator, which is an aural communications system. It is meant to enable players to speak to each other in real time so they can strategize as they play and issue commands and so on. But the device also has a feature called a "voice mask" that lets players disguise their voices, much like wearing a Halloween mask disguises a person's face. Players have had great fun using the voice mask system to enhance the experience of "becoming" a fictional character. Thanks to the device, a young teen could sound like a tough mafioso or a creepy space alien instead of the squeaky-voiced 13-year-old kid he really happens to be.

It is a mistake, however, to think that advancements in digital storytelling are entirely dependent on breakthroughs in convergence or on technology in general. A number of innovations in digital storytelling occur because storytellers are looking for new ways to involve users or are searching for a new way to construct an interactive narrative. As we will see, we can also find a number of instances of "soft" forms of convergence that impact digital storytelling but are independent of any specific technology.

Transmedia Storytelling as a Form of Convergence

Transmedia storytelling, which also goes by the name of multiplatforming, integrated media, and cross-media productions, is a relatively new approach to narrative. In this approach, which we briefly discussed in Chapter 2, a single entertainment property is merged over multiple forms of media, at least one of which is interactive. It is a special way of combining media to tell a single story.

Although primarily employed for story-based projects and games, a few productions of this type have been produced for information-based projects as well, usually with a television documentary as the hub component.

In transmedia storytelling, a project is designed from its very inception to span more than one medium. The project might incorporate such elements as a movie, a website, a DVD, a wireless game, a linear or interactive TV show, a novel, or even a live event. It might involve all of these media or just a few, and it may well involve other platforms or methods of communication not mentioned here. Some works of transmedia storytelling mix both narrative and gaming elements, including a new genre called Alternate Reality Games (ARGs). For more about ARGs, please see Chapter 17.

The objective of transmedia projects is to expand the fictional (or informational) universe of the core material and to make it "live" across a variety of media. The subject matter for each of the components closely relates to the same core material, but the approach used for each medium or platform is designed to take advantage of its unique strengths and capabilities. For example, the material might be offered as a linear dramatic narrative for a TV show or a movie, but it might be presented as an interactive timeline or community message board for a website and as a trivia game for a wireless device. For more on transmedia storytelling, please see Chapters 9 and 17.

Adaptation as a Form of Convergence

A far older approach to story-based material, which sounds similar to crossmedia productions but is actually quite different, is the process of adaptation. Properties have been adapted from one medium and used in another ever since the days when we had at least one other medium to borrow (or steal) from. The ancient Greeks freely took stories from their myths and oral traditions and turned them into works for the theatre, just as many of today's movies are based on earlier source material, such as novels, plays, and comic books.

PART 1 New Technologies, New Creative Opportunities

Unlike the cross-media approach, however, an adaptation is not something that is developed simultaneously for several media. Instead, it is just a retelling the same story—a way to get more mileage out of good material.

In terms of interactive media, adaptation has primarily involved turning video games into movies and vice versa. In 1993, *Super Mario Brothers* became the first game to become a movie. Unfortunately, the adaptation was not the box office sensation that was hoped for, and other such adaptations in the years that followed did not do well, either. However, the huge success of *Lara Croft: Tomb Raider* in 2001 proved that it was indeed possible to turn a popular game into a popular movie. *Lara Croft: Tomb Raider* spurred a great increase in such adaptations.

It has also become increasingly common to develop a video game and a movie simultaneously, as Peter Jackson did with *King Kong*. But whether done simultaneously or many years apart, the process of adaptation is filled with challenges. This was as true for Greek playwrights who ventured to turn a myth into a dramatic stage play as it is for today's writers when they try to turn a linear comic book into an interactive game.

All types of adaptations have their own inherent problems. In adapting a novel into a movie, for instance, you must figure out how to translate passive descriptive material and internal monologues into a visual narrative told through dramatic action. You also have to pare down or eliminate an abundance of plot and characters.

In adapting a game into a movie, you need to figure out how to convey the sense of interactivity and choice that is so much part of a video game, but without making this seem repetitious. You also need to take what are typically one-dimensional characters in games and fill them out with more richly shaded personalities and backstories. Characters in movies usually need to be given a "character arc" so that they change and grow in the course of the story. This is something that movie audiences expect to see, but it is rare in games. You almost inevitably need to condense what is often a huge game environment with many worlds and locations into a more contained filmlike environment. These are a few of the issues that today's screenwriters are grappling with when they turn a game into a movie.

In the reverse sort of situation, turning a movie into a game, you are faced with an opposite set of problems. Most importantly, you need to work out how to convert a linear storyline with a single through-line into a multidimensional interactive experience. How will the user participate in the story world; what kinds of things will he or she do; and what will the overall goal or mission be? Characters usually need to be simplified and their most important traits highlighted. More plot lines or layers of action will need to be provided than are usually found in a movie, and the story universe will generally need to be built out. Game designers have as many challenges in adapting a movie as film producers have in adapting a game, if not more.

In addition to video games, film producers have been eyeing other interactive media for prospective works to turn into movies. The first Internet-based material to make it to the big screen was Urban Entertainment's webisode Undercover Brother in 2002. The trend has gone the other way, too, with movies sometimes becoming material for the Web. For example, Star Wars has been turned into a MMOG. Sometimes TV shows become video games, too, as with the X-Files, Law and Order, Buffy the Vampire Slayer, and Sabrina the Teenage Witch. And sometimes video games become online games, as with The Sims, which lives on the Web as a MMOG called The Sims Online. This migration of a property from one medium to another is hardly a new phenomenon. What is relatively new, though, is that interactive media have joined the great pool of work that is regarded as attractive source material.

Intermedia Influences as a Form of Convergence

In addition to adaptations and transmedia narratives, we can find another, though quite subtle, form of convergence involving digital storytelling—the way traditional forms of narrative and new media narratives are influencing each other in terms of structure, visual presentation, style, and a general approach to storytelling.

This is most clearly apparent in the way video games are influencing motion pictures. Just as one example, consider the German film Run, Lola, Run. The film is about a young woman who goes on a life and death mission to save her boyfriend. With its eclectic mix of animation and high-speed live action, it has a distinctly gamelike look, feel, and pace. The movie is structured in three "rounds," each giving Lola 20 minutes to successfully achieve her goal. The first two rounds end badly, so the game (or story) is "reset", and Lola gets another chance. In each round she has to deal with many of the same obstacles, but it is not until round three that she manages to figure out how to deal with all of them and is able to "win."

To a lesser extent, we can also find examples of the impact of the Internet on linear entertainment, particularly on television. Certainly the influence can be seen in the way material is presented visually on a TV screen. Instead of one single image, the frame is now often filled with multiple images like a Web page. Often the frame is divided into separate boxes, and we even find text scrolling at the bottom of the screen. The visually dense style we have become familiar with from Web surfing has become common in news programs, documentaries, and sports shows. In another borrowing from the Internet, we can now see commercials that look strikingly like the amateur videos posted on YouTube, complete with cute-only-to-their-parents children and irritating pets.

On TV, we can also find cases where video gamelike influences have crept into dramatic series. The hit Fox series, 24, for example, is quite gamelike in terms of its story content, structure, and main character. The main character, Jack Baurer, played by Kiefer Sutherland, works for a government counterterrorist agency, and each season is faced with preventing a new and horrifying catastrophe from happening. In the series, Jack resolves one set of challenges only to be forced to deal with another set, much like advancing level by level in a game. In each of these "levels," he encounters a new group of bad guys and must overcome new obstacles or solve new puzzles, many of them quite gamelike in nature. And as with a video game hero, we become extremely knowledgeable about Jack's physical and intellectual skills, but we learn little about his thoughts or feelings. Not surprisingly, the series has been turned into a video game.

Just as TV and films contain elements influenced or directly borrowed from interactive media, the converse is also true. Interactive media borrow from established media, too. The cut scenes in video games are highly cinematic in content and style. Genres developed for radio and television turn up on the Web. Techniques of character development and structure that were first devised for the theatre and for film are now employed in video games and interactive cinema. Thus, in the cross-pollination among media, we have a form of narrative convergence.

CONCLUSION

Though industry leaders may not always agree on a definition of convergence, and some even doubt that convergence can ever be realized, we can nonetheless find concrete examples of digital convergence in today's world. We can also look at transmedia storytelling and adaptation as two "soft" forms of convergence.

Many content creators have found innovative ways to incorporate new forms of digital convergence into their narratives. It behooves us as digital storytellers to be aware of developments in convergence and so we too can utilize them in our stories.

IDEA-GENERATING EXERCISES

- **1.** Describe a convergent device that you have used and are quite familiar with. What can this device do? What do you most like about it? What design flaws, if any, does it have?
- **2.** On a sheet of paper, make a list of 10 simple electronic devices. Then randomly select two of them and try to determine how they could be converged into a single device. Can you think of any way your new invention could be used as part of a work of interactive entertainment?
- **3.** What movie or TV show have you seen recently that seemed to be influenced by video games? In what way was this influence apparent?
- **4.** What computer game have you played that might make a good movie? What about it would lend itself well to a cinematic adaptation? What about it would need to be changed in order to make it work as a movie?
- **5.** What movie have you seen lately, or what novel or other material have you read, that might make a good video game or online game? What about it would lend itself well to such an adaptation? What about it would need to be changed in order to make it work as a game?

PART 2 Creating Story-Rich Projects

Interactivity and Its Effects

How does the use of interactivity radically change the way an audience experiences a narrative?

How does the use of interactivity radically change the narrative material itself?

What are the pros and cons of giving the audience some control over the story?

What techniques can be used to help create cohesion in works of digital storytelling?

WHAT IS INTERACTIVITY?

Without interactivity, digital entertainment would simply be a duplicate of traditional entertainment, except that the medium in which it is presented, such as video or audio, would be in a digital form rather than an analog form. To the audience member or listener, however, the difference would be minimal except perhaps in the quality of the picture or sound. Essentially, the experience of "consuming" the entertainment would be exactly the same.

It is interactivity that makes digital media such a completely different animal from traditional storytelling forms, like movies, television, and novels. All stories, no matter how they are told—whether recited by a shaman, projected onto a movie screen, or played out on a game console—have certain universal qualities: They portray characters caught up in a dramatic situation, depicting events from the inception of the drama to its conclusion. Interactivity, however, profoundly changes the core material, and it profoundly changes the experience of those who are the receivers of it.

We've all probably heard and used the word "interactivity" hundreds, even thousands, of times. Because of overuse, the word has lost its fresh edge, somewhat like a kitchen knife that has grown dull because it's been utilized so often. Let's take a moment to consider what interactivity means and what it does.

Interactivity is a two-part word. The first part, *inter*, a prefix, means "between," implying a two-way exchange, a dialogue. The second part, *active*, means doing something, being involved or engaged. Thus the word as a whole indicates an active relationship between two entities. When used in the context of narrative content, it indicates a relationship where both entities—the audience and the material—are responsive to each other. You, the audience member, have the ability to manipulate, explore, or influence the content in one of a variety of ways, and the content can respond. Or the content demands something from you, and you respond.

Essentially, interactivity is one of only two possible ways of relating to narrative content; the other way is to relate to it passively. If you are passively enjoying a form of entertainment, you are doing nothing more than watching, listening, or reading. But with interactive content, you actually become a participant. This is radically different from the way narratives have traditionally been experienced.

INTERACTIVITY AS A CONVERSATION

Interactivity can be thought of as a conversation between the user and the content, a concept articulated to me by Greg Roach during a conversation about the subject. Roach is CEO of HyperBole Studios, the company that made such award-winning games as *The X-Files Game* and *Quantum Gate*, and as a digital media pioneer, he has given a great deal of thought to the subject of interactivity.

Roach compared the act of designing interactivity to the act of writing a sentence in a language like English, which uses the grammatical structure of a subject,

object, and verb. As an example, he used a simple interactive scene in which you give your character a gun. The interactive "sentence" would be: He (the subject) can shoot (the verb) another character (the object). Carrying Roach's grammatical analogy a step further, the sentences you construct in interactive media use the active voice and are not weighed down by descriptive phrases. ("He watered his horse" rather than "He was seen leading his dusty old horse down to the rocky creek, where he encouraged it to drink.") These interactive sentences are short and to the point, far more like Hemingway than Faulkner.

Roach is not alone in using grammatical terms to talk about interactivity. Many game designers use the phrase verb set in referring to the actions that can be performed in an interactive work. The verb set of a game consists of all the things players can make their characters do. The most common verbs are walk, run, turn, jump, pick up, and shoot.

LEAN BACK VERSUS LEAN FORWARD

Passive entertainment and interactive entertainment are often differentiated as "lean back" and "lean forward" experiences, respectively. With a passive form of entertainment like a movie or stage play, you are reclining in your seat, letting the drama come to you. But with an interactive work—a video game or a MMOG, for instance—you are leaning forward toward the screen, controlling the action with your joystick or keyboard.

WHAT HAPPENS TO THE AUDIENCE?

The way one experiences interactive entertainment is so different from the way passive entertainment is experienced that we rarely even use the word "audience" when we are talking about interactive works. More often than not, we talk about such people in the singular rather than in the plural. This is probably because each individual journeys through the interactive environment as a solo traveler, and each route through the material is unique to that person.

Because each user is in control of his or her own path through the material, interactivity can never truly be a mass audience experience. This is the case even when thousands of people are simultaneously participating in an interactive work, as they may be doing with a MMOG or an iTV show. Think how different this is from how an audience partakes of a movie or TV show, watching the same unvarying story unfold simultaneously with hundreds—or even millions—of other viewers. Of course, each member of the audience is running the story through his or her own personal filter and is probably having a somewhat different emotional response to the material. Yet no matter how intensely people might be reacting, there is nothing any member of the audience can do to alter a single beat of the tale.

It is an entirely different case when we are talking about interactive entertainment, and we may call upon one of several terms to describe the person who is in the process of experiencing it. If we're referring to someone playing a video game, we will use the term "player" or "gamer," while if a person is surfing the Web, we may use the term "visitor," and for simulations and immersive environments, we often call the person a "participant." One term that fits all types of interactive experiences is the word "user," which is the standard term we are employing in this book.

THE USER, THE AUTHOR, AND INTERACTIVITY

The people who participate in interactive entertainments are given two gifts that are never offered to audiences of passive entertainments: choice and control. They get to choose what to see and do within an interactive work, and the decisions they make have an impact on the story. Less than 50 years ago, such freedom to manipulate a work of entertainment would have been unimaginable.

The user's ability to control aspects of the narrative is called *agency*. Essentially, agency gives the user the ability to make choices and to see and enjoy the results of those choices. Agency is one of the unique pleasures of digital storytelling. It is not limited to the kinds of verb sets we discussed earlier (run, jump, shoot, and so on) but also allows the user to navigate through the story space, create an avatar, change points of view, and enjoy many other kinds of interactive experiences that we will discuss later in this chapter.

Agency is something that is built into an interactive work right from the start, as an integral part of the concept, and in fact helps define what kind of work it will be. It is up to the creative team to decide what kind of agency the user will have and how it will be integrated into the work. Experienced interactive designers and producers know that great care must be given to crafting the way the user can interact with the work. Interactivity must be meaningful to be satisfying. In other words, the choices offered must make sense, must have consequences that make sense, and what the user does must have a true impact on the story. Users will quickly become dissatisfied with pointless, empty interactivity.

HOW AGENCY CAN BACKFIRE

Experienced designers know that it can be a risky proposition to give users agency without thinking ahead to the various ways they might use or misuse it. A 2007 interactive advertising campaign for the Chevy Tahoe SUV underscores how agency can be used in unintended ways and can backfire on the producers. This online ad campaign gave users the chance to make their own commercial for the car, offering them a generous selection of videos of the interior and exterior of the vehicle, exotic settings to place it in, and background music, plus the ability to write their own text. To encourage participation, Chevy presented this as a contest, a version of Donald Trump's TV show, *The Apprentice*.

But the campaign went terribly wrong for Chevy. People who detested the Tahoe and hulking SUVs in general gleefully used the tools to make scathingly satirical commercials about the vehicle's role in creating pollution, waste, environmental destruction, and global warming. To its credit, Chevy actually ran some of these commercials on the contest website, but it was an embarrassing situation for the company, and the commercials were pulled after a short time.

Many kinds of interactive works, most particularly virtual worlds and MMOGs, have been plagued with run-amuck agency, with a handful of players threatening to spoil the fun the designers had intended to offer. These ill-spirited players have had their avatars bully other players, engage in lewd acts, and even rob, steal, and murder.

As the Chevy Tahoe campaign illustrates, agency is a gift to the user but can cause serious trouble for the creative team. Designers invest a significant amount of time in devising ways to preventing the agency they offer from getting out of hand, while not unduly restricting the sense of freedom they want to give to the users. Agency can also thrust writers of interactive works into an unfamiliar and uncomfortable position, particularly if they come from the worlds of more traditional forms of writing, like screenplays, novels, or television shows. In those fields, the writer has God-like powers over the narrative. The writer gets to choose who the characters are, what they do, and what they say. And the writer controls what happens to them. But in an interactive work, this kind of God-like control over the material must be shared with those individuals who, in an earlier era, would have been powerless and in your thrall—the members of the audience.

Although agency gives users exciting new powers, not all the benefits go to them, and the creators of interactive narratives benefit, too. While it's true that those of use who are writers must give up a certain amount of control, we now have the opportunity to work on a far vaster canvas than in previous media and with story tools never before available. We also have the exhilarating chance to create brand new kinds of narratives. And despite the amount of agency given to the user, we still do retain ultimate authorial control. We, along with our fellow design team members, create the project's narrative world and its possibilities; the kinds of characters who will live there and the kinds of challenges they will face; and the specific actions the users will be able to take there.

IMMERSIVENESS

One of the hallmarks of a successful interactive production is that it envelops the user in a rich, fully involving environment. The user interacts with the virtual world and the characters and objects within it in many ways and on many levels, and the experience might even be multisensory, meaning that it may stimulate multiple senses. In other words, an interactive production is immersive. It catches you up and involves you in ways that passive forms of entertainment can rarely do.

The power of immersiveness was brought home to me by an experience I had during the Christmas season one year in Santa Fe, New Mexico. It was my first year of living there, and I'd heard a great deal about the city's traditional holiday procession called Las Posadas, so I decided to see it for myself.

Las Posadas originated in medieval Spain as a nativity passion play and was brought to New Mexico about 400 years ago by the Spanish missionaries. They felt Las Posadas would be a simple and dramatic way to ignite the religious spirit of the local Pueblo Indians and hopefully turn them into good Catholics.

Las Posadas, which is Spanish for "the inns," recreates the Biblical story of Mary and Joseph's search for a place to spend the night and where Mary can give birth. It is performed with different variations in towns all over the Southwest and Mexico, but the basic elements remain the same. In Santa Fe, the procession takes place around the historic town plaza. Mary and Joseph, accompanied by a group of musicians and carolers, go from building to building asking for admittance, but each time the devil appears and denies them entrance, until at last they find a place that will receive them.

On the evening of Santa Fe's *Las Posadas*, my husband and I waited in the crowd with the other spectators, all of us clutching candles and shivering in the icy night air, waiting for the event to begin. Finally the first members of the procession appeared, holding torches to light the way. Mary and Joseph followed, with a group of carolers around them. The group paused in front of a building not far from us, and all proceeded to sing the traditional song, which pleads for lodging. The devil popped up from a hiding place on the roof and scornfully sang his song of refusal. It was very colorful, very different from anything I'd seen before back in California, and I was glad we had come.

But then I noticed that a number of people were breaking away from the throng of bystanders and joining in the procession. Spontaneously, I pulled my startled husband into the street after them. In a flash, we went from being observers to being participants, and we began to experience *Las Posadas* in an entirely different way. Marching with the procession, we became part of the drama, too, and were fully immersed in it. (See Figure 4.1.)

Figure 4.1
The Las Posadas
procession in Santa
Fe. By participating in
a traditional event like
this, one can experience
the powerful nature of
immersiveness.
Photograph by Kathy
De La Torre of the
Santa Fe New Mexican,
courtesy of the Santa
Fe New Mexican.

For the hour or so that it lasted, I became someone else. No longer was I a twenty-first century Jewish writer. I became a pious Catholic pilgrim transported back to a wintry medieval Spanish village. Some of this I experienced on a personal and physical level: I had to watch my step, taking care not to slip on a patch of ice or trip on a curb or get ahead of the holy family. I was aware of the scent of burning candles all around me and the press of the crowd. Much of the experience was emotional and communal: My husband and I would do our best to sing along with the carolers and holy family when it came time to ask for a room at the inn. Whenever the devil would appear on a rooftop or balcony, we would join in the hearty boos and derisive shouts of the processioners.

The best moment came when Mary and Joseph stopped in front of the heavy gates of the historic Palace of the Governors, the former seat of New Mexico's colonial government. Once again we all sang the imploring song, but this time the gates swung open! A joyous cheer went up from the processioners, our voices among them, and we all surged into the courtyard. Welcoming bonfires and cups of hot cocoa awaited us.

Becoming part of Las Posadas instead of merely observing it transformed the experience for me. It was like the difference between watching a movie and suddenly becoming a character in it. To me, it vividly demonstrated the power of immersiveness—one of the most compelling and magical aspects of interactive media.

TYPES OF INTERACTIVITY

Users can interact with digital content in a variety of ways, and different types of interactive media lend themselves to different types of interactivity. For instance, the Internet is particularly good at providing opportunities to communicate with other users; smart toys excel at offering one-on-one play experiences; wireless devices do well at engaging users in short bursts of text or visuals. Each of the interactive media has its limitations, as well. In an immersive environment, a participant's ability to control objects may be limited. Game consoles, unless connected to the Internet, are restricted to just a few players at a time. Interactive TV, at least for now, does not lend itself to interactions with fictional characters or with participating in a narrative story. When it comes to the types of interactivity offered by the various digital media, no one size fits all.

That said, however, six basic types of interactivity can be found in almost every form of digital storytelling. They are like the basic foodstuffs a good cook always keeps in the pantry that can be used to make a wide variety of dishes. The basic types of interactivity are as follows:

1. Stimulus and response. The stimulus might be something as simple as a highlighted image that the user clicks on and is rewarded by a little animated sequence or hearing a funny sound, or it might involve having to solve a puzzle, after which the user is rewarded by the occurrence of some sought-after event: The door to the safe swings open or a character reveals a secret. Generally speaking, the stimulus comes from the program and the response from the user, although there are exceptions.

For instance, smart toys recognize and respond to actions taken by their child owners. The stimulus–response exchange is a universal component of all interactive programming.

- 2. The ability to navigate and move. Users can move through the program in a free-form manner; in other words, they can simply choose what to do. Navigation may offer a vast 3-D world to explore, as in a video game or MMOG. Or it may be more limited, restricted to choosing options from a menu offered on a DVD or icons on a website. Navigation, like the stimulus–response exchange, is a universal component of every form of interactive programming.
- **3.** Contol of virtual objects. This includes such things as shooting guns, opening drawers, and moving items from one place to another. While a fairly common form of interactivity, this one is not universal.
- **4.** Communication. The user can communicate with other characters, including those controlled by the computer and other human players. Communication can be done via text that the user types in or via choosing from a dialogue menu, by voice, or by actions (such as squeezing a smart doll's hand). Generally, communication goes both ways—characters or other players can communicate with the user, too. As with #3, it is a common, but not universal form of interactivity.
- **5.** The sending of information. The type of information that can be sent can range from comments to online forums to videos to YouTube, and it can also include the creation of objects for virtual worlds. This form of interactivity is generally found in devices that have a connection to the Internet or to an iTV service.
- **6.** Receiving or acquiring items. The nature of the material that can be received can range from virtual to concrete, and the methods of acquiring it can range greatly as well. Users can collect information (such as news bulletins or medical facts); purchase physical objects (books or clothing); and receive video on demand. They can also collect virtual objects or assets in a game (a magic sword; the ability to fly). This type of interactivity is common in any medium that involves the Internet, wireless services, or iTV, as well as almost all video games.

Using these six basic "ingredients," digital creators can cook up a great diversity of experiences for people to participate in. They include

- **1.** playing games. There is an almost infinite variety of games that users can play: trivia games, adventure games, shooters, mysteries, ball games, role-playing games, and so on;
- 2. participating in a fictional narrative;
- 3. exploring a virtual environment;
- **4.** controlling a simulated vehicle or device: a fighter jet, a submarine, a space ship, or a machine gun;
- **5.** creating an avatar, including its physical appearance, personality traits, and skills;

- **6.** manipulating virtual objects: changing the color, shape, or size of an object; changing the notes in a piece of music; changing the physical appearance of a room;
- **7.** constructing virtual objects such as houses, clothing, tools, towns, machines, and vehicles;
- 8. taking part in polls, surveys, voting, tests, and contests;
- **9.** interacting with smart physical objects: dolls, robotic pets, wireless devices, animatronic characters;
- **10.** learning about something. Interactive learning experiences include edutainment games for children, training programs for employees, and online courses for students:
- **11.** taking part in a simulation, either for educational purposes or for entertainment;
- 12. setting a virtual clock or calendar to change, compress, or expand time;
- 13. socializing with others and participating in a virtual community;
- **14.** searching for various types of information or for clues in a game;
- **15.** sending or receiving items, for free or for money, including physical objects, virtual objects, VOD, and information.

This is by no means an exhaustive list, though it does illustrate the great variety of experiences that interactivity can offer and the uses to which it can be put.

HOW INTERACTIVITY IMPACTS CONTENT

These various forms of interacting inevitably affect your content. Users expect to be offered a selection of choices, but by offering them, you give up your ability to tell a strictly determined linear story or to provide information in a fixed order.

To see how this works, let's compare a linear and interactive version of a familiar story, the Garden of Eden episode from the Bible. The Garden of Eden episode is one of the best-known creation stories in the Western world, and thus seems an appropriate choice to illustrate the creative possibilities of changing a linear story into an interactive one.

As it is handed down in Genesis, the story involves three mortal characters: Adam, Eve, and the serpent. (See Figure 4.2.) Each of them behaves in exactly the same way no matter how often one reads about them in the Old Testament. And the alluring tree that is the centerpiece of the story is always the Tree of the Knowledge of Good and Evil. God has warned Adam and Eve not to eat its fruit, though they are free to enjoy anything else in the garden. The serpent, however, convinces Eve to sample the forbidden fruit, which she does. She gets Adam to try it, too, at which point they lose their innocence and are expelled from the Garden.

Now let's construct an interactive version of the same story. We'll use the same three characters and the same tree but offer the player an array of choices. Let's say the tree now offers five kinds of fruit, each with the potential for a different outcome. If Eve picks the pomegranate, for instance, she might immediately

Figure 4.2
Rafael's Garden of Eden, showing Adam, Eve, and the serpent. An interactive version of this simple Bible tale can quickly spin out of control.

become pregnant; if she eats too many cherries, she might get fat; only if she eats the forbidden fruit would the narrative progress toward the results depicted in the Bible.

As for the serpent, let's allow the user to decide what this character should be: malevolent or kindly, wise or silly. And we'll let the user decide how Eve responds to him, too. She might ignore him, or tell him to get lost, or try to turn him into a docile house pet, or she might actually listen to him, as she does in the Bible. We'll give the user a chance to determine the nature of Adam

and Eve's exchange, too. Adam might reject Eve's suggestion to try the fruit, or he might come up with several suggestions of his own (open up a fruit stand or make jam out of the tree's cherries). Or they may hotly disagree with each other, resulting in the Bible's first marital spat. Suddenly we have a vast multitude of permutations springing out of a simple story.

Note that all of this complexity comes from merely allowing the player one of several options at various nodes in the story. But what if you gave the players other types of interactive tools? You might allow them the opportunity to explore the entire Garden of Eden and interact with anything in it. They could investigate its rocky grottos, follow paths through the dense foliage, or even snoop around Adam and Eve's private glade. Or what if you turned this into a simulation and let users design their own Garden of Eden? Or how would it be if you turned this into a role-playing game and let the user play as Adam, as Eve, or even as the serpent? Or what if you designed this as a community experience and gave users the chance to vote on whether Eve should be blamed for committing the original sin?

Our simple story is now fragmenting into dozens of pieces. What once progressed in an orderly manner, with a straightforward beginning, middle, and end, and had a clear and simple plot, has now fallen into total anarchy. If adding interactivity to a simple story like the Garden of Eden can create such chaos, what does it do to a more complex work?

USING GAMING TECHNIQUES TO SUPPLY THE MISSING COHESION

Because interactivity can break up the cohesiveness of a narrative, it becomes necessary to look for other ways to tie the various elements together and to supply the momentum that, in traditional storytelling, would be supplied by the plot. Many professionals in digital media believe that the best solution is to use a gaming model as the core of an interactive work and build narrative elements around it. Games provide an attractive solution because they involve competition, contain obstacles and a goal, and achieving the goal is usually a game's driving force. While stories in traditional media use these same elements, they are less obvious, and great attention is placed on other things, such as character development, motivation, the relationship between characters, and so on.

Designer Greg Roach, introduced earlier in this chapter, is one of those professionals who is inclined to turn to games to help knit the various pieces of an interactive work together. "When you discard all aspects of gaming, how do you motivate people to move through the narrative?" he asks rhetorically. "The fundamental mechanisms of games are valuable because they provide the basic tool sets."

Roach sees stories and games as two very different types of artifacts—artifacts being objects created by human beings. Roach says, "A story is an artifact you experience as a dynamic process while a game is a process you enter into that

creates an artifact when it ends." Roach feels that interactive works have, as he puts it, "immense granularity." Granularity is a term Roach and others in interactive media use to mean the quality of being composed of many extremely small pieces.

Roach describes films and other types of linear narratives as "monoliths, like a block of salt," and for interactivity to be possible, he says the monoliths must be broken up into fine pieces. "These granules of information can be character, atmosphere, or action. But if a work is too granular, if the user is inputting constantly, there are no opportunities for story." Roach stresses that in order to have an interactive story, "You must find a balance between granularity and solidity. You need to find the 'sweet spot'—the best path through the narrative, the one with the optimum number of variables."

Despite the differences between stories and games, Roach believes a middle ground can be found, a place to facilitate story and character development in an interactive environment.

One of the challenges Roach sees in constructing a nongaming interactive story is the task of providing the player with motivation, an incentive to spend time working through the narrative. But he suggests an answer as well. Roach believes that people like to solve problems, the tougher the better, and he feels that a major distinction between games and stories is the types of problems they present plus the tools you can use to solve them. In a game, he suggested, the problem might be getting past the monster on the bridge. In a story, the problem might be getting your son off drugs and into rehabilitation.

GAMES AS ABSTRACT STORIES

Janet H. Murray, a professor at the Georgia Institute of Technology and the author of one of the best-known books on interactive narrative, *Hamlet on the Holodeck*, takes things a step further than Roach. In her book, she asserts that games and drama are actually quite closely aligned and that games are really a form of "abstract storytelling."

To underscore the close connection between stories and games, Murray points out that one of our oldest, most pervasive, and popular types of games—the battle between opposing contestants or forces—is also one of the first and most basic forms of drama. The Greeks called this opposition *agon*, for conflict or contest. Murray reminds us that opposition, or the struggle between opposites, is one of the fundamental concepts that we use to interpret the world around us (big-little; boy-girl; good-evil).

Although Murray does not say so explicitly, every writer of screenplays is keenly aware of the importance of opposition and realizes that unless the hero of the drama is faced with an imposing challenge or opponent, a script will lack energy and interest. For an interactive narrative to work, it too must pit opposing forces against each other. Thus, games and dramas utilize the same key dynamic: opposition. As we will see in Chapter 6, which focuses on character,

Interactivity and Its Effects CHAPTER 4

this concept of opposition is so key to drama that it defines how we think of our heroes and villains.

Opposition is not the only way that games and drama are alike, Murray believes. She suggests, in fact, that games "can be experienced as symbolic drama." She holds that games reflect events that we have lived through or have had to deal with, though in a compressed form. When we play a game, she says, we become the protagonist of a symbolic action. Some of the life-based plot lines she feels can be found in games include

- being faced with an emergency and surviving it;
- taking a risk and being rewarded for acting courageously;
- finding a world that has fallen into ruin and managing to restore it; and, of course,
- being confronted with an imposing antagonist or difficult test of skill and achieving a successful outcome.

DRAMA IN AN ABSTRACT GAME

Janet Murray is even able to find a lifelike symbolic drama in an abstract game like *Tetris*. In *Tetris*, players have to maneuver falling puzzle pieces so they fit together and form a straight row. Each completed row floats off the bottom of the game board, leaving room for still more falling puzzle pieces. To Murray, the game resembles our struggles to deal with our over-busy lives, and is like "the constant bombardment of tasks that demand our attention and that we must somehow fit into our overcrowded schedules and clear off our desks in order to make room for the next onslaught."

Games, Murray asserts, give us an opportunity to act out the important conflicts and challenges in our lives and to create order and harmony where there was messiness and conflict.

In many ways, Murray's view of games is much like Joseph Campbell's view of ritual ceremonies—activities that provide us with a way to give meaning to important life experiences and to provide us with emotional release. In its most powerful form, this emotional release is experienced as a catharsis.

STORIES THAT ARE NOT GAMES

In examining the relationship between stories and games, let us not forget what designer Greg Roach asserted: that it is possible to create interactive stories that are not based on game models. We can find examples of game-free narratives in many genres of digital storytelling. One small enclave of such narratives is called, fittingly enough, *interactive fiction* (IF). Works of IF can be found on the Internet, and they are also available on CD-ROMs. Though the creators and fans of IF are a fairly small group, often found within academic circles, they are dedicated to advancing this particular form of storytelling.

True works of IF are entirely text based (although the term is sometimes used for adventure games and other works that are animated or are done on video). To see/read/play a work of IF, you need to be sitting in front of a computer, inputting your commands with a keyboard. The story advances and reveals itself as the user types in commands ("open the door" or "look under the bed" or "ask about the diamond"). Unlike hypertext, you must do more than click on a link; you must devise phrases that will give you the most meaningful and useful reply.

IF stories can be about almost any topic, and they can be written in just about any fictional genre, although they work best when the plots call for you to be active, to explore, and to make things happen. They need not be plot driven, however. *Galatea*, written by Emily Short, is an intriguing character sketch that is constructed as a dialogue between the user and a *nonplayer character* (NPC)—a character that is controlled by the computer. The story is based on the Greek myth of Pygmalion, a sculptor who carves a beautiful statue, *Galatea*. The statue comes to life after he falls in love with her. It is the same myth that inspired the Broadway musical *My Fair Lady*.

In this interactive version of the myth, you visit the art gallery where *Galatea* is displayed and discover that you are able to talk with her. As you converse with her, you gain insights into her history and troubled emotional state. Her responses to your questions vary, as does her attitude toward you, depending on how you treat her. (See Figure 4.3.)

bask about eyes

What was it like, having your eyes carved?" you ask.

"He drilled at the corners," she says. "And that was agony -- waiting to see whether he would go too deep. He never did, hut there was always doubt."

ask about seeing

"When did you first begin to see?" you ask. "Was it when your eyes were finished, or could you somehow see before that?"

"Before that," she says. "Certainly before he began to drill in the corners. It was a gradual thing: everything was dim and shadowed, and it grew brighter and sharper the closer he came to the surface of my eyes, until I could recognize colors, and know his face."

>ask about face She just shrugs.

Figure 4.3

A segment of the IF work Galatea, designed and written by Emily Short. It is a character study based on the Greek myth of Pygmalion. Image courtesy of Emily Short.

IF stories resemble text-based adventure games as well as online MUDs and MOOs (MUD object oriented). Unlike MUDs and MOOs, however, they are played by a single individual rather than with a group. Furthermore, they do not have the win/lose outcomes that are so much a part of adventure games, though they do often include puzzles that must be solved in order to progress. These narratives cannot be as tightly plotted as linear fiction, but they do generally have overarching storylines.

Conceivably, the IF genre could be used as a model for interactive stories that are not merely text based but are told in moving images as well. Throughout this book, we will be examining other works of digital storytelling that contain no overt elements of gaming. These stories demonstrate that even though games are extremely useful vehicles for holding interactive narratives together, works of digital storytelling do not need to depend on game models in order to succeed.

CONCLUSION

Interactivity, as we have seen, profoundly changes the way we experience a work of entertainment. We go from being a passive member of the audience to becoming a participant with an active and meaningful role, wielding a new power called agency.

Interactivity, however, changes the role of the storyteller. Instead of being the sole creator of the story, this role must now be shared with the user. And interactivity makes the telling of a fixed, sequential, linear story impossible. To knit the story together and make it compelling, storytellers must find new models to use. Many rely on game techniques to achieve narrative cohesion, although some digital storytellers are finding other ways to construct satisfying interactive narratives.

While interactivity creates new challenges for storytellers, it also gives them new powers. Thanks to interactivity, it is possible to tell stories that are deeply immersive and intensely absorbing, that take place on a much vaster canvas, and that can be experienced from more than one point of view. The challenge for storytellers is to find ways to use interactivity effectively so that users can enjoy both agency and a meaningful narrative experience.

IDEA-GENERATING EXERCISES

- **1.** Describe an event or occasion where you went from being a passive observer to an active participant. How did this shift affect the way you experienced the event? Your example could be something as simple as going from being a passenger in a car to actually driving the vehicle, or it could involve a more complex situation, like the *Las Posadas* procession described in this chapter.
- **2.** If you are working on a project for a specific interactive medium or platform, make a list of the types of interactivity the medium or platform

- lends itself to most strongly and the types of interactivity it does not support well or at all. Is your project making good use of the platform's strengths and avoiding its weaknesses?
- **3.** Take a very simple, familiar story and work out different ways it would be changed by injecting interactivity into it, as with the Garden of Eden example. Your examples might be a story from the Bible, a child's nursery rhyme, or a recent news item.
- **4.** Using a simple story like one chosen for the exercise above, redesign it as two different interactive experiences: one that is very story-like and the other that is very game-like.

Old Tools/New Tools

What can an ancient Greek like Aristotle teach us that we can apply to modern interactive entertainment?

What aspects of traditional storytelling can be successfully used in digital storytelling?

When writers of traditional stories at first move into digital storytelling, what do they find most challenging?

What 10 entirely new tools must creators learn to use when they construct interactive narratives?

AN ASSORTMENT OF STORYTELLING TOOLS

Embarking on a new work of digital storytelling is usually a daunting proposition, even for veterans in the field. Each new project seems to chart new ground. Some call for a unique creative approach; others utilize new technology. And those who work in the newer areas of interactive entertainment—wireless devices, transmedia productions, and innovative types of immersive environments—are faced with having to be a pioneer almost every time out. Furthermore, the complexities posed by interactivity, plus the sheer volume of material contained in most works of digital storytelling, can be overwhelming. No wonder starting work on a new project can feel like plunging into the abyss.

Nevertheless, even though we may feel we are starting from scratch, we actually have a wonderfully serviceable set of tools and techniques at our disposal, some of which we glimpsed in Chapter 1. Aristotle first articulated a number of these tools over 2000 years ago. Other tools go back still further, to preliterate storytellers. And we can also borrow an array of tools from more recent storytellers—from novelists, playwrights, and screenwriters. Furthermore, we can raid the supply of tools originally developed for preelectronic games of all types, from athletic competitions to board games.

As is to be expected, of course, the majority of these borrowed tools and techniques need to be reshaped to some degree for digital media. And at some point, we finally empty out our old toolbox and reach the point where we need to pick up and master some entirely new implements. Ultimately, it is a combination of the old and the new, seamlessly integrated together, that enables us to create engaging works of digital storytelling.

LEARNING FROM GAMES

Some of the most effective tools of storytelling, tools that can inject an intense jolt of energy into any type of narrative, were not even developed by storytellers. They originated in games. Games are one of the most ancient forms of human social interaction, and storytellers in both linear and nonlinear media have borrowed heavily from them, as we saw in Chapters 1 and 4. Games can be used as a form of glue to hold an interactive work together.

Above all else, games teach us the critical importance of having a clear-cut goal and also show us the importance of putting obstacles in the way of that goal. In games, the ultimate goal is to win the competition, and the players on the other side—the opponents—provide the biggest impediment to achieving that goal. This player versus player opposition is what provides much of the excitement and drama in an athletic competition, in much the same way it does in storytelling. In addition, participants in sporting competitions must contend with physical obstacles and challenges, such as the hurdles on a track field, the net on the tennis court, or the steep roads in a cycling race.

GOALS IN GAMES AND STORIES

In a good game, as well as in a good story, the best goals are

- · specific;
- · simple to understand:
- · highly desirable;
- · difficult to achieve.

Try to imagine a game or story without a goal. What would the players or characters be trying to do? What would keep the audience interested in watching something that has no clear objective? What would give the experience meaning?

The essential mechanics of stories are remarkably similar to games, especially when it comes to goals and obstacles. In a story, the protagonist wants to achieve a goal, just as an athlete does, even though the type of goal being sought after is of a different order. The objective may be to find the buried treasure, win the love of the adored one, track down the killer, or find a cure for a desperately sick child. A goal provides motivation for the main character, a sharp focus for the action, and a through-line for the plot, just as a goal provides motivation and focus for a game. And in a story, as with a game, obstacles provide the drama, and the most daunting obstacles are human ones—the antagonists that the hero has to contend with.

Of course, some novels and works of short fiction present narratives in which the protagonist has no apparent goal, and so do some art house films. But even though such slice-of-life stories may be interesting character studies or may be admirable for some other artistic reason, the narrative will usually feel flat because nothing is at stake. That is why it is difficult for such works to attract a wide audience.

The conflict between achieving a goal and the obstacles that hinder this victory is what creates conflict, and conflict is the heart of drama. The clearer the goal, and the more monumental the obstacles that stand in the way of achieving it, the greater the drama. The very first storytellers—those who recited the ancient myths and heroic epics of their culture—understood this and made sure to emphasize all the difficulties their heroes had to overcome. Later storytellers, working in succeeding waves of media from classic theatre to television and everything in between, recognized the value of goals and obstacles just as clearly. Not surprisingly, these fundamental story ingredients are just as useful in the creation of digital entertainment.

Games have provided storytellers with other valuable tools as well. From games we learn that the most thrilling competitions are those that demand the most from a player—the most skill, the most courage, the most strategizing. Similarly, a good story demands that the protagonist give his or her all to the

struggle. In an interactive work, the same demand is made on the user or the player. The greater the personal investment and the tougher the challenge, the more satisfying the ultimate victory.

In addition, games are governed by specific sets of regulations. These not only add to the challenges but also help to keep the game fair. For example, players are only allowed to use approved types of equipment, or employ certain maneuvers and not others, or score a goal by doing X and not Y. Without such rules, victory would be too easy, and the game would lack interest. Games not only have rules but also follow a set structure or format, though the specifics vary greatly among types of games. For example, a football game begins with a kickoff; a baseball game has nine innings; a basketball game is divided into quarters. No doubt, the first players of ancient sports soon found that without structure or rules, their games would quickly disintegrate into anarchy, and one side would use tactics that seemed completely unexpected and unfair to the other side. Rules and structure provide an equally fair, consistent playing environment to all players.

For the same reason, stories in every medium have a structure and format for how they begin, how they develop, and how they end. Furthermore, although stories don't follow set rules, they are guided by internal conventions. This ensures that behaviors and events within the fictional universe are consistent and logical and make sense within the story. Even a fantasy universe like the one portrayed in the Harry Potter novels, films, and games must remain faithful to its own internal set of rules. For instance, if it is established that characters cannot pass through physical structures unless they recite a secret spell, Harry or one of his classmates should not suddenly be able to blithely walk through a wall without using the spell. That would violate the rules of magic already established in the story. Internal conventions provide a narrative equivalent of a fair playing field.

LEARNING FROM MYTHS

Contemporary storytellers, whether working in linear or interactive media, are also indebted to the great mythmakers of ancient days. These master tellers of tales built their stories upon themes with deep emotional and psychological underpinnings. As noted in Chapter 1, many of these old stories feature young heroes and heroines who must triumph over a series of harrowing obstacles before finally reaching their goal, and in the course of their adventures they must undergo a form of death and rebirth.

Joseph Campbell, introduced in Chapter 1, analyzed the core elements of the hero's journey and found that such myths contained characters that were remarkably similar from story to story and that the myths contained extremely similar plot points. He held that the hero's journey tapped into the universal experiences shared by humans everywhere, reflecting their hopes and fears, and thus resonated deeply with the audience.

More recently, Christopher Vogler interpreted Campbell's work for contemporary readers and writers in a book called *The Writer's Journey*. The book profiles the archetypal figures who commonly populate the hero's journey—characters with specific functions and roles to play—and he describes each of the 12 stages of the journey that the hero must pass through before being able to return home, victorious.

The hero's mythic journey has had a deep influence on storytellers throughout the world. Countless works of linear fiction—novels, plays, comic books, and movies—have been built on the model provided by the hero's journey. Among them are the films made by the great filmmaker George Lucas, who has often spoken of his debt to Joseph Campbell and the hero's journey. Even the magnificent film *Spirited Away*, a work of Japanese anime about a little girl trapped in a mysterious resort for ghosts, closely follows the 12 stages of this ancient myth.

This enduring model works equally well for interactive narratives. For example, the immensely involving game *Final Fantasy VII* contains many of the elements of the hero's journey, and a number of MMOGs incorporate it as well. After all, as a player, you set off for a journey into the unknown, meet up with various helpful, dangerous, or trickster characters along the way, find yourself tested in all sorts of ways, and do battle against powerful opponents.

Do writers, producers, and designers of these interactive versions of the hero's journey deliberately use this genre as a model? In some cases, yes, this modeling is conscious and intentional. For example, Katie Fisher, a producer/designer for the game company Quicksilver Software, Inc., is quick to acknowledge that she based the game *Invictus* on the hero's journey and used Christopher Vogler's book as a guide. In other cases, though, the hero's journey is probably an unconscious influence. After all, it is a story that is familiar to us from childhood; even many of our favorite fairy tales are simplified hero's journeys. And many a designer's most beloved movies are also closely based on this model, including such films as *The Wizard of Oz* and *Star Wars*. Obviously, elements in the hero's journey strike a deep chord within audiences both past and present. There is no reason why creators of interactive entertainment should not be able to find inspiration, as Katie Fisher has, in this compelling model.

LEARNING FROM ARISTOTLE

Mythological themes have provided fodder not only for our first narrative tales, but also for our earliest theatrical works. As noted in Chapter 1, rituals based on the myths of Dionysus led to the development of classic Greek theatre. Aristotle, one of the greatest thinkers of the ancient world, closely studied Greek theater, particularly the serious dramas, which were then always called tragedies. Based on his observations, he developed an insightful series of principles and recorded them in a slender, densely written volume, *The Poetics*. Though drafted in the fourth century BC, his ideas have held up astoundingly well right up to the present day. The principles discussed in *The Poetics* have

been applied not only to stage plays, but also to movies, TV shows, and, most recently, they are finding their way into interactive narratives.

Aristotle articulated such concepts as dramatic structure, unity of action, plot reversals, and the tragic flaw. He also made perceptive comments about character development, dialogue, plot, and techniques of eliciting a strong emotional response from the audience. Furthermore, he warned against using cheap devices that would undermine the drama. One such device he felt was unworthy of serious theater was the deus ex machina, Latin for "God from a machine." This device was called into play when a writer was desperate for a way to get a character out of a predicament and would solve the problem by having a god suddenly descend to the stage from an overhead apparatus and save the day. Aristotle decried such techniques and believed that plot developments should be logical and grow naturally out of the action.

One of Aristotle's greatest contributions to dramatic theory was his realization that the effective dramas were based on a three-act structure. He noted that such dramas imitated a complete action and always had a beginning, a middle, and an end (acts I, II, and III). He explained in *The Poetics* (Chapter VII, Section 3) that

A beginning is that which does not itself follow anything by causal necessity, but after which something naturally is or comes to be. An end, on the contrary, is that which itself naturally follows some other thing, either by necessity, or as a rule, but has nothing following it. A middle is that which follows something as some other thing follows it. A well-constructed plot, therefore, must neither begin or end at haphazard, but conform to these principles.

Entire books have been written on the three-act structure, derived from this short passage, applying it to contemporary works of entertainment, particularly to films. One of the most widely used in the motion picture industry is Syd Field's *Screenplay: The Foundations of Screenwriting*. The book breaks down Aristotle's points and expands on them in a way that modern writers can readily understand. The three-act structure is so widely accepted in Hollywood that even nonwriters, professionals like studio development executives and producers, feel completely comfortable talking about such things as "the first act inciting incident," "the second act turning point," and the "third act climax."

The idea of the three-act structure has also found a place in interactive media, most noticeably in games. But it is used in other types of interactive entertainment as well, including virtual reality simulations, location-based entertainment, interactive movies, and webisodes. Of course, inserting interactivity into a narrative project impacts enormously on its structure, so additional models must also be called into play. Often they are used in conjunction with the classic three acts first spelled out by Aristotle. (For a more detailed examination of structure in interactive works, please see Chapter 7.)

Aristotle also had valuable things to say about character motivation. He noted that motivation is the fuel that leads to action and that action is one of the most important elements of drama. Just as the players' striving toward a goal is the driving force in a game, a character striving toward an objective is the driving force of a drama. Aristotle believed that there are two types of human motivation. One, he felt, is driven by passion and based on emotion. The other, he said, is based on reason or conscious will. In other words, one comes from the heart, the other from the head.

In interactive media, motivation is also of tremendous importance. It is what pulls the user through a vast universe of competing choices. By understanding motivation, we can create more compelling works of interactive entertainment.

Aristotle also believed that drama could have a profound affect on the audience, eliciting such emotions as pity and fear. The most effective dramas, he felt, could create a feeling of catharsis or emotional purging and relief—the same sort of catharsis Joseph Campbell said occurred when people took part in a reenactment of a powerful myth. Creators of interactive works have not, as a rule, put much effort into trying to produce projects with an emotional punch. Today, however, more attention is being paid to this subject, and it will be discussed in more detail in Chapter 6.

LEARNING FROM CONTEMPORARY STORYTELLERS

When it comes to interactive entertainment, we can also learn a great deal from the creators of linear narrative, particularly from film and TV. These forms of entertainment already have great similarities to interactive media because they are stories told in moving images and sound, which is also how most interactive narrative is conveyed.

Two of the most important skills that can be ported over from film and television are character development and story construction. These are the fundamental building blocks of any type of narrative. Of course, they cannot be adapted without some adjustments, for interactivity has a profound impact on all aspects of the creative process. (Character development in interactive media will be more fully discussed in Chapter 6; structure in Chapter 7; and the creative process in Chapter 10.)

Having made the transition myself from television and film into the interactive field, I am well aware of how closely the techniques of character and story development used in filmed narratives work in digital storytelling. For example, one of my first jobs in interactive media was as a freelance writer doing some work on Broderbund's pioneering *Carmen Sandiego* series, a game that had kids playing the part of a detective and trying to track down the thieving Carmen or one of her henchmen. My assignment called for me to create four new characters for the game and to write dialogue for two of its already-established characters, the Chief of Detectives and Wanda, his assistant. These tasks were

almost identical to work I might have done for a TV show, except that I had to write numerous variations of every line of dialogue. Thus, I found myself coming up with about a dozen different ways to say "you bungled the case."

Another early assignment had me working out an interactive adventure story for children based on an idea proposed by actress–producer Shelley Duvall. Called *Shelley Duvall Presents Digby's Adventures* and developed by Sanctuary Woods, the CD-ROM was a story about a little dog who goes exploring, gets lost, and tries to find his way home. It was the kind of tale that could have easily been a kid's TV show, except for one thing: This was a branching, interactive story, so the little dog gets lost in three completely different ways. Each version offers the player numerous opportunities to become involved in the dog's adventures and help him find his way back.

OTHER USEFUL OLD TOOLS

Aside from character development and story construction, what else can be borrowed from traditional storytelling? One excellent tool is tension. Although tension is something we try to avoid in our daily lives, it serves an important function in both linear and interactive narratives. It keeps the audience riveted to the story, experiencing a mixture of apprehension and hope, wondering how things will turn out. Tension is particularly important in interactive narratives because they don't have the benefit of linear plots: the carefully constructed sequence of events that advances the action and builds up the excitement in traditional stories. Creators of interactive stories have to work extra hard keep users involved with their narratives, and ramping up the tension is a good way to keep them hooked.

One reliable method of inserting tension in a nonlinear story is to put your main character (who is often the player via the avatar he or she is controlling) into great jeopardy: risking death in a snake infested jungle, caught behind enemy lines in a war, or pursued by brain sucking aliens in a sci-fi story. But the jeopardy need not be something that could cause bodily harm; the risk of losing anything of great value to the protagonist can also produce dramatic tension. Thus, the jeopardy can involve the threat of relinquishing everything your hero has worked so hard to achieve in the story, whether it is a vast sum of money, solving a baffling mystery, or becoming a mafia godfather.

Introducing an element of uncertainty can also increase dramatic tension. Which of the characters that you encounter can you trust? Which ones are actually enemies in disguise? Which route through the forest will get you to your destination quickly and safely, and which one might be a long and dangerous detour? Uncertainty is a close cousin to suspense, which is the burning desire to know what will happen next. It is the feeling of suspense that keeps us turning the pages of a novel until long past our bedtime and keeps us glued to a television movie when we know we really should be paying bills or doing something similarly responsible.

To pump up the adrenaline and keep the audience glued to the story, many works of both linear and nonlinear narrative use a device called a *ticking clock*. With a ticking clock, the protagonist is given a specific and limited period of time to accomplish his goal. Otherwise there will be serious and perhaps even deadly consequences. A ticking clock is an excellent way to keep the momentum of a story going. The ticking clock can even be found in children's fairy tales. Cinderella, for example, has to rush out of the ballroom before the clock strikes 12 or else she will be caught in public in her humiliating rags. Movies and TV shows are full of ticking clocks, and an entire TV series, 24, is built around a literal ticking clock counting off the minutes and hours the main character has left to save the day. The awareness of time running out can dramatically increase one's heartbeat, and it is as effective in digital storytelling as it is in films and television.

THE STORYLINE IN LINEAR AND INTERACTIVE NARRATIVES

As we have seen, many techniques first developed for linear narratives also work extremely well in interactive media. Yet when it comes to the role of the *storyline*—the way the narrative unfolds and is told, beat-by-beat—we are faced with a major difference. In traditional linear narratives, the storyline is all-important, and it needs to be strong and clear. It is "the bones" of a story. But narrative works in digital media are nonlinear, which means that events cannot unfold in a tight sequential order the way a carefully plotted linear story does. Digital storytelling also needs to support interactivity, which, as we've seen, can be extremely disruptive to narrative. And, in the case of games, the actual gaming elements of the work become paramount. In order to offer players a pleasurable and dynamic experience, gameplay is often given prominence over a developed storyline.

Works of digital storytelling vary enormously when it comes to how developed a storyline they can or should carry. Some genres, especially *casual games* (short, lightweight entertainments), often contain little or no storyline to speak of. They may not even have characters or a plot; they may be totally abstract, like an electronic version of tic-tac-toe. Simulations might have just enough of a storyline to give users a framework for what they'll be doing. But at the other extreme, we have projects with richly plotted through-lines, dramatic turns and twists, and even subplots, as is true with certain video games and works of interactive cinema. Given the fact that there is such a vast spectrum of interactive entertainment media, and a great variety of genres within each of the media, it is not possible to formulate a set of rules to govern the "right" amount of story that is appropriate for a given project. The best guide is the project itself. You need to consider its genre, its target audience, its goal, and the nature of the interactivity.

WHAT IS "JUST ENOUGH" OF A STORYLINE?

The JumpStart line of edutainment games for children seems to have found just the right balance between storyline and other demands of educational titles. The JumpStart products are developed by Knowledge Adventure, part of the Universal Vivendi portfolio of game companies, and they are great fun for kids. Their actual purpose, however, is to drill the young users in specific skills they need to master at school, like multiplication or spelling. The drills are incorporated into games that are so entertaining that they feel more like play than like learning. So where do storylines fit in here?

According to Diana Pray, a senior producer on the *JumpStart* titles, the storyline is important to give the game a context; it drives the game toward a particular desired outcome. The *JumpStart* titles feature a cast of highly appealing animated characters, and, in a typical storyline, one or more of the characters has a problem, and the child's help is needed to solve it. "The story encourages kids to reach the end goal," she explained. "We give them enough story so they feel they are in the game. The storyline gives them the incentive to play the games and get the rewards. Incentives are embedded in the story. But kids want to play; they don't want a lot of interruptions. So we don't do very deep stories. We don't want to risk boring the child. We have to be efficient in the storyline."

A HOLLYWOOD WRITER'S VIEW OF INTERACTIVE MEDIA

Writers moving from the linear world of Hollywood screenwriting into the field of interactive media are often as struck, as I was, by the similarities in crafting scripts in these two seemingly antithetical arenas. A number of people interviewed for this book remarked on this. Among them was Anne Collins-Ludwick. Collins-Ludwick comes from the field of mainstream nighttime television and has worked on such successful television series as *Vegas, Fantasy Island*, and the mystery series *Matlock*. In 2002, she made a major career switch and became a scriptwriter and producer for Her Interactive, which makes the *Nancy Drew* mystery-adventure games. It was her first professional exposure to interactive media, and she plunged in headfirst. In just a little over a year, she helped develop four new titles, including *The Haunted Carousel*. (See Figure 5.1.)

"The parallels between what I do here and working on a weekly TV show are phenomenal," she told me. "Lots of the elements are just the same." Chief among them, she noted, was the process of developing the story and characters and the designing of the environments (though they are called "interiors" and "exteriors" in Hollywood scripts). "I found I knew everything I needed to know," she added. "It was just a different application."

For Collins-Ludwick, accustomed to the taut linear scripts of Hollywood, the one major difference was the way interactivity impacted the story. "Giving the

Figure 5.1
Nancy Drew
mystery—adventure
games like *The*Haunted Carousel
utilize many tools
drawn from linear
screenwriting. Image
courtesy of Her
Interactive.

player choices was the hardest part for me," she recalled. "We want to give the players as much freedom to explore as possible, but we also want to relate a story. We need to move them from A to B to C." The challenge was to find a way to reveal the mystery while also offering the players a significant amount of choice and to balance the need to tell a story against the need to give players the opportunity to explore.

The other big challenge for her, and what she considered to be her steepest learning curve, was mastering an interactive script format. She had to learn how to flag material so that once the player had performed a certain task, something could happen that could not have happened previously. For instance, if a player found a hidden letter, she could now ask a character an important question, or she could enter an area that had previously been off limits.

"It was a lot to keep straight in my head; there was a lot of logic to get used to, and a lot of details. It's a matter of training your brain to think in a certain pattern," she said. But she was taken in hand and helped by a staffer with a great deal of technical savvy, and she also found that the company's thorough

documentation process helped her keep track of things. "It's easy now," she reports, "but in the beginning it was very intimidating."

Of course, works of digital storytelling may contain segments that are not interactive but are, instead, like a linear scene from a movie. Linear scenes are used in different ways in different genres of digital storytelling. In video games, these linear passages are called cut scenes. They are usually found at the beginning of a game, serving as an introduction to the world where the game is set. They also give enough information to make it clear what you as a player need to do in this virtual world, and why. Cut scenes are also sprinkled through most games, often triggered when a player has accomplished a particular task. At such points they function as an opportunity to advance the narrative aspects of the game. They may also give important pieces of the backstory (elements of the narrative that took place before the game opens and are important to the understanding of the game's story). These scenes are really no different from scenes you'd find in a movie or a television show except that in today's games they are animated rather than live action. Thus, any of the cinematic or dramatic techniques employed in these older media can be used just as successfully in the linear sequences of interactive works, though cut scenes should be kept as short and used as sparingly as possible.

TEN NEW TOOLS

Although many well-seasoned tools of traditional storytelling can, with certain modifications, still be used in digital storytelling, working in this arena also requires utilizing some entirely new tools. And it also calls for something else: an attitude adjustment. In order to create these new kinds of stories, we must release our mental grip on sequential narrative and be open to the possibilities that interactivity offers us.

This is not only true for those who are accustomed to working in traditional screen-based media, like Anne Collins-Ludwick. It also applies to anyone who has grown up watching TV and movies and has developed the expectation that stories should have tightly constructed linear plots. It is usually less of an issue for those people who, from childhood on, have played video games or surfed the Web. Yet even members of this generation can have trouble functioning in a nonsequential story world.

But no matter which category you fall into—the group who embraces non-linearity or the group who is uneasy with it—you still need to learn how to use a new set of tools if you want to work in digital storytelling. They will be explored in detail in future chapters, but we will offer a brief rundown of 10 of the most essential tools here, along with information about where more extensive discussions of each can be found.

1. Interface and Navigation

The users of an interactive work need a way to connect with the material, perform actions, and move around. This is where interface design and navigational

tools come in. They provide a way for users to make their wishes known and control what they see and do and where they go. The many visual devices used in interface design and navigation include menus, navigation bars, icons, buttons, cursors, rollovers, maps, and directional symbols. Hardware devices include video game controllers, touch screens, and virtual reality (VR) wands. (Chapter 7, Structure in Digital Storytelling; Chapter 14, Video Games; Chapter 22, Immersive Environments.)

2. Systems for Determining Events and Assigning Variables

In order for the events within an interactive project to occur at an appropriate time, and not have the narrative self-destruct into chaos, there needs to be an orderly system of logic that will guide the programming. Most members of the creative team are not expected to do any programming themselves, but they still must understand the basic principles governing *what* happens *when*.

Also, interactive projects typically involve a great number of variables. For example, characters may be constructed from variables including body types, physical attributes, and special skills. To organize such variables, the design team will often construct a *matrix* to help assign and track them. As a member of the design team or as a writer, it is necessary to understand how to work with the variables and the system of logic in your project. (Chapter 6, Characters, Dialogue, and Emotions; Chapter 7, Structure in Digital Storytelling; Chapter 10, Creating a Work of Digital Storytelling: The Development Process.)

3. Assigning a Role and Point of View to the User

Users have many possible roles they can play in an interactive narrative, and they can also view the virtual world from more than one possible point of view. One thing the creative team decides early on is who the user will "be" in the story and how the user will view the virtual world that is portrayed in the narrative. (Chapter 6, Characters, Dialogue, and Emotions.)

4. Working with New Types of Characters and Artificial Intelligence

Thanks to interactive media, a strange new cast of character types has sprung into being. Among them are avatars, chatterbots, and nonplayer characters (characters controlled by the computer, usually called NPCs). In some cases, digital characters have artificial intelligence (AI). They seem to understand what the player is doing or saying, and they act appropriately in response. The way characters are developed and given personality and AI calls for considerations never encountered in linear media. (Chapter 6, Characters, Dialogue, and Emotions.)

5. New Ways of Connecting Story Elements

In linear entertainment, the various media elements—audio, graphics, moving images, and text—come "glued" together and cannot be pried apart, as do the

various scenes that constitute the story. But in interactive media, media assets, scenes, and major pieces of story can be presented or accessed as separate entities and connected in various ways. These various ways of connecting story pieces exist on both micro and macro levels.

As we saw in Chapters 1 and 2, hypertext is one way of connecting assets. It requires an active decision on the part of the user to make the connection. But story elements can also be connected indirectly. In Chapter 7, on structure, we will see how pieces of a story such as a cut scene or the appearance of a new character or the discovery of a clue can be triggered indirectly once the user has performed a specific set of actions or solved a puzzle.

On the macro level, works of digital storytelling can be constructed to exist across a number of media platforms such as mobile devices, broadcast television, and the Internet, with parts of each story available on different media platforms and with the whole story interconnected. This is known as a *transmedia approach*, and it includes a new type of narrative–game hybrid, the *Alternate Reality Game*. (Chapter 9, Using a Transmedia Approach; Chapter 17, Alternate Reality Games.)

6. Gameplay

As we have discussed, many works of digital storytelling are built around games, and in such works, the creative team must give a serious amount of attention to developing satisfactory *gameplay* for the project. Gameplay is the overall experience of playing a game and what makes it fun and pleasurable; it is what the player can do in the game. It includes the game's challenges, how they can be overcome, the game's rules, and what it takes to win (or lose).

Even works that are not primarily games may require users to solve puzzles, answer trivia questions, or play a series of minigames. Thus, it is important to understand games and have a basic grasp of what constitutes good gameplay. (Chapter 1, Storytelling, Old and New; Chapter 4, Interactivity and Its Effects; Chapter 5, Old Tools/New Tools; Chapter 14, Video Games; Chapter 16, Massively Multiplayer Online Games (MMOGs); Chapter 17, Alternate Reality Games (ARGs).)

7. Rewards and Penalties

Rewards are an effective way to keep users motivated, while penalties keep them on their toes and add an agreeable amount of tension. They are usually found in games but may be used in other types of digital storytelling as well. Rewards may be in the form of points, play money, or a valuable object for one's inventory. Players may also be rewarded by rising to a higher level, getting a virtual career promotion, or receiving extra powers for their avatars. Penalties, on the other hand, can be the deduction of anything that can be earned as a reward. The ultimate penalty is a virtual death or losing the game. It is important to know what kinds of rewards and penalties work well for your genre and are appropriate for

your audience. (Chapter 8, Tackling Projects for Children; Chapter 11, Using Digital Storytelling to Teach and Train; Chapter 14, Video Games.)

8. New Kinds of Building Blocks

Most forms of linear narrative use the same basic building block or unit of organization: the scene. Scenes move the overall story along, but they are also complete little dramas in themselves. Interactive media, however, uses very different units of organization. Each of these units offers a specific set of possibilities—things the user can do or discover within them. As part of the creative team, you need to have an understanding of the basic building blocks of whatever genre you are working in. (Chapter 7, Structure in Digital Storytelling.)

9. The Use of Time and Space

Time and space are far more dynamic factors of interactive narration than they are of linear media. For example, games may present a persistent universe, where time moves on and events occur even when the game or story is turned off. Thus, if users fail to log on to a MMOG they've subscribed to, they may forego the opportunity to take part in an exciting adventure, or if a user has adopted a virtual pet, it may die if not fed regularly.

In a different use of time, the interactive medium may keep track of things like holidays and important anniversaries in your personal life. For instance, a smart doll may wish its child companion a happy birthday or a Merry Christmas on the appropriate dates.

In many fictional interactive worlds, time is cycled on a regular basis, so that during a single session of play, the user might experience dawn, the midday sun, and sunset. The virtual world may also cycle through different seasons of the year, and sometimes the changing of a season will trigger a dramatic event in the story. In some games, you can slow down time or speed it up. And in some works of interactive cinema, you may be able to select which time period of a story you want to visit.

In addition, geographical space is experienced on a different scale and in a different way in interactive media than in linear media. Some games contain multiple parallel universes, where events are going on simultaneously in more than one place and you can hop back and forth between these worlds. In other games, the geographical scope of a game can be vast, and it can take hours or even days for the player to travel from one point to another.

As part of a creative team, you need to have a basic knowledge of the various possibilities of space and time in digital storytelling, and you should have some idea of how they might be utilized in the type of project you are working on. (Chapter 14, Video Games; Chapter 16, Massively Multiplayer Online Games (MMOGs); Chapter 19, Smart Toys and Lifelike Robots; Chapter 21, Interactive Cinema (iCinema).)

10. Sensors and Special Hardware

Certain forms of interactive entertainment require sensors or other devices in order to simulate reality or control or trigger events. For example, a smart doll might have a built-in sensor that can detect light and darkness, and it can be sleepy when it grows dark and wide awake in the morning. In immersive environments, users need to wear special equipment to see virtual images, and such environments may use a variety of other devices to simulate reality. As a member of the creative team of a project that uses sensors or other special hardware, you will need to know enough about what the devices can do so that you can use them effectively in your project. (Chapter 19, Smart Toys and Lifelike Robots; Chapter 22, Immersive Environments.)

THE COLLABORATIVE PROCESS

Working with an unfamiliar and complex set of tools—even a single new tool—can be an anxiety-producing experience. For someone who has never worked in interactive media, the first exposure can be something of a culture shock. Fortunately, professionals in interactive media seldom work in a vacuum. It is not a field populated by hermit-like artists slaving away in lonely garrets. On the contrary, it is a field that almost evangelically promotes the team process. Colleagues are encouraged to share ideas in freewheeling brainstorming sessions. Even staffers low on the totem pole are encouraged to contribute ideas. Since almost every company has its own idiosyncratic methods of operating, newcomers are taken in hand by veterans and shown the ropes.

ONE NEWCOMER'S EXPERIENCE WITH COLLABORATION

Anne Collins-Ludwick, who came from the highly competitive, dog-eat-dog world of prime time television, is one person who has found the working conditions of interactive media to be extremely supportive. She said she was immediately struck by that when she began working on her first *Nancy Drew* title for Her Interactive. "It was one of the most collaborative works of fiction I'd ever been involved with," she reported enthusiastically. "It was collaborative from Day One, when I was first brought into the game."

At virtually all software companies, projects are developed by an entire team rather than by a single individual. The team typically includes specialists from several key areas, such as game design, project management, art direction, and programming. Thus, no one person has the burden of having to be an expert in every facet of the project.

CONCLUSION

Interactive entertainment utilizes an array of tools, some drawn from extremely ancient sources, others from contemporary linear storytellers, and still others

Old Tools/New Tools CHAPTER 5

that are unique to new media. Although ancient and more contemporary storytelling tools are highly useful, we must move beyond them and master 10 new tools.

Often the greatest challenge for people new to digital storytelling is overcoming the discomfort of working with unfamiliar concepts. Depending on our mindset, the chance to pick up and use the new tools employed in this field can be either exhilarating or intimidating.

For those willing to jump in and try them out, a great deal of help is available. As Collins-Ludwick and others have been pleased to discover, digital entertainment is an enormously collaborative field, and even when the learning curve is steep, newcomers can count on getting the support they need from their teammates.

IDEA-GENERATING EXERCISES

- 1. Analyze a computer game you are familiar with (such as a video game or mobile game) and compare it to a specific type of athletic game. In each case, what is the goal, what are the obstacles, and how do you win or lose? In what major ways are they alike or different?
- **2.** Pick a movie, TV show, or novel that you think used tension effectively. What kept you riveted to this story? Do you think this is this something that could be used effectively in digital storytelling?
- **3.** Select an interactive project that you are familiar with, and describe what was built into this material that would make users want to invest their time in it. What would keep them interested and involved?
- **4.** Which of the 10 tools unique to interactive storytelling do you feel is the most challenging or intimidating? Why do you feel this is so?
- **5.** Which of the 10 new tools do you feel is the most creatively exciting? Can you describe something you'd like to try to do with this tool?

Characters, Dialogue, and Emotions

What are the major types of characters in digital storytelling, and how do they differ from characters found in linear media?

Why is it worthwhile to give time and attention to creating your villains?

How does interactivity affect the way characters communicate with us?

What can you do to increase the user's emotional response to an interactive work, and why is this matter even worth considering?

CHARACTERS IN AN INTERACTIVE ENVIRONMENT

Characters are an essential element of all forms of storytelling, from our ancestors' oral recitations of myths and epics to today's high-tech computer-assisted narratives. Characters pull us into the story and give it life. We empathize with our heroes and identify with their struggles; we fear the villains and long to see them defeated. Thanks to characters, both noble and malevolent, we connect with the story on a deep emotional level.

The Role of Characters in Digital Storytelling

If anything, characters are even more important to digital storytelling than they are to linear narratives. In addition to adding life to these narratives and an emotional context, they also serve some specialized roles. They can

- give users entry into an unfamiliar or intimidating world and allow them to explore it in a way that feels inviting and safe;
- increase a project's perception of being entertaining, even if the underlying purpose of the project is educational or instructional;
- add refreshing touches of humor;
- keep people hooked, willing to spend hours immersed in the character's life and environment;
- offer assistance to users when they are confused and answer their questions;
- add excitement, obstacles, and challenges in the form of antagonists.

In addition to all these contributions, strong, unique characters can make a work stand out from others in the market and become a hit. After all, why is it that so many people love the *Tomb Raider* games? The primary reason people love these games is because of the appeal of Lara Croft. She not only leads an exciting life, but she's rich, beautiful, brave, and a phenomenal athlete. Lara is a great aspirational figure for girls, and, as a plus for the guys, well, she's got a great body. (See Figure 6.1.)

Lara Croft and other vivid characters from computer games—characters like Mario, Sonic the Hedgehog, and Carmen Sandiego—have begun to take their place alongside other icons of popular culture like Dick Tracy and Mickey Mouse. The day may not be far off when a character created for a website or a wireless game joins their ranks. In the short time that interactive entertainment has existed, it has proven that it is capable of producing enduring characters, characters who have what it takes to become household names and to sell everything from plastic action figures to lunch boxes.

The Differences between Characters in Linear and Interactive Storytelling

The characters we find in traditional media and the ones we find in digital storytelling are different both in what gives them life and in what they can do. Characters in linear media are created exclusively by writers and can never

Figure 6.1
Lara Croft in a screen capture from
Lara Croft Tomb Raider: The Angel of
Darkness. Lara Croft exemplifies the
enormous drawing power of a wellconceived character. Image courtesy of
Eidos Interactive.

change. The Hamlet created by Shakespeare, for example, will always be plagued by the same doubts and will always speak the same soliloquies, even 400 years after the bard wrote a play about him. As much as members of the audience might want to make Hamlet act differently, there is nothing they can do.

In interactive narratives, however, users can share the job of character creation with the writer, and they can step right into a story. Furthermore, characters in interactive narratives can, as discussed in Chapter 1, break the fourth wall and talk directly with the user. They can also possess artificial intelligence and respond in believable ways to things that the users do. Just imagine, then, what a digital storytelling version of *Hamlet* would be like if it could have a cast of interactive characters and these characters could play a meaningful part in the unfolding of events facing the troubled prince in long ago Denmark!

In digital storytelling, we have two major categories of characters. The terminology to describe them comes from video games. One large group consists of the *player characters*. These are the characters that users have direct control over. The second large group consists of *nonplayer characters*, or *NPCs*. These are the characters that, as the term indicates, are controlled by the computer and not the user.

Interactivity makes it more difficult to construct complex characters and portray how they transform emotionally over time, a change known in linear media as a *character arc*. Without a fixed sequence of events, how do you reveal a character's flaws, needs, and special gifts? How do you show the character growing as

a human being? How can you even produce a vivid portrait of your protagonist when that character might never even be seen because your user has stepped into that character's shoes and has "become" the character? Yet techniques do exist that deal with these challenges, as we will see later in the chapter.

Where Did All the Characters Go?

If good characters add so much appeal to a work of interactive entertainment, how can it be that some immensely popular interactive games don't have any characters at all? After all, the world's first successful computer game, *Pong*, consisted of only a ball and paddle, and *Tetris*, an ever-popular puzzle game, lacks characters, too. And so does the simple but addictive wireless game, *Snake*. In *Snake*, you try to lengthen a skinny snakelike shape by "eating" dots. It's a stretch to call the snake a character, though, as it has no personality whatsoever.

True, a number of interactive works have no characters. But they do have something that traditional stories lack: the user. Users actually share many of the qualities possessed by protagonists in linear works, and to a great degree they fill in for a missing main character. They are active; they strive for a goal; they are challenged by obstacles. Furthermore, users are personally invested in the outcome of the story. Their actions, not those of a fictional character, will determine how things turn out. It is the user who brings an interactive construct to life.

CLASSIC CHARACTERS FROM LINEAR MEDIA

Let's now turn to the basic character types of traditional storytelling and see how these models might serve us in interactive media. The two classic archetypes, the must-haves of every work of linear storytelling, originated in the classic Greek theatre. The first is the protagonist, the central figure of the drama, whose mission, goal, or objective provides the story with its forward momentum. The second archetype is the antagonist, the adversary who stands in the way of the protagonist and whose opposition gives heat to the drama and provides the story with exciting conflict.

For anyone who might still have a lingering doubt about the critical role competitive games have played in the origin of drama and storytelling, consider this: The words "antagonist" and "protagonist" are both formed around the same Greek root, agon. As mentioned in Chapter 4, the word *agon* means a contest for a prize at a public game. The protagonist is literally one who goes after the prize, and the antagonist is the one who tries to prevent this; their struggle is the core of the story.

In works of linear storytelling, the protagonist is the character the audience is rooting for. Audience members invest their emotions in the protagonist's struggle and want to see this character succeed. In an interactive work, the emotional investment is often even greater, for in most cases, the protagonist and player are one and the same; the protagonist is a player character, controlled by the user. A protagonist in an interactive work can give the user an opportunity to

live out a fantasy by virtually walking in that character's shoes. Antagonists, on the other hand, stand in the way of the outcome the user most wants. Almost inevitably, antagonists in digital storytelling are NPCs.

THE USER AS PROTAGONIST

As we have learned from traditional media, a protagonist need not be a saint. After all, Tony Soprano in the HBO series, *The Sopranos*, is hardly a man of virtue. He's the head of a Mafia family, a murderer and a philanderer, and yet he is unquestionably the protagonist of the series. It is easy to find tarnished protagonists in interactive media as well; we need look no further than the enormously successful video game *Grand Theft Auto: Vice City.* Our protagonist here is Tommy Vercetti, also a mafioso, and he delights in causing mayhem.

Many authorities in drama, beginning with Aristotle, have contended that the most interesting characters are not perfect. In classic Greek theatre, as with Shakespeare's plays, the main characters are afflicted by what is often termed "a tragic flaw." Though noble in many ways, they also possess some weakness—jealousy, self-doubt, ambition—a trait that leads to their undoing. In lighter stories, protagonists usually have flaws, too, though of a less serious nature. These dings in their personalities will not lead to tragic consequences, but they will often cause them trouble and can also be the source of comic moments. Not every protagonist in interactive media has a flaw or a quirk, but such weaknesses are not uncommon. That's even true of the little mouse, Mia, who is the star of a hit series of children's titles. Mia has a perky, adventurous, can-do personality, but she has some flaws as well. She can be stubborn and recklessly curious and doesn't always think ahead, and all of these traits can land her in trouble. (See Figure 6.2.)

Figure 6.2
Mia, the perky little mouse who stars in a hit series of CD-ROM titles for kids, is not without her flaws. Image Courtesy of Kutoka Interactive.

According to Richard Vincent, president of Kutoka Interactive, the Canadian company that makes the *Mia* edutainment titles, the work spent in character design is critical. "Games really end up being about character," he told me. "If people don't identify with the character, they won't play it. I admit in the beginning I wasn't thinking like that; I wasn't thinking characters were that important." But the success of Mia convinced him of the pivotal role characters play, and the company has changed its preproduction process accordingly, devoting time to preparing a complete bible of all the characters, their personalities, and their worlds.

What we need in a protagonist are qualities that make them likable, believable, and attractive enough for us to want to spend time in their company. We need to understand why they have chosen to go after the particular goal they are seeking—their passion to do this must make sense to us. In other words, we must be able to identify with them—be able to imagine ourselves in their position and feel what they are feeling. This becomes even more important in interactive media, where in so many cases, we actually take on the role of the protagonist. If the main character is distasteful to us, or if the character's motivation baffles us, we are not going to want to invest our time in this particular work of digital entertainment.

The User's Avatar

Player characters often appear on the screen in the form of an *avatar*—a graphic representation of the character. The word *avatar* comes from the Hindu religion, where it means an incarnation or physical representation of a deity. The avatar's movements and choices are controlled by the player. In some cases, avatars are predefined and unchangeable, but in other cases, players can construct avatars out of a selection of heads, body parts, and clothing and gear, and they can also choose such things as special skills and powers for them. The make-it-yourself avatars are extremely common in MMOGs and in many video games. As yet another possibility, users can sometimes pick their character from several possible predefined choices.

It is important to note that in some forms of digital storytelling, we have no physical representation of the user on the screen at all. This is true in works where the user sees things from the first-person point of view, as we will be discussing. It is also true when the user plays a God-like role and is able to see and do things but is not actually a character in the story. Furthermore, in some kinds of nonscreen based forms of digital storytelling, the user is actually physically present and is interacting directly with the narrative. This is the case when the user is participating in an immersive environment or playing with a smart toy.

The User's Point of View

One of the most unique aspects of digital storytelling is its use of *point of view* (POV). The user has two, or possibly three, very different ways of seeing things

Figure 6.3
With a first-person
POV, as in this
example from *Thief*,
we do not see the
character we are
playing, except
perhaps a hand or
a foot or a weapon.
Image courtesy of
Eidos Interactive.

in a virtual world: via the first-person and third-person POV. Some would argue that there is a second-person POV as well.

With a *first-person POV*, we see the action as if we were actually right there and viewing it through our own eyes. We see the world around us, but we don't see ourselves, except for perhaps a hand or a foot or a weapon we are holding. It is the "I" experience: I am doing this, I am doing that. The first-person POV is much like the way we experience things in real life. For instance, I don't see myself as I type on my computer, though I can see my hands on the keyboard. This is the same way first-person perspective works in interactive media. With this POV, it is quite easy to put ourselves completely into the role of the character we are playing and invest in the illusion that we really are the hero of the story. There is nothing visual on the screen to remind us we are not really that character. (See Figure 6.3.)

In some cases with the first-person POV, the pointer on the screen may indicate where we are in the virtual world and may even change into an iconic symbol in certain situations. For example, if we are playing a detective, the pointer may change into a magnifying glass when we are physically close to a clue.

With the *third-person POV*, on the other hand, we are watching our character from a distance, much like we watch the protagonist in a movie. We can see the character in action and can see his or her facial expressions, too. With the

Figure 6.4
In a third-person
POV, as in this screen
capture from Lara
Croft Tomb Raider:
Angel of Darkness,
we can fully see the
character we are
playing, much as if
we were watching a
movie. Image courtesy
of Eidos Interactive.

third-person POV, our protagonist can be extremely well developed visually. (See Figure 6.4.) Cut scenes show characters from the third-person POV, as well.

Some professionals in the field also contend that a number of interactive works also offer a second-person POV, a view that combines the intimacy of first person with the objectivity of third person. In a second-person POV, they hold, we largely see things as if we were really in the scene, but we also see a little of our avatar—the back of the head, perhaps, or a shoulder. It's almost like being right on top of your character but not "inside" the character. Others would argue that the so-called second-person POV does not actually exist but is actually a variation on the third-person POV.

The first- and third-person POVs each have their advantages and disadvantages. The first-person perspective gives us great immediacy and immersiveness. However, we never get to see what our characters look like and cannot watch their reactions. It's also difficult to portray certain kinds of actions with the first-person POV. How can you show the character drinking a glass of whiskey, for instance, or hugging another character? On the other hand, the third-person POV allows us to see the character's movements and facial expressions, but since the character is so well defined visually, it is more difficult for us to put

ourselves into the role. It can create a sense of disconnect between the user and the material.

In video games, the decision whether to use the first- or third-person POV depends to a large degree on the kind of gameplay being offered. In games that emphasize shooting action, the first-person POV is the most often used, since that gives the player the sense of actually controlling the gun. In fact, such games are usually referred to as *first-person shooters*. On the other hand, when games have the main character doing a great deal of running, jumping, and climbing, like the *Tomb Raider* series, it is advantageous to use the third-person POV. That way, you can see your character's body and have better control over what the character is doing.

Many interactive works try to get around the perspective problem by offering different POVs in different situations. They give the user the first-person POV for the most adrenaline-intense action scenes and use the third-person POV for exploratory situations. However, the jump between the different perspectives can be jarring and break the user's sense of immersion.

Determining which point of view to use for your project is an important decision, and it is one that must be made early on because so many other factors will be impacted by it, from character design to graphics issues to types of interactivity.

The User's Many Possible Roles

Another critical matter to determine is what role the user plays in the narrative. So far, we have been focusing on the user as the hero of the story—as the protagonist. But in some digital storytelling works, you play the assistant or helper of the "star" of the story and help this character reach a particular goal. Who are you in a case like that? You might be thought of as a sidekick or pal, but you could also claim to be the protagonist since your actions will determine how things end.

In some interactive narratives, you are assigned to a particular role at the very beginning, such as a rookie detective of a junior mafioso, and from there you try to work your way up to the top of your virtual profession. In other interactive narratives, you play a voyeur and spy on people, but you are also a character in the story and can get caught spying, with possible fatal consequences. In yet other works, you become a deity-like figure, controlling the destiny of a virtual world, or a particular piece of that world—a military unit or a sports team. As still another possibility, and quite a common one, you just play yourself, though you interact with fictional characters. And sometimes you are not a character at all and do not take a direct part in the story. Instead your choices determine what part of the story you will see.

As a member of the creative team for a digital storytelling project, among the first decisions you will need to make is who the user is in the story and what the user will be able to do.

COMPUTER CONTROLLED CHARACTERS: ANTAGONISTS AND OTHERS

While it is impossible to conceive of an interactive work without a protagonist, or at the very least, without a player–participant, can the same be said for the necessity of an antagonist? Is it essential to include an oppositional character or series of them in every work of digital entertainment?

In order to answer this question, you must first consider the nature of your project. Where does it fit within the overall entertainment spectrum, with free-form experiences on one end and works with strong storylines and goals on the other? If it leans more toward the free-form end, you probably won't need an antagonist. Such projects tend to be more like unstructured play (activities involving smart toys, for example) or offer the user the opportunity to construct items with digital tools (artwork, simulated neighborhoods, or theme park rides). Activities like these can be quite engrossing without inserting an antagonist; in a sense, the challenges they offer serve the same function. For the most part, antagonists can be an unwelcome and disruptive presence in free-form projects, unless they are created by the users themselves.

On the other hand, interactive experiences that have clear-cut goals and the other hallmarks of games and stories will definitely require oppositional forces. Most frequently, these forces will be characters. However, opposition can also come from natural forces, such as violent storms, or from physical challenges, such as negotiating a boot camp obstacle course. Opposition may also come from nonhuman characters, such as dangerous animals.

In general, opposing forces in the form of sentient characters will make the conflicts more dramatic and more "personal." Being pitted against an intelligent adversary will ratchet up the user's feeling of danger and jeopardy. An opponent who is capable of reason and strategy is far more formidable and far scarier than any inanimate obstacle can be.

FAMILY FRIENDLY AND COMIC ANTAGONISTS

Even games made for young children usually include villains of one kind or another. The opponents in projects for young children tend to be humorous bad guys, rather than the truly menacing opponents that are found in works for older users. For instance, one of the antagonists in the <code>JumpStart</code> line is a snail named Dr. O. Senior producer Diana Pray described him to me as "spineless, armless, slimy and silly, sort of a family-friendly villain." She told me that research had shown that kids really like to have bad guys in their games and that parents didn't mind as long as the characters weren't evil. As with <code>JumpStart</code>, the bad guys in Kutoka's children's titles are done with a light touch. In the <code>Didi</code> and <code>Ditto</code> games, for example, the antagonist is a wolf, but not a vicious, carnivorous one.

(Continued)

This wolf happens to be a vegetarian, and he's a little embarrassed about his unusual food preferences.

Even humorous opponents fill an important function:

- . They help sharpen the conflict.
- · They supply obstacles.
- They pit the protagonist against a force that is easy to comprehend.

Creating Worthy Opponents

Just as the time spent developing your protagonist pays off in a more engaging product, so does the time invested in creating your antagonists. Well-drawn antagonists, especially ones that are not stereotypes, can give your work depth and richness. In interactive media, opponents are almost always violent and evil characters who cannot be overcome except by the use of physical violence. But is it inevitable that they must follow this model? Certainly not if we follow the examples set in traditional storytelling.

For instance, in romantic comedies, the antagonist can be an otherwise nice individual who just happens to cause the protagonist a great deal of trouble. In domestic dramas, too, the protagonist is usually pitted against a mostly decent, likeable person, often a spouse or family member. Such adversarial relationships are the staple of novels, independent films, and television sitcoms and soap operas. They demonstrate that opponents do not have to be villainous or pose a physical threat in order to be compelling.

Here are a few other factors to keep in mind when you are creating an opponent for your protagonist:

- For maximum sizzle, make your antagonist and protagonist evenly matched. If your opponent is too menacing or overpowering, the protagonist's struggle will seem hopeless, and the users will be tempted to give up. On the other hand, if the antagonist is too weak, users will lose interest, perceiving the struggle as unchallenging.
- Provide your antagonist with an understandable motive to explain why he or she is blocking the hero's way. The more intensely motivated the antagonist, the more dramatic the story. And the motive must seem logical and justified, at least to the opponent.
- The more the hero knows about the opponent, and the more the opponent knows about the hero, the more interesting and personal the battle will be.

A Multiple Number or Succession of Antagonists

In some interactive works, the protagonist might be pitted against multiple opponents, one after another. The fiercest and scariest of these opponents will

usually make an appearance very near the end of a level or other segment of the work and must be defeated in order for the player to make further progress in the story. In games, this formidable type of antagonist is known as a *boss monster*, and the fight between the boss monster and the player is known as the *boss battle*.

In works with a succession of antagonists, creative teams sometimes cut corners and make all of these bad guys practically indistinguishable from one another (nearly identical enemy soldiers or werewolves, for example). However, projects are far more interesting when each opponent is unique and intriguing.

Other Types of NPCs

Antagonists are by no means the only type of NPCs to be found in digital storytelling. They can also be allies of the protagonist (friends, family members, fellow warriors) and neutral characters (shopkeepers, customers, drinkers in a bar). NPCs often serve the same purpose as the minor characters in a movie or TV show, though they may also have specialized functions in digital works that do not exist in traditional narratives, such as helper characters you can call on when you are stuck or have a question.

NPCs serve many functions. They populate a virtual world, provide clues, serve as gatekeepers, add color, and supply comic relief. They can also act as employers, providing users with a way to earn money and an incentive to perform particular actions.

Even minor characters, if well developed, can help inject richness and originality into a project. Just as with a succession of opponents, it is a wasted opportunity to have a group of minor characters—be they hairy monsters, little bears, or school kids—all resemble each other. To help illustrate this point, there's a wonderful story about the making of the Disney classic *Snow White and the Seven Dwarfs*. Evidently, Walt Disney was originally planning to make all the dwarfs alike; they'd all just be little old men. But then he decided to give them each a name that reflected something about them and dubbed them Sleepy, Dopey, Sneezy, Bashful, Happy, Doc, and Grumpy. Suddenly these little guys sprang to life, and each became a vivid individual in his own right. Many adults can still remember and name these beloved characters long after having seen the movie in childhood.

INTELLIGENT CHARACTERS

Within the vast population of nonplayer characters, just as within the human population, you can find a great range of mental capabilities. On the low end, NPCs can be extremely dumb; on the high end, they can be impressively bright. The dumbest of the computer-controlled characters do not have the ability to communicate and do not have variable behavior. In the middle range, users and characters can "converse" with each other, though the ability of the NPCs to understand and react is limited. But on the smartest end of the scale, we

have characters who seem to understand human language and who respond in a lifelike way to what the users are saying to them. The very brightest are said to possess *artificial intelligence*.

The very first of these super-bright characters was a "virtual psychiatrist" named ELIZA. She was created in the mid-1960s by Joseph Weizenbaum, a professor of computer science at MIT. He programmed ELIZA to meet the rigorous standards of AI set in 1950 by Alan Turing. In what is now known as the "Turing Test," both a human and a computer are asked a series of questions. If the computer's answers cannot be distinguished from the human's, the computer is regarded as having AI.

ELIZA, the intelligent character that Professor Weizenbaum created, would ask the user probing questions much like a real psychiatrist, and she would comment on the user's responses in a surprisingly thoughtful and lifelike way, often with questions of her own. ELIZA did not actually appear on the screen but manifested herself only through the typed questions and comments she would send to the user. Nevertheless, she was evidently so convincing that the people who interacted with her, including the professor's own secretary, were convinced that ELIZA truly understood them.

Chatterbots

ELIZA gave birth to a new kind of digital character, the *chatterbot*—in other words, a bot (artificial character, short for robot) with whom you can chat. Dozens of chatterbots "live" on the Internet and are available to converse around the clock. You chat with them by typing in your part of the conversation, and they respond either by typing back or by speaking. And unlike ELIZA, who was invisible, most of these contemporary chatterbots have an animated presence on the screen.

Among those that I have conversed with is A.L.I.C.E., who lives on the website of the Artificial Intelligence Foundation. During a recent rather mundane chitchat about the weather, I mentioned that we were having a hot day in Los Angeles. She surprised me by asking if we were experiencing global warming. Pretty smart! Another is Cybelle, who lives in AgentLand, which she describes as being high in the skies of cyberspace. She apologized for misunderstanding one of my questions, explaining that her botmaster was still working on her brain. The most surreal chatterbot of all is God, with whom you can converse by visiting a website called *iGod*. God tells me he is a chatterbot "created by Myself" and goes on to say that he is a "flawless entity." Although A.L.I.C.E. and Cybelle are animated, God, appropriately enough, is invisible.

Synthetic Characters

When a character can "understand" the words the user freely types or says and is able to respond appropriately, it is called *natural language interface*. Sometimes characters with this capacity are fully animated and highly lifelike,

unlike the more cartoony chatterbots on the Internet. These realistic intelligent creations are called synthetic characters.

Some of these synthetic characters have been put to work in military training simulations made for the U.S. Army. Unlike ELIZA and her kin, these synthetic characters are capable of a wide range of behaviors, and their backgrounds, personalities, and motivations are developed in depth in much the same way as major characters are developed for feature films and television scripts.

The goal is to make these synthetic characters as lifelike as possible and to make the exchanges between them and the user feel emotionally authentic. These synthetic characters have individual attitudes and agendas, and their behavior toward the trainee is influenced by the conversations between them. If the trainee handles the conversation in one way, the attitude of the synthetic character might possibly change from cordial to hostile, but if it goes a different way, the character becomes extremely cooperative.

The holy grail of natural language interface is *voice recognition*. Voice recognition allows the user to talk in a normal way instead of typing, and the character responds orally, thus duplicating a human conversation. Though voice recognition exists, it is still far from perfect. To have a truly realistic conversation with a synthetic character, four goals must be accomplished:

- **1.** The synthetic character (actually, the computer) has to be able to understand what a user is saying.
- **2.** The synthetic character (the computer) has to be able to formulate and express a verbal response.
- **3.** The synthetic character must look convincing while speaking, with the lip movements in sync with the words and with appropriate facial expressions.
- **4.** The synthetic character must sound convincing, with natural inflections and speech rhythms.

TAKING "LIFELIKE" TO THE OUTER EDGE

While most digital characters are total fabrications of the imagination, the technology now exists to recreate the images, voices, and personalities of real people, including those who have passed away. In 2007, Orville Redenbacher, the popcorn guru, became the first digital character to rise from the dead. He was reconstructed 12 years after his demise by the well-known special effects house, Digital Domain, enabling him to pitch his beloved popcorn in TV commercials once again.

In a similar fashion, the latest generation of androids, robots, and animatronic characters is pushing the envelope of realism to a degree never before possible. In Chapter 19, we will meet three-dimensional characters that can talk, bleed, and even give birth. And in Chapter 22, we will encounter a lifelike animatronic dolphin that actually swims in the ocean among snorkelers.

CREATING CHARACTERS FOR AN INTERACTIVE ENVIRONMENT

Creating complex and dimensional characters is more challenging in digital storytelling than it is for works of linear media since we don't have a number of the same techniques available to us. For example, in films and TV shows, we can cut away to scenes the protagonist is not part of, and during these scenes we can learn important things about our main character. But cutaways are not usually possible in interactive narratives since the protagonist and the user are often the same. In addition, the scenes and dialogue exchanges in interactive media tend to be short, leaving little room to reveal subtle character traits.

Furthermore, because events in interactive narratives do not occur in a fixed sequence, it is extremely difficult to portray a *character arc*, a process during the course of the story in which the protagonist grows and changes. In linear stories, for example, the heroine may go from being self-centered and egotistical to becoming a loving and caring individual, or the hero may go from cowardly to brave. Such change is a staple element of linear drama, but the protagonists in interactive narratives tend to remain essentially unchanged from the beginning to end.

Despite these challenges, however, it is possible to create dimensional, original, and evolving characters for works of digital storytelling, and, as we will see, it is also possible to portray dramatic character arcs.

Techniques for Developing Memorable Characters

As we have noted, works of digital storytelling benefit when they are populated by dynamic, unique, and memorable characters. Here are seven pointers that can help you create them:

- **1.** Develop character biographies: Invest time in working out the backstories and psychological profiles of each of your main characters. What are their personal and professional histories? What are their hopes and fears? Though you may never use most of this information, it will help you develop rich and interesting characters.
- **2. Motivate your characters:** Your protagonist, antagonist, and other important characters should have clear goals. This will energize them and make them understandable. What are they striving for and why is it so important to them?
- **3.** Make them vivid: Interactive media does not leave any room for subtlety. Your characters' most important traits should shine through clearly. For models, study comic strips, graphic novels, and animated movies, all of which use shorthand techniques to convey character.
- **4.** Avoid stereotypes, or alternatively, play against them: Stereotypes can make your work seem predictable and bland. Either avoid them completely or take a familiar stereotype and give it a twist it. For example, make your mad scientist a little old lady, or have your tough enemy solider be an expert on French champagne.

- **5. Give characters a distinct look:** The appearance of your characters can telegraph a great deal about them. Consider their body language, how they hold themselves, and how they move (arms clenched to their bodies, stooped over a walker, a cocky swagger). Their clothing can also provide clues as can the objects they typically have with them.
- **6.** Make them fun: Not all characters can be humorous, but people do love characters that are amusing. A droll appearance, an eccentric quirk, or an amusing way of speaking will help characters stand out. Be aware, however, that "fun" and "cute" are not necessarily the same thing. Cute characters may feel too young to teenagers, though they tend to be popular with all age groups in Asia.
- **7. Give them a standout name:** Some designers are fervent in their belief that a catchy name is critical. While not all popular characters have arresting names, we can find some distinctive ones from the world of video games, including Duke Nukem, Max Payne, Earthworm Jim, and Sonic the Hedgehog. Certainly a memorable name can't hurt.

ADAPTING CHARACTERS FROM ANOTHER MEDIUM

Frequently, a character who is "born" in one medium—a novel, a movie, a TV show, a comic book, or even a board game—will be ported over to a work of interactive entertainment. Such an adaptation calls for careful handling, especially if it involves a well-known figure. The primary consideration is to be as faithful as possible to the original. Otherwise, you risk disappointing the character's fans.

One company that is familiar with this adaptation process is Her Interactive, which develops the *Nancy Drew* mystery titles. Each title is based on one of the beloved Nancy Drew novels, books that have been popular with young girls since 1930. By transporting Nancy Drew from a thirties-era print series to a contemporary interactive game, Her Interactive has managed to retain Nancy Drew's core personality and values while updating her devices. Yes, Nancy now has a laptop and a cell phone, but she still has the same spunky personality and the same enthusiasm for sleuthing she had decades ago.

Constructing a Character Arc

Even though the protagonists in most works of digital entertainment do not grow or change, such static characters are not inevitable. Several techniques can be employed to show your hero or heroine learning, evolving, and changing—in other words, undergoing the emotional transformation that is characteristic of a character arc.

One technique is to employ the structure of your work to your advantage. This works particularly well if your narrative is broken into levels or other progressive units and your protagonist must overcome specific challenges in each level in order to progress to the next structural level. This type of structure is typical

of video games, and you can use it to show your protagonist changing in small increments level by level as he or she advances through the story.

For example, in a video game I worked on recently, the player starts out as a mercenary only interested in his own welfare and getting his job done, no questions asked. But in each level the player learns a little more about his corrupt bosses and their sinister objectives, and by the end of the game, if he survives, he is transformed into a true hero, willing to sacrifice his own life in order to defy the immoral organization he works for. He undergoes a character arc worthy of a first class film, evolving from a cynic to a highly altruistic individual.

A second way to build in a character arc is to allow your user-protagonist to attain new strengths or attributes by earning them through succeeding at certain challenges, by trading with other players for them, or by buying them. This is a common device in video games and MMOGs. Although it is primarily used in settings that feature physical challenges, quests, and combats, there's no reason why it couldn't be used in other types of digital storytelling. For example, consider an interactive drama about a young man who is poor and uncouth but extremely ambitious. You could give him a series of challenges, which, if he succeeds at them, would enable him to acquire a smoother set of social skills, a higher degree of business savvy, and a more ruthless way of dealing with people, along with a better wardrobe and a country club membership. Ultimately, by the time he has attained the success he has dreamed of—becoming a rich and powerful CEO and marrying a beautiful socialite—he would have undergone a significant character transformation.

A third technique is one that is employed in interactive training projects, particularly ones focusing on interpersonal skills. For example, after working through a module on dealing with disgruntled customers, the trainee takes part in a simulation calling for encounters with a series of rude, demanding customers. By handling these situations well, the trainee demonstrates the mastery of the new skills. The protagonist in such cases is a real person, not a fictional character; but even so, this technique could be used in story-based environments to test out new skills and demonstrate change.

Emergent Behavior

In certain extremely sophisticated works of digital storytelling, computer controlled characters may act in ways that go beyond the things they have been specifically programmed to do. At moments like these, they almost seem to have an inner life and be capable of human thought. Janet Murray, in *Hamlet on the Holodeck: The Future of Narrative in Cyberspace*, describes this as *emergent behavior*.

As she explains it (pp. 239–242), a character is capable of emergent behavior when we give it a repertoire of actions, motivations, and behaviors. Programmed with a large cluster of these attributes, each one simple in itself, an NPC is capable of performing in complex and unexpected ways. Sometimes these behaviors may seem very reasonable and understandable and sometimes they may seem ludicrous.

According to Murray, the more abilities we program into our characters, the more unpredictable they can become, and the more apt they are to surprise us. A character programmed to do only one thing—toss snowballs, for example—can be counted on to only toss snowballs. But if we program a character to whistle at women, steal food when feeling hunger, fear men in uniform, and to run fast, we have a character capable of acting in some extremely interesting ways.

Procedural animation is, along with motion-capture and a few other techniques, a way to endow characters with lifelike behavior and a wider range of actions. In procedural animation, characters are generated on the fly, in real time, based on the principles of physics, rather than being rigidly prerendered. To make such a character, the animator provides a set of rules and initial conditions—in other words, a procedure. Will Wright's new game, *Spore*, promises to contain characters developed by procedural animation, although as of this writing, the game has not yet been released.

At this point in time, works containing these lifelike kinds of characters are found primarily in academic computer labs at places like MIT and New York University. However, it is tantalizing to think of being able to employ them in works of digital storytelling.

DIALOGUE AND OTHER FORMS OF VERBAL COMMUNICATION

Characters in movies, plays, and TV shows communicate their thoughts and feelings most directly through dialogue—the verbal exchanges they have with other characters. Dialogue is used to advance the story and to supply critical information necessary for understanding it. It's also a way to gain insight into the characters, their relationships, and their feelings about each other.

In documentaries and educational programs, dialogue spoken "voice-over" by a narrator can be used to impart information and act as an unseen tutor.

Dialogue in interactive media entertainment fills exactly the same role and serves other functions as well. It can be used to

- welcome users to a program;
- explain the program's interface;
- provide help functions;
- coach and correct the user in an educational or training program.

In interactive media, not only do verbal communications serve more functions than in linear media, but we also have a more varied communications palette to work with. For one thing, characters can speak directly to the user, which makes for a far more personalized experience. And for another thing, the user can have an active part in dialogue exchanges.

But in addition to dialogue, we have many other forms of verbal communications we can use, written as well as oral. In terms of oral communications, not only do we have dialogue exchanges, but player characters can also "turn on" a TV or radio and hear a news broadcast that contains key information. Characters also communicate through telephone calls—and often users themselves, as the protagonist, can place the calls and get phone messages from NPCs.

In terms of written communications, player characters can find and read old newspaper clippings, diaries, letters, and documents of every kind, all of which can provide important information about characters and events. They may also be able to read a character's emails and computer files, even "deleted" ones. In additional, fictional characters may have their own Web pages and blogs, which can offer excellent insights into their personalities and motivations. They can also send users emails, faxes, and text messages to their cell phones. By using contemporary methods of communications as part of a story, we have an abundance of new ways that characters can tell us about themselves.

Classic Dialogue

Despite all these new ways of communicating, classic dialogue—a verbal exchange between two or more characters—is still a supremely important tool in most forms of digital storytelling. It is a tool that has been refined and shaped though centuries of use. Even Aristotle, in his typically pithy way, offered some good pointers on writing effective dialogue. In the *Poetics* (Chapter XI, Section 16), he explained that dialogue is "the faculty of saying what is possible and pertinent in a given circumstance." In other words, the character's lines should be believable and reveal only what is possible for him or her to know. And the speech should not ramble; it should be focused on the matter at hand.

In addition to Aristotle, we can learn about dialogue from modern day screen-writers. One of the most valuable things they can teach us is to use dialogue sparingly, only when there is no other means of conveying the information. "Show," they advise, "don't tell." But when screenwriters do use dialogue, they make sure the exchanges are brisk and easy to understand. They use simple, clear words, knowing this is not the place to show off one's vocabulary. And they break the exchanges between characters into short, bite-sized pieces because long speeches make an audience restless. These are all practical principles we can port over to digital media.

Dialogue in Digital Storytelling

Writers and producers in interactive media have discovered that dialogue needs to be even leaner than it is in traditional media. Users become impatient with long stretches of speech; they want to move on to the action. Furthermore, interactive dialogue doesn't lend itself very well to subtlety. In traditional media, when actors say a line of dialogue, we look at their faces for an indication of their emotional states. But the computer-generated animation in most digital programs is usually not up to the task of conveying shades of emotion. Thus, we are better off using more direct language than we would in a play or film.

In interactive media, exposition can be a particular challenge. Exposition is information that is essential for the understanding of the story. It includes the relationships of your characters to each other, salient facts about their backstory and their goals. Many writers are tempted to dump a huge amount of exposition in one speech, very near the beginning of a work, and are relieved at having disposed of it. But beware! When characters reel off a big lump of exposition, the speech sounds unnatural. Furthermore, it brings everything to a halt while it is being delivered. The trick is to work it in naturally, in small doses. And if you can find ways other than dialogue to slip in some of this exposition, all the better.

When dialogue is written as text rather than spoken, we have additional limitations. We don't have the cues available to us that an actor's voice would give us, so it is difficult to suggest nuances such as irony or sarcasm. Written dialogue also rules out some common devices available in oral speech. How do you have a character angrily interrupt another? How do you show a character speaking with hesitation? How can you have two characters excitedly talking at the same time?

Though dialogue in interactive media, whether written or spoken, has certain limitations, it also offers us a tremendous opportunity: The user–player character can actually participate in it. Interactive dialogue can be done in one of several ways.

Some works of digital storytelling support natural language interface, which, as we saw earlier in this chapter, gives the user the opportunity to type a line of dialogue, or speak it, and an NPC will respond in a believable and appropriate way.

Other works of digital storytelling utilize a technique called a *dialogue tree*, in which the player character or user is presented with several lines of dialogue to choose from. Each line will trigger a different response from the NPC being addressed and in some cases may even lead the user or player character down different narrative paths. For example, let's say the player character is walking along the street of a virtual city and encounters a scruffy beggar. The beggar says to the player: "Say, friend, can you spare some change?" The player can now pick one of the following replies:

Choice A: "Well, sure, here's a few bucks. Go get yourself something to eat. (In which case, the beggar makes a sweeping bow and thanks the player profusely.)

Choice B: "No. Can't. I'm in a rush." (In which case, the beggar says sarcastically, "Yeah, you have a nice day, too.")

Choice C: "Are you kidding?! You panhandlers make me sick! Go get a job like the rest of us!" (In which case, the beggar whips out a knife and threatens to stab the player, saying, "Yeah? Well, how do you like this for a job?)

Choice A, furthermore, might result in the beggar giving the player an important piece of information; Choice B might have no consequences; and Choice C

might have disastrous consequences, or, on the other hand, might trigger a surprise twist.

For another example of a dialogue tree see Figure 10.2, Dick and Jane, in Chapter 10.

In some dialogue trees, the line chosen by the user may be spoken aloud by his avatar, and the character who is being addressed will reply out loud as well. But in some cases, the whole exchange is done in text. Sometimes we don't hear the avatar speak the line, though we do hear the NPC's response.

As a third possibility, the user can select from a choice of attitudes and intentions rather than lines of dialogue, a technique that we will call, for lack of a commonly used term, an *attitude selection*. The player's choices in the beggar scenario, for example, might be "kind and obliging," "brusque," or "hostile." We will then hear our avatar speak a line matching the attitude we selected and act accordingly. Usually the types of choices given for attitudes or intents are provocative and are designed to elicit a strong response from the NPC.

In terms of the user's part of the exchange, the important question is how this dialogue will impact the narrative. Will it have consequences, and if so, how profound might they be? This varies greatly from project to project. In some cases, the impact is minimal to none. Though there's an illusion of interactivity, the dialogue choices don't have any affect on the story. This is a weak use of interactivity and a meaningless form of agency. But in other cases, the choices have a significant impact on the narrative. Though this sort of interactive story-telling is more challenging to create, it results in a far more robust project than one with inconsequential dialogue.

Guidelines for Verbal Communications

In addition to the points already mentioned, a few other basic guidelines can be helpful for writing effective dialogue and other forms of oral communications:

- **1.** The lines a character speaks should be "in character." In other words, what the character says should reflect his personality, his age, his mood, his educational level, his profession, his goals, and his point of view.
- **2.** If writing lines to be delivered by an unseen narrator, particularly an authority figure, you will want to use a somewhat formal style. But it is still important to use easy to understand words and to avoid complex sentence construction.
- **3.** If writing for a telephone conversation, study how people talk on the phone. Such exchanges tend to be breezy and brief.
- **4.** If writing a fictional news broadcast, study the format, pacing, and style of a professional news show. Also, listen to how the announcer "teases" an upcoming story.
- **5.** Read what you have written out loud, listening for inadvertent tongue twisters, awkward phrases, unnatural speech, and overly long lines. Then cut and polish.

And here are a few guidelines for written communications:

- **1.** If producing a document that one of the fictional characters supposedly wrote, the writing should be "in character," as with #1 previously.
- **2.** To make the document look authentic, include some typos or misspellings—but only if your character is likely to make such mistakes.
- **3.** Keep the document short. People don't want to spend much time reading.
- **4.** If writing an email, model the telegraphic style of real emails, and even include an *emoticon* or two. (An emoticon is a symbol used in text messages to express an emotion.)
- **5.** In the same way, model any other specialized type of written communication—including Web pages, blogs, and newspaper articles—on reallife examples. Strive to make the piece of writing as authentic looking as possible. From a user's point of view, part of the fun of stumbling across a fictional document is the sense that it could be "real."

THE ROLE OF EMOTION

In character-centric media like novels and movies, not only do the characters in the stories experience strong feelings, but so do the readers and viewers of these stories. Even comic animated films like the *Shrek* series portray characters with easily identifiable emotions, such as loneliness, fear of rejection, fright, and budding love, and the audience easily identifies with their feelings and is moved by them. For some reason, however, most people do not associate interactive projects with deep emotion except, perhaps, for the feelings of tension and excitement and the thrill of combat aroused by the more violent types of video games.

Yet emotions can and do play a role in digital storytelling, and the contribution of emotions can be extremely significant. They can make the work seem less computerized and more real. They also add richness and dimension to the narrative. Above all, they make the experience more immersive and compelling, intensifying the connection between the user and the material.

Video games, the oldest form of digital storytelling, clearly have the power to arouse a wider repertoire of emotions than they are generally given credit for. In a groundbreaking study conducted by Hugh Bowen in 2005, Can Video Games Make you Cry?, 535 gamers were surveyed about the importance of emotions in games. The gamers described feeling a great many nontypical emotions while playing games. They reported strong empathy with many characters and being brought to tears when a favorite one died. They also admitted to becoming moved to tears by certain love stories, by the self-sacrifice of a brave heroine, and by the plight of a broken hearted parent whose child has disappeared. Most surprisingly, two-thirds of them believed that video games presently excelled, or could excel in the future, in offering the emotional richness found in other major forms of art and entertainment.

The potential of digital storytelling to stir the emotions has sparked the interest of a number of people in the interactive media industry. Many of the people interviewed for this book were consciously developing ways to inject emotion into their work, and a number of the projects I investigated contained strong emotional elements.

Some experts interviewed for this book even asserted that when an interactive work is emotionally potent, it will make a greater impression on the user than an emotionally barren work, and that building emotion into an educational project can help people remember the instructional content for an extended period of time.

Some experimental training projects are specifically designed to rouse strong emotions in order to make a deep impression on trainees. One such project, *DarkCon*, is a virtual reality simulation designed to train U.S. soldiers on how to conduct a surveillance mission. This mission is extremely dangerous, but to make the simulation even more frightening and lifelike, it is enhanced by some cutting edge technology. These include a *rumble floor* (a floor that vibrates at appropriate times, such as when there's an explosion) and a *scent necklace* (a device that emits certain smells, like gunpowder).

Jacquelyn Ford Morie, who is producing this project, explained to me that making the simulation emotionally powerful was a deliberate and stated goal. "Studies show you remember emotionally charged events better than neutral ones," she said. So important is putting an emotional bang into *DarkCon* that Morie has actually designed what she calls an "emotional score," a document not unlike a musical score. It maps out the high and low points the participant can experience—feelings of anxiety as well as feelings of relief—pacing the emotions for maximum impact. (See Figure 6.5.)

Though the *DarkCon* scenario is designed to induce feelings of tension and fear, Morie believes many other types of emotions could be incorporated into a simulation and could also have a powerful impact. She is currently working on another VR project, *Memory Stairs*, that centers on an entirely different set of emotions, such as nostalgia and tenderness. (For more on this work, please see Chapter 22, Immersive Environments.)

Cisco's Journal, discussed more fully in Chapter 18, is another work that deals with strong emotions, though its purpose is to entertain, not train. The project was created to provide interactive enhancements for the TV drama, *An American Family*. Made in the form of an illustrated, interactive diary, it offered a revealing window into the turbulent inner life of one of the main characters.

These three examples, all extremely different from each other, and all in different forms of interactive media, illustrate some of the work being done to enrich the emotional content of digital creations. Design teams are working with many other techniques, a number of which will be explored in later chapters.

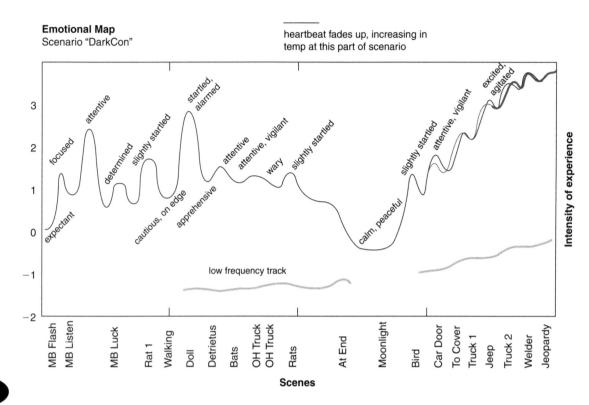

Figure 6.5The emotional score for *DarkCon* maps out the feelings a participant should experience at different points in the VR simulation.

CONCLUSION

As we have seen, characters in interactive dramas can be every bit as vivid and interesting as those in traditional media. However, when we develop fictional beings for our projects, we have to ask ourselves questions we'd never need to ask in creating a traditional story, and such questions are never simple to answer. They are among the most demanding issues that we have to deal with in creating a work of digital entertainment. But when they are addressed thoughtfully, and the necessary time is invested in working them out, they can help us produce outstanding characters who in turn can make the narratives they are in truly memorable.

There's every reason to think that interactive narratives, containing characters and storylines as they do, should be able to be as emotionally rich as traditional narratives. Perhaps it is even possible for an interactive work to induce the ultimate emotional experience that Aristotle described in his analysis of drama: the feeling of catharsis, the profound sense of release. After all, the creators of interactive stories have a powerful tool that wasn't available to Greek

dramatists: immersiveness. Our "audience"—our users—can actually step inside the story world and experience it in a highly personal way. With immersiveness and the other tools at our disposal, we have the potential to produce highly charged works of entertainment, should we choose to do so.

IDEA-GENERATING EXERCISES

- **1.** Create two characters for an interactive work, a protagonist and antagonist, coming up with brief descriptions of each. What is it that your protagonist most wants, and why is the antagonist standing in the way? Try, however, to avoid using the familiar good versus evil model or the need for either one to resort to violence. Instead, strive to invent an antagonist who has some positive qualities, though has some reason to create trouble for the protagonist.
- **2.** Using the same antagonist, come up with three characters who might act as his or her assistants. Do a brief character description of each, striving to make each unique and different from each other, as Disney did with *Snow White and the Seven Dwarfs*.
- **3.** Take your protagonist from Exercise #1 and describe how this character might change from the start of the work to the end. In other words, what kind of character arc might this character experience? Discuss how you could show this transformation in an interactive narrative, using one of the techniques described in this chapter for portraying a character arc.
- **4.** What emotions is your protagonist likely to experience in this conflict with the antagonist? What could add even more emotional richness to this clash between the two characters?
- **5.** Write an interactive dialogue exchange between your protagonist and antagonist, using a dialogue tree.

Structure in Digital Storytelling

How is it possible to organize an experience that is all about free choice? How can you order something that is supposed to be nonlinear?

What kinds of structural "building blocks" exist in interactive media, and how can you use them to help build a work of digital storytelling?

What do you need to know or decide before you begin to structure a new project?

STYROFOAM PEANUTS

Structure: it is the unseen but all-important method of organizing a work of digital storytelling. It functions much like the bones in our bodies. Without our internal skeleton, we would have no shape, and our flesh would have nothing to support it. In a work of digital storytelling, the structure not only supports the narrative and gaming elements but also helps determine the nature of the interactivity.

Structure should not be confused with plot. Plot consists of the basic beats of a story, the "what happens next." Structure is the framework of the story. It connects the basic pieces of the narrative and ensures that the work flows in a satisfying way.

Without question, structure is one of the most daunting aspects of creating a work of interactive entertainment. Yes, character design and the issues that go with it create a host of challenges, as we saw in the previous chapter, but the questions springing up around structure can make one's head spin. How do you organize and shape an experience that is supposed to be free flowing? How do you create a pathway through a nonlinear environment, and when is trying to do that even a good idea? Where do you find usable structural models, when a great many people in the field can't even articulate the models that they are currently using? When you're dealing with interactive structure, it can be extremely hard to find anything solid enough to grasp hold of—it can feel somewhat akin to trying to construct a house out of Styrofoam peanuts.

The job of designing the structure falls to specialists—the game designers in the game world, the information architects of the Internet and information-based projects, and the engineers and computer programmers and designers and inventors and producers in other fields of interactive media. But even if you are not tasked with designing the structure yourself, that doesn't mean you can ignore the topic. That's because every member of the creative team needs to have a basic understanding of the framework that's being used in order to do his or her job. Furthermore, each member of the creative team has valuable input to give since each is viewing the structure from a unique professional vantage point.

Curiously enough, considering that structure is such an essential aspect of creating an interactive project, the language we have to describe it is still largely unfixed. Even basic words like "node" or "level" may be used one way at company A and in quite a different way at company B. As for company C, it is very possible they have no terminology at all to describe the structural model that they use and reuse for their projects. Yes, they will probably be able to describe the structure in a loose sort of way, but if you really want a clear understanding of it, you'll have to work your way through several of their projects to learn how they are put together.

Fortunately, we do have some basic structural concepts and models that we can use as a starting place to discuss structure. Furthermore, the fundamental

questions of structure are essentially the same across the board, for all types of interactive media. And, as always, we can look to traditional linear narratives for some initial guidance.

THE BASIC BUILDING BLOCKS OF TRADITIONAL DRAMA

Structure plays an important role in every type of narrative, whether the work is linear or interactive, and it is built in the same fundamental way across all kinds of stories as well. Small units of material are assembled into a greater, interconnected whole. The units are the basic building blocks of the work, and they may be combined together to form still larger building blocks and these, in turn, are assembled and become the final product.

In a linear work of drama, such as a movie or play, the smallest building blocks would be the story beats. They'd then be organized into scenes, and from there into acts. If we look at classic drama, as we did in Chapter 5, we see that Aristotle believed that every effective theatrical work contained three acts, with Act I being the beginning, Act II being the middle, and Act III being the end.

THE THREE-ACT STRUCTURE IN MOTION PICTURES

Dr. Linda Seger, an internationally known script consultant and author of many books on screenwriting, describes the three act structure this way:

In the first act, a catalyst begins the action—an event that gets the story going and orients the audience to genre, context, and story. The middle act (which is usually twice as long as Acts One and Three) develops and explores conflict, relationships, and theme, using action and events (whether large or small) to move the story forward. The final act is the consequence of the work of Act One and Act Two, paying off all the development, strategizing, and struggle that went on throughout Acts One and Two.

Although Aristotle was talking about classic Greek drama when he described the three-act structure, the same basic structure can be applied to video games and other forms of interactive media as well, as long as the work has at least a thread of a story. In other words, interactivity and the three-act structure are not mutually exclusive; on the contrary, this structure still plays an important role even in the most cutting edge kinds of storytelling. Sometimes the three acts can be hard to spot, and they may not be connected in a sequential order, but if you study the work closely, the three acts will shine through.

At some companies, the creative teams are highly aware of the three-act structure and use it consciously. In other organizations, however, it may be employed in a less conscious fashion, although it still shapes their products.

After all, we are inundated almost since birth in story-based material organized around the three acts. How could this degree of exposure not affect our interactive storytelling?

Her Interactive, the company that makes the *Nancy Drew* mystery-adventure games, finds the three-act structure a highly useful organizational tool. Creative director Max Holechek told me that they definitely think in terms of a beginning, middle, and end. "We have to make sure there's a good story that keeps evolving," he told me. "And the characters have to evolve in one way or another." He echoed many of the things Dr. Seger said about the function of the second act. "In the middle act we do things like up the dangers, or put in some plot twists, or add some intrigue," he said. "These things help keep the game fresh."

Quicksilver Software is another software developer that consciously employs the classic three-act structure. This company has developed dozens of strategy, simulation, and action/role-playing games, including *Master of Orion 3*, *Invictus, Castles, Star Trek: Starfleet Command*, and *Shanghai: Second Dynasty*. Katie Fisher, a producer-designer for the company, told me without equivocation: "The three-act structure is the backbone of everything we do here." But she also noted that the nonlinear nature of games added a special wrinkle. "How you get to the plot points—that's where interactivity comes in." That, of course, is the critical question. How and where does the interactivity come in, and how do you structure it into your story world? How do you combine story and interactivity—and gaming elements, as well, if you are making a game—into one organic, seamless whole?

THE BASIC BUILDING BLOCKS OF INTERACTIVE NARRATIVES

In any type of narrative, in order to form a structure, you must work with both your smallest and largest building blocks. In interactive narratives, your smallest building blocks are your decision or action points—the places where the user can make a choice or perform an action. They are the equivalent of story beats in a linear narrative. Decision and action points are also known as *nodes*, although to make things especially confusing, "node" is also a term used for some types of macro units. In order to create your structure, you need to determine the kinds of things the users can do at each node. Can they pick things up? Shoot weapons? Converse with characters? Rearrange objects?

In some cases, users are given several specific options to choose from in the form of a menu. For example, let's say we have a story in which the player character is a young woman, and let's say she's being followed down the street by an odd-looking man. The user can decide whether to have the young woman (a) run, (b) turn and confront the stranger, or (c) ask a policeman for help. Each choice will result in a different outcome. Decision points are not always so obvious, though, and in most cases, the player is not given a menu of possibilities to

select from. For instance, let's say our same player character, the young woman, has successfully dealt with the odd-looking man and is continuing down the street toward her destination. As she is walking along, a piece of paper flutters out of a window above her. She must decide whether to pick it up or to continue walking, and is thus a decision point.

On the macro level, you'll need to work out the nature of your biggest units or divisions. In video games, where there is a relatively standardized approach to structure, the most common type of large division is the *level*. Each level takes place in a different setting and has a different group of NPCs and a different set of challenges. The player usually (but not always) works through the levels in sequential order. The challenges become more difficult as he or she ascends through the levels, with the ultimate challenges awaiting the player in the final level. Some games are instead organized by missions, where users are given assignments they must complete one at a time.

Many interactive narratives use a *world structure*, where the narrative is divided into different geographical spaces—the rooms of a house, different parts of a town, or different planets. Still another type of organizational unit is the *module*, which is often used in educational and training projects. Each module customarily focuses on one element in the curriculum or one learning objective. Yet other types of interactive projects may be divided into episodes, as a webisode is, or into chapters, as DVDs often are. Or, if this work is being made for the Internet, your macro units may be Web pages.

Once you know the type of large building blocks you'll be using, you can begin to determine the core content of each unit, what the user does in each one, and how many units you will have in all. You'll also be able to begin populating them with characters. Thinking in terms of large building blocks can help bring order to the organizational process.

THE IF/THEN CONSTRUCT

As we noted a little earlier, the decision or action points are the smallest building blocks of interactive narratives. These choices or actions will trigger specific events to happen during the narrative—sometimes immediately, sometimes further down the road. The logic system that determines the triggering of events is implemented using a piece of computer code called an *algorithm*. An algorithm determines such things as what the player needs to do before gaining access to "X" or what steps must be taken in order to trigger "Y." Algorithms are a little like recipes, but instead of the ingredients being foods, they are events or actions. For instance, an algorithm for opening a safe may require the player to find the secret combination for the lock, get past the growling guard dog, and dismantle the alarm system. Only then can the safe be opened.

Logic in digital storytelling is often expressed in *if/then* terms. If the player does "A," then "B" will happen. Another way of expressing the steps needed to trigger an event is through *Boolean logic*. Boolean logic is based on only two

variables, such as 0 and 1, or true and false. It allows for only two possible outcomes for every choice (live/die; open/close; explode/not explode). A string of such variables can determine a fairly complex sequence of events. Boolean logic can be regarded as a series of conditions that determine when a "gate" is opened—when something previously unavailable becomes available, or when something previously undoable becomes doable.

Having only two possible options for each decision or action is also called *binary choice*. However, there's also a more subtle type of choice mechanism available, the *state engine approach*, which allows for a greater range of stimuli and responses instead of a simple if/then. Game producer Greg Roach, introduced in Chapter 4, described to me how a state engine works in a video game. In his sample scenario, the player wants to smash open a wooden crate with an axe, the one tool available to him. With binary choice, the crate could only exist in one of two possible conditions: broken or unbroken. It would remain unbroken until the user succeeded in smashing it. At that point, Roach said, its status would switch to broken.

"But a state engine approach works differently," Roach explained. "It tracks cumulative force and damage, allowing for a richer set of player choices. Each player can make a different set of choices and the state engine construct will respond appropriately. So a player who chips away at the crate with a penknife will take 10 times longer to get it open than a player who runs it over with a vehicle and breaks it open with a single move."

Thus, the state engine approach offers users a broader range of actions and responses than simple binary choice.

BRANCHING STRUCTURES

Many, if not most, interactive narratives still rely to a greater or lesser degree on the if/then construct, and this construct is the foundation of one of the most common structural models of digital storytelling: the *branching structure*. A branching structure is made up of a great many interconnected if/then constructs. It works a little like a pathway over which the user travels. Every so often, the user will come to a fork in the path—a decision or action point—which may offer several different choices. Upon selecting one, the user will then travel a bit farther until reaching another fork, with several more choices, and so on. Thus, this structure is extremely similar to the old *Choose Your Own Adventure* books, described in Chapter 1. (To see a script using a branching structure, see Figure 10.2, *Dick and Jane*, in Chapter 10.)

The problem with a branching structure is that in a very short time it escalates out of control. After just two forks in the path, with three choices at each, you'd have racked up 13 possible choices, and by the third opportunity for choice, you'd have a total of 39 possible outcomes. Although the user would only experience three of them, you'd still have to produce the other 36 in case the user made a different selection. A branching structure like this squanders valuable resources. (See Figure 7.1.)

Figure 7.1
The simple branching structure can easily escalate out of control. Image courtesy of Terry Borst.

Designers employ a number of techniques to rein in runaway branching, some of which, like the *faux choice*, offer little or no meaningful agency. In a faux choice construct, the user is presented with several options, but no matter which is picked, the end result will be the same. Runaway branching can also be contained by *cul-de-sacs*, *loop backs*, and *barriers*. Cul-de-sacs are areas off the main story path that the user is free to explore, but these areas are walled in and ultimately force the user back to the main story path. In a loop back construct, the user must return to a previously visited area in order to fulfill a task or acquire some necessary information. In a barrier construct, the user can only activate a choice or move forward by first succeeding at a "gateway" task, such as solving a puzzle.

Some designers rein in runaway branching trees by constructing more modest branching shrubs, each with a specific subgoal. The branching shrubs all link to the major story path, but the branching is more contained. For instance, the ultimate goal might be to save the princess in the tower. Subgoal number one requires that you poison the dragon (shrub #1); subgoal number two requires that you pass over the bridge that is guarded by ogres (shrub #2); and subgoal number three requires that you outwit the princess's evil stepsisters who are keeping her locked up (shrub #3).

Other designers strive for an illusive structural form called "bushiness," which offers a maximum amount of choice but which prevents unlimited branching by having many of the links share communal outcomes.

The branching structure is often used within large structural building blocks, such as levels, missions, and worlds.

THE CRITICAL STORY PATH

In works of digital storytelling, the underlying structure has a great impact on the overall user experience. Structures can range from quite restrictive in terms of choice to being extremely free ranging. The structure for a particular project is typically determined by the type of interactive experience the designers want to provide.

If the goal is to allow users to be able to explore freely, interact with other users, and make up their own adventures, the structure will be designed for maximum openness and the least amount of restraint. But if the project is essentially a story-based one, such as an adventure game, a mystery, or a drama, it will need a fairly restrictive structure that invisibly nudges the user down a linear narrative passageway.

Many professionals within the new media industry refer to this linear passageway as the *critical story path*. This path contains everything the user must do or must discover in order to achieve the full story experience and reach a meaningful ending point.

The critical story path makes it possible to reveal key pieces of information in an incremental way and at an optimal time. It also facilitates dramatic intensity. With the critical story path, you can ratchet up the spookiness of a scary story by controlling when the player will see the shadowy figure outside the window, or hear the scurry of footsteps on the roof, or find the dead dog in the refrigerator. The critical story path can also be used to dramatize the protagonist's character arc. It is useful whenever you want certain things to happen in some rough order.

Devising the critical story path is a four-step process. To create one, you:

- **1.** make a list of all the *critical beats*—the things the users must experience or the information they must discover in order for the narrative to make sense and to build in an appropriate way;
- **2.** determine what needs to be conveyed through cut scenes;
- **3.** determine the essential actions the user must perform in order to trigger the critical beats;
- **4.** determine the interactive possibilities between the essential actions—things that might enrich the narrative or heighten the gameplay but are not strictly necessary to make the story progress.

Her Interactive, which develops the *Nancy Drew* mystery adventure games, is one of the software companies that utilizes a critical story path. Players can travel down this path in many different ways and can collect items and clues at their own pace, but they must perform certain actions in order to solve the mystery.

"We want to give players as much freedom to explore as possible," writer—producer Anne Collins-Ludwick told me. "But we also want to relate a story, so we have to move them from A to B to C." She said sometimes the methods to get the players to move down this path will be obvious, but sometimes they go on behind the scenes. "For instance," she said, "you might not be able to get inside a certain environment until you've done something else."

However, the company also wants to pace each adventure so players don't race down the critical story path too quickly or else the experience won't feel like

a game. Thus, they devise puzzles, activities, and various kinds of obstacles to heighten the gameplay and make the mystery more challenging to solve.

While the creative team of the *Nancy Drew* titles uses the term "critical story path," over at Quicksilver Software they use a different way to talk about the through-line for their games. Producer-designer Katie Fisher calls it a *malleable linear path*. She said: "Even though we use a three-act structure, we give the players lots of ways to get to the end. We want to avoid the need to hang things on one specific event to move the story forward. We don't know what order things will happen in, but we can say that five different things will happen before X happens."

Structural Models That Support the Critical Story Path

An often-used structural model for the linear story path is as *a string of pearls*. Each of the "pearls" is a world, and players are able to move freely inside each of them. But in order to progress in the story, the player must first successfully perform certain tasks. Sometimes they cannot enter a new pearl until every task in the prior one is completed; sometimes they can enter other pearls, but access to certain areas within them will be blocked. (See Figure 7.2.)

Figure 7.2
With a string of pearls
structure, the player
progresses through a
series of worlds.

A ROPE WITH NODES

Game designer Greg Roach calls structures like the string of pearls *a rope with nodes*. He explains that the nodes offer a rich degree of interactivity, but they are strung together in a linear fashion. According to Roach's model, players can do three different things in each node:

- They must "eat their meat and potatoes"—a term he uses for tasks that must be
 performed in order for the story to proceed properly, make sense, and become
 emotionally satisfying. The "meat and potatoes" can be such things as acquiring
 objects or information, encounters with characters, or experiencing events.
- They can choose to have as much or as little "candy" as they like—by which he
 means they can do enjoyable things that enrich the story and add depth to the
 experience but which are not critical to the overall narrative success.
- They can activate triggers—they can do or encounter things that bring about a change in the mood, narrative structure, character attitudes, environment, or experience.

In this model, players cannot move to the next node until they have eaten all the meat and potatoes in the node they are currently in.

The Passenger Train Model

A number of other structures also channel users down a linear path, some more restrictive than others. Most are applicable both to story-based material and to nonfiction material. One that offers the least amount of freedom is *sequential linearity*, a structure that I prefer to call the *passenger train*. It was the model used in the first children's interactive storybooks. It is still used for this purpose, and it is also commonly employed in interactive training applications. It is similar to the string of pearls structure.

In the passenger train model, users begin at the engine end of the train and work their way down car by car until they reach the caboose end. They can explore the interior of each car at will, but they usually cannot leave until the program releases them—sometimes they must first listen to some narration, or watch some animation, or work through some exercises. They also must move in sequence; they cannot jump, say, from car number two to car number six. Once users reach the caboose, they are usually able to explore more freely. Many projects built on this model offer a menu to allow users to revisit a particular car or to go directly back to a specific game, activity, or exercise.

OTHER STRUCTURAL MODELS

If you look closely at interactive models, you might see that they fall into two broad groups: rounded and angular. Angular structures tend to channel users along a particular path and have a more linear core. On the other hand, rounded structures do not support much of a story thread, but they do promote a great deal of freedom and exploration. Some structural models combine rounded and angular elements and thus can combine narrative with a certain amount of freedom.

Spaces to Explore

Some people refer to an unrestricted, free-range environment as an *explorato-rium*. I prefer to think of this structure as an *aquarium* because it is so much like a three-dimensional fish bowl. Users can navigate through it in any direction, though it may be dotted with "islands" of story elements. It is better suited for experiential interactive journeys or "scavenger hunt" types of experiences than for dramatic narratives.

The aquarium model is frequently found in MMOGs, which typically offer a number of free-ranging worlds through which players can journey. A MMOG universe can be vast in scale. Robert Pfister, senior producer of *EverQuest*, told me that his game contains about 220 adventure zones. It would take months for a player to visit them all. And Ben Bell, producer of the PlayStation2 version of *EverQuest*, said of MMOGs in general that: "Most are loosely structured in terms of plot and level design." He feels that in such games setting is more important than the story because "supporting thousands of players in a single game world is prohibitive to supporting a single story line." He said designers

Structure in Digital Storytelling CHAPTER 7

of these games generally convey a linear plot through suggestions in a handful of subplots. "Quests, items, and the movement of NPC populations are all tools that we use for plot exposition."

Some designers call the most free form structures a *sandbox*. Unlike games, they have no specific goals to achieve and no victory conditions. And unlike narratives, they have no plot. However, they do provide users with objects to manipulate and things to do, and they do have spatial boundaries. Virtual worlds like *Second Life* have many of the characteristics of the sandbox.

Marie-Laure Ryan, in her book *Narrative as Virtual Reality*, describes an extremely free-form structure she calls *the complete graph*. In these works, each node can be connected to every other node, and all paths are bidirectional. In this type of structure, the user can move in any direction, but it is hard to imagine how it could be capable of sustaining any kind of narrative thread.

Structures That Are More Angular

Several basic structural models have been devised for works that have a narrative through-line, though they also offer a certain amount of navigational freedom. These structures include the funnel, the pyramid, the coal mine, parallel worlds, and the hero's journey.

The hero's journey, described in Chapter 5, is one of the best known of these quasi-linear models. This type of work is structured around the classic myth about the youth who must survive and triumph over a number of terrible ordeals and is transformed by the experience. The classic journey contains 12 stages, so an interactive model using the hero's journey would incorporate a critical story path and could logically be broken into 12 levels or missions or "pearls on a string," although there could be fewer or more structural units.

Another model is the *funnel*, which is sometimes called a *pyramid* (a pyramid is essentially just an upside down funnel). It is often used in games. In this structure, players start at the "fattest" end, where there is a great deal of freedom of movement. But as they work their way through the game and are nearing the conclusion, their choices become more constrained, though they also may be more challenging.

In interactive environments that call for users to "drill down"—a term frequently used in regard to the Internet—we can find several different types of structures. In general, however, they can be clustered together as *coal mine* models. The coal mine is most common on the Web, but it can be employed for any project that encourages a burrowing process for fictional or informational material. In a coal mine model, you gather new material via a series of links and move through lateral as well as vertical passageways.

The parallel world, also known as parallel streaming or even harmonic paths, is another quasi-linear structure. It contains several layers of story, each set in its own virtual world, and the user can jump between them. Often each world is a persistent universe, meaning that events continue to unfurl there even when

the user is not present. Since it is not possible to be in more than one world at a time, the player must carefully decide which to visit because being in one of these places inevitably means missing out in events taking place in the others.

The Modular Structure

As noted earlier, the modular structure is often used in education and training. These kinds of projects often open with a noninteractive introduction, and then the users are presented with a choice of modules, which they visit in any order. Modules within a single work may vary greatly in style, much like a variety show with different acts. Once all the modules have been visited and the required tasks in each have been completed, the program may end with a linear wrap-up or the user might be offered a "reward" activity.

At *JumpStart*, they refer to this structure as a *hub and spoke* model. The player starts from a central location (the hub), and all the modules radiate out from there (the spokes). This structure is extremely clear and simple to navigate, making it especially suitable for children's projects. (See Figure 7.3.)

Sophisticated Story Models

Designers of interactive content have come up with a number of structural models that work particularly well in supporting complex interactive narratives.

One such structure is what I refer to as the *Rashomon* model, though it goes by a number of different names. This model contains several versions of the same

Figure 7.3 The main screen of JumpStart Advanced First Grade illustrates the hub and spoke structure. The modules, represented by the various structures, are accessed from the main screen-the hub of the wheel. The reward activity takes place in the Race Arena (upper left of the main screen). Image courtesy of Knowledge Adventure, Inc. and used under license.

story, each version seen from the POV of one of the characters. The model resembles the Japanese movie *Roshomon*, described in Chapter 1, about a crime viewed by four people, each of whom saw it differently. In interactive narratives that use this model, the user can move between storylines to get a full picture of the incidents at the core of the story. Though it is primarily used for works of fiction, it has also been used in at least one interactive documentary.

The model I call the *archeological dig* uses quite a different approach. The narrative in these works takes place over a long stretch of time, and the user digs down through these different time periods to reconstruct the story. In Chapter 23, we will be looking at works that utilize both the archeological dig model and the Rashomon model.

In *Hamlet on the Holodeck*, Janet Murray deconstructs a number of narrative models, some of which resemble ones already discussed here, though they go by different names. Two, however, are quite different. The *rhizome* model takes its name from the field of botany, where it is used to describe an interconnecting root system. Murray applies this term to stories where each piece can be connected to every other piece and where there is no end point and no way out. Thus, it is much like a maze. This model, she feels, is particularly good for journey stories and can offer many surprises, though navigating the rhizome can be challenging to the player.

Another model she describes is the *electronic construction kit*. In this model, users are given a number of story components, like characters and settings, and they can use them to assemble their own narratives. It is an open-ended construct, with the user in control of how the story will unfold.

In *Narrative as Virtual Reality*, Marie-Laure Ryan describes two particularly interesting narrative models. One, which she calls *the hidden story*, contains two layers of narrative. The top layer contains clues to a story that took place in the past. The user explores this top layer to uncover the second layer, the hidden story, and to assemble the pieces of the hidden story into a coherent and linear whole. Although not specifically noted by Ms. Ryan, this type of structure is often used in Alternate Reality Games (ARGs). In these games, players uncover clues to a mystery and reassemble them to form a cohesive narrative, often working on the clues at the same time as the fictional characters in the game. (For more on ARGs, please see Chapter 17.)

Another model she offers is the *fractal structure*. "Fractal" is a mathematic term for a pattern that repeats itself endlessly in smaller and larger forms. Ryan uses this term in an interactive narrative context to describe a story that does not advance but instead expands. In the example she gives, a miniaturized version of the core story is presented right at the start. It grows in scope as the player interacts with it, but the essence of the story never changes.

Video game scholar Joris Dormans sees great potential in this model, which he discusses in an article called *Lost in a Forest*, posted on the Game Research website. He feels that fractal stories contain many pluses and avoid some of the problems

characteristic of other structures. Like interactive stories with a fairly linear plot and clearly defined goal, the fractal story also has an ultimate destination, but it does not narrowly push the user toward it. And like structures that emphasize exploration, it offers a great deal of freedom but without sacrificing the narrative elements. Thus it is a middle ground between the two ends of the spectrum: strict linearity on one hand and unrestricted freedom on the other. It also supports replayability because with each play, users can experience the story differently.

CREATING YOUR OWN STRUCTURAL MODEL

Sometimes no ready-made model exists for the type of interactive narrative you have in mind, and in cases like this, you need to invent your own structural model. I faced a situation like this when I was pitching a series of interactive stories for a children's website. I wanted a structure that contained a linear entrance and exit but that was interactive in the center. I thus came up with a model that I named the *python that swallowed a pig*. In this model, the head portion, or entrance to the story, is narrow, and the tail portion, which is the exit, is also narrow. But the middle is fat, and here is where most of the interactive events occur. Though you can experience these events in any order, you must be careful in the "pig" section or else you will not succeed in accomplishing your goal and will be forced to exit from the snake prematurely. Thus, the beginning and the end are essentially linear, while the middle is interactive, a model that combines the rounded and angular forms. This structure lends itself well to a goal-oriented narrative experience. Multiple pythons can be connected together in various ways to produce a more dimensional experience, somewhat like a lumpy string of pearls.

Another model I took the liberty of naming is one of my favorites: *the balloon man*. Like the python, it combines angular and rounded elements, but it is far more complex. The balloon man can be an effective vehicle for exploring psychological themes and revealing hidden facets of a character. It resembles a handholding of a cluster of strings, and every string is attached to a balloon—each a world in the balloon man's universe. Your mission begins in the hand, and from there you choose which string—or pathway—to move along. When you reach a balloon, you experience events much as you would in the interior of the snake except that you are free to leave at any time. To visit another balloon, you must first travel back to the balloon man's hand and select another string. Each journey along the same string produces new experiences or yields new insights. Once you have neared your overall goal, the ultimate revelation or triumph often awaits you back in the balloon man's hand.

DETERMINING A STRUCTURE

It is one thing to talk about structure in an abstract way and to examine a variety of models; it is an entirely different thing to decide which structure to use for a particular project or line of titles. Often, the decision is guided by practical considerations or by the type of experience the creative team wants to provide for the user.

Structure in Digital Storytelling CHAPTER 7

Different factors come to the forefront at different software companies. For instance, at Training Systems Design, which makes interactive training programs, they regularly use a modular structure with an open architecture because it can accommodate a variety of ways of presenting material and multiple learning styles. Dr. Robert Steinmetz, the company's president and senior designer, told me they like to promote "discovery learning" rather than a tutorial approach. A modular structure with an open architecture lends itself well to this type of learning.

WHY ONE STRUCTURE AND NOT ANOTHER?

The JumpStart edutainment games typically employ a hub and spoke structure, as noted earlier. When I asked senior producer Diana Pray why they use it, I was surprised to learn that the needs and desires of the ultimate purchasers—the parents—heavily factored into this choice. Of course, the needs and desires of the end-users—the kids—have also been given consideration. Of the hub and spoke structure Pray said: "It's an easy kind of navigation. We have tried more complex ways, but parents had trouble with them. They don't want to spend time showing the kids how to do the game. They want to cook dinner, do the laundry. They don't want to hear: 'Mom, I'm stuck!"

And, she went on to say: "Kids don't like the computer to tell them what to do; they like to choose. They like a game that gives them the power to go where they want. If the kids don't like the style of gameplay in a particular module, they can go into another module. We don't force them along one story path."

Obviously, there is no "one size fits all" when it comes to structure. And in some cases, as we've seen, you might find that no off-the-shelf model will work for what you want to do, and it may be necessary to customize a unique structure for your project. Your decisions about structure will be determined, to a large extent, by the project itself. Here are some questions you can ask that will help guide you:

- **1.** What platform or device is this project being made for, and what structures are most suitable for it?
- **2.** What projects like it already exist, and what structural models do they use? What can you learn from them, in terms of where they work well and where they are weak?
- **3.** What types of structures is your target audience likely to be comfortable with?
- **4.** How important is it that the users move down a predetermined story, informational, or training path?
- **5.** How important is it that users can navigate freely?
- **6.** What kinds of choices will be offered?
- **7.** What kinds of large building blocks will be most useful in organizing this project?

CONCLUSION

We have described a variety of structural models here, some widely recognized in the field, others not. Often professionals use different names to describe the same models. Perhaps, because of the evolving nature of digital media, we will never reach the point of having one standard set of models, each with a specific name and architectural form. And in some cases, it is left to the creative team to shape their own structures.

Fortunately, it is not necessary to completely start from scratch. We can study the models that are most frequently used, and we can deconstruct already-made projects to see how they work. And, as we begin to shape one of our own projects, we can be guided by its specific purpose and requirements. Once we do that, we will find that it is not as impossible as it might seem to give order to an experience that should, to the user, feel free of constraint. In actuality, we do have far more to work with than Styrofoam peanuts.

IDEA-GENERATING EXERCISES

- 1. Select a work of interactive entertainment—one that you are very familiar with or have access to—and analyze its structure. What are its major structural units, and how does the user move from one to another? Is it possible to travel anywhere in this interactive environment right from the start, or do certain activities need to be performed before wider access is allowed? Why (or why not) do you think this structure works well for this particular project?
- **2.** Come up with an example of an if/then choice and reaction. Express the same situation using a state engine approach.
- **3.** If you are familiar with any structural models that have not been identified in this chapter, how would you describe them, and what name would you give them?
- **4.** Pick a myth, story, movie, or TV show that you are familiar with. Imagine that you have been tasked with turning it into an interactive narrative. Take one section of this story and devise a critical story path for it.

Tackling Projects for Children

What special considerations must we be aware of in designing a work of digital storytelling for children?

How much of a role, if any, do parents play in determining their children's access to interactive media, and what are their chief concerns in this area?

In making products for kids, how useful are professional experts, focus groups, and testing?

What Seven Kisses of Death can doom an interactive media project for children, and what are some effective strategies for combating them?

A SIGNIFICANT PIECE OF THE DIGITAL PIE

Although some people are fairly dismissive of projects made for young audiences and do not take this sector of new media seriously, this is a sadly short-sighted attitude. Content made for children and teens is not only every bit as demanding as content made for adults, but it is also a tremendously important arena in terms of the volume of products produced for it. Furthermore, children and teens are among the most enthusiastic fans of digital media, and they often lead the way when it comes to the adaptation of new forms of interactive entertainment. Thus they often help push the entire field forward.

Not only are close to a third of all video game players under the age of 18 (28.2%, according to the 2007 report of the Entertainment Software Association), but young people also spend a considerable amount of time online. Many children now spend more time online than they do watching TV. Of children who use the Internet, 61% spend at least 5 to 10 hours online each week, and 24% spend more than 10 hours on the Web every week, according to a study conducted in 2007 by Circle 1 Network/Kidscom.com. It is interesting to note that young people typically *multitask* while online, simultaneously talking on the phone, listening to the radio, or watching TV. This proclivity to multitask is not lost on producers of children's media, who build multitasking components into many entertainment products made for this group.

Along with the Internet and video games, young people have also enthusiastically taken to wireless devices, using them not only for talking but also for sending text messages, for playing games, and for hooking up to the Web. Many transmedia entertainments (projects that utilize several media to create a large interactive entertainment universe) now usually contain a wireless component, recognizing that this feature particularly appeals to young people.

Theme parks, which are also primarily geared for children and teens, include many interactive attractions, which often go under the heading of "immersive environments." Cultural institutions, too, recognize the innate appeal interactivity has for children, and they build interactivity into their exhibits whenever their budgets permit.

Several entire segments of the interactive market are devoted almost exclusively to young people. They include smart toys, edutainment games, and *lapwear*, software products made for little tots between nine months and two years of age. And lately, an arena that was once the exclusive domain of older teens and young adults, the MMOG, has offerings for younger children, as well.

Thus, interactive entertainment for children spans a vast spectrum of media and products.

UNDERSTANDING THE YOUNG USER

Although creating content for young users is full of special pleasures, it is also full of daunting challenges. Even though the individuals who make up this

Tackling Projects for Children CHAPTER 8

particular demographic are young, relatively unsophisticated, and hungry for amusement, it is a dangerous mistake to believe they are an easy group to please. Making successful products for children and teens requires an awareness of many special factors, including

- · the developmental stages of childhood;
- gender considerations;
- the desires and fears of parents;
- · the desires and aspirations of children;
- an understanding of what sort of content is most appealing to young people;
- an awareness of the kinds of things that can repel young people and be a Kiss of Death.

Children and teenagers have their own culture, language, and values. In order to be able to make content that will appeal to them, we have to understand them. But right here is where many content developers make a serious error: This audience cannot be lumped into an all-inclusive "them." Children at different ages are vastly different from each other in terms of what they enjoy doing, are capable of doing, and are able to understand. Furthermore, boys and girls do not necessarily like the same kind of content.

A CASE OF MASSIVE MISJUDGMENT

Chinese Hero Registry, an online game sponsored by the government of China and targeted at Chinese youth, is a perfect example of misjudging one's target audience. According to the Los Angeles Times (November 4, 2005), the game was built to lure kids away from violent online games and to entice them to play something more "wholesome." And from the perspective of a Chinese adult and dedicated Communist, this game probably sounded like wonderful fun. Players are given virtuous role models from Chinese history to emulate, and they are rewarded for performing good works that reflect good old-fashioned Communist values. They score high by mending socks, helping old ladies home during a rainstorm, and stopping people from cursing and spitting on the sidewalks. Not surprisingly, when real kids in China got a chance to test it out, they found it to be incredibly dull and abandoned it after just a few minutes of play.

Fortunately, we do not have to rely on guesswork when creating content for young users. We have several forms of guidance available to us: developmental psychologists, educational specialists, and children themselves. In addition, we can study the market and analyze the most successful products made for the group we wish to reach. By doing this, we can glean useful clues about what works in terms of subject matter, tone, humor, characters, and style of graphics.

How Children Develop

One excellent place to turn for help is the field of developmental psychology. The specialists in this area make it their business to study the different stages of childhood and understand how a child progresses mentally, physically, and emotionally from the diaper stage to the drivers' ed stage.

The study of child development is a fairly new science. Until sometime in the seventeenth century, children were regarded as small adults who, in almost every regard, were just miniature versions of their elders. In the eighteenth century, however, Jean-Jacques Rousseau proposed a radical idea for his time: that children started out as immature creatures but went through distinct stages of development as they grew up. Each stage, he proposed, had its characteristic thought patterns and interests, and each built upon the earlier stages.

Other intellectuals came to agree with Rousseau and endorsed his theories, but none more articulately than Jean Piaget, the great twentieth century Swiss psychologist. Piaget systematically and scientifically explored the mental growth of children and documented his findings in 1948 in his seminal work, *The Origins of Intelligence in Children*. Although other psychologists have weighed in since with amplifications or alternate theories, Piaget's work remains the touchstone study of the stages of childhood. Almost everyone who develops products for children and who is concerned with age appropriateness uses Piaget's work as a guide.

Piaget divided childhood into four stages, and within each of these stages, he asserted, children have a particular preoccupation and favored type of play. For those of us who create interactive entertainments for children, Piaget's theories regarding play are particularly relevant. He felt that play was serious business for children, a critical activity necessary in order to achieve a healthy adulthood. He held that play was a form of mental gymnastics that helped train and exercise the developing mind and prepared the individual for the challenges of life.

AGE GROUPS AND PLAY PATTERNS

Like Piaget, the children's software industry breaks children into four distinct groups, but it uses a slightly different division of ages than Piaget did. This list combines the widely used age categories of the software industry with the preferred play patterns at each stage of development that Piaget described:

- Toddlers, preschool, and kindergarten: Young children love to experiment with objects and enjoy activities involving practice. They particularly love to repeat a task over and over until mastery is accomplished.
- 2. Children from 5 to 8 (early elementary): Children at this age are fascinated with symbols, such as letters and numbers. They are also absorbed with fantasy pastimes, such as games that give them a chance to try out different roles and to feel powerful and unafraid.

(Continued)

Tackling Projects for Children CHAPTER 8

- Children from 8 to 12 (late elementary; also known as "tweens"): At this age, children like to try out their reasoning skills and prefer play activities that emphasize rules, order, and predictability.
- 4. Teenagers: Teens are most concerned with trying to understand abstract concepts and testing out hypotheses. They enjoy activities that involve constructing things and making models.

Although Piaget linked each form of play to a specific stage of childhood, he also recognized that these preferences were not etched in stone. For example, a seven-year-old might experiment with forms of play that were characteristic of older children, such as making simple models, while teenagers might well still enjoy activities associated with earlier developmental stages, like fantasy role-play, and incorporate those earlier play patterns into their current games.

The principles laid down by Piaget and other developmental psychologists can help us build age-appropriate interactive entertainments and can also guide us in making products that will appeal to a broad spectrum of young people.

Soliciting Help from Experts, Large and Small

While obtaining the assistance of a developmental psychologist or child psychologist might not always be feasible, it certainly makes sense to become familiar with the literature of Piaget and others in the field. Also, it is usually possible to seek help from educational specialists, a group that includes professors of education, consultants to schools and cultural institutions, and classroom teachers. These professionals deal with children and how they learn, and they are almost certain to be familiar with the tenets of developmental psychology. Most software companies that make edutainment products regularly consult with such specialists.

A final and excellent source of help can be obtained from children themselves. You can seek this type of help by forming focus groups; by visiting classrooms (with permission from the school, of course); or by talking with individual children. A word of warning here, though. For an objective opinion, it is best to try your ideas out on young strangers. Your own children or children who know you will try to please you by telling you what they think you want to hear.

AGE APPROPRIATENESS AND GENDER ISSUES

When undertaking any work for a young audience, one essential question that must be asked and answered is whether the project is *age appropriate* for its target audience. Do the characters, story, or content feel too young or too old for the intended users?

Children like to feel they are more grown up than they really are and as a rule prefer to have their characters be a bit older than they are, too. To borrow a

term from the child psychologists, kids have *aspirational* desires. In other words, they aspire to accomplish certain things or behave in certain ways that seem attractive and grown up to them, and they look to their favorite characters to serve as models. Even a character like Barbie is seen as an aspirational figure: She is older, more glamorous, more sophisticated, and more accomplished than are the children who play with her.

Aspirations are engines that help push children toward maturity and hence serve a useful purpose in development. It is understandable that when a product seems too babyish, a child will be insulted and will not want to have anything to do with it. Designing something "just right" in terms of age appropriateness can be quite challenging.

Along with age appropriateness, one must also determine whether a product will appeal across both genders or be more attractive either to boys or to girls. Entertainment products made for very young children, as well as for older teenagers, may well be acceptable to both genders, but this is far less true of products made for children in between these age extremes. Thus, many children's products are marketed either to girls or to boys.

The idea that girls inherently like one kind of thing and boys inherently like another is not a popular one in today's world. A fierce debate has been raging for years about the origins of gender preferences—it is a major issue in the famous nature versus nurture debate. Proponents on the nature side assert that gender preferences are inherited and are among the traits one is born with; those on the nurture side, on the other hand, contend that such preferences are determined by one's social environment and by how one is raised. In the end, however, our opinions about gender do not matter. Gender preferences are a reality in today's world, and one must be aware of them.

In broad strokes, experts in child development have noted the following differences between boys and girls:

- When playing with others, girls prefer play that is collaborative while boys like activities that are competitive.
- Boys are drawn to activities that involve objects while girls are drawn to activities that involve other people or animals.
- Girls are good at activities that employ fine motor skills; boys prefer activities that call for gross motor skills.
- Boys look for opportunities to be aggressive, while girls are more comfortable in nonviolent, socially peaceful play situations.
- Girls enjoy activities that call for organizing and arranging; boys like activities that require building, digging, and constructing.

Gender differences between boys and girls can even involve such minute matters as color preferences. Girls are notoriously fond of two colors: purple and pink, and software companies that want to attract girls tend to bow to this color preference.

It should be noted, however, that preferences differ from culture to culture, which is an important consideration if a product is to be marketed internationally. For example, boys in North America over the age of 8 or 9 find cute animal characters "too young," but such characters are highly popular in Asia across all age groups and both genders.

THE PARENTS' POINT OF VIEW

In designing products for children, you cannot afford to concern yourself only with what the young users might like or not like. You must consider their parents' attitudes as well. After all, in most cases, it is the parents who will be purchasing the product or allowing access to the content.

So what are parents looking for in interactive entertainment for their kids, and what do they *not* want it to contain? On the positive side, they are hoping for a product that offers high quality entertainment and content that is wholesome and that supports family values. Furthermore, parents see it as a big plus if the work is educationally enriching. In addition, parents of young children are greatly pleased when the material is enjoyable for them as well as for their kids since they will probably be playing it with them. For models of family-friendly entertainment that appeals to both adults and children, study hit animated films *Shrek*, *Toy Story*, and *Finding Nemo*.

On the negative side, almost without exception and no matter what the interactive medium, parents do not want their children exposed to graphic violence, and they are equally against products that contain sexual content. When it comes to the Internet, parents have more specialized concerns. The things they most fear revolve around the three Big Ps: Predators, Pornography, and Privacy (children being manipulated into giving away personal or financial information to strangers). For this reason, many sites for kids build in safety features that restrict communications that can occur between users. Many also restrict which sites the young users can link to, making sure whatever sites they can visit are safe. Although this makes for a less expressive, freewheeling experience for the child, it provides some measure of reassurance to the parent.

CONTENT FOR CHILDREN: A VAST LANDSCAPE

As noted earlier, interactive entertainment for children covers a vast landscape of different products deployed across a great variety of media. Some of these product types can be further broken down into genres—categories of programming that contain characteristic elements. If you are making a product that is to fit within a specific genre, you will want to make sure it reflects the basic characteristics that define the genre. Otherwise, you risk disappointing the children who will be using it and the parents who have purchased it.

A Brief Look at Genre

Let's look at some of the major types of computer and game console software products for children. They include the following:

- Interactive storybooks: animated, interactive versions of picture books, which the user advances page by page. They usually contain clickables, games, activities, and songs.
- Edutainment products like drill and kill games: games that drill children in particular skills.
- Creativity tools: programs that let the child create artwork, cards, doll clothes, and so on.
- Reference tools: encyclopedias and other organized works, often with audio and sound, and sometimes with "host" figures to guide the young user around.
- Informational works: factual information about subjects that children find particularly interesting, such as animals, sports, and outer space.
- Activity centers: entertainments that contain a number of games and activities often based on a favorite movie or character.

Games for children largely mirror video games made for older players, which are described in more detail in Chapter 14. They include the following genres:

- Platform games: fast-paced games that require quick reflexes and manual dexterity. You must make your character jump, run, climb, dodge objects, and move through various levels.
- Adventure games: story-based games with a clear-cut mission and that invite the exploration of various environments. They generally involve a quest and call for the solving of riddles or puzzles.
- Mystery or mystery-adventure games: games in which you must solve a mystery, with some of the same elements as an adventure game.
- Role-playing games: games in which you play a character that you yourself have defined by appearance and attributes such as species, occupation, physical abilities, and the skills you possess.
- Simulations: junior versions of sim games in which you have godlike powers over a world or an enterprise and must make critical decisions regarding the sphere you control.
- Sports games and racing games: games in which you compete as a solo player or control a team.
- Fantasy games: games that you play with a favorite storybook character, popular doll, or cartoon figure or movie character, or actually become that character.

Whether you are making a project for a well-established area or a newly emerging one, you will need to familiarize yourself with as many of its products as possible. Take note of its characteristic features and try to discern what makes the popular titles particularly attractive to its target audience.

Children's Websites

The Internet is an extremely robust arena for children, with a dizzying array of attractions. While some focus on special topics, like science or sports, most websites designed for young people cannot easily be broken into genres. Instead, most mix a variety of approaches and types of content. For instance, AOL's massive site for children 6 to 12, KOL (Kids Online) contains cartoons, games, music, a creativity center, homework help, and special areas for perennial favorites like sports, animals, and style. A number of websites for children offer ways for them to participate in polls and contests, and many sites also give them a chance to share their artwork and express their opinions.

Because of the growth of broadband, many new types of Web offerings for children have been introduced in recent years. They include robust entertainment sites; MMOGs specifically designed for children; and children's networking sites—junior versions of Second Life.

Social networking sites, discussed in Chapter 2, are an especially recent phenomenon, and ones specifically for children are particularly new. Some are closely related to MMOGs in that users create their own avatars and interact with other users in a virtual world. But social networking sites are primarily about personal interactions (though some for children also offer games), while MMOGs are primarily about gaming (though they also facilitate personal interactions). Club Penguin is one of the most popular of these MMOG-like social networking sites for children, attracting four million visitors a month. Here, children create their own penguin avatars, decorate their own igloos, and waddle around in an ice-covered wonderland.

Teens need not worry about being left out of this craze for social networking in virtual worlds: they have VirtualMTV, among other choices. VirtualMTV is a glamorous world designed to fulfill any teen's fantasy life of driving hot cars, wearing hot clothes, and going to hot clubs. Teens are also enormous fans of the social networking sites such as MySpace, where they post their bios and homemade videos.

As with video games, websites for young people are often geared for specific age groups, from preschoolers through teens. For example, the children's media giant Disney has a keen appreciation for age appropriateness, and this is clearly reflected in its many offerings for children and teens. Each website has a distinctly different look, different type of interactivity, and different types of characters.

Playhouse Disney Preschool Time Online, for instance, is for children who are not yet in kindergarten, too young to read or type. The site is designed with bright happy colors and features popular Disney characters like Bear from Bear in the Big Blue House. Though the atmosphere is calm and soothing, there's plenty to do-the site is full of simple games and activities. Graduates of this site can move on up to Disney Game Kingdom Online, geared for kids aged roughly 5 to 8. This site feels almost raucous compared to serenity of *Preschool Time Online*, and it offers an enormous suite of games and many customizable features, like decorating your own house and adopting your own virtual pet.

Moving on up the age ladder, Disney's *Toontown Online* is a MMOG for children aged 8 and up, as well as their parents, and is a light-hearted role-playing game set in a cheerful cartoon world. In contrast, Pirates of the Caribbean Online, a MMOG geared for young teenagers, is far grittier and offers a certain amount of fierce physical combat. (Both are described in more detail in Chapter 16.)

Recently, the Internet has seen a miniexplosion of sites for girls, mostly offering fashion activities, shopping, decorating, and chat features. These sites include *Cartoon Doll Emporium* and *Stardoll.com*, both of which let users dress up virtual paper dolls; *BarbieGirls.com*, where users create their own Barbie doll avatars and interact with each other, and *TyGirls.com*.

BRANDED VERSUS ORIGINAL PROPERTIES

Many interactive products for children are based on *branded properties*. A branded property is one that is widely known and that has such a distinct identity that it stands out from other products in the same category. Such products are much easier to market than unknown ones, no matter how many attractive qualities the unknown product has. For example, it becomes much easier to sell Harry Potter video games and toys once the novels and movies have become a big hit; Harry Potter is a branded property.

Branded products are increasingly dominating the children's entertainment marketplace, to the degree that original products are having an uphill battle achieving success. Yet we can find ample significant evidence that original products can and do make a place for themselves, though such products must struggle hard for recognition. But the little mouse Mia, a tiny underdog (or underrodent) if there ever was one, is certainly proof that an original line of games can become a true success story. And every character in the popular *JumpStart* line is an original, too, as is the world-famous thief, Carmen Sandiego.

To create a successful original product, however, generally requires more of everything than a branded product does: more effort, more creativity, more attention to content, more testing, and more investment in marketing. Plus a little something that is beyond anyone's control: luck.

Adapting from Another Media

Taking a branded character or story from one medium and adapting it for another can definitely give it a leg up on the road to success. But, as we saw in Chapter 3, adaptation also comes with a set of inherent problems. It is not possible to simply port over a property from one medium to another and expect it to flourish in its new venue, especially if the original medium was linear and its new home will be an interactive venue. For this to work well, you must give serious thought to what it is about the linear work that lends itself to interactivity

and what opportunities you can build into the interactive version that allow the user to participate in it.

For example, when Warner Brothers created The Official Harry Potter Website (www.HarryPotter.com), they came up with some extremely clever ways to find interactive adaptations of elements that were already well-known and loved in the Harry Potter books and films. Children who visit this site can actually become "students" at Hogwarts, the school of wizardry that Harry attends. First, however, they must "enroll" in the school, just as Harry and his classmates had to do, by going go through a special initiation process conducted by the school's famous Sorting Hat. Once enrolled, they can play the school's unique sport, Quidditch, an aerial form of field hockey; pick out a custom-fitted wand at the wand shop; and explore buildings along Diagon Alley, a street catering to the specialized needs of wizards. They can even attend the same classes as Harry does and try out some of the same experiments, such as transplanting a mandrake, which resembles a baby with leaves growing out of its head. (See Figure 8.1.)

Figure 8.1 When you visit The Official Harry Potter Website, you can become a student at Hogwarts, and, among other things. learn to transplant a mandrake plant during a class in herbology. Image courtesy of Warner Bros. HARRY POTTER and all related characters and elements are trademarks of Warner Bros. Entertainment Inc. Harry Potter Publishing

Each time a new Potter film is released, Warner Brothers adds new games and activities to the site, making this magical world ever richer (though the older features are a bit more difficult to find). The interactivity offered on the website is completely in keeping with the books and movies, but in addition, it gives young users an active way to participate in Harry's world, quite different from the passive experience of reading the novels or watching the films.

In a very different type of adaptation, Her Interactive turns the *Nancy Drew* novels into interactive games, a process described to some degree in Chapter 6. Their first challenge in the adaptation process is to choose a book from the approximately 300 novels in the series that will lend itself to an interactive approach. They look for a story that has strong characters, interesting locations, and opportunities for puzzles. The adaptation process usually calls for some nips and tucks in the story, though they are careful not to remove anything that a devoted reader of the book might miss. And in terms of what may need to be added, the major task is to figure out ways to intimately involve the user in solving the mystery, throwing up enough obstacles, twists, puzzles, and surprises to keep things interesting.

Original Properties

But what if you were developing an original property instead of working with an already established one? Where do you begin? In Chapter 10, we will be discussing a 10-step creative process that applies to all types of digital storytelling, but children's media is somewhat more specialized. As with all projects, one of the earliest steps is the development of protagonist. In a project for young users, you must work out what will make this character appealing to them and what the relationship will be between the users and this character.

For the Kutoka team, which developed the Mia edutainment titles (introduced in Chapter 6), creating Mia's personality was something of a trial and error process. Richard Vincent, the company's CEO, told me he was planning to use four primary characters in his first game, and one of them was going to be a cowardly little mouse. But as work on the project developed, the three other characters were dropped and the character of the little mouse changed dramatically. All that remained of the original concept of her was her small size and the fact that she needed help. "She ended up being strong, having chutzpah," Vincent said. "Her personality was molded by the needs of the game."

To be the major mover and shaker of an adventure game, Mia had to become courageous where once she was timid. She had to be able to fearlessly slide down furniture, scale walls, and hurl herself into the unknown, something she does in *Mia: Just in Time*, where she plunges into a dark, seemingly bottomless mole hole. Mia evolved into something of a role model for kids, with a spunky, helpful, positive personality. But because of her diminutive size, just three and a half inches tall, kids could understand why Mia needed their assistance.

While Mia, the prima donna of the series, gets the lion's share of attention, serious time is also spent on other characters, including the chief villain of the Mia titles, a greedy, ugly rat by the name of Romaine. "We wanted a character who could immediately be recognized as a bad guy," Vincent said. They concentrated first on communicating his nastiness through his looks then worked out details of his character and personality. "Romaine would sell his own mom for sparklies (valuable gemlike objects)," Vincent said. "Sometimes he slips and does something good, but he quickly catches himself." (See Figure 8.2.)

The time Kutoka has spent in developing strong titles has been well worth it in terms of the success of the Mia titles. The series was launched in 1998 and not only has it picked up dozens of awards, but it is still going strong. "It shows that if you put the quality in, you can keep the product around a long while," Vincent recently told me.

The development of characters in children's products is influenced by the overall needs and goals of the project. At Knowledge Adventure, which makes the JumpStart line of edutainment games, the cast of regular characters for JumpStart was revamped to make them more efficient within the educational context of the titles. Thus, for JumpStart Advanced First Grade, each character has been given a special skill as a way to help the young learner. For example, Eleanor, the pink elephant, is gifted in linguistic skills and hosts the reading modules, while Kisha,

Figure 8.2 Romaine the Rat is never up to any good in the Mia titles. Image courtesy of Kutoka Interactive.

Figure 8.3 Each cast member of JumpStart Advanced First Grade has a special skill that he or she uses to help voung learners. Image courtesy of Knowledge Adventure, Inc., and used under license.

the artist of the bunch, supports the players by providing helpful pictures. The revamped cast is now collectively called the Learning Buddies. (See Figure 8.3.)

But even at JumpStart, where educational objectives are taken with great seriousness, they recognize that perfection can be a little boring and thus give the cast some little flaws. "We are building in more conflict," senior producer Diana Pray reported. "We aren't the 'village of the happy people' anymore."

THE USE OF HUMOR

Kids love to laugh, and an interactive work that is full of humor will make it extra attractive to them. But comedy is a slippery beast, especially when you are working in children's media. Despite the willingness of young people to be amused, it is not necessarily easy to make something funny for them. What tickles children is sometimes quite different from what we adults consider to be amusing.

For one thing, kids' taste in humor is often what many adults regard as bad taste. They are drawn to content that causes nice grown-ups to squirm. They giggle at bathroom humor, at foul language, at odd-looking people, and at characters who break the rules of polite society. Kids also have a great sense of the absurd. They see what a silly place the world is, and they appreciate anything that celebrates its ridiculousness. Humor that pokes fun at adults, or that has a rebellious tinge, is therefore greatly relished. They love humor that is wacky, unexpected, and off the wall.

In general, visual humor works better than verbal humor; puns and word play will mostly go right over the heads of younger children. The young ones, on the other hand, love to click or roll over an object and have something silly or unexpected happen—an amusing piece of animation or a funny sound. But if you want to expand the age range of your product, it is a smart strategy to include humor that appeals to children in different age groups. And, if you think their parents might be playing along with them, throw in some funny things for them, too, as they're doing at Toontown Online. The adults will appreciate it, and the kids won't even realize that they've missed a joke or two.

Overall, the best kind of humor in children's interactive works is not very different from the best kind of humor in children's linear works: It is built into the character or into the situation and is integrated into the work from the concept stage on. It isn't just pasted on as an afterthought. So, if you want your projects to be truly funny, begin factoring in the humor from the earliest development stages. One final thought about humor: To be on the safe side, test your comic elements on kids to make sure they find it as amusing as you do.

THE SEVEN KISSES OF DEATH

As must be apparent by now, the process of creating interactive projects for children is riddled with possible pitfalls. Some of these pitfalls are particularly sly and seductive, and over the years I have given them a name: The Seven Kisses of Death. They are dangerous because they seem to make so much sense, but they are based on faulty assumptions. I first encountered these kisses as a writer of children's television programs, and I encountered them once again, largely unchanged, when I moved into interactive media. Thus, I speak from personal experience when I say that they can invade projects for young people with great ease. The good news is that these blights can be overcome by various strategies, and I'll be reviewing them after describing the Death Kisses.

Death Kiss # 1: Kids Love Anything Sweet

Yes, it is true that children love all kinds of sugary things—candy, ice cream, sugar frosted breakfast cereals. But this doesn't mean they also like their entertainment to be sweet, except when they are very young. For some reason, however, when adults design projects for kids, they often tend to heap on the sugar. In truth, sweetness is an adult concept of what kids should enjoy. Many adults feel a compulsion to make all their characters kind, gentle, and loving and to portray the world as a sunny, happy place without a smidgen of discontent. But real children above toddler age appreciate something with an edge, something that has some reality or bite to it, even in a fantasy game.

Death Kiss #2: Give Them What's Good for Them

This death kiss is usually committed by adults who are sure they know what's best for children, and they are determined to give it to them whether the kids like it or not; it is the "medicinal" approach.

Educational works are often plagued with this type of thinking. All too often, people approach such products with a great earnestness and a zeal to make something that will be really good for children. Unfortunately, they overdo it, and the resulting product is lifeless and dull. That doesn't mean, of course, that interactive works for children can't have solid educational content, as we will see in Chapter 11. But the educational material needs to be skillfully integrated with entertainment or otherwise the kids will tune it out.

Death Kiss #3: You've Just Got to Amuse Them

This could be called the "junk food approach." It is based on the assumption that it is far easier and cheaper to make products for children than products for adults because children are less discriminating—a fatal assumption right there. Children are actually quite discriminating—though in different ways than adults. And while kids love to be entertained, they are also hungry for content. If a product is fun but has no substance, you might not have any trouble getting kids to play it, but they'll get bored with it quickly and move on to other things.

Death Kiss #4: Always Play It Safe!

In the desire to avoid violence, sex, and controversy, it is all too easy to go to the other extreme and produce something so safe that it is boring. In actuality, avoiding objectionable material does not mean forgoing excitement or drama. It just means find other ways to keep the adrenaline pumping.

Death Kiss #5: All Kids Are Created Equal

This particular Death Kiss is committed when we are trying to make a product that will appeal to an extremely broad demographic, without taking into account how different children are at different ages. But, as we saw earlier in this chapter, children go through distinct stages of development, each with characteristic interests and play patterns. Thus, projects for children must be designed with a clear target age group in mind.

Death Kiss #6: Explain Everything

In our desire to make things perfectly clear, we often overdo it and drown them with words. It is hard for us to realize that kids are really clever at figuring things out, and they aren't nearly as averse to the trial and error process as we grown-ups are. Children have little patience for lengthy instructions or explanations, and they particularly dislike being lectured at by a single talking head. We're being lazy when we do this because we aren't doing the tough creative job of devising better ways to convey information.

Death Kiss #7: Be Sure Your Characters Are Wholesome!

This death kiss is particularly slippery because it seems so laudable. Of course we want our characters to be positive role models. Unfortunately, characters that are totally good are dull and also totally boring. You have to move beyond wholesome if you want to have truly interesting characters for children. And if

you don't have interesting characters, you're missing one of the key ingredients of a successful product, as we emphasized earlier in this chapter.

COUNTERING THE DEATH KISSES

Now that we've isolated The Seven Kisses of Death, we can review some strategies for combating them. Essentially, we have 10 effective ones available to us:

1. Build Your Project on a Compelling Mission

This tactic counters the "play it safe" Kiss of Death and also the junk food approach. In fact, it is powerful against all the death kisses. The idea is to hook your young users with an absorbing and meaningful challenge or purpose. We can give the child a mystery to solve, or a quest to go on, or a secret to discover. Or, if this is a creativity tool, we can give them something enormously desirable to make. If it's a simulation, we can give them the ability to control a fascinating miniature world or enterprise. The hook should be clear-cut and readily identifiable; it won't serve its purpose if the players don't know what it is. This is not the place for subtlety.

2. Inject an Ample Dose of Tension

As we saw in Chapter 5, tension is an extremely useful storytelling technique for keeping users engaged in an interactive work. If anything, it is even more effective with children than it is with adults because children have a shorter attention span. It is also an excellent antidote to Death Kiss #4, "Always play it safe." It's a dynamic way to add excitement without falling back on violence. Tension can be ramped up by creating a powerful antagonist or by building in substantial challenges to overcome, techniques that work particularly well in games or story-based projects. Of course, you don't want to use any forms of tension that might be disturbing to your target age-group.

When works have no gaming or narrative elements, you can create tension by harnessing the child's own curiosity. After all, curiosity is an intense anxiety to find something out or to see how something is resolved. Even a creativity tool can draw on the force of the child's curiosity, especially if it is leading toward a big finale or reward once the project is all put together.

3. Offer Genuine Substance

By integrating meaningful content into your project, you will be countering Death Kiss #1, "Kids love anything sweet," and Death Kiss #3, "You've just got to amuse them." Children are like sponges; they are eager for information about what the world is really like and how to live in it. And even very young children must contend with certain things that can be upsetting, such as a fear of the unfamiliar, sibling rivalry, and anxieties about being abandoned. Older kids have different concerns, of course, including peer pressure, conflicts with parents, and the yearning to be accepted. If you address some of these issues in your

work, you will be sure to capture the attention of your audience. Of course, they must be presented from a child's point of view, well integrated into the overall frame of the work, and age appropriate.

4. Create Multifaceted, Dynamic Characters

Good characters are powerful ammunition against all seven Death Kisses, but most particularly against Death Kiss #7, "Be sure your characters are wholesome." They add interest and excitement to your product and bring it to life. We've discussed techniques of character design earlier in this chapter, as well as throughout Chapter 6. When designing your characters, don't forget to pay attention to the opponents if antagonists are appropriate for your project. They can be even more fun to design than your heroes, and the more multidimensional and unusual they are, the more energy they will give to the work.

5. Offer Satisfying Challenges and Rewards

Rewards are a powerful motivator. A key strategy for grabbing the attention of children is to break the content into a series of small, exciting challenges and to offer rewards each time a challenge is met. Challenges should increase in difficulty as the child's mastery increases, thus keeping the work interesting.

Rewards provide positive reinforcement and also serve as a measuring stick for how well the child is doing. The trick is to emphasize success and to play down failure. If the player makes a mistake, soften the sting with a little humor and with words of encouragement from one of the nonplayer characters. You want to keep them involved and eager to do more, rather than become discouraged and quit.

6. Make the Product Easy to Use and Understand

This guideline will help you deal with Death Kiss #6, "Explain everything." When it comes to guiding a child through your product, good interface design is the best way to reduce the need for lengthy explanations. The more intuitive the interface, the less the need to give instructions about how to navigate through it.

If your product calls for text, make sure it is as readable as possible. Your font should be attractive and large enough for children to read easily, and the words shouldn't be crowded closely together. Remember, it is daunting even for adults to wade through a big chunk of text on a screen. Think what it must be like for new readers. You can learn a great deal about design, and the interplay between visuals and text, from studying fine picture books for children. Whenever possible, use visual images and action rather than spoken or written words to get your message across.

7. Make the Product Adjustable to the Child's Abilities

When it comes to age appropriateness, interactive works have a great advantage over linear works: They can be built with different degrees of difficulty. That means less accomplished users will not be frustrated, and more skillful users will continue to be challenged. Many products let the child or parent set the

difficulty level, and in some cases the difficulty level even invisibly adjusts to the user's ability. By offering activities or games with different degrees of difficulty, you are also giving your project greater repeatability. Children will come back to it again and again because they will find new challenges every time they play. Levels of difficulty can help disarm Death Kiss #5, "All kids are created equal."

8. Supply Liberal Doses of Humor

Humor is the perfect antidote to sweetness and blandness. It adds life and color. Almost any product you make for children has room for humor, so put some quality time into thinking up ways to inject it. We've discussed some of the things kids find funny earlier in this chapter.

9. Build in Meaningful Interactivity

The interactivity in your product should be well integrated into the overall content. The players' role in the work—their agency—should make sense, and make a difference, just as with a work designed for adults. Your young users should not have to sit through long stretches of passive material before finally reaching the parts where they can actually do something. They should be able to be active participants throughout.

10. Be Respectful of Your Audience

Here is a strategy, or actually a philosophy, that is a powerful defense against every single one of the Death Kisses. Being respectful, first of all, means not talking down to the young users or patronizing them. Being respectful also means creating a product for them that is age appropriate and truly engaging. Finally, being respectful shows you care enough about your young audience to make something that challenges them, but is not beyond their abilities, and that is entertaining, but isn't "dumbed down." Overall, it means offering them plenty to do and lots of fun, but meaningful content, too.

A HELPFUL RESOURCE

To stay up to date on children's software, websites, and smart toys, you might consider subscribing to Children's Technology Review (www.childrenssoftware.com). This monthly report is available as a print publication, in a PDF format, and online. A subscription also gives you access to its online archives, which include a stash of over 7500 product reviews.

CONCLUSION

As we have seen, designing a successful interactive project for children calls for an awareness of the developmental stages of childhood, gender issues, the desires of the parents, and the tastes of the children themselves. It also calls for vigilance against The Seven Kisses of Death and the use of techniques that can help bring a project to life and make it engaging.

The issues and concerns brought up in this chapter may cause us to lose sight of one extremely important thing: that the reason most people design projects for kids in the first place is because it's fun! And not only that: It is an opportunity to give pleasure to children and enrich their lives, and it is a chance to contribute something worthwhile to the next generation.

IDEA-GENERATING EXERCISES

- 1. Take a familiar myth or children's fairy tale (like *King Midas* or *Cinderella*) and analyze what the "template" or core story is; in other words, what its "bones" are. Then discuss how this template could be used as a framework for an interactive work that would appeal to each of the four major age groups of young audiences. How would it need to be changed to be appropriate to each group? Do you think your ideas could appeal equally to boys and girls in each of these age groups, or would a different approach be needed for each?
- **2.** If possible, have a child give you a "tour" of a favorite interactive work, like a video game or a website. Try to determine what it is about this work that the child especially enjoys. What, if anything, about this child's-eyeview of the work surprised you?
- **3.** Work your own way through an interactive game or other project designed for children, and analyze its strengths and weaknesses. What about it do you think would hook children and keep them involved? What kinds of rewards does it offer? Has it committed any of The Seven Kisses of Death?
- **4.** Choose a noninteractive branded children's property—a book, a TV show, a toy, a comic book figure, even a breakfast cereal mascot. Come up with a concept for adapting this property to an interactive medium. What about it lends itself to interactivity? What would the particular creative challenges be in the adaptation process?

Using a Transmedia Approach

How can you tell a story by tying the content together across multiple platforms?

Why is the transmedia approach so attractive from a creative person's point of view?

How is the transmedia approach being used for nonfiction endeavors like documentaries and reality-based projects?

Why is Hollywood taking such a keen interest in transmedia entertainment?

A DIFFERENT APPROACH TO STORYTELLING

Traditionally, narratives have been created for a single and specific medium—to be acted on the stage, for instance, or to be printed in a book or filmed for a movie. Sometimes a work might later be adapted into another medium, but such adaptations are rarely planned in advance; essentially, adaptations are just another way to tell the same story. Quite recently, however, content creators have begun to take a very different approach to storytelling. They have started to devise narratives that are designed from the ground up to "live" on several forms of media simultaneously. Each relates a different aspect of the story or relates it in a different manner. In this new approach, at least some of the story is offered on an interactive medium so that people can participate in it. This new type of storytelling, which we briefly discussed in Chapters 2 and 3, uses a transmedia approach to narrative.

The first transmedia production to catch the attention of the public was *The Blair Witch Project*, which was made in 1999. It consisted of just two components: a movie and website. The movie told the story of three young filmmakers who venture into the woods to make a documentary about a legendary witch and then vanish under terrifying circumstances, leaving behind their videotapes. The movie is constructed solely of the footage that is allegedly discovered after their disappearance, and it is presented as a factual documentary.

The website focused on the same central narrative idea that was developed in the film. At the time of the movie's release in 1999, plenty of other websites had already been tied into movies. But what made *The Blair Witch Project* so remarkable, and what created such a sensation, was the way the website enhanced and magnified the "documentary" content of the film. It bore no resemblance to the typical promotion site for a movie, with the usual bios of the actors and director and behind-the-scenes photos taken on the set. In fact, it contained nothing to indicate that *The Blair Witch Project* was a horror movie or that it was even a movie at all.

Instead, the material on the website treated the account of the filmmakers' trip into the woods as if were absolute fact. It offered additional information about the events depicted in the movie, including things that happened before and after the three filmmakers ventured into the woods. Visitors to the site could view video interviews with the filmmakers' relatives, townspeople, and law enforcement officers, or examine an abundance of "archival" material. Thus, they could construct their own version of the mystery surrounding the missing filmmakers. The content of the website was so realistic than many fans were convinced that everything depicted in *The Blair Witch Project* actually took place.

Of course, the website was, in fact, just an extremely clever and inexpensive way to promote the low-budget movie. It accomplished this goal supremely well, and it created such intense interest and curiosity that *The Blair Witch Project* became an instant hit. Though simple by today's transmedia productions, made up of just a movie and a website, it dramatically illustrated the synergistic power of using multiple platforms to expand a story. The website (www.blairwitch.com)

has become an Internet classic and remains popular even now, though not all of its features are still functioning.

DEFINING THE TRANSMEDIA APPROACH

Transmedia storytelling is still so new that it goes by many different names. Some call it *multiplatforming* or *cross-media producing*. It is known to others as "networked entertainment" or "integrated media." When used for a project with a strong story component, it may be called a "distributed narrative." Gaming projects that use the transmedia approach may be called "pervasive gaming" or sometimes "trans-media gaming." When this kind of gaming blurs reality and fiction, it is often called "Alternative Reality Gaming" or an "ARG." The term "transmedia entertainment" seems to be gaining the most favor, however, and this is the term we are using here.

In any case, no matter what terminology is employed, these works adhere to the same basic principles:

- The project in question exists over more than a single medium.
- It is at least partially interactive.
- The different components are used to expand the core material.
- The components are closely integrated.

Transmedia productions must combine at least two media, though most utilize more than that. The linear components may be a movie, a TV show, a newspaper ad, a novel, or even a billboard. The interactive elements may be content for the Web, a video game, wireless communications, or a DVD. In addition, these projects may also utilize everyday communications tools like faxes, voice mail, and instant messaging. Some of these projects also include the staging of live events. The choice of platforms is totally up to the development team; no fixed set of components exists for these projects. Any platform or medium that the creators can put to good use is perfectly acceptable in these ventures.

AN INTERNATIONAL PHENOMENON

The use of the transmedia approach is spreading throughout the world. In South Africa, for example, the reality show *Big Brother Africa* was designed from the ground up to span a variety of media, as was the Danish music video show *Boogie*. From Finland and Sweden we can find a cluster of clever transmedia games centered on mobile devices. Great Britain is by no means being left in the dust here, particularly thanks to the BBC's mandate that all its programs include an interactive element. Thus, the BBC is no longer thinking in terms of single-medium programming but is consistently taking a more property-centric approach. In addition, transmedia storytelling is being studied across the world, from MIT's august program of Comparative Media Studies in North America to the University of Sydney in Australia.

To get the most from the transmedia approach, production companies that work in this area usually tackle such a project as a total package, as opposed to pasting enhancements onto a linear project. This is the philosophy that guides the South African firm Underdog, for example, which has helped develop the *Big Brother Africa* series. Underdog specializes in transmedia and is the leading producer of such projects on the African continent. Luiz DeBarros, Underdog's creative director and executive producer, stressed the importance of considering the property as a whole instead of a single aspect of it. He said that at Underdog, they take the approach that a brand or property is separate from the platform. "In other words," he explained, "we develop brands, not TV shows or websites, and we aim to make them work across a number of platforms. The brand dictates the platform, not the other way around." DeBarros went on to give an excellent nutshell definition of the transmedia method of development, saying that it "is a property that has been created specifically to be exploited across several media in a cohesive and integrated manner."

THE CREATIVE POTENTIAL OF TRANSMEDIA PRODUCTIONS

One reason that the transmedia approach is such a powerful storytelling technique is because it enables the user to become involved in the material in an extremely deep way and sometimes in a manner that eerily simulates a real-life experience. For instance, the user might receive phone calls, letters, or faxes from fictional characters in the story, or even engage in IM (instant message) sessions with them. By spanning a number of media, a project can become far richer, more detailed, and multifaceted.

It also offers the story creators an exceptional opportunity to develop extremely deep stories. Unlike television shows or a feature film, there is no time constraint on how long they can be. Some of these works utilize hundreds of fictional websites to spin out their narratives, including some that contain audio, animation, and video clips. It is not unusual for a full-length book to be commissioned as one of the media elements. And because these narratives can utilize virtually any communications medium in existence, they offer a tantalizing variety of ways to play out the story, limited only by the creators' imaginations and by the budget.

While some of the motivation to create transmedia properties stems from promotional goals or the desire to build a more loyal audience for a TV show or a movie, commercial considerations are not necessarily the primary attraction for those who work on them. Many creative teams are drawn to this approach because of its untapped creative potential. In fact, I was fortunate enough to consult on such a project with my colleague Dr. Linda Seger. We were invited to assist with a highly innovative project from Denmark called *E-daze*, which was entirely original (not based on any existing property) and was self-funded by its three creators.

A contemporary story of love and friendship set against the turbulent background of the dot com industry, the *E-daze* story followed the same four characters across five interconnected media: the Web, a feature film, an interactive TV

show, a novel, and a DVD. Each medium told the story from a somewhat different angle, and in its use of the website and the interactive TV show, *E-daze* found clever ways to involve the audience and to blur the lines between fiction and reality. Unfortunately, its creators were not able to secure the necessary financial backing to move it beyond the development stage, although it attracted considerable interest. Nevertheless, the *E-daze* project illustrated the unique ability of transmedia storytelling to import a rich dimensionality to a property and to tell a story in a deeper and more lifelike, immersive way than would be possible via a single medium. It is no wonder that many creators of such projects find the experience exhilarating despite the many complexities they inevitably engender.

GOING PRIME-TIME WITH TRANSMEDIA STORYTELLING

Until fairly recently, content producers have been hesitant to undertake any expensive transmedia productions involving major forms of media, despite the great success of *The Blair Witch Project*. This is understandable, given that it is such a new and ambitious approach to storytelling. Thus, in the years immediately following *The Blair Witch Project*, the most interesting work being done in this arena was a new form of gaming, the *Alternate Reality Game (ARG)*. This new genre intricately blends story and gaming elements together in a way that seems more like real life than fiction. The first of these works primarily centered around the Internet and were supported by a variety of adjunct communications components. Compared to a major motion picture or a television series, ARGs are relatively inexpensive to produce. (We will be discussing ARGs in Chapter 17.)

Then in the fall of 2002, a bold new kind of transmedia venture was introduced to the public. Entitled *Push, Nevada*, it combined both a story and a game, blurred fiction and reality, and used multiple media. Thus, it had all the characteristics of an ARG. *Push, Nevada*, however, was the first such project to use a prime-time TV drama as its fulcrum. The project was produced by LivePlanet, a company founded, in part, by Ben Affleck and Matt Damon, and the project had some of Hollywood's most sophisticated talent behind it. With a first-class production team, network television backing, and over a million dollars in prize money, *Push, Nevada* was Hollywood's first major step into transmedia waters.

The components that made up the *Push*, *Nevada* galaxy revolved around a quirky mystery that was devised to unfold in 13 60-minute television episodes on ABC. The unlikely hero of the story is an IRS investigator, Jim Prufrock, a clean-cut and earnest young man. One day, Prufrock receives a fax alerting him to an irregularity, possibly an embezzlement, in the finances of a casino in a town called Push, Nevada. He sets off to Push to investigate and becomes entangled in the strange goings on of this extremely peculiar town. The mostly unfriendly residents clearly have something—perhaps many things—to hide. An uneasy aura of corruption hangs over the town, and the tone of the television show is intriguingly off center, reminiscent of the old TV series *Twin Peaks*. With its complex plot, allusions to T.S. Eliot, and unresolved episode endings, the series was not the kind of TV fare that most viewers were used to.

Figure 9.1
A portion of the Integrated Media
Timeline developed by LivePlanet for *Push*, *Nevada* to keep track of how the story and game unfolded across multiple platforms. Image courtesy of LivePlanet.

The TV show, although obviously a critical element, was just one of several components employed to tell the story and support the game. Other elements included a number of faux websites, wireless applications, a book, and telephone messaging. During the preproduction process, great attention was paid to the development of both the story and the game, and to make sure all the elements worked together, LivePlanet created a document called an Integrated Media Bible. They also developed an Integrated Media Timeline, which showed the relationship between the various media as the story and game played out over a number of weeks. (See Figure 9.1.)

WADING, SWIMMING AND DIVING

Just before the first episode of *Push*, *Nevada* aired, LivePlanet's CEO, Larry Tanz, gave a presentation about the new venture to a group of industry professionals at the American Film Institute. In his talk, he described the project as "a treasure hunt for waders, swimmers, and divers." In other words, members of the audience could determine the degree of involvement they wished to have. Some might only want to "wade" into its fictional world, which they could do just by watching the TV show. Others might choose to "swim" and sample parts of the story on other media. And still others might want to "dive in" and actively follow the clues and try to win the prize money, in which case they would be able to make full use of the other platforms that supported *Push*, *Nevada*. Ideally, as Tanz suggested, transmedia narratives should accommodate the full spectrum of audience members, from those who are primarily interested in passive entertainment to those who relish an extremely active experience.

Figure 9.2
With LivePlanet's
integrated media
approach, properties
are developed across
multiple platforms
and are integrated
at the core. Image
adaptation courtesy of
LivePlanet.

The concept behind *Push*, *Nevada* was exactly in keeping with the thrust of LivePlanet's strategy at the time, and which they continue to use now with projects that lend themselves to it. The company terms this strategy as an "integrated media" approach. As Larry Tanz described it to me, it means developing a property and having it operate over three platforms: traditional media (TV, film, and radio), which is the "driver" of each project; interactive media (the Internet, wireless devices, and so on), which allows the audience to participate; and the physical world, which brings the story into people's lives. The goal is to have these three platforms overlap in such a way that they are integrated at the core. (See Figure 9.2.)

Despite the high hopes for the project, and despite the fact that the interactive components proved to be extremely popular, the TV component of *Push*, *Nevada* failed to catch on, and after only seven episodes, ABC discontinued the show.

By many other measurements, though, it was clear that many people were closely following the *Push*, *Nevada* story/game. About 200,000 people visited the *Push*, *Nevada* websites, making it one of the largest online games in history, according to ABC's calculations. Over 100,000 viewers followed the clues closely enough to figure out the phone numbers of fictitious people on the show, call the numbers, and hear the characters give them recorded messages. In addition, about 60,000 people downloaded the "Deep Throat" conspiracy book written for the project. All told, ABC estimates that 600,000 people actively participated in the game.

TRANSMEDIA STORYTELLING AND FEATURE FILMS

Less than a year after *Push*, *Nevada* debuted, another high-profile transmedia narrative was released, and like *Push*, *Nevada*, it, too, had roots in glamorous Hollywood media. This venture was the sequel to the enormously popular feature film, *The Matrix*. Unlike a regular movie sequel, however, it was not just another feature film. Instead, the producers, the visionary Wachowski brothers, created a transmedia sequel of breathtaking scope. It was composed of two feature films, *The Matrix Reloaded* and *The Matrix Revolutions*, and it also included a video game, *Enter the Matrix*; a DVD, *The Animatrix*; and a website, *ThisistheMatrix com*.

This high-tech, new media crossover was particularly apt, given that the *Matrix* story depicts a society in which the digital and physical worlds collide and in which virtual reality runs amok.

As with all true transmedia narratives, each component of the *Matrix* collection of properties tells a different piece of the *Matrix* story. The two movie sequels and the video game were actually developed as one single project. The brothers Wachowski, Andy and Larry, who are reputed to be avid gamers, were at the helm of all three projects. All were shot at the same time. Not only did the Wachowskis write and direct the two movies, but they also wrote a 244-page dialogue script for the game and shot a full hour of extra footage for it—the equivalent of half a movie. In terms of the filming, the movies and game shared the same 25 characters, the same sets, the same crews, the same costume designers, and the same choreographers.

Although it is not necessary to see the movies in order to play the game, or vice versa, the games and movies, when experienced as a totality, are designed to deepen *The Matrix* experience and give the viewer–player a more complete understanding of the story. As one small example, in *The Matrix Reloaded*, the audience sees a character exit from a scene and return sometime later carrying a package. But only by playing *Enter the Matrix* will people understand how the character obtained that package.

The game contains all the dazzling special effects that are hallmarks of the movies, such as walking on walls and the slow motion bullets, known as "bullet time." It was one of the most expensive video games in history to make, costing \$30 million, and took two and a half years to complete. Nevertheless, despite the cost and a certain amount of criticism of the game and films, the game and the movies were a great success and benefited from the transmedia storytelling approach. Both the game and the first of the sequels, *The Matrix Reloaded*, debuted on the same day in May 2003 (a first in media history). By the end of the first week, the game had already sold one million units, selling a total of five million copies in all. As for *The Matrix Reloaded*, it earned a record-breaking \$42.5 million on its opening day and a stunning \$738,599,701 worldwide. (Though the second sequel, *The Matrix Revolutions*, fared somewhat less well, it earned a respectable \$425,000,000 worldwide.)

HOLLYWOOD'S KEEN INTEREST IN TRANSMEDIA STORYTELLING

Both the *Push*, *Nevada* story/game and *The Matrix* transmedia sequels were pioneering projects and were ahead of their time, but more recently, as noted in Chapter 2, mainstream Hollywood studios and producers have woken up to the fact that a transmedia approach to content can be an effective antidote to shrinking audiences, and it can also give them new revenue streams to tap.

As an excellent example of this new attitude, we can look at the pronouncement made by Jeff Zucker when he was CEO of the NBC Universal television group (he is now president and CEO of the entire NBC Universal empire). Mr. Zucker told *Television Week* (March 13, 2006) that he expected all producers of television shows to deliver packages that included not just television series but also content for the Internet, VOD, and mobile phones. "What it really means is producers can no longer just come in with a TV show," he told the publication. "It has to have an online component, a sell-through component, and a wireless component. It's the way we're trying to do business on the content side, giving the consumer ways to watch their show however they want to watch it." As Mr. Zucker clearly realizes, the use of multiple platforms is one way to reach audiences who have slipped away from TV, many of whom can now be found enjoying entertainment on their laptops and cell phones.

USING MULTIPLE PLATFORMS JUDICIOUSLY

Stephen McPherson, the president of ABC prime-time development, is the among the TV executives who are extremely enthusiastic about the use of multiple media. However, in an interview with the *Los Angeles Times* (January 3, 2006), he cautions that digital media should be used judiciously and not be allowed to dominate the content. "There are so many different aspects that go into all these multiple platforms that you just can't say it's a successful show, so let's put it on 20 platforms," he said. "But the idea that great content can be used in a multitude of different ways is a wonderful challenge and a wonderful opportunity." In other words, careful thought and planning needs to be given to how to best use digital media to enhance a television series. Merely slapping it onto additional platforms for the sake of appearing trendy is a poor use of what they have to offer.

Producers themselves are beginning to take a more proactive stance when it comes to using multiple media for their productions. For example, Jesse Alexander, executive producer of such popular shows as *Alias* and *Heroes*, is a firm believer in such an approach. He told the *Los Angeles Times* (June 27, 2007): "We call it transmedia storytelling. When we create a new franchise, we talk about how we can extend the narrative as a game, as a book, how it would look on the Internet, and so forth."

Thus far, however, the majority of producers and TV networks have not taken full advantage of the potential of transmedia storytelling. The majority of these new ventures use only two media (usually TV and the Internet, or TV and mobile devices), and very few offer interactivity.

For the most part, the transmedia material created for TV series has been in the form of webisodes and mobisodes—serialized stories told in extremely short episodes, one to six minutes in length, either for the Web or for mobile devices. These minidramas have spun out the TV series in a number of different ways. For example, a 10-part webisode was produced for the hit comedy, The Office. Called The Office: The Accountants, it was a story about a large sum of missing money and involved some of the background characters in the series, rather than the stars, giving the audience a chance to know them better. Sometimes a webisode will fill in pieces of the backstory of a TV series, as was done with the teen drama, Wildfire, with a webisode focusing on the life of the main character's troubled life before the series begins. And in still other cases, a webisode fills in story gaps between TV seasons, as with the 10-part webisode of the sci-fi show Battlestar Galactica.

Sometimes, instead of creating a webisode, the TV series will create fictional blogs for their main characters and fictional bios for MySpace and Facebook.

Various techniques are being used for mobile devices, too, with spinoffs in the form of mobisodes being the most common approach. For example, the six-part mobisode made for *Smallville*, a TV series about Superman's boyhood, told the backstory of an important character featured in the TV show, the Green Arrow. In a somewhat different approach, the mobisode *24: The Conspiracy*, which was a spinoff of the TV suspense drama, *24*, used the same type of storyline and same setting as the TV show, but a completely different cast of characters.

Several innovative projects have been undertaken by TV series that go beyond the typical webisode and mobisode approach. One interesting example is 24: Countdown, an online game built for 24, the same suspense drama mentioned above. Unlike the mobisode, however, this was a highly interactive venture, and it also tied together three types of media: network television, the Internet, and mobile phones. Players could actually take part in the same type of heart-pumping drama typically portrayed on the TV series and play a heroic role much like the star of the show, who works for a counterterrorist government agency. In the game, they work for the same counterterrorist agency and are tasked with the job of averting a nuclear catastrophe in a major American city, much like the scenarios in the TV series. In order to foil the terrorists, players must be able to receive urgent directives from counterterrorist headquarters. These messages are delivered to their cell phones, thus bringing the third media element into the narrative.

Nigelblog.com is another extremely clever transmedia venture tied to a TV series. Nigel is a character on *Crossing Jordan*, a crime drama set in a city coroner's office in Boston. Nigel, one of the fictional characters in the show, shares his observations with viewers on a blog written in his character's voice.

Occasionally, he even posts videos he makes with a webcam, sometimes secretly taping interchanges with other fictional characters. Though this example of transmedia storytelling only uses two media (TV and the Internet), it is highly interactive and also completely immerses viewers in the fictional world of the television drama

For example, during the first season of the blog, Nigel solicited viewers' help in solving several "cold case" murders, posting a number of clues on his blog. The blog created for the second season had a more personal twist to it, with Nigel asking viewers to help him handle a messy office love triangle. Throughout the season, Nigel encourages viewers to offer their advice on how to handle this complicated romance and frequently quotes their comments on his blog. In one of his blog entries, he decides that one of the characters embroiled in this romantic triangle needs to meet more women, and he asks viewers to write an online dating profile for the poor guy (with the winning profile posted for all to read). He also asks viewers to weigh in on the wedding dress choice of the prospective bride. And thus, real living people—the viewers—get to enter this fictional story and feel as if they are playing a meaningful part in it.

The Lost Experience, however, is possibly the most ambitious of transmedia storytelling applied to a TV series. The Lost Experience is an Alternate Reality Game (ARG) created around the TV drama, Lost, about a group of survivors of an airline crash marooned on a mysterious tropical island. The game was created by three TV companies, ABC in the United States, Channel 7 in Australia, and Channel 4 in the United Kingdom. The clues and narrative content were embedded in faux TV commercials and websites, in phone messages, in emails from characters, and in roadside billboards. In one eerie beat of this unfolding ARG, a "spokesperson" (actually an actor) from the Hanso Foundation even appeared on an actual late night TV show to defend his organization, which has played an ongoing and possibly nefarious role in the mystery.

Though the *Lost* ARG gave viewers the chance to actively participate in solving a mystery relating to the show and shed light on some of the secrets that had tantalized its viewers, it is worth noting that it did not reveal any essential parts of the narrative. Thus TV viewers who didn't participate in the ARG would not miss any essential parts of the story, while viewers who played the ARG would enjoy a fuller experience of the *Lost* drama.

As ambitious as *The Lost Experience* was, it was by no means the series' sole venture in transmedia storytelling. *Lost* has always been a leading innovator in the use of multiple platforms. For example, it created a mobisode called the *Lost Video Diaries* that featured the stories of other characters who were in the fictional airline crash but were not part of the TV drama. And in another bit of transmedia storytelling, viewers of the TV show would see a character find a suitcase from the wrecked plane that has washed up on the beach. Upon opening the suitcase, he discovers it contains a manuscript for a novel. Careful viewers who go to the trouble of looking up the title and author on *Amazon .com* will actually find the book listed, along with some information about

the author being one of the passengers of an airline lost in midflight. Viewers could actually order the full-length book and read it, should they wish, or buy the audio version, and possibly pick up more clues about the *Lost* saga.

Carlton Cruse, the executive producer of *Lost*, told the *Los Angles Times* (January 3, 2006) how he regards the use of digital platforms to help tell the *Lost* story. "The show is the mother ship," he stated, "but I think with all the new emerging technology, what we've discovered is that the world of *Lost* is not basically circumscribed by the actual show itself. . . . We have ways of expressing ideas we have for the show that wouldn't fit into the television series."

The Lost Experience and other transmedia narratives based on TV series have been extremely popular with viewers, giving them new ways to enjoy their favorite TV shows. From the networks' point of view, they have been successful in achieving their twin goals of keeping audiences involved between episodes and seasons and in providing new revenue streams. And, for TV writers and producers, these new ventures have offered fresh ways to expand the fictional worlds they have created.

USING THE TRANSMEDIA APPROACH FOR NONFICTION PROJECTS

Although in most cases, the transmedia approach to storytelling has been used for works of fiction, this technique can also be successfully employed in non-fiction projects. For example, public television station KCET in Los Angeles used multiple media to tell the story of Woodrow Wilson, the president of the United States from 1913–1921, a project we will discuss in more detail in Chapter 13. The fulcrum here was a television biography, and two interactive components were developed in conjunction with it, a website and a DVD. By spreading the story of Wilson's life over three different media, it was possible to portray him in far more depth than if this had solely been a TV documentary. Much thought was given about how to divide up the material about Wilson among the three different media to take advantage of what each had to offer.

On the other side of the globe, the South African company Underdog specializes in developing transmedia projects for nonfiction material, as we have noted. They've applied multiplatforming to a diverse array of works, including *Big Brother Africa* series; *Mambaonline*, a gay lifestyle property; *All You Need Is Love*, a teenage dating show; *Below the Belt*, a variety show; and *loveLife*, an HIV awareness project.

Underdog's involvement in interactive media dates back to about 1994. They were the first production house in South Africa to have an online presence, and they began offering multiplatform production services to other companies, utilizing the new technologies as a way to facilitate interaction and communication. Luiz DeBarros, who cofounded the company with Marc Schwinges, described to me why they believe the transmedia approach is so important. DeBarros explains: "There is a passion to connect with audiences in new ways and to find content and strategies that best do this," he said.

In developing a property across multiple media, DeBarros explained their goal is to do so using "a cohesive and synergistic strategy." The technologies and media they utilize include cinema, television, DVD/CD-ROM, telephony, the Internet, games, wireless, and print, selecting whichever platforms are the most appropriate for the property.

For example, Big Brother Africa utilizes the following: websites and webcams; interactive television; telephony via IVR (Interactive Voice Response); and wireless, with SMS (Short Message Service). The concept of the TV series is much like others in the Big Brother franchise. A group of strangers is isolated in a house for a long period of time. Video cameras are planted around the house and run 24 hours a day, and viewers get to observe what happens. At various intervals, viewers vote on which housemate they want to have ejected until only one remains. To keep things lively, the housemates are given various challenges to perform. In the case of Big Brother Africa, the show starts with 12 housemates, one each from 12 different African countries. The technology utilized in producing the show allows viewers to watch the housemates online via streaming video as well as on TV. They can also communicate with other viewers in various ways, as well as read online features and news about the various contestants. While the program is being broadcast on TV, viewers can send in SMS messages, which are then scrolled across the bottom of the TV screen. Often these messages are written in response to something that is going on in the house, and they frequently trigger messages from other viewers, creating a kind of onscreen SMS dialogue on live television.

Endemol, the company that produces Big Brother Africa, stays on top of what the audience is saying by reviewing the content of online forums, chats, and email that has been collated by Underdog on a weekly basis. They often use this input to give a new twist or direction to the show, DeBarros said. As for the importance of the interactive components, he stressed that the show simply would not work without them. "There is a strategy that aims to create an audience loop that pushes people from TV to telephony, to iTV to the Internet, and back to TV," he said.

When Underdog undertakes a new project, it prefers whenever possible to build in the transmedia components right from the beginning, while the project is still in the conceptual stage. And what does the company believe is the key to a successful production? Flexibility, DeBarros asserted; it's of the utmost importance in situations where the audience is interacting with a property. A process needs to be established that can "assess audience impact and what is working and what isn't, and adapt accordingly," he said.

GUIDELINES FOR CREATING TRANSMEDIA NARRATIVES

In this chapter, we have described a number of transmedia narratives, and these projects used a great diversity of techniques and media to tell a story across multiple platforms. As different as they are from each other, however, we can learn some important general lessons from them that can be applied to other transmedia projects:

- As always, you need to understand your audience and provide it with an
 experience they will perceive as enjoyable, not as too difficult or too simple, or too confusing or overwhelming.
- Give members of the audience some way to participate in the narrative in a meaningful way. They want to have some impact on the story.
- When at all possible, develop all components of a project simultaneously, from the ground up, and work out how they will be integrated from the beginning, too.
- Each platform should contribute something to the overall story. Don't just paste new components onto an already existing property without considering how they will enhance the narrative.

CONCLUSION

As we have seen from the projects discussed in this chapter, the transmedia approach can offer the user a new and extremely involving way to enjoy narratives and to interact with content. Forward-thinking broadcasters are looking at this approach as a way to potentially strengthen the connection between their viewers and their programming, an especially important goal as television audiences steadily decline.

Unfortunately, however, not all projects utilizing the transmedia approach have been successful, not even when supported by high budgets and produced by highly talented individuals. Yet it should always be kept in mind that creative ventures inevitably carry the possibility of failure, even in well-established areas like motion pictures and television. The risk is even greater when undertaken in a relatively uncharted area such as transmedia storytelling.

Clearly, the transmedia approach is an area that invites further exploration. Almost certainly, more experience with this approach will help content creators to find successful new ways of combining media platforms. We can also expect to see combinations of media not tried before. More work in this area should result in the creation of exciting new storytelling experiences.

IDEA-GENERATING EXERCISES

- 1. What kinds of projects do you believe are best suited to a transmedia approach, and why? What kinds of projects would you say do not lend themselves to this, and why? If you are doing this exercise as part of a group, see if someone else in your group can take the unpromising types of projects and come up with a transmedia approach for them that might work.
- 2. A variety of different media and communications tools have been employed in transmedia productions. Can you think of any media or

- tools that, to your knowledge, have not yet been employed? If so, can you suggest how such media or tools could be employed in an entertainment experience?
- **3.** Discuss some possible transmedia approaches that could make a documentary or reality-based project extremely involving for the audience.
- **4.** Try sketching out a story that would lend itself to a transmedia approach. What media would you use, and what would be the function of each in telling this story?

Creating a Work of Digital Storytelling: The Development Process

What is the very first step that needs to be taken in developing a new project, and why is it so important?

What are the five most common mistakes people make when developing an interactive project?

Why is so much time and attention spent on creating certain types of documents during the development process, and are these documents even necessary?

What are the 10 most important questions that must be addressed before production begins?

THE DEVELOPMENT PERIOD AND WHY IT IS CRITICAL

Before a work of interactive entertainment is ever built—before the interactivity is programmed, or the visuals are produced, or the sound is recorded—a tremendous amount of planning must first take place. This phase of the work is known as the development process or the preproduction period. It is a time of tremendous creative ferment. In its own way, it is not unlike the period described in ancient creation myths when all was nothingness and then, after a series of miraculous events, the earth was formed and its myriad beings were given life.

The creation of a work of interactive entertainment is a totally human endeavor, of course, but it, too, begins with nothingness, and to successfully bring such a complex endeavor to fruition can almost seem miraculous. To achieve the end goal, a tiny sliver of an idea must be nurtured and shaped, amplified and refined. And, instead of miracles, it requires a tremendous amount of hard work. Bringing a project up to the point where it is ready for production requires a team of individuals with diverse skills who perform an array of different tasks.

Surprising though it may be, the work that goes on during preproduction is much the same for every type of interactive project, whether the end product is a video game, content for the Web, a VR simulation, or a wireless game. The specific documents that are called for may vary, and the specific technical issues may be different, but the core process varies little, no matter what the interactive medium may be.

THE ADVANTAGES OF GOOD DOCUMENTATION

A well-utilized preproduction period can save not only time and money during production, but it can also help avert the risk of a product that fails. Furthermore, the documents generated during development can go a long way toward keeping the entire team on track while the project is actually being built. Good documentation can mean that everyone is working with the same vision of the end product in mind. It helps avoid confusion, prevents mistakes, and reduces the likelihood of work having to be redone. And if a new member is added to the team midway through, the documentation can quickly bring that individual up to speed.

The tasks that take place during the development period include the conceptualizing of the project; addressing marketing issues; producing design documents, art work, and other materials; building a prototype; and doing testing. Not every task done during this period deals specifically with creative issues, although invariably everything does impact the content, including the drawing up of budgets and schedules and the preparing of marketing plans.

The development process typically lasts an average of six months. However, it can be as brief as a few days or take as long as a year or more, depending on the complexity of the project, the experience of the creative team, and whether or not it involves a new type of technology or content. At the end of the development process, the company should be ready to swing into full-scale production.

FIVE ALL-TOO-COMMON ERRORS

Unfortunately, certain serious mistakes tend to be made during the development process. Some of these errors are caused by inexperience. Others may be fueled by the team's admirable intention of making something remarkable, yet being unable to rein in their ideas and set reasonable limits. And quite often, problems arise because the creative team is eager to plunge into preproduction and is too impatient to invest sufficient time in planning. Based on my own experience and on interviews with experts, here are five of the most common and serious errors that occur during the creative process:

- **1.** Throwing too much into the project: In cases like this, the creative team may have become intoxicated with a promising new technology or with exciting new ways to expand the content. But this sort of enthusiasm can lead to many problems. It can cause the project to go over budget or require it to carry too expensive a price tag for the market. The project may take far longer to produce than the time originally slotted for it, causing it to miss an important market date. Or the finished product may be too complex for the end-user to enjoy.
- **2. Not considering your audience:** This error can be fatal to a project. If you do not have a good understanding of your audience, how can you be sure you are making something it will want or will have the ability to use? Misjudging your audience can lead to:
 - creating subject matter they are not interested in or find distasteful;
 - developing content for a platform, device, or technical ability they do not possess;
 - developing an educational or training program that omits key points they need to know or that goes over their heads;
 - developing content for children that is not age appropriate.
- **3.** Making the product too hard or complicated: This error can stem in part from Error #2, not considering your audience. You need to understand what the end-users are capable of doing and not make unrealistic demands on their abilities. Sometimes this error is caused by poor design, and it is allowed to slip by because of inadequate testing. Whatever the cause, an overly difficult product will lead to unhappy end-users. As game designer Katie Fisher of Quicksilver Software said: "When a game becomes work, it's not fun for the player." Her comment is true not just of games but for any work of interactive entertainment, be it a smart toy, an immersive movie, or an iTV show. If it is too hard to figure out, people are not going to want to invest their time in it.
- **4.** Making the product too simple: This is the other side of the coin for Error #3. We are not talking here, however, about the product being too simple to use—simplicity in functionality is a good thing. We are referring to overly simple content. The content of an interactive work needs to be challenging in some way; otherwise, users will lose interest. It should also contain enough material to explore, and things to do, to keep the users absorbed for a significant amount of time. If it is too thin, they will

- feel they have not gotten their money's worth. To gauge the appropriate amount of playing time for your product, it is advisable to become familiar with similar products on the market. Focus group testing is also helpful in this matter.
- **5.** Not making the product truly interactive: In such cases, users are not given sufficient agency to keep them involved. When this happens, the flaw can usually be traced back all the way to the initial concept. In all likelihood, the premise that the product was built upon was weak in terms of its interactive potential, even if it might have been an interesting one for a noninteractive type of entertainment. In a successful interactive product, the interactivity must be organic from the outset and not just an afterthought.

THE FIRST STEP: CREATING THE CORE CONCEPT

The development phase begins with deciding what, in essence, the new project will be—the core concept. The initial idea may come about in one of several ways, and how it is initiated varies from medium to medium, company to company, project to project. Sometimes the concept is proposed by the CEO or president of the company; sometimes a staff member comes up with the idea; and sometimes it emerges during a staff brainstorming session. In a long-established software company, the concept may be a sequel to an already existing title. In a start-up company, it may be the dream project of a single individual or a small group of colleagues.

WHERE DO IDEAS FOR NEW PROJECTS COME FROM?

Ideas for new projects can come about in many ways. Sometimes they are inspired by a myth or true event from history or from an incident in someone's personal life. Sometimes the starting place begins with someone dreaming up an intriguing fantasy setting or exciting world to explore. Many times ideas take shape just by letting the imagination run free or by a group brainstorming session. In other cases, an idea is sparked by a new technology when someone envisions how it could be used as a medium for an interactive narrative. (For more on creating an original project, read the case histories throughout this book, and see Chapter 26, Creating Your Own Showcase.)

In many instances, of course, a company is given an assignment by an outside client and needs to find a creative way to fulfill it: to come up with an entertaining way to teach high school physics, for example, or to use digital story-telling techniques to promote a movie or sell a line of automobiles.

In many companies, the raw idea is set before the entire creative team and subjected to some rigorous brainstorming. During brainstorming, even the wildest ideas are encouraged in order to explore the full potential of the project.

Once a consensus of the core idea is reached, a description of it needs to be articulated in a way that adequately reflects what the group has worked out. Ideally, one person on the team will boil the concept down to a clear and vivid *premise*. The premise, which is usually just one sentence long, describes the concept in a way that indicates where its energy will come from, what the challenges might be, and what will hook the users. The premise is often written in the second person, "you," to put the listener or reader right into the action.

For example, a description of the premise of a new game might sound something like this: "In *Runway*, you are thrust into the glamorous but cutthroat world of the fashion industry, where you play the head of a small fashion house competing against powerful rivals and try to come up with the winning line for the new season." Or a description for a smart toy might be described this way: "Perry the Talking Parrot can be trained to speak and repeat phrases, but you can never predict what Perry might say because he has a mind of his own!"

In the film business, they call this one sentence description a "log line." The term got its name from the concise descriptions of movies given in television logs and other entertainment guides. However, the idea of boiling down a premise to a few words is equally useful for interactive entertainment. By nailing it down this way, the team will have a clear grasp of what it is setting out to do. They will also be able to communicate this vision to everyone who will be working on it or whose support will be needed to bring the project to fruition. And ultimately, this log line will be a valuable marketing tool.

OTHER EARLY DECISIONS

Early on during the development period, the creative team needs to make certain fundamental decisions about the project, assuming they are not already incorporated into the basic concept. First of all, what specific medium and platform is the project being made for, and what genre does it belong to? Once these basic "What is it?" questions have been addressed, it is time to consider important marketing issues. Who will the target audience be? What competing products are already available? And, if this a retail product, what will the intended price tag be? All these matters can have a significant impact on the design.

To help answer these questions, many companies either use a marketing person on staff or hire an outside consultant. This marketing expert might determine, for example, that the idea you have in mind sounds too expensive for your target audience, and if you don't want to overprice your product, you will need to rethink the design and leave out some of the cutting-edge features you were hoping to build in. Or your marketing expert might tell you your product would have a better chance with a different demographic than you had in mind. This information would require a different kind of adjustment. For instance, if you found out it would have a higher appeal with teens rather than with preteens, you may need to make the product more sophisticated and edgier than you'd intended at first.

Somewhere early on during the development period, the project manager will also be working out a preproduction and production schedule that will include specific milestones—dates when specific elements must be completed and delivered. A budget for the project will also be drawn up. Now, armed with a clearer idea of your project and its parameters, the team can brainstorm to refine the concept and begin to develop its specific features. Unlike the very first brainstorming sessions, where the sky was the limit, these later brainstorming sessions are tempered by reality.

FIVE POUNDS OF STUFF

Designer Greg Roach, introduced in Chapter 4, points out that you only have limited resources for any project you undertake, and you have to decide how best to use them. "It's like being given five pounds of stuff," he said. "You can't do everything you want." Thus, you have to make trade-offs—if you really want Feature X, then you may have to scratch Feature Y or Feature Z. In other worlds you can't build a 10-pound project with only five pounds of stuff.

HOW PROJECTS EVOLVE DURING DEVELOPMENT

As a project moves through the development process, it evolves from a raw idea to a polished state where it is capable of being produced.

During this preproduction phase, many projects require the input of *subject matter experts*, known as *SMEs*. Projects designed for educational, informational, or training purposes will inevitably require help from experts on the content and often on the target learners. But even when the sole goal of the project is to entertain, it might be necessary to seek expert help or to assign someone to do research. For instance, if you are actually doing a game about the fashion industry, you will want to find out everything you can about the world of high fashion, from how a new line of clothes is designed to how a fashion show is staged. Based on this knowledge, you can build specific challenges and puzzles into the game and make the project far richer and more realistic than it would be if you had attempted to rely on your imagination alone.

As the project develops, the team will be setting the ideas down in various types of documents. They will also be producing flowcharts, character sketches, and other visuals to further refine the interactivity, characterization, and look of the project. The various documents and artwork will be described in more detail a little later in this chapter, in the section entitled "Documents and Artwork."

At various points during the development process, ideas and visuals may be tested on *focus groups*—representative members of the target audience. If a client company is involved in this project, it will also need to be briefed on ideas and shown visuals. Based on the feedback that is received, further refinements may be made. The final step in preproduction is often the building of a prototype, a

working model of a small part of the overall project. This is especially typical in cases where the project incorporates novel features or new technology or is the first of an intended line of similar products.

The prototype will demonstrate how the project actually operates, how the user interacts with the content, and what the look and feel of it will be like. For many interactive projects, the prototype is the make or break point. If it lives up to expectations and funding for the product and other considerations are in place, the project will receive the green light to proceed to development. But if the prototype reveals serious flaws in the concept or in its functionality, it may mean going back to the drawing board, or it could even be the end of the line for that particular concept.

A 10-STEP DEVELOPMENT CHECKLIST

As we've already seen, the process of creating an interactive project involves the asking and answering of some fundamental questions. Based on my own experience and on the interviews done for this book, I have put together a list of 10 critical questions that must be addressed early in the development process, each with its own set of subquestions. These questions and subquestions apply to virtually any type of work of interactive entertainment. The answers will help you shape your concept, define your characters and structure, and work out the project's interactivity. The 10 questions are listed below:

1. Premise and purpose:

- What is the premise of the project; the core idea in a nutshell? What about it will make it engaging? Try to capture its essential qualities in a single sentence.
- What is its fundamental purpose? To entertain? To teach or inform? To make people laugh? To market a product?

2. Audience and market:

- Who is the intended user?
- What type of entertainment do people in this group enjoy? How technically sophisticated are they?
- Why should your project appeal to them?
- What other projects like yours already exist, and how well are they doing?

3. Medium, platform, and genre:

- What interactive medium or media is this work being made for (such as
 the Internet, mobile phones, interactive TV, or several media together);
 what are the special strengths and limitations of this medium, and how
 will the project take advantage of these strengths and minimize these
 limitations?
- What type of platform (hardware) will it use? (For example, a PC, a game console, a mobile phone, etc.)
- What genre (category of programming, such as simulation, webisode, or action game) does it fall into, and in what ways does your work contain the key characteristics of this genre?

4. Narrative/gaming elements:

- Does your work contain narrative elements (such as a plot or characters)? If so, has the storyline been fully worked out? What are the major events or challenges that the user will need to deal with during the narrative?
- Does this work utilize gaming elements? If so, is the gameplay thoroughly worked out? What constitutes winning or losing?

5. User's role and POV:

- What character or role will the user play in this interactive environment?
- What is the nature of the user's agency? How will the user effect the outcome?
- Through what POV will the user view this world: first person, third person, or a mix of both?

6. Characters:

- Who are the nonplayer characters in this project?
- What role or function do they serve (allies, adversaries, helper figures)?
- If your project contains a number of characters, have you developed a character bible to describe them?

7. Structure and interface:

- What is the starting place in terms of the user's experience and what are the possible end points?
- How will the project be structured? What are the major units of organization (such as modules or levels), and how many of them will there be? What structural model are you using?
- How will the user control the material and navigate through it? How will the user be able to tell how well he or she is doing? Will your project be making use of navigation bars, menus, icons, inventories, maps, or other interface devices?

8. Fictional world and settings:

- What is the central fictional world where your project is set?
- How is it divided geographically? What are its major settings, what do they look like, and how are they different from each other?
- What challenges, dangers, or special pleasures are inherent to these worlds?

9. User engagement:

- What about your project will keep the user engaged and want to spend time with it?
- What important goal is the user trying to accomplish by the end of this work?
- What will make the user want to spend time accomplishing this goal?
- What is the nature of the oppositional forces that the user will encounter?
- What will add tension to the experience? Will there be a ticking clock?
- Are you building in a system of rewards and penalties?
- What kind of meaningful interactivity are you offering the user, and will this interactivity have a significant impact on the material?

10. Overall look and sound:

- What kinds of visuals will you be using (animation, video, graphics, text on the screen, a mix)?
- Is the overall look realistic or a fantasy environment?
- How do you plan to use audio in your work? Will characters speak? Do you have plans for ambient sound (rain, wind, traffic noises, background office sounds)? Will there be sound effects? Music?

Once you have answered these 10 questions as completely as possible, you should have a pretty good grasp of the major elements of the project or know what needs to be developed more fully. If your project is one that blends entertainment with other goals, such as education or promotion, it will be helpful to also review the checklist given in Chapter 11, in the section entitled "Guidelines for Projects That Blend Storytelling with Teaching and Training."

DOCUMENTS AND ARTWORK

While each company may have its own unique method of doing documentation and preproduction artwork, certain types of written materials and visuals are universal throughout the interactive entertainment universe, even though their names may vary from company to company. The most frequently used forms of documentation and visual presentations are as follows:

1. The Concept Document

The concept document is a brief description of the project and is usually the first piece of written material to be generated. It includes such essential information as the premise, the intended medium and platform, and the genre. It also notes the intended audience for the project and the nature of the interactivity, and it gives a succinct overview of the characters and the main features of the story and game. Concept documents may be used as in-house tools to give everyone on the team a quick picture of what the project will be, and they can also be used as sales tools to secure support or funding for a project. If intended to be used in the second capacity, the concept document should be written in a vivid, engaging style that will convince readers of the project's viability. Concept documents tend to be quite short, generally under 10 pages in length.

2. The Bible

A bible is an expanded version of a concept document, and it is strictly an inhouse working document. Bibles are most frequently used for complex, storyrich projects; they may not be written at all for certain types of interactive projects, such as puzzle games. A bible fully describes significant elements of the work. It includes all the settings or worlds and what happens in them and all the major characters, and it may also give the backstories of these characters (their personal histories up to the point where the story or game begins). Some bibles, called character bibles, only describe the characters. Bibles vary quite a bit in length, depending on the breadth of the project and their intended purpose

within the company. In some companies, the bible is a collection of all the preproduction documents written for the project.

3. The Design Document

The design document serves as a written blueprint of the entire interactive work. It vastly expands the information given in either a concept document or bible, and it contains specific technical information about the interactivity and functionality. It is the primary working document of any new media project. At some companies, the design document evolves from the concept document or bible; at other companies, it is written from scratch.

The design document is a living construct begun during preproduction but never truly completed until the project itself is finished. As new features are added to the project, they are added to the design document, or if a feature is changed, the design document is revised accordingly. Because a design document is such an enormous and ever-changing work, and because so many different people contribute to it, it is vital that one person takes charge of overseeing it. This person coordinates and integrates the updates and makes sure that only one official version exists and that no outdated versions are still floating around.

Design documents are organized in various ways. Some are organized by structure, with a section for each module, world, environment, or level. Others are organized by topic. For instance, the design document for the strategy game *Age of Empires* contained a section just on buildings and how they worked.

To get an idea of the type of information that can be included in a design document, let's take a look at a few pages of one prepared for *JumpStart Advanced First Grade*. (See Figure 10.1.) The document is organized module by module; this module is for Hopsalot's Bridge, a sorting game. It is hosted by a character named Hopsalot, who is a rabbit.

At the top of the first page is a picture of Hopsalot's Bridge, from the POV of the player. Beneath it is a list of the curriculum points the game will teach, followed by brief summaries of the introduction speeches, one for first-time visitors and one for repeat visitors. This is followed by a detailed description of the gameplay, levels, and functionality. The full documentation of this module would also note what objects on the screen are clickable and what happens when the player clicks on them—what the pop-ups will be and what the audio will be, as well as a description of all the buttons on the screen and on the tool bar and what each of them does. It would also indicate every line of dialogue that Hopsalot would speak and would include special notes for the programmer and graphic artist.

Because design documents incorporate such a vast amount of detail, they sometimes reach 1000 pages or more in length. Some companies also produce a "lite" version for a quicker read. Companies often keep the design document on the organization's Intranet so it can be readily available to everyone on the team, and some companies only produce electronic versions of the document, finding paper versions to be inadequate.

Hopsalot's Bridge Module (Hb)

Access

Click Hopsalot's House, on the Main Menu Screen to get here.

Page Descriptionw

The curriculum for this module is the Sorting of:

- Parts of speech
- Words
- Geometry: shapes
- Science: Health/Nutrition, Animals, Weather

On Your First Visit:

Hopsalot gives long intro. Hopsalot's turbo carrot juice is one of the most prized power-ups for the scooters. Or at least he thinks it is, so he has gone to extremes to protect his supply.

Return Visit:

Gives short intro.

Gameplay

Hopsalot has made an island to hide his high-octane carrot juice on and he has to build a bridge to get to it. He has columns in the water that divide the bridge into 3 sections. He has also created little remote controlled balloon blimps to drop into place and create the bridge.

Each balloon has a word or picture on it (depending on the content selected for the session). For example: each word would be a Noun, Verb or Adjective. You must sort the balloons so that each column of the bridge has the same type of word. Use the left and right arrow keys to steer the balloons and use the down arrow key to make them drop faster.

Figure 10.1

A few pages from the design document of JumpStart Advanced first Grade. Document courtesy of Knowledge Adventure, Inc., and used under license.

(Continued)

If you send a balloon into the wrong column it will bounce back up into the air so that you can try again. Hopsalot will also hold a pin that will pop the balloons that you don't need (distractor blimps in L2 and L3).

When the bridge is complete, Hops will run over to grab a carrot powerup and bring it back. Now for the fun part! He can't leave the bridge up or Jimmy Bumples might sneak across, so you'll need to repeat the activity. but this time matching object will pop the balloon underneath.

After you've destroyed the bridge, Hops will reward you with the power-up.

Content Leveling

Note: the levels are related to each topic.

1. Parts of speech

Level 1: Verbs, Adjectives and nouns

Level 2: Verbs. Adjectives and nouns

Level 3: Verbs, Adjectives and nouns

Add words that do not fit into the category such as an adverb or preposition.

2. Syllables

Level 1: 1 to 3 syllables; pronounced

Level 2: 2 to 4 syllables; pronounced

Level 3: 2 to 4 syllables; regular pronunciation

3. Health-Nutrition (food groups)

Level 1: 3 categories: Grains, Meats, Dairy

Level 2: 4 categories: Grains, Meats, Dairy, Fruits

Level 3: 5 categories: Grains, Meats, Dairy, Fruits, Vegetables

4. Animals

Level 1: Habitat: water, land, air

Level 2: Attributes: scales, fur, feathers

Level 3: Zoological type: mammals, reptiles, insects; amphibians as distracters

5. Science - Weather

Level 1: 3 categories: sunny, rainy, snowy; outdoors activities

Level 2: 3 categories: sunny, rainy, snowy; outdoors activities + clothes

Level 3: seasons: winter, spring, summer; fall as distracter

6. Geometry - Shapes and Forms

Level 1: 2D shapes: squares, triangles, circles, rectangles

Level 2: 3D shapes: cubes, cones, cylinders, spheres

Level 3: everyday objects by their 3D shape: cubes, cones, cylinders,

spheres

Game Play Leveling

Level 1: Slow falling pieces.

Level 2: Medium speed falling pieces.

Level 3: Fast falling pieces.

Functionality

I. On entering the Module:

A. Play Background: BkgG1HbBackground

B. Play Background Music: G1HbAmbient.wav

Creating a Work of Digital Storytelling CHAPTER 10

- II. Introduction Functionality
 - A. Long Introduction (played the first time a player visits this module) Follow standards for interruptability
 - a) Play Hopsalot waving at Player
 - Hopsalot's Body: AniG1HbHopsalot, FX Wave
 - b) Play Hopsalot giving his Long Intro
 (Note: during Intro, Hopsalot will be Pointing at item as he speaks about them; items will highlight, and Hopsalot will have corresponding "Point" FX going on)
- i) Long Intro:
- Hopsalot's Body: AniG1HbHopsalot, FX Point01
- Hopsalot's Talk: AniG1HbHopsalotTalk, FX LongIntro01
- Hopsalot's VO: DgG1HbHopsalotTalkLongIntro01.wav
- c) Go to Gameplay
- B. Short Intro (played on any return visits)

Follow standards for interruptability

- a) Play Hopsalot giving one of the 3 Short Intros: (Random without repetition)
 - Hopsalot's Body: AniG1HbHopsalot, FX Point{01-03}
 - Hopsalot's Talk: AniG1HbHopsalotTalk, FX ShortIntro{01-03}
 - Hopsalot's VO: DgG1HbHopsalotTalkShortIntro{01-03}.wav
- b) Go to Gameplay
- III. Gameplay Interaction
- A. Display
 - 1. Hopsalot
 - a) Hopsalot's Body: AniG1HbHopsalot, FX Still
 - b) Hopsalot's Talk: AniG1HbHopsalotTalk, FX Still
 - 2. Device to throw Balloons
 - a) Device: AniG1HbDevice, FX Still
 - 3. Falling Balloons

(note: will appear on screen one after the other, according to order set for current level; those will be the same sprite, replicated at {x} instances; use datadict for coordinates)

- a) Play first Balloon ready on the Device: AniG1HbBalloon, FX Still
- 4. Carrot Case

(note: at the right side of screen = case containing the power-up)

- a) Case standing there: AniG1HbCarrotCase, FX Still
- 5. Labels

(Note: located at the bottom of each section of the bridge, they will display the name of each category; they will appear one by one when Hopsalot gives instruction: see below)

a) Labels sprites are not visible when entering the module

Not only does the design document help keep things on track during development and production, but it is also the point of origin for many other important documents. For example, the programming department will use the design document for creating its own technical design document, and the test team will use it to prepare a list of all the systems to be tested. The design document also helps the marketing group put together promotional materials and prepare for the product launch. If a manual or clue book or novelization is to be written for the project, the design document will come into play for those endeavors as well.

4. The Dialogue Script

In some companies, as we've seen, the dialogue script is incorporated into the design document, but quite often these scripts are stand-alone documents. The dialogue script sets down all the lines that the characters will speak during the interactive program. These scripts often describe the visuals and the actions that accompany the dialogue, as well. Dialogue may either be spoken by characters on the screen (animated figures or actual actors shot in video) or spoken voice-over by characters who are not visible. Their voices may be heard via a telephone, a radio, or some other device, or the dialogue may be delivered by an off screen character who is offering help and support. In cases when only voice-over actors will be used, and no live characters appear on screen, a separate voice-over dialogue script will be prepared that contains nothing but lines of dialogue.

Formats for interactive scripts vary widely, and no single industry standard exists at this time. Companies will use a format that works best for the types of projects they develop, and many customize their own formats.

One fairly common script style resembles the format for feature film screenplays, except that it incorporates instructions for the interactive elements. This format works particularly well in story-rich projects and games in which the level of interactivity is not too complex. In such scripts, the dialogue is centered in the middle of the page, with the descriptive material extending out further to the left and right margins. When using such a format, it is important to clearly indicate all the dialogue choices being offered to the user, and the responses the other character gives to each one of them. For an example, see Figure 10.2, *Dick and Jane*, a sample script I wrote for instructional purposes. The script incorporates an if/then branching structure.

DICK AND JANE

(Sample script using if/then technique)

JANE, the player character, leaves her house to go for a walk. She is a pretty young woman in her early 20s.

She can 1.) go straight; 2.) turn to the left or 3.) turn to the right.

1. Straight path:

If she goes straight, then she must cross a busy street and dodge heavy traffic.

[The script would continue to follow her actions from this point on]

2. Left path:

If she turns to the left, then she will pass a pretty flower garden.

If she stops to pick a flower in the flower garden, then a bee will sting her.

[The script would continue to follow her actions from this point on]

(Continued)

Figure 10.2
Dick and Jane, a
sample dialogue
script, uses a modified
screenplay format and
an if/then structure.
This script was written
for instructional
purposes, and thus
each if and then has
been emphasized.
Script by Carolyn
Handler Miller.

3. Right path:

If she turns to the right, **then** she will come to the house of her handsome neighbor, DICK. Dick is trimming a hedge. Jane can either ignore him or wave at him.

If Jane ignores him and walks on, then Dick will continue to trim the hedge.

[The script would continue to follow her actions from this point on]

If Jane waves at Dick, then he will speak to her.

DICK

(awkwardly, very shy)

Oh, hi, Jane. Nice to see you.

(beat)

... Uh, any chance you'd be interested in going on a long walk with me on the beach tonight? It's a full moon, and...

User can pick one of three responses for Jane to give:

Response A:

JANE

(clearly not interested)

Oh, sorry, I can't. There's this great sale at the mall tonight... half off designer pumps. Fabulous! Thanks, though.

If A is selected, then go to A1.

Response B:

JANE

(with genuine enthusiasm) Gee, Dick, I'd love to!

If B is selected, then go to B1.

Response C:

JANE

No way! For heaven's sake, Dick, has anyone ever told you you sound like a total cliché?

If C, then go to C1.

A1:

DICK

(sagging with humiliation)

Uh, OK. Guess I can take the hint.

B1:

DICK

Great! How 'bout I swing by your

place about 7:30?

C1:

DICK

Well, Jane, has anyone ever told you you sound like a total [bleep]?!

Some companies prefer to use a multicolumn format. This formatting style roughly resembles the traditional audio/video two-column format used in the making of documentaries and other types of linear programs, where one column is used for visuals (the video) and the other is for voice and sound (the audio). Interactive scripts, however, may use several more columns. At Training Systems Design, the company uses anywhere from three to five columns. The number of columns varies from script to script and even from module to module. The number of columns used depends on the needs of the programming and graphics groups. Their scripts also contain artwork indicating what will appear on the learner's screen. The company calls this type of formatting "scripts and screens."

One example of a five-column scripts and screens format is the company's script for the *Save Your Co-Worker* game, part of the *Code Alert* training program discussed in Chapter 11. (See Figure 10.3.) The script for the game was written by Dr. Robert Steinmetz. The artwork depicts the setting for this portion of the

Figure 10.3
The script for the Save
Your Co-Worker game
written by Dr. Robert
Steinmetz for the Code
Alert training program.
It utilizes a five-column
scripts and screens
format. Document
courtesy of Training
Systems Design.

(Continued)

Creating a Work of Digital Storytelling CHAPTER 10

Spot	Programming instructions	Value (if selected)	Audio label	Sound effect/voice over
1: Printer	If selected, add value to score bar, play good beep and play audio VO 5.1.2-1A	1	5.1.2- 1 A	(Good Beep) it all depends on frequency of use. But, based on where she has her mouse, we can assume this person is right handed, therefore it might be better to swap the phone position and the printer. However, sometimes it is good to move things around to avoid repetitive motion syndrome.
2: Phone	If selected, add value to score bar, play good beep and play audio VO 5.1.2-1A	1		
3: Monitor	If selected, add value to score bar, play good beep and play audio VO 5.1.2-1B	3	5.1.2- 1B	(Good Beep) Right! She really should orient herself so that her eyes are level with the monitor and her neck is in a neutral position
4: Head position	If selected, add value to score bar, play good beep and play audio VO 5.1.2-1B	3		ş.
5: Keyboard	If selected, add value to score bar, play bad beep and play audio VO 5.1.2-1C	1	5.1.2- 1C	(no beep) The problem isn't really with keyboardthough you could consider it part of a larger overall work habit problem.
6: Mouse	If selected, add value to score bar, play bad beep and play audio VO 5.1.0-3	0		
7: Lifting position	If selected, add value to score bar, play bad beep and play audio VO 5.1.2-1D	0	5.1.2- 1D	(Bad Beep) Nope, he is lifting with his legs, and he is tucking the load in toward his torso.

game, an office cubicle, and also shows the bar that keeps track of the learner's score, as well as an icon the learner can click on to receive help (upper left). Column one, labeled Spot, indicates the hot spots on the screen—objects the learner can click on to get some sort of response from the program. Column two, Programming Instructions, gives notes to the programmers, explaining what needs to happen when the user clicks on a specific hot spot. Column 3, Value, shows how the learner's choice will affect his or her score. Column 4, Audio Label, gives the code for the audio that will be heard in Column 5. Column 5, Sound Effect/Voice-Over, describes the audio effects that will be heard and the voice-over dialogue that the narrator will speak.

The multicolumn style of formatting is extremely precise and works particularly well for educational, informational, and training programs. However, it is cumbersome to use for projects that involve a number of dialogue exchanges.

Yet another scripting option is to use a spreadsheet. Spreadsheets are most popular when characters have numerous lines to say and when there are multiple variations of the same speech, such as five different ways for a character to say "Yes! You're right!"

Some companies create their own in-house software programs for script formatting, but off-the-shelf programs are available as well. Two of the better-known commercial products, both of which format linear types of scripts as well, are Final Draft and Movie Magic Screenwriter.

5. Flowcharts

Flowcharts are a visual expression of the narrative line of the program, and they illustrate decision points, branches, and other interactive possibilities. Flowcharting often begins early in the development process as a way to sketch out how portions of the program will work. As the project evolves, flowcharts serve as a valuable communications device for various members of the team, everyone from writers to programmers. They are also useful for explaining the project to people not directly on the team, such as marketing specialists or clients. As a visual method of illustrating how the program works, they can be much easier to grasp than a densely detailed design document.

Flowcharts vary a great deal in style and appearance. The least adorned ones, such as the one designed by Terry Borst to illustrate the interactivity for a short script called *Pop Quiz*, are composed of lines and geometric shapes like a simple diagram. (See Figure 10.4.) More detailed, higher-level flowcharts may also be made for programming, with each element coded to reflect specific functions or types of content.

Rock Dead End Engage with Student Starting Point Thru Doorway to Lab No Engagement: Retreat Student Artiste: Dead End "POP QUIZ" Interactivity Flowchart

Figure 10.4 The flowchart for Pop Quiz, a script written by Terry Borst, illustrates the narrative flow of the script and the various branching points. Image courtesy of Terry Borst.

More elaborate flowcharts may include detailed visuals of the screens and short explanations of functionality, such as the flowcharts produced for Code Alert. (See Figure 10.5.) Flowcharts like these are particularly useful for explaining the program to the client or to potential investors.

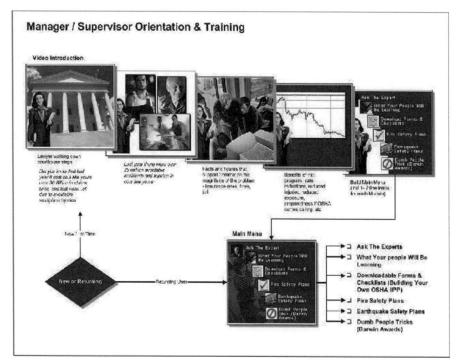

Figure 10.5

The macro level flowchart for Code Alert uses screen images and short explanations to describe how the program works. Document courtesy of Training Systems Design.

According to Dr. Steinmetz, the president of Training Systems Design, the company uses two levels of flowcharts. A macro level flowchart, like the one pictured here, gives an overview of the training program and is the type of flowchart that would most likely be used in a company proposal. Such flowcharts are made once the major instructional objectives have been identified. A more detailed flowchart, made later in the development period, would indicate all the branching. It would be produced once the specific teaching points had been identified, and it would be cross referenced to the document that laid out the teaching points.

As with scriptwriting, many off-the-shelf software programs are available to make flowcharts. Two that are popular with people in the software industry are Inspiration and Microsoft Visio.

6. Concept Art

Concept art, also called concept drawings or concept sketches, is a visual rendering of some aspect of the program. Such artwork is often used to depict characters and locations. Such images may be used as trial balloons and shown to team members or focus groups to test possible character designs or settings. They will then be refined until a consensus is reached and the team agrees on a final version.

When members of the art department are working on a character design, they might make a series of poses for each character. For example, at Her Interactive, for the *Nancy Drew* games, each character is given a set of eight different poses that reflect the character's personality and emotional state. The clothing the character is wearing can serve as a useful way to reveal character, too. For instance, a depressed young woman may be wrapped in layers of dark clothing, while a cocky politician may stick his thumbs in his suspenders.

7. Storyboards

Storyboards are graphical illustrations of the flow of action and other elements of the content, and they are displayed sequentially. They are somewhat similar to illustrated flowcharts. In the feature film world, movie directors storyboard every scene before filming begins. Storyboarding is often used in interactive media in much the same way. At some companies, it is used primarily for linear sequences, though other companies use them to work out interactive elements as well.

Storyboards resemble comic book art in that each frame advances the story. Each frame will indicate the location of the objects within the scene, the placement of the character or characters, the position of the camera, and the direction of the movement within the scene. Because storyboards are so visual, they are simple to comprehend. They are a useful preproduction tool for many kinds of interactive projects, including VR simulations, immersive environments, and interactive movies—in short, for any interactive endeavor that contains rich visual sequences.

8. Prototype

As noted earlier in this chapter, a prototype is a working model of a small portion of the program. It is the ultimate way of testing a concept. Many people

within the interactive community consider it to be a more useful method of trying out the concept's viability than flowcharting or storyboarding because it gives a more accurate indication of the look, feel, and functionality of the program. It's a chance to find out how the navigation works and to actually interact with the material. Prototyping is not necessarily done only at the end of the preproduction process. Small prototypes might also be built along the way to test out specific features. Also, it should be noted that prototyping is not necessarily done for every interactive project. For example, if the company has already made many similar products, and if this is just another product in an already-established line, prototyping may not be called for.

Specialized Documents and Artwork

As mentioned earlier in this chapter, other types of documents are customarily generated during the development process as well, although they do not specifically focus on the creative aspects of the project. They include a technical document containing the technical specifications, a budget, a schedule, a marketing plan, and a test plan. In addition to the fairly ubiquitous types of documents, visuals, and models already described, many companies work with customized tools that are particularly helpful for the type of project they are creating.

For example, at Her Interactive, they use several kinds of special documents when they make the *Nancy Drew* mystery–adventure games. One is the "critical path document," which lists the events that must occur, the discoveries that the player must make, and the obstacles that must be overcome in order to successfully reach the end point in the game. This critical path document is extremely succinct, about a page and a half of bullet points. Another document they produce is the "environmental synergy document," which is organized around specific environments (locations) in the game. For instance, for an interior of a room, it would note how the furniture is arranged, how the room is decorated, what "plot critical" objects it contains, what other less essential clues can be found here, and information about any characters who will be found in this room. It also notes what puzzles need to be solved within this environment. In addition to these two documents, the company also creates a highly detailed puzzle document, which lists all the game's puzzles and specifies how they work. All these documents are cross referenced and collected together as a project bible so that if a team member needs more information on any aspect of the game, it will be easy to find.

When a project contains a great many variables in terms of characters or types of actions, some companies create matrixes to keep track of them. A *matrix* looks much like a table, with horizontal rows and vertical columns. For instance, when I worked on the *Carmen Sandiego* series and was writing dialogue clues to help identify various suspects, I was given a matrix to use. It organized the variable characteristics of the suspects by categories, such as hair color, eye color, favorite hobbies, favorite sport, and favorite foods, and then it listed all the possibilities for each category. I was to write four lines of dialogue clues for each variable.

Within the world of smart toys, inventors and designers create something they call a skeleton logic chart or logic flow document. This tool illustrates how the toy and the child will interact with each other, and it shows the direction of the narrative line. And for projects that are designed to train or teach, a document is often prepared that lists the main teaching points or training goals.

CONCLUSION

As we have seen here, during a well-utilized preproduction period, a concept for an interactive work moves from an extremely rudimentary premise to a well-thought-out project that is detailed enough in every regard to be moved into production. This outcome is only obtainable, however, when teams go through the steps described here or through similar ones that might be more appropriate to their particular project.

Unfortunately, teams are sometimes tempted to jump into production before they've worked out important details, thinking they can do the detail work as they move along. But moving into production prematurely can be a costly mistake.

The development process, when undertaken with care, generates a number of highly useful documents, but it also involves an even more important task: conceptualizing. The creative team needs to work out exactly what the project is, whom it is for, and how people will interact with it. Above all, what about the project will make people eager to spend their time engaged with it? Finding satisfactory answers to questions like these can go a long way toward helping you create a viable project with genuine appeal.

IDEA-GENERATING EXERCISES

- **1.** Pick a work of digital storytelling that you have just begun to work on or that you are interested in doing. The work can be in any medium or for any type of platform. Take this project through the 10-Step Development Process to determine if any aspect of the project needs more thought or needs to be strengthened before moving more deeply into development.
- **2.** Using the same project from #1 as your model, determine what types of specialized tasks would need to be done during the preproduction process.
- **3.** Again, using the same project as above for your model, determine what kinds of documents you would need to generate in order to effectively take this project through the preproduction stage. What would each type of document contain?
- **4.** Using the same project as your model, consider your marketing specialist. What information do you think this person could give you and the rest of the team that would be helpful? And what documents do you think your team could give to the marketing specialist that would be useful in terms of launching the product?

PART 3 Harnessing Digital Storytelling for Pragmatic Goals

Using Digital Storytelling to Teach and Train

In what ways can projects designed to teach or train benefit by an interactive storytelling approach?

Why are organizations as different from each other as the United Nations, a chain of ice cream shops, the United States Department of Defense, and a group of Christian fundamentalists all turning to digital storytelling to help them fulfill their objectives?

What is a "serious game," and isn't this a contradiction in terms?

In what important ways should projects designed to teach or train be approached differently from projects whose only goal is to entertain?

"A SPOONFUL OF SUGAR"

Many tasks in life are important but not necessarily appealing. Of such activities, Mary Poppins had some excellent advice, declaring that "a spoonful of sugar helps the medicine go down." What's true of swallowing medicine is also true of other tasks in life that are usually regarded as uninviting—such as doing schoolwork or undergoing on-the-job training. When digital media are used to teach and train, that spoonful of sugar is an infusion of entertainment content and interactivity. This sweet combination helps makes learning far more appealing than it ordinarily would be, and it works equally well for teaching students in the classroom as it does for teaching employees in a workplace setting, although, as we will see, the techniques used in these situations are somewhat different.

The idea of integrating entertainment and education is not new. Our grandparents, and probably our great grandparents, too, learned to read from school-books that looked just like attractive children's storybooks. They played with educational toys like building blocks and magnets, and they took part in costume dramas where they reenacted important moments in history. It's also not a new concept to use the latest technology to teach. Both film and video, for example, were quickly put to use in the classroom and for training purposes as soon as it became possible to do so.

What is entirely new, however, is the use of digital technology as a vehicle to teach and train and the packaging of educational content in a format that is both entertaining and interactive. This new approach often uses digital storytelling techniques and is effective for young learners and older ones alike.

The "sugar" in this approach, as we've noted, is made up of both entertainment and interactivity. By incorporating entertainment into a work designed to teach or train, we create something that engages and engrosses the learner. The experience of learning the material is perceived as pleasurable, and learners willingly spend time working their way through it instead of trying to dodge it.

Furthermore, an entertaining environment is not perceived as intimidating. Let's face it: Classroom learning can be extremely uncomfortable for many people. In this public environment, surrounded by your peers, you are expected to perform and seem knowledgeable. No one relishes making a mistake in such a setting. But interactive education, especially when it is entertaining, is not only private but is also perceived as nonthreatening and nonjudgmental. Thus, learners don't feel the need to put up their defenses. They are more receptive to the educational objectives.

In many cases, projects that blend entertainment with teaching or training employ a gamelike format, though they may employ other digital storytelling techniques as well. Some rely on compelling storylines and dramatic narrative. Others use appealing characters to put a human face on the material. Still other projects employ humor as their primary form of appeal. And some projects use a Chinese-menu approach, employing a variety of storytelling techniques.

Using Digital Storytelling to Teach and Train CHAPTER 11

Interactivity is the other powerful component in the "spoonful of sugar." Interactive content engages multiple senses and offers multiple ways of acquiring information and new skills. Instead of just obtaining information from a textbook or a classroom lecture, for example, learners may take part in interactive simulations where they are called upon to observe their surroundings, converse with characters, manipulate objects, search for clues, and analyze data. This type of educational experience requires them to be fully alert and active, and the wealth and variety of stimuli make for a deeply engaged learner.

Moreover, interactive learning is highly flexible: The same program can usually accommodate different levels of learners and different learning styles. Many interactive titles offer several levels of difficulty and various kinds of learning activities, making it more likely that users will be challenged—but not beyond their ability—and will find material that matches their preferred personal style of acquiring new knowledge. Unlike traditional classroom learning, the students can proceed at their own pace. They are not held captive by the teacher's need to get through certain curriculum points by a certain time. They are also not held back by other students who may be slower at catching on than they are. Nor are they in danger of finding themselves lost if the rest of the students are ready to move on while they are still struggling to understand a key point in the lesson. They can repeat a section of the program, drop down a level, or access a help function or tutorial for extra guidance.

Thus, these programs accommodate struggling learners as well as ones who learn more readily. And they can be enormously empowering to students of all abilities. As learners work their way through an interactive program, they gain a satisfying feeling of mastery and accomplishment.

DIGITAL MEDIA AND YOUNG LEARNERS

Interactive educational software for young learners often goes by the term *edutainment*, a word that combines both education and entertainment. Although the term may be jarring to the ear, it effectively expresses its intent: to blend educational content with entertainment in a way that makes the material appealing to the intended learners. This technique, it should be noted, is not exclusive to interactive media. Television series like *Sesame Street* also use an edutainment approach to content.

Educational software titles are made both for home use and for the classroom. Edutainment titles were among the biggest success stories of the early 1990s, during the CD-ROM boom. Among the biggest hits during this period were the *Carmen Sandiego* series (used to teach geography, history, and astronomy) and the various *Math Blaster* and *Reader Rabbit* titles.

Children's edutainment software continues to be highly popular today. Some of these titles are curriculum specific, geared for a particular school grade, and cover several core skills that need to be mastered for that grade, such as *JumpStart Advanced First Grade*. Other titles target just one subject, such as

Mia: Romaine's New Hat, a science title developed by the Canadian company Kutoka. Some of these single-subject titles are tied to the curriculum of a specific school grade while others are appropriate for several grades. Still other edutainment titles have a softer focus. They may center on subjects such as wildlife or geography, or they may be designed to develop a child's reasoning skills or appreciation of art. Such titles are not curriculum specific and are meant to be inclusive of a broader age group.

To a certain extent, edutainment titles build on the inborn desire of all children to acquire new skills and information. Producer Diana Pray of Knowledge Adventure, the developers of the *JumpStart* titles, noted this when she said to me: "Younger kids love learning, even when it means lots of repetition. When they accomplish something, you can see the pride and pleasure in their faces. They think it's fun."

WHAT IS A "DRILL AND KILL" GAME?

Edutainment titles like the *JumpStart* line offer a great deal of repetitive practice, and this genre of game often goes by the name of "drill and kill." Though not an especially flattering term, it reflects that a certain amount of repetition is necessary in order to master basic skills. Although children obviously learn from these drill and kill games, the companies that make them do not necessarily feel that they "teach," in the true sense of the word. Diana Pray of Knowledge Adventure believes their value lies in offering an interactive supplement to what the children are learning in school. "The products are meant to help kids practice their skills, never to replace the teacher. They are not a substitute to what goes on in the classroom," she said. And the students enjoy these games far more than the more traditional way of practicing skills, which used to call for hours spent with flash cards.

DIGITAL MEDIA AND OLDER LEARNERS

While countless edutainment software titles have been developed for school children since the early 1990s, it is only recently that serious attention has been paid to using the same approach for older students. Complex subjects like Newtonian physics and microbiology were considered too difficult to teach using digital media and entertainment techniques. However, this reluctance to develop such software for advanced subjects has changed radically in recent years, thanks in large part to work that was initiated at MIT under a program called the *Games-to-Teach Project*.

The two-year program, a collaboration between MIT and Microsoft, was launched in 2001 with the goal of developing conceptual prototypes for a new generation of games based on sound educational principles. It brought together an eclectic mix of specialists from various fields—game designers, teachers, media experts, research scientists, and educational technologists. The 15 game concepts developed under this program, which tackled difficult subject matter in science, math,

engineering, and humanities, were geared for advanced placement high school students or lower level college students. By taking advantage of the latest technology and design principles, these games were meant to excite the curiosity and imagination of the students while giving them the opportunity to explore complex systems and concepts.

Many of these projects offered networked gaming environments, and these multiplayer games were designed to deeply engage learners by competing, collaborating, and interacting with their peers and overcoming challenges in a communal environment. Research suggests that the kind of trial and error experimentation and problem solving that takes place in such environments can promote the retention of newly gained knowledge.

Professor Henry Jenkins, director of MIT's Department of Comparative Media Studies, served as principal director of Games-to-Teach. Discussing the philosophy behind the project in an article published on the TechTv website, Professor Jenkins made an interesting comment about what games can do. "Games push learners forward, forcing them to stretch in order to respond to problems just on the outer limits of their current mastery," he said.

Like Diana Pray of JumpStart, Jenkins believes that the role of educational games is not to replace teachers but to enhance what they do. Games help make the subject matter come alive for students, he noted in the article; they motivate them to learn. He said he felt educational games could be of particular value in the areas of science and engineering because they offer "rich and compelling problems" and model the scientific process.

The 15 game concepts developed under the MIT program focused on many different educational subjects and used a variety of digital storytelling techniques. For example, in a game called Hephaestus, designed to teach mechanical engineering and physics, players find themselves on a formidable volcanic planet. Here they must work together to build and operate a workforce of specialized robots in order to survive. Another game, La Jungla de Optica, was a role-playing adventure game set in the Amazon jungle and designed to teach optical physics. It involved two primary characters, an archeologist and his niece, who must contend with a bunch of criminally minded marauders; something like a Tomb Raider for the physics set.

The Games-to-Teach Project helped spur the serious games movement—a movement that promotes the development of games designed to teach difficult subjects, and which we will be discussing later in this chapter.

USEFUL TECHNIQUES FOR COMBINING TEACHING WITH DIGITAL STORYTELLING

As can be imagined, it can be extremely challenging to create a project in which teaching goals and entertainment goals are both successfully met. Let's examine some techniques that can be employed to help accomplish this.

Putting Education First

The key to a successful edutainment title seems to be in finding the right mix of educational material and entertainment and to blend them seamlessly together. But what guidelines can be used to work out the ratio of fun to education? In other words, how do you integrate the "edu" and the "tainment," and balance the two?

Experts in the field unanimously advocate starting with the educational goals and building the entertainment around them. For example, at Knowledge Adventure, which has been turning out successful edutainment games for over 20 years, they always begin by setting the educational objectives of a new *JumpStart* game. The creative team starts the process off by soliciting the input of outside experts. Typically, these experts are classroom teachers who teach the grade or subject matter of the title. In some cases, they also use subject matter experts (SMEs)—specialists in a particular field—particularly when a title focuses on a specific topic. For instance, during the development of *JumpStart Artist*, which dealt with the visual arts, they used art experts from the Los Angeles County Museum of Art.

Organizations that make educational software for older learners, including companies that make training software and the U.S. Army, start the development process in the same way—by first defining the pedagogical goals.

Setting the Curriculum

Once the general educational goals are established, a specific curriculum needs to be established—the specific teaching points that the work will cover. Games designed for grades K-12 face a particular challenge in this regard. Curriculum standards vary widely from state to state, and standards can change quickly. Furthermore, some companies market their products internationally, and standards can vary significantly from country to country. For instance, in France they don't teach subtraction until third grade, while in the United States it is taught in first grade. Adding to the challenge is the teachers themselves, who often have strong opinions about what is age appropriate and what is not.

In working out the curriculum, many companies not only consult with teachers and content experts but also turn to resources that specialize in curriculum information and that offer compilations of curriculum standards. One good online resource for curriculum compendia is McCrel (Mid-continent Research of Education and Learning). At *JumpStart*, they not only use McCrel and other published resources, but they also create their own nationwide compendium of curriculum standards.

Educational software designed for older students and for use in the workplace will also need to meet the general standards of the organizations the finished product will be marketed to. This is usually done by working with subject matter experts and building a consensus on the curriculum.

Creating a Program Conducive to Active Learning

The great advantage of using digital platforms to teach is that they are interactive. Interactivity promotes active learning, which is also known as experiential learning. Both terms mean learning by doing, acting, and experiencing, as opposed to passive forms of learning, such as listening to lectures or reading books. Content designed for digital media should take full advantage of interactivity. Thus, thought must be given to how best to involve the learners. Will your program invite them to role-play? Take part in simulations? Invite them to test themselves in quizzes? Have them participate in peer-to-peer learning? Offer them games to play?

WHAT MAKES AN EDUCATIONAL GAME EFFECTIVE?

James Paul Gee, a scholar of educational games at the University of Wisconsin and author of What Video Games Have to Teach us About Learning and Literacy, has made many useful observations about effective educational games in his book. He believes that for such a game to achieve its goals, it must be enticing enough for learners to want to play it and enjoyable enough for them to put a great deal of effort into it. Learners, he says, need to be rewarded for their efforts, with more rewards offered for greater efforts, and they need to be able to achieve meaningful success in the virtual world they are playing in. Furthermore, he believes that a good game should offer many opportunities to practice skills and in a way that is not boring. The learning in a game should be ongoing, he feels, so the players cannot operate on automatic pilot. They should continually be offered fresh challenges as they play, but the game should not be so challenging that players will feel defeated by it and give up.

Setting Levels of Difficulty

By setting several levels of difficulty within the educational program, its audience can be extended beyond a specific curriculum or narrow age range or specific skill set. Having levels of difficulty also adds to the program's repeatability. The JumpStart games, for example, are built with three levels of difficulty, with the expectation that a child will fit inside one of these levels. The parent or child can set the level of difficulty, but the games also include an assessment tool that automatically sets the level for a child, and it offers up games that have a natural progression in difficulty.

Having various levels of difficulty works equally well for older learners and for training programs meant for the workplace.

Establishing a Compelling Premise and End Goal

As we have discussed throughout this book, when users are immersed in a nonlinear work, it is extremely helpful to give them a strong incentive so that they will work their way through to the end. This is where effective techniques of digital storytelling come into play. Enticements on the macro level are usually in the form of a dramatic premise and a highly attractive end goal.

For example, in *Mia: Just in Time*, a game that focuses on math skills, the story begins with a disastrous fire that burns down the quaint Victorian cottage where Mia lives. But, we soon learn, this calamity can be reversed! But first, Mia must assemble and operate an old time machine, and four essential parts are missing. Mia needs the player to help her find them, a quest that requires the solving of many math problems. The adventure takes players deep underground into a mole's hole and into a gadget-filled inventor's cave, and finally, if all the parts are found, on a flight on the now operating time machine. (See Figure 11.1.) Thus, the entertaining aspects and educational aspects of the game are tightly bound together and neither dominates.

Not all edutainment titles have as strong a storyline as *Mia: Just in Time*, but they almost invariably contain a compelling goal to strive for to keep users playing all the way through to the end. As an example, a title I worked on, *JumpStart Artist*, is set at a carnival-like art fair, with various art-related games and activities available in each of several tents. But at the start of the game, the most exciting part of the art fair—the section where the carnival rides are located—is still under construction. In order to erect the carnival rides and be able to go for a spin on them, the learner has to win coveted pieces of blueprints, which are won by playing the educational games and doing the activities in the art fair tents. Thus, the carnival rides serve as the carrot that entices learners to work through the whole game.

Figure 11.1
In this screen capture from *Mia: Just in Time*, an educational game to teach math skills, Mia points to the time machine, which two of the perpetrator's inept cousins are trying to steal from her. Image courtesy of Kutoka Interactive.

Dramatic premises and compelling end goals are equally effective in works for older learners. Of course, they need to be appropriate for the sophistication level and tastes of the target audience.

Employing Other Digital Storytelling Techniques

A number of other digital storytelling techniques are used effectively in interactive educational titles. For example, most titles for young children contain generous amounts of humor because they enjoy it so much. Attractive settings are also an important draw for this group—favorite places like the beach, a zoo, or an amusement park, or fantasy settings like outer space or an underground "alternate" universe. Fantasy settings can also be attractive to older audiences, though titles designed for training are usually set in realistic contemporary workplaces.

Well-developed characters are an important element in all works meant to be both educational and entertaining, no matter what the target age group is. And, as always, a solidly designed structure, appropriate for the project's pedagogical goals, is an important asset.

Creating a Rewards System

Rewards are tremendously powerful motivators. They encourage learners through the hard parts and keep them involved for the duration of the program. Adults enjoy winning rewards just as much as children do, though the types of rewards doled out to older people will, of course, be different. Rewards come in many different forms, including

- · being praised by a synthetic character;
- receiving a good score;
- winning some kind of prize;
- obtaining a coveted item;
- moving up a level;
- being promoted in rank or power within the fictional world of the project;
- making some type of significant advance within the game or story context;
- achieving a successful outcome in a simulation.

Rewards can also be in the form of intangible benefits like a boost in self-confidence or the satisfaction that comes with mastering something difficult.

BUILDING IN REWARDS

Rewards should always be in keeping with the storyline and setting of the work; in effective educational titles, they work hand in hand. The incentives are embedded in the story; the story motivates the learners to stay involved and earn the rewards. Rewards can be handed out whenever the learner successfully completes a task, solves a puzzle,

(Continued)

or works all the way through a quiz. Programs for young learners tend to be generously sprinkled with rewards, while those made for adults normally use rewards more sparingly, but they are strategically placed to give them maximum punch.

In children's educational games, rewards are especially important in holding the players' attention. "With rewards, the kids want to play longer," Diana Pray of Knowledge Adventure explained to me. Along with major rewards, like the blueprint pieces described earlier, many titles also offer smaller rewards each time the child successfully completes an individual exercise within the game. These rewards are the equivalent of a friendly pat on the back. Sometimes it will be in the form of a snatch of triumphant music or a brief piece of reward animation; sometimes a character, usually off screen, will congratulate the learner with a "bravo; well done!"

When a learner succeeds at a task, it is common for a graphic (such as a score or a status bar) on the screen to note this and to show the learner's progress in the game. Rewards, however, are not necessarily seen or heard. Often they work as invisible passes, granting the user the ability to advance in the program. Another powerful type of reward is an elevation in status, a technique found in educational works for every age group, as well as works produced for pure entertainment.

Using Simulations

Simulations are a particularly powerful tool for teaching, though they are most often used for older students and adults. Simulations are unfolding dramas that immerse the user in a realistic and engaging scenario. They are experienced from a first person point of view, and the user's choices determine the outcome. Thus, they promote experiential learning—learning by experiencing and doing, as opposed to passive forms of learning. They can be used for a wide variety of learning situations, from teaching world history to training workers in how to serve ice cream cones, and they are frequently employed in teaching interpersonal skills.

Using Peer-to-Peer Learning

Peer-to-peer learning is another technique often used in teaching older students. In such a learning environment, students help each other solve problems and work together to carry out tasks. Scholars of educational games have found that such peer-to-peer learning reinforces mastery. The *Hephaestus* game developed at MIT, described earlier, is an excellent example of how peer-to-peer learning can be designed into an educational game.

THE GROWTH OF THE SERIOUS GAMES MOVEMENT

As noted earlier in this chapter, serious games are games designed to teach difficult subjects, either to advanced students or to learners outside of academic

settings. Because serious games are meant to be entertaining as well as teaching vehicles, they make intensive use of digital storytelling techniques. We will be examining a variety of serious games during the rest of this chapter and throughout the book. Unfortunately, because of space limitations, not every type of serious game can be discussed.

The *serious games movement* is a loosely organized group of designers, developers, and scholars who promote the development of such games. The movement got its start around 1996, when the U.S. Army began to work with Hollywood professionals and the games community to develop games and simulations for military training. Serious games went mainstream in 2004, when the first Serious Games Summit was held at the Game Developers Conference.

Serious games cover a great variety of topics and are built for many different kinds of users. In fact, there is no one generally agreed-upon definition of what constitutes a serious game. Most people involved in the field, however, would agree that serious games include

- high-level academic games;
- corporate training games;
- simulations used to train military personnel;
- training for emergency workers and "first responders," such as police officers, medical personnel, and firefighters;
- social impact games (games designed to have a social impact and raise public consciousness of important issues, such as famine and international conflicts);
- games meant to help individuals deal with physical, emotional, and spiritual health.

Some people in the field would also include games designed to advertise and to promote products in the broad category of serious games, an area we will be covering in Chapter 11. In addition, some also include games designed to inform, a topic covered in Chapter 13.

A CROSS SECTION OF SERIOUS GAMES

Serious games, as we've noted, cover a vast spectrum of projects. Let's take a brief look at several of them to get an idea of the diverse subjects they tackle and the range of approaches they use.

- Stone Cold Creamery, a chain of ice cream shops, created a fast-paced online training game for its employees. A simulation, the game is set in a virtual ice cream store, and players strive to dish up ice cream, and in the correct amounts, before time runs out.
- Left Behind: Eternal Forces is a single and multiplayer real time strategy game with a fundamentalist Christian perspective. It is designed to compete directly with traditional hard-core video games like the Grand Theft Auto series while instilling spirituality and Christian values. Based on a

- series of books by the same name, *Left Behind* focuses on the raging apocalyptic battle ("spiritual warfare," as its designers put it) fought by those left on earth after the Rapture, when all good Christians are swept into heaven.
- Fully Involved, a single player PC game that has not yet been released, aims to train firefighters for the difficult role of serving as commanding officers in emergency situations. The game's realistic simulations take players through increasingly dangerous fires while simultaneously dealing with demanding personnel issues. In some cases, the firefighters must contend with flammable chemicals; in other cases, victims are trapped inside houses. The goal is to foster good management skills and strategies, while always keeping firefighter safety in mind.
- Earthquake in Zipland is a children's adventure game that helps youngsters cope with the emotional trauma of their parents' divorce or separation. Designed for ages 7 to 13, it is set in a colorful fantasy environment. The lead character, Moose, lives on an idyllic island, but an earthquake (symbolizing a divorce) tears apart this once happy place. The player must help Moose try to put things to right again.
- Food Force, produced by the United Nations, is a game that dramatizes the issue of global hunger. Though set on a fictional island, the challenges depicted in the game are realistic. The player becomes a rookie member of a team of emergency workers trying to save the starving islanders from famine and civil unrest. The game can be downloaded for free from the Internet.
- Darfur is Dying is another game focusing on an international crisis situation, in this case the civil war/genocide in Sudan. The game is set in a refugee camp in Darfur. As a player, your task is to survive and help your family survive. The game is designed to be a call to action and encourages players to take steps to help end the crisis. An Internet-based game, it requires no downloading and is designed for players with minimal game-playing experience.
- *Re-mission* is a third-person shooting game for young cancer patients. The goal is to give them a sense of control over their cancer, help them adhere to treatment programs, and improve the quality of their lives. Set inside a human body, players operate a nanorobot named Roxxi and blast away at malignant cells. They can receive power-ups that energize cancer-fighting weapons like radiation, diet, and chemotherapy. The game is distributed at no charge through the game's website.

DEVELOPING SERIOUS GAMES FOR THE MILITARY

As we have already noted, the U.S. Army was one of the first organizations to recognize the value of using gaming techniques and digital technology for training purposes. The Army and other military organizations continue to be leaders in the development of serious games. Not only does the military have an ongoing need for training, but games are also safer and less expensive than

Using Digital Storytelling to Teach and Train CHAPTER 11

live exercises. Furthermore, games are highly portable and deployable. In addition, using gaming techniques for training builds on the recognized popularity of video games, especially with the young people who comprise such a large percent of the armed forces.

Dr. Elaine M. Raybourn, one of the leading experts in this field, talked with me recently about creating games for military training. She said she has found that serious games are well-suited for experiential learning and can help the trainees master critical skills in decision making and communication. Dr. Raybourn designs, writes, and produces games for the Sandia National Laboratories in New Mexico, a multiprogram laboratory under the U.S. Department of Energy that develops technologies to support national security. The games that Dr. Raybourn develops focus on interpersonal skills rather than on procedural training (such as how to load a gun or toss a grenade). They are used to train individuals in leadership, cultural awareness, problem solving, flexible thinking, and making difficult decisions under stress.

Dr. Raybourn calls the approach she uses in her games *adaptive training systems*. By this she means the games are designed to facilitate feedback and communication during and after play, as well as the sharing of strategies and solutions. The end goal is to help the players understand their personal strengths and weakness in terms of leadership and to acquire skills they need to carry out to the real world. Such an approach fosters what she terms an *emergent culture*, an experience that begins during the game but continues long after gameplay as trainees continue to think and talk about what they learned.

Most of the projects she works on are multiplayer role-playing games. Trainees are divided into two teams of 8 to 10 players who do the role-playing, while the rest of the players serve as observers and offer feedback. Trainees switch positions at least three times during the game, giving everyone a varied perspective. While role-playing, the trainees communicate with each other by speech, talking through microphones that mask their voices to preserve anonymity. Dr. Raybourn explained to me that she is not fond of dialogue trees because "the answers have always been prescripted."

Though the projects she designs are for training, she believes that they are also very gamelike, noting that they are full of action; that players have the goal of winning; and that they contain rewards and consequences. "That's what makes them fun," she said. The rewards in these games, she pointed out, go beyond the game itself. They increase the players' self-confidence and self-understanding.

In order to design these games, Dr. Raybourn stays on top of developments in the commercial game world, particularly action games, first-person shooters and real time strategy games. She studies how these games keep the action flowing; how they put the player in danger; and how they ramp up the stress level.

In designing her games, she uses a process call the Simulation Experience Design Method. She begins by determining the specific training need that the game will focus on and how it will fit in with the training the intended learners are already receiving. She then does what she calls *ethnographic field research*, going to military bases, studying the intended users and sitting in on their training sessions. As an aid to her preproduction phase, she takes a great many photographs, documenting small details like how people gesture, how they stand in groups, and the items around them in their environment—what she refers to as a photojournalist approach. She also meets with cultural informants—people from the part of the world where the game will be set—and studies their body language and how they communicate with each other.

One of the most important aspects of her preproduction process is creating a profile of a single target user, an approach to character design termed the *persona method*. It involves developing the characteristics of one fictitious but realistic individual who will represent the target player. She establishes this individual's stressors, values and belief system, strengths and weakness, and what this person has been through. She uses this representative individual as a guide for developing the game's narrative, its rewards system, and the creation of character arcs.

Once the persona has been created and the training objectives determined, she will then design the narrative flow of the game: where it starts and what situations the players will encounter in it. As with most games, however, there is no one set finishing point; the participants themselves create the resolution as well as many of the narrative elements. She strives to create scenarios that will pump up the players' adrenalin levels and that are emotionally engaging, though leaving room for improvisation.

The narratives she develops are extremely realistic, with every detail appropriate to the part of the world where the game is set. The visuals, the audio, and even the vegetation are as accurate as possible. For example, a game she created for the U.S. Army Special Forces on cross-cultural engagements is set in Afghanistan. It includes a mission where players try to remove a vehicle that is blocking the road to a village. The vehicle in this particular mission is a colorfully decorated *jingle truck*, an important mode of transportation in Afghanistan. (See Figure 11.2.)

In the simulations she designs, she strives to create what she calls a *crucible experience*, an in-game experience that will be emotionally powerful and believable enough for the player to undergo a meaningful change in thinking, understanding, and perception that will cause the player to have, as she puts it, "an aha moment." This epiphany, she explained, is somewhat similar to the experience of the hero's journey, an intense adventure that can transform the person who undertakes it. The hero's journey, as you might recall, was first articulated by Joseph Campbell, and it is described in Chapters 1 and 5.

Dr. Raybourn's simulations are often designed with built-in tools so that the instructor can modify elements during gameplay—increasing or decreasing the stress level, for example, or inserting twists in the scenario, or even building scenarios of their own. These simulations also contain in-game and after-game

Figure 11.2 Dr. Elaine M. Raybourn, on the left, stands in front of an image of a multiplayer game set in Afghanistan that she developed for the U.S. Army Special Forces. The vehicle in the center is a iinale truck. and it is blocking the road to the village in the background. Image courtesy of Randy Montoya and Sandia National Laboratories.

assessment tools. The patent-pending in-game assessment approach exercises a player's analysis and thinking skills. After-game assessment tools are called After Action Review (AAR). Players can analyze actions and share their observations while the game is in progress, and the instructor can bookmark segments of the game and play them back later in the session, even from different angles, so players can analyze them and discuss alternate strategies. Dr. Raybourn emphasizes that AAR is an extremely important part of the learning experience.

SERIOUS GAMES RESOURCES

The following websites provide a great deal of information on serious games topics and relevant conferences:

- Serious Games Source: http://seriousgamessource.com/index.php
- Water Cooler Games: http://www.watercoolergames.org/
- · Games for Health: http://www.gamesforhealth.org/index3.html
- Games for Change: http://www.gamesforchange.org/

COMBINING DIGITAL STORYTELLING AND TRAINING

Training is an activity that is essential to business. Sooner or later, almost everyone who holds a job will be asked to participate in a training session, whether the employee is a new hire whose job it is to stock shelves or a seasoned manager who oversees a large staff. Training sessions can cover anything from a basic company orientation to leadership skills and from customer service to complex legal or scientific topics. At one time, such sessions were usually led by a facilitator and conducted much like a school or college class. Increasingly, however, training is done via computer technology, including the Internet, CD-ROMs, DVDs, and various blends of media.

The use of digital media to train employees has all the advantages as interactive software designed for education, including the facilitation of active learning. The chief difference between them is that interactive training courses focus on practical or interpersonal skills, while educational software focuses on academic learning. But as with educational software, the learners find training software more stimulating and engaging than traditional classroom experiences and appreciate the opportunity to learn at their own pace.

In addition, digital training has another advantage that appeals to businesses: It is cost effective. Employees can do the coursework while sitting at their workstations or from home, eliminating the need to travel to a training seminar.

Given the fact that corporate training is usually a mandatory part of one's employment, and that these courses focus on the skills that employees must master in order to succeed at their jobs, it is reasonable to wonder if it is necessary, or even possible, to make such courses entertaining. Nevertheless, the companies that create training software, as well as the companies that purchase it, recognize the value of making training engaging, and they understand that entertainment elements can help hold the users' attention. And they are also mindful of the fact that interactive training is competing to some extent with other forms of interactive programming, particularly games. This is especially true when the training material is directed at younger learners.

For example, Dr. Robert Steinmetz, who heads the software firm Training Systems Design, noted that he was very aware of the developments in interactive gaming and of the expectations of the younger generations for interactivity and for visual richness. Dr. Steinmetz, who holds a Ph.D. in Instructional Technology and Educational Psychology and has had over 20 years' experience in training, has a good grasp of what these courses need to be like in order to make them effective with the designated learners. He said it was necessary not only to take the expectations of the younger learners into consideration but also to consider the older learner, the person who says "just give it to me in spoon-sized bites. Don't overwhelm me."

Although story scenarios can be effective teaching tools, training specialists recommend that they be set in a realistic workplace environment in order to make them meaningful to the user. The more similar a story scenario is to real life, the easier it is for learners to transfer the training to their jobs.

Games, like story scenarios, can be very attractive to learners and can be valuable teaching tools. Care must be taken, however, to make sure they reinforce the training message and don't divert attention away from it. Like story scenarios, they should be as closely related to the users' jobs as possible. Games, simulations, and story-based scenarios can all be part of the courses' mix, offering users a variety of ways to learn.

A Sample Interactive Training Course

At Training Systems Design, the company employs an open architecture that can accommodate many types of learners. Typically in their courses, the subject matter is divided into modules, and each module is given an engaging and appropriate theme. A single interactive course may contain a great variety of interactive approaches, including gamelike activities, simulations, and modules that offer a user-directed path through informational material.

For example, the company's course of office safety, *Code Alert*, makes good use of simulations as a training technique. One especially tense simulation features a disgruntled employee who is armed and potentially dangerous. You, the user, have to calm him down and get him to leave the office without the encounter erupting into violence. Another simulation has you dealing with a suspicious package that has just been delivered to your office and that could contain an explosive device. If you don't handle the situation correctly, the device will go off. Without question, such gripping simulations give users the sense that a great deal rides on whether they make the right decisions. Immersive dramas like these are likely to keep them highly involved in the training program.

Using a different approach, the module called *Save Your Co-Worker* is a game in which the user must navigate around the office and spot things that could be unsafe. (See Figure 11.3.) Potential "hot spots" include a man with a necktie bending over a shredder; a man perched high on a ladder; and a top-heavy file cabinet. If you leave the office without spotting all the potential hazards, the consequences

Figure 11.3 A screen capture from the Save Your Co-Worker game of Code Alert. The objective is to spot potential hazards, like this man on the ladder, and to prevent accidents from happening. Image courtesy of Training Systems Design.

can be disastrous to your fellow workers. For instance, if you have failed to note the man on the ladder, he will topple over backwards. For those learners who respond better to more traditional learning, a mentor can be accessed from the upper right corner of the screen and is available to give a tutorial on the subject.

Still another module is called *Dumb People Tricks* and documents foolish accidents people have had on the job, while another, *How Safe Are You?* is a Cosmostyle quiz about the user's own office safety practices. Thus, *Code Alert* offers a diverse array of activities, some gamelike, some with touches of humor, some highly dramatic. "We took a topic which most people would say 'ho hum' to," Dr. Steinmetz said of *Code Alert*, "and tried to make it engaging and attention sustaining." As *Code Alert* illustrates, storytelling and entertainment techniques can play an important role in enhancing the effectiveness of interactive training.

THE VARIETY OF DIGITAL MEDIA USED TO TEACH AND TRAIN

While CD-ROMs and DVDs were once the most popular platforms for interactive teaching, many educational and training courses are now taught entirely online. Online education and training is often referred to as *e-learning* or *distance learning*. College courses, university extension courses, and adult education courses are all offered as e-learning opportunities, as is a great deal of corporate training. E-learning has two great advantages over classroom learning: location and time. It solves the problem of learners being widely separated from each other (the location factor), and also takes care of the issue of scheduling, since students can usually log on to a class whenever it is convenient for them (the time factor).

Thanks to broadband, online courses can now contain all the bells and whistles once only found on CD-ROMs and DVDs, and as a result, they contain many features of digital storytelling. These features include the use of avatars, plots, gaming elements (one large overarching game or one or more small games), simulations, videos, and animation. However, as with all software designed to teach or train, the entertainment components must be used judiciously so that they do not distract from the academic or pragmatic material that is to be mastered.

One new digital venue for learning that is rapidly increasing in popularity is the online virtual world. By mid-2007, at least 125 academic institutions were conducting classes in *Second Life* alone. They include such top-notch American universities as Harvard, Stanford, and Columbia. Universities and colleges in the United Kingdom, Australia, New Zealand, Austria, Singapore, and Germany are conducting classes in *Second Life*, as well.

Instructors who have taught courses in this virtual world have had positive things to say about the experience, reporting that unlike other forms of online education, virtual worlds promote a real sense of community among the students and instructors, and people are far more likely to interact with each other. The virtual world environment is conducive to the building of collaborative projects and thus promotes active learning and peer-to-peer education.

And, unlike on-the-ground classes, shy students are more willing to participate (perhaps because they can act through their avatars, or because they can type in their comments), while students who tend to be domineering lose the ability to control the classroom. On the downside, however, some people new to virtual worlds complain of the steep learning curve, and others have mentioned strange distractions, such as people teleporting overhead.

VIRTUAL WORLD TEACHING PROJECTS

As an example of a virtual world educational project, a physics professor at the University of Denver is preparing to build a nuclear reactor in *Second Life* to explore issues relating to nuclear waste, which, of course, will be far safer than experimenting with nuclear waste in the real world. And while *Second Life* is geared for adults, younger students can also participate in learning experiences in virtual worlds. For instance, at *Whyville*, a site for 8 to 15 year olds, sixth-graders recently took part in an experiment involving the spread of disease, learning about epidemics, infection, and contagion. During the experiment, their avatars broke out in red spots and started sneezing involuntarily.

Virtual worlds are, as we have noted, closely related to Massively Multiplayer Online Role-Playing Games (MMORPGs), and this type of game is just now beginning to be used as a venue for education. A project I am currently working on is, to my knowledge, the first serious game to be developed as a MMORPG. Since the game is still under wraps, I can't disclose any details about the content, though I can discuss some generalities about using a MMORPG as a teaching vehicle for a demanding real-world career.

Commercial MMORPGs developed for pure entertainment are typically set in fantasy landscapes and often have a "sword and sorcery" theme. But to be useful for students who are preparing for a modern career, as our users are, it makes more sense to set the game in a realistic contemporary world and have players face the kinds of challenges they might actually encounter in their professional lives. Like other MMORPGs, though, the students will create avatars and be able to explore an enormous and well-populated virtual world. Thus, this game will be far more like a MMORPG than the types of role-playing games that are developed for military use. It will also be quite different from the way virtual worlds like *Second Life* are being used in education.

The Internet, CD-ROMs, and DVDs are not the only digital options for teaching. As we've already mentioned, military organizations use virtual reality and other types of immersive environments to prepare officers and troops for active duty. And, to a limited degree, iTV is also being used as an educational platform.

It should be stressed that digital instruction does not necessarily replace live teachers. Often these programs are played in a classroom setting, and the teacher uses them to stimulate discussion and reinforce important points. And sometimes students log into an online course in a classroom with a live instructor acting as facilitator, a combination sometimes called a *webinar*.

208

STORYTELLING WITH TEACHING AND TRAINING Obviously, big differences exist between making an edutainment ga

GUIDELINES FOR PROJECTS THAT BLEND

Obviously, big differences exist between making an edutainment game for young students, making a training simulation for the workplace, and making an interactive educational title for advanced students. However, as we have seen, digital storytelling techniques can successfully be applied to a wide spectrum of projects designed to teach or train. All such projects begin with the same basic considerations and questions. Here are some of the things that need to be thought out at an early stage:

- What is the need for this particular project? What is the ultimate goal of the organization that is sponsoring it?
- What are the specific teaching or training objectives of this project?
- Who is the intended audience, and how comfortable is this group with interactive media?
- What digital platform is this project best suited for?
- Will you be using subject matter experts? If so, what kinds of expertise do you want them to furnish?
- What interactive educational techniques will you use to make this an effective teaching tool?
- What will make the content engaging? What digital storytelling approach might work well to teach this particular subject?
- How will you integrate the educational content with the entertainment content?

The answers to these questions, along with the 10-Step Development Process offered in Chapter 10, will help you shape almost any project that blends digital storytelling with teaching and training.

CONCLUSION

Projects with workhorse missions like teaching and training might at first seem to be unlikely venues for entertainment. Yet, as we have seen in this chapter, such projects can successfully be blended with traditional techniques of story-telling and contemporary techniques of gaming.

Unfortunately, because these types of projects are not works of "pure" entertainment, they may be perceived as lacking the glamour of areas like video games. Nonetheless, we have seen many examples here of titles that are extraordinarily creative and cutting edge, just as much so as projects that have no other mission but to entertain.

Furthermore, endeavors like these perform a genuine service in the world. In addition, they offer a great many employment opportunities. As the use of interactive media continues to spread, it is highly likely that the use of digital media for teaching and training will expand as well. If this prediction is correct, we can expect to see a steady demand for people with the creative ability to stir sugar and medicine together and turn it into a palatable, tasty brew.

IDEA-GENERATING EXERCISES

- **1.** Select a topic that is taught in elementary school and sketch out a general concept for an edutainment game that would teach this subject.
- **2.** Select a subject for older learners that could be taught as a serious game. This game could be for training purposes, for an advanced educational topic, or to educate people about a health, social, or public policy issue. What is the "spoonful of sugar" in this game?
- **3.** Devise an overarching goal for the player in each of these games.
- **4.** Devise a rewards system that would be appropriate for each of these games. How would the rewards for the younger learners differ from those developed for the older group?
- **5.** What types of teaching techniques would you use for each of these games? Why do you feel one approach is better suited for schoolchildren and the other for adults?

Note: If these exercises are being done in a group setting, divide the group in half. One half should work on the game for the schoolchildren and the other half on the game for adults. Once all the exercises have been completed, the two groups can compare and discuss their approaches.

Using Digital Storytelling for Promotion, Advertising, and Other Business Purposes

How can digital storytelling techniques be applied to serious business endeavors like promotion and advertising?

In terms of digital storytelling and promotion, what could the U.S. Army and a hamburger chain possibly have in common?

Why are alternate reality games catching on as promotional vehicles?

In addition to promotion and advertising, how else can interactive media be used for business purposes?

OLD ENDEAVORS/NEW TECHNIQUES

On the face of it, it may be difficult to see any similarities between a music video featuring a group of preppy rappers, an alternative reality game about mysterious crop circles, a gritty video game about military combat, and a reality show where all the contestants are housecats. Yet all four of these projects do have key characteristics in common: they use interactive media and storytelling for advertising and promotional purposes.

The need to advertise and promote probably goes all the way back to the time when humans were still living in caves. Perhaps the first manifestation of this type of activity began when an enterprising caveman set up shop under a tree and tried to trade his surplus chunks of wooly mammoth meat for some sharp pieces of flint. But when he attracted more flies than customers, he realized he would never do any business unless he could make his fellow cavemen aware that he had mammoth meat to trade, and excellent meat at that. Thus the first attempt to promote and advertise might have been born.

While no one can say for sure if such a scenario ever took place, we can be quite confident that the need to promote and advertise has existed as long as people have had products, services, or ideas that they wanted other people to purchase or willingly accept.

The methods have changed with the technology, of course. Our enterprising caveman would only have had his own voice and his gestures to make people aware of his excellent wooly mammoth meat. In time, however, merchants would be able to tout their wares on strips of papyrus, and then in printed newspapers and magazines, and ultimately, in radio and television commercials. Today we have still another technology at our disposal, and an incredibly powerful one: interactive digital media.

Unlike earlier forms of promotion and advertising, which used passive forms of media, interactive digital media encourages an active involvement with the message. Because this form of promotion and advertising can be so entertaining, people willingly become involved with it. Furthermore, they enjoy it so much that they even tell their friends about it—a phenomenon known as viral marketing, which is the voluntary spread of information by means of digital media. And, unlike earlier forms of advertising and promotion, the exposure to the message is not a fleeting experience. In some cases, the involvement can last for days or weeks, and it can even lead to a life-long connection to the product or idea. Think how different this is from fast-forwarding through a commercial or barely skimming the ads in a magazine or newspaper!

With interactive digital media, we have an enormous variety of techniques we can use to promote and advertise. The ones we will focus on in this chapter are not "hard sell" forms of advertising like the online pop-up and banner ads that most people find intrusive and annoying. Instead, they use various aspects of digital storytelling such as plot, characters, suspense, conflict, competition, humor, and the striving to obtain a highly desirable goal.

As we will see, many of these projects are remarkably ingenious. The techniques we will be examining can be used to promote products (automobiles, shoes, candy, cat food); entertainment properties (movies, TV shows, video games, theme parks); ideas and causes (health issues, international crises, social issues); and organizations or groups (political parties, religious faiths, professions).

THE DIFFERENCE BETWEEN PROMOTION AND ADVERTISING

With promotion and advertising, we are, of course, talking about two somewhat different endeavors. Although both have the goal of attracting people to certain goods, services, organizations, or ideas, they are somewhat unalike in terms of their end goals. Promotional activities are designed to attract favorable attention to a product, organization, or idea, while advertising goes one step further and tries to encourage a purchase or a commitment. The line between promotion and advertising can get quite blurry in digital media, although most projects that use a digital storytelling approach fall along the promotional end of the spectrum.

One of the most desired outcomes of both advertising and promotion is something called branding, a concept briefly introduced in Chapter 8. Branding is a way of establishing a distinctive identity for a product or service, an image that makes it stand out from the crowd. By successful branding, the product is differentiated from its competitors and is made to seem alluring in a unique way.

DIGITAL MEDIA VENUES FOR PROMOTION AND ADVERTISING

As we saw in Chapter 11, many different forms of digital media can be used to teach and train. The same is true of promotion and advertising, which can also employ many different types of digital media to accomplish their goals. Before discussing the specific techniques of narrative-based promotion and advertising, let's first take a look at the major digital venues and see how they are being used. They include the following:

- The Internet: The Internet is undoubtedly the most heavily used digital medium for promotion and advertising. Among the many online narrative-based genres used for these purposes are real and faux websites, fictional blogs, webisodes, virtual worlds, MMOGs, and short, fast-paced games known as *advergames*.
- Mobile devices: Mobile devices are fast becoming an important venue for advergaming, and they are often used as part of an overall transmedia promotional campaign. In addition, mobisodes (episodic dramas for mobile devices) are used to promote entertainment properties and may also be used to promote consumer products like automobiles.

- iTV: Although iTV is not yet flourishing in most parts of the world, some companies do use interactive commercials for advertising. Some are also sponsoring entire entertainment programs, incorporating promotional messages into the content itself.
- Video games: Video games are being used to promote and advertise both
 on the macro and micro levels. On the macro level, entire games are
 devoted to a single promotional goal. On the micro level, various products or companies are promoted through *product placement*—the integration of products into a game or other form of screen-based entertainment.
- *Virtual reality*: Full-scale VR installations are sometimes used for promotional purposes, and portable VR kits have been developed to advertise various products.
- Smart toys and theme park rides: Toys and rides are primarily used to reinforce consumers' awareness of branded entertainment properties.

APPLYING DIGITAL STORYTELLING TECHNIQUES TO PROMOTION AND ADVERTISING

In the short time that digital media has been used to promote and advertise, content creators have developed an extremely varied palette of techniques to engage their target audiences and get their messages out to the public. Let's take a look at some of the most widely used of these techniques.

Advergaming

Advergaming, introduced briefly earlier, is, as the name suggests, a combination of gaming and advertising. Advergaming, also known as *promotional gaming*, began on the Web, but now these games are also appearing on wireless devices, where they work equally well.

Advergames are meant to be short pieces of entertainment, lasting just a few minutes. However, they are also designed to be highly addictive and fun. Usually they start off as very easy to play but quickly become more difficult. Thus, people become hooked on them and play again and again, trying to do better with each go-round. Furthermore, they are not demanding in terms of the technology or skill level needed to play them, so they are as enjoyable for inexperienced players as they are for people who play games regularly.

Advergames are popular with advertisers because they

- are so engaging that consumers will willingly play them;
- increase brand awareness;
- can be spread to an ever-expanding group of players through viral marketing;
- are an effective way to highlight a brand's special features.

Often these games contain a little backstory to set up the gameplay and put it in context, though the backstory needs to be established quickly because users want to get into a game as soon as possible. Advergames often contain an indirect message reinforcing positive aspects of the product.

For example, *The Race to School Game* was developed around a particular type of athletic shoe, Reebok's Traxtar. It features a character named Sammy Smartshoe. In the backstory, we learn that Sammy has missed his school bus and has to get to school in time for an important math test. So Sammy decides to beat the bus to school. As the player, you help Sammy race against the bus, making him leap over a variety of obstacles and avoid hazards like slippery mud puddles. Sammy's jumps in the game have a springy, bouncy quality that sends him effortlessly over obstacles—a subtext indicating what the user can look forward to if he purchases this particular brand of shoe.

Advergames are most likely to catch on when they are a good fit with the tastes and sensibilities of the target audience, which is one of the reasons cited for a game called *King Kong Jump* becoming an international hit. This zany game promotes two different products: the movie *King Kong* and Pringles potato chips. Though tying potato chips and an adventure movie together in the same advergame might seem like a quite a stretch, the company that made it, Inbox Digital, based in the United Kingdom, recognized that both products were perceived as fun and both appealed to the same demographic.

The game is set in the jungle of Skull Island, where much of the movie takes place. You, as the player, are the would-be hero of the game, and you must save a helpless young woman from King Kong's jungle. For some reason, this is accomplished by dodging and jumping over cans of Pringles potato chips, which are rapidly rolling down a hill directly at you. If you fail to get out of the way in time, you get squished flat. But if you achieve enough points, the gorilla beats his chest and roars approvingly, and you move on to the next level.

Product Placement

As we noted in Chapter 2, product placement is the integration of products into a game or other form of screen-based entertainment. Product placement is becoming a highly popular form of promotion in video games, where you might find NPCs wearing ball caps embellished with clothing logos or skimming the waves on surfboards decorated with soft drink logos. Product placement in video games is becoming a major form of advertising, and it is expected to continue to grow because ad agencies realize it is one of the best ways to reach the favored demographic, males between the ages of 18–34. One might think that players would find product placement intrusive, but a focus group conducted by a New York ad agency showed that to the contrary, 70% of those in the group felt that seeing familiar products in a game "added realism."

Product placement is also finding its way into virtual worlds and MMOGs. For example, players of the *Sims Online* can set up McDonald's restaurants or

equip their offices with PCs from Intel. Furthermore, media companies like CBS, NBC, and Sony are establishing outposts in *Second Life*. AOL has created an entire island there, *AOL Pointe*, with many attractions geared to lure Second Lifers to pay a visit.

For the most part, product placement is a static form of advertising and is not directly related to digital storytelling. However, product placement is increasingly becoming a more active device and at times does contain elements of narrative, in the form of characters and little storylines.

For example, the famed science fiction novelist William Gibson, via his avatar, visited *Second Life* in 2007 to promote his new novel, *Spook Country*, and did a reading of his book there. During the holiday season of 2006, NBC held a tree lighting ceremony in *Second Life*. The ceremony took place at a virtual version of Rockefeller Center, which even had a virtual skating rink. Avatars of characters from the cast of an MTV show visited MTV's virtual world, *Virtual Hills*, and interacted with the avatars of fans, and avatars of famous movie stars and musicians are becoming increasingly common.

If this phenomenon of active product placement continues, we can expect content creators to become involved by creating little scenarios or even larger dramas to integrate the products into some kind of engaging narrative.

Branded Content

Branded content is programming that is funded by an advertiser and integrates promotional elements with the entertainment content. Unlike traditional advertising sponsorship, where the advertising is done through commercials, the entire program can be thought of as a "soft" commercial. To be effective, the promotional elements need to be woven into the narrative content, and the narrative content must be highly attractive to the audience.

Many examples of branded content can be found on the Internet and, to some degree, on mobile devices, as well. Advergaming is a form of branded content, and so are a number of amusing videos found on sites like YouTube. Sometimes entire websites are forms of branded content. For example, The Official Harry Potter Website, described in Chapter 8, invites users to explore and play in Harry Potter's world. It is highly entertaining and interactive, but its true goal is to promote the Harry Potter films.

The Way Beyond Trail, an online interactive adventure story promoting the 2007 Jeep Patriot, is another example of branded content, and it is a good illustration of how digital storytelling techniques can be applied to promotion. It follows the same model as the old *Choose Your Own Adventure* books mentioned in Chapter 1 where the user (the reader, in the old days) is asked to make a choice at crucial points in the story, and the choices affect the way the game will end. It thus uses the classic branching structure described in Chapter 7. But even though the structure is hardly innovative, the story is clever and fresh, and you as the user feel quite engaged.

The Way Beyond Trail, shot on video, is a tale about three hip young adults traveling around the backcountry—in what else but a shiny new Jeep Patriot. When you first log on to the story, you are asked to fill out a passport with your name and gender. Thus, you become the fourth member of the party and are even addressed by name at a few points. The camping trip soon turns into a search for buried treasure, and things soon become a little wacky—just how wacky depends on the choices you make. But you will almost certainly make several wrong turns before you find the treasure and encounter some bizarre individuals along the way, a little like characters from the classic TV series *Twin Peaks*.

The Way Beyond Trail works well as a branded content story because the user is actively involved and pulled into the adventure. Furthermore, the promotional material does not intrude in the story. Of course, as you and your new friends drive around the woods and search for the treasure, you get a good look at the Jeep's interior and exterior and get to see how well it maneuvers on rough terrain. Also, as with the athletic shoe advergame, it has a subtle subtext: By owning one of these Jeeps, the story implies, you, too, can go on cool adventures with cool friends and have a great time.

In quite a different application of branded content, Meow Mix cat food created a reality show in 2006 that followed all the conventions of the genre, except that the contestants in this case were all house cats. The show, *Meow Mix House*, was a transmedia entertainment, using television (broadcast on the Animal Planet network), the Internet, and a real-world venue, a custom built home for the cats in a storefront on New York's Madison Avenue. Visitors to the website could view the 10 competitors through webcams, read their bios, see recaps of the episodes, and vote for their favorite feline. Just as with a human reality show, the cats were given challenges, but these were more in line with their natural talents. They were judged on such things as purring, climbing, and catching toy mice. The website was an enormous success, receiving over 2 million unique visitors.

Social Marketing

Social marketing is a specialized form of promotion that is designed to change the way people behave—to motivate them to break harmful habits like smoking or overeating and to encourage them to take up positive behaviors, like wearing seat belts or exercising. Though digital platforms have only recently been used in social marketing campaigns, the concept itself has been around since the 1970s, when social marketing campaigns were mostly conducted through televised public service announcements.

Today's digital social marketing campaigns are far more sophisticated. They avoid lectures and scare tactics and instead are positive, upbeat, and involving. America on the Move, for example, is a healthy lifestyle campaign to get people to walk more. Individuals who register for the program are encouraged to go for daily walks and to gradually increase the number of steps they take, measuring their daily distance with a pedometer. As a motivator, the website contains a virtual trails system with such routes as Alaska's Iditarod Trail and China's Silk

Road. Participants pick a trail that interests them and try to complete it within a certain number of days. At the end of each day, they log in their steps, and the steps are converted into miles along the trail. Their progress is charted on an online map, and they can even enjoy some sightseeing as they "hike." To further motivate the participants, daily emails are sent out with tips and encouragement, and they receive a certificate suitable for framing when they complete their trail.

Public Advocacy Campaigns

Like social marketing, public advocacy campaigns are meant to sell ideas, not products. Such campaigns are intended to raise public consciousness about serious issues and to inspire people to take action. To date, one of the most successful ways of doing this with digital media has been to combine Flash animated cartoons with calls to action. Unlike objective informational pieces, social advocacy cartoons take a strong position on whatever issue they are tackling, though the stand they take may be supported by solid facts.

As an example of a public advocacy campaign, let's consider the case of a series of clever little Flash animated cartoons called *The Meatrix*. The cartoons are a parody of the popular film, *The Matrix*, and are a call to action against factory farming. The first *Meatrix* debuted online in 2003, with sequels *Meatrix II* and *Meatrix III*/2 coming out in succeeding years.

Produced by the design firm Free Range Graphics, *The Meatrix* tells the story of a naïve young pig, Leo, who is living contentedly on a bucolic family farm until he meets a cow named Moopheus, an underground resistance fighter. When Leo takes the red pill Moopheus offers him, he is introduced to a ghastly alternate reality and learns the shocking truth: Family farms are mostly a fantasy, having been stomped out by agribusiness and replaced by cruel, filthy, and diseconomic factory farms. (See Figure 12.1.) Leo joins Moopheus as a resistance fighter, and the sequels continue his adventures and include more shocking revelations of the meat industry.

Though *The Meatrix* has a troubling message, it has been so skillfully integrated into the story that the series feel more like entertainment than a sermon, even though the serious points shine through clearly. Those who are unsettled by its message are not left hanging. At the end of each cartoon comes a call to action, offering various measures people can take.

The Meatrix has been an unqualified success story for a public advocacy campaign. Free Range Graphics estimates that over 15 million people have seen the cartoons, which have mostly been spread by viral marketing, and the series has won basketfuls of awards. The Meatrix proves the value of having a smart script, a striking visual style, and the right balance between entertainment and message. It also demonstrates the enormous power of using popular iconography like The Matrix to help get an idea across. It puts the cartoons into a context that people can readily understand, avoiding the need for heavy explanations, and the witty references to the movie are almost certainly a major reason for its success.

Figure 12.1 A scene from The Meatrix, with Leo and Moopheus silhouetted in the foreground. Moopheus is explaining the reality behind the Meatrix. Image courtesy of Free Range Graphics and GRACE (Global Resource Action Center for the Environment).

A CROSS SECTION OF GENRES

A great number of genres have been used for digital promotion and advertising, and we can expect to see new ones emerging on a regular basis. Novelty is a powerful asset in this arena because it helps attract welcome attention to a campaign. Let's take a look at some of the genres and innovative techniques that have been used thus far.

Webisodes

Webisodes—serialized dramas broadcast in installments—are often used as promotional vehicles for TV series, as we saw in Chapter 9, where we discussed several examples. Mobisodes can be employed in this way, too. In addition, however, webisodes are being used to promote such products as automobiles and beauty products, and they can be viewed as a form of branded content.

In 2006, Dove, which makes beauty products for women, created a somewhat loony webisode, *Nightime Classics*, that highlighted its Calming Night line of products. In the series, Felicity Huffman, star of the TV series *Desperate Housewives*, dreams she is visiting the fictional homes of vintage TV shows, like *Leave It to Beaver* and *The Brady Bunch*, and she is interacting with the characters who live in each household. With veteran director Penny Marshall at the helm, new footage was shot and skillfully interwoven into excerpts from the classic TV shows, so it looks as if Huffman is actually conversing with the characters in the old series. The escapist dreams that Huffman enjoys tie in nicely with Dove's nighttime beauty products, and the campaign included a call to action: Women who viewed *Nighttime Classics* were invited to request free samples of the products.

In quite a different take on promotional webisodes, Ford created two live-action interlocking dramas to promote two brands of cars. Together they told the story of a novelist who was having trouble with one of her fictional characters—he was starting to intrude in her life in an all-too-real way. *Lovely by Surprise* (for the Lincoln Zephyr) was the novelist's personal story, and *The Neverything* (for the Mercury Milan) was about the novel she was writing, a tale of two eccentric brothers who live on a boat in the middle of an empty field. Highly sophisticated and handsomely produced, the webisodes took a very low-key approach to promotion, though each webisode thematically reflected the motto of the car it was promoting: discovery in the case of *The Neverything* and fulfilling one's dreams in the case of *Lovely by Surprise*.

Alternate Reality Games

Alternate Reality Games (ARGs) are often used to promote entertainment properties, and we noted one example in Chapter 9, *The Lost Experience*. But in addition, ARGs are being used to promote restaurant chains, automobiles, and other products. They are particularly effective as promotional vehicles because players become deeply invested in them and in the brand being promoted, often for weeks at a time. Furthermore, these games are especially enjoyed by people between the ages of 18 to 34, a prime demographic for advertisers.

For example, *Who is Benjamin Stove*, sponsored by General Motors, promoted the awareness of ethanol fuel and, in an extremely low-key way, the awareness of their Flex Ford line of vehicles. The mystery story involves an enigmatic

Figure 12.2
General Motors took
out this ad on the USA
Today website as a
way to step into the
Who is Benjamin Stove
ARG, without revealing
that it was actually the
sponsor of the game.
Image courtesy of
Dave Szulborski, GMD
Studios, and General
Motors' Live Green, Go
Yellow campaign.

character named Benjamin Stove as well as crop circles, sacred geometry, and mystical archeological sites. According to Dave Szulborski, the game's puzzle designer and a story consultant on the project, the game was unusual in that it kept the identity of the sponsor, General Motors, a secret until very near the end. General Motors actually stepped into the game as a character, addressing the fictional Benjamin Stove in an ad that appeared in the *USA Today* newspaper and website. (See Figure 12.2.) *Who is Benjamin Stove* will be discussed in more detail in Chapter 17, as will ARGs in general.

CREATING A PROMOTIONAL ARG

Dave Szulborski not only served on the creative team of *Who is Benjamin Stove* but on 11 other ARGs as well, and he is one of the world's most experienced people in the ARG universe. He offered this perspective on creating a promotional ARG:

In most cases, the very idea to create an ARG for promotional purposes is generated as part of the discussion of a larger marketing campaign, with the ARG representing just a portion of the overall budget and scope of the campaign, so their creative genesis usually is expressly to promote a product, brand, or idea in a way that complements the more traditional marketing they will be doing.

This doesn't mean, however, that the narratives of promotional ARGs necessarily need to be full of product references or even explicitly mention a company or brand to be successful. And that's really the trick of being successful as an ARG designer, isn't it? Finding ways to tell an engaging story that also accomplishes the goals of the sponsors.

Music Videos

In 2006, a music video called *Tea Partay* debuted on YouTube, and it may well have been the first music video on the Internet to be used for promotional purposes. The clever tongue-in-cheek video, sponsored by Smirnoff, featured a group of East Coast preppies rapping about a new Smirnoff beverage, Raw Tea. Spread quickly by viral marketing, it was viewed an estimated 3.5 million times on YouTube alone. This was a great coup for Smirnoff, since YouTube viewers are a prime demographic for their new beverage. A year later, in the wake of this success, Smirnoff released a follow-up video, *Green Tea Partay*, featuring a rival group of rappers on the West Coast singing about another Smirnoff beverage. The company has now created a whole website revolving around this alleged East Coast/West Coast rivalry, complete with a Prepsta Party Guide.

"Construction Kit" Commercials

"Construction kit" commercials are online promotions in which users are given all the tools they need to create a commercial for a specific product, competing for prizes and recognition. As we saw in Chapter 4, Chevy used this technique with its Chevy Tahoe, but the venture backfired badly when some users created venomous commercials about the SUV. Nevertheless, the concept itself is a promising one, encouraging interactivity and engagement, though for it to be effective for promotional uses, some restrictions would need to be built in.

Faux or Fictional Blogs

Faux or fictional blogs, like webisodes and mobisodes, are often used to promote TV series. We examined one such blog in Chapter 9, *Nigelblog.com*, and there is every reason to think that such blogs can be effectively used to promote other types of things, not just entertainment properties. However, it should be noted that blogs, like construction kit commercials, have the potential to backfire.

In 2006, NBC attempted to promote a new TV series, *Studio 60*, by a faux blog called *Defaker*, modeled closely on a popular real blog, *Defamer*, which covers entertainment gossip. *Defaker's* first entry was mostly an uninspired rehash of the first episode of *Studio 60*, and almost immediately the negative comments poured in, posted on the blog's own comments section, on other blogs, and even in mainstream news media. Scorn was heaped on *Defaker* for being a poorly written, clumsy, blatant plug for the show. *Defaker* soon became the poster child of a fictional blog gone wrong, making NBC something of a laughingstock. The blog was pulled in just a few days.

The *Defaker* fiasco is a vivid illustration of the importance of using a light hand and a fresh approach when employing digital media for promotion.

Video Games

As briefly noted earlier, entire video games are sometimes devoted to a single promotional objective. In Chapter 11, we discussed one example of this, *Left Behind*, a game that promotes a fundamentalist form of Christianity. *America's Army*, launched in 2002, is another such promotional game. It was made by the United States Army with the goal of recruiting young people to join the armed forces.

America's Army realistically but excitingly portrays army life and combat, taking players from boot camp training right through to dangerous combat missions. The weaponry and tactics are all authentic. The developers took great pains to be accurate, while focusing, of course, on the most thrilling and glamorous parts of military life; KP (Kitchen Patrol) and pushups are not featured in the game. To make sure they were getting everything right, the developers even rode in Blackhawk helicopters and jumped out of airplanes in parachutes.

America's Army cost an estimated \$5 million to make, but the military considered it a worthwhile investment because, without a national draft system, it was essential to get young men and women to voluntarily enlist in the armed services. In a leap of faith, they gambled that a game would be far more effective in attracting prospective recruits than the usual way of doing things, with some

old Army guy in a dreary recruitment office trying to sell young kids on life in the military.

The game exceeded all expectations, in part because of its content and in part because it was perfectly aimed at its target demographic, the young men and women who love to play video games. It has become one of the most successful video games ever. As of mid-2007, according to the game's developers, over 8.6 people had registered to play. The producers offer regular updates, and versions have been made for cell phone games and the latest game consoles.

Short Films

Short films for the Internet, both linear ones and interactive ones, are logical vehicles for promotional endeavors. Earlier in this chapter, we examined the interactive film, *The Way Beyond Trail*, launched in 2007. But the concept of using short online films as branded entertainment dates back to 2001, when BMW began promoting its sleek, high-end vehicles online via a series of sleek, high-end short films. Collectively called *The Hire*, the eight films were united by a recurring character, a mysterious driver-for-hire, who operates the car in all the little movies. Heavy hitters like Guy Ritchie, John Frankenheimer, and Ang Lee directed the films, and one even stars Madonna. No overt advertising was contained in any of them. *The Hire* has received many accolades and brought much favorable attention to BMW. The films have even been screened at Cannes, though they are no longer available online.

Promotional MMOGs and Virtual Worlds

To some extent, MMOGs are being used as promotional devices, though so far this technique has been limited to cross promoting other entertainment properties. For example, Disney's *Pirates of the Caribbean Online* (described in detail in Chapter 16) ties into the *Pirates of the Caribbean* movies and theme park ride, and *Toontown Online* (also described in Chapter 16) ties into the Toontown area in Disneyland and into popular Disney characters. *Disney's Virtual Magic Kingdom*, which is part MMOG and part social networking site, brings a virtual Disneyland to the Internet. Participants create avatars, chat with each other, and play minigames based on rides in the real-world theme park.

MTV, another entertainment giant, is also making use of virtual worlds, as noted in Chapter 8. As of this writing, MTV operates six virtual worlds, mostly based on their popular TV shows. It will be interesting to see if nonentertainment entities will also find a way to utilize this approach.

Webcam Peepshows

Webcam peepshows, where the user can type in commands that the person shown on the webcam video must follow, have to be among the most bizarre methods of promotion ever devised. Evidently, webcam peepshows are fairly common forms of pornography, but it takes a leap of imagination to consider this as a model for promotional purposes. Yet Burger King did just that with

PART 3 Harnessing Digital Storytelling for Pragmatic Goals

its edgy *Subservient Chicken* campaign in 2004 to promote chicken sandwiches. News of the website spread like wildfire through viral marketing and TV tie-ins.

The show featured a person dressed in a chicken costume and a garter belt who would obey approximately 400 typed in commands. Though made to look like a live feed, the videos were actually prerecorded responses triggered by key words. The peepshow cleverly reflected Burger King's slogan, "Get chicken your way." The chicken would even turn itself into a chicken sandwich, if requested, by tucking itself in between two cushions.

According to the ad agency that oversaw the website, Crispin Porter + Bogusky, *Subservient Chicken* received a million hits within hours of launching and over 15 million hits within a few months. With a success of this magnitude, it would be surprising if others did not imitate it.

ADDITIONAL RESOURCES

To keep up to date on the use of interactive digital media for promotion and advertising, visit iMedia Connection or subscribe to its daily newsletter: http://www.imediaconnection.com/index.asp. The publication offers news and features about all forms of interactive marketing; conducts insightful case studies; and does podcasts.

Also, Rachel Clarke, who works for the JWT ad agency, writes an interesting blog about digital marketing: http://www.b5media.com/rachel-clarke.

OTHER BUSINESS PURPOSES

As we have seen throughout this chapter, techniques of digital storytelling lend themselves extremely well to promotion and advertising. And, in Chapter 11, we explored how digital storytelling could be used in corporate training. But other than these endeavors, businesses are still struggling to find the best way to make use of the new opportunities presented by digital media other than their obvious technological and communications capabilities.

For many companies, virtual worlds like *Second Life* seem to be the most promising new territory to explore. As of this writing, at least 85 major brands have established outposts in *Second Life*. They have been dipping their toes in these virtual waters in various ways: setting up retail stores; offering customer support; testing designs for new products and buildings; collaborating on projects; and holding meetings, events, and international conferences. The results have been mixed because there is an inherent clash of cultures between the fantasy role-play typical of virtual worlds and the suit-and-tie mentality of the business world. But corporations are slowly beginning to discover that their ventures in virtual worlds fare best when done in the spirit of these environments.

For example, Nissan has retooled its *Altima Island* base several times, trying to find an approach that would appeal to Second Lifers. Its first attempt, a conventional virtual showroom, drew little interest, and after another unsuccessful design, it launched its third offering in 2007. This version is a fanciful automotive amusement park where avatars can ride hamster balls and test drive vehicles on a gravity-defying track. They can even design their own custom vehicles using open-source codes. As of this writing, the *Altima Island* redesign is still too new to be able to judge its success, but it seems far more in keeping with the *Second Life* ethos than Nissan's earlier attempts.

In a similar fashion, an executive with Sun Microsystems, Chris Melisinos, has also adapted to *Second Life* culture. He regularly visits the virtual world dressed in a sci-fi cowboy costume. In an article in *Information Week* (February 26, 2007), he noted he would not be well received if he dressed instead in a business suit. "If you try and paint on that corporate face," he noted, "you devalue your message and basically announce that you are just using the space for PR."

And do you remember William Gibson's book reading described earlier in the chapter? That also had an appropriate virtual world twist. An overflow crowd of avatars squeezed into the hall where the event was to take place and eagerly awaited Gibson's arrival. But Gibson's avatar did not make his entrance from a mundane side door. Instead, he descended from the ceiling in a large object shaped like a tanker container. The doors of the vessel opened, and Gibson's avatar stepped out to huge (typed) applause.

It remains to be seen how, in the long run, businesses will adapt to virtual worlds and other new digital genres. It is also too soon to know how, if at all, digital storytelling will fit into this picture. But as these examples illustrate, an element of playfulness and fantasy—close relatives of storytelling—can certainly help bridge the disparate cultures of business and digital media.

CONCLUSION

As we have seen in this chapter, digital storytelling techniques can be applied to advertising and promotion in a great many ways, and these works can be highly entertaining and engaging. However, we have also seen some instances where projects did not succeed as anticipated and, in fact, some badly backfired. We can learn a great deal both by the successes and failures that we have studied.

First of all, it is important for content creators to give thoughtful consideration to the message they want to send, the culture of the medium they are using, and how best to appeal to their target demographic. Care must be taken to seamlessly integrate the promotional content into the narrative content, without allowing the promotional message to intrude jarringly. Humor is always an asset and should be used to the maximum degree appropriate, since it is the rare individual who doesn't enjoy a good laugh now and then. As we have seen, material that is fresh, fun, edgy, and original has the best chance of reaching a wide audience.

Finally, it can be risky to give users too much control because they might be tempted to play havoc with it. This is far less likely to happen, however, when they enjoy and genuinely respect the material. This respect for the material must originate with the creators themselves. If they feel they are "slumming" and don't exert themselves creatively, this attitude will be perceived by the users. The truth is, creating a successful campaign in this arena requires pulling out all creative stops.

When digital storytelling techniques are used imaginatively, and when everything comes together in a well-planned campaign, it can result in a resounding success. Furthermore, the process of developing such a project is hardly drudgery. Instead, the work can be a creative joy.

IDEA-GENERATING EXERCISES

- **1.** Choose a product that you are familiar with and devise a concept for an advergame or other form of branded content that would highlight its strongest qualities. Try to find an indirect way to give an important message about this product, using subtext rather than a blatant hard sell approach.
- **2.** Select an organization or profession that you know well and that has a specific need. Sketch out a campaign using digital media and digital storytelling that could make the public aware of the organization and its need, as the U.S. Army did with *America's Army*.
- **3.** Think of a social problem that is currently a public concern and devise a social marketing campaign that could help address this problem.
- **4.** In terms of promotion, can you think of any products or types of organizations that definitely do not lend themselves to an approach that is entertaining? Why do you think entertainment elements would be inappropriate or unwelcome in such cases? If you are exploring this question as part of a group, see if anyone else in your group can think of a way to promote this product or organization that is both interactive and entertaining.

Using Digital Storytelling to Inform

How and why are traditional media outlets like newspapers, news magazines, and television networks turning to interactive media as an adjunct to their news services?

How are digital storytelling techniques being applied to informational content?

In what ways are such disparate forms of digital media like interactive television, virtual reality, electronic kiosks, and interactive cinema being used to disseminate informational content?

What are some of the criticisms that have been leveled at the way digital media has been used to disseminate information?

THE IMPACT OF DIGITAL MEDIA ON NEWS AND INFORMATION

The proliferation of digital media is rapidly transforming the way we receive news and information. Until recently, most people obtained their news and information from print publications or from radio and television broadcasts. Now, however, digital technology is giving us new options. We can stay informed via websites, blogs, podcasts, and news bulletins delivered by email and in text messages on our mobile devices. We can receive the latest news almost as soon as it happens—and sometimes as it is actually taking place. With digital media, we also have the ability to customize the information we receive. We can choose the categories of content that interest us; we can specify whether we want to receive news bulletins or full stories; and we can determine when and how often we want to receive this content.

In addition to the Internet and mobile devices, we can receive information from iTV, DVDs, and electronic kiosks. These information-providing digital platforms can be found almost everywhere, from public spaces like cultural institutions and airports to private spaces like our homes, our schools, and our places of employment. In many cases, we carry them around with us in our pockets or handbags.

Not only is digital content highly portable and customizable, but it also gives us the opportunity to participate in the content. Newspapers allow for extremely limited forms of participation—readers can write letters to the editor and that's about it. But interactive media allows us to contribute by sharing our stories and videos, voicing our opinions in forums and polls, and joining in live chats and other types of community experiences.

The radical shift in the way information is sent and received, as we noted in Chapter 2, is having a profound impact on traditional media and on how journalism is practiced. And, of particular interest to those of us involved in digital storytelling, these developments in the sphere of news and information are giving us the opportunity to use powerful new techniques of interactive narrative for informational purposes.

The Digital Revolution and Traditional News Media

The popularity of digital media is putting intense pressure on traditional news outlets. In Chapter 2, we described how competition from the Internet and other forms of digital media has caused newspaper circulation to plummet and audiences for televised news broadcasts to shrink. An article in the Santa Fe New Mexican (April 3, 2007) vividly described what traditional news sources are undergoing as being "under an unprecedented state of siege from the Internet." As audiences shrink, so do ad revenues, which puts traditional news outlets in an ever-tighter bind.

In business, the customary response to competition is to engage in an all-out battle with the rival, seeking to beat down and eliminate the usurper. But in

the case of the competition between traditional and digital news sources, many forwarding thinking newspapers and broadcasters are using a more adventurous strategy. They are embracing their rival, digital media, and integrating new types of interactive content into their operations.

For example, the Newspaper Association of America (NAA) has organized a special group, the Digital Media Federation, specifically to explore ways of harnessing digital media. The group has its own extremely vibrant website, The Digital Edge. For many newspapers, the embracing of digital media involves a shift of self-perception. As another article in the Santa Fe New Mexican put it (April 10, 2007), many papers no longer think of themselves as being in the "newspaper business" but simply as being in the "news business." In other words, their primary mission is to deliver the news. The medium of delivery is irrelevant.

Most traditional news organizations that commit to digital media focus on developing a robust website and employ a large website staff. The website of The Washington Post, for example, has a staff of 200-larger than some newspapers. A few news organizations are taking a more proactive stance, teaching their reporters to develop stories for multiple media, using video and audio as well as print. Others are making significant changes in how and where they offer the news. For example, The Wall Street Journal puts breaking news and financial data on its website, and it uses its print publication for in-depth articles.

The changes in the way news is being covered is even sifting down to journalism schools, and it is impacting on the way news writing is being taught. At my old graduate school, the Medill School of Journalism at Northwestern University, they are now training all students to use digital media to cover stories. Students learn to create blogs and websites; develop content for mobile devices; do podcasts; and write interactive narratives. They also learn to use an array of digital equipment. The professors have had to go back to school themselves to learn how to teach these new courses.

A few news organizations are doing more than just beefing up their websites. They are breaking new ground with digital media. For example, the news service Reuters has dispatched a reporter to cover the fast growing virtual world, Second Life. However, the reporter, Adam Pasick, does not just observe the world as a spectator. He has created his own avatar (whom he calls Adam Reuters) and regularly travels around inside Second Life to gather information for his stories.

The New York Times, as might be expected, is also taking some innovative approaches with digital media. For instance, it is now publishing video games as part of its page. These are serious games and, like an op-ed piece, they take a position on an important issue. The first such game, Food Import Folly, centers around the problems of imported food and the shortcomings of government food inspectors.

SETTING INFORMATION TO MUSIC

Not only is *The New York Times* beginning to produce games for its editorial page, but it has also started to produce musical videos for its website. Staff writer David Pogue, who covers technology, created the first such project for the paper. Pogue normally writes text-based stories, but when Apple introduced the iPhone in the summer of 2007, he couldn't resist doing something totally different. He went all out and created a humorous musical video about the new device, portraying how he was obsessed with the desire to possess one. Though the musical took a tongue-in-cheek, mock-serious tone, the production also contained a thoughtful rundown of the iPhone's assets and shortcomings. Pogue composed his own lyrics (to the tune of *I Did It My Way*) and even sang most of the music himself, though a few people waiting in line to buy iPhones were corralled into singing a few lines.

Not to be left in the dust, TV networks are also venturing out beyond the standard website approach in utilizing new media. For example, ABC/Disney developed a two-screen interactive TV show (using a website synchronized with the TV broadcast) for the 2007 Oscar awards. The production also included mobile devices, giving people the opportunity to download a backstage blog and highlights from the show. The material on the Web featured background stories about all the nominees, allowing viewers to get detailed information about anyone they were interested in. An interactive wrap-up of the show was produced for the website after the broadcast.

Using quite a different approach to digital media, CNN and YouTube joined forces in 2007 to produce a highly unusual debate featuring eight candidates for the 2008 U.S. presidential elections. The candidates, all Democrats, answered questions submitted in the form of YouTube videos. YouTube fans submitted nearly 3000 videos for consideration; 39 were selected for the debate. Most of the questioners in the videos were people asking about issues that personally concerned them. One humorous video, however, featured a snowman worriedly asking about global warming. The questions posed on the videos were unusually blunt for a presidential debate and sparked some lively discussions. The format was highly successful with viewers and drew far better numbers than the standard presidential debate. In fact, among adults aged 18–34, a prime demographic, it received the highest Nielsen ratings of any debate ever broadcasted on a cable news network.

In still another approach, the cable TV network MSNBC has created an extremely rich and deep community-based website revolving around the Hurricane Katrina disaster in 2005. Called *Rising from Ruin*, the site contains stories written by professional journalists as well as individuals from the affected region. It includes numerous heartbreaking and inspirational first person accounts of the aftermath of this monumentally destructive storm, told in text, still photos, audio, and video. New stories are added on a regular basis, keeping the site fresh and current.

APPLYING DIGITAL STORYTELLING TECHNIQUES TO NEWS AND INFORMATION

Digital storytelling techniques can make an otherwise dry or difficult subject come alive, and it can make the material extremely engaging to users. The combination of information and entertainment gives us another genre of "tainment" programming—infotainment—a blending of information and entertainment, much as edutainment is a blending of education and entertainment. However, the term "infotainment" has fallen into disfavor because to some people it connotes a trivialization of factual content. Thus, even though the infotainment approach is perfectly valid when handled responsibly, we will refrain from using the term in this book because it might be distracting.

OBJECTIVE VERSUS SUBJECTIVE

We have many techniques at our disposal for making information engaging. But first of all, a basic decision must be made. Will we be taking a subjective or objective approach to delivering the content? Traditional journalism is objective. It is told in the third person and the writer avoids voicing his or her personal opinion. The facts in the story are checked out and validated; usually the sources of the facts are cited. A subjective approach, on the other hand, is a more personal one, and the material is often written in the first person. The writer's opinion is clearly expressed, and facts may not be as carefully vetted or noted as with an objective approach. The subjective point of view is often used in blogs and personal websites. It is also fairly common in interactive documentaries and in audio and video podcasts and is even used in some informational games.

A fundamental goal in combining information, entertainment, and interactivity is to offer users an opportunity to relate to the material in an experiential manner, as opposed to one in which they are merely passive recipients of the information. The experiential approach to the presentation of information allows users to interact with it, participate with it, and manipulate it. As we will see, a variety of digital storytelling techniques can be used to create experiential forms of informational content.

Devising Interactive Narratives

One way to involve users is by creating highly involving and interactive personal narratives. This is the approach used in Rising from Ruin about Hurricane Katrina victims, described above. The same approach is being used in a website called the Hawai'i Nisei Story, an emotionally rich website featuring the stories of Hawaiians of Japanese descent and their often harrowing experiences during World War II. (Nisei is a Japanese term for second generation Japanese Americans.) The stories on this website are told in a mixture of video, audio, still photos, archival material, and text. Each person's story is quite detailed, but users have the ability to choose their own path through the narratives and go as deeply as they wish.

Sometimes a story contains a natural narrative thread that can be exploited through good design and interactivity. This is the case with *El Camino Real de Tierra Adentro*, a journey story about the old Spanish Colonial route from Mexico City to Santa Fe. The route is an historic landmark, and the 1500 mile-long road itself serves as the narrative thread here. *El Camino Real de Tierra Adentro* uses photographs, drawings, and audio to make the story of this road come to life. The project was produced by the U.S. Bureau of Land Management.

To create an effective narrative, the story or stories should be involving; multiple modes of communication should be employed; and users should have the ability to pick their own path through the material, as these works illustrate.

Community Building Elements

Users want to be able to personally participate in the story in some way. As we saw earlier in the description of *Rising from Ruin*, one method is to invite users to share their own personal stories. The website *Participate* uses a similar approach, inviting users to become investigative reporters and report on issues that concern them in their own communities. *Participate* grew out of the movie *Good Night, Good Luck*, a biography of the courageous television journalist, Edward R. Murrow.

Other community building techniques including inviting users to participate in polls; share their thoughts on forums, message boards, and listservs; and join in live chat sessions. Some community building techniques encourage the use of mobile devices: People can use them to vote, send in text messages, or even create videos to share with others.

Games and Gamelike Activities

Games are a highly effective way and popular way to involve users in informational material and to absorb it in an experiential manner. This technique was used by the game developed for *The New York Times* on food inspection, *Food Import Folly.* It was also used in two serious games described in Chapter 11, *Darfur is Dying* and *Food Force*.

The Internet abounds in informational games for all age groups and on a vast assortment of topics. Just to pick one example, let's focus for a moment on a website called *The MesoAmerican BallGame*. The site was produced in conjunction with a traveling museum show, and it does an excellent job of involving the user in games and gamelike activities. The focus of this website is the ancient basketball-like sport played in Mexico and Central America, a game that was also a serious religious ritual. As you may recall, this game was described in Chapter 1.

The MesoAmerican BallGame gives users a chance to "play" a version of the ball-game itself, though they score points by answering trivia questions about the game instead of tossing the ball through the hoop. In addition, the website contains a number of gamelike activities. For example, users can bounce some

of the traditional balls, and with each bounce, they learn an interesting fact about them. Another gamelike activity lets users dress one of the players in his game uniform. In addition to games and gamelike activities, visitors can "tour" a virtual ball court and learn more about how the game was played and also view MesoAmerican artifacts relating to the ball court. The website makes excellent use of animation, sound effects, music, and interactive time charts to make its subject matter vivid and understandable.

Using Humor

Humor is a traditional and effective way to make content engaging. We have seen how The New York Times used humor in its iPhone musical, a work clearly geared for an adult audience. But, as we discussed in Chapter 8, humor is also an excellent way to involve young people.

For instance, Yucky.com, a children's informational site about biology, is filled with outrageous humor. This site proudly bills itself as "the Yuckiest Site on the Internet" but, in reality, it offers legitimate scientific content. It is hosted by a slimy reporter named Wendell the Worm, who offers features on disgusting (but fascinating) subjects like poop, zits, sweat, and dandruff—all as enticements to learn more about how the human body works. The site offers audio to underscore various points. On the poop page, for example, visitors can click on a button and hear a toilet flush.

The site also gives a great deal of information about cockroaches. One of Wendell's fellow denizens on Yucky.com is a character named Ralph Roach, who keeps a diary reflecting the daily life of a cockroach. Visitors to the site can read Ralph's diary and take a virtual tour of roach anatomy. They can also play a fast-paced game of Whack-a-roach.

Offering Multiple Points of View

Because works of digital storytelling are nonlinear and interactive, they can be designed to give users the ability to explore information from more than one point of view. As we will see a little later in this chapter, this technique is sometimes used in interactive documentaries. It can also be employed in works of virtual reality, as was done in a work called Conversations, described in Chapter 22. By allowing users to see a work from more than one point of view, you give them the opportunity to examine the factual evidence in a number of ways and then come to their own conclusions. This is quite different from linear information content, which only provides one predetermined way of viewing the material.

AN ARRAY OF PLATFORMS

Throughout this chapter, we have mentioned many different platforms that are used to deliver informational content. Now let's look at them one by one and examine how each serves as a vehicle for information.

The Internet

When it comes to informational platforms, the Internet is certainly the grande dame of them all, having been used for this purpose far longer than another other digital medium. It now rivals traditional media as a delivery platform for information and news, and it is excellent at delivering densely factual material in an easily accessible manner. And, much in the manner of a grande dame, Web content can be beautifully dressed up in a great many ways. It can be enhanced by media elements like animation, video, sound effects, music and other types of audio, as well as by interactive elements like multiple narrative paths, diagrams with "hot spots," games, timelines, and activities of various kinds.

However, the Internet's content can also be "dressed down," harkening back to the Internet's modest roots as a text-based medium. Many informational websites are still primarily text-based, lacking most or all of the "glittery" elements we have described. In such cases (and even when there is plenty of "glitter"), the content needs to be organized in a way that is logical, easy to find, and "chunked" into small pieces, so users are not forced to read long stretches of text. Also, whenever possible, a narrative thread should be teased out of the source material so the content on the website tells an involving story. As experienced journalists know, engaging stories can be pulled out of virtually any source material and assembled in a compelling way.

WHAT IS TAXONOMY AND HOW DOES IT RELATE TO THE INTERNET?

In scientific circles, *taxonomy* is the discipline of classifying and organizing plants and animals. The underlying concept of taxonomy is extremely useful for organizing informational content on the Internet as well as other digital media. The word "taxonomy" comes from Greek and is composed of two parts: *taxis*, meaning order or arrangement, and *nomia*, meaning method or law. Though the organization of organisms in biology and the organization of text and graphics for a website might seem to be worlds apart, the basic approach is quite similar. In biology, taxonomy is a hierarchical system, starting with the largest category at the top, and then dividing the organisms into smaller and smaller categories, organized logically by commonalities. The same system works well on a website, and the underlying logic makes it easy for users to find the information they are looking for.

Mobile Devices

Mobile devices are increasingly being used as a portable tool to stay informed about breaking news, sports, weather, stocks, and entertainment. It is particularly useful for delivering short pieces of information. Owners of mobile devices can subscribe to any number of news services that will send the kinds of information they are interested in directly to their cell phones. Some of these news sources, like CNN and Reuters, were originally established for traditional media.

Others, like Google Mobile, have their roots in new media. Many mobile devices can play video and can connect directly to the Internet, thus widely expanding their utility. Also, it should be stressed that mobile devices are designed as two-way streets. Not only can owners of them receive information, but they can also capture and send out breaking news—in text, stills, and video.

Interactive TV (iTV)

By making television content interactive, viewers can be pulled into the presentation and become actively involved in the program. It offers viewers a much richer connection to the informational content than they would have with a linear TV show. We briefly examined one example of iTV programming, the 2007 Oscar award show. A number of techniques can be used to enhance linear TV programming. They include access to background information (in text, audio, or video); play-along trivia games; participating in polls; and being able to vote in a contest or issue presented on the show and witnessing the results of the vote.

Virtual Reality (VR)

Virtual reality installations are unique in the way they can give participants a chance to connect with information content in a deeply experiential manner. As we will see in Chapter 22, VR can be used to immerse people in a recreated news story and observe it from multiple points of view, as with *Conversations*, the true story of a prison breakout. VR has exciting potential as a platform for experiential treatments of information content, but thus far its potential has barely been explored.

Electronic Kiosks

Electronic kiosks are ideal for offering informational content in a public setting, since they are reasonably portable, sturdy, and easy to operate. However, content for kiosk delivery must necessarily be quite concise, since kiosks must serve large numbers of people. They are well suited as informational delivery systems in government buildings, trade shows, and as adjunctions to museum exhibitions. The housing for kiosks can be dressed up in imaginative ways, serving as an enticement for visitors to try them out. Nonfiction content for kiosks is more thoroughly explored in Chapter 24.

Large and Small Screen Works of Interactive Cinema (iCinema)

Large screen *iCinema* productions, works that are viewed by audiences in theatres, are primarily found in cultural institutions. They are particularly well suited to nonfiction content that is emotionally engaging and offers an interactive exploration of a particular theme, such as marine life, astronomy, or human biology.

The more intimate works of small screen iCinema, designed for individual use, are an ideal platform for interactive documentaries because they encourage in-depth examinations of a particular subject or event. Such interactive documentaries offer

PART 3 Harnessing Digital Storytelling for Pragmatic Goals

multiple points of view, allowing users to experience the story from various angles. Others, known as *database narratives*, give users the chance to select and assemble small pieces of factual material into a cohesive story.

Examples of nonfiction projects for both types of iCinema can be found in Chapter 21.

Museum Installations

With digital technology, museum installations have the power to make static displays of artifacts become highly involving and interactive. To do this, museums are making use of animatronic characters, holographic images, and powerful sound and motion effects, as well as immersive environment techniques used in high tech theme park rides. A number of examples of how museums are using digital technology can be found in Chapter 22, on immersive environments.

Transmedia Productions

The transmedia approach to content, explored in depth in Chapter 9, presents an integrated narrative over a number of different platforms, and it allows users to experience the content and interact with it in a number of ways. Transmedia productions are not constrained in terms of length or style by a singe medium, and they provide a deeper and more dimensional understanding of informational material than does content delivered over a single platform.

To get a better understanding of how a nonfiction transmedia project works, let's take a closer look at the biography of American President Woodrow Wilson, briefly described in Chapter 9. The project integrated a linear three-hour TV documentary with two interactive productions, a website and a DVD. Jackie Kain, VP of New Media for public station KCET in Los Angeles, was in charge of developing both the website and DVD.

As an initial step, Kain closely studied the core material. She noted that the documentary was "a rich story that was narrative driven" and therefore decided to capitalize as much as possible on its narrative qualities through the interactivity that would be offered. In addition, while the TV biography focused primarily on the international aspects of Wilson's career, she decided to use the website and DVD to portray other parts of his presidency—his domestic policies and personal life. Thus, the interactive elements of the transmedia production would serve to round out this portrait of a president.

The website would be more text based, while the DVD would contain more video, thus coming at the same subject matter in somewhat different but complementary ways. They would be tied by a similar graphic design as well.

The website included an interactive timeline; commentary by historians; and additional information about the people, issues, and events that were important in Wilson's life. One of the site's most engaging and imaginative features was an activity called "Win the Election of 1912." It challenged users to run their own

political campaign to see if they could do better than other contenders in that historic race. Players got to invent the name of their party and then decide their stance on certain critical issues of the time. Based on their selections, they either won or lost the election.

The DVD contained 80 minutes of video expressly produced for it, material not included in the TV show. This additional footage, broken into small "consumable" chunks, consisted of minidocumentaries and interviews with scholars. Kain described them as "short documentaries that tell you a story." (See Figure 13.1.) Thus, the DVD and the website enhanced the TV documentary, and they did so in a highly engaging manner.

Figure 13.1 An image from the DVD that was part of the Woodrow Wilson transmedia production. The project tied together a TV biography, a website, and a DVD. This image shows the chapter menu for the DVD. The features on the left, the "mini docs" and the interviews with scholars, were made just for the DVD version of the biography. Image courtesy of PBS. WGBH, and KCET.

SPECIAL CONSIDERATIONS FOR CREATING INFORMATIONAL PROJECTS

By their very nature, informational projects are based on facts, and factual material needs to be handled more carefully than material that is pure fiction, especially when incorporating the information into an interactive narrative. Care must be taken not to misconstrue or trivialize the facts or "dumb down" a complex issue. But on the other hand, you do want to create an engaging story that is not bogged down with an over-abundance of dry material. The answer

to the following questions can help you shape a nonfiction project that marries factual material with digital storytelling and does justice to both:

- Will you be taking a subjective or objective approach to the factual material? If your point of view is a personal one, how will you make this clear to users?
- What narrative thread can you pull out of the source material that will be
 engaging to users and also give a fair representation of the various sides of
 the story? If your narrative thread is unbalanced in some way, how can you
 provide users with the opportunity to explore other sides of the story?
- In dramatizing the nonfiction material, are you providing ways for users to get all the important facts of the story? Will you build in ways for people to access supplementary material that is not part of the main narrative path?
- What kinds of interactive enhancements can you build in that will contribute to an understanding of the material?
- How will you give users an opportunity to participate in the story, so that
 it is not just a one-way street? Can they contribute stories of their own, or
 comments, or additional facts? Can they participate in polls relating to
 the story or vote on some aspect of it?

CONCLUSION

As we have seen, digital storytelling techniques, if handled carefully, can successfully be applied to virtually any type of informational project. In this chapter alone, we have discussed a diverse array of works, including biographies of unknown private citizens (Japanese-Americans in Hawaii) and of a powerful U.S. president (Woodrow Wilson); stories about a natural disaster (Hurricane Katrina) and a natural pest (the cockroach); interactive narratives about an historic landmark (El Camino Real) and a modern-day crime (*Conversations*); and others about a contemporary entertainment ritual (the Oscars) and an ancient cultural ritual (the MesoAmerican ballgame).

The "infotainment" approach to informational content has sometimes been criticized for trivializing serious content. Unfortunately, this allegation is quite valid in cases where the subject matter is oversimplified, or when entertainment elements overshadow the informational content, or when important facts are omitted.

However, the judicious use of digital storytelling techniques can actually be a tremendous asset to informational projects. By making the informational content engaging, they can entice people to learn about a subject they would ordinarily regard as too dull or difficult to be of interest to them. With interactivity, users can connect with the material in an experiential manner and come to a far deeper understanding of it.

Applying digital storytelling techniques to an information subject can work surprisingly well even for complex issues. Through interactivity and multiple story paths, these works can offer users more than one way to view the subject.

230

A well-designed project can offer far more than a superficial presentation of a topic because users can view the material from different angles and dig deeply for additional information.

Some of the most multidimensional and multilayered works in the informational arena have been produced in the fields of VR and iCinema, and, unfortunately, they are largely unknown by the general public. Thus far, most members of the public have only had limited exposure to interactive informational narratives, and in the great majority of cases, they have encountered these works on the Internet. However, as other digital platforms like iTV and transmedia productions become more commonplace, we are likely to see exciting new developments in this area.

IDEA-GENERATING EXERCISES

- **1.** Take a current news story that you have read about in a newspaper or magazine or seen on a TV news show. Imagine that you have been tasked with the job of turning this story into an interactive narrative for a newsoriented website. Sketch out how you would make it both informative and engaging. How could you involve users in the story?
- **2.** Pick a subject from history and sketch out an idea on how you could develop it as an interactive narrative. What platform would you use? What digital storytelling techniques would you employ?
- **3.** Select a current events topic that is the subject of public concern, such as global warming or terrorism. Sketch out an idea for an informational game on this topic.
- **4.** Based on the discussion in this chapter of the website *Yuky.com*, "The Yuckiest Site on the Internet," what other kinds of informational topics aimed at young audiences do you think might be made enticing by utilizing such an approach? Do you think such an approach could work for adults, too, and if so, on what types of subjects? If not, why not?

PART 4 Media and Models: Under the Hood

Video Games

What is the debate over storytelling and games all about?

In what ways are games growing more cinematic?

What is it about video games that makes them so appealing to gamers?

What do games do well, and what are some of their limitations?

What can we learn from video games that we can apply to other forms of interactive entertainment?

THE GREAT DEBATE

Video games are the granddaddy of all forms of interactive digital entertainment. *Pong*, the world's first successful video game, debuted in 1972, almost two full decades before the World Wide Web was even born and long before other types of digital media were introduced. In the intervening years, video games have not only evolved enormously but have also had a profound influence on a great many other forms of interactive digital entertainment. In addition, as we saw in Chapters 11, 12, and 13, games are not just a significant form of entertainment, but they are also being used to teach, promote, and inform. Thus, it would be impossible to write a book about digital storytelling without a deep bow of acknowledgment to this pioneering form of entertainment. Unfortunately, however, to try to cover the vast field of video games in a single chapter and to do it justice is an impossible task. Thus, we will concentrate here on a handful of particularly important game-related topics and keep the focus as close as possible to discussions relating specifically to digital storytelling.

In doing so, the very first thing we need to address is the intense debate that games scholars are conducting about whether or not games can even be regarded as a form of storytelling. Two warring groups have squared off on this issue. On one side, we have the *narratology* camp. They say, ves, of course, games are a form of storytelling and they can be studied as narratives. (The term "narratology" simply means the theory and study of narrative). Janet Murray, the author of Hamlet on the Holodeck and a professor at the Georgia Institute of Technology, is a leading advocate of the narratology position. On the other side of the battlefield, we have the ludology camp. The term "ludology" comes from the Latin word ludus, for game. The ludologists argue that even though games have elements of narrative like characters and plot, this is incidental to the things that make them a distinct creative form, such as gameplay. Thus, they assert, games should be studied as unique constructs. This debate has an emotional undercurrent to it, because the ludologists suggest that the academics who espouse narratology are elitist and fail to recognize games as worthy of study on their own merits. Espen J. Aarseth, a professor at the University of Bergen, is the most vocal proponent of the ludologists camp.

Interestingly, Janet Murray herself, in a speech at the 2005 conference for the Digital Games Research Association (DiGra), threw up the white flag and asserted that both points of view were valid and nonexclusionary. It should also be noted that many games scholars take a middle position and advance a variety of ways to regard storytelling in games. Nevertheless, the great narratology–ludology debate refuses to go away. Clearly, if sides must be chosen, this book is most closely in allegiance with the narratologists.

CATEGORIES AND GENRES OF GAMES

Video games comprise an enormous universe made up of a diverse array of offerings. In order to get a clearer picture of this universe, it is useful to know the different ways video games are categorized.

Game Platforms

Even though members of the general public often lump together all types of games and refer to them generically as video games, gamers themselves and professionals in the field customarily divide them into several large categories, based on the type of platform (hardware and/or software system) they are designed to run on. The major types of platforms are

- video game consoles (devices that are specifically made to play games);
- personal computers;
- cell phones and other mobile devices;
- · arcade machines.

Each platform is best suited for a particular type of play experience, and the popularity of the various platforms has shifted over the years.

Arcade machines, designed for public spaces, used to be the only way games could be played. In the early days of the industry, they were found primarily in video game parlors teeming with adolescent boys. Today these once bustling parlors have largely vanished, though arcade machines can still be found in sports bars and in the lobbies of movie theatres.

Computer (PC) games and console games long had an informal rivalry, but currently, console games have a far greater share of the market, with PC games holding onto a shrinking piece of it. The latest consoles now have features that were once exclusive to PCs, such as excellent graphics and the ability to support online gameplay. Many gamers like the fact that they can sprawl on the living room couch and watch the action on the TV set or play on a portable device anywhere they happen to be, as opposed to sitting at a desk playing on a computer. Console games are particularly well suited for fast action. One of the newest consoles on the market, Nintendo's Wii, comes with a controller much like a TV remote and responds to arm and hand motions, making it an exciting new way to engage in virtual sword fights and sports games, a feature that is enticing both to hard-core gamers and newbies.

Despite the many attractions of game consoles, however, some kinds of games play better on a PC than on a console, such as strategy games. As for mobile devices like cell phones, they are becoming an increasingly popular platform for games and are particularly well suited for short and easy-to-play entertainments.

Game Genres

Films, novels, and other forms of linear narratives are often divided into categories, called genres, and the same is true of games. Works within a specific genre follow the same conventions, almost like a formula. These commonalities include having similar settings, characters, values, subject matter, action, style, and tone. It is extremely useful to be knowledgeable about these genres because it gives us a handy kind of shorthand to refer to different games and to understand their prominent characteristics. Furthermore, an understanding of video game genres is useful for anyone interested in interactive entertainment. By

Figure 14.1
A scene from Deus
Ex, Invisible War,
which falls into the
action genre. It tells
a complex story
involving global conflict
and intrigue. Image
courtesy of Eidos
Interactive.

studying the various genres, one gets a sense of the scope and variety of experiences possible within interactive media and begins to see how some of these elements can be ported over to other forms of interactive entertainment.

As important as it is to have an understanding of game genres, however, the process of assigning a particular game to a particular category can be fairly tricky. No two experts will agree to exactly the same definition of a genre, and no ruling body exists to regulate what game belongs where. To further complicate the situation, the dividing lines separating genres are sometimes blurry, with a particular game having characteristics of more than one genre. Nevertheless, here is a list of what most people would consider to be the most common genres of games:

- Action games: These games are fast-paced, full of physical action, and often call for a great deal of hand-eye coordination and strategy. Some, like the popular *Deus Ex* and its sequel, *Deus Ex*, *Invisible War*, contain a great amount of story. (See Figure 14.1.) The top-selling *Tomb Raider* series and the *Grand Theft Auto* series are action games, as is *Max Payne*. Action games are one of the most popular of all genres.
- Sports and driving games: These games focus on various types of team or individual sports or on car racing. The sports games are highly realistic and call for strategy as well as good control of the action. Gamers may play as an individual team member or may control an entire team. A number of major athletic organizations, such as the National Football League, license their names for sports games, as do star athletes, like

Tiger Woods. In driving games, players may either race against a clock or against other competitors, maneuvering around difficult courses and dodging hazards. Driving games include *Indy 500* and *Street Racer*. Sports and driving games are an extremely popular genre.

- Role-playing games (RPGs): In this genre of game, the player controls one or more avatars, which are defined by a set of attributes, such as species, occupation, skill, and special talents. RPGs include the Final Fantasy series and Neverwinter Nights. The genre evolved from the precomputer version of Dungeons and Dragons. Contemporary descendents are highly popular as MMORPGS (Massively Multiplayer Online Role-Playing Games) and include World of Warcraft and EverQuest.
- Strategy games: These games, as the name suggests, emphasize the use of strategy and logic rather than quick reflexes and hand-eye coordination. In these games, the players manage resources, military units, or communities. Examples include *Command and Conquer* and the *World in Conflict*. Some people would also put *The Sims* series here, while others put *The Sims* in the simulation genre.
- Adventure games: More than any other type of game, adventure games feature the strongest use of story. Typically, the player is sent on a quest or has a clear-cut mission and must solve a number of riddles or puzzles in order to succeed. Players also explore rich environments and collect items for their inventories as they move about. Typically, these games use a predefined protagonist, as opposed to one that the player creates or defines. These games have a very old history, dating back to text-based games such as the *Colossal Cave Adventure*, though they are now only a small part of the video game universe. Games in this genre include *Beyond Good and Evil* and *The Grim Fandango*. A subgenre of the adventure game is the mystery–adventure game, which includes the *Nancy Drew* series.
- Shooters: Shooters, as the name suggests, involve shooting at things—either at living creatures or at targets. In a shooter, the player is pitted against multiple opponents and can also be a target; in a first-person shooter (FPS), the player is given a first-person point of view of the action. Examples of shooter games include the wildly popular *Halo* series and *Half-Life* and its sequel.
- Puzzle games: Puzzle games are generally abstract and highly graphical and call for the solving of various types of puzzles. Some would also assert that the genre includes games that offer story-based environments that are generously studded with puzzles. Tetris is an example of the abstract type of puzzle game, while Myst and The 7th Guest would be examples of the story-based type of puzzle game.
- Fighting games: In these games, players confront opponents in an up close and personal way. The encounter may lead to death or at least to a clear-cut defeat for one of the opponents. The games typically emphasize hand-to-hand combat instead of guns or other modern weapons. The *Mortal Kombat* games are fighting games.
- **Simulations**: A simulation may offer the player a physical experience such as flying a plane or parachute jumping, or they may offer the opportunity

to create a simulated living community. Examples of the first type include the *Fighter Ace* series and *Naval Ops: Warship Gunner*. The community building type of simulation would include *The Sims* series, *SimAnt*, and *Sid Meier's Civilization*, although some would argue that these games belong to the strategy category.

• Platform games: These fast-paced games call for making your character jump, run, or climb through a challenging terrain, often while dodging falling objects or avoiding pitfalls. Such games require quick reflexes and manual dexterity. Classics of this genre include *Donkey Kong*, the *Super Mario Brothers*, and *Sonic the Hedgehog*.

As noted earlier, some genres are more popular on game consoles, while others are more popular on computers. To further underscore this, figures compiled in 2007 by the Entertainment Software Association (ESA) show that the five best-selling genres for game consoles were almost completely different than those for PCs. The favored genres for game consoles were action, sports, racing, shooters, and role-playing, while for PCs, the five top genres were strategy, role-playing, family, shooters, and a tie for children's and adventure games.

THE RISE OF CASUAL GAMES

In recent years, casual games have been one of the fastest growing sectors of the games market. Such games can be easily learned (though they are often challenging to master) and can be played in brief periods of time—they are little forms of recreation like coffee breaks or recess at school. They are also highly replayable; some would say addicting. They are played online and on game consoles, PCs, cell phones, and other portable devices. The development of the Wii has helped increase their popularity. Casual games have their roots in the oldest types of video games, such as *Pong* and other arcade games, and include a wide variety of genres, such as abstract puzzle games, shooters, and racing games. Advergames, covered in Chapter 12, are another from of casual game. New kinds of casual games are also being developed to help older individuals retain cognitive functions, serving as a form of exercise for the brain.

Casual games are popular around the world and are enjoyed by young children, senior citizens, and everyone in between. Women are a substantial part of the player base, even outnumbering men, according to many studies. Not only do people find them fun, but players who are not hard-core gamers enjoy them because, unlike traditional video games, they are easy to play and can be satisfying without demanding a large investment of time.

Game developers have a different set of reasons for liking casual games: They are far less expensive to develop than a full-length video game, which can have budgets reaching \$25 million, and the development cycle is also considerably shorter. Developing a traditional video game can be big gamble because, while some are big hits, many others are big losers. Casual games, however, with their lower budgets and speedier development cycles, are substantially less risky.

Because casual games are so popular with players, and also so advantageous to developers, we can expect to see this sector of the market continue to grow.

However, because casual games can only support a small amount of narrative, at best, they do not appear to be a promising arena for digital storytelling.

WHO PLAYS GAMES AND WHY?

While many people are under the impression that the majority of gamers are teenage boys, the truth is that the average age of gamers has been rising steadily, and by 2007 it was up to 33, according to a survey of the ESA. The same survey found that 71.8% of video game players were over the age of 18. It is still true, however, that women and girls continue to be significantly underrepresented. They comprise 38% of all gamers, as opposed to the 62% of gamers who are male. Males have also been playing longer than females, an average of 14 years as opposed to 11 years.

While it is important to know who is playing games, an even more interesting question, especially to those of us who are interested in creating compelling interactive entertainment, is *why* people play games—what is it about games that is so appealing to those who play them?

For one thing, as we noted earlier in the book, games are experienced as fun. They satisfy a desire we all have to play, and that desire doesn't go away even after we've left our childhoods far behind. Games offer us a socially acceptable form of play at any age and an enjoyable stimulus to the imagination. To maintain the sense of fun, a good game offers just the right amount of challenge—not too little, or it would be boring, and not too much, or it would be discouraging.

For another thing, they take you out of your ordinary life and give you a chance to do things you'd never be able to do in reality, and all without any actual risk to yourself. You are given plenty to do in these game worlds and can pretty much decide how you want to interact with it. In other words, you control the shots—often literally.

CLASSIC GAMER PERSONALITIES

William Fisher, the founder and president of Quicksilver Software, pointed out to me that not everyone plays games for the same reasons. Fisher, a seasoned games professional, who was in the business even before founding his company back in 1984, told me he has observed several kinds of "classic gamer personalities." People may play, he believes, for one of several reasons. It may be because they are

- · looking to escape;
- · want to blow off steam;
- · enjoy the intellectual challenge;
- · want to compete with other people.

"What hooks people initially is the visual and conceptual part of the game—what it looks like, and what it's about," he said. "What keeps them [hooked] is the progressive challenge of the game, the gradual increase in difficulty that keeps them scaling the mountain one step at a time." In other words, the challenges continue to escalate, keeping the player alert and involved.

Veteran game producer and designer Darlene Waddington, who worked on the classic game *Dragon's Lair*, offered up another reason people get hooked on games: the adrenaline rush. She believes players become caught up in the intense struggle to overcome a challenge, absorbed to the point of tunnel vision, and when they finally do succeed, they are rewarded with a gratifying sense of release. In other words, games can produce an emotion akin to catharsis.

ENHANCING THE PLEASURE OF PLAYING

A well-designed video game has certain characteristics that make it enjoyable to play and that facilitate the experience of playing. The characteristics relate directly or indirectly to the game's narrative. Let's take a look at three of these characteristics.

Gameplay

In the broadest of strokes, gameplay is two things: It is what make a game fun, and it is how a person plays the game—the way in which they control it and the way in which it responds. It is what gives a game its energy and makes it exciting. To understand gameplay, you must understand what a game is. Games involve the player in achieving an ultimate goal, but in order to do this, the player must first overcome a series of challenges. If successful, the game is won; if unsuccessful, it is lost. Games also provide a unique kind of instantaneous feedback to the players' input and choices. If this feedback/response mechanism is satisfying, intuitive, and smooth, then the players' experience of the gameplay will probably be a positive one. If the game's response is imbalanced, jerky, slow, or confusing, then the gameplay will probably be perceived negatively.

Gameplay consists of the specific challenges that are presented to the player and the actions the player can take in order to overcome them. Victory and loss conditions are also part of the gameplay, as are the rules of the game. Story enters into this dynamic because it is what puts gameplay in context. The game's overall goal is established through the story, as are the challenges the player encounters and the victory and loss conditions. Story provides motivation for the player to want to keep playing and makes the experience richer.

Game Structure

Structure is what connects the various parts of the game together. It gives the game shape and helps make the gameplay flow in a satisfying way. Furthermore, structure determines when and how the narrative elements of the game will be presented.

As we saw in Chapter 7, most video games are structured around a series of levels. Each level is like a chapter in a book, and like a chapter in a book, it needs to fulfill a meaningful role in the overall game. In fact, each level is like a miniature game, with its own goals and challenges.

CONSIDERATIONS IN CREATING LEVELS

For a level to offer satisfying gameplay, make sense in terms of the narrative, and serve the overall game in a satisfactory way, certain things must be determined:

- What is its overall function in the game (for example, to introduce a character, provide a new type of challenge, or introduce a plot point)?
- What is the setting of this level? (What does it look like; what features does it contain?)
- · What NPCs will the player encounter here?
- What are the major challenges the player will face here, and where will they take place?
- · What is the player's main objective in this level?
- · What narrative elements will be revealed in this level?

Interface and Navigation

Interface is what connects the player and the game. It enables the player to receive important information and to take actions within the game. Furthermore, it gives the player a way to evaluate how well he or she is doing. Good interfaces can help make a game fun, and poor interfaces can make it frustrating and disappointing.

There are three major forms of interface: manual (hardware such as controllers and keyboards); visual (icons, maps, meters); and auditory (verbal feedback, cues from the environment, music). Interface provides important information about geography, player status, inventory, and whether the player is succeeding or failing. Interface also gives the player the ability to do such things as run, jump, shoot, and use weapons or tools. In addition, a game must have navigational mechanisms so that the player has the ability to move his or her avatars, vehicles, or objects from one point to another in the virtual world.

Serving the Greater Good

Gameplay, structure, interface, and navigation all serve the same overall purpose: to help make a game satisfying to play and to help it make sense. Without any one of these fundamental elements, there simply would be no game.

THE WRITERS' PERSPECTIVE

The task of integrating the storyline and character development into the gameplay is a writer's job, or at least it is being increasingly perceived that way. At one time, however, programmers and game designers often filled this role. Even today, many writers are only asked to write dialogue, thus bypassing their abilities to make significant contributions to the projects they work on. Still, as games have become more sophisticated, developers are increasingly turning to professional writers to produce game scripts.

As we saw in Chapter 5, many of these writers are drawn from the ranks of Hollywood scriptwriters, as Anne Collins-Ludwick was, and some adjust quite

well, as she did. Others, however, struggle with the complexities of this new arena and quickly bow out. One veteran Hollywood writer who successfully made the transition is Randall Jahnson, who wrote the films *Mask of Zorro* and *The Doors* and then crossed over to games in 2005, when he wrote the Western themed adventure game, *Gun*, for Activision.

"The process of writing for the two mediums is like apples and oranges," Jahnson told *The Hollywood Reporter* (November 23, 2005). "Both games and movies strive to tell a narrative story and both mediums are slaves to technology, time, and budget, but after that, things are completely different." He compared writing for games to writing haiku because the plot points and dialogue had to be far more compressed than in a screenplay, where you don't have a player itching to jump into the gameplay. On the other hand, he found that games gave him the opportunity to explore subplots and tangents of the story that there would be no time to develop in a screenplay.

The other differences the writers cite most frequently are dealing with non-linearity and the far longer dialogue scripts (which can be 10 times longer than a screenplay). Marc Laidlaw, who wrote the well-received script for *Half-Life 2*, a sci-fi first-person shooter, noted to *The Hollywood Reporter* (January 20, 2006) that even when there isn't a great deal of narrative in a game, there has to be enough of a dramatic story to move the play along.

Laidlaw also pointed out that a writer's role on a video game involves a great deal of collaboration with others on the team to ensure that there is an internal logic to the game and that the player is given agency that makes sense in the context of the game. He explained: "I am continually getting input in order to create a big suspension field to hold the gameplay together so that the gamers aren't doing arbitrary tasks, so that they are doing things that seem meaningful."

A GAME EXECUTIVE'S VIEW OF WRITERS

Some game executives, like David Perry, president of Atari's Shiny Entertainment Studio, assert that good writing is extremely important in video games. As Perry told *The Hollywood Reporter* (January 20, 2006): "It saddens me a lot that many video game companies don't hire triple-A writers and that they use their game designers instead. That's why, when real writers look at video game stories, they kind of roll their eyes. But that's something that I see changing, I really do."

THE CINEMATIC QUALITY OF TODAY'S GAMES

In recent years, a great deal of press has been devoted to discussions of how games are becoming increasingly *cinematic*—in other words, like movies. These articles cite the fact that games are now utilizing high-quality visual effects, sophisticated sound effects, and original scores. They are also hiring top Hollywood stars to read the voice-over lines of the characters, and the dialogue

these actors are reading is becoming more polished and more extensive. Today's plots are, for the most part, far more compelling than the plots of earlier games and often sound quite movie-like. One often used example of a movie-like plot is the storyline of *Tomb Raider: Angel of Darkness*. In the game, Lara Croft is accused of the murder of her one-time mentor, Von Croy, and becomes a fugitive on the run. With the police in hot pursuit of her, she tries to find out who murdered Von Croy and why. (See Figure 14.2.)

Figure 14.2
Lara Croft becomes enmeshed in a dark, movie-like plot in Tomb Raider: The Angel of Darkness. Image courtesy of Eidos Interactive.

While it is true, however, that today's games look and sound more like movies, and they often have far stronger storylines than in the past, many people within the gaming community are uncomfortable with calling games "cinematic." They stress, as Randall Jahnson did, that the two forms of entertainment are "apples and oranges." They point to the fact that despite the rush to adapt games as movies and vice versa, many movie–game adaptations are unsuccessful, underscoring that these forms are not as similar as they appear to be on the surface. They are also troubled by the lavish use of cut scenes, a very cinematic-like aspect of games but one that can stop game-play cold.

In an article for *Wired* magazine (April 2006), game designer Jordan Mechner, who wrote and directed the original *Prince of Persia* game and has worked on many other games as well, noted that newer media often model themselves on older media until they develop as a unique art form. For example, he said, the first movies were filmed like stage plays, with the camera remaining in a static position. Mechner went on to say: "As we gamemakers discover new ways to take storytelling out of cut scenes and bring it into gameplay, we're taking the first steps toward a true video game storytelling language—just as our filmmaking forebearers did the first time they cut to a close-up. One day soon, calling a game 'cinematic' will be a backhanded compliment, like calling a movie 'stagy!"

WHAT CAN WE LEARN FROM GAMES?

Possibly more than any other form of entertainment, video games are powerfully effective at actively involving users in a fictional experience. Designer Greg Roach, introduced in Chapter 4, puts it this way: "Novels tell; movies show; games do." In other words, games are all about doing, about action—things that you, the player, do. Games are performance experiences. But this focus on action has a downside, as well. Game designer Darlene Waddington notes that "games tend to be all about the 'hows' and not about the 'whys.'" She feels, for instance, that they are good at getting the player into a combat situation but are less good at probing the psychological or human reasons for getting into combat in the first place.

Waddington's point about the focus being on action while giving scant attention to motivation is a criticism often leveled at games. While games are now offering more fully developed characters and storylines, they generally lack the depth of older forms of entertainment. With few exceptions, they do not look deeply into the human psyche or deal with a full spectrum of emotions. How often, for example, do we encounter or play characters who are motivated by shame, love, compassion, guilt, grief, or the dozens of other emotions we humans feel? Yet such emotions are the underpinnings of dramas we regularly see in the movies or on TV or the stories we read in novels.

Many game developers assert that the nature of nonlinearity makes it too difficult to portray complex emotions or subject matter in games, though others feel that the medium itself is not to blame and that it is indeed possible to build games with deeper psychological shadings or more complex subject matter. The problem, they assert, is that game publishers and their sales and marketing departments are simply uninterested in exploring new territory, preferring to stick with the tried and true. In truth, many of the limitations we place on games may be self-imposed, and we can be almost certain that we have not yet fully explored what games are capable of.

Nevertheless, video games have already proven to be a compelling form of entertainment, and many of the characteristics of games can be applied to other forms of digital storytelling. For example

- people regard games as play, as an escape from the pressures of everyday life, and overcoming the challenges in a game offers them an empowering sense of achievement;
- games are most effective when they give participants an opportunity to do things—to actively engage in an experience—and these tasks should be meaningful in the context of the game;
- to keep players involved, games use devices like a strong over-arching goal; a rewards system; challenges; and an escalation of suspense and tension;
- games need to make sense and have an internal logic; this cannot be sacrificed to gameplay;
- players are drawn to games for a variety of reasons, and it is important to understand one's target audience in order to create an experience that will please them.

These guidelines can be applied to virtually any type of interactive story experience just by removing the word "game" and substituting the appropriate interactive medium. Although some interactive entertainments will lean more heavily to the gaming end of the spectrum and others toward the narrative end, the basic principles will still apply.

ADDITIONAL RESOURCES

The Internet is full of excellent information about video games. Among them are the following:

- · Gamespot (www.Gamespot.com)
- The International Game Developers Association (www.igda.org) and Gamasutra (www.gamasutra.com), which the IGDA hosts
- Moby Games (http://www.mobygames.com/home)

For books on video games, refer to Additional Readings.

CONCLUSION

The field of video games, our oldest form of interactive entertainment, is enormously robust and successful, and it has a great deal to teach us about digital storytelling. Yet one has to wonder if games are reaching their full potential as an entertainment medium and what they might be like if market forces and the culture of the game industry did not discourage the development of new kinds of games.

At the 2003 E3 conference, Douglas Lowenstein, then president of the ESA, warned against the dangers of complacency and laziness. Emphasizing the value of innovation, he noted that "games with original content have done the best over the past three decades." He urged the games community to remember that "innovation is the way to push forward progress."

Certainly, games have made a light year's worth of progress since the first games were introduced back in the 1970s. One need only compare *Pong* to *Final Fantasy XII* or the *Grand Theft Auto* series to see how far they have come. What kinds of games might we be playing a few decades from now? And what role will games play in the overall universe of interactive entertainment and entertainment in general? If only we could consult one of the wizards who populate so many role-playing games and learn the answers to these questions!

IDEA-GENERATING EXERCISES

- **1.** To test your understanding of genre, take a game you are familiar with, name its genre, and then assign it an entirely different genre. What elements would need to be added or changed, and what could remain, to make the game fit the conventions of this new genre?
- **2.** Analyze your own experiences in playing games. What about them makes them appealing to you? What makes you feel involved with a game, and what makes you want to spend time playing it? What emotions do you experience as you play?
- **3.** Consider recent movies or TV shows that you have seen. What kinds of storylines, characters, or themes have they contained that you've never seen included in a game? Do you think it would be possible to include this kind of content in a game? How?
- **4.** What experience from real life have you never seen tackled in a game but believe could be? How do you think this idea could be implemented?

The Internet

What are the unique characteristics of the Internet, and how can you make the most of them when creating narratives for this medium?

What is meant by "stickiness" when referring to content on the Internet?

In terms of story-based entertainment on the Internet, what do users find particularly attractive, and what kinds of things risk being kisses of death?

How are Web-based technologies that were originally developed for nonfiction purposes now being used for digital storytelling?

THE EVOLUTION OF THE INTERNET

The Internet has been through some massive changes and several dramatic reversals of fortune since its origins in the late 1960s. It started out in relative obscurity, and with an entirely different name—ARPANET—and was developed to assist the military during the cold war. But in a little over two decades, it underwent a name change and morphed into the more populist communications tool known as the Internet. By the mid 1990s, this once plebian communications tool was beginning to be perceived as a viable medium for entertainment.

This was the time of the dot com boom, and there was frenzied launching of new websites, many of them built for entertainment purposes. Everyone was hoping to "strike gold in cyberspace." Unfortunately, within a few short years, just after the new millennium arrived, it became evident that the great majority of these brash new websites were not generating the profits that were anticipated. The plug was pulled on many a site, and we were suddenly looking at a dot com bust.

In recent years, however, the Internet has not only rebounded but has become an even more robust medium for entertainment than almost anyone during the boom years could have predicted. In large part, this resurgence has been due to the growing numbers of households with broadband connectivity, which makes it possible to enjoy video on the Internet, as well as other forms of entertainment that require high speed access.

The Internet is now home to a diverse array of narrative-based genres, a number of them unique to this medium. We have already discussed several of them in previous chapters, such as webisodes and faux blogs, as well as Alternate Reality Games (ARGs) and Massively Multiplayer Online Games (MMOGs), which we will be exploring in more detail in future chapters. The Internet is also an important component of many works of transmedia storytelling and interactive TV. Furthermore, as we have seen, it is often used as a platform for narrative-rich projects used to teach, promote, and inform. And finally, as we have also seen, there has been an explosion of user-generated material, virtual worlds, and social networking sites, many of which contain narrative content.

In addition to all these relatively well-established types of content, the Internet is also home to such new forms of digital storytelling that they don't even have generic names yet. We will be looking at several of them in this chapter.

THE QUEST FOR "STICKINESS"

The Internet has many attributes which, when taken individually, may mirror other media, but when bundled together, make it a unique venue for enjoying entertainment. When a website contains a great many of these attributes, it is also likely to possess a quality known as *stickiness*. Though stickiness is unwelcome when it comes to doorknobs or furniture, it is an extremely desirable attribute for a website. It connotes the ability to draw people to the site and entice them to linger for long periods of time. If you want to create an

entertainment site that is sticky, and hence appealing to users, you will want to include as many of these attributes as you can, providing, of course, that they make sense in terms of the project. Users are attracted to the Internet because it offers them experiences that are:

- Community building: One of the most unique aspects of the Web is that it allows individuals to communicate with each other and share their thoughts, concerns, and opinions. When they visit a website, particularly one that focuses on a fictional world they especially care about, they look for community-fostering options like message boards and chat features.
- Dynamic: Well-maintained websites are refreshed on a regular basis, and users look forward to seeing new features on sites that they visit frequently. The adding of fresh content gives the website a vibrant, responsive quality. Websites that are not updated begin to seem stagnant and "canned," as if they had just been stuck up on the Internet and then abandoned.
- Participatory: Users want to interact with content; they look for ways of
 becoming involved with it. Participation in story-based entertainment on
 the Web can take many forms. It can mean chatting with a fictional character; suggesting new twists in a plot; snooping around in a character's
 computer files; or, in the case of a MMOG, creating an avatar and becoming an active character in a fictional world.
- Deep: Users expect websites to offer them opportunities to dig down into the content. Even story-rich environments can offer a variety of ways to satisfy this expectation, from reading diaries "written" by the characters to viewing their "home movies" to visiting the online newspaper of their fictional hometown.
- Edgy: The Internet has something of the persona of a cheeky adolescent. Users enjoy irreverent humor, opinions that challenge conventional thinking, and content that they are unlikely to find in mainstream media like television and newspapers.
- Personal: The Web allows users to express themselves and be creative. Users enjoy customizing and personalizing content in various ways.
- Easy to navigate and well-organized: Users want to be able to quickly locate the content they are interested in and appreciate it when content is organized logically, or, as we discussed in Chapter 13, has a well-ordered *taxonomy*.
- "Snackable": Most users are looking for short entertainment breaks rather than extended ones, or, as *Wired* magazine puts it, *snack-o-tainment*. Content should be broken into consumable pieces that can be enjoyed within a few minutes of time.

TV AS A ROLE MODEL?

Because the Web supports audio and video, and because it is viewed on a monitor that looks much like a TV screen, inexperienced Web developers are sometimes lulled into the belief that creating stories for the Web is much like creating

stories for TV. While many important similarities do exist, so do significant differences, and ignoring those differences can seriously undermine a project.

This was one of the most important lessons learned by writers and producers who worked on the Internet's earliest version of a webisode, *The Spot*, which began its run in 1995. The storylines revolved around a group of young singles living in a California beach house. Because of its focus on highly emotionally-charged relationships, *The Spot* had much in common with television soap operas. However, unlike TV, each of their stories was told from a first-person point of view, largely through journals. And somewhat like the movie *Rashomon*, the characters often gave different versions of the same events.

Stewart St. John, a writer–producer with an extensive background in television, served as the executive producer and head writer of *The Spot* during its last year, from 1996 to 1997. But his work on *The Spot* quickly taught him to appreciate the differences between TV and the Internet.

A KISS OF DEATH

Visitors to online fictional worlds want to be able to participate in the story, something Stewart St. John learned the hard way. "In the beginning, I brought my conventional TV background to *The Spot*," St. John admitted to me. "I plotted it weeks and weeks in advance and expected the storyline to stay true to what I wrote, never straying. It was the kiss of death. The fans went berserk. They didn't feel emotionally connected. It was too much like television."

To allow for more user participation, St. John found ways to integrate input from the fans to shape the direction of the plot. Over time, he came to realize that it was particularly effective to build consequences—both positive and negative—into the choices the fans are offered in the narrative, believing this pulled them more deeply into the story. By loosening his control and becoming more flexible, he was able to provide an experience that was both narrative and interactive.

One way staff members on *The Spot* would involve fans in the story was to go into its chat room in character and chat with them. Some of these exchanges would be mentioned in the online journals "written" by fictitious characters, even weaving the users' names into the accounts. Not only did this give the fans a few minutes of glory but it also made the show seem all the more real. In fact, many fans of *The Spot* were under the impression that the characters were actual people, which put extra pressure on the writers to keep them consistent and believable.

"You can't think in terms of the way you'd create for television," St. John asserted. "The Internet is its own world, and the language of that world is interactivity. This is the biggest mistake I've seen over the past few years; creators creating Internet sites using a television format. It won't work."

SOME UNIQUE WEB GENRES

As noted earlier, a number of story-rich genres have been created specifically for the Internet, and it also supports certain forms of narrative that blend several different media elements together, such as ARGs and transmedia storytelling. One of the most successful genres of Web entertainment, the MMOG, will be addressed in the next chapter. Now, however, let's take a look at several other important Web-based narrative genres.

The Webisode

The webisode is a serialized story that is broken into short installments, each just a few minutes long, and each of which often ends in a cliffhanger. The genre evolved from *The Spot*, but while the storylines of *The Spot* were primarily conveyed by text and still images, today's webisodes use full motion video or animation. Most webisodes revolve around contemporary characters in modern settings and center on personal dramas. And, despite the lessons learned by Stewart St. John and others working on *The Spot*, many of today's webisodes are presented in a linear fashion, much like a TV show, with little or no opportunity for user participation.

Many of the new webisodes, as we discussed in Chapter 9, are spinoffs of popular TV shows. For example, *The Office: The Accountants* is the story of several regular characters from the hit TV show, *The Office*. However, a number of entirely original webisodes have debuted in recent years. One of the longest running webisodes is *Something to Be Desired*, which debuted in 2003, and as of this writing is in its fifth season. Shot in full motion video, it is the story of a group of young deejays who work at an FM radio station in Pittsburgh, Pennsylvania. Though done on a low budget with a local Pittsburgh crew and using local actors, it is well produced and has managed to attract enough fans to keep going.

Webisodics like *Something to Be Desired* and a handful of others illustrate that low budget webisodics can find a home on the Internet, but they are now facing competition from major Hollywood players. Professionals from TV and feature films are beginning to get into original webisodics in a big way. Three major entries with impressive Hollywood connections are *The Strand, Prom Queen*, and *Afterworld*.

The Strand, the "old-timer" of the group, debuted at the Sundance Film Festival in 2005. It is headed up Dan Myrick, one of the creators of *The Blair Witch Project. The Strand* is set in the funky beach community of Venice, California and follows the intertwined lives of a group of offbeat characters, some played by actors and others who are real street people. Many of the scenes are improvised, and the production has a fresh and stylish feel to it. Though viewers cannot interact directly with the story, they can click on video bios of the characters and read the blog written by one of them. A more mainstream entry, *Prom Queen*, is produced by the great Hollywood luminary Michael Eisner, who once ran the Disney Studios. It debuted in 2007, and like *Something to Be Desired* and *The Strand*, it is shot on video. With 80 episodes, each just 90 seconds long, the steamy drama revolves around a seminal high school event: prom night.

Of the three, *Afterworld* is the most cutting-edge and contains the most interactive features. Coming online in 2007, it was made by a group of Hollywood professionals on a hefty \$3 million budget. The first season consists of 130 episodes of two to three minutes in length, and unlike most new webisodes, it is animated. The arresting look of the series is part graphic novel, part anime. It is a grippingly told story of an ad executive who travels to New York on a business trip, only to wake up one morning to find that all humans have vanished and that anything dependent on modern technology no longer functions. The website features an interactive map and timeline, an illustrated journal "written" by the main character, and a forum filled with viewers' observations of the story. *Afterworld's* producers promise to add more interactive features, such as letting viewers interact with some of the characters, solve puzzles, and suggest plot lines.

Faux Blogs

The *blog*, short for Web log, is one of the most pervasive forms of communication on the Internet. A type of grassroots journalism, blogs are usually highly personal and are written much like diaries, often with daily entries. Many blogs use not only text and stills but also video. At last count, somewhere between 60 and 100 million blogs had been created, with a new one appearing every 1.4 seconds. With blogs achieving this sort of massive popularity, it was only a matter of time before the creative community recognized their potential for storytelling and started to develop faux blogs that looked just like the real thing.

We discussed one such faux blog in Chapter 9, *Nigelblog*, allegedly written by a character from the TV show *Crossing Jordan*. However, a number of faux blogs have been created that have no connection at all to Hollywood entertainment properties. *Belle de Jour*, for example, is a juicy blog "written" by a London call girl, and *Ghost Town* is a blog "written" by a young Ukrainian woman named Elena who likes to ride her motorcycle through the dead zone of Chernobyl. Her faux blog, illustrated with her own photographs, is a disturbing warning of the dangers of nuclear accidents. It is so convincingly done that it spread like wildfire around the Internet, with most people believing it was a true story.

Though many faux blogs are created as components of larger transmedia stories, *Belle de Jour* and *Ghost Town* indicate this genre can stand on its own as a form of fictional narrative.

Webcam Dramas

In a conceit that could only be possible on the Internet, a number of Web dramas have been presented as true-life video blogs made by someone using his or her own webcam. As series of such videos, purportedly made by a teenaged girl named Bree, caused a huge stir when they turned up on YouTube in 2006. The homemade-looking videos, collectively known as *LonelyGirl15* (the girl's user name) was an intimate portrait of a shy, awkward teenager and her friendship with a boy named Daniel. Bree corresponded with her fans by email (actually written by a woman involved with the production), and viewers in turn sent

her videos they had made. The storylines of *LonelyGirl15* were shaped to some degree on viewers' feedback. Some of the videos contained hints that Bree was possibly being pulled into a sinister cult, and viewers grew increasingly alarmed by her situation. About four months after the first video appeared, however, it was revealed that Bree was actually an actress and that *LonelyGirl15* was a work of fiction, a discovery that brought the series even more attention. (The making of *LonelyGirl15* is discussed in Chapter 26.)

Though by far the best known of these webcam dramas, it was not the first. Two such works, *Online Caroline* and *Planet Jemma*, were produced several years earlier in the United Kingdom, as was the American-made *Rachel's Room*, which we will be discussing a little later in this chapter.

Comedy Shorts

Comedy shorts are immensely popular on the Web. Because they are amusing, and usually just a few minutes long, they work extremely well as a form of "snack-o-tainment." Many of these shorts tackle subject matter that would be considered in bad taste or too extreme for mainstream TV, further adding to their popularity. Three sites devoted to comedy shorts are *Icebox*, *JibJab*, and *Funny or Die. Icebox* specializes in animated shorts written by some of Hollywood's funniest writers. *JibJab*, a site literally started in a garage by two brothers, was initially dedicated to Flash animated cartoons that they had created themselves, but it now carries the work of other people as well. Many of the cartoons are political in nature. The shorts on *Funny or Die* are mostly shot in full motion video and seem primarily to be targeted to young males. The site was founded by actor Will Ferrell.

Interactive Mysteries and Adventures

Although not at all numerous as compared to webisodes and other forms of Internet narratives, interactive mysteries and adventures are a dynamic form of Web entertainment. Such narratives give viewers the opportunity to become a participant in a story and solve a crime or a mystery, sometimes for prize money. For example, *Save My Husband*, which will be discussed in Chapter 17, solicits the help of viewers in finding a man who has been kidnapped. In *Underground Bounty Hunter*, viewers "become" bounty hunters and try to track down a villain without getting wounded, captured, or killed. And *Stranger Adventures*, which will be discussed later in the chapter, sends viewers on a new adventure each week to help a character find a hidden treasure.

AN ORGANIC APPROACH

Rachel's Room, which debuted in 2001, took a highly innovative and organic approach to storytelling on the Web, fully using everything the Internet had to offer at the time to serve the purposes of the narrative. It was developed as

part of Sony's ambitious broadband initiative, *Sony Screenblast*, which catered to users with high bandwidth, and thus made heavy use of video, offering 50 video installments running between 3 and 5 minutes. In pushing the envelope of the Internet as a medium for fiction, it was one of the first dramas on the Web to utilize webcams to construct a "video diary." Six long years later, *LonelyGirl15* used an almost identical approach.

Rachel's Room is a story that could only exist on the Web—the very fact that it takes place on the Internet is an integral part of the concept. Here is the conceit: 16-year-old Rachel Reed is at a crisis point in her life. Her father has recently passed away, and she is at war with her mother, who has a serious drinking problem. Like Holden Caulfield in *The Catcher in the Rye*, Rachel feels misunderstood by everyone around her. Thus, in an effort to break out of her isolation and get a handle on things, she makes a radical decision: She will open herself up to strangers in the outside world. So they can see who she really is, she will place webcams around her bedroom and let them roll (though she plans to edit out the "boring parts" before putting the videos up on the Web). Furthermore, she will keep an online journal and also regularly go into a chat room to talk with members of her cyber support group. (See Figure 15.1.)

Arika Lisanne Mittman, who served as producer and head writer of *Rachel's Room*, utilized both familiar and novel methods of telling Rachel's story and encouraging audience participation. Pieces of Rachel's story were revealed via the video episodes, her journal, and the chat sessions, and all three were coordinated in terms of content. Viewers could express themselves via message boards, emails, chats, and in certain special ways, such as the "Dreams" section of the site. The chat sessions were an important part of the *Rachel's Room* experience. Mittman herself went into the chat room every weekday night, playing the part of Rachel. Sometimes these sessions contained serious discussions

Figure 15.1
Rachel's Room
appeared to be
the website of a
real teenager, but
it was actually
a professionally
written drama. Image
courtesy of Sony
Pictures Digital.

of teen-related issues, but sometimes they also advanced the story. In a clever blending of reality and fiction, she had Rachel meet a boy fan during one of these sessions, a charmer whom Rachel believes to be her soul mate. Against all common sense, she invites the boy (actually an actor playing a fan) to her room, unaware that he's made a bet with his friends that he could seduce her on camera. Naturally, the relationship ends badly, but it caused great anxiety among Rachel's real fans, many of whom were convinced that Rachel was a real girl and not a character in a fictional drama. Mittman says she developed this subplot in part as a cautionary tale for the site's visitors.

DRAWING FROM TRADITIONAL MEDIA

By having Rachel share her most personal thoughts and her teenage angst, often breaking the fourth wall by addressing the viewers directly, the character touched a nerve among the site's fans. They closely identified with her and were intensely concerned with what happened to her. In creating such a compelling protagonist, *Rachel's Room* was actually borrowing a valuable technique from older forms of storytelling: good character development.

"It's wrong to think characters for the Web don't need much depth," Mittman asserted. She believes character development is as important for the Web as it is for any other medium. She strove to create a multidimensional, realistic teen, tapping into her "inner teenager" to do so. She gave Rachel "a certain mopey cynicism" and had her do dumb things at times. In other words, she was flawed, which helped her seem real, and contributed to her appeal.

Mittman also took pains to develop an overall good story for the series, "arcing it out" (constructing an arc for it) as would be done for a television drama. For the Web, she stressed, "you have to try that much harder to keep people coming back." To Mittman, that means not only constructing strong storylines with cliffhangers but also giving viewers a meaningful role in the story. "You have to keep them in mind," she told me, "and keep in mind why they are going to come back. You have to make them a part of it."

CREATING A NEW NARRATIVE FORM

As we have seen with *Rachel's Room*, the unique attributes of the Internet can successfully be harnessed to construct new types of narratives. As to be expected, however, the process of creating a new form can be full of challenges. As an example, let's look at the case of the interactive adventure series, *Stranger Adventures*. In devising this series, the producers chose to break new ground and take Internet entertainment in an entirely new direction. But in doing so, they took care to invest a great deal of creative energy early on to get the series off to a good start.

Stranger Adventures, which debuted in 2006, is an anthology series, a form rare to the Web. A new story comes online each week on a Sunday and runs until

the following Saturday. The stories thrust viewers into a first-person drama that begins when an individual they do not know (the "stranger" of the title) urgently requests their help in finding a treasure of some kind. Each story features a different stranger with a different need for help, and finding the treasure requires cracking a 10-digit code, which is done by uncovering clues embedded in the story. The first viewer to succeed receives a thank you gift in the form of \$25,000 in cash. Thus, *Stranger Adventures* combines some of the features of TV drama with some elements of video games, creating a unique narrative genre. (See Figure 15.2.)

Richie Solomon, the supervising producer of the series, describes it as "a story that takes an ordinary person on an extraordinary adventure." The drama

Figure 15.2
The anthology series
Stranger Adventures
involves viewers in an
interactive adventure
story. Image courtesy
of Riddle Productions,
Inc.

unfolds in real time through the emails and videos—usually several a day—sent to you by the stranger. If the stranger finds herself in trouble and needs your help at 3:30 in the morning, for example, you will receive a communication from her at 3:30 in the morning. "Our format is something entirely new," Solomon said. "Our stories are extremely personal. The viewer needs to feel like the protagonist is talking directly to them. It's very intimate and confessional. It shatters the fourth wall."

Before the series was launched, its creator, Chris Tyler, CEO of Riddle Productions, spent over a year developing the concept. After writing and producing a demo episode, he conducted five online trials with focus groups to see if his concept would fly. The results were encouraging enough for Tyler to move his production company from Dallas to Hollywood. Solomon was hired shortly afterwards, and he worked closely with Tyler in refining the overall structure of the show. They examined what worked and what didn't in the demo episode and applied that knowledge to a new pilot episode. The pilot was so successful that it earned the show an Emmy nomination (the series has since gone on to receive two more Emmy nominations).

Solomon, who was involved in hiring the writers for first season, told me how challenging many writers find this new form of writing to be. "Our writers have to relearn storytelling," he said. "Many of the writers we interviewed in the beginning of the season just couldn't get it. . . . It's definitely a challenge to write a story that is told through video one moment and then through a text email the next and then through a series of interactive animations, all the while keeping the adventure engaging and exciting from one day to the next. And the writer must provide ample material for the designers, animators, and puzzle master to work with, all the while keeping these separate elements organic to the storytelling."

WHY SUSPENSE WORKS

Over time, Solomon told me, the creative staff found that the more suspenseful stories in the series received better viewer feedback. "You almost have to end every communication from the stranger with its own cliffhanger," he said. "That way the viewers are eagerly anticipating and actively checking for the next communication."

As successful as the first season was, this innovative series is constantly evolving. "Just looking at one episode to the next is like comparing the special effects from the original *Star Trek* series to the latest movie version," Solomon said. "Our technology is constantly improving as we continue to learn what works and what doesn't." Looking ahead, Riddle Productions plans to incorporate mobile SMS, faxes, and IM into the storytelling and is also exploring ways to expand the interactive aspects of the series.

CONCLUSION

As we have seen, the Internet has successfully recovered from the dot com bust at the turn of the millennium and has proven to be a robust vehicle for new kinds of entertainment experiences. In this chapter, we have seen some compelling examples of how stories developed for the Web can be told differently than stories developed for other media, especially TV. The most innovative of these new kinds of narratives are participatory and use a variety of Web-based technologies to advance the storyline. Many also break the fourth wall and blur reality and fiction in intriguing ways.

As the Internet continues to mature, we can expect to see new kinds of narratives that will advance the art of digital storytelling in this medium.

IDEA-GENERATING EXERCISES

- **1.** Select a website that has story-rich content. What demographic do you think this content is designed to attract and why do you think this group would find it appealing? How, if at all, does it use the special attributes of the Web? What about it, if anything, do you think users might dislike? Can you suggest anything that might make it more enjoyable?
- **2.** Sketch out an idea for an original fiction-based work for the Internet. How would you make it "sticky?" How could users become involved with the content?
- **3.** Select a character you are extremely familiar with from a TV show or movie and write several entries for a faux blog in this person's voice. Alternatively, create a fictional character of your own and write a potion of this person's blog.
- **4.** Many people enjoy dramas on the Internet that, like *Rachel's Room* and *LonelyGirl15*, are works of fiction but seem real. Other people, however, object to stories that blur fiction and reality in this way, feeling they are a form of lying and deception. What are your views of such stories, and why?

Massively Multiplayer Online Games (MMOGs)

What is it about Massively Multiplayer Online Games that makes them such a potent form of entertainment, to the point that some players become addicted to them?

How much story content can such sprawling games support, and what kinds of story elements serve them best?

What kinds of characters populate these games?

What can be done to attract new kinds of players to MMOGs and to expand the market for them beyond the small group of hard-core fans they typically attract?

MMOGs: THE NEW KID ON THE BLOCK

You're walking down a street lined with drab gray skyscrapers, interspersed here and there with colorful low-rise structures. Robotic-looking characters wearing business suits hurry by, fellows with names like Number Cruncher, Flunky, and Head Hunter. You carefully sidestep a guy named Pencil Pusher, who has a pencil point for a head, and then dodge another unfriendly looking gentleman, Micromanager, whom you certainly want to avoid, because he'll tie you up in red tape if you fall into his clutches.

No, these characters are not escapees from a *Dilbert* comic strip. They're actually NPCs in *Toontown Online*, Disney's lighthearted Massively Multiplayer Online Game, or MMOG. *Toontown* is a member of one of the most rapidly growing and financially lucrative forms of interactive entertainment ever to be devised. MMOGs are mere youngsters compared to video games—the first major ones out of the box, *Ultima Online* and *EverQuest*, were not launched until the late 1990s. Yet they've already drawn an intensely dedicated fan base in many parts of the world. In some regions, they are even more popular than traditional single-player video games.

MMOGs are derived from MUDs, text-based adventure games in which players assume fictional personas, explore virtual worlds, and interact with each other. MUD stands for Multi-User Dungeon (or Multi-User Domain or Multi-User Dimension). The MUD, and its close cousin, the MOO (MUD, Object Oriented) can support the simultaneous play by a great number of participants. The first MUD (and MUD was indeed its name) was developed in Great Britain in 1978. It was a team effort of Richard Bartle and Roy Trubshaw, both students at the University of Essex. It is quite easy to detect the close family resemblance between the MUDs and MMOGs. However, MUDs are text based, while MMOGs immerse players in a world of richly animated graphics.

THE CHARACTERISTICS OF THE MMOG

MMOGs, sometimes also called MMOs or MMPs, have several characteristics that set them apart from other games, even online games. For one thing, they are played simultaneously by tens of thousands of people, and the interactions between the players are a significant part of the experience. They are set in sprawling fictional landscapes that usually include multiple complex worlds, all of which may be populated. These game worlds are also persistent universes, meaning that the activities going on in them continue even after a player has logged off, just as in the real world things continue to happen even when we go to sleep.

One of the most popular subsets of the MMOG is the Massively Multiplayer Online Role-Playing Game (MMORPG). It observes many of the characteristics of RPGs discussed in Chapter 14 on video games. Players create and control one or more avatars who are defined by a set of attributes, such as species, occupation, and special skill. These player-controlled characters strategize

with each other, go on quests, and explore. Players work hard to advance their avatars' skills and powers. A great many MMORPGs revolve around so-called "sword and sorcery" medieval fantasies and feature bloody encounters with NPCs and player controlled avatars.

Typically, MMOGs are supported by subscriptions. To play them, people pay a regular monthly fee, much like a magazine subscription (although in some Asian countries, where MMOGs are typically played in cafes, players may pay by the hour). In addition to the subscription, players usually have to purchase the initial software, often sold on a CD-ROM. Many games also come up with periodic expansion packs, and players are encouraged to buy them so they can have access to new features of the game. A MMOG needs only to attract a few hundred thousand players to generate a considerable income, and over the course of several years, a successful MMOG can take in more money than even a hit video game or movie.

However, because MMOGs demand so much attention from their players, it is generally believed that most people will only subscribe to one at a time. Thus, the key to success for a new crop of MMOGs is to appeal to a new audience. This is exactly the approach Disney has taken with its two MMOGs, *Toontown Online*, introduced at the beginning of this chapter, and *Pirates of the Caribbean Online*, both of which will be discussed in more detail later in this chapter.

THE MMOG'S CLOSEST COUSIN: SOCIAL NETWORKING VIRTUAL WORLDS

Second Life and similar avatar-driven social networking sites, introduced in Chapter 2, are close cousins to MMOGs. Residents of these virtual worlds can create their own avatars, explore vast landscapes, and socialize with each other, just as they do in MMOGs. However, on closer inspection they have three important differences:

- Social networking sites, unlike MMOGs, are not games: Participants do not go on quests, engage in combat, advance in skill level, or have any game-based goals to fulfill.
- 2. Second Life and other avatar-based virtual worlds do not contain any narrative elements. They are not stories in any way.
- 3. The focus of social networking sites is different from that of MMOGs. As the term implies, the emphasis is heavily on socializing. Another important element, particularly in Second Life, is commercial element. Second Life is a thriving marketplace, where residents buy, sell, or trade items with other residents. Although this sort of activity can also occur in MMOGs, it plays a far greater role in Second Life.

NARRATIVE IN MMOGs

Essentially, the production team for a MMOG creates a framework for people to play in. They devise an intriguing backstory, various narrative elements to

be discovered during play, and set up quests for players to undertake. They also create the virtual landscapes for the MMOG, the NPCs, and the types of avatars that players can build and control. But although MMOGs contain a certain amount of story material created by the production team, they also contain narrative elements that the players themselves have initiated and that emerges as they play.

A MMOG typically contains a number of simultaneous storylines as well as an overarching narrative. The overarching storyline is set up in the backstory and gives context and excitement to the fictional world of the game. But within this framework are a number of ministories. In fact, each quest that a player goes on may be regarded as a story, with a starting point, a period of intense conflict and action, and a resolution—a traditional three-act structure. However, the overarching storyline of the MMOG is left open ended.

This type of narrative is in some respects quite similar to the type of storytelling found in soap operas, a point made by Nick Iuppa and Terry Borst in their book, *Story and Simulations for Serious Games*. As with a soap opera, the core story in a MMOG is never resolved. This is quite different from the narratives found in movies, which have clear-cut endings, with all the pieces neatly tied up. Yet the audiences of soap operas and the players of MMOGs find them intensely involving; the lack of closure of the central storyline does not diminish the pleasure of watching or participating in these stories, for there is always something new to discover and a new twist to the tale. The lack of closure also makes MMOGs different from other kinds of games. Although a game may have a number of possible endings, it does have a point in which it comes to a conclusion, even if the conclusion is the player's death.

WHY SO POWERFULLY ADDICTING?

Much to the fascination of journalists and to the dismay of psychologists, parents, and spouses, MMOGs are such a potent form of entertainment that some players have actually become addicted to them. These games are sometimes referred to as "heroinware," and *EverQuest* has been nicknamed "EverCrack." Gamers who cross the line from recreational play to something more serious exhibit all the classic signs of addiction. They lie about the time they spend playing; develop problems with work, school, or relationships; and are unable to stop playing, even when they try. In South Korea, there's even a documented case of a young man who dropped dead after playing a MMOG for 50 hours straight.

While this is an extreme case, most fans of these games do spend a surprisingly large amount of time on them—as much as 20 to 40 hours a week. Anyone with a professional interest in this arena has to wonder what it is that makes these games so compelling and wonder if these factors can be incorporated into new games—not to make more MMOG junkies, of course, but in order to attract new players to this arena.

Massively Multiplayer Online Games (MMOGs) CHAPTER 16

Players cite these qualities that make MMOGs so compelling:

- They provide an escape from the blandness of everyday life.
- Via role-playing, players can become powerful, awe-inspiring figures.
- Players have a great deal at stake in terms of the investments they've made in avatars and acquisitions and don't want to lose them.
- MMOGs have a strong social component; people make close friends in these worlds and want to stay connected to them.
- They are challenging and highly goal-oriented—every time a goal is achieved, there's a new one looming.

THE COMMUNITY ASPECTS OF MMOGS

Richard Bartle, codesigner of the world's first *MUD*, the predecessor to the MMOG, does not consider MMOGs to be games at all. Instead, he regards them as "places." In an article written for *Business Week Online* (December 13, 2001), he noted that MMOGs, unlike games, offered a sense of community, which he believes makes them more like real life. This, he feels, is an important part of their appeal. He noted: "When you visit those places, you can play, sure, but you [also] can talk, you can explore, you can boss people around. They are environments, and they have real people in them." Many experts in the field agree with Bartle that the social aspect of MMOGs, and the friendships formed while playing, are a major reason why people are drawn to them.

The World's Most Popular MMOG

To date, the Western world's most successful MMOG is World of Warcraft (WoW). It has made hundreds of millions of dollars, and according to the most recent statistics available, it has 9 million subscribers worldwide. Lineage II, a South Korean MMOG, is also enormously popular, though mostly played in Asia. WoW, a Tolkien-inspired game from Blizzard Entertainment, has attained its immense popularity for a variety of reasons. It presents a richly detailed, enormous fantasy world to adventure in, and players appreciate the different kinds of gameplay it offers and diversity of character types and professions available to them for their avatars. It offers exciting combat with a variety of opponents, and the pacing is brisk. In addition, players regard it as easy to learn and play.

A PLAYER'S POINT OF VIEW

In order to gain a better understanding of how a fan experiences one of these games, and what in particular appeals to them, I spent an afternoon with 15-year-old Michael Loeser as he played the *Dark Age of Camelot*, a popular medieval fantasy game developed by Mythic Entertainment. Loeser, who had been playing the game for a month or so, said he liked it because it had good character control, was easy to use, and he could make his character look really cool. "I don't like games that are too difficult," he told me. "They are more annoying than fun." For him, he said, most of the satisfaction of this kind of game comes from "working up levels and getting cooler stuff and going into battle."

Figure 16.1
A misty landscape in Albion, one of the three realms of the Dark Age of Camelot. Image courtesy of Mythic Entertainment.

He said he particularly likes medieval games because of their magic and sword-play and also because he thought it was an interesting time frame. He took me on a tour of his favorite of its three realms, the island of Albion, via his avatar, a poor but strapping warrior. I was struck by the lush exterior environments and the beautifully detailed interiors of the taverns and shops we visited. (See Figure 16.1.) The island seemed immense. Loeser said it could take hours to cross on foot, though if you were in a hurry and had money, you could buy a ticket to ride a horse. Day also changes to night in this game, and Loeser told me weather could also be a factor in the game play. Just as in England, it can be foggy and rainy here, making it difficult to spot your quarry.

Loeser enjoys playing in character and demonstrated how he does this, begging a passerby, a wealthy-looking nobleman, for some coins by way of a courtly typed message sprinkled with *thees* and *thous*. To my surprise, the passerby generously complied. And what would Loeser do with his newfound bounty? He promptly spent most of it to have all his clothes dyed red, along with much of his equipment. Clearly, this game was some kind of medieval fashion show. "If you have money, you may as well make your character look good," he told me. But he justified the expense by explaining "people are more eager to let you join their group if you look cool."

With that, Loeser activated a function that signaled he was looking for company, and in short order we hooked up with about a dozen other players and were off on a monster hunt. The fog was rolling in and dusk was falling, reducing

Figure 16.2
EverQuest, a medieval fantasy game, is vast in scope, with 220 adventure zones, 16 city zones and approximately 40,000 NPCs. Image courtesy of Sony Online Entertainment.

visibility, but just enough light was left for the group to track a lumbering, furry-looking creature, to surround it, and to do it in—the conclusion of a good day's work in Albion.

THE MOOG-MAKERS' POINT OF VIEW

A player's point of view can be illuminating, but to understand how these games are put together, I turned to several expert sources: the duo that heads up production for *EverQuest*, developed and published by Sony Online Entertainment, and the person who heads up the creative team of Disney's *Toontown Online* and *Pirates of the Caribbean Online*.

EverQuest, like The Dark Age of Camelot, is a medieval fantasy game. (See Figure 16.2.) And, until WoW came along, it was the most popular MMOG in the western hemisphere, with only Lineage beating it internationally. My experts at EverQuest were the two people who headed up the game's day-to-day production work and who know as much as anyone in the world about creating and producing MMOGs: Rich Waters, design director, and Robert Pfister, senior producer.

Waters and Pfister told me (answering my questions jointly) that one of the greatest challenges of producing a game like *EverQuest* is its vast scope. They compared what they did to running a small city, requiring the juggling of multiple and highly demanding responsibilities. The game has 220 adventure zones, 16 city zones, and some 40,000 NPCs. "That's a lot to look after, each day, every day,"

they pointed out, an understatement if ever there was one. And, on top of that, they are continually writing new stories and developing new features.

Essential Questions

Designing a new MMOG, they told me, is a multiyear project requiring a staff of 20 to 70 people. The first questions you must answer are the game's genre (role-playing? action? strategy?) and the setting (medieval times? space? postapocalyptic?). Then you must determine the basis of the game's conflict, which might be player versus player, group versus group, player versus computer, or a combination of all of these. Another key question, they said, is how players will be rewarded for the risks they take.

Character and Story

The two elements that demand special attention, they said, are story and character. "Story is very important to a game," they asserted. In the context of a MMOG, story is primarily considered to be the history, backstory, and lore of the fictional world, as well as the conflicts within it. Story, they explained, "can be introduced in a two-minute cut scene at the beginning of the game, or can be spread across the world in books, tales told, and in quest backgrounds The richer you make your world, the more likely people are to come to visit and stay." They told me that players can, and do, spend years exploring <code>EverQuest.</code> "They find that every inch is covered with lore and story." But, they added, part of their job is also to create "very specific adventures for people to complete—fight this dragon, defeat this god, rescue that person."

The characters in MMOGs, as with video games, fall into two broad categories: the NPCs and the PCs (avatars). In *EverQuest*, the NPCs may be monsters you fight or human characters like shopkeepers or guild masters. The monsters fall into a category called a *MOB*, short for *Mobile Object*, which is an object in the game that moves, as opposed to an inanimate object like a door or chest that you must "attack" in order to open. In developing an NPC that will have a role in a new quest, the design team works out what its function will be in the overall quest, what its backstory is, how players will interact with it, and what lines of dialogue it will speak. The artists will then do concept drawings of the new NPC, working with the designers to refine the look, and then add clothing and "attachments"—things like shields and hats. The final step is to animate the character, giving it actions like running, swimming, fighting, casting spells, or dying. That done, the character is imported into the game.

The design process for the avatars is somewhat different. In *EverQuest*, the basic character types are either drawn from standard mythology (archetypes like ogres, trolls, elves, and gnomes) or else from *Ever Quest's* own mythology. Waters and Pfister said that the critical thing, when designing a new class or race, is to take care that it does not create an overwhelming advantage to one particular group of characters. They consider how the character will work on its own, how it will play in a group, how it will play in a large raid, and what affect it will have on all the different types of NPCs.

Because a MMOG like *EverQuest* has to accommodate hundreds of thousands of players, many things must be considered before any new features are added, imagining all the different ways it might be used and how its presence might impact the game. For example, Waters and Pfister told me they recently added horses to the game. In doing so, they had to address such questions as: Can people steal horses? Can horses be killed? What role will horses play with the most competitive players? With more casual ones?

Overall, they also cautioned against making a game too technically demanding, stressing instead that it must be enjoyable to play. "You can have the most detailed online world imaginable down to the cracks in the sidewalk," they asserted, "but if it isn't fun, no one will play."

BREAKING FRESH GROUND

Obviously, the challenges of running an established MMORPG are enormously daunting. But imagine what it would be like to start with a blank sheet of paper and create an entirely new sort of MMORPG—one that was a steep departure from the familiar "swords and sorcery" motif and that was intended to attract a completely new demographic. Instead of being geared to the young males who were drawn to these games because of their fierce competitiveness and bloody combat, this one would feature cartoon characters and plenty of humor and would be designed to attract both children and adults. This was the formidable task faced by the creators of Disney's *Toontown Online*, the game portrayed at the beginning of this chapter. (See Figure 16.3.)

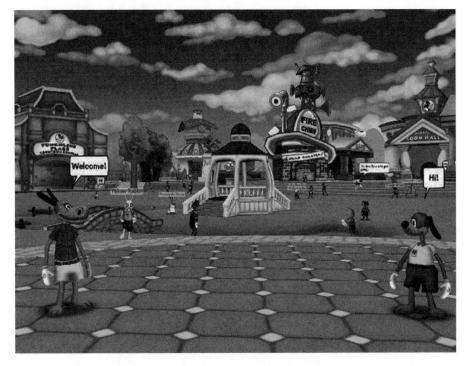

Figure 16.3
Toontown Online is a cheerful place full of friendly Toons, but the Cogs threaten to make unwelcome changes. This is the playground in Toontown Central, one of the six Toontown neighborhoods. Image courtesy of © Disney Enterprises, Inc.

Toontown Online, released in 2003, is a colorful world inhabited by Toons, or cartoon characters, many of which are avatars controlled by the players. All is not well in Toontown, however. This cheerful place is being threatened by business-minded robotic creatures called Cogs with a single-minded agenda: to take over the Toons' buildings and convert them into drab office structures. As a player, your mission is to protect Toontown from the Cogs. To battle these robots, you launch "gags" at them—the Toontown version of ammunition. For example, you can pelt them with cream pies or drench them with your personal rain cloud.

This innovative, humorous approach to the MMOG was dreamed up by Mike Goslin, vice president of Disney's Virtual Reality Studio. As Goslin relates it, the idea came to him late one night in 1999 as he was working on an attraction for DisneyQuest, an urban interactive indoor theme park in Orlando. It was born out of a "what if" question: What if you took the skills and experience acquired from designing theme parks and applied them to a MMOG? He told me it was like a light going on overhead, especially as he realized that a MMOG was really "a place more than a game, and we know how to build places." Strikingly, though he was coming at it from a totally different set of experiences, Goslin's vision of the MMOG as a "place" closely echoed that of Richard Bartle, quoted earlier in this chapter.

Early Development Work

Once the project received the green light from Disney higher-ups, the game took the creative team approximately three and a half years to develop. Interestingly, the idea of setting the game in Toontown evolved during development—it was not a core part of the concept from the very start. But once this critical decision about the world was made, Goslin said, many things started to fall into place. For instance, it helped define the nature of the core conflict in this world—the ongoing clash between the Toons and the Cogs. It also made it possible to lay out the geography of the game—six different neighborhoods, each with a distinctive flavor and set of characters. Each neighborhood would have its own central playground, where Toons could go to relax and rejuvenate after encounters with Cogs—they would be Cog-free zones. From there they could take trolleys to Toontown's many minigames, and by playing them, they could try to win valuable jelly beans, the equivalent to money in this world. (See Figure 16.4.)

The trolley system used to transport players to the minigames was another *Toontown* innovation. The trolleys were devised to vastly speed up time spent getting from one place to another in the game. Though time-consuming navigation is characteristic of most MMOGs, Goslin's team realized it was not something young children were likely to have much patience with.

Figure 16.4
The cannon game is one of the many minigames which Toons play in order to earn valuable jelly beans. Image courtesy of © Disney Enterprises, Inc.

The Characters

Just as with MMOGs for adults, this new game would be populated both by NPCs and PCs. The NPCs would fall into two basic categories: Cogs (the game's antagonists) and other Toons (neutral characters). The creative team came up with 32 different types of Cogs, all based on the theme of big business. Four different variables would determine each Cog's persona: its name, physical appearance, dialogue, and mode of attack. For example, a Cog named Cold Caller would have a block of ice for a head, and his mode of attack might be to throw a telephone; when encountered in the street, he might say something like "Sorry to interrupt your dinner." The game would replenish any defeated Cogs; there would be no end to them.

The other group of NPCs, the nonplayer Toons, would mostly be shopkeepers, and about 800 of them would be dispersed around Toontown. They would be on hand to interact with player-controlled Toons and to give them tasks to do. Along with these working Toons were also some "star" Toons of the Disney universe, familiar characters like Mickey, Minnie, and Pluto. They would circulate through Toontown and thrill players when they appeared.

As with adult MMOGs, players would get to design their own avatars, molding them from a million possible combinations. They could choose from six

possible species—dog, cat, mouse, horse, rabbit, or duck—and pick different body types, color combinations, and clothing styles. (See Figure 16.5.) They would then get to name their Toon. During the game, they would be viewing their Toon from a third-person point of view, which Goslin termed "the wing man view." It would be as if the camera were tethered right behind the Toon.

Toons would have plenty to keep them busy. Along with the aforementioned minigames, they could shop for gags, socialize with other Toons, and run errands for Toon merchants to earn extra jelly beans. Also, since all Toons received a house when first joining the game, they could decorate their abodes and embellish them with all manner of purchased furnishings. But their chief occupation would be fighting the loathsome Cogs.

Reaching a Broad Demographic

One of the most important tasks during preproduction was to take every possible step they could to ensure the game would appeal to the broad demographic they were hoping to attract. Thus, they did not merely rely on their theme park background, but they also read social science research; studied Jean Piaget (for more on Piaget, see Chapter 8); did focus group testing; consulted with experts in children's content; and used play testers.

During development, they considered each demographic group they wanted to attract and built in elements that would appeal to each. For adults, for example, the primary attraction would be the game's sophisticated workplace humor

Figure 16.6
Screen capture of a Toontown battle scene: the Toons (on the left) versus the Cogs (on the right). In Toontown Online, the Toons use gags, not swords or guns, to fight their enemies, the Cogs. Image courtesy of © Disney Enterprises. Inc.

and wordplay, such as the puns in the Toontown shop signs. Working in things for boys was not difficult, Goslin said, because, based on the history of how boys have responded to prior games, "we know what they like." But shaping the content to appeal to girls was harder, he noted, because "no one's done it before." The team felt girls would respond well to the emphasis on cooperative play and to the social aspects of the game and would enjoy being able to customize the avatars. They also considered the tastes of girls in the visual design, with Toontown's bright colors and rounded shapes.

The design team also took steps to ensure that the game would not be plagued with *griefers* (players who deliberately make life miserable for other players). One way they handled this was by preventing unrestricted chat. Instead, they offered a "speed chat" system, giving players a selection of words and phrases to choose from. This short-circuited the ability of ill-mannered players to verbally harass others and also protected young users against predators and the invasion of privacy, an important consideration for families. The downside, of course, was that it could limit the social aspects of the game. However, with parental approval and a special code, kids could enjoy free chat privileges with people they knew from outside the game.

To further ensure a positive experience, the game encouraged good behavior by rewarding cooperation and team play. It offered no incentive to compete, and no opportunities for *player versus player* (PvP) battles. It thus circumvented the bloody player attacks prevalent in most MMOGs. Even the battles between the players and the Cogs were nongory affairs, emphasizing strategy and humor rather than physical force. (See Figure 16.6.) Not only would the Toons use gags for ammunition, but the Cogs would retaliate in kind. For example, they might spray a Toon with ink from a fountain pen or fling half-Windsor neckties.

The Role of the Treadmill

One feature that can be found in classic MMORPGs like *EverQuest* and *WoW* is a device called a *treadmill*, and this device was built into *Toontown* as well. A treadmill is an internal structural system that keeps the player hooked, cycling repeatedly through the same types of beats in order to advance in the game.

In an old-line MMOG, the treadmill might require players to kill monsters to earn money to buy swords to kill more monsters. But in *Toontown Online*, the treadmill works like this: Toons play minigames to earn jelly beans; Toons use the jelly beans to buy gags; Toons use the gags to fight the Cogs, at which point their inventory of gags is depleted; then, once again, the Toons must play minigames to earn jelly beans. Players cannot advance in the game without using the gags, and the gags get better—more effective and more fun—as players work their way up. For instance, one line of progression begins with throwing cupcakes, advances to slices of pie, and then to entire wedding cakes. The best treadmills, according to Goslin, are integrated into the game in a natural way, as part of the overall game world.

Story and Structure

One of the toughest challenges Goslin found in developing *Toontown* was dealing with the story. In a shared world like a MMOG, he said, "It is a unique challenge to do storytelling ... you stretch the limits of storytelling in this kind of thing." As he pointed out, in a traditional story, you have one story structure featuring one hero and one major encounter. But in a MMOG, each player is the hero of his or her own experience of the game. Furthermore, you need a reusable climax, something that can be played through by each person. This precludes having a fixed ending. And finally, you don't want the game to come to a conclusive and final end, because this would undercut its subscription basis.

THREE LEVELS OF STORY

Goslin sees stories in MMOGs as operating on three levels: high, medium, and low. The high-level story, he feels, gives players a context and meaning to the overall state of affairs that they find in this world and for the core conflicts that exist there. In *Toontown*, this would be the backstory of who the Cogs are and how they became unleashed on the Toons. The medium-level story, he feels, is a template everyone can share, perhaps a quest experience. He sees it as being a little like the season finale of a TV show, tying up some loose ends and shedding some new light on the high-level story. The low-level story, he suggests, is about the individual player's role in the story, that player's personal narrative within the game.

How Toontown Has Been Received by the Players

Although Disney does not release subscription numbers, its own surveys indicate that people play *Toontown Online*, on average, for an astonishing 22 hours a week, and that fans of the game include a significant number of adults. Thus, it demonstrates that the MMOG genre can successfully be extended beyond the traditional "swords and sorcery" games and can appeal to a new demographic of gamers.

A NEW KIND OF MMOG SETS SAIL

Following up on the success of *Toontown Online*, Disney launched a new MMOG in the fall of 2007, *Pirates of the Caribbean Online*. Mike Goslin, who headed up the *Toontown Online* team, took on the same daunting role for this new MMOG.

With *Pirates of the Caribbean Online*, everyone who had ever fantasized about sailing away on a pirate ship, engaging in swashbuckling swordfights, and digging for buried treasure would have the opportunity to indulge that fantasy to their heart's content. Clearly, this MMOG would be quite different from the safe cartoony world of *Toontown Online*, as the swordplay alone suggests. While all the physical encounters in Toontown feature NPCs (the Cogs) and involve weapons no more lethal than cream pies, this game would offer live player versus player (PvP) combat with an arsenal of potentially dangerous weapons. Furthermore, players would be able to communicate via open chat, unlike the tightly restricted player exchanges in *Toontown*.

A Knotty Matter: The Franchise Tie-in

Unlike *Toontown Online*, the pirates game is closely tied to other well-known Disney properties—the beloved Disneyland Park ride, three hit movies, and the virtual reality version of *Pirates of the Caribbean* at the DisneyQuest indoor theme park. Tying a MMOG into such a well-known and successful franchise would present challenges not faced in the development of the Toontown game.

In designing the new MMOG, Goslin told me, the movies were envisioned as a bridge to the game, giving players the chance to live in the adventurous world they'd come to know so well in the films. Goslin recognized that for this MMOG to succeed, it would have to meet and exceed the expectations of the films' fanbase. It needed to include familiar settings from the films and many of the most popular characters, first and foremost the dazzling, offbeat pirate character Jack Sparrow, played by Johnny Depp. The game's overarching storyline and its special brand of fantasy-horror and humor would also need to feel as if they were cut from the same piece of cloth as the films. The characteristics that made the movies so distinctive and turned them into such megahits would be woven into the quests and storylines. They would also be layered into the game via high-end cut scenes and via the NPCs and their lines of dialogue.

The backstory and overarching storyline for the game remains within the same setting as the films but introduces a new villain, the evil Jolly Roger, who has the power to wake the dead and then enslave them so they will do his bidding and fulfill his ultimate goal: to take over the Caribbean. Naturally, it is the player's job as a pirate to prevent this from happening while at the same time seeking fame and fortune of one's own. And as player–pirates make their way through this treacherous world and complete various quests, more pieces of the backstory will be uncovered.

Additional chapters of this saga, revealing new parts of the story, will be released as expansion packs. Each new chapter, Goslin said, will be presented as a new island—a natural way to add to the game, given its Caribbean setting.

Attracting Young Pirates—And Older Ones, Too

Unlike the hard-core gamers who might be found inhabiting traditional MMOGs like *World of Warcraft*, the target demographic for the pirates game is young teenagers, and beyond that, anyone who loves the theme park ride and the films. Finding ways to appeal to this new group of players was another challenge for Goslin's team.

They realized the game would have to be faster and easier to play than a typical MMOG, which were often highly labor-intense, sometimes taking days of real time to travel from Point A to Point B to join a quest. They decided to liberate players from this kind of work and jump right into the fun. To achieve this, the creative team deconstructed the vast physical geography of the game and devised a system of "teleporting" that would let players go directly to wherever they wanted.

Tone was another important consideration for Goslin's team. They knew they'd have to strike just the right note to appeal to young teens. In particular, they had to walk a fine line when it came to fantasy. Fantasy would certainly have to be part of the game—after all, the *Pirates of the Caribbean* films were heavily laced with fantasy. But the wrong kind of fantasy in the game—fairy tale fantasy, for instance—would turn this age group off, because it would hearken back to their childhoods, which they were eager to leave behind. On the other hand, the game designers were confident of the appeal of the special type of fantasy that was the hallmark of the films—a special mix of fantasy and horror, liberally sprinkled with gritty realism and spiced with dark humor. According to Goslin, the creepiness, the scariness of this type of fantasy "ages the game up."

ATTRACTING THE GIRL PIRATES

The Pirates team recognized that the swashbuckling nature of the new MOOG, with its emphasis on combat, would skew it more toward boys than girls. However, they made sure to include some features that they believed girls would enjoy. For example, the game offers a great deal of avatar customization in terms of facial features and body types, and the avatars can be dressed up in a variety of clothing and accessories. Players can also have their own pirate ships, and over time, they, too, can be customized. And what young teen, male or female, would not jump at the chance to use voodoo magic and try out some voodoo curses?

The Future of MMOGs

Goslin believes that the potential audience for MMOGs is still largely untapped, and he looks forward to breaking yet new ground. One possibility he mentioned to me was building a MMOG based on the animated movie *Cars*. He feels a number of genres have yet to be explored. Among them are horror stories and sports-based games. But he advises anyone venturing into this arena to be careful of making assumptions about the game's potential players. "If you think you know how they will use it, you will probably miss something," he asserts. He recommends thoroughly testing every aspect of the game before releasing it, and he thinks the testing process should continue for weeks, even months. But he also believes this is not an area for the timid. Though it requires discipline, he said, it also requires passion. "It's not a mistake to aim high," he asserts. "If you aren't aiming high, you can't hit high."

CONCLUSION

From this examination of several MMOGs, we can see that even games as disparate as *Toontown Online* and *WoW* have many things in common, and that players of these games are, in general, attracted to the same things. They enjoy playing MMOGs that

- give them an easy-to-understand way to start playing and gradually introduce them to more challenging tasks;
- are free of technical glitches;
- offer them a variety of places to explore and things to do;
- encourage socializing and making connections with other players;
- · offer opportunities to customize their avatars and their residences;
- allow them to be the hero of their own story;
- give them the opportunity to master new challenges and advance in power;
- give them the sense they can discover something new around every corner;
- stay fresh and interesting by adding new content on a regular basis.

Clearly, the process of developing a MMOG is not suited to those with short attention spans, shallow pockets, or a lack of creative vision. The vast scale of MMOGs, coupled with the fact that they must be able to support tens of thousands of simultaneous players, has substantial impact on story, structure, and character development. These games require that their creators be able to let go of familiar narrative techniques and regard storytelling in a bold new light.

IDEA-GENERATING EXERCISES

1. Analyze a MMOG that you are familiar with, noting the kinds of worlds it contains and the kinds of characters that populate it (NPCs as well as player-controlled characters). What is its core premise? What is its treadmill? What about this game do you think makes it attractive to players?

- If you have not personally played a MMOG, track down someone who is a regular player and ask for a personalized tour. Then analyze the game with these same questions in mind.
- **2.** Sketch out a premise for a MMOG. What world or worlds would it be set in? What would be the fundamental goal of the players? What would be the central conflict?
- **3.** What, if anything, about the idea you sketched out might make this MMOG inviting to the people who do not ordinarily play them? Can you think of ways to broaden its appeal?
- **4.** Can you construct a treadmill for this game? What would its basic beats be?
- **5.** Sketch out some ideas about the characters in the game. What kinds of avatars could the players build? What kinds of NPCs would inhabit the game? How would they look and how would they behave? Which group of them, if any, might pose a threat to the player-controlled characters?

Alternate Reality Games (ARGs)

In the ARGs thus far produced, what techniques have proven to be most successful?

Why have some ARGs not done well?

What are some of the unusual elements that have found their way into ARGs?

How important is narrative in ARGs, and what kinds of stories do these works generally contain?

287

SMUDGING THE BOUNDARY BETWEEN REAL LIFE AND FICTION

In three cities across the United States, dozens of people take part in stormy rallies opposing the emancipation of robots. The protests are real, although they pertain to issues set in the future, in the year 2142, not in 2001, when the rallies actually take place. At about the same time, a young girl sends a moving email to her friends, mourning the death of her grandmother, and she receives 340 sympathetic condolence messages in return. The young girl is a fictional character, but the people who write to her are real. And within that same few weeks, at some unidentified-location, a musician tunes up his lute and prepares to play a piece of sixteenth-century music, hoping it will help him find clues to a murder mystery.

What exactly is going on here? As it happens, these people have not collectively lost their minds. Instead, they are all participating in a deeply immersive, narrative-rich game, a sci-fi murder mystery nicknamed *The Beast*. The game belongs to a relatively new but immensely successful genre of interactive entertainment called an Alternate Reality Game, or ARG.

"THIS IS NOT A GAME"

We first touched on ARGs in Chapter 9, focusing particularly on how they figured into transmedia entertainment, and again in Chapter 12, in a discussion of how ARGs are often used as vehicles for promotion. Now, however, let's look at ARGs specifically as a new form of digital storytelling.

ARGs, perhaps more than any other form of digital storytelling, tightly integrate story and game elements together. Typically, ARGs have a strong and complex narrative, but it is broken into tiny fragments and embedded in a great variety of media assets and other forms of communication. In order to assemble the story and make sense of it, players have to solve a series of puzzles. These games often take players out into the real world in search of clues or to participate in story-related events.

ARGs are intense experiences for both the players and the developers that they usually run for only a limited span of time, typically about three months. They play out in real time, adding to the intensity of the experience, and unfold much like a serialized story, with new pieces of narrative being unlocked as players solve the puzzles.

ARGs have become so popular that four or five of them are usually running at the same time. The rapid rise of this new form of story-game has caught many people by surprise, for the phenomenon seems to have sprung up from nowhere. In point of fact, however, ARGs are closely related to live role-playing games, which have been around for decades. They also have some of the characteristics of earlier works of digital storytelling, such as *The Blair Witch Project* and *The Spot*, both of which presented fictional stories as true-life events. In addition, the

antecedents of ARGs date back to even earlier forms of entertainment, such as mystery novels and scavenger hunts.

People who play ARGs call themselves ARGers, and they are often passionately devoted to the genre. They have coined a mantra for this type of entertainment: "This is not a game." It reflects the way ARGs spill out into the real world and seem not to be fiction at all. In fact, ARGers use another term to describe works in this genre, "unfiction," which also happens to be the name of a major website about ARGs. As a striking case of art imitating art, the characteristic blurring of gameplay and real life in ARGs was captured in 1997 in David Fincher's film, *The Game*, released four years before the first ARG was ever made.

The ARGs that have reached the public thus far have used an astounding variety of media and techniques to impart clues, puzzles, and bits of the story. The Internet has been employed in virtually every way imaginable, including faux websites and blogs, emails, webcams, podcasts, and instant messaging, with much use of Flash animation, audio, and video. Mobile devices have also been pressed into service in a variety of ways, as we will see in Chapter 20, as have landline phones and even pay phones. Faxes, letters, and postcards have also played a role in ARGs, and so have full-length books. In addition, ARGs have partially played out in such "old media" forms of communication as newspapers, magazines, radio and TV commercials, TV shows, posters, and billboards. Clues have even been embedded in jars of honey and printed on banners pulled by airplanes.

Furthermore, almost all major ARGs have staged live events, with professional actors playing the parts of characters in the story. Two particularly dramatic scenes were a fake fight that broke out at a video game conference and an extremely realistic break-in of an automobile showroom and the theft of a valuable car.

THE CREATION OF THE WORLD'S FIRST ARG

The Beast, described at the beginning of this chapter, was the first ARG ever to be made, debuting in 2001. It was produced by Microsoft to serve as a stealth marketing device to promote Steven Spielberg's movie AI. The creative work fell to an enormously talented and visionary four-person team, headed up by executive producer Jordan Weisman. In time, the players would affectionately dub this group "the Puppetmasters," a term that is now applied universally to all ARG creative teams.

Even though *The Beast* was designed to promote a major movie, it did so in a very surreptitious way. It was given no publicity but instead was spread by viral marketing. Furthermore, nothing in the game directly referred to the film. The project was not even given a formal name. It received its nickname, *The Beast*, because at one point its asset list totaled 666 items, the numeric sign of the Devil. *The Beast* name stuck, no doubt in part because its puzzles were so fiendishly difficult to solve and because its story elements were so complex and challenging to piece together.

Story or Game?

The people who played *The Beast* were united by a common goal: to figure out who killed a fictional scientist named Evan Chan, and to learn why he was murdered. The mystery could only be solved by working through a series of complex puzzles. So, did that make *The Beast* a story or a game? With its well-structured story arcs, fully developed characters, and emotional punch, it had strong narrative elements. Yet, unlike other kinds of stories, it was broken into tiny fragments that had to be discovered and pieced together. And the use of puzzles gave it a strong, gamelike quality. Unlike a game, however, it had no rules, no prizes, or victory conditions. When all was said and done, it was a new type of experience, both story and game, and not definitively one or the other.

The Beast was "told" in part via everyday methods of communication like telephone calls and emails. It penetrated the real world even further by staging live events, like the antirobot rallies mentioned earlier. Websites, its major workhorse component, numbered in the hundreds. They looked completely realistic and bore no traceable link to the movie or to Microsoft. Both the copy and the graphic design of these sites were entirely in keeping with the various organizations or individuals who were purported to own them, and, like websites in the real world, they varied enormously in style. The copy for each was written in a style appropriate for its owner, just as a character in a screenplay speaks in his or her own unique voice. (See Figure 17.1.)

Figure 17.1

The Belladerma website is one of the hundreds of faux websites created for The Beast, each a tiny fictional universe. This website "belongs" to a company that manufactures sexy artificial companions. One of its products, a robot named Venus, is a suspect in the murder mystery. Image courtesy of Microsoft.

Only one aspect of these websites indicated that they were not as real as they seemed to be: They all pertained in one way or another to the future, to the year 2142. Though the players recognized that the mystery was a fiction and that the story was set decades in the future, the realism of *The Beast* made it possible to temporarily suspend disbelief and to plunge them fully into the drama.

According to Sean Stewart, the lead writer and codesigner of *The Beast*, the narrative contained five arcs, something like the acts in a play or the movements of a symphony. The plotlines started as far away as possible from the story in the film, but they gradually converged and pointed to the events portrayed in the movie. And although Stewart and others on the creative team controlled the basic beats of the story, they did give the players a hand in shaping certain aspects of the narrative and in giving them a say on how it would end. The climax revolved around whether or not the robots in this futurist world would be emancipated. The Puppetmasters put that decision up to the players and let them vote on it. "The players genuinely affected the world," Stewart said. "Their vote determined the fate of intelligent machines."

The Rabbit Hole

The first clue that tipped people off to the existence of the game was a strange piece of information included in a trailer for the movie. A woman named Jeanine Salla was given credit as the film's "sentient machine therapist"—in other words, a shrink who treated robots. A little online research by a curious observer of this credit would uncover the puzzle-looking Salla family website, made by Dr. Salla's granddaughter. (See Figure 17.2.) In turn, it linked to a number of other odd websites, all set in the future, and the game was off and running. The Salla website was thus the path into the story, an entry point known in ARGs as *the rabbit hole*.

Soon after the game went live, several thousand hard-core players joined forces and worked together in a tightly knit online association, the Cloudmakers. They collaborated in finding and interpreting clues and solving the puzzles, and they posted thousands of messages speculating with each other about the twists and turns of the story. This type of player collaboration and socialization has become a hallmark of ARG playing.

The Puzzles

In order to follow the story of Evan Chan and the half-dozen or so other major characters, and to be able to solve the murder mystery, it was necessary to solve the puzzles. The Puppetmasters deliberately constructed them to promote collaborative puzzle solving, which was an enormous gamble, since nothing like this had been tried before. To get the players to work together, the Puppetmasters designed them in such a way that they required a greater sweep of knowledge than any single individual was likely to possess. Some, in order to be solvable, also required critical pieces of information found in geographically separate places. Others called for unusual devices or special

Figure 17.2
The Salla family home page on the Web was the portal, or "rabbit hole," through which most players entered the futuristic world of *The Beast*. Image courtesy of Microsoft.

technologies like a certain type of Japanese cell phone or sound editing software. Many required fairly uncommon skill sets like translating archaic languages or the ability to read and play sixteenth century lute tablature.

However, not all the puzzles were meant to be tremendously difficult. Some, especially at the beginning of the game, were designed to appear baffling but to be fairly simple to figure out to give players confidence in their ability. For example, the game's chemistry puzzle looks extremely intimidating (see Figure 17.3), but it can be worked out by pretty much anyone who thinks of downloading the periodic table of the chemical elements. The solution to the puzzle spells out "coronersweborg," which is clearly the URL for a website—a coroner's office. Players who visited it could learn more about the murder victim, Evan Chan.

Figure 17.3
The chemistry puzzle from *The Beast* seems much harder to figure out than it actually is. Image courtesy of Microsoft.

But Can You Take out the Puzzles?

But what if you took away the puzzles, or had players who simply didn't want to spend time solving them—could *The Beast* just be enjoyed as a story? Stewart says many participants experienced *The Beast* in just that way. The Puppetmasters referred to them as *lurkers*, a term now widely used in discussions of ARGs. *The Beast's* lurkers followed the events of the story and the puzzle solving by reading the discussions on the Cloudmakers site. This way, they could enjoy the vicarious pleasure of seeing puzzles solved without having to do the work themselves. They could receive emails, call the phone numbers of the fictional characters or institutions, and visit the websites that interested them. "Most people are lurkers," Stewart said. "They like to eavesdrop. You've got to make things fun for them, and not obligate them to play."

Nevertheless, Stewart believes both the story and the puzzles were critical parts of *The Beast*. The story was important, he said, because "if you don't have a cool story, you are dead. Narrative always works. It is a very well-tested medium." As for the puzzles, he said, they added the important element of interactivity and provided an impetus for the players to collaborate and form a community.

Why So Compelling?

Many players poured every free moment of their time into the game, and one has to ask what made it so compelling. Certainly, part of it was the desire to solve the puzzles and to uncover the secrets hidden in the story, to see the plotlines resolved. But Stewart points to two other possible reasons that are unique to the ARG: First, because *The Beast* entered the players' daily lives in the way it did, it pulled them right into the drama. The game gave them a heightened sense of reality, of their lives being less humdrum and more dramatic. Every

aspect of their lives had the potential of being part of the unfolding murder mystery. When the phone rang, a player would never know whether it was his mother on the line or one of the characters in the game.

Second, Stewart suggests that the game empowered the players in a highly intoxicating way. It gave them the sense that by working together, they could solve any challenge; that collectively they were incredibly smart, far smarter than they were as separate individuals.

A New Form of Storytelling?

Stewart's perspective of *The Beast* is that of a novelist, his primary occupation (he is the author of a number of highly regarded works of literary science fiction and fantasy). He regards *The Beast* as a prototype for a new form of fictional narrative, calling it "the storytelling of the twenty-first century." He calls this new genre a *distributed narrative*. This type of storytelling, he notes, places the onus on the audience to gather the pieces and make sense of them, somewhat like assembling a jigsaw puzzle.

Though working on the game required Stewart and the other Puppetmasters to be trailblazers, and it had them bushwhacking through some totally unexplored territory, Stewart recognized that in some ways his writing role was not too unlike what other writers had done before him. Essentially he saw himself as following the old-fashioned craft of serial writing, a form of fiction that Charles Dickens had practiced so successfully in the nineteenth century. But, of course, a few things made this particular writing job unique. The story was being told via methods of communication that had never before been used for telling stories before, such as the Internet and phone calls, and it was a collaborative experience between the authors and "the audience."

"STAYING IN THE CAR"

At one point in his life, Stewart had been a game master of live role-playing games, and he recognized that an interactive game like *The Beast* had to be a two-way process. The creators could not just put something out there on the Internet and leave it at that. They had to be responsive to the players and give them a certain amount of behind-the-scenes direction. As he put it: "Once you let them drive the car, you have to stay in the car."

Like almost all new developments in the arts, *The Beast* and other ARGs could only be possible because of technological advancements—in this case, digital media. As Stewart pointed out, the novel could not exist until someone invented the printing press. "Anything that allows you to lie will become an artistic medium," he asserted. "After all, what are stories, but artistically presented lies?" Of course, it takes time for a new art form to develop its own unique characteristics. For example, the first automobiles closely resembled the

horse-drawn buggies they replaced because buggies were the logical model for the manufacturers to draw from, and automobiles were even called "horseless carriages." Perhaps someday, Stewart speculated, *The Beast* will seem like a narrative version of the horseless carriage.

MAJESTIC WADES INTO THE WATERS

Just about the time *The Beast* was rolling to a close, another major ARG entered the market, the highly anticipated *Majestic*, produced by heavy-hitter Electronic Arts. Set in the contemporary world, the story revolved around an intense conspiracy-driven plot. Like *The Beast*, it was largely played on the Internet, and many of its narrative elements were embedded in realistic-looking websites. Its characters communicated with the participants by instant messaging and email, though they also sent faxes and made phone calls. Players could follow the story by downloading videos that had been "shot" by the characters and by listening to audio messages.

Pulling out all stops, EA hired a Hollywood feature film writer to write large parts of the story and it got off to an ingenious start. Soon after players signed up for the game, they would receive a shocking fax saying that the game had to be suspended—a fire had destroyed *Majestic's* development company, Anim-X studios. The fax was on the EA letterhead and signed by the EA customer service department; it looked completely authentic. Actually, of course, the document was just part of the game. It was an effective way to thrust the player into a tale involving youthful high-tech professionals—people probably much like themselves or their friends—who become unwittingly sucked into a conspiracy involving aliens, government mind control experiments, and New Age mysticism.

The game utilized technology in innovative ways, including a clever IM system in which bots realistically conversed with the players. The story was well developed, and the game's assets were generally of high quality, with video and audio segments made by Hollywood professionals. Nevertheless, despite its ambitiousness and generous funding, estimated at some \$10 million, *Majestic* fared poorly in the marketplace. The game was never able to achieve the critical mass it needed to sustain itself, and EA pulled the plug several months after its launch.

The Beast versus Majestic

Because *Majestic* made its debut several months after *The Beast* did, in the summer of 2001, many people erroneously believed it was imitating the Microsoft game. In truth, however, the development teams of the two games just happened to be working along parallel tracks. The emergence of these games within such a close span of time was sheer coincidence. Certainly, however, they were both spurred by similar perceptions: that the Internet was robust enough to use for a new type of gaming; that various communications technologies could be used in conjunction with the Internet to simulate real life; and that people might enjoy a game that blurred the lines between games and reality.

However, significant differences existed between the two games. For one thing, *The Beast* took an under-the-radar approach to making itself known, depending on viral marketing, and hiding the fact that it was a fiction. *Majestic*, on the other hand, mounted a multimillion dollar marketing campaign to publicize itself, and in doing so, flagged the fact that it was a game. The publicity undermined *Majestic's* ability to make the events of the story seem real and believable, and disenchanted hard-core ARGers, who enjoyed the illusion that "this is not a game." For another thing, *The Beast* was free, while *Majestic* was a subscription service. And *The Beast* was a continuous, unbroken playing experience, while *Majestic* was divided into episodes.

But perhaps more significant than these differences were their dissimilar approaches to content. *Majestic* was designed for solo play and did not lend itself to the collaboration so important to playing *The Beast*. Furthermore, players had virtually no way to have an impact on *Majestic's* storyline or to affect the way the game proceeded. It was stubbornly unresponsive. The Puppetmasters of *The Beast*, on the other hand, stayed keenly in tune with their players. They tooled and retooled the game with them in mind, gave them ways to feel involved, and let them decide on the ending.

Serving Two Masters

Quite possibly, *Majestic* tried too hard to serve two masters and was unable to please either one sufficiently well. According to Neil Young, the EA executive who created *Majestic*, the game hoped to attract both the newbie player and the experienced gamer. The company believed that by having an exciting story, by painting the game on a new kind of canvas, and by inventing a compelling concept—"the game that plays YOU"—they would draw people who did not normally play games. They also felt that by offering the game in monthly episodes, with about 30 minutes of playing time a day, they would appeal to older gamers. These gamers, it was felt, still yearned for interactive entertainment but no longer had the time for demanding video games or MMOGs.

But in trying to serve two masters, *Majestic* ended up disappointing both. The newbies complained about having to download the tools needed to play the game, and they had trouble following the clues and solving the puzzles. Meanwhile, the experienced gamers grumbled that the puzzles were not challenging enough.

SOME OTHER NOTEWORTHY ARGS

As a genre, ARGs are still in their infancy, and almost every new ARG breaks fresh ground. In Chapter 9, for example, we saw how *Push*, *Nevada* was the first ARG to be built around a prime-time television series. We also saw how *The Lost Experience* employed such devices as faux TV commercials and planting a "spokesman" from a fictitious organization on a TV talk show. In Chapter 20,

we will be discussing two games that have found innovative ways to use mobile devices as the fulcrum medium in ARGs, *The Q Game* and *The Nokia Game*.

Though space does not allow for an examination of all the interesting ARGs that have been introduced since *The Beast*, let's look at a handful of noteworthy ones.

Who is Benjamin Stove?

In Chapter 12, in our discussion of how ARGs are used in promotion, we briefly discussed the ARG, *Who is Benjamin Stove?* Let's take another look at this game, focusing particularly on its story and gameplay.

The rabbit hole in this case is a website that seeks information about a strange painting of crop circles and a man named Benjamin Stove who evidently has some connection to it. To unravel this mystery, players must follow clues that lead them to certain books in various public libraries. If they succeed at this, they will find handwritten notes tucked inside the books that have supposedly been written by Benjamin Stove and contain valuable information relating to the story. (See Figure 17.4.) The concept of creating realistic "artifacts" in the form of handwritten notes and concealing them inside public library books are two of the highly innovative features of this ARG.

THE PRESSURE TO BE INNOVATIVE

According to Dave Szulborski, who not only served on Benjamin Stove's creative team but on 11 other ARGs as well, designers of ARGs are under constant pressure to find new ways "to move the narrative and interactivity into the real world, as well as incorporating new and exciting technologies into the structure of the ARG. It's important to remember, however, that no matter how clever or innovative the delivery mechanism may be, a well written and engaging story is still the single most important element of any successful ARG."

Thus, Szulborski reaffirms what has been stressed throughout this book: That good solid storytelling is of critical importance in digital entertainment. Cutting-edge technology and clever approaches, while attractive assets, are no substitutes for strong narratives.

I Love Bees

I Love Bees, an ARG that was developed to market the video game Halo 2, was created by the same team responsible for The Beast, though by this point they had formed their own company, 42 Entertainment. The game started off in an intriguing way, with influential ARGers receiving jars of honey containing clues leading them to a website called Ilovebees.com. The most innovative feature of this ARG, however, was the use of pay phones. Players would receive the GPS

Figure 17.4

One of the artifacts from Who is Benjamin Stove?, a handwritten note that was tucked inside a library book in a public library in Seattle. Image courtesy of Dave Szulborski, GMD Studios, and General Motor's Live Green, Go Yellow campaign.

coordinates leading them to payphones all over the United States and would stand by the phones, waiting for them to ring. When they did, they would hear cryptic messages with important bits of the story. Sometimes the messages were delivered by a recorded voice and sometimes by a live actor representing a character in the story.

The Art of the Heist

The Art of the Heist was created to promote the A3 Audi, and the ARG was a standout for its innovative use of staged events. It started off with the seeming break-in of an Audi showroom on Manhattan's upscale Park Avenue and the theft of a brand new A3. It was the players' "job" to track down the stolen car and to discover the role it played in a much larger criminal scheme involving an art heist. The game culminated at a live event in front of a New York hotel that revealed the identity of the story's master criminal.

Last Call Poker

Like I Love Bees, Last Call Poker was created by 42 Entertainment and was also designed to promote a video game, in this case, the Western-themed Gun. Even the registration process for Last Call Poker contained an odd twist, for instead of being asked your birth date, you were asked instead for the date of your death. True to its name, the game offered ample opportunities to play poker. You could play the game online, with long-dead characters from the old West. But, if that were not strange enough, you could join other players in the game's most unique feature, a live version of poker called Tombstone Hold 'Em. This game of poker, played in six cemeteries in the United States, involved the use of tombstones as "cards." Playing the game unlocked clues to the story, and ARGers flew in from distant locations to participate.

Perplex City

Perplex City is one of the rare ARGs that is not designed as a promotional vehicle but instead functioned as an independent game. It was developed by the London-based company Mind Candy and was created in part by two brothers who were avid players of The Beast. The storyline centers on the theft and attempted retrieval of a strange cube-shaped object that may have come from an alternative universe. ARGers were alerted to the game by a "lost and found" ad placed in English-language papers all over the world.

The most unique aspect of *Perplex City* was the role of collectible puzzle cards. About the size of standard postcards, they not only held clues to the game but were entertaining in the their own right. The materials for the game also included a realistic-looking tourist brochure for the metropolis of the fictional Perplex City, complete with a map of its subway system. As an enticement to play, potential retrievers of the cube were offered a \$200,000 reward.

Save My Husband

Initially, *Save My Husband* appeared to be a true-life crime story. It began with a distraught woman appearing in a TV clip on the Court TV channel, pleading for the return of her kidnapped husband, and directing people to a website with more information. At first the website also looked authentic. It contained a grainy video of the kidnapping scene and additional video from the victim's wife. But soon disclaimers began to appear on the website, making it clear that this was a sponsored game, backed by a restaurant chain, a brand of automobile, and the Court TV channel.

The eight-day long game invited players to solve puzzles that would unlock clues to why the husband had been kidnapped and where he might be. Any players who correctly identified the kidnapper and the address where the victim was being held would receive a share of a \$25,000 reward. As promising as the concept sounded, however, it was severely criticized both by experienced ARGers and by newbies, and for some of the same reasons leveled at *Majestic*.

First of all, the website's disclaimers and the heavy-handed promotion of the restaurant chain (where many of the game's videos were set, with the restaurant's logo featured prominently in the background) violated the "This is not a game" mantra of ARGers. Second of all, the developers thoroughly misjudged their audience. On one hand, they underestimated the sophistication of the experienced ARGers, who quickly figured out where the clues were "parked" and solved them long before they were even released. And they hadn't anticipated the confusion and anger of the newbies, who regarded the communal sharing of clues and information to be "cheating." In addition, many players found the story disjointed and the puzzles too easy, though it should also be noted that other players enjoyed the experience, despite the game's shortcomings.

THE "OVALTINE MOMENT"

As we have seen here, ARGs are often used as promotional vehicles. Designer Dave Szulborski advises that when ARGs are used for promotion, the creators should be careful to avoid what is known as the "Ovaltine Moment." The term comes from a scene in the movie *A Christmas Story* in which a boy named Ralphie eagerly uses a decoding ring to decipher an encrypted message only to discover it urges him to drink Ovaltine.

Says Szulborski of using such a blatant approach in an ARG: "It's not necessarily bad for an ARG to be obviously promotional What's critical, though, is that the corporate sponsorship or their message isn't part of the 'big reveal' or climax of the game. That's the Ovaltine Moment—when a player has devoted a lot of time and energy following a game and trying to figure out all its mysteries, only to have it all lead to a web page saying 'Drive Fords! They're great!'"

Casablanca

In an inventive blending of two different types of experiences, *Casablanca* combines an ARG with a social networking game. Primarily played on mobile phones and the Internet, the game is set against the backdrop of World War II. Essentially, it is an acting out of the basic conflict depicted in the movie *Casablanca*. Players form two teams, the Resistance on one side and the Occupation on the other. The Resistance Fighters try to recruit as many people as possible to their network, while the Occupation tries to infiltrate the group and bring them down.

The game was dreamed up by four students at New York University. They entered the concept in the "Digital Incubator" competition sponsored by mtvU and Cisco Systems and won a \$30,000 grant to develop it. As of this writing, the game is in its first weeks of being played, but early word on it has been extremely positive.

LESSONS LEARNED

Not all ARGs have been commercially successful or have reached their desired audiences, but the vast majority of them have been quite innovative, and some have been stunning achievements in breaking new narrative ground. As different as these various projects have been from each other, we can some learn important lessons both from the successful ARGs and the less successful ones:

- As always, you need to understand your audience and provide it with an
 experience they will perceive as enjoyable, not as too difficult or too simple, or too confusing or overwhelming.
- In an ARG, story elements and gaming elements are both extremely important, and neither can be shortchanged without weakening the overall project.
- Members of the audience want to be able to participate in a meaningful way and have some impact on the story or game.
- The creative team cannot set the game in motion and then walk away from it; they need to "stay in the car" and be responsive to the players.
- The barriers to entry should be set as low as possible, so you don't discourage those who are less technologically sophisticated from participating.
- If possible, provide a way for people who are not hard-core gamers to enjoy the experience, but on the other hand, don't cater to the newbies to such an extent that serious gamers will be disenchanted.
- When at all possible, develop all components of a project simultaneously, from the ground up, and work how the narrative will be divided up among the different types of media and vehicles of communication that are being used.
- Construct the property in such a way that it will foster community building and interplayer collaboration. ARGs that encourage group play, as opposed to solo play, tend to fare better.

ADDITIONAL RESOURCES

Two websites have been established that focus exclusively on ARGs. They are the ARG Network (www.argn.com) and Unfiction (www.unfiction.com).

Also, the players' website made for *The Beast* has been preserved. Called Cloudmakers, it contains links to its archived websites, a walkthrough, and a guide, which includes an excellent postmortem. The materials on the site comprise a fascinating study of the game: www.cloudmakers.org.

CONCLUSION

As we have seen, the ARGs created so far have employed a wide variety of approaches. Although not every ARG has been a successful venture, as a whole they exemplify what digital storytelling is all about: They contain strong narratives; they offer genuine agency; they are extremely engaging; and they make good use of the unique attributes of digital media.

Even though the fist ARG debuted as recently as 2001, many outstanding works have already been produced for this genre. Still, Sean Stewart, lead writer for *The Beast* and other ARGs, suggests that ARGs are still in their "horseless carriage" days. If this is true, we have some exciting things to look forward to as this new form of narrative evolves.

IDEA-GENERATING EXERCISES

- **1.** Have you personally played an ARG? If not, why have you not done so, and what do you think would make you more interested in entertaining yourself this way? If you have, what about the experience did you enjoy most? What about it did you not enjoy? How do you think your own experiences and perceptions of ARGs could be used to make this form of narrative attractive to greater numbers of people?
- **2.** Many ARGs include complex puzzles, and such puzzles often require the collaboration of many players in order to be solved. What specialized areas of knowledge do you have that might lend themselves to the development of puzzles? Can you suggest how a puzzle might be constructed based on one of your special areas of knowledge?
- **3.** A variety of different media and communications tools have been employed in ARGs. Can you think of any media or tools that, to your knowledge, have not yet been used but might lend themselves to an ARG? If so, how do you think such media or tools could be employed?
- **4.** Select a type of product that you feel could be promoted in an ARG. Sketch out an idea for an ARG that could be built around this product.

Interactive Television (iTV)

What are some of the major creative hurdles that developers of iTV programming are faced with?

In creating interactive programming for television, what kinds of enhancements work best, and what tends to detract from the linear content?

Is it possible to develop effective interactive enhancements for a drama, and if so, how can this be done in a way that does not interfere with the core program?

WINNING OVER THE COUCH POTATO

OK, Mr. or Ms. Couch Potato, which will it be?

- The chance to compete with other viewers and win prizes in a trivia competition based on the TV show you are watching?
- The chance to see highly personal and emotional "bonus" material from the point of view of one of the characters in a serialized drama?
- The chance to determine which camera angle to watch the NASCAR race from, including one from the point of view of the driver? Or.
- The chance to solve tonight's mystery on your favorite crime show?

In truth, the most likely answer is "none of the above." Though all four of these iTV scenarios have been produced and broadcast, most viewers are not aware of them and would have trouble seeing them even if they wanted to. This is because iTV is an area that has progressed in fits and starts, and it has suffered significant setbacks over the years.

Surprisingly, iTV has a very old history in terms of interactive media. The first public iTV trials date way back to the 1970s, when the Internet hadn't even been born. But unlike the Internet, which took off in a massive way, the progress of iTV has been unsteady, and at times it has threatened to disappear altogether. Thus, despite the fact that millions of homes possess the capability of receiving some form of iTV, most viewers are under the impression that this form of entertainment is something for the far-off future, not something available in the here and now. And, to a large extent, they are correct, because even though the technology for iTV is far more widespread than most people realize, in general there is very little iTV programming to see in most parts of the world.

Unfortunately, iTV must overcome many problems if it is ever to become a mainstream form of entertainment. Professionals within the industry are even hard pressed to agree on a uniform definition of what it is, or what to call it. Along with iTV, it is also referred to as enhanced TV (eTV) and smart TV. Forms of video interactivity cover many possibilities, and not everyone agrees what actually constitutes true iTV. Among the types of video experiences that people in the industry have placed under the iTV and eTV umbrellas are these:

- Interactive programming furnished via a digital set top box provided by a satellite or cable company, known as *single-screen interactivity*.
- The synchronization of content on TV and the Web, calling for a secondary device like an Internet-connected computer or cell phone, known as dual-screen or synchronous interactivity.
- Video on demand (VOD), in which viewers can order movies or other video content from their TV sets or while online.
- Devices like *TiVo*, which are known as personal video recorders or digital video recorders (*PVR*s or *DVR*s) and which offer features like pausing live TV and skipping commercials.

- Interactive program guides.
- Noninteractive enhancements in which additional information appears
 on the screen as a graphical overlay, such as financial news or sports
 scores.

To further complicate matters, the widespread penetration of broadband has turned the Internet into a viable medium for video. As a result, there has been a surge in the numbers of viewers in developed countries watching video online. In addition, thanks to portable devices like the video iPod and advanced types of cell phones, viewers no longer have to be tethered to a TV set to enjoy video content. While some of the video viewed on digital platforms is programming ported over from "regular" TV, an increasing percentage of it has been produced specifically for digital media.

Thus, we are not only looking at many ways of defining iTV but also at a quickly changing landscape for video content in general. For our purposes, let's keep things simple and say that iTV is programming that allows viewers to interact in some meaningful way with the content of a television show or other forms of video, no matter what the platform.

MAJOR HURDLES

Even though our definition of iTV might be simple, little else about it is. This is especially true in the United States, where the field is far less advanced than it is in the United Kingdom, Australia, Europe, and in parts of Asia. Deployment in the United States has been slow because no one uniform standard of iTV broadcasting has yet been adopted. Though several satellite and cable companies offer iTV service, they are not compatible with each other. Also, only a small number of homes are equipped with digital set top boxes that are robust enough to receive iTV programming, and competing iTV set top systems and a lack of uniform standards lead to consumer confusion. Interface devices pose another obstacle. The most common type of interface device in the United States is the remote control, which is not as easy to use for iTV as the color-coded "fast keys" system found in the United Kingdom and Europe. In addition, no strong financial incentives exist among cable and satellite services, broadcasters, or advertisers to press for iTV, leaving the creative end of the field under-supported and under-promoted to the public.

THE CREATIVE CHALLENGES OF ITV

As if the technological hurdles of iTV were not enough, developers face an incredibly difficult challenge when it comes to the creation of programming, and it is this: How do you design content for the interactive aspects of the program that enhances, and does not detract from, the linear content? This is the fundamental conundrum of all iTV developers,

(Continued)

and one for which no clear answers have yet been found. Two other creative challenges they deal with are these:

- Few successful models of iTV exist, and little user testing has been done thus far to see how viewers respond to interactive enhancements. Thus, creators are left without informed guidelines.
- Producers of linear TV shows are generally unwelcoming of iTV producers who
 want access to the set to shoot additional material for iTV elements, which means
 that most iTV content is added after the linear TV show has already been produced.
 This prevents iTV developers from integrating the interactivity from the ground up.

With so many hurdles, it is not surprising that development has not been more rapid or that television viewers have largely been left in the dark about what is happening in the field. If Mr. or Ms. Couch Potato is ever going to become excited about iTV and eager to try it, many of these hurdles will have to be overcome.

THE VIEW FROM THE FRONTIER

Despite the impediments that are slowing the progress of iTV, a number of dedicated professionals in the industry are persevering. They remain upbeat about its potential and are managing to create extremely interesting work in this area. One such person is Dale Herigstad, the chief creative officer of Schematic LLC, an iTV design and production firm. He's been involved in iTV since Time Warner introduced the Full Service Network in Orlando, Florida, back in 1994. Herigstad, who is considered to be a visionary in the field, has probably brought interactivity to more American television shows than anyone in the business.

"This is the frontier," he told me, speaking with relish, not distress. "There are no books on this, no classes on this. We have to invent the rules and figure things out for ourselves. It's a learning experience for all of us." But he admits to certain impatience at how slowly the business side of things is moving. "My mind is exploding with stuff, and it's frustrating because the [set top] boxes aren't there, and the money isn't there."

One of Herigstad's best-known projects is his groundbreaking work on the hit CBS crime series *CSI* (Crime Scene Investigation), which was America's first interactive prime-time network drama. He and his company designed and produced single-screen iTV enhancements for every show in the first two seasons, a total of 48 episodes. In the linear version of the show, viewers watch a team of investigators as they visit crime scenes and uncover clues, using logic, experience, and scientific tools to solve their cases. Viewers fortunate enough to be able to see the interactive version of this show could probe more deeply into the cases, getting additional information, for example, on the science of

fiber analysis or about the geographical relationships between the different locations in the mystery. One of the most unique aspects of the interactive version was the chance to solve the case alongside the fictional investigators, as if you were one of the team, with the chance of "becoming" a highly ranked investigator.

Herigstad termed *CSI* "the perfect show to work on" because it was so well suited for enhancements. Curiosity about the clues and the desire to figure out the mystery gave viewers a powerful incentive to utilize its interactive features. However, because his company did not have access to the set during filming, the enhancements had to be added after each show had already been shot. His company would get the work print of the show and watch it with an eye toward elements that would lend themselves to different types of enhancements, and then his writer would work on the interactive content.

A "Perfect World" Vision

Although Herigstad called the *CSI* assignment "a dream job" and said he learned a great deal from it, he indicated that in a perfect world, he would have done some things differently. For example, he felt the enhanced version could have been richer if his team had had access to more assets, such as B roll footage (scenes that focus on details or general shots rather than on the main characters), or even better, had been able to have a production crew on the set.

Had that been possible, he said, they could have shot special footage just for the enhancements. For instance, they could have added more of an emotional dimension to the story by creating flashbacks showing scenes from a character's past. They could also have shot footage that would have offered the viewer a choice of camera angles for important scenes.

LESSONS LEARNED

For all the challenges that developers of iTV programming face, Herigstad nevertheless remains enthusiastic about its possibilities, and he shared with me some general lessons he has gleaned about developing interactive content for television. He said the work he has done so far has shown him that

- interactive enhancements should be choreographed to the program and not forced upon it; the pacing is important;
- 90% of what you are trying to figure out is the balance between the passive and the interactive elements;
- what constitutes a value-added experience is different for every show, and what is successful for one will not necessarily be appropriate for another;
- because TV viewers are sitting back and can't see the TV very well, they need the visuals to be very clear and simple, and they don't want to read much text;
- they like things to be easy and prefer to respond, not to initiate.

Herigstad says he has a mantra about enhanced television, and it is this: Enhanced TV is television, television. It's not the Web and it's not something else. And television, above all, has always been a simple experience.

PUSHING THE ENVELOPE

One institution that is committed to pushing forward on the creative front is the highly regarded American Film Institute, which runs an iTV initiative called the Digital Content Lab. It was founded in 1998 to stimulate the creation of compelling work in iTV and to serve as an evangelist for the medium. In recent years, it has expanded its mandate to include all types of television-like content, no matter what digital platform it runs on.

Each year the Lab coordinates the production of an average of 8 to 10 prototypes of iTV programming. Usually they use already-produced television shows as the linear base, although sometimes they develop projects from the ground up. To create and build the prototypes, representatives from the linear TV production company are matched with volunteer mentors from the iTV community. The mentor group typically includes a production manager, an interactive designer, a programmer, a commercial strategist, and sometimes a writer. In addition to prototype development, the Digital Content Lab holds at least one major event a year that brings together an international group of experts on iTV and showcases some of the world's most innovative work in interactive programming.

AFI encourages its prototype teams to begin their work by first considering the main objectives of the enhancements. The possibilities they suggest are

- to add dimension to the show's characters (which can pertain to real people in nonfiction programs as well as characters in dramas and comedies);
- to allow viewers to delve more deeply into the subject matter;
- to serve as an educational springboard for young learners;
- to provide an opportunity for self-exploration;
- to explore sensitive social issues and offer a forum for community building.

Over 50 prototypes have been made so far, and they run the gamut of TV fare, including sports, news, and award shows; comedies, dramas, documentaries, and commercials; and educational, informational, and children's programs. Each type of show has raised a unique set of questions and has led to unique solutions, adding up to a stunning array of prototypes.

For example, the team assigned to *The L Word* had to figure out how to enhance a drama. The Showtime cable series is an emotionally intense portrayal of a group of lesbian and bisexual women in Los Angeles (the "L" in the show's title stands both for love and lesbian). The team decided to do two things with the enhancements: to expand the narrative aspects of the show and to pull viewers into the story in a personal way. Thus, they gave viewers the opportunity to watch soliloquies of the characters, during which they revealed feelings that

they hid from other characters in the show. In addition, the drama would pause at several key points and present viewers with multiple-choice questions about their own views of romance. At the end of each episode, the viewer would be rewarded by receiving a personal message from the character who most resembled her (as gauged by the answers she gave to the questions), offering additional comments on the theme of the show.

In a very different type of prototype, done for the HBO show *Arli\$\$*, the team had to figure out how to enhance a comedy. Comedy is tricky because, as Marcia Zellers, the workshop's former director, points out, the danger "is trumping the joke."

And for a project on which I had the opportunity to serve as mentor, our team was given an educational show called *TV411* to enhance. A so-called "adult literacy" project, it is designed to help adults improve their reading and math skills. Our prototype actually made use of two platforms: interactive TV and cell phones. The iTV prototype worked as a tutorial for the subject matter addressed on the linear show, giving viewers extra help with the concepts covered in it. At the end, they could take an interactive quiz to test themselves to see if they grasped the lesson. The cell phone enhancements were done as a game, designed to be short and easy to play, in keeping with the limited literacy skills of the target audience.

With dozens of prototypes now under its belt, the Lab has succeeded in breaking ground in many new directions. Yet its former director, Zellers, believes much still remains to be discovered. "We are in the early stages of this medium," she told me, noting that the participants are still wrestling with the essential puzzle of interactive TV—how to enhance the content without being distracting. "It is a very tough thing to do," Zellers said. "I don't think we've found the golden nugget yet." However, a few general rules can be extracted from the work done so far. She said they've found that

- networks and advertisers don't want attention taken away from the commercials;
- anything that makes it difficult to follow the story is distracting;
- enhancements that are too fast or too difficult or that require too much thinking can be distracting;
- the typically chunky style of Web design is distracting on TV;
- the user interface must be clear and must not be hard to figure out while looking at the TV screen.

iTV'S TO DO LIST

In speaking of where further work needs to be done to advance iTV, Zellers said: "I think we still need to keep hammering away at it. What is the right interface? What truly enhances the program? Technology is just bells and whistles. But how do the enhancements make television more compelling than if we didn't have this technology?"

WHEN ITV BECOMES "JUST TELEVISION"

One often hears a wistful phrase at AFI's iTV events: "Someday we'll just call it television." In this vision of the future, iTV will have become so widespread that it will just be a normal part of the entertainment landscape. Though still a ways off in the United States, the dream is already largely realized in the United Kingdom, thanks primarily to the BBC. Over half the homes in the United Kingdom have access to two-way iTV services from the BBC. And these people don't just have access to iTV; they avail themselves of it. For example, during a recent Wimbledon tennis competition, 64% of those equipped with iTV technology took advantage of it to watch the tournament, switching at will between the action going on in five different courts.

Surprisingly, the success of iTV in the United Kingdom has been an extremely swift development. In November 2001, the BBC created BBCi as a one-stop-shop for all of the BBC's interactive content. This initiative spanned a number of media, including television, the Web, and broadband and mobile devices, and its goal was to give the BBC audience access to interactive content at any time, any place, and in practically any way. At a presentation at AFI's 2002 Creative Showcase, Ashley Highfield, the BBC's visionary Director of New Media (a title that has since been elevated to Director of Future Media and Technology), noted that usage of iTV had surged from 0 to 8.1 million people in a single year. "It took us eight years to do the same on the Internet. If people say interactivity is not possible, they are wrong," he asserted.

Choosing not to rest on its laurels, the BBC has continued to strengthen its iTV and new media programming. In 2006, it reorganized the entire network in order to fulfill its "Creative Future" content strategy, giving new media an even larger role than before.

A Variety of Approaches

The BBC takes a diversity of approaches toward iTV. With the *Antiques Roadshow*, for example, it employed an interactive overlay on top of the video that let viewers guess the value of the heirlooms being examined. This interactive gaming element helped the BBC solve a vexing problem: that of drawing younger viewers to a show that had primarily attracted an older demographic. The gaming overlay not only brought in a new audience, but it did so without changing the show itself.

With the highly provocative series *Diners*, the BBC used an approach similar to the Wimbledon telecast, but in this case the setting was a restaurant. And, as you would expect, the people in the room are eating and chatting. The twist here is that cameras are aimed at diners all over the room—real people, not actors—and the viewer can decide which table they'd like to "visit" and then eavesdrop on the conversation going on there. The multiple camera approach

used on *Diners* suggests some intriguing possibilities for a drama. One can imagine, for example, what Robert Altman could do with this.

The BBC has a large audience of older people and is using different approaches to bring such viewers into the interactive tent. For this demographic, the interactive features are designed to be uncomplicated but satisfying. Thus, the BBC designs shows for older viewers that give them an opportunity to vote on matters they care greatly about, and when feasible, these votes trigger an action. For example, in *Restoration*, a show about Britain's historic houses, they invited viewers to vote on which structure was the most deserving to receive a large grant for renovations. This type of interactivity has proven to be highly popular with the over-40 crowd.

Applying iTV to Drama

The BBC has also experimented with iTV dramas. For example, in a trial in the north of England, it aired short daily segments of a month-long episodic drama called *Thunder Road*. (See Figure 18.1.) The drama was set in a real town, Hull, where the trial was taking place, and it was presented as a blend of fiction and faux documentary. It revolved around a married couple that takes over a rundown pub, the Thunder Road, and has to make a success of it in 30 days or risk losing not only the pub but also their livelihood and possibly their marriage. Each little episode ended on a cliffhanger.

Among the interactive possibilities was the chance to see, via VOD, additional "documentary footage" about the story. These video segments were monologues

Figure 18.1
The BBC's interactive episodic drama,
Thunder Road, offered viewers a variety of ways to interact with the story. Image courtesy of the BBC.

NO "BOLT ONS"

One reason that the BBC has been able to produce so many breakthrough iTV projects is because of the broadcaster's approach to creating them: These projects are created from the very beginning to be interactive, instead of the interactivity being pasted onto already-produced linear shows. As Ashley Highfield explained to me in an email: "Regardless of genre, all our interactive applications begin from the ground up at the time of the programme's commission. They are not considered 'bolt ons' to the linear programme." The BBC's approach encourages far greater freedom in designing the relationship between the linear and interactive content, and it also means that the interactive elements can be produced at the same time as the linear ones, using the same actors, sets, and other assets.

of each of the characters, shot with a hand-held camera to heighten the documentary effect, in which they revealed their thoughts and feelings about the unfolding events. Viewers could also participate in message boards and quizzes. The additional scenes did not change the story itself but gave viewers a greater understanding of the characters.

THE DUAL-SCREEN EXPERIENCE: A REAL-LIFE EXAMPLE

While the United Kingdom has an established infrastructure for single-screen interactivity, the same is not yet true in the United States, as we've noted. Thus, the relatively small number of Americans who have experienced iTV have mostly done so in a dual-screen configuration, watching the linear program on a TV set and interacting through a synchronized website or mobile device. So far, such shows have only been offered on a scattershot basis.

To get a sense of what such an iTV experience is like, allow me to give you a firsthand account of one I participated in, called *Boys' Toys*. It was a weeklong series on the History Channel about gadgets and vehicles that particularly appeal to men—things like motorcycles, private planes, and convertibles.

The main interactive enhancement of the series was a quiz game that viewers could play along with the show. Those with the highest scores for the week could win prizes in the sweepstakes. I logged on to the History Channel's website in order to register and to check starting times and subjects. Scanning the schedule, I decided to go for the one on private planes, which sounded like the most fun. To play, I'd need Macromedia's Shockwave plug in, which I already had. The registration process was easy. I was asked to give my time zone, a password, a user name, and some contact information. Unfortunately, not seeing ahead, I typed in my real first name as a user name, never stopping to think how uncool a girlie name like Carolyn would look if I were lucky enough to make the leaderboard.

A few minutes before the show was to start, I logged on and waited, not knowing quite what to expect. The action got going at 9 p.m., right on the dot, when the interactive interface popped up on my computer screen. It had an appropriately

high-tech gadgety look, complete with gears, reflecting the theme of the series. (See Figure 18.2.) Soon I was engaged in the nonstop business of trying to accumulate points. I had no trouble watching the TV show while keeping up with what was happening on my computer, and the synchronization worked flaw-lessly; but the quiz kept me plenty busy. Some of the questions were giveaways, earning you points just for participating in a poll ("if you could have your own private aircraft, which would you choose?"). But some questions required prior knowledge of aviation (a subject I knew pretty well, being a frequent flyer) and some were based on information already imparted on the show, and you had to stay alert. Slyly, some of the questions were based on commercials run by the sponsor, IBM, so you couldn't slip out for a bathroom break while they were running. The most stressful questions were those that had you wagering a percentage of your accumulated points, and being right or wrong here could drastically affect your total score.

The first time the leaderboard popped up, I was thrilled to see my name on it, number 6! Though I hadn't intended to play for the whole show, I was hooked. But I certainly wished I'd picked a cooler user name, especially because my fellow high scorers had such macho ones—Gundoc, Scuba Steve, and White Boy. No time for reflection, though; the game was on again, and my adrenaline was pumping. Next time the leaderboard appeared, I had risen to number 5. But then came one of those wager questions, and I answered incorrectly. My score plummeted by 600 points and my ranking to 7. It was now the final stretch of the game and I vowed to regain those lost points. Sure enough, when the game ended, I had

Figure 18.2
The interface for *Boys' Toys*, as it looked on a computer screen.
The interactivity was synchronized to the TV broadcast. Image courtesy of A&E
Television Networks.
Reprinted with permission. All rights

risen to number 4! I felt proud of upholding the honor of my gender, though if I were to do it again, I'd pick a name like ToughChik or SmartyPants, just to give the guys a poke. But overall, it was a completely enjoyable and engaging experience. The interactivity added a whole other dimension to TV viewing and kept me glued to the two screens. I had only one complaint with this interactive TV experience, as opposed to a more laid-back linear one: It was impossible to snack.

DIMENSIONALIZING A DRAMA: A CASE STUDY

Using gaming techniques to draw viewers into a linear program, as *Boys' Toys* did so compellingly, has become a fairly standard strategy in iTV, with voting, polling, multiple camera angles, and informational overlays being other popular strategies. But it is far more difficult to find projects that have used storytelling techniques to add interactivity and to enrich the linear program. One rare exception to this is *Cisco's Journal*, an interactive enhancement of the PBS series, *American Family*, produced by El Norte Productions. The project was initially developed for dual-screen interactivity, but when it became apparent that the technology was not yet up to what the producers had in mind, they had to scrap their plans for synchronous interactivity. However, each new installment of the website was launched at the same time as the corresponding TV episode and could be enjoyed alongside it. And even without synchronous interactivity, *Cisco's Journal* illustrates, in a way that is completely different from *Thunder Road* or *CSI*, how a drama can be enhanced using an iTV-like approach.

The series revolves around a multigenerational Latino family in East Los Angeles. One of the members of this large family is Cisco, a talented teenager who is an aspiring filmmaker and artist. Each week that the series was on the air, Cisco would post his artwork online on his blog. It is this intensely personal artwork that comprises *Cisco's Journal* and enhances the linear TV show. Thus, Cisco used his blog to reach out to the world much like Rachel did in *Rachel's Room*, described in Chapter 15.

The idea of employing a character's blog as an enhancement to *American Family* was part of the show's concept right from the beginning, and the part of Cisco was developed with the enhancement in mind. Barbara Martinez-Jitner, the show's supervising producer, writer, and director (sharing writing and directing tasks with producer Gregory Nava), loosely based the story of the fictional Gonzalez family on her own experiences growing up as a Mexican-American in East Los Angeles. She believed *Cisco's Journal* could help her portray the dynamics of a contemporary Latino family, as well as pieces of the backstory, in a highly personal, engaging way—from the perspective of one of the characters. She also felt it would add additional emotional texture to the story.

"I was interested in this as a storyteller, and I wanted to see what you could do with this as a narrative experience," she told me. She also wanted to explore "how to transport people emotionally." She felt *Cisco's Journal* could be a powerful tool, especially with younger viewers, and might help draw them to the show.

To create what would become Cisco's visual blog, Steve Armstrong and his company, Artifact, were brought into the project. The journal that Armstrong

and his group produced is more akin to an artist's sketchpad than a journal. Their use of visuals, sounds, and interactivity proved to be a surprisingly effective way to add dimension to the story of the Gonzalez family and to get underneath the skin of the characters, particularly Cisco's. Armstrong described the journal to me as "an emotional extension" of Cisco and of the TV series.

Cisco is a young man who is wrestling with his identity as a member of his family, as a Latino, and as an American, and all of this is reflected in the pages of the journal. It is a densely layered portrait of a complex character. In order to be able to produce the journal, Armstrong immersed himself in Latino culture, spent time with people Cisco's age, and listened to the music Cisco would listen to. He also worked closely with Martinez-Jitner and read all the scripts. The picture he developed of Cisco was one of an undisciplined youth who, when we first meet him, is a little detached from things. But in the course of doing the journal, he matures. He comes to appreciate himself more, discovers his powers as an artist, and gains a deeper appreciation of his culture. In other words, he moves through a classic character arc.

Cisco's growth as a character is portrayed viscerally through his artwork. Each new entry is thematically tied to a specific episode in the series and is presented as a diptych, an artwork made up of two parts, which, Armstrong explained, is a traditional Latino form. It is reminiscent of an altarpiece made up of two tablets, though in this case, the two parts are two pages of an open journal, with the spiral spine down the center. Sometimes Armstrong would use the diptych form as a way to illustrate emotional conflict (with each side representing an opposing feeling) and sometimes to show complementary versions of the same subject, as in the tribute Cisco made for his recently deceased mother. (See Figure 18.3.) In this diptych, her memorial candles are on one side (and they light up when you roll your cursor over them); on the other side is her beloved sewing machine (which clatters when you run your cursor over it). Another entry about his mother features an image of her pearl necklace. It is coiled in such a way that it spells out her name, Berta. But if you roll your cursor over it, the pearls will drop to the floor one by one, like teardrops.

Armstrong used a mixture of artistic styles to convey Cisco's inner life, often referencing Latino artistic styles and folkloric traditions. One work features dancing Day of the Dead figures; another is an old-fashioned linoleum cut; still another models popular mural art. Most contain an interactive element that lets the viewer participate in the story in some way. For instance, for an episode about the importance of art to the community's young people, you, the viewer, could test your own ability as a spray paint artist. (See Figure 18.4.)

At first, PBS did not quite grasp what Armstrong and Martinez-Jitner were trying to achieve, and they regarded *Cisco's Journal* as just another promotional website. They wanted Armstrong to put a PBS banner across the top and add typical information about the show and cast. But Armstrong stoutly denied that it was a website, contending that it was a fictional extension of the *American Family* story. To add banners and other Web features, he asserted, would eliminate its believability in terms of the story. Cisco was an artist, he told them, not a Web

Figure 18.3
This diptych from Cisco's Journal is a memorial to his mother, who had recently passed away. Image courtesy of Twentieth Century Fox Film Corporation, PBS, and KCET.

Figure 18.4
In this entry of Cisco's Journal, the viewer can become a spray paint artist. Image courtesy of Twentieth Century Fox Film Corporation, PBS, and KCET.

master. Ultimately, PBS came to understand and appreciate the journal's conceit and even ordered new episodes of *Cisco's Journal* when it renewed the series.

Looking back now on the unique work they managed to produce, Armstrong maintains that they were not consciously trying to push the envelope. "We just wanted to solve the creative and character development issues as we confronted them," he said. "We would just ask 'who is Cisco, how would he react, and what are the materials he has on hand?" 'As simple as these questions seem,

by staying focused on them, they were able to create a completely new way to enhance a television program, one that portrays a sophisticated character arc and resonates on a deep emotional level, all with a minimum use of words.

ADDITIONAL RESOURCES

Two good sources of information on iTV are

- iTVT, a publication devoted to iTV: http://www.itvt.com/
- The Interactive Television Alliance (ITA): http://www.itvalliance.org/

CONCLUSION

It would be nice to think that iTV, like the fictional Cisco, could move through a character arc and could metamorphose from an unsure adolescent into a more mature and dependable entity capable of supporting strong artistic visions. Certainly, we can find some hopeful indications that this day is coming. We know that when television viewers have the opportunity to try out iTV, they find it engaging. Audiences in the United Kingdom have demonstrated that even middle-aged couch potatoes, when presented with something that interests them, will willingly participate. And we can also find a number of creative individuals who believe in its potential and are pushing forward on the development front. If and when the technological and financial hurdles are eventually surmounted, it is possible that iTV may finally become, in the words of the folks at AFI, "just television."

IDEA-GENERATING EXERCISES

- **1.** If possible, watch and interact with either a single- or dual-screen iTV program. Analyze the experience, noting whether the interactivity detracted from the linear program or whether it made you feel more involved with it. What aspects of the interactivity, if any, did you think worked particularly well? What aspects did you think were less than successful? What changes would you suggest making?
- **2.** Record a nonfiction TV show, such as a cooking show, a news analysis show, or a children's show, so you can study it. Once you are extremely familiar with it, work out some ways to add interactive enhancements to it.
- **3.** Record a TV show with a strong narrative line, such as documentary, drama, or comedy. Once you have studied it closely, work out some ways to add interactive enhancements to it, first deciding what the goal of these enhancements should be.
- **4.** Sketch out an idea of an original iTV show, either a single program or a series, in which the interactivity is integrated into the concept. What would the objective of these interactive elements be and how would they work with the linear content?

CHAPTER 19

Smart Toys and Lifelike Robots

What could smart toys and lifelike robots possibly have in common with other types of digital entertainment?

When you are dealing with lifelike physical characters, what special challenges do you face?

How is it possible for non-living characters like robots to arouse powerful emotions in humans?

VENTURING INTO THE METAPHYSICAL

The area of smart toys and lifelike robots is an immensely intriguing sector of digital entertainment. It not only involves storytelling skills but also bends one's mind in ways one might never believe possible. I have worked on several smart toy projects myself and can personally attest to the fact that they are uniquely challenging. The work done in this arena alternates between fascinating and frustrating, but it is never humdrum.

Not surprisingly, one finds oneself dealing with a host of creative and technical issues. But in addition, because these objects blur the lines between what is alive and what is mechanical, you must also grapple with perplexing questions touching on psychology, human development, ethics, and even metaphysics. At one point or another, if you work in this area long enough, you will find yourself asking such questions as: "What is intelligence?" or "What is the dividing line between a living creature and a human-made creation?" You might also find yourself pondering this one: "Is it immoral to create a lifelike object that can elicit deep emotions from a human?" or this one: "Is it irresponsible to create objects that blur reality and make-believe to the point where it is difficult to tell them apart?"

EXPLORING THE HUMAN-NONHUMAN CONNECTION

MIT professor Sherry Turkle has spent years investigating the relationships between virtual pets and smart dolls and their human owners. In an article for UNESCO's magazine, *Courier* (September 2000), she said "when we are asked to care for an object, when this cared-for object thrives and offers us its attention and concern, we experience it as intelligent, but more important, we feel a connection to it. The old Al debates were about the technical abilities of machines. The new ones will be about the emotional vulnerabilities of people."

It is unlikely that any other sector of interactive entertainment raises as many profound questions that go to the heart of our identity as humans and as creators.

SMART TOYS AND LIFELIKE ROBOTS: WHAT DO THEY HAVE IN COMMON?

This chapter focuses on the types of smart toys and robots that either have some of the attributes of fictional characters or that can be incorporated into interactive stories. These creations actually span work that is going on in a number of different fields, but we are combining them into a single chapter because of the characteristics they have in common. They are

- lifelike;
- interactive;
- physical as opposed to virtual;

- operated by computer technology;
- endowed with enough personality to enable them to become part of a storytelling experience.

In addition, working with any of these creations involves answering a similar set of questions. How do you use physical, lifelike creations in a narrative framework? How do you advance the plot of such a story? How do you involve the user in it? How do you give personality to an artificial character? How do you communicate with a physical, lifelike artificial character?

Smart toys and robots, are, of course, usually designed for quite different uses—one for play, the other for pragmatic purposes, although the dividing line is not a rigid one.

Smart toys are an enormous sector of the toy market. They include any kind of plaything with a built-in microprocessing chip. The chips operate like tiny computers; they are programmable and hold the instructions and memory of the toys, controlling what they do. Smart toys can include educational playthings that are the equivalent to electronic flash cards. They can also be musical games, touch-sensitive picture books, or child-friendly computers designed for the toddler set (so-called "lapware"). For our purposes, though, we are going to focus on three-dimensional toys that represent living things—humans or animals or fantasy creatures—or playsets that tell a story.

Like smart toys, robots are an enormous category. A robot is generally defined as a device that operates either by remote control or on its own, and it relates in some way to its surroundings. Some robots are designed to be playthings for children or adults and are actually a type of smart toy, and others are built to be part of entertainment or educational experiences. Many robots, however, are specifically built for highly pragmatic functions. In fact, the word "robot" is a variation of the Czech word, *robota*, which means slavelike labor or drudgery.

Robots can be programmed to work in factories and in outer space. Specialized robots perform hazardous duties like defusing bombs, and miniature robots perform various functions inside the human body. Many of these "employed" robots do not resemble in any way what we commonly think of as a robot—an anthropomorphic mechanical creature with arms and legs that are capable of movement and sometimes of speech. However, two members of the robot family, androids and animatronic characters, can look, move, and make sounds like living beings and respond to humans in a lifelike way. These robots have particular relevance to digital storytelling.

A LONG HISTORY

Although computerized versions of living beings are a relatively new phenomenon, people throughout history have been beguiled by the idea of a nonliving creature coming to life. Myths, legends, and works of literature and popular entertainment are filled with such tales. One of the best-known Greek myths, that of Pygmalion and Galatea, is about a sculptor whose carving of a beautiful

woman comes to life. The story inspired the musical comedy for *My Fair Lady*, as well as the work of interactive fiction *Galatea*, described in Chapter 4.

In medieval times, Jews told a story about the Golem, a mystically created monster made out of clay who was called upon to protect the Jewish community from attackers. Children have their beloved story of Pinocchio, of course, about the puppet who longs to be a real boy. Science fiction writer Brian Aldiss wrote a short story, *Supertoys Last All Summer*, based on a similar theme, about a robotic boy who longs to become human. Steven Spielberg turned the story into the movie *AI*. If you saw it, you might remember that the little robotic boy in the film has a smart toy of his own, a wise and endearing teddy bear. *AI* was, in turn, the springboard for the ARG *The Beast*, described in Chapter 17, which is all about robots intermingling with humans.

But robotic characters do not merely exist in works of the imagination. Almost as long as we have told tales about such beings, we have also tried to construct them. Over 2000 years ago, for example, a brilliant Greek engineer named Hero of Alexandria was famous for inventing a number of astounding automata self-operating mechanical figures that could move, and, in some cases, make lifelike sounds. Among his works were singing birds, a satyr pouring wine, and a scene depicting Hercules shooting an arrow into a dragon that hisses. The demanding craft of constructing automata was taken up by Arabians and then revived in Europe in the Middle Ages, leading to wondrous clocks that featured parades of mechanical characters when the hours were struck. One craftsman even invented a duck that could supposedly eat, digest food, and eliminate the waste. Many of the most illustrious scientists of the day worked on automata, leading to some important breakthroughs in science and engineering. The tradition continued into the nineteenth century, with no less an inventor than Thomas Edison applying his genius to the construction of lifelike animated figures. Edison successfully created a talking doll, patented in 1878, which caused a sensation. It used a miniaturized version of another of his inventions, the phonograph record.

TODAY'S SMART TOYS

Beginning in 1985, the first true smart toys entered the world, led by Teddy Ruxpin, a singing, storytelling teddy bear. Each new generation of smart toys was increasingly sophisticated. Many of the smart toys available now have various types of sensors that enable them to "perceive" things like sound, touch, or changes in position or light. Sensors can also enable them to "recognize" objects—pretend food, an article of clothing, or a playpiece like a sword or magic wand. They may also have sensors that enable them to recognize and interact with fellow toys. A number of smart toys also "talk"; some even have voice recognition and can carry on a simple conversation. They may also have individualized emotional responses and in turn may be designed to elicit emotions from their owners. Smart toys may develop intellectually and physically over time like a real puppy or human child. Some even have built-in calendars

and can wish their owners happy birthday or Merry Christmas on the appropriate days. It is no wonder that a toy that possesses many of these traits is called smart.

Smart toys utilize some of the most advanced technology of any of the interactive platforms. Thus, breakthroughs in smart toys can potentially lead to breakthroughs in other areas, just as the work done on automata in the Middle Ages led to advances in science and engineering. Furthermore, designers of smart playsets deal with many of the same spatial, structural, and architectural issues as designers of video games and interactive cinema, potentially leading to a cross-fertilization of works in these areas.

THE CHALLENGES OF CREATING A SMART TOY

To illustrate some of the challenges one is faced with in designing a new smart toy, let's look at a project I was called in to work on, an interactive dollhouse populated by a family of four tiny dolls. I was part of the development team assembled by a subcontractor to the large toy company that would be manufacturing it. At the time we were brought in, the toy manufacturer had already done considerable groundwork in terms of the architecture of the house and had also determined that its residents would be a mother, father, and two girls. Our job would be to work out what happened when a child actually played with the dollhouse—the nature of the interactivity and how the dollhouse could "tell" stories. Among the questions we had to ask ourselves (and which we eventually managed to answer, after much brainstorming and hair tugging) were:

- What kinds of stories could you tell in a little physical world, especially when you did not know when a particular character would be present or what room it would be in?
- How could we control the action or flow of a story in this environment?
 What would trigger the advancement of the storyline? What kind of structure could work here?
- What genres of stories could work in an environment like this? Was the dollhouse best suited to realistic narratives, to fantasy, or to mystery? What about humor?
- What kinds of controls could we give the child over the experience?
 Could we let the child determine the time of day, what the weather was, or the season? If so, how would these choices determine the narrative experiences?
- How much personality could we give to the residents of the house, and how would they relate to each other? Would they break the fourth wall and address us directly, or would they be oblivious of our presence?

THE PROCESS OF DEVELOPING A SMART TOY

Smart toys reflect the increasingly computerized world around us. Electronics have become so cheap and pervasive that even toys for infants light up and

sparkle. Microchips are coming down in price and size, while increasing in power, so they can be inserted into more things and given more to do. Despite the opportunities presented by technological advances, however, it is not easy for a new toy to become successful. Thousands of new toys are introduced each year, and they have to compete for limited shelf space and also capture the fancy of the consumer. Before a toy ever reaches the stores, it has to be invented, developed, and manufactured, and each step is filled with challenges.

The Toy Inventor's Perspective

How does someone go about creating a smart toy that has a chance of becoming a winner? Let's hear what Judy Shackelford, a prominent toy inventor, has to say about the process. Shackelford's creations include the landmark doll, Amazing Amy, plus many other groundbreaking toys. Before launching her own company, J. Shackelford and Associates, she had a 10-year stint at Mattel toys, rising to the position of Executive Vice President of Marketing and Product Development Worldwide.

The main challenge in inventing a new toy, Shackelford told me, is to find the point of differentiation—to come up with something that hasn't been done before, something that makes it unlike other toys. This point of differentiation can be a look, a mechanism, or any number of other things. "People like me figure out new applications for interactive toys, often by incorporating technology used in computers or other electronics," she explained. "I invent something when there was nothing there before. I conceptualize it and then I hire the appropriate people to work on it on a for-hire basis to help get it born. In a sense, I'm the producer of the toy."

Shackelford describes the process as being highly collaborative, calling for an assortment of experts in various fields, from people who specialize in doll hair design to sculptors to various kinds of technicians. She said an array of factors must be considered when inventing a toy. One of the most important is its play pattern—what you want to happen between the child and the toy. You also need to consider how it will appeal to the prospective purchaser (usually a parent or grandparent) and what its competition will be. In designing a toy, Shackelford cautioned, you have to avoid the temptation to throw everything into it that the toy could possibly do. "That would make it far too expensive," she pointed out. "You can't make a toy the dumping ground for every new technology." Altogether, she said, it takes "an unbelievably complex blend of things to successfully bring a toy to market."

One of Shackelford's most recent inventions was a doll called Baby Bright Eyes, which was manufactured by Playmates Toys. In this case, her starting point was a new technology, a miniature motor developed by a company called Nano-Muscle. She realized that this tiny motor could be used to give a doll extremely realistic eye movements. Out of this idea Baby Bright Eyes was born, a doll who

Figure 19.1
Baby Bright
Eyes utilizes
nanotechnology
for realistic eye
movement, and she
recognizes her bottle
and her teddy bear.
Image courtesy of
Playmates Toys.

is about a year and a half old, with large expressive eyes and a sweet face. (See Figure 19.1.) Her eyes, Shackelford said, convey the doll's feelings and give her the semblance of artificial intelligence. Though Baby Bright Eyes has the limited vocabulary of a one-and-a-half-year-old child, what she does say and do is synchronized with her eye movements.

Like the Amazing Amy doll, she contains special sensors that enable her to "recognize" objects. She knows when you put a bottle in her mouth or a teddy bear in her hand, and she'll look at these objects when you give them to her. She conveys shyness by partially closing her eyes and shows surprise by opening her eyes wide. The toy illustrates that technology and design can be used to give personality to a doll.

TOO SPOOKY?

New technologies, such as the miniature motor used in Baby Bright Eyes, are giving dolls the ever-increasing ability to model living creatures. I asked Shackelford if dolls could possibly become too realistic, even to the point of being scary, as some people allege. Shackelford insists this is not the case. "I think the kinds of interactive properties we design in dolls are gentle and natural. They're not scary," she asserted. "An adult may look at a lifelike doll and say: 'Oh, that's spooky,' but it's not spooky to kids. It's just real." Referring to the graphic violence in many video games, she added: "Now, that's what I think is spooky!"

A Toy Manufacturer's Perspective

An inventor like Shackelford must try to anticipate what toy manufacturers will find attractive. And what, in general, do they look for? To find out, I talked with Lori Farbanish, Vice President of Girls' Marketing for Playmates Toys, a leader in interactive dolls. According to Farbanish, for a smart doll to succeed, it must possess an illusive quality she termed as "magical"—the quality to excite the child and capture her imagination. This is one of the biggest challenges of toy design, she told me, trying to "bring magic to a toy in a totally different way."

Playmates gives great consideration to how a child will most likely play with the toy and what type of play pattern it fits into, and it looks for ways for the smart features to enhance the anticipated play experience. Doll babies like Baby Bright Eyes typically elicit nurturing play, with the little girl taking care of the doll much as a mother does a baby. Nurturing activities include amusing the baby with a plaything, giving it a bottle, and putting it to bed. A child can do all of these things with Baby Bright Eyes and receive a response back from the toy, both with her eye movements and her baby-like vocabulary.

A second type of play Farbanish mentioned was *fiddle play*. It's the kind of activity that keeps little fingers busy, doing things like pulling open little drawers or rolling tiny carts or opening and closing doors. Opportunities for fiddle play are built into many interactive playsets. In working out how a smart toy will be played with, Playmates makes sure it offers not only interactive features but also opportunities for traditional imaginative play, things like combing the doll's hair, dressing it up, or inventing little scenarios for it.

In a third type of play, the child relates to the doll as a friend or companion. Sometimes this companion doll is regarded as an aspirational figure—someone the child looks up to and hopes to be like. This is the type of relationship Playmate toys wanted to build into their Belle doll when they adapted the character from Disney's movie *The Beauty and the Beast*. The challenge here was to find a way for the doll to come to life and tell you about her romance with the Beast but to do so without it being a passive experience, with the doll telling the story and the child just sitting there listening. The solution that Playmate

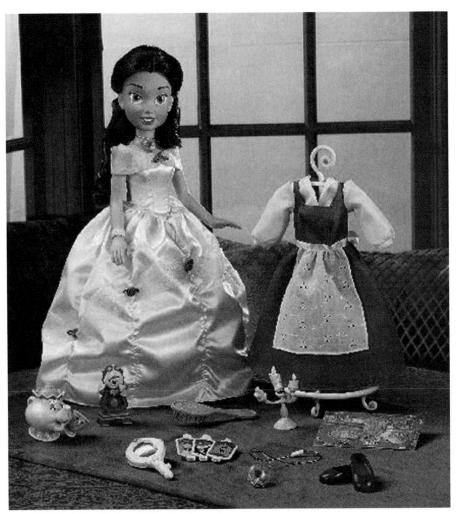

Figure 19.2 Little girls share in Belle's adventure by exploring the enchanted castle with her and attending the ball. The story is advanced by dressing Belle up in different outfits, and characters from the film talk to Belle and the child when placed in Belle's hand. Image courtesy of Playmates Toys. Belle @ Disney Enterprises, Inc. Used by permission from Disney Enterprises, Inc.

Toys came up with was to give the child an opportunity to participate in Belle's story via "costume changes" and an array of talking props. (See Figure 19.2.)

The adventure story the child shares with Belle is broken into two parts, roughly following the plot of the movie. Part one is devoted to the exploration of the castle and meeting some of its inhabitants. Part two, which is triggered when the child removes Belle's workaday pinafore and changes her into her beautiful party gown, takes place at the ball and climaxes when Belle dances with the Beast. The story is conveyed primarily through sound—by dialogue, music, and lively sound effects. As Farbanish puts it, "Your imagination is the set."

In addition to the change in costume, the story is advanced by inserting the different props into Belle's hand. Some of the props even speak in their character voices from the movie. Among them are Mrs. Potts, the chatty, motherly teapot, and Lumiere, the candelabra, who speaks with a French accent. In many of these little scenes, the characters acknowledge the child's presence as Belle's friend, as if she were standing there right beside Belle. These encounters help personalize the story for the child.

Thus, Belle is a companion doll who is also aspirational. She includes the child in an exciting adventure, and the doll's smart features makes the experience interactive and advances the story. Most important of all, the child has a meaningful role: She helps Belle explore the castle, gets her ready for the ball, and prepares her for her encounter with the Beast.

The Toy Developer's Perspective

Toy manufacturers like Playmates often collaborate closely with outside development companies when they are bringing out a new toy, and much of the actual work of creating a toy's personality and "intelligence" may be done by these specialists. One such company is Pangea Corp., which developed Belle, among many other smart toys. Two of the company's principals, John Schulte and John C. Besmehn, who use the titles "Big Dog" and "Little Dog," respectively, talked to me about their company's role in bringing dolls to life, and they jointly shared their observations of smart toys in general.

Schulte and Besmehn believe today's children are far more excited about playthings that offer a multisensory experience than they are about static toys, and they will no longer settle for "inert chunks of plastic." But they also feel that if a toy is too smart, it becomes too limiting. Children, they say, become disenchanted when a doll is overly bossy, narrowly restricting their experience by demanding that they "do this; do this; do this." They believe that the best smart toys serve as a stimulus, kindling the child's own sense of imaginative play, and that's the approach they take with the dolls they develop. There's a lot to be said, John Schulte told me, about technology "being used cleverly to open doors to parts of a girl's imagination she would otherwise ignore with a 'dumb' doll. That's why we try to imagine open-ended play patterns; we conjure up creative situations and scenarios that will evoke emotional responses, but allow for the girl herself to travel pathways of logic or illogic in a more open manner. We create the frame and provide the canvas. It's up to the girl to paint the picture as she sees it and feels it."

In working with a manufacturer on a new toy, Pangea comes aboard the project at an early concept stage and stays involved until the chips are burned. The development process starts by fleshing out each character and its world, looking for ways to harness the technology so that it will bring the character to life—by how it speaks or moves or reacts to a playpiece. Biographies are written for each character, sometimes done as autobiographies, as if written by the characters themselves. If they are developing a multitoy line, they also consider the other characters in the line, looking for balance and variety. Everything, they say, always leads back to the essence of the toy: What is the play pattern and what

will the child's experience of it be? These are the concepts upon which the toy is built.

Once they've gotten the basics nailed down, they begin to map out the interactivity, working out the variables and laying down the protocols for the most likely and least likely choices the child will make. All of this is written out in a document that goes by various names in the toy business: a logic flow chart, a logic script, a matrix, or a *flow chart*. Once the interactivity is worked out, a branching if/then script is written for the experience, much as it would be for any other interactive narrative.

One of the biggest challenges, they say, is writing the dialogue, because storage is at such a premium on the chips, and it competes for room with programming code, sound effects, and music. The chips for Belle, for example, could contain a maximum of eight minutes of sound. To get the most mileage possible from the available storage, they make use of *concatenation*, a technique of efficiently reusing words and phrases. Common words, phrases and sound effects are stored in a "sound data bank" and pulled out whenever needed. For example, it may store words for all the common colors, and if an NPC talks at one point about her friend's blue eyes and at another point about her new blue dress, the same word, "blue," would be used both times.

Once the script is complete, they do a table reading and time it all out before giving it to the actors to record. For a toy like Belle, which was based on a hit movie, the stars of the film do the voices. For example, Angela Lansbury, who played Mrs. Potts in the film, does the voice of Mrs. Potts for the toy. However, they said, it can be a major adjustment for actors to work within the time constraints of a toy script, which may give them just 3.2 seconds per line to express their character's personality.

Interestingly, Schulte and Besmehn consider the development process for a smart doll to be very much like a video game, requiring many of the same considerations in terms of characters, interactivity, and script writing. The goal is to make the play experience as nonrestrictive as possible, letting the child feel in control, while inconspicuously channeling her toward an end goal.

TOY ROBOTS: NOT JUST FOR KIDS

As we noted earlier, robots are devices that operate either by remote control or on their own and respond in some way to their environments. Robots can closely resemble living creatures like humans, dogs, and other animals. In fact, dolls like Belle and Baby Bright Eyes are really robots, though they do not look like the stereotypical robots with the jerky movements and hard metal bodies that we are familiar with from the movies. A smart toy named Robosapien, however, very much does resemble these movie robots.

With his black and white body made of manufactured material, enormous arms, bowlegged legs, and glowing red eyes, one could never mistake

Robosapien for a human. Yet he can actually "walk" on those two bowed legs, moving one leg in front of the other, just like a human, though an extremely ungainly one. Furthermore, he can execute 67 commands that are much like a *verb set* from a video game, including throw, kick, and pick up. Others, however, such as belch, are of a more earthy nature and are meant to give him "attitude." Surprisingly, Robosapien robots can be purchased for under \$100 and are marketed as children's toys.

Not all robotic toys are meant to be children's playthings, however. In 1999, Sony introduced a sophisticated robotic "companion" dog named Aibo to the public. With a price tag of over \$2000, it was definitely not a kid's toy. These smart dogs can see (via a camera), hear, walk, obey commands, do tricks, and express canine-appropriate emotions. They love being petted and are responsive to their masters; their personalities are shaped by how they are treated. Some adult enthusiasts have acquired whole packs of them and swear that each dog has its own personality. A number of owners get together regularly with other owners for the equivalent of "play dates." Students at some universities have even programmed teams of Aibos to take part in soccer matches. Impressively, the dogs can play the game autonomously, on their own, without the use of remote controls. It is hardly surprising, then, that Aibo owners were dismayed when Sony announced in 2006 that they were discontinuing production of Aibos in a cost-cutting move.

ANIMATRONIC CHARACTERS: STARS OF THE STAGE AND SCREEN

Animatronic characters are a particular type of robot that is made to look believably lifelike. They are primarily found in motion pictures and theme parks and are also turning up frequently in museum installations. These specialized robots can resemble historic and contemporary figures, birds, bugs, sea creatures, and other animals. Animatronic characters can move, talk, and sing, but the movements and sounds they make are preprogrammed or prerecorded. Essentially, they are mechanized puppets. The term Audio-Animatronic is a Walt Disney Engineering trademark and dates back to 1961.

Some of the first animatronic characters played important roles in movies (the giant squid in 20,000 Leagues Under the Sea and the human-eating shark in Jaws.) In Chapter 22, on immersive environments, we will describe a number of animatronic characters who play parts in theme park shows and museum displays, including a giant grasshopper, a fierce pirate, and a soldier from the American Revolutionary War.

ANDROIDS: TOO MUCH LIKE US?

An *android* is a type of robot that is meant to look and act as much like a human being as possible, ideally to the point of passing as human. The word "android" comes from Greek and means "resembling man." Unlike mechanized robots,

androids are capable of responding to visual and vocal stimuli. Some androids are capable of voice recognition and can converse in a fairly believable way.

Androids are often used for training purposes in the military and in medical schools. For example, life-sized androids serve in the U.S. Army, where they simulate wounded patients and are used by medics in training to prepare them for field conditions. With realistic faces and the height and weight of adult men and women, they look extremely convincing. But what makes them even more compelling is the fact that their chests rise and fall with raspy or wheezy breathing sounds. In addition, they possess an artificial pulse; their eyes tear; and they bleed and expel mucus. And when the wounded soldiers are not given the proper medical treatment, they can die.

Far away from the battlefield, a pretty blond android named Noelle is being used for medical school training. Like the android soldiers, she has a pulse and can breathe and bleed; she can also urinate. But what makes Noelle particularly interesting is that she is pregnant. She goes through labor and, if all goes well, she will give birth, even to twins. But, just as in real life, serious complications can develop and the medical students have to handle the crises well in order to keep Noelle and the baby or babies alive. Unlike real life, however, the complications are orchestrated by an instructor who controls Noelle via a laptop and in a sense serves as a dungeon master.

While the field of robotics used to be the domain of engineers and technologyminded scientists, a newer type of roboticist has become active in this arena. These scientists are particularly interested in robot-human interaction and in creating robots that communicate in a lifelike way, with nods, gestures, and eye contact. Such androids, they believe, can eventually perform important services in taking care of the elderly, the disabled, and other dependent individuals.

THE "UNCANNY VALLEY SYNDROME"

Roboticists are striving to make their creations seem as human as possible, but they have discovered that too much realism can have an unwanted negative effect. Known as "the uncanny valley syndrome," a term coined by Japanese roboticist Masahiro Mori, it seems that when a robot resembles a human too closely, people will find it too eerie and reject it. Thus, roboticists walk a thin line between making their androids convincingly human but not too human.

One of the most realistic androids ever designed is a Japanese creation called Repliee Q1, developed by Professor Hiroshi Ishiguro of Osaka University. The slender, dark haired android caused a sensation when she appeared at the 2005 World Expo and even appeared on CNN and other TV news outlets. Called Q1 for short, she can converse in a believable fashion and gestures much like a real person. To contribute to her realism, she is programmed with 42 points of articulation in her upper body; she "breathes" with the aid of an air compressor, and her skin is made of soft, pliant silicone. And if Q1 receives too much annoying attention from a male admirer, she will react just like a real woman might, swatting him away with her hand.

At present Q1 is an experimental model, and despite her celebrity, she has not become involved in any works of digital storytelling. But it is interesting to speculate how androids like Q1, Noelle, and the wounded soldiers might be used in the future, playing lifelike roles in productions that blend reality and fantasy in entirely new ways. Certainly, compelling scenarios could be built around their capabilities.

ADDITIONAL RESOURCES

To learn more about smart toys and robots, the following resources may be helpful:

- The Dr. Toy website, www.drtoy.com. Dr. Toy reviews toys, including smart toys.
- Children's Technology Review, http://www.childrenssoftware.com/, both a print magazine and a website, carries reviews of smart toys, primarily educational toys.
- The Toy Guy, www.thetoyguy.com, has news and reviews of all types of toys.
- Animatronics.org is a clearinghouse of information about animatronics and other types of robots: http://www.animatronics.org/.
- Robotics Trends, an online publication about robots: http://www.roboticstrends.com/

CONCLUSION

As we've seen with the Belle doll from *The Beauty and the Beast*, smart toys can be given personalities and support interactive narratives. And as we've seen with Noelle, the pregnant android, robots can be the center of lifelike dramas. In addition, theme parks and museums are finding innovative ways to use animatronic characters. Even though the work being done in robotics does not often intersect with the work going on in smart toys, both fields can contribute concepts and technology to new kinds of digital storytelling experiences.

The challenges of creating compelling interactive narratives with physical, lifelike characters can be daunting, as this chapter has illustrated. Yet Lori Farbanish of Playmates Toys has a valuable piece of advice for creating smart toys that can be applied in general to all of these characters. "Sometimes," she says, "we think too much like adults. Sometimes you just have to dump all the pieces on the floor and play."

IDEA-GENERATING EXERCISES

1. Select an existing smart toy—one that has narrative features or a developed personality—and spend some time playing with it. Analyze what

Smart Toys and Lifelike Robots CHAPTER 19

- is compelling about the toy and where it may fall short. Do you think it could be improved, and if so, how? Can you see a way to use it as a model for another toy? How like or unlike do you think this toy is to other forms of interactive entertainment, such as a video game or VR installation?
- **2.** Sketch out an idea for an interactive 3-D playset "world." How would this playset tell a story? How would the child interact with it? What is the target demographic of your playset, and what type of play pattern does it fit into?
- **3.** Describe an android or an animatronic character that you have seen at a theme park, museum, or elsewhere. What about the character made it lifelike? What about it did not seem "real?"
- **4.** Sketch out an idea for an interactive talking character. How would it be part of an overall narrative experience? How would it communicate its personality? Would it require props, and if so, what kind?

Mobile Devices

How are tiny devices like mobile phones and PDAs being used for entertainment purposes?

What are some of the unique features of mobile devices that make them attractive as platforms for digital storytelling and other forms of entertainment?

What are some of the challenges that arise when trying to develop works of entertainment for mobile devices?

What are some of the innovative ways that wireless devices are being used to create new kinds of digital storytelling experiences?

THE METAMORPHOSIS OF THE TELEPHONE

Just a few short years ago, we used our telephones for just one purpose: to talk with other people. It was a convenient method of verbal communication. But thanks to the development of wireless phones and other mobile devices, the possibilities for the once strictly utilitarian telephone have expanded exponentially. Consider some of the things we can do with these devices that we could never dream of doing with our old phones:

- Send and receive SMS text messages, email and IM
- · Take and send digital photos
- Scan barcodes
- Get updates on news, sports, and weather
- Connect to the Internet
- Use embedded GPS (Global Positioning System) technology
- · Listen to music
- Watch comedy shows, cartoons, and dramas
- · Play games

Clearly, the old rotary-dial telephone with its cumbersome cord has evolved into something far more sophisticated. We now have not only cell phones but also PDAs (*Personal Digital Assistants*), portable game consoles that double as phones, and many other kinds of portable communications devices that are capable of a variety of functions.

THE TECHNOLOGY THAT MAKES MOBILE ENTERTAINMENT POSSIBLE

Wireless phones can accomplish so many new tasks in large part because of the new technologies and delivery systems they use—microwave, satellite, and electromagnetic frequencies—and also because of the digital nature of the communication in combination with increased processing power and improved compression protocols. Thus, unlike the old analog telephones, they can transmit great amounts of data, including text and moving images.

With mobile devices, text can be sent and received by SMS (Short Messaging Service), which is a text-only service for sending and receiving messages up to 160 characters in length. Photos, animation, and video, as well as longer text messages, can be sent and received via MMS (Multi-Media Service). Protocols like WAP (Wireless Application Protocol) enable mobile devices to access wireless services; protocols like Wi-Fi and Bluetooth enable mobile devices to have high-speed connections to the Internet and to connect with other devices, like game consoles and PDAs.

The spread of cell phones across the globe has occurred with remarkable speed. The first cell phones were tested in 1979 in Chicago and Japan. By 2007, in less than 30 years, approximately 2.2 billion individuals around the world were using

them. Furthermore, technological advances in wireless devices have been made at a steady pace. Many phones now use 3G (for *Third Generation*) technology, which enables full motion video and high-speed, wireless access to the Internet.

Cell phones have proven to be particularly popular in Asia, with Hong Kong leading the world with the highest number of cell phone subscribers. As of late 2006, according to the *Santa Fe New Mexican*, Hong Kong had a rate of 1184 subscribers per 1000 people—more than one cell phone per person. Cell phones have also flourished in Western Europe, but perhaps surprisingly, North America lags far behind. The United States has a mere 671 subscribers per 1000 people, putting it in 49th place internationally, and the rate is even lower in Canada, with 469 subscribers per 1000 people. As to be expected, the parts of the world with the highest use of cell phones—Asia and Europe—are also two parts of the world where wireless entertainment has flourished. Japan and Scandinavia, in particular, have been hotbeds of cutting-edge development.

THE PROGENITOR: A SNAKE

Given the short history of the wireless phone, an impressive amount of entertainment, some of it highly innovative, has already been developed for this platform. Oddly enough, it was a serpent that started it all, the star of the mobile game *Snake*. Nokia introduced *Snake*, a retooling of an old video game, in 1997 as a novelty on a new line of phones. Though rudimentary by today's standards, this progenitor of all wireless entertainment is still popular. And, like the appearance of the serpent in the Biblical Garden of Eden, its arrival on the wireless scene served as a major eye-opener, bringing about a dramatic change in perception. Before the arrival of *Snake*, we regarded our telephone as a utility device; thanks to *Snake*, we were able to see its potential for entertainment.

In the years since *Snake* first slithered across the screens of the world's cell phones, entertainment on mobile devices has evolved dramatically. We can now use them to play many genres of games, some of them unique to this platform; watch *mobisodes* (serialized stories, told in installments, created specifically for mobile devices); and also enjoy comedies custom-made for this platform. Even music videos are being tailored to this new entertainment venue.

Owners of mobile devices appreciate receiving entertainment in this new way because it is immensely portable and because it offers content in bite-sized, easily consumed pieces. *Wired* magazine (March, 2007) terms this kind of content *snack-o-tainment*. It's the perfect solution to those situations in life that are usually entertainment dead zones: riding elevators, waiting for busses, or sitting around in waiting rooms.

Developers of entertainment content have also quickly gravitated to mobile devices, and for a number of reasons, including the following:

 They are an extremely common device, dwarfing the number of game consoles and computers in comparison, and thus offer a vast potential audience.

- Mobile phone subscribers are highly diverse demographically, making it
 possible to reach new groups of users.
- The technology allows for fresh content to be offered on the fly.
- Entertainment content comes with a built-in billing method.
- Mobile devices offer connectivity with other devices and other participants.
- They play a major role in social interactions and can facilitate social forms of entertainment.
- Producing content for mobile devices generally costs less than other forms of entertainment, such as TV shows and video games, and the development period is usually shorter as well.

DEALING WITH MOBILE'S SPECIAL CHALLENGES

Despite the enormous potential audience for mobile entertainment, and despite its many attractions for content creators, developing entertainment in this arena poses a set of significant challenges. Some of these challenges are particularly daunting in North America, which is not yet a ripe market for mobile entertainment. As we have seen, the rate of cell phone subscribers in the United States and Canada is relatively low. This is in part due to the excellent landline service in this part of the world, which has made it less needful of wireless devices. Furthermore, North Americans are more likely to drive to work than their counterparts in Asia and Europe, who usually rely on public transportation, and commute time is prime time for mobile entertainment. In addition, the wireless phones available in North American are less advanced than in many parts of the world. According to The New York Times (May 7, 2007), out of 195 million mobile phone subscribers in the United States, only 5 million of these can play video. Understandably, with numbers this low, advertisers in the United States and Canada have been reluctant to support video content.

As another impediment, the mobile devices on the market vary considerably in terms of technology and features, making it hard to create content that can be enjoyed on a variety of devices. Furthermore, content creators must find ways to cope with tiny screens and with graphics that are usually far from crisp.

As if these challenges were not enough, it is extremely difficult for the "little guys" who make games of mobile devices to market their products and to compete against the major players like LucasArts and Electronic Arts. Yet there is an answer to this, according to Bill Klein, president of the start up company, Extreme AI, Inc., a mobile game developer. According to Klein, while you can't compete directly against the big companies, which have enormous resources, "you can compete in terms of novel ideas." Klein told me it is important not to look at mobile devices as "just a piece of hardware for playing video games, but as a device with special attributes, especially involving communications." He believes in order to compete, developers need to come up with new ways to incorporate these special attributes into the games they make.

Klein's company is doing exactly that. It is developing new kinds of games that are community based, using "community" in two senses of the word. In one sense, it means games that are meant to be played in the local community, not in a virtual world. In the second sense, these games are social in nature, partly competitive and partly collaborative, and thus are shared by a community of players.

At the time of this writing, his company is in the first months of running a 12-month game called *The Q Game: City of Riddles.* (See Figure 20.1.) "Q" is a nickname for Albuquerque, where the game is being played, and the slogan for the game is "Do you Q?" Sponsored by local businesses, it is a community-based game that blends aspects of ARGs and adventure games together, combining a strong storyline and puzzle solving with questlike missions. Though it is cell phone-centric, it uses many forms of communication to convey the narrative and the clues, including websites, emails, text messages, and posters. Parts of the story are also played out at live events. Some clues are placed on the game's website and contain images of unique landmarks in Albuquerque. (See Figure 20.2.)

Players are dispatched to real world locations to find clues, which in turn lead them to other clues. For example, they may be sent to an art museum to try to find a specific artwork. If they succeed at locating it they may be buzzed while still at the museum and receive a message giving them their next mission. In one particularly innovative type of assignment, players are asked to use their cell phones to photograph a sheet of paper that contains various images, including a bar code. Since cell phones can be used to scan and decode bar codes, the player can use the decoded information to unlock a website with important information. (See Figure 20.3.)

Figure 20.1

A "clue card" from

The Q Game: City
of Riddles. Clue
cards are placed at
various public spots
(on bulletin boards,
tabletops and so on)
in the city where the
game is being played.
Image courtesy of
Extreme Al, Inc.

Figure 20.2 This image of an old gas pump, a local landmark in Albuquerque, is a story clue for *The Q Game* that was posted on the game's website. Image courtesy of Extreme AI, Inc.

Though set in the contemporary world, the narrative of *The Q Game* is based on Greek mythology. Klein describes it this way: "The storyline is based on the return of the mythical Greek Titans to our world. In the game, the Titans are ordinary people, many of whom don't realize what they are. As the story progresses, one of the Titans enlists the aid of the players to reawaken the others and prepare them all for the coming conflict with Zeus."

3/1

http://reader.kaywa.com

cityofriddles.com

8675309

Figure 20.3
A barcode clue from *The Q Game*. Image courtesy of Extreme Al, Inc.

The game and narrative unfold over a 12-month period, with new clues and story elements released episodically on a monthly basis. Thus, it is an *emergent narrative*, with the story emerging as you play, much like a mystery. The clues are "not just interesting for their own sake," Klein stressed, but "are relevant to the content of story or else lead you further into the game."

Eventually, his company plans to expand *The Q Game* concept to other cities. An overarching version of the game could be played simultaneously at many different locations, though the clues would all be local. Thus, Klein and his team have developed a game that makes good use of the unique qualities of mobile devices and the compelling aspects of adventure games and ARGs. Yet they have done so in a way that is manageable by a small start-up and that does not directly compete with major game companies.

MOBILE ENTERTAINMENT AND DIGITAL STORYTELLING

The Q Game illustrates how mobile technology can be used for digital story-telling. The game contains a strong narrative, and the players are active participants in an interactive drama. Not all forms of mobile entertainment, however, offer narrative content or even interactivity. Using mobile devices as a platform for digital storytelling is still an extremely recent development, with mobisodics and games being the two most established forms.

Just as *Snake* evolved into more sophisticated forms of games, character-based entertainment on mobile devices has also been evolving steadily. In 2001, when cell phone graphics were still extremely primitive, a Finnish company, Riot-E, thought of a clever way to use text messages as a storytelling device. At the time, the movie, *Bridget Jones' Diary*, the story of the world's most miserable unmarried woman, was a huge hit. Riot-E offered subscribers short daily SMS updates "written" by Bridget herself. For instance, one of her communications, referring to her dismal text-messaging habits, reads: "Text messages from Daniel: 0 (bad). Text messages sent and received regarding lack of text messages from Daniel: 492 (very, very bad)." Bridget also conducted polls, asking her wireless friends their opinion of the following: "Valentine's Day should be banned by law. Reply with Y/N." Anyone familiar with Bridget would certainly know how she stood on that one. With *Bridget Jones' Diary*, Riot-E cleverly used SMS technology in a way that fit snugly with the persona of the fictional Bridget, and it was a big hit for its time.

Mobisodes

Story-based content for mobile devices took a great leap forward in 2004 with the announcement that News Corp. and Twentieth Century Fox would be releasing what many regard as the world's first mobisode, 24: Conspiracy. The mobisode debuted early the following year to great fanfare, and it was made available in 23 countries. It was a spin-off of the TV suspense drama 24, about the dangerous world of counterterrorist agents. The mobisode had the same type of storyline and same setting as the TV series but a different group of characters. Each of the 24 episodes was one minute long and ended on a nail-biting cliffhanger. And while the little snippets of Bridget Jones' life were conveyed in simple text, 24: Conspiracy was shown in full motion video. As revolutionary as this mobisode was, however, it could only be watched on sophisticated mobile phones with 3G video-enabled technology, which few people at the time owned. Furthermore, unlike Bridget Jones' text messages, the mobisode did not offer even the most rudimentary form of interactivity.

Other mobisodes that have been introduced since 24: Conspiracy have followed a similar pattern. For the most part, they have been based on TV series, shot on video, and told in installments. In Asia and Europe, where 3G phones are more readily available than in North America, youth-oriented mobisodes based on popular TV shows are particularly popular with young people.

However, a few wholly original mobisodes can be found among the spin-offs. They include two soap operas, *The Sunset Hotel* and *Love and Hate*, which were actually developed at about the same time as 24: *Conspiracy* and were produced by the same company, News Corp. And, not to be left in the dust, Singapore has produced a handsome original soap opera of its own, *PS I Luv U*, about a pair of young star-crossed lovers. The 30 three-minute episodes, which the producer, Mediacorp, refers to as "3G mobi-drama," feature popular Taiwanese actors and are available in many parts of Asia.

Although the mobisodes made thus far do contain well-developed storylines, they do not yet give the audience any opportunity to participate. Perhaps as this genre matures a little, we will begin to see some amount of interactivity introduced into these narratives.

Games

Snake pioneered the way for games on mobile devices, and they are an enormously successful form of mobile entertainment. Mobile games contain varying degrees of narrative, much like games played on other digital platforms, and unlike mobisodes, they offer built-in interactivity. Almost any type of game found on other platforms can be found on mobile devices: puzzle games, shooters, strategy games, racing games, war games, and even single-player versions of MMOGs. For the most part, however, developers have not taken advantage of the special attributes of mobile devices as was done with *The Q Game*.

Games that are miniature interactive versions of successful movies form a large and especially successful category of mobile gaming. For example, Disney offers *Pirates of the Caribbean Multiplayer*, a version of their hit series of movies. In this multiplayer game (up to 16 players), players can select one of three different types of ships to sail and join teams of other pirates to plunder coastal towns and go on other pirate adventures. In a much less bloodthirsty game, a close adaptation of the animated film *Finding Nemo*, the player gets to step into the shoes (or fins) of Marlin, Nemo's anxious father. As Marlin, you must swim through the ocean, dodging various obstacles and enemies, trying to find your son before your time runs out or before you lose the three lives that are allotted to you. Like many video games, *Finding Nemo* offers levels of difficulty—four, in this case—which get progressively harder as you move up.

While the *Finding Nemo* and *Pirates* games are animated, not all games make use of graphics. In deference to owners of older-style mobile devices, Vibes Media makes a variety of text-based games. For example, *Rock, Paper, Kiss* is a kissing game that is a version of the classic game played with one's hands: rock, paper, scissors.

On the more sophisticated end of the spectrum we can find examples like *Botfighters*, a robot fighting game. Developed by the Swedish company It's Alive and launched in 2001, it was incredibly advanced for its time. It made clever use of the GPS technology embedded in European mobile phones to enable players

to locate other participants in the game and interact with them, blending roleplaying and fictional scenarios with actual urban locations. Players went online and created robots—their avatars—and then, using GPS, located and "shot" other robots in the cities where the game took place. Thus, like *The Q Game*, it was largely played in the physical world, a form of gaming called *location-based gaming*.

From 1999 to 2005, Nokia, the Finnish mobile phone company, produced an annual series of cutting-edge mobile games. With the umbrella title, *The Nokia Game*, these events were geared primarily for young people and were played throughout Europe. Unfortunately, they have gone on hiatus for the time being, but while they were being run, they took clever advantage of Nokia phones' special features. *Nokia 2003*, for instance, the game's fifth incarnation, was essentially an ARG. The game not only made extensive use of mobile devices and the Internet (folding in the then newly released N-Gage) but also used all types of traditional media. Clues and plot developments were planted in radio announcements and in newspaper and magazine ads, and the story was advanced on wireless devices by Flash animations and text messages.

The game was played out over an eight-week period in 35 countries and in 10 different languages, drawing over a million player participants. It revolved around a virtual heroine named Flo, a professional "mobile reporter," champion online gamer, and avid snowboarder. When Flo's cell phone is stolen, she goes on a global search to find the criminals who swiped it, getting caught up in a dangerous conspiracy scheme in the process. Players joined in the search, uncovering clues, solving puzzles, and communicating with each other via SMS and email.

Another innovative location-based game, *Mogi, Item Hunt,* has been all the rage in Tokyo. Like *Botfighters,* it utilizes GPS technology. It is a virtual scavenger hunt with virtual objects planted in real locations, and players use their phones to search for them. Some of these items are virtual creatures who move around and have certain behaviors—they may be only active at night, for instance, or gravitate to parks—which adds an extra challenge and element of fun to the game. And, like *The Q Game, Mogi* has a strong social element. Players are encouraged to trade items with other players in order to complete their virtual collections. The game was developed by the French company Newt Games.

Thus, as we can see from these examples, games made for mobile phones can be used to create exciting forms of immersive and participatory narratives that break entirely new ground.

MOBILE CONTENT IN THE LIMELIGHT

Producers of mobile content are beginning to take a cue from the feature film world, where glamorous awards ceremonies, screenings, and competitions draw welcome publicity to the motion picture industry. Awards ceremonies, screenings, and competitions are also beginning to pop up to honor mobile content and its creators.

(Continued)

In 2005, one of the first such events was held in Cannes, France, home of the glittery Cannes Film Festival. It was a made-for-mobile competition and screening held as part of "MIPTV featuring MILIA," an annual global content conference. Over 60 companies from 14 different countries entered the competition.

Special forms of mobile content are also getting their 15 minutes of fame. For example, Ithaca College in New York State holds an annual competition, the CellFlix Festival, for films just 30 seconds long that have been shot on cell phones. And in 2005, the Singapore media operator, M1, sponsored a mobisode competition called Project Pilot: 3G. Each competitor submitted a one-minute pilot for a mobisode, and the 10 best competitors got to have their concept turned into a 10-part mobisode and screened on M1's 3G mobile portal, MiWorld Mobile.

USING MOBILE DEVICES FOR TEACHING AND PROMOTING

To some extent, businesses and educational entities are beginning to see the potential of using mobile devices to teach and promote, and they are also beginning to use entertainment techniques to accomplish this.

For example, earlier in the book, in Chapter 12, we noted that advergaming, which began on the Internet, is now also finding a home on mobile devices. In fact, one of the games described earlier in this chapter, *Rock, Paper, Kiss*, is actually an advergame; it promotes a brand of toothpaste.

In a different approach to advergaming, one in which the games are played in real world locations, Heineken used a mobile game in the United Kingdom to promote and sell its beer. The game was played in pubs, and people were alerted to it by "tent cards" placed on tables. The game was in the form of a trivia quiz, and if players answered three questions correctly, they could win a free pint of Heineken beer. In many cases, the pub-goers played so often, trying to win, that they spent more money on the SMS charges than the cost of the pint. Another campaign that partly spilled out into the real world, this one for Pepsi and held in Finland, involved players in a wireless soccer match. In order to compete, participants had to collect "virtual skills" from the labels of Pepsi bottles. The game was so popular that the sale of Pepsi spiked 13% during the campaign.

In a nongaming approach to promotion, the TV series *Dog the Bounty Hunter* invited people to sign up to receive weekly text messages from the show's colorful main character, Dog—shades of Bridget Jones' text messages back in 2001. Yet the device proved as popular as ever, with 62% of the participants saying that they were planning to watch the show more often because of Dog's messages.

Turning now to education, MIT was perhaps the first institution of higher learning to recognize the potential of mobile devices for educational simulations. Under its *Games-to-Teach Project*, described in Chapter 11, MIT developed

a wireless role-playing game called *Environmental Detectives*. Students playing it are divided into five groups, each representing different professions and concerns, and in these roles they must investigate the causes of an environmental disaster and work out how to deal with its effects. The game is played on PDAs, which they use to gather and process data and to communicate with each other.

One could imagine these concepts being applied to other educational experiences, such as a geological or archeological field trip where students are sent on a specific quest. PDAs could also be incorporated into a historic role-playing game where students recreate a historic battle or other event and use wireless devices to communicate with each other and also to supply support materials such as maps or timelines.

MOBISODES GO TO COLLEGE

In an interesting twist on the use of mobile devices for teaching, a course offered at UCLA in 2006 actually taught students how to make content for mobile devices. Under the tutelage of Hollywood director Kevin Smith (Clerks, Chasing Amy) the students wrote, directed, and produced six nine-minute mobisodes called Sucks Less with Kevin Smith.

Unlike most mobisodes, which tell a serialized story, *Sucks Less* is more of a sketch comedy show dotted with offbeat documentaries. However, the students themselves, and their mock-cantankerous dealings with Smith, often become part of the comedy. The mobisodes air on three venues: on the cellular startup Amp'd Mobile, Inc.; on the mtvU channel, and on the channel's website.

On the website, Smith describes the genesis of the project this way: "So I hit up the guys at mtvU with an idea for short-form program. . . . They went for it, and then came up with an even better idea: . . . we set it up over at UCLA and make an accredited course out of it, with the students actually fulfilling all the various production roles. They get experience, make connections and earn college credits, I get cheap labor; everybody wins."

A FEW CONSIDERATIONS

Mobile entertainment is evolving so quickly that it is difficult to nail down guidelines for how such a project should be developed. However, a few overall considerations can be extrapolated from the examples we have studied here and from comments made by professionals in the field. In general

- if you want your content to stand out, be as original as possible, not derivate of works found on other media;
- when at all feasible, use the technology unique to mobile devices to the best advantage;
- when at all feasible, promote social interaction among users;
- when at all feasible, offer users a way to actively participate in the content;

- develop content that is geared for short periods of play; in other words, that serves as "snack-o-tainment";
- if a game, make it rewarding for the time invested, even if the player does not win;
- if a game, make it relatively simple to learn and fun for players who are not hard-core gamers;
- if story based, the characters should have vivid personalities and their motivations should be clear;
- use visuals that come through clearly on a small screen.

ADDITIONAL RESOURCES

To learn more about mobile entertainment and developments in the mobile industry, some helpful resources are

- GameSpot Mobile (http://www.gamespot.com/mobile/index.html), which offers
 reviews of games and wireless devices as well as general articles on wireless
 entertainment;
- The Mobile Entertainment Forum (www.mobileentertainmentforum.org), a global trade organization for the mobile industry;
- Fierce Mobile Content, a daily update on mobile content and marketing (http://www.fiercemobilecontent.com/);
- Mobile Magazine (http://www.mobilemag.com/content/100/345/), which covers the mobile world;
- Mobile Entertainment (http://www.mobile-ent.biz/), which covers games and other forms of mobile entertainment.

CONCLUSION

From the projects we have examined here, it is quite evident that mobile platforms can support a diverse array of entertainment experiences, including story-based narratives. Some of the projects featured in this chapter have made exciting use of the unique attributes of mobile devices and have found innovative ways to involve users. It will be interesting to see what new techniques developers will use in the future to integrate interactivity and narrative into mobile content, especially as increasingly sophisticated mobile devices, like Apple's iPhone, become more widespread.

When thinking about what can or cannot be done with mobile devices, we must bear in mind that the very first wireless game, *Snake*, made its debut in 1997, a relatively short time ago. This medium is still in its early formative years. We are just beginning to understand its potential and to comprehend how it may be used as a tool for digital storytelling. Without doubt, innovative digital storytellers will make new breakthroughs in this area and will discover ways to use it that we have not yet imagined.

IDEA-GENERATING EXERCISES

- **1.** Have you personally used a mobile device as a platform to enjoy entertainment? If not, why have you not done so, and what do you think would make you more interested in entertaining yourself that way? If you have, what forms of mobile entertainment have you enjoyed most, and why? How do you think your own experiences and perceptions of mobile entertainment could be used to make it attractive to greater numbers of people?
- **2.** Choose a film or TV show that you are familiar with and sketch out an idea for a form of mobile entertainment that could be based on its characters or story.
- **3.** Pick a consumer product and devise a concept for mobile devices that could promote it.
- **4.** Choose a technology used in the more advanced mobile phones (such as GPS or the ability to shoot video) and sketch out an idea for how this technology could be used in a work of digital storytelling.

CHAPTER 21

Interactive Cinema (iCinema)

Movie stories traditionally follow a linear path, and movie going has always been a passive experience, so how do you open up a movie to a nonlinear narrative and give the audience a dynamic way to interact with it?

What is "group-based interactivity" and how does it fit into an interactive movie experience?

How is it similar to or different from multiuser interactivity found in such areas as MMOGs and iTV?

What narrative models are being used for interactive movies?

HOLD THE POPCORN!

Consider these three movie scenarios:

- An astroscientist, on a return trip from Mars, is struck by a mysterious and life-threatening illness after her space ship collides with some debris in outer space.
- An emotional family drama, a true story, reveals what it is like to grow up poor and black in the segregated American south.
- Cloned twins confront the drug-addicted scientist who created them.

All three stories have an intriguing premise and would seem to promise good movie entertainment. But if you planned on watching any of them while munching popcorn and reclining in a theatre seat or on your couch at home, you'd have a problem. That's because all three are interactive movies. In other words, they are works of interactive cinema, or iCinema, and in order to enjoy them, you would need to be an active participant. This is no place for popcorn. You'd be too busy using your hands to eat it.

All interactive movies fall into one of two quite different categories. One type is designed for a large theatre screen and usually intended to be a group experience. The other type is for a small screen and is usually viewed at home. It is a much more intimate experience, meant to be enjoyed by a single individual. Of the three movie scenarios described above, the first, the outer space story, was designed for a group experience in a theatre; the second and third are small-screen films. Although the kinds of interactivity and the overall experience offered by the two types of iCinema are quite dissimilar, they do share some important characteristics:

- They are story driven.
- They have dimensional characters.
- Even when they have some gamelike features, narrative plays an essential role.
- Choices made by the users profoundly affect how the story is experienced.

A BIRD'S EYE VIEW OF THE FIELD

Because interactive cinema is a direct descendent of the movies, one of the contemporary world's most beloved forms of entertainment, and because movies are so heavily narrative driven, one might expect that interactive cinema would be ground zero for digital storytelling. Unfortunately, such is not the case. Relatively little work is currently being done either for large-screen or small-screen interactive cinema.

Large-screen interactive movies can primarily be found in museums and other cultural institutions. The field is dominated by one innovative company that is based in Toronto. As for small-screen interactive movies, most that have been produced to date have been made under the umbrella of universities or government-funded film institutes, where interactive storytellers can get the necessary support

to work in this field. Thus far, the marketplace has not been particularly receptive to small screen iCinema, making it extremely difficult for such movies to succeed commercially. So far, only a small niche market exists for them, primarily among people in academic circles and those with a strong interest in cutting-edge storytelling. But even though this is hardly a booming field, the work being done in iCinema continues to break fresh ground in terms of devising new ways to combine story and interactivity, and it gives us a number of useful examples of digital storytelling.

LARGE-SCREEN INTERACTIVE CINEMA

The first large-screen interactive movies to be widely disseminated were produced between 1992–1995 by a company called Interfilm, under a four-picture deal with Sony. However, these movies offered extremely limited interactivity, especially for anyone used to the fast pace of video games. Furthermore, the storylines, acting, and production values were quite weak. Not surprisingly, they were commercially unsuccessful, and their failure to generate any enthusiasm from the public pretty much killed off interest in this area for many years.

More recently, however, a company called Immersion Studios has shown considerable faith in this type of interactivity, particularly for projects that combine entertainment and education. In other words, they are works of edutainment. Many of them tackle scientific themes such as human biology, pollution, and nuclear energy. Based in Toronto, the company has produced large-screen interactive films for a prestigious roster of international clients, including the Smithsonian Institution in the United States, La Cité in Paris, and the Science Museum in the United Kingdom.

At Immersion Studios, they term the work they do "immersive cinema," and immersion is the operative word here. Audiences are enveloped by surround sound and images projected on a large screen, and the films combine dramatic storylines with fast-paced gaming elements. These movies use both live action and 3-D animation, sometimes in the same production. The interactivity offered to audiences is far richer and more dynamic than the old Interfilm model, and it is more purposeful, too. The Interfilm productions gave audiences only three choices at various parts in the movie, and people made their choices known via a three-button system embedded in the armrests of the theatre seats. Otherwise, they had no role in the film. The branching storyline structure they used was thus quite similar to the old *Choose Your Own Adventure* books and offered about the same amount of meaningful agency—none, really.

With an Immersion Studios film, however, audience members are made to feel that they have an essential role to play in the unfolding drama. In one case, for example, they play time travelers, and their decisions help determine what species will survive into the present day. In another case, they take on the role of marine biologists and try to prevent a die-off of sea lions.

Furthermore, the interactivity is far more versatile and extensive. Each singleperson or two-person team is seated beside a touch screen computer console,

Figure 21.1 Immersion Studio's approach to interactive cinema combines a large-screen and a small-screen experience. Here, the audience is watching a film called *Vital Space*, interacting with it via touch screen consoles. Image courtesy of Immersion Studios.

through which they indicate their choices. In addition, the computer gives them a way to dig deeply into the subject matter, somewhat like exploring a website. During the gamelike segments, it serves as a virtual control panel to direct the action. Thus, the Immersive Studio approach combines an audience-shared large-screen theatrical experience with a more personal small-screen experience and control system. (See Figure 21.1.)

Group-Based Interactivity

While participating in an Immersion Studios film, audience members are called upon to interact with each other, sometimes by competing and sometimes by collaborating. Some exchanges are done electronically, but at other times, people communicate the old-fashioned way—by talking with each other. At least one of the Immersion Studios projects is also networked, linking students at several different institutions. This type of shared communications, group-based interactivity, also known as multiuser interactivity, is the hallmark of an Immersion Studios experience.

TYPES OF GROUP-BASED INTERACTIVITY

The group-based interactivity that is built into productions made by Immersion Studios bears some interesting similarities to the types of interactivity found in iTV and MMOGs. All three are enjoyed simultaneously by multiple users/viewers, and all offer both solo and multiuser types of interactivity. Some of Immersion Studios' new work even gives the participants the opportunity to control avatars, just as they would in a MMOG. For the (Continued)

most part, however, interactive movies and MMOGs are way ahead of iTV when it comes to integrating interactivity into the core content. In an Immersive Studios production, and also in a MMOG, users can affect the narrative itself, while with iTV, the audience primarily participates via trivia questions, polls, and the seeking of additional information—and rarely interacts with the story itself. It remains to be seen if these three areas will cross pollinate each other in ways that will lead to advances in multiuser digital storytelling.

Involving the Audience

Stacey Spiegel, the CEO of Immersion Studios, believes his company's approach to iCinema is highly effective for teaching, and for three important reasons. First of all, he pointed out, the immersiveness of the stories facilitates the suspension of disbelief. In traditional media, he noted, "You are outside the window looking in. But here, the window disappears and you feel you are a part of what's happening." Second of all, the members of the audience are put in the position of having to make decisions, and their decisions have consequences. This causes them to be extremely alert and mindful of the material they are dealing with. And third, the collaborative social element—being an active participant in a group drama—reinforces learning. This type of audience involvement thus combines *peer-to-peer* and *active learning*, both described in Chapter 11. Spiegel noted that the company's philosophy of engaging the audience is reflected in the old proverb that goes: "Tell me and I'll forget; show me and I may remember; involve me and I'll understand."

Competitive gameplay is often built into these productions, because, Spiegel reports, their audiences respond so positively to it. Still, he stressed, narrative remains a vital element, giving their films a context and framework and contributing to their emotional power.

A Sample Large-Screen Experience

To see how an Immersion Studios movie works, let's take a closer look at one of its films, *Vital Space*. The educational goal here is to give the audience an inside look at the major human body systems. The story, briefly sketched out at the opening of this chapter, is set in outer space. As the film opens, two space scientists, a married couple, have just completed a successful mission to Mars. Commander Susan Grant is examining a vial of Martian soil while her husband, Dr. John Osborne, is busy in another part of the space ship. Suddenly, the ship is struck by space debris, causing the soil sample to spill and contaminate the chamber where she is working. Thinking quickly, Commander Grant seals herself off in the lab to prevent further contamination, but she is already experiencing symptoms of a serious health problem.

At this point, just a few minutes into the movie, the audience is about to become intimately involved in the story, and their actions will determine Commander Grant's fate. Her husband informs us that since she has quarantined

Figure 21.2
Screen capture from the touch screen of Vital Space, showing types of microrobots. During Vital Space, audience members control a virtual medical system via their touch screens. Image courtesy of Immersion Studios.

herself, making it impossible for him to examine her, the only way to diagnose and treat her illness is by using an experimental, remote-controlled medical system called VIVISYS, never utilized before under field conditions. And he'll need the help of those of us in "ground control" (the audience) to guide and direct VIVISYS, which we'll do via our touch screen consoles. From this point on, we are faced with a series of decisions, such as selecting which type of microrobot should begin the diagnostic process. (See Figure 21.2.)

In a race against time, we try to determine the cause of Commander Grant's illness by investigating the various systems of her body. But her condition worsens, and in a dramatic twist, VIVISYS picks up a second heartbeat—shades of the movie *Alien!*—and is at the point of destroying it. But at the last moment, Commander Grant, writhing in pain, orders the procedure halted. It is a good thing she does because it turns out that the second heartbeat belongs to her unborn child—unbeknownst to the couple, they have a baby on the way. As the investigation into her illness proceeds, the audience may or may not find the true cause of her problem: a lethal parasitic infection. If the audience does find it, the film turns more gamelike, somewhat like a first-person shooter, with audience members trying to shoot down the intruders. Thus, the life or death drama of the plot helps keep the audience engaged in the film, and the combination of the large theatre screen and the small console screens gives them the means to become deeply immersed in this unique journey through the human body.

Special Challenges of Large-Screen Interactive Cinema

According to Brian Katz, the company's VP of corporate development, most of the films made by Immersion Studios have been for cultural institutions, who like them because they help attract visitors. Although such large-screen installations require a great deal of special hardware and servicing, which can be expensive, they further the educational goals of these institutions. Also, because these films are suitable for all ages, they offer visitors a positive family experience. However, not all audience members are comfortable with this type of media-rich interactivity, Katz says. While young people are used to multitasking and have no problems with the large-screen/small-screen configuration, he reports that some older people become confused and wonder "where should I look?" Often the kids fall into the role of coaching their parents, he says.

Katz also noted some of the special creative challenges posed by large-screen interactive cinema, including

- devising a scenario that is gripping right from the start and that thrusts the audience members into the action;
- avoiding a presentation that is overly complicated and could turn people off;
- creating gameplay that is exciting and complements the narrative;
- devising interactivity that calls for meaningful choices and not just guesswork.

TYING THE LARGE AND SMALL SCREENS TOGETHER

One special challenge with the type of iCinema produced by Immersive Studios is tying together the content of the large and small screens. To illustrate how the action on the two screens can be made into a cohesive whole, Spiegel described a scene from a film they'd made on the space program. On the large screen, astronauts are seen outside the space station working on a robotic arm system. But when they try to return to the space station, they find the door is locked! While the astronauts hover helplessly in space, their oxygen running low, members of the audience feverishly work at their consoles, trying to find a way to unlock the door. Thus the action on the large and small screens is closely and dramatically integrated.

Other Venues for Large-Screen iCinema

With Immersion Studios blazing the way with large-screen iCinema and racking up an impressive collection of titles, one has to wonder why other companies are not following in the company's footsteps.

Meanwhile, however, large-screen iCinema is finding new homes outside the public eye. As we will see in the next chapter, it is being used in immersive training simulations for military and law enforcement personnel. In addition,

large-screen immersive iCinema experiences are offered at theme parks (also discussed in the next chapter), though these films do not offer audiences any way to interact.

SMALL-SCREEN INTERACTIVE CINEMA

Examples of small-screen interactive movies are somewhat easier to find than their larger relatives, but they are by no means abundant, even though most people have the hardware necessary to play them. These movies are made for the Internet, DVD-ROM, DVD-Video, and CD-ROMs, and thus they can be played on a variety of familiar platforms. The awareness of iCinema is greater in Europe than in the United States, but there are indications that even in the United States interest in them may slowly be growing. Some of these productions are now being shown at international festivals, and they are also being sold at brick and mortar bookstores and at online sites like Amazon.com, all signs that a market for them may gradually be developing.

These productions are somewhat like the films one can find in art house movie theatres. Unlike commercial movies, they are not fantasies about comic book heroes or gory action-adventure pictures. Instead, they are apt to have an intellectual underpinning and focus more on human relationships and sophisticated psychological or philosophical themes. Unlike linear films, they lend themselves well to telling a story from multiple points of view and often offer viewers a wealth of visual material to investigate. Filmmakers working in this area have developed several different models of interactive narrative, including

- the hyperstory;
- the database narrative;
- the user as fulcrum;
- the spatial narrative.

We will be looking at examples of all five approaches here, and further examples can be found in Chapter 23 on DVDs.

The Hyperstory

Hyperstory is a term used by filmmaker Margi Szperling to describe the works of iCinema she produces. A hyperstory, like hypertext, links different elements together, but instead of linking a word to another piece of text, a visual element is linked to another visual element, offering a different view of the same scene or story. Szperling believes her hyperstory approach to filmmaking offers a deeper and more complex view of the world than the typical Hollywood linear movie.

Before becoming interested in interactive media, Szperling had been an architect, and she told me the disciplines have much in common, since both deal with structure, the movement through space, and design issues. In describing her hyperstory approach to me, Szperling said: "We can tell different kinds of stories in this medium, from multiple perspectives. These are databases that respond to people's choices." Among her influences, she said, were the novels

of James Joyce, the movie *Rashomon*, and the theories of the Russian experimental documentary filmmaker, Dziga Vertov (1896–1954). Vertov expounded an idea of "film truth," holding that fragments of film, when organized, could reveal a truth not perceptible to the naked eye.

Szperling's first film, *Uncompressed*, was, at its core, a science fiction drama about a drug-addicted scientist and the set of twins he has cloned in his lab. However, with its six intersecting storylines, the film is far more layered than a typical sci-fi film. The stories of the scientist and the twins form two of the narrative paths. The four other follow on a man with a life-threatening illness, a telepathic grandmother and granddaughter, a woman who has passed away, and the man who still loves her. Unlike the typical Hollywood movie, *Uncompressed* does not have a central protagonist. Instead, each character or set of characters serves as the protagonist of their individual storylines.

Though the characters all seem to live in disparate worlds, their stories are all interconnected. The drama culminates with a violent confrontation in which a gun is fired and someone is shot, but unless you work your way through all six paths, you cannot have a clear understanding of what has happened. To some degree, therefore, the film uses a *Rashomon* model, in which a single event is seen through the eyes of different characters.

When playing *Uncompressed*, the first thing one comes to is a screen divided into six frames. Each frame contains an image of the characters, singly or in pairs. (See Figure 21.3.) By running your cursor over any of the frames, the character or characters inside will reveal a brief bit about themselves. By clicking

Figure 21.3
Each of the six characters and pairs of characters in *Uncompressed* will give you a different view of the story. Image courtesy of Margi Szperling and substanz.

Figure 21.4
The chapter index of Uncompressed is one of several ways in which viewers can switch perspectives. Image courtesy of Margi Szperling and substanz.

on one of the frames, you will go to their storyline. The characters' paths cross at various points in the film. If you wish, you can follow each of the six stories from start to finish, in a linear fashion, but you can also switch to another character's perspective at various junctions. In addition, you can choose specific scenes to watch by going to the chapter index. (See Figure 21.4.)

Szperling says *Uncompressed* allows the viewer to "see between the panes of glass." Her hope in making this work, she told me, "was to create a series of subtle questions meant to discredit and validate themselves within the storyline. I realize this is a conundrum," she admitted, but added "most provocative artwork contains opposites. Every storyline shows how different the same reality can appear; it shows perspectives as they intersect with each other. This is where the strength of the piece lies. With this vast an amount of interactive content, much is learned by traveling in between the layers."

Uncompressed runs 36 minutes, though it takes hours to play in all its variations. Despite the low budget and the various challenges encountered while making it, the film has notably high production values. This, coupled with its

innovative design and intricately crafted story, has earned it nominations in about 50 international competitions and awards in several of them. Szperling believes her narrative model, the hyperstory, has great potential, and she looks at *Uncompressed* as a prototype of what is possible. She believes this form can give us "a way to understand who we are and to understand the complexities of the world around us."

Database Narratives

The Labyrinth Project at the University of Southern California specializes in what it calls "database narratives." These are works of iCinema made up of tiny pieces of data that users can assemble in various ways to form their own versions of the narrative. The Labyrinth Project is under the direction of cultural theorist Marsha Kinder, who serves as executive producer of the works made under its auspices. These interactive narratives explore, as Kinder terms it, "the border between documentary and fiction."

The website for the Labyrinth Project explains: "Although a database narrative may have no clear-cut beginning, no narrative closure, no three-act structure, and no coherent chain of causality, it still presents a narrative field full of story elements that are capable of arousing a user's curiosity and desire."

Documentaries, compiled as they are from a great mass of material, are particularly well suited to the database narrative approach. In linear documentaries, the production team decides which version of the truth to present. It selects which materials to show the viewer and which to exclude, and it arranges the order in which the scenes will be shown. But in a nonlinear documentary, the selection process is turned over to the viewers, and ultimately, they can form their own version of the truth.

Unlike traditional linear documentaries, database narratives "frequently have a subversive edge," the Labyrinth Project website asserts. "For, in calling attention to the database infrastructure of all narratives, they reveal a fuller range of alternatives. In this way, they expose the arbitrariness of so-called master narratives, which are frequently designed to appear natural or inevitable."

The Labyrinth Project has undertaken a variety of disparate projects, many of them based on the works of artists and writers. For example, *The Dawn at My Back*, a DVD-ROM, is a memoir created by an African American woman about her life and family and relates what it was like to grow up poor and black in Texas. It uses a quilt metaphor to present the different pieces of her story, and, like a handmade quilt, the memoir is composed of many small fragments. The task of stitching them together, however, is given to the viewer. The pieces of the quilt are an assortment of old photos, contemporary videos, interviews, voices, and animations. The quilt that forms the backdrop of this work is an heirloom from the filmmaker's own family, giving her story an even deeper emotional resonance.

In Chapter 23, we will be discussing another film made under the umbrella of the Labyrinth Project. Called *Bleeding Through: Layers of Los Angeles*, is an

innovative blending of nonfiction with fiction. Thus far, the Labyrinth Project has not undertaken a work of pure fiction, and it would be interesting to see how a fictional story would fare with a database narrative approach. What kinds of story pieces would go into the database? And would any kind of storytelling be possible without a three-act structure, a beginning or ending, or a coherent sense of cause and effect? These are among the many fascinating questions that have yet to be answered in this arena.

User as Fulcrum

In the *user as fulcrum* model of iCinema, the viewer is actually inserted into the story, and the decisions that he or she makes drive the narrative forward. Unlike a role-playing game, however, users do not take on a fictional identity. Instead, they step into the story as the person they are in real life.

To date, the best example of this approach to iCinema is a domestic drama called *Façade*. It contains just three characters: a married couple, Trip and Grace (both NPCs), and you, an old friend of theirs. You experience the drama from the first-person POV, and it begins when you accept Trip's invitation to come over to their apartment for an evening of socializing. However, after a few pleasantries, the façade of their happy marriage slips off and the true strains become too obvious to miss, a shade like an interactive version of Edward Albee's play, *Who's Afraid of Virginia Woolf*. Things become even more awkward when one of the characters begins to flirt with you. The way you handle the situation and how you interact with the two (which is done by typing in your end of the conversation) shapes the way the evening unfolds. The characters of Grace and Trip have been given a robust amount of AI, and the twists and turns of the drama are not prescripted; they are rendered on the fly.

One of the most noteworthy aspects of *Façade*, aside from its impressive use of AI, is the intent behind it—to produce a believable interactive drama with psychologically complex characters and emotional intensity. The work, created by Andrew Stern and Michael Mateas, was five years in the making. According to the *Façade* website, the pair did not want the work to be like a typical fantasy video game "about manipulating magical objects, fighting monsters, and rescuing princesses." Instead, they wanted to make something about real human relationships. "Rather than focusing on the traditional gamer market, we are interested in interactive experiences that appeal to the adult, non-computer geek, movie-and-theater-going public.

The Spatial Narrative

A *spatial narrative* is an interactive drama in which the story elements are embedded in a three dimensional space, and the user discovers narrative fragments while exploring the fictional environment. One excellent example of this approach to iCinema is a work called *A Space of Time*, created by Diego Bonilla. The story (which can be viewed online) is about a homeless man who lives in an abandoned school building. As you navigate around the building, you

get glimpses not only of his past and present life there, but also of other individuals who spent time in the school. *A Space of Time* is composed of over 700 quick time videos, making the possible permutations of this story enormous.

Another extremely interesting spatial narrative is a work by Julia Heyward called *Miracles in Reverse*. A story about the trauma of child sexual abuse, it is at once deeply personal and profoundly surrealistic. In order to put the pieces of the story together, one must first select one of three possible ways to enter it—from the point of view of a mom, an alien, or Jesus Christ. Once one of these characters is selected, the user is free to explore the protagonist's home, garden, tool shed, and neighborhood, uncovering pieces of her disturbing story along the way. Though still a work in progress as of this writing, Heyward has shown her work at a number of venues, including Lincoln Center in New York City, to much positive acclaim.

ICINEMA AND ACADEMIA

As we have noted throughout this chapter, much of the work done in iCinema has been under the helm of academic institutions. To a large degree, colleges, universities, and film schools are the major force pushing this field forward. The Massachusetts Institute of Technology has an entire program devoted to iCinema (http://ic.media.mit.edu/), and their website offers a great deal of information about research and projects relating to iCinema. The Labyrinth Project (http://thelabyrinthproject.com/), with its innovative program on database narrative, is under the wing of the famed School of Cinematic Arts at the University of Southern California.

And the iCinema Centre for Interactive Cinema Research at the University of New South Wales is another program to keep an eye on, even though a great deal of this program's emphasis is on virtual reality and other forms of immersive experiences. Nevertheless, its website (http://www.icinema.unsw.edu.au/) contains much of interest

CONCLUSION

As we have seen in this chapter, the field of iCinema may be small, but the work that is being produced here is dynamic and innovative. It encompasses both large-screen theatrical experiences and intimate small-screen interactivity, sometimes within the same work, and the practitioners of iCinema employ highly diverse approaches for the works they create.

Each new venture in iCinema pushes the envelope of digital storytelling a little bit further. It is a field that cries out for more study and more experimentation. Advances, however, have been slowed by the dearth of successful business models. Even more daunting, however, has been the lack thus far of a receptive audience for this type of storytelling. Some critics have argued that iCinema has not caught on because it is simply not a viable form of entertainment and that cinematic storytelling and interactivity cannot be melded together in a satisfactory way.

However, it must be remembered that in the early days of linear cinema, it too met with a negative reception. Audiences reacted to the first movies they saw with bewilderment and hardly knew what to make of them. With time and increased familiarity, however, they came to accept and understand the grammar of this new medium—techniques like the montage, the dissolve, and the flashback. In fact, if we look at the history of each new art form, we will usually find that the public reacts with skepticism and an initial lack of enthusiasm. Not so long ago, when music videos were first aired on TV, they too had a chilly reception, especially from adults who had grown up watching the more stately paced movies of the mid-twentieth century. Many found music videos to be a dizzying barrage of unconnected images and could find nothing to enjoy about them. Although some people will never like them, they have become an immensely popular and influential part of contemporary culture.

As for interactive cinema, it is critically important that it, too, develop a support base of users. Otherwise, its creators are laboring in a vacuum. Josephine Anstey, who created the VR work *A Thing Growing* (described in Chapter 22), stated this dilemma eloquently when she said: "We need practitioners and experimentalists, but we also need an increasingly sophisticated audience and the feedback between the two. No interactive fiction can be made without constant testing and feedback from users" (*Computer Graphics World*, February 2001).

Hopefully, as more people are exposed to iCinema, they will begin to develop an understanding and appreciation of a new cinematic language and a new storytelling art form, and this promising arena will receive the support it needs to move forward.

IDEA-GENERATING EXERCISES

- **1.** What do you think might eventually help iCinema reach a greater audience?
- **2.** Pick a subject that you think might work well as a fiction-based interactive movie. Do you think this topic would be better suited to a large-screen experience or a small-screen experience, and why? Which approach to iCinema described in this chapter do you think would be most appropriate for your premise, or do you feel that you would need to work out an original approach of your own?
- **3.** Pick a subject that you think lends itself well to a documentary work for iCinema. How would you take advantage of the interactivity that digital media provides?
- **4.** Sketch out an idea for an interactive movie that involves a large-screen and small-screen configuration, as with the Immersive Studios model, and work out one sample idea that offers multiuser interactivity. What would be happening on the large screen, and what would participants be doing on the small screen?

Immersive Environments

What is meant by an "immersive environment?"

What are some of the special methods used to create the illusion of being "inside" a digitally created virtual world?

What are some of the greatest challenges of creating a story-based experience for immersive environments?

What unique opportunities do these virtual worlds present to storytellers?

SCIENCE FICTION TERRITORY

In real life, it is highly unlikely you'd get to go on a dangerous military reconnaissance mission behind enemy lines without risk of injury or death. And unless you had supernatural powers, you couldn't expect to hear the voices of the departed when you visited a graveyard. And you'd certainly have to have a pretty powerful imagination to see yourself flying on a magic carpet or receiving a guided tour of the ocean by a friendly dolphin. But thanks to various forms of digitally created immersive environments, you can experience all of these things, and in a way that is convincingly lifelike.

When we move into the world of immersive environments, we are entering serious science fiction territory—but science fiction that has become entertainment fact. One of the most dramatic visions of this type of experience, as portrayed by the media, was given to us by the classic *Star Trek* TV series, with a device called the holodeck. In this make-believe vision of VR, the crew of the starship Enterprise and then Voyager could entertain themselves in their off hours by visiting the holodeck and becoming actors in computer-generated dramas. These experiences were much like novels that had come to life, complete with props, sets, lifelike characters, virtual food, and scenarios capable of eliciting intense emotions. The holodeck was such a compelling vision of the possibilities of marrying narrative to digital technology that Janet Murray even named her book on the future of storytelling after it, calling it *Hamlet on the Holodeck*.

To date, of course, nothing as convincing and detailed as the alternate reality of the *Star Trek* holodeck has been achieved here on Planet Earth. However, computer scientists and imaginative twenty-first century storytellers, progressing in small increments, are moving ever closer. Before we investigate what they've accomplished and discuss the implications their work has for new types of narratives, let's first take a moment to pin down what we are talking about.

DEFINING IMMERSIVE ENVIRONMENTS

Immersive environments can be roughly defined by what they are intended to do. The goal of a digitally created, or digitally enhanced, immersive environment is to give users an intense and seemingly real experience they could not otherwise have. They put the participants right "inside" a digitally created world, hence the term *environment*. In other words, the participant is not just looking at something on a screen or monitor but is instead surrounded by the work and, in many cases, is interacting with it.

Many of these experiences fall into a category of works called *Location Based Entertainment* (LBE), which are entertainment experiences that take place outside the home. LBE includes various kinds of theme park attractions as well as multiplayer competitions like racing simulations and outer space combats. It also includes attractions set in museums, aquariums, and Las Vegas hotels.

Immersive environments encompass a very broad and diverse group of digital works, with at least six different subgenres, and we will be examining each of them in this chapter. They include

- virtual reality (VR);
- · mixed or augmented reality;
- large screen immersive experiences for audiences, or ridefilms;
- large screen immersive experiences for single participants;
- interactive theme park rides;
- fulldome productions.

Immersive environments use a large palette of techniques to create their fantasy worlds. Some, like virtual reality, require the user to wear heavy-duty hardware. Others utilize large curved screens. Still others employ animatronic characters. Often, immersive environments are *multisensory*, meaning they stimulate the senses in a number of ways. Traditional screen-based works like movies and television only employ the senses of seeing and hearing, but immersive environments also employ touch and smell, making them uniquely powerful. Techniques for doing this may include variations in room temperature, special effects like snow and fog, various forms of tactile sensations such as vibrations and sprays of water, the movement of a seat or floor, and artificially produced smells.

Like other forms of digital storytelling, immersive environments contain narrative elements, like plots, characters, and dramatic situations. However, they also have a set of unique challenges, which we will be exploring. While many works of immersive environments are designed for pure entertainment, they are used for other purposes as well. These include teaching and training; psychotherapy; promotion; and the enhancement of information, particularly in cultural institutions.

VIRTUAL REALITY: WELCOME TO THE OUTER EDGES OF CYBERSPACE

A true VR environment is an extreme form of cyberspace, a 3-D artificial world generated by computers that seems believably real. Within such a space, one is able to move around and view the virtual structures and objects from any angle. But a VR world requires special hardware to be perceived. In one of its most common forms, visitors are outfitted with a helmet-like *head-mounted display* (HMD), earphones, and gloves, which give them the ability to perceive and manipulate the computer-generated representations. Another important type of VR is called the *CAVE*, where the users are surrounded by rear view projection screens and wear stereoscopic glasses to see 3-D images.

It should be noted, however, that we are talking about immersive VR experiences here and that VR is not necessarily a space that one enters. Some VR creations are designed just for observation purposes. They may be quite small, just of tabletop size. Such VR creations are chiefly constructed for scientific, engineering, or architectural purposes, not for entertainment.

While most individuals have had at least one experience inside an immersive environment, usually as an attraction at a theme park, true VR installations are much harder to come by. Except for a small handful of theme parks, most VR is confined to the research divisions of academic, military, or industrial organizations. But to make matters a bit more complicated, the term "virtual reality" is often applied indiscriminately to immersive experiences that have some, but not all, of the components of true VR.

A Close-Up Look at a Work of VR

Let's examine a true work of VR in more detail. Our example will be *DarkCon*, an intensely gripping military simulation discussed briefly in Chapter 6 under "The Role of Emotion." The name, *DarkCon*, comes from "dark reconnaissance mission." It is part of the United States Army's endeavor to utilize interactive digital media to create safe but effective training methods. *DarkCon* is being produced for the Army by the USC Institute for Creative Technologies (ICT), which is a research arm of the University of Southern California.

To experience *DarkCon*, each soldier/trainee, one by one, dons a Head Mounted Display and earphones and steps onto a large bare platform. Via the three-dimensional images seen through the HMD and the sounds heard through the earphones, the soldier is plunged into a frighteningly realistic surveillance mission. As the soldier turns or moves in one direction or another, specific images and sounds are activated. In a sense, the soldier acts as a computer cursor. By moving to position A, one type of response from the program will be triggered; moving to position B will trigger another.

The soldier's assignment is to observe members of a rogue paramilitary troop suspected of stockpiling illegal weapons, moving as close to them as possible but avoiding attracting their attention; otherwise the consequences could be fatal. The mission begins in a dark culvert near a bridge and an abandoned mill. (See Figure 22.1.) Although there is no dialogue, sound effects—such as dripping water, a barking dog, or the scurrying of a rat—play an important role. The participant will even hear the sound of his own footsteps as he moves through the virtual landscape, and they'll match the terrain he or she is moving over—the squishing of mud, the crunch of gravel, the rustling of dry leaves. The footsteps are also synced up to the soldier's movements. If he or she starts to run, the footsteps will quicken.

The realism of the simulation is further enhanced by both a *scent necklace* and a *rumble floor*. The rumble floor is built into the platform the trainee moves across during the mission, and it vibrates when cued by certain events, such as an explosion or a truck passing over the bridge. The "scent necklace," worn around the neck, gives off specific scents at key points during the simulation, and it is geared to enhance the frightening moments as well as the moments of relief. For instance, while moving through the dark and dangerous culvert, the trainee might smell a mustiness that hints of decay or rats, but at better

Figure 22.1
The DarkCon VR
simulation begins
in a dark culvert.
The realism of
this simulation is
enhanced by sound
effects, a rumble floor,
and a scent necklace.
Image courtesy of
USC's Institute for
Creative Technologies.

moments, such as emerging unharmed from the culvert, the necklace might emit the fragrance of fresh pine.

Writer Larry Tuch, a professional screenwriter with a Hollywood television background and a long-term involvement with ICT, was given the task of writing the initial demo script for *DarkCon*. In describing his role to me, he said he was called upon to create a context for the surveillance mission and a structural spine for the experience. He also had to find ways of ramping up the tension and the soldier's sense of jeopardy. He scripted in a number of objects, events, and visual clues for the soldier to discover during the mission. One of them was a child's broken doll, which was possibly abandoned by a family of fleeing refugees. Another was a blood-spattered wall, possibly evidence of a slaughter.

From his television experience, Tuch was used to developing stories with three acts, and he used this model for *DarkCon*. The first act set up the mission, and the second act introduced a series of complications, much like a typical Hollywood script. However, the third act was left open ended, without a fixed resolution; the ending would be shaped by the decisions the soldier/trainee made along the way. Thus, although *DarkCon* might not contain as complex a story as a Hollywood movie, it does contain many important narrative elements: a protagonist, opponents, a goal, obstacles, a structural spine, and an increasing degree of jeopardy. And it is these narrative features that make it so gripping and effective as a VR simulation.

Using VR for Artistic Expression and Storytelling

Outside of the military, the most adventurous storytelling in VR work takes place within academic institutions. In this setting, professors and students are

keen to push the boundaries of this medium and have more latitude to experiment than they would in the outside world, where commercial considerations are often constricting. At Iowa State University, for example, faculty and students have worked together within the university's Virtual Reality Applications Center to produce some extremely innovative work.

Their project, *Ashes to Ashes*, is a particularly dramatic one. It is an emotional memorial to the victims and survivors of the New York City terrorist attacks on 9/11. It was built for a six-sided CAVE called the C6, which offers 360-degree immersion. In a C6, the ceiling, walls, and floor are all stereoscopic screens, and it has a 3-D sound system as well. An extremely ambitious undertaking, *Ashes to Ashes* combines abstract dance, music, and narrative accounts of the survivors and witnesses, all in a technical environment that does not normally support any of these things. (See Figure 22.2.)

To help shape the work and give it a narrative cohesion, the VRAC team brought in writer Larry Tuch from Los Angeles. Tuch had had a positive experience working on the *DarkCon* VR project for the Army, and he understood many of the challenges of story creation in a VR environment. Nevertheless, Tuch told me he found the project a tough nut to crack. He felt it "would not jell unless it had structure and meaning for the participant." And he wrestled with how to integrate all its disparate elements. "You have to decide what experience you want to offer people," he said, "and how you'll use these elements you have—the cube, the surround sound, the dancers, and so on—to give them that experience." He was also well aware of the risk of basing an experimental artistic work on such a well-known, profoundly emotional tragedy. If handled

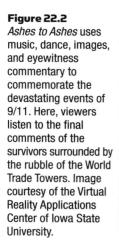

in the wrong way, he could inadvertently trivialize it. Yet, handled in the right way, the work had the potential to be truly cathartic.

Another tough challenge was the C6 itself, which to him seemed like an unnatural space for a narrative experience. "Who'd want to tell a story in a box?" he wondered. Designing for the cube meant taking everything into account, including the floor, which, like all the other walls, was a projection surface for digital images. But he didn't want the C6's shape to impose on the experience. "Literalness is the enemy," he said. "You aren't just doing it for four or six walls." In other words, you have to try to make those walls disappear, to push the experience beyond the physical boundaries. So he worked on devising ways to help participants forget they were in a cube.

Fortunately, he had one major asset going for him: access to audiotapes of survivors giving eyewitness accounts of the event. From these, he shaped a through-line using the harrowing account of a fireman named Billy, with other survivor's stories branching out from it. This yielded the framework that enabled participants to relive the drama of that fateful day.

The Virtual Temple Project

Another VR project produced at Iowa State is *The Virtual Temple*. It invites visitors to explore a Hindu temple and experience a traditional devotional ritual. The project was initiated by Whitney Sanford, an associate professor of religion and philosophy at the university. She was intrigued by the possibilities of using VR to tell the story of the Hindu religion, convinced that a 3-D immersive scenario would be far more effective than classroom lectures on the topic and certainly more feasible than taking the students on a field trip to India.

The principal technical challenge was the requirement that everything be highly realistic, unlike *Ashes to Ashes*, which was an abstract piece. To achieve this realism, the VRAC team produced a detailed 3-D model of an existing temple in India, using video footage and photos. To bring the simulation to life, the temple was peopled with priests and worshippers engaged in devotional ritual for the Hindu god Krishna.

Professor Sanford says of the simulation: "it's almost like entering a story," adding "ultimately, with this concept of digital storytelling—creating narratives where people go into a site or an historical place—we can create an entire new generation of immersive scenarios that can be used in a variety of disciplines."

Discovering the Dramatic Potential of VR

In some cases, digital storytellers are going beyond classic techniques and experimenting with new ways to tell stories in VR environments. Such is the case with *Conversations*, a work produced by iCinema Centre for Interactive Cinema Research at the University of New South Wales in Australia.

Conversations is a dramatic reenactment of a famous prison escape that took place in Australia in the mid-1960s. During the escape, a prison guard was shot and

killed. Later, one of the prison escapees, Ronald Ryan, was convicted of his murder and executed. However, the case remains highly disputed. *Conversations* uses a VR installation to let participants make their own determination of the truth.

Part one of *Conversations* recreates the prison escape and shooting, thrusting users into the center of the chaotic events. Users, wearing HMDs and earphones, can view the action from all angles, but because so much is going on at once, it is impossible to take in everything. Part two is set in a virtual investigation room, where users can interrogate key people (played by actors) involved in the case.

Unlike traditional dramas, users have a proactive role in the narrative: to decide how to observe the crime scene, to determine which people to interrogate, and to decide what questions to ask. And ultimately, the users must decide for themselves what really happened. Consider how different this is from watching a film, where the screenwriter has selected what the audience will see and has scripted one particular version of a drama.

The Thing Growing, created by Josephine Anstey for her master of fine arts thesis project at the University of Illinois, is another experimental project to emerge from academia. Like Ashes to Ashes, it, too, was built for a CAVE environment. The Thing Growing, however, is a work of pure fiction. In it, Anstey wanted to portray the kind of struggle that goes on when a person tries to escape an abusive relationship. The piece is constructed to give the user, who plays the part of the abuse victim, the sense of emotional claustrophobia that is characteristic of such a relationship. The antagonist in this scenario is an abstract computergenerated creature made up of pyramid shapes, called the Thing. Ultimately, the user participant can confront the Thing and put an end to the torment by shooting it. As with all classic drama, the piece is structured in three acts. Act One introduces the protagonist and the goal; Act Two centers on the struggle to reach the goal; and Act Three is the resolution.

The Importance of Finding a "Grammar" for VR

Jacquelyn Ford Morie, the producer of the *DarkCon* military simulation, is one of the leading pioneers in terms of using VR as a dramatic medium. She is also a fine artist, which very much informs her approach to VR. She is currently working on a project called *Memory Stairs*, which, like *A Thing Growing*, sharply focuses on the emotions of the participant.

The physical centerpiece of *Memory Stairs* is a spiral staircase. (See Figure 22.3.) Each stair that the participant steps on will trigger a memory experience, nine recollections in all, from prebirth to old age. The stairway thus serves as a linear pathway, and the participant ascends it as if going on a chronological journey through key life experiences. Participants will wear HMDs and other devices to be able to see, hear, and smell the virtual memories, and they use a joystick to maneuver through the 3-D images.

In part, Morie is creating the project to explore how personal memories can be translated into universal ones and how emotions can be integrated into a VR

Figure 22.3
A concept rendering of the spiral stairway of *Memory Stairs*. Spectators can watch the screens on the sides to view the images that the participant is seeing. Computer concept rendering by Jared Leshin. Image courtesy of Jacquelyn Ford Morie.

experience. (Her work in creating an emotional score for *DarkCon* was previously discussed in Chapter 6.) But another important goal for her in *Memory Stairs* is to explore the possible *grammar*—artistic principles or rules—that can be employed in VR. She feels VR still relies heavily on older concepts borrowed from earlier forms of entertainment, in part because the practitioners in this field have placed more emphasis on developing hardware and software than on exploring content. As a result, it is short on artistic ideas that are specifically geared for VR's unique attributes. Every new medium requires its own artistic vocabulary, but that takes time to develop, and audiences often have trouble at first in interpreting what they are experiencing. For instance, when the jump cut was first introduced in the early development of cinema, people didn't understand what it meant.

"But what is the equivalent of a 'jump cut' in VR?" she wonders. "Can you do a break in time and make it work? And is there a way for the participant to control time?" These are some of the questions Morie would like to see addressed in VR works. She feels that answers to these and other questions will come from the artists who are working in VR, not from the technologists. "I think the artists push more than the technologists," she asserted.

VR in Entertainment

To an extremely limited degree, VR can also be found in commercial entertainment venues. Probably the most impressive example of this is the *DisneyQuest* indoor theme park. Within this five-story structure in Orlando, *DisneyQuest* offers a diverse array of VR amusements utilizing HMDs, CAVE environments, and simulators. For example, visitors can take a ride on Aladdin's magic carpet, go on a jungle riverboat ride, or have a swashbuckling laser sword fight with super villains from the world of comic strips. They can also become virtual

pirates of the Caribbean and sail their own pirate ship, or even design a roller coaster at a touch screen kiosk, and then, via a simulator, take a ride in it. But few commercial venues other than DisneyQuest are currently offering guests the opportunity to sample VR.

Pragmatic Uses of VR Technology

Although VR has not yet become a major medium for entertainment, and perhaps never will, it has an important role to play in other areas. They include the following:

- **1. Teaching and training:** As we have seen, VR is being used by the military as a training tool. It is also being used in the classroom to teach difficult subjects. For instance, a VR program on chemistry lets students play a game where they catch protons and electrons and make atoms.
- **2. Psychotherapy:** VR is being used by therapists to help patients overcome phobias such as the fear of spiders, the fear of driving, and the fear of flying. By giving them the virtual experience in a nonthreatening environment, the patients become desensitized to the situations that cause them anxiety. VR is also being used to treat military veterans who suffer from posttraumatic stress disorder, and these simulations not only contain the sights and sounds of the battlefield but even the smells.
- **3. Promotion:** Several industries are turning to VR for promotional purposes. Some have even utilized portable, suitcase-sized VR units for cutting-edge promotions. One model even comes with a head-mounted device that has its own built-in scent dispenser. Buick commissioned such a unit so it could take potential customers on a virtual test drive. The "drivers" were treated to the scent of fresh cut grass as they tooled along the virtual road.

It is quite possible that forward progress in one of these arenas, such as the suitcase-sized VR kits, could spur new advances in using VR for entertainment purposes.

THE CHALLENGES OF CREATING NARRATIVES FOR VR

As we have seen from the various VR projects we've examined, developing narrative-based projects for VR can be difficult due to a number of factors, including the following:

Creators must deal with an entirely new paradigm. In traditional media, such as
movies, television, and the theatre, viewers watch something that takes place in
front of them. This is true even with video games and content made for mobile
devices. But in VR, the participant is inside the entertainment content and is
surrounded by it. We do not yet have a body of experience to guide us in creating
content for such a medium.

- Storytelling tends to take a back seat to technology in this field, and most developments are spurred by scientific interests, not by entertainment objectives.
- Creators in the field have a lack of models to draw upon—few successful projects are available to serve as examples.
- The field still lacks a developed aesthetic grammar of its own, and it has not
 yet found commonly recognized ways of dealing with creative issues.

All of these factors call for developers in this arena to stretch themselves to the limits creatively and to be willing to break new artistic ground.

MIXED OR AUGMENTED REALITY

In *mixed reality* immersive environments, digital technology is used in conjunction with physical props or in real physical settings to create a variety of unique experiences. These types of immersive environments are also sometimes referred to as works of *augmented reality*. All these works have one thing in common: Digitally created elements and real physical objects (including people) are contained within the same space and may interact with each other.

Mixed Reality in a Military Scenario

In *Flat World*, an experimental military installation being developed by ICT, participants wear lightweight stereoscopic glasses to make the virtual elements seem real. The title *Flat World* refers to the idea that part of the environment is made up of theatrical-style flats, not to the antiquated idea that the world is flat. The scenario is set in a compound in the Middle East that is being bombarded by enemy fire. When you are inside of this environment, you can duck into a building and watch the virtual warfare out the window. You can see and hear a helicopter passing by overhead and land in the distance. While you are inside, you might hear pounding at the door and open it to a virtual soldier who warns you to leave immediately, saying it is too dangerous to remain where you are! If you look up as you hurry out of the building, you will see a young boy on a roof of the building across the way—also a virtual character—preparing to hurl a rock at you. Though the digital characters are not realistic enough to be entirely believable, *Flat World* demonstrates the potential of mixing the real and the virtual in the same setting.

Cultural Institutions: A New Home for Mixed Reality

In recent years, museum designers and curators have begun to appreciate how a mixed reality approach can make their exhibits more interesting and exciting to the general public, and they have been applying mixed reality techniques to their exhibits. For example, at the newly opened Abraham Lincoln Presidential Library and Museum, visitors encounter the "ghosts" of Lincoln and some of his contemporaries. At the American Museum of Natural History in New York, visitors "feel" the impact of a meteorite slamming into the earth. At the Pirate Soul Museum in Key West, Florida, visitors encounter a menacing animatronic Blackbeard.

And at the new visitors' complex at Mount Vernon, where President George Washington lived, visitors to the exhibit portraying the disastrously cold winter of the Revolutionary War feel a sharp drop in temperature. Inside a wooden hut, they will see a sickly looking soldier lying under a blanket. The chest of this animatronic character rises and falls, and he coughs and moans plaintively.

MUSEUMS AND STORYTELLING

Jeff Rosen, director of project development for BRC Imagination Arts, the multinational firm that developed the innovative exhibits for both the Civil War Museum and the new Lincoln Library, made a strong statement about the importance of good storytelling on the firm's website. He asserted: "As a result of shorter attention spans, the 21st Century will need even better storytellers in cultural attractions. We must capture the public's imagination in less time and hold it for longer. We must be worthy of the . . . (subject matter) . . . entrusted to our care."

Ghosts in the Graveyard; Dolphins in the Ocean

Unlike the artificially constructed settings of the museum exhibits just described, a project called *The Voices of Oakland* is a mixed reality work set square in the middle of a real life environment—an old cemetery in Atlanta, Georgia. Visitors to the cemetery, wearing headphones and carrying a tracking device and laptop, select gravestones that catch their interest and listen to the voices of the dead beneath their feet. They can also opt to hear audio segments about the history, art, and architecture of the graveyard that surrounds them. The work was devised by students at the Georgia Institute of Technology, who term this approach *augmented reality*.

In a similar fashion, a mixed reality work called DRU is set in another real environment—in this case, the Caribbean ocean. DRU stands for Dolphin Robotic Unit, and as the name suggests, DRU is a lifelike robotic dolphin, a free-swimming Audio-Animatronics puppet. It is the exact size and weight of a real dolphin, and its swimming motions are precisely like a living dolphin as well.

DRU was introduced to the world at an aquarium at a Walt Disney resort in Florida, and after initial testing, he was taken out of the tank and given a chance to swim in the real ocean. He became the star of a prototype "swimming with the dolphins" attraction for snorkelers at Disney's private island, Castaway Cay. (See Figure 22.4.)

As with all good immersive environments, a story was created to enhance this new attraction. Roger Holzberg, senior show producer of Walt Disney Imagineering, described the story to me as a mix of scientific fact and Disney fantasy. The idea was that a pod of intelligent dolphins lived just off the island's coast. By successfully summoning one of them (DRU, of course, who was actually controlled by an operator disguised as a fellow guest), the friendly animal would give the snorklers a personal tour of the ocean from a dolphin's

Figure 22.4
DRU, an AudioAnimatronics dolphin
project conceived and
tested by Walt Disney
Imagineers, on an
ocean swim with a
Disney cast member.
Image courtesy of ©
Disney Enterprises,
Inc.

perspective, communicating with the snorklers by nodding or shaking its head or opening its mouth and splashing water, all in a friendly manner.

Even though the people who participated in this attraction were told in advance that DRU was not a living creature, Holzberg says, "Every single human being who swam with the Audio-Animatronics dolphin believed it was real." He told me that at one point they were considering adding a shark to the act, but knowing how convincing DRU had been, they were afraid that the sudden appearance of a shark, up close and personal, might be a bit more than a swimming guest's comfort level could handle.

Holzberg feels that attractions like DRU and other immersive theme park experiences are very much in keeping with an idea called *dimensional storytelling*, a concept articulated by that master storyteller himself, Walt Disney. Disney, he said, saw dimensional storytelling as a way for kids and parents to become involved with the stories he created, and it was this idea that led to the creation of the original Disneyland Park. Holzberg believes that everything done by Walt Disney Imagineering (the division of The Walt Disney Company that designs and builds the theme parks and attractions) is a story of some kind, "Though it isn't always traditional storytelling," he said, "it is storytelling. Writing, filmmaking, and interactive design are what the storytelling of today is all about," and, he added, "this type of immersive storytelling takes a story from make-believe to real."

LARGE SCREEN IMMERSIVENESS FOR AUDIENCES—THE RIDEFILM

Immersive environments sometimes make use of large theatrical-sized movie screens to envelop participants in a dramatic experience. Sometimes these

environments are designed for a single individual and sometimes for a large group. In some regards, projects that use a large-screen format are easier to design than VR experiences because they draw upon cinematic narrative tools that the creative community is already quite familiar with.

One such immersive environment for groups, the *ridefilm*, is set in a specially designed theatre and includes seats that move in synch with the story's action (*motion base chairs*). In this type of experience, one stays seated and cannot move around as one can in other forms of immersive environments.

Large-screen experiences lend themselves well to taking participants on a fictional journey, much like a movie. Even though they typically offer little or no opportunity for interaction, unlike the large screen works of iCinema, discussed in the last chapter, they can offer an intensely involving, even enthralling, experience. This is due both to good storytelling and to how these films are shown. The screens are not only tall but have a wraparound 180° curve, thus totally encompassing each person's peripheral vision. They also use state-of-the art surround sound systems. And to further enhance the immersive experience and trick the senses, designers may call upon a variety of ingenious enhancements, such as artificial smell, tactile stimulation, vibrations, artificial weather effects, and temperature change.

A BUGGY RIDEFILM

A ridefilm called *It's Tough to be a Bug* is a popular attraction at Disney's California Adventure theme park. It features a 3-D film, an animatronic grasshopper, and a cast of amusing characters to give audiences an inside view on what it's like to be a bug. To enhance the "buggy" experience even further, giant spiders drop on top of you from the ceiling; you "feel" bugs crawling on you (via vibrations in your seats); are misted with "acid" by termites; and get squirted by a smelly stinkbug. The shocker in this ridefilm occurs when you are swarmed by angry wasps and "stung" in the back (also via the motion base chair). At this point, the screams of audience members almost drown out the sound track.

Ridefilms cannot only be found in IMAX theatres and at theme parks, but they are even finding their way into cultural institutions. For instance, at historic Mount Vernon, when visitors watch a film called *Revolutionary War Immersive Experience*, snowflakes fall down on them from the sky, fog rolls in, and through their chairs—which are actually rumble seats—they can feel the thumping of cannons going off.

SINGLE-PARTICIPANT LARGE SCREEN IMMERSIVENESS

In some cases, large screen immersive environments are designed for one single participant. Most frequently, they are used for cutting-edge training simulations.

They often employ sophisticated AI, synthetic characters, voice recognition systems, and multisensory stimuli.

Mission Rehearsal, a military training project, is a good example of a single-participant large-screen simulation. Like many of the military simulations already discussed, it was produced by ICT, and writer Larry Tuch, who scripted many of the other simulations, wrote this one as well. Mission Rehearsal is set in a war zone and requires the trainee, a young officer, to handle a volatile situation—a child has been run over and severely injured by a military vehicle, attracting a hostile crowd.

The trainee stands in a physical space surrounded by the lifelike virtual characters on the screen. (See Figure 22.5.) To diffuse the rapidly escalating crisis, the trainee must get essential information from the synthetic characters on the screen, particularly from the central onscreen figure, the platoon sergeant. (This character has been built with a high degree of AI and can understand spoken language and respond convincingly.) Once the trainee has a grasp of the situation, he or she must give the appropriate orders to peacefully resolve it. Otherwise, things get even more dangerously out of hand.

As with the other military simulations he worked on, Tuch said the events unfolded at a relentless pace, with unexpected twists and turns. Unlike a TV set, it cannot be turned off. "You're inside the story," Tuch explained, "and there's no pausing or doing it on your own time. It doesn't wait for you." This type of

Figure 22.5
Mission Rehearsal, an immersive simulation made for the U.S.
Army, makes use of a large curved screen, surround sound, and virtual characters.
Image courtesy of USC's Institute for Creative Technologies.

pressure, intertwined with the unfolding drama, calls for quick decisions and prepares the trainees for situations that they may well encounter during actual military operations.

Very similar techniques are being used to train law officers in how to handle particularly volatile situations, such as when hostages are involved. One company, VirTraSystems, employs a five-screen system that completely surrounds the trainees, creating a full 360° perimeter. The characters on the screen are rendered with photorealistic precision, making the drama extremely compelling. The trainees have to be aware of what's going on all around them, and the situations they are faced with call for both good judgment and good marksmanship. They hold a prop gun, and if they discharge it at one of the virtual characters, it can actually "kill" the person struck. But it is also possible to hit the wrong target and set off an explosive device, and furthermore, the trainees themselves can be "shot." In some of these simulations, they are wired to a special device, and if they are "hit" by a bullet, they will receive an electric jolt.

However, not all large screen, single participant environments are designed for training. Some are meant for leisure-time enjoyment. For instance, the School of Computing at the University of Utah has designed a system that incorporates a treadmill and three large screens for a 180° view, and as individuals walk or run on the treadmill, they feel as if they are hiking or running in various exotic spots. They call this method of employing a treadmill in a large screen environment a *locomotion interface*.

INTERACTIVE THEME PARK RIDES

Most theme park rides, though they can be extremely exciting, are passive experiences—the riders cannot interact in any way with the objects or characters they see around them. Today's theme parks designers, however, recognize that the new generation of park visitors enjoys interactive experiences, and thus they have begun to create new kinds of attractions. One such ride is *The Buzz Lightyear AstroBlaster*, built around one of the primary characters of the *Toy Story* films, the toy space ranger, Buzz Lightyear. This ride has a clear storyline: You, the rider, play an ally of Buzz, and you are sent off on an intergalactic mission to fight the evil emperor Zurg.

In this highly interactive ride, you can manipulate your Star Cruiser spacecraft, tilting it and spinning it around in any direction, and can shoot your handheld laser cannon at various types of outer space villains. You play against others who are taking the ride at the same time, and you can compare your score to theirs at the end of the space voyage. At one point in this adventure, a picture is snapped of you engaged in battle, and when you dismount from your Star Cruiser, you can view your photo at kiosks lining the wall and even email it to admiring friends and family members back home.

FULLDOME PRODUCTIONS

One of the newest forms of immersive environments are works called *fulldome*. In these works, images are projected onto the entire surface of a planetarium dome or a similarly shaped theatre. To get a sense of what watching a fulldome work is like, picture yourself sitting inside a huge upside down bowl, surrounded on all sides by moving images.

The fulldome area is one of the fastest growing of all forms of immersive entertainment and edutainment, now numbering approximately 300 theatres since its beginnings in 1999. Like other forms of immersive environments, fulldome has the power to transport you to a place you could probably never visit in real life and to give you an experience you could not otherwise have. Many full-dome productions are set in outer space or in the ocean, perhaps because these themes lend themselves well to narratives about all-enveloping environments. One of the more adventurous of these scientifically themed works is a trip inside a black hole and to the other side of infinity, a visualized representation of Einstein's equations. Another is a dazzling, kaleidoscopic investigation of the mathematic patterns known as fractals. Some people working in the dome arena are also beginning to experiment with interactivity.

In addition, a handful of people around the world are actively experimenting with fulldome works that are purely narrative or artistic in nature. For example, the well-known artist and muralist, Gronk, created a stunning semiabstract piece called *Gronk's BrainFlame*, which is about the power of imagination and the birth of artistic ideas. And a team at the University of New Mexico is currently working on an adaptation of Gerald McDermott's Caldecott Medal winning children's book, *Arrow to the Sun*. This mythlike story is about a Native American boy from a Southwestern pueblo who discovers his father is the sun god.

An Artist's Take on Creating for Fulldome

To try to understand what it is like to create artistic and narrative works for full-dome, I met with Hue Walker, a poet and fine artist and one of the pioneering practitioners of this field, or a "domer," as these digital artists call themselves. Walker not only creates original works for fulldome but also served as producer of *BrainFlame* and is currently producing the adaptation of *Arrow to the Sun*. In addition, she teaches fulldome production classes at the University of New Mexico. We met inside UNM's small scale, portable fulldome, a perfect place for such a conversation.

Walker's own fulldome works are highly personal and rich with poetic imagery. For example, in *Wings of Memory*, Walker explored the power of memory and why one life moment flows forward throughout one's lifetime and even beyond while other memories disappear. The piece combines old family photos and moving images, including a dancer dressed in white and beating wings. The wings, she said, represent "the memories moving along with us." The piece won a Domie

Figure 22.6
An image from Hue
Walker's Wings of
Memory, a fulldome
work. Note that the
image is a 180°
fish-eye projection
to conform to the
shape of the dome.
Image courtesy of Hue
Walker.

award for Best Art Piece at the 2004 Domefest, a festival of fulldome works held annually at the LodeStar Planetarium in Albuquerque. (See Figure 22.6.)

Walker told me one of the greatest challenges of creating fulldome pieces is dealing with the shape of the dome. In today's world, we are totally familiar with setting our work inside a frame— the rectangle of a canvas or a movie screen, for example—but we are not at all used to setting a work inside a domed space. "It's closer to the images you see in your mind when we hear a story around a campfire, more like how we dream," she said. "There's no frame around these images."

In creating for a domed space, familiar film techniques like close-ups and cuts either do not work at all or are confusing to the audience. Domers have to learn to work with a 180° by 360° viewpoint and have to create for a fisheye shape. Just as with VR installations, it calls for the creation of a new visual vocabulary.

THE EMOTIONAL POWER OF FULLDOME

Walker stressed that there are positive trade-offs to the challenges the domed shape presents. Foremost of these is the power of the dome to elicit intense emotions in the audience—emotions like joy, fear, mistrust, and enthrallment. She explained that triggering these emotions is connected to the sense of body weight, body position, and velocity and can be induced by how images and sounds are used within the dome. For instance, you can elicit a feeling of mistrust or fear by having an image sneak up behind the audience. And having an image plunge downwards can produce a dropping sensation, which sometimes can feel like doom or death, while a soaring image can produce a sense of weightlessness, which is interpreted emotionally as joy.

Walker does not believe that there is one particular genre of storytelling or another that is more or less suited to fulldome. The important thing, she stresses, is that your storytelling should relate to the space and make good use of it. "If you are attracted to it because this is where the story belongs, then it will happen," she asserted.

CONCLUSION

More than any other set of technologies, immersive environments and VR give us the ability to create deeply dimensional narratives and simulations that put the user in the center of the action. These works can visualize abstract concepts and can seemingly make fantasies come to life in real physical spaces. Not only do they possess all the components of other engaging forms of digital entertainment—sound and moving images, interactivity, and computer-generated intelligent characters—they offer storytellers additional tools to use, as well. These include three-dimensional images, props and sets, animatronic characters, new types of spaces, and multisensory stimuli.

Yet, despite all the creative opportunities they offer, there are serious hurdles standing in the way of some of these forms becoming widely utilized by the creative community or enjoyed by the public—issues like the complexity and costs of the technologies involved, the fact that some of these forms can only be enjoyed by one individual at a time, and, in some cases, the lack of financial support for artistic productions.

However, as the examples in this chapter illustrate, immersive environments can offer unparalleled storytelling opportunities to individuals who have the vision and pioneering spirit to work in this arena.

IDEA-GENERATING EXERCISES

1. Describe an immersive environment that you have personally visited. What about the experience made it seem believable to you? What about it did not feel like "real life"? If you could improve anything about this particular immersive environment, without having to consider cost or technical impediments, what would it be?

- **2.** What kind of narrative experience could you imagine creating for an immersive environment? Which of these seven genres would you use? Sketch out this experience, describing some of the visuals, sounds, and other elements it might contain. Describe how it would start and how it would end.
- **3.** Can you think of any component or element that might be used for an immersive environment but to your knowledge has not thus far been used? How would you use this element? What kind of experience could it help create?
- **4.** On a piece of paper, list the six genres of immersive environments described in this chapter. Then take a current news story, a scientific idea, a short story, or even a movie or TV show you saw recently, and try to adapt it to each of these six genres. Why do you think your idea adapts itself relatively easily to some of these genres and not to others?

DVDs

DVDs are most commonly used as a way for watching movies at home, but how are they being used for original content, particularly for works of digital storytelling?

What are some of the characteristics of the DVD that make it an attractive platform for interactive entertainment?

When creating content for a DVD, what are some important things to keep in mind?

A PUZZLEMENT

In terms of interactive media, the DVD is something of a puzzlement. Although they are an enormous hit with consumers, and in spite of becoming the most swiftly adapted electronics platform of all time, very little original entertainment content has been developed for it, almost none of which takes advantage of the interactive potential of the platform. The single major exception to this is video games, a great many of which are distributed on DVD-ROMs. However, games fall into a whole other category of entertainment, and they are programmed for PCs or game consoles like the Xbox 360 and PlayStation3, rather than the DVD platform, and thus are not generally thought of as being DVDs.

A single DVD disc can hold a great quantity of high-quality video and audio, and this one factor, coupled with the ease of use of DVD players, has helped boost its popularity, particularly for watching feature films and compilations of favorite TV series. To most consumers, the DVD is just a convenient way to watch linear entertainment, and they aren't expecting anything more from it. Aside from the typical bonus features that accompany feature films and TV shows, it is extremely difficult to find any type of original programming for DVDs. The great majority of DVD content we see today has begun life in another medium—as a movie, a TV series, or a documentary.

This dearth of original production is a strikingly different state of affairs from the CD-ROM phenomenon in the early and mid-1990s. Back then, developers swiftly recognized the CD-ROM as a vast improvement over the old floppy discs, particularly when it came to audio and video. They seized upon the new platform and churned out hundreds of original games, interactive children's projects, and a variety of interactive nonfiction works. In contrast, the potential for DVDs to support interactive programming and original content goes largely untapped. Could this be because developers sense that consumers are quite satisfied with what they are being offered and have no interest in other kinds of experiences? Or are developers simply unsure of how to exploit the features of this platform? As we will see a little later in this chapter, the modest amount of original work being made for DVDs is, for the most part, coming from outside the mainstream.

THE FEATURES OF THE DVD

DVDs come in several different formats, each used for a different purpose. Consumers are most familiar with DVD-Video, a playback format that carries both sound and images, and is usually just called DVD (which we will do throughout this chapter). Other familiar formats include DVD-Audio, which is audio only and mostly used for listening to music, and DVD-ROM, played on computers in much the same way as CD-ROMs but holding much more data. At the present time, producers of original interactive-rich content prefer to develop for DVD-ROM rather than for DVD-Video because standard definition DVD players are not as well equipped to handle robust interactivity as high-end Macs or PCs, though this could change as sophisticated new players with greatly enhanced features become more widely available.

DVDs can be used to deliver materials for Macs and PCs, for game consoles, or for DVD players connected to TV sets. The next generation of DVD players and disc formats, Blu-ray and HD-DVD, offer not only greater storage capacity and better image quality but greatly enhanced interactive capabilities as well.

DVDs VERSUS CD-ROMs

The DVD disc, with its round shape, overall dimensions, and shiny surface, looks virtually identical to a CD-ROM—so much so that one would be hard-pressed to tell them apart. Yet the DVD is capable of storing a vastly greater amount of information. A dual-layer, double-sided DVD can store approximately 30 times more data than a CD-ROM.

Along with the DVD's ability to store great quantities of data, a number of other characteristics make it stand out from other popular technologies and make it highly attractive from the point of view both of the developer and the consumer. Consumers like DVDs because

- they are extremely easy to install and use, and they do not require any competency with computers or technology;
- · the video and audio are of extremely high quality;
- it is simple to go directly to any scene or any bonus feature, via an easy-to-understand menu system;
- they offer features like fast forward, freeze frame, and multiple camera angles;
- they can be operated by a device that consumers are already familiar with: the remote control;
- they are lightweight, durable, and highly portable;
- they are versatile in how they can be used since they can be played on computers, stand-alone players, game consoles, and portable devices.

Content developers for DVDs like them for many of the same reasons and also because

- they offer multiple audio and subtitle tracks, opening up a variety of content possibilities;
- various degrees of interactivity can be built into them, from basic menu choices to little games and other kinds of activities offered as bonus features. They can also be used as the delivery medium for full-scale video games.

DVD CONTENT—A BIRD'S EYE VIEW

As we've noted previously, the most popular use of DVDs is as a medium to watch feature films, compilations of TV shows, and documentaries. This approach to content is known as *repurposing*, a concept discussed in Chapter

2. Repurposing is the taking of material from one medium and porting it over to another.

Some classic video games from an earlier era are now making their way onto DVDs, including the beloved *Dragon's Lair*, the arcade hit made in the early 1980s and described in Chapter 2. Interestingly, a large number of people who own DVD-equipped game consoles are using them to watch movies.

Despite the enormous popularity of repurposed material, several genres of original content are being made for DVDs. One major genre is the *direct-to-DVD movie*. Such movies are made specifically for home use and are not intended for theatrical release. Many of them are sequels of popular films, especially animated family films. Another relatively new and successful category of DVD is a genre aimed squarely at the tiniest of viewers—babies. This category includes DVD series like *Baby Einstein* and *Brainy Baby*. Such DVDs are intended to help babies develop language and other skills, though some experts dispute the claims that have been made for them and assert that they actually impede language development. Nevertheless, they remain extremely popular with new parents.

Two other major categories of DVDs are fitness programs and music. DVD music videos and videotaped concerts of popular performers are a big hit with music fans because of the excellent quality of their sound. In addition, DVDs are being used to market products and services and for corporate promotion. Outside of the commercial arena, DVDs are being pressed into service as electronic high school yearbooks, as repositories for family histories, and to commemorate special occasions.

THE BONUS FACTOR

When a property is repurposed as a DVD, it is almost invariably enhanced in ways that have become fairly standardized. To access the various bonus features, viewers make their choices from the menu, and that is about as interactive as most commercial DVDs get. On a typical DVD you will usually find

- the core material is broken into chapters or scenes;
- a selection of bonus features, such as a "making of" documentary, interviews with the cast and others involved in making the film, and deleted scenes from the original property;
- a selection of sound tracks, offering such things as a choice of languages, a track of the director's comments, or a sound effects-only track.

As elementary as all this sounds in terms of interactivity, it should be noted that even the capability to select which scenes to watch and in what order is a radical departure from the linear experience one has in a movie theatre, even though it is virtually ubiquitous on DVDs. But some bonus features give home viewers even more profound ways to alter a film. For example, with *Star Wars: Episode I The Phantom Menace*, viewers can edit characters out of scenes; in the DVD version of *Shrek*, viewers can substitute their own voices and lines for the

ones spoken by the characters in the film. Other bonus features offer home viewers quite different ways to gain insight into the source material or to experience it in new ways.

INTERACTIVE BONUS FEATURES

In some cases, DVDs take advantage of interactivity in the bonus features they offer. Sometimes this is done in the form of little games, using characters or locations from the movie. A few DVD producers go even further and create more innovative options. For example, with *Harry Potter and the Chamber of Secrets*, producer Sven Krong created a bonus feature that lets viewers drive a flying car through the Forbidden Forest while trying to dodge menacing spiders. They can also take a self-guided tour through some of Harry's haunts, like Diagon Alley, or investigate normally off-limits locations like Dumbledore's office and the Chamber of Secrets itself.

The bonus features on documentaries often offer viewers the opportunity to study the film's subject matter in greater depth. One such documentary, discussed in Chapter 13, is the biography *Woodrow Wilson*. In addition to the three-hour TV show, the two-DVD set contained over 80 minutes of original video. Much of this new material is in the form of "minidocumentaries," each about three to five minutes long. According to Jackie Kain, VP of new media at KCET, these supplemental documentaries were purposely kept short so they would not compete with the film itself.

Based on her experience with the *Woodrow Wilson* project, Kain was impressed by the ability of DVDs to present material in a compelling way. "For nonfiction TV, the DVD is an extraordinary medium to be exploring," she said. "It's an amazing platform for aggregating information."

ORIGINAL STORY-BASED PROJECTS

Original full-length interactive narratives for the DVD, though relatively rare, are being made. In Chapter 21 on interactive cinema, we discussed such one such work, *The Dawn at My Back*, a database narrative documentary made by Carroll Parrott Blue. Let's now look at three other interactive narratives.

Manuela's Children, like The Dawn at My Back, is an interactive documentary. The film, created by artist Eva Koch, was funded by the Danish Film Institute and released in 2001. It is a true-life, highly personal saga of five Spanish children torn apart by personal and national tragedy. Soon after the children's father dies, their mother, the Manuela of the title, becomes too ill to care for them. When the Spanish Civil War breaks out, the children are separated and scattered to various places. One dies in infancy and another ends up in Scandinavia—the woman who is destined to become the mother of filmmaker Koch. Years later, Koch travels back to Spain to reconstruct her family's history on film and reunite as many of her kin as she can.

However, instead of taking the familiar documentary approach, which would force her to take a restrictive linear path, she chose to use the interactive features of the DVD, which offered her a more fluid, open framework. She gives the siblings' accounts as individual but parallel chronological journeys, using a variation of the *Rashomon* model described in Chapter 7. Each account contributes a different layer to the narrative. Viewers can choose to follow one sibling's story at a time, or, more provocatively, they can switch back and forth between them, allowing them to view this family drama from alternate viewpoints. This approach reflected the reality of the situation: Each member of the family had a unique and personal view of their family's history. To try to present their memories as a single united version of the truth would have done their stories a disservice.

Bleeding Through: Layers of Los Angeles, as the title suggests, also takes a layered approach to narrative, but it goes beyond Manuela's Children by boldly intertwining historic fact and invented fiction. Set in downtown Los Angeles and spanning over 60 years of time, from 1920 to 1986, it tells the story of a fictitious woman named Molly (based on a real person) who may—or may not—have murdered one of her husbands. Users are invited to piece together their own version of Molly's alleged crime, which they can do by sifting through a great amount of historical material. The narrative thus uses the archeological dig structural model described in Chapter 7.

The work is the creation of Norman Klein, a novelist, historian, and cultural critic. He not only wears all three hats in this interactive narrative but also appears in a window on the screen, adding his own commentary. The work, a DVD-ROM, was an international coproduction of the ZKM Center for Art and Media in Germany and the Labyrinth Project at USC's Annenberg Center.

Although Molly is an invented character, her story is shaped by the history of her time and place. It is set in downtown Los Angeles during a period when that part of the city was undergoing profound cultural change. *Bleeding Through* uses vintage film clips, maps, reconstructed scenes of actual events, historic photos, and contemporary interviews to tell Molly's story. (See Figure 23.1.) As we saw in Chapter 21, Klein and his colleagues at the Labyrinth Project refer to this genre of interactive cinema as *database narrative*. Klein notes: "We're a civilization of layers. We no longer think in montage and collage; we multitask in layers more and more" (*San Francisco Chronicle*, in a story by Glen Hellfand, September 18, 2003).

Like other database narratives produced by the Labyrinth Project, *Bleeding Through* is highly cinematic and visually arresting. One particularly striking feature is the way old and new photos of Los Angeles, taken from exactly the same angle, are layered on top of each other. By sliding between them, users can see the images literally bleed through each other and watch landmarks appear and disappear. It is a visual metaphor for the way the present overtakes the past, but by peeling back the present, the past can be revealed.

Figure 23.1
Bleeding Through:
Layers of Los Angeles
is a multilayered
narrative that
blends history and
invented narrative.
Image courtesy
of the Labyrinth
Project of USC's
Annenberg Center for
Communication and
the ZKM Center for Art
and Media.

In a third approach to interactive narrative, producers of *Scourges of the World*, a dungeons and dragons animated adventure, took advantage of the DVD's generous storage capacity and menu system to produce a story with multiple branches. Viewers are asked to make decisions at critical parts of the story (using the menu system and the DVD remote), and their choices determine what version of the narrative they see and how the version ends. This branching tree structure is, of course, not exactly a novel one. It's the same concept that was used in the old *Choose Your Own Adventure* books, mentioned several times in this book, and it has been the underlying structure for many interactive screen-based narratives. However, *Scourge of the Worlds*, released in 2003, is probably the first use of this structure for a DVD film, as well as an original use of the DVD's menu system. According to the producers, the Canadian company DKP Effects, it contains 996 possible variations and four possible endings, thus offering a fairly generous amount of agency for a branching tree structure.

Each of these three interactive DVD films uses quite a different approach to nonlinear narrative. When more filmmakers venture into these waters, and hopefully they will, we can expect to see still other approaches.

A FEW GENERAL GUIDELINES

Like websites, DVDs are relatively easy to author, but they are demanding in terms of design. Aside from the bonus features on repurposed properties,

creating original material for them is still relatively uncharted territory, and we only have a few models to serve as examples. However, we can offer a few general guidelines based on the projects described here, plus some additional thoughts shared by people who were interviewed for this book, including John Tollett, coauthor (with Robin Williams and David Rohn) of *Robin Williams DVD Design Workshop*. Here are some things to keep in mind:

- **1.** Because DVDs can hold so much data, particularly video, it can be tempting to shoot a great deal of footage, thinking you can edit it down and organize it later. However, it is far better to resist this temptation and instead to plan in advance what the work will contain and how it will be organized. Not only will production proceed more smoothly, but your work will be stronger and more focused as a result.
- **2.** When determining an organizational approach to a nonfiction story, try to sort the material in a logical and orderly manner, using the taxonomy method described in Chapter 13. Each unit of material should be small enough to be a "consumable" piece, as Jackie Kain puts it—a manageable size that will not be overwhelming in scope.
- **3.** For an especially pleasing presentation, think of ways to make your menu relate in some way to the content itself, either visually or thematically. The bonus features for the *Toy Story* DVD did this effectively by using toy characters from the movie. For instance, the choices for the section on story development were displayed on the speller toy; the choices for character design were displayed on the "Etch-a-Sketch" toy; the choices for music and sound design were presented on the instrument panel that Buzz Lightyear wears on his wrist.
- **4.** If you are creating bonus features for a property ported over from another medium, let the core property be the "star" of the DVD. Bonus features should augment the primary material and enhance it, not dominate it.
- **5.** If you will be producing bonus features for a live action film, whenever possible plan to shoot the bonus features at the same time the film is being shot. That way you will be able to more easily utilize locations and individuals from the core property for the bonus features, and the bonus features you produce will be well integrated into the project as a whole.
- **6.** If you are making an original narrative-based DVD, consider how best to use the special capabilities of the DVD platform right at the start of your development work so you can factor them into your design, rather than trying to retrofit your project once it is produced.

CONCLUSION

The DVD, introduced in 1997, caught on with consumers at lightning speed. Unfortunately, however, most content is repurposed and follows a standardized formula. Only a few projects have managed to break out of this mold and illustrate how DVDs can be used as a platform for interactive narratives. It is

391

possible that the next generation of DVD players and disc formats, which offer more robust interactivity, will spur the creation of a new generation of interactive DVDs.

It remains to be seen whether other creative individuals will step forward and use DVDs to tell new kinds of stories or whether this promising platform is going to fall victim to its own success, continuing to churn out titles that endlessly imitate each other.

Another intriguing possibility exists as well: DVDs of feature films and television programs may gradually acclimate viewers to nonlinearity and accustom them to choosing their own path through narrative material. Thus, the ubiquitous bonus features on commercial DVDs may serve as a stimulus to the DVD becoming an established platform for digital storytelling.

IDEA-GENERATING EXERCISES

- 1. Choose several DVDs of repurposed properties—feature films, compilations of TV shows, or documentaries—and analyze and compare them. How are they organized? In what ways are the menus alike and different? What types of bonus features do they offer? Of these DVDs, which do you think were the most effective, which the least effective, and why?
- **2.** Choose an already-produced narrative property you are familiar with, but one that has not, to your knowledge, become available on DVD. Sketch out several DVD bonus features for this work that you think would enhance it. Try to come up with ideas that go beyond the standard features offered on most DVDs (like the "making of" documentary and cast biographies) and that utilize interactivity.
- **3.** Sketch out a concept for an original DVD project, either fiction or nonfiction, that utilizes the special features of the DVD platform. What is the premise, and what are its interactive elements? What makes the project particularly well suited for a DVD? How would this project be organized?

Electronic Kiosks

How can something as utilitarian as an electronic kiosk be transformed into an attractive medium for storytelling?

What are some of the features that make kiosks especially desirable for use in public places?

Why do museums and other cultural institutions often incorporate kiosks into their exhibits, and why do companies frequently use kiosks as part of their displays at trade shows?

What are the most important considerations to keep in mind when developing a narrative-based kiosk project?

A HUMBLE BEGINNING

The electronic kiosk, sometimes also called the multimedia kiosk or the interactive kiosk, is perhaps the most modest and unassuming of all interactive platforms. Essentially, kiosks are simply booths or other small structures that offer the user an easy-to-operate computerized service, often via a touch screen. Kiosks are so universal and so much a part of our everyday landscape that we barely give them a second thought, though we are constantly using them to obtain cash, buy gas, or find books in the library. Yet these Plain-Jane devices are capable of supporting some surprisingly creative projects and can be transported into excellent vehicles for entertainment, information, or promotion. In a way, they are a bit like an electronic version of Cinderella—the scorned stepchild who metamorphoses into a beautiful young woman when her fairy godmother dresses her up for the ball.

The electronic kiosk had a humble beginning, devised for an entirely pragmatic purpose: to reduce the number of tellers in banks. The first electronic kiosk was the handy Automated Teller Machine (ATM), introduced by Chemical Bank in 1969. Since then, however, kiosks have been used for a vast array of purposes. They are particularly well suited for use in public places, either indoors or outdoors. Their popularity continues to grow as the cost of computer technology drops and the speed of computers increases, making kiosks ever more affordable and useful. Furthermore, members of the public have become so accustomed to using ATM machines that it is not much of a leap for them to use a kiosk for many other kinds of tasks.

WHAT KIOSKS CAN DO

Kiosks are immensely versatile in how they operate and what they can do. They are inherently interactive and can

- be used for any type of content enjoyed on any other computerized system, including games;
- · accommodate both single users and small groups;
- · read credit cards:
- · scan codes;
- · print out receipts and other documents;
- be equipped with teleconferencing capability;
- · be connected to the Internet;
- be operated by touch screens, keyboards, track balls, videogame controllers and push buttons;
- be networked together so users can communicate with each other and share interactive experiences with people in distant places.

THE KIOSK'S VERSATILITY

Kiosks are particularly useful in spaces with high pedestrian traffic, such as shopping malls, airports, trade shows, lobbies of large buildings, and theme parks. Because they are typically rugged and designed for ease of use, they require no staffing and little maintenance. They have the excellent advantage of being operational 24 hours a day, 7 days a week. Furthermore, they are quite portable and thus are highly suitable for traveling exhibits and trade shows. In terms of cost, they are cheap to run and relatively inexpensive to build.

Though a great many of the services provided by kiosks are strictly utilitarian, the jobs they do so efficiently can be harnessed equally well for entertainment, infotainment, or promotion. If you can create a virtual tour of a retail store, for example, can you not just as easily create a virtual tour of the solar system, or of a historic battleground, or a theme park? And if you can ask a kiosk to print out a receipt for an ATM transaction, can you not also ask it to print out a prize for playing a game, a list of fun facts, or information about a new product?

The Kiosk as a Medium for Storytelling

As versatile as kiosks can be, they do have limitations when it comes to offering pure storytelling experiences. These limitations have nothing to do with technology. From a technological point of view, kiosks are fully capable of supporting rich interactive narratives. It is more a matter of how kiosks are perceived and how they are used. Typically, they are regarded as a "workhorse" medium, designed to fulfill specific pragmatic functions. Furthermore, they are almost always intended to serve a high volume of users, each spending just a few minutes interacting with the content. These short sessions of usage are antithetical to content that contains complex storylines or characters.

Storytelling does play an important role, however, when it comes to making the utilitarian functions of the kiosk inviting and enjoyable to the user. We will be discussing strategies for applying narrative techniques to kiosk programs later in this chapter.

DEVELOPING CONTENT FOR THE KIOSK

As one might expect, the process of developing content for the kiosk is somewhat different from developing content for other interactive platforms. The differences are guided by two important factors. First, as we have already noted, kiosks are usually placed in public spaces. Second, they are typically used by individuals from an extremely wide demographic pool. Users will be of different ages, educational backgrounds, and socioeconomic groups, and they will have different attitudes about computer technology as well. With these factors in mind, here are some key guidelines for developing content for this medium:

1. The kiosk should capture the attention of passersby with an enticing onscreen visual. In the kiosk world, this visual is known as the *attract*

- *mode* or the *attract routine*. This little visual tease should loop continuously until a user engages with the kiosk and triggers the opening screen. The attract mode should be friendly and welcoming.
- **2.** The program should be easy to start. It should not require any training, the need for a manual, or detailed written instructions.
- **3.** The interface and navigation should be as intuitive as possible. Prompts and other kinds of help should be built in to assist users who are having trouble. Whenever possible, audio prompts should be used instead of written instructions. If you must use text, keep it to a bare minimum, and use a large, legible font.
- **4.** Input devices should be easy to use. Most kiosk designers prefer touch screens, trackballs, or video game controllers to keyboards. Not all users are comfortable at typing. Also, keyboards are prone to break.
- **5.** The content should be extremely engaging and presented in as visual and interactive a manner as possible.
- **6.** The script or text should be written with a general audience in mind, suitable for users of different educational backgrounds. The vocabulary and grammar should be simple, though expressive. Difficult concepts should be explained in an engaging way. On the other hand, the material should not be over simplified in such a way that it sounds patronizing.
- **7.** The user's role should be clear and immediately apparent so people will be able to use the kiosk immediately and without confusion.
- **8.** The program should be designed to be a brief experience from start to finish, just a few minutes in length. Keep in mind that many users stop at kiosks on impulse, on their way to do something else. Also, others may be waiting to use the kiosk.
- **9.** As with all interactive content, it is wise to test your program on a representative group of users before making it available to the public.

AN INTERACTIVE MICKEY

To get an idea of how the humble kiosk can be transformed into a medium for a richly inventive and entertaining experience, let's take a look at a project developed for the four Walt Disney World Resort theme parks near Orlando, Florida. Called *Discover the Stories Behind the Magic*, these 42 kiosks were built as part of the 100 Years of Magic celebration to celebrate the centennial of Walt Disney's birth. According to Roger Holzberg of Walt Disney Imagineering, who was creative lead for the celebration project (and was previously introduced in Chapter 22), the goal of the kiosks was to give park guests an appreciation of the breadth of Walt Disney's imagination. And, for people who knew nothing about Disney history and thought Walt Disney "was just a brand name like Sara Lee," they wanted to demonstrate that a real person existed behind the familiar name, Holzberg said. To do this in a way that would be enjoyable both for adult guests and for young visitors they decided to present the content in the form of a game.

Each of the Florida theme parks (Disney-MGM Studios, Epcot, Magic Kingdom, and Disney's Animal Kingdom) had its own style of kiosk and its own game, though all four games employed the same fundamental approach, interface, and

Figure 24.1
Each of the 42 kiosks designed for Disney's Discover the Stories Behind the Magic resembles Mickey Mouse. Visitors spin the ears and push the nose to interact with the content. Image courtesy of © Disney Enterprises, Inc. and Roger Holzberg.

style. The housing for the four kiosks had a distinctive feature in common as well: The main body of all four models resembled Mickey Mouse. And they all operated in the same way, too. Visitors spun Mickey's ears and pushed his nose to interact with the content. (See Figure 24.1.)

One special feature of this kiosk project was its multiuser design. It was envisioned as an experience that parents could enjoy with their children. Thus, the

Figure 24.2
These interactive
Magic Moment Pins,
when worn by a guest
to one of the Disney
parks in Florida, would
light up and become
animated as the guest
approached and used
the kiosks. Image
courtesy of © Disney
Enterprises. Inc.

interface was designed in such a way that two to four people could play the game in tandem. A stair step was even built into the kiosk to make it easier for small children to play.

Interactivity on a Tiny Scale

This kiosk project included another innovative element: tiny interactive collectable pins. Called the *Magic Moment Pins*, they came in five different styles. (See Figure 24.2.) The pins were embedded with tiny lights that lit up and became animated when the guest interacted with the kiosk as well as with other attractions and entertainment in all four theme parks. Holzberg, one of the inventors of the pins and one of the three people who contributed to the patent, calls the concept *merchant-tainment*. In other words, they are physical items that you can purchase and that will contribute to the entertainment experience.

Although guests didn't need to wear a pin to enjoy the kiosks, Holzberg said, it added "an additional interactive overlay." The pin would start to flash as the guest approached the kiosk, and if the wearer did well in the game, he said, "it would go crazy." The design of the little pins was echoed in the design of the kiosks themselves. The *headers* (the marquees) of the kiosk structures were giant versions of the pins, done in the same five patterns. Like the pins, they lit up in response to the guest's interactions.

Figure 24.3
The attract mode for the *Discover the Stories Behind the Magic* kiosk game. Image courtesy of © Disney Enterprises, Inc.

The Games for the Mickey Kiosks

All four games used the same attract mode. Pixie dust floated across the screen and set the interface aglow. Text appeared, inviting the guest to "spin the ear." (See Figure 24.3.) In addition, Mickey's nose flashed, as did the lights in the kiosk's header. When a guest pressed Mickey's nose or spun his ear, the attract mode dissolved into the primary interface screen of the game.

The interface was a stylized map of the theme park the player was in. To move through the map and select a particular land, the player spun Mickey's ear. The movement through the park was synchronized with the direction in which the ear was spun. Instead of a cursor, an area would be lit up to indicate it was "hot." A hot item would be selected by pressing Mickey's nose.

To play a kiosk game, guests answered multiple-choice questions about various attractions in the particular theme park they were visiting. (For a sample script, see Figure 24.4.) The games were designed in such a way that children might know some of the answers while their parents might know others. To avoid unhappiness, guests could not lose the game; they could only win, or win bigger. Each time they answered a question, they'd learn a little bit about the attraction and how its inspiration had been drawn from Walt Disney himself. When a question was answered correctly, the guest would be rewarded by seeing a 3-D animated model of that attraction materialize on the screen. By answering

The signature animation of the Sorcerer's Hat plays. The hat lifts up, magic spills out and the camera pushes into the hat.

Beauty shot image of Cinderella Castle.

NARRATOR

Cinderella Castle at the Magic Kingdom in Walt Disney World is taller than Sleeping Beauty Castle at Disneyland in California. Can you quess how much?

Cinderella Castle "slides over" and makes way for Sleeping Beauty Castle as it slides into frame and stops next to its east coast sister. To start out, the two side-by-side castles are the same size.

NARRATOR (cont'd)

Is it 10 feet taller?

In the side-by-side comparison, Cinderella Castle grows 10 feet (accompanied by slide whistle sound effect).

NARRATOR (cont'd)

32 and 1/2 feet taller?

Cinderella Castle grows 32 and 1/2 feet taller.

NARRATOR (cont'd)

Or 112 feet taller?

Cinderella Castle grows 112 feet taller!

TEXT APPEARS: TURN EAR AND PRESS BUTTON TO MAKE A SELECTION.

NARRATOR (cont'd)

Turn Mickey's ear to select your answer and press his nose when you're ready.

As guest turns ear, each answer choice highlights in sequence. If guest leaves a choice highlighted for more than a second, the NOSE BUTTON flashes.

WHEN GUEST MAKES A SELECTION, his or her magic pin activates.

Montage of concept sketches of Sleeping Beauty Castle.

NARRATOR (cont'd)

When Walt Disney was designing Disneyland, he dreamed of having a beautiful fairy tale castle at the heart of his Magic Kingdom.

Footage of the first-ever children running through.

NARRATOR (cont'd)

And when his dream came true, Sleeping Beauty Castle, at 77 feet tall, was just the right size for his 50-acre park.

Footage of Walt pointing to a map of central Florida.

(Continued)

Figure 24.4

A script for Magic Kingdom: Cinderella Castle, one of the Discover The Stories Behind the Magic kiosk games, written by Kevin P. Rafferty, Senior Concept Writer and Director, Walt Disney Imagineering. Script courtesy of © Disney Enterprises, Inc.

NARRATOR (cont'd)

But when Walt started dreaming about Walt Disney World, he had nearly 30,000 acres to build on! That's twice the size of Manhattan Island!

Special effect of Cinderella Castle popping into the New York City skyline.

NARRATOR (cont'd)

And even though there was enough land to build a skyscraper-sized castle...

Overlay of Sleeping Beauty Castle against Cinderella Castle.

NARRATOR (cont'd)

...Cinderella Castle measured in at 'only' 112 feet taller than its little sister in California.

Footage of fireworks exploding over Sleeping Beauty Castle.

NARRATOR

After all, it's not the size of the castle that counts...

Tinker Bell flies in and changes the scene with her magic wand to fireworks exploding above Cinderella Castle..

NARRATOR (cont'd)

...it's the size of the magic in the Kingdom!

IF GUEST HAD SELECTED "112 FEET TALLER," TEXT APPEARS: "YOU'RE RIGHT!"

MICKEY MOUSE

You're right! Great job!

IF GUEST HAD SELECTED ANOTHER ANSWER:

MICKEY MOUSE (cont'd)

Gosh, I didn't know that!

all the questions correctly, the entire theme park would be assembled, and Mickey himself would congratulate the guest. Thus, guests would be using Disney's imagination to build a theme park; they would literally be experiencing the connection between Disney's imagination and the parks he inspired.

CATCHING THE EYE

The Mickey Mouse kiosks are not only fun to use, but they also do a good job of catching the eye of passersby and enticing them to give the kiosks a whirl. Kiosk designers on other projects have used a similar approach, creating housing that not only attracts attention but also reflects the theme or message that the kiosk is meant to send out.

For example, the University of North Carolina, which is located near the seacoast, developed a kiosk program called *Surf the Seaweb* that would give students and visitors easy access to information about the school. The kiosk designed for this project resembles a full-size surfboard, aptly in keeping with both its seashore location and with the metaphor of surfing for information.

A chain of movie theatres in Canada has installed "character kiosks" in its movie house lobbies to serve as ticket sellers and ticket takers. Each reflects the theme of the movie house where it is located. One of the most colorful, set in an Egyptian themed theatre, is an exotic jackal figure. Standing on two legs and the height of a tall man, it looks as if it had sprung right out of an Egyptian pyramid.

And, as a final example, a firm in North Carolina created a teepee-like structure to promote the work of Native American artists. It is constructed along traditional lines, supported in the center by tent poles and decorated with authentic Native American symbols. Yet it is a fully functional kiosk, fitted out with three computer units and monitors.

USING KIOSKS AS PART OF A LARGER EXPERIENCE

Kiosks are often used as adjuncts to cultural exhibits, trade shows, and other types of installations. In such cases, the kiosk's program is usually coordinated with other parts of the exhibition so that it is thematically in keeping with them, both visually and in terms of style and subject matter. This integrated approach is similar to the philosophy of designing a transmedia production, discussed in Chapter 9.

Since different users will come to the kiosk with different degrees of interest in the subject matter it presents and different degrees of knowledge about it, a well-designed kiosk program will offer visitors as much choice as possible about what they can see or do. Some of the choices may be geared for those who just have a passing curiosity about the subject, while other choices might be suitable for those who want to delve deeper.

Ideally, the kiosk will offer users an opportunity to experience some element of the exhibit in greater depth or in a way that would not otherwise be possible. And even when kiosks are expected to fulfill some type of pragmatic goal, they will be more effective if the contents are entertaining.

THE KIOSK AS A VIRTUAL EYE

Kiosks can give users an opportunity to see things that are impossible to view under any other circumstance. For instance, in its exhibit of antique Greek vases, the Getty Museum in Los Angeles designed a kiosk that lets visitors examine a precious vase from any angle

(Continued)

they choose, as if they were holding the vase in their own hands, and even as if examining it through a magnifying glass. In reality, of course, a museum visitor would never be allowed to touch such a vase, so the kiosk offered them a special experience.

In a similar fashion, the Galleria dell'Accademia in Florence, Italy, installed a kiosk in conjunction with its display of the world famous statue of Michelangelo's David. The kiosk allowed museum visitors to view parts of the giant statue at close range, including parts of the statue that are normally hidden from view.

MIXING IN THE ENTERTAINMENT

To better understand the process of designing a kiosk project that has a purposeful goal, yet is also highly entertaining, let's take a look at an air pollution project on which I served as a consultant. The client was a government environmental protection agency in the state of California. Here are some of the questions we needed to address right at the start of the project and how we answered them:

- **1.** What is the goal of the project? We established that the goal was to increase the kiosk visitor's awareness of air pollution, especially pollution produced by motor vehicles.
- **2.** Who would our target audience be? We determined that the program would be directed at adult drivers. However, because the kiosks would be placed in various public spaces, we realized we could have no direct control over who might be visiting them, so we had to make the program meaningful to others as well.
- **3.** What was the project's objective? We established three objectives. First, to raise awareness that the air pollution problem in California was not "solved," and that motor vehicles were a large part of the problem. Second, to educate visitors about the harmful effects of air pollution. And third, to inform users of simple steps they could take, as drivers, to reduce air pollution.
- **4.** What format would we use to get our message across? Since this would be reaching an extremely broad demographic, we wanted to make the program as entertaining and engaging as possible. Thus, we decided to design a game around the core message. We wanted the game to be fun, yet relatively quick to play.
- **5.** What would the thrust of the game be, and how would it be structured? We built the game around the idea of an imaginary road trip, appropriate for a target audience of drivers. The player would travel along a fictional highway and could stop at various roadside attractions along the way, advertised by humorous-looking billboards. Each attraction would be a module devoted to one aspect of air pollution and would contain a brief, light introduction and a trivia game relating to the topic.

6. How would we reward the players for playing the game? In addition to verbal rewards for answering the trivia questions correctly, we decided to make use of the kiosk's ability to print. Players would receive a souvenir bumper sticker for each of the attractions they visited (thus reinforcing what they learned in the module) and also get one random "air pollution resolution"—an easy-to-apply idea for reducing motor vehicle emissions.

Based on these initial decisions, we could then go ahead and do the other development tasks that needed to be done. These included working out a concept for the attract mode, deciding on the theme of each module, and determining the game's overall visual style. Finally, we'd turn to the time-consuming job of filling in the details: putting together a list of the facts we wanted to impart, writing the trivia questions, and producing the artwork.

PLUMBING THE CREATIVE POSSIBILITIES OF THE KIOSK

One of the most attractive attributes of the kiosk is its versatility and the ease with which it lends itself to various add-ons. In a way, the kiosk is like a bland food, such as chicken, that can be dressed up in an endless variety of sauces and served in many delectable ways. Just as chefs make good use of the adaptability of the chicken, we can put our inventive powers to work to plumb the possibilities of the kiosk.

Time-Travel via Kiosk

A project called *An Imagined Place* is an excellent example of how the basic kiosk can be enriched by using sophisticated technologies. *An Imagined Place* was developed by designer Greg Roach, first introduced in Chapter 4. He describes *An Imagined Place* as "a way to be a tourist in time" and to virtually travel to some of the greatest archeological sites in the world. The project has been developed with the encouragement of Microsoft, Cambridge University, and UNESCO. Although still in its conceptual stage, with its ultimate destiny unknown, enough groundwork has been done on it to illustrate how a specially outfitted kiosk can transport users to a lost civilization and allow them to have a unique interactive journey.

Roach named the prototype for his project *Virtual Luxor* because he conceived of his idea while visiting the temples of ancient Egypt. The portal into this lost world of ancient Egypt would be through a specially outfitted kiosk. (See Figure 24.5.) Once visitors entered the kiosk booth, an Internet connection and video-conferencing would be used to transport them back in time to the temple complex at Luxor. There they would see their own image inside the ancient tomb complex (via the teleconferencing technology) and be able to interact with virtual characters from ancient Egypt.

The technology for producing a project like *Virtual Luxor* would seem to be extremely expensive and perhaps difficult to execute, but Roach asserts that this

Figure 24.5
The specially outfitted kiosk booth for Virtual Luxor utilizes a videoconferencing camera (upper right) to transport the visitor to ancient archeological sites. Image courtesy of Hyperbole Studios.

is no longer the case. He points out that thanks to advances in graphics, bandwidth, and computing power, a project like this can almost be done with an "off the shelf" approach.

Assisting in Life and Death

With the technology that has become available since 1969, when the first ATMs were introduced, kiosks are being called upon to handle tasks that were unimaginable back then. For example, a cosmetics company has developed kiosks that can not only show informational videos about its product line but also dispense sample fragrances. Called the *In-Store Interactive Fragrance Assistant*, the kiosk lets customers sniff a whiff of a selected scent. It then quickly dissipates the perfume, leaving the air fragrance-free for another choice.

Kiosks are also assisting those who have passed away, and the ones who grieve for them, projecting images of the deceased from beyond the grave. Mourners or people who plan well ahead can now commission a tombstone—a so-called *vidstone*—to commemorate the life of the deceased individual. The tombstone kiosk contains a video record of the departed's life. The vidstones utilize solar-powered technology and weatherproof LCD panels. A smaller version, called the *VIDpet memorial*, is now available for cherished animal companions.

The Kiosk as Avatar

Certainly one of the most unique examples of kiosk technology is the robotic kiosk project known as PEBBLES. PEBBLES stands for Providing Education by Bringing Learning Environments to Students and these cutting-edge kiosks are designed to connect hospitalized children with their schools. The system makes use of two matching life-sized robotic kiosks and videoconferencing technology, with a monitor embedded in the robot's "face." (See Figure 24.6.)

One unit is deployed to the patient's school and acts as the child's avatar, while the second unit stays beside the patient's bed and serves as a window into the classroom. Using video game controls to manipulate the avatar at school, the child can direct it to move around the classroom, zoom into the blackboard for a better look at what the teacher is writing, turn its robotic head to see what the students in the back of the room are doing, or even raise its hand to ask a question. The units also contain printers and scanners so the patient and teacher can exchange documents—homework, tests, handouts, and so on. The monitor in the classroom unit shows a live video feed of the patient in the hospital, creating a real sense that the child is actually present. Furthermore, the school-based robotic kiosk is not just restricted to a single classroom. It can move from room to room, hang out with friends at the cafeteria, and even participate in school performances.

The PEBBLES units have full-time jobs connecting sick children to their classrooms, but imagine the possibilities if similar robotic kiosks were available for other types of activities. For example, they might be employed to take part in role-playing games, or be put to work exploring inhospitable terrain, or be used to visit places the person operating it cannot visit in person. In terms of storytelling, these robotic kiosks could become leading characters in the digital dramas of the future.

ADDITIONAL RESOURCES

News and feature articles about kiosks can be found at the *Self Service World* website, http://www.selfserviceworld.com/. The publication, which was begun in 1999 and which was formally known as *Kiosk* magazine, carries information on all aspects of interactive kiosks.

In addition, Summit Research Associates (http://www.summit-res.com/index.html) researches and sells highly specialized reports on kiosks, on topics ranging from market segments, design and development issues, and statistics about the kiosk business.

Figure 24.6
PEBBLES, the robotic kiosk, serves as an avatar for hospitalized children. Image courtesy of the PEBBLES project.

CONCLUSION

Although the basic kiosk is quite simple—just a computer and screen placed within some kind of rugged housing—we have seen how it can be dressed up in a great variety of ways. Because of its versatility, the kiosk can readily be combined with other technologies to give users unique kinds of experiences. As the projects described in this chapter have illustrated, the humble kiosk can be transformed into a dynamic medium for entertainment, education, information, and social interaction.

The kiosk is an exceptionally democratic tool, well suited for use in public places and for all types of users. It offers interactive experiences to any and all, usually free of charge. And even those who might normally consider themselves technophobic are apt to find kiosks user-friendly and not at all intimidating.

Furthermore, kiosks adapt readily to new technologies. Almost certainly, innovative designers and content creators will be putting them to work in ways we cannot yet imagine as new technologies come down the pike.

IDEA-GENERATING EXERCISES

- **1.** List the various things you have been able to do via electronic kiosks, including utilitarian tasks as well as other kinds of experiences. What was the most inventive use of a kiosk that you've personally encountered? Are there certain things you think could be done via a kiosk but have not yet seen offered?
- **2.** Pick a topic that one might find as the subject of a museum exhibition, historic site, or other type of cultural or recreational institution. Sketch out an idea related to this topic that could be explored via an electronic kiosk. How would this kiosk program broaden the visitor's understanding of the exhibit? What kinds of things would it allow the user to do?
- **3.** Imagine that you were in charge of a large public facility such as a hospital, train station, or theatre lobby—a place where people often have time on their hands. What type of entertainment experience could you provide via a kiosk that would be appropriate to your facility? If money were no object, what kind of design would you choose for the physical housing of this kiosk and for the interface devices?

PART 5 Career Considerations

Working as a Digital Storyteller

How do you find work as a digital storyteller?

If you've got a great idea for a video game or other work of interactive entertainment, how do you sell it?

How do you build a career in such a quickly changing field as interactive entertainment?

A NEW OCCUPATION

The pioneering individuals that we've met along the way in this book are all practitioners of a new type of creative endeavor, a craft that did not even exist a few decades ago. They are digital storytellers. The work they do spans an assortment of technologies, and the projects they create are a contrast in opposites—everything from talking baby dolls to gritty video games. Some of these creations appear on the tiny screens of wireless devices, while others play out on huge movie screens. The venues where these works are enjoyed run a gamut of possibilities, too. They may be seen in one's living room, in a theme park, in a schoolroom, in an office—even in the ocean, as with the robotic dolphin, DRU. Yet, despite the great differences among them, the works they create have significant points in common. All of them

- utilize digital technologies;
- tell a story;
- · are perceived as being entertaining;
- · engage the users in an interactive experience.

Even though being a digital storyteller is a relatively new occupation, it is a type of work that is increasingly in demand. True, you won't find jobs for "digital storytellers" listed in the want ads. That's because the jobs in this arena go by a great variety of titles and call for various kinds of skill sets. As we've seen throughout this book, the people that we would consider to be digital storytellers carry many official titles, including designer, graphic artist, information architect, producer, project manager, writer, and director. The most visionary of the digital storytellers may work across a number of different platforms and media. This chapter will explore ways of finding work and developing a career in the field of digital storytelling.

THE LIFE OF A DIGITAL STORYTELLER

If you were to round up 10 people who could be described as digital storytellers and ask them how they got started, the chances are that they would give you 10 entirely different answers. Many, especially the younger ones, will probably have had some kind of college training in the area, but almost certainly, their career paths will not have been straight ones. Most will have come to their present job by following a dream, by hard work, and by a willingness to take chances.

Kevin Rafferty's career is a perfect illustration of this. Rafferty is a senior concept writer and director for Walt Disney Imagineering, the group at Disney that creates attractions for the theme parks. It's work that Rafferty and other Imagineers refer to as the "dimensional entertainment" side of the storytelling fence, as we saw in Chapter 22, and, as you may recall, Rafferty was the writer of the kiosk script in Chapter 24 for the *Discover the Stories Behind the Magic* project. Rafferty's job calls for a mixture of tasks besides writing. He also creates ideas for theme park attractions and helps to take them from concept all the way to completion. In addition, he writes original music, casts and directs voice and

camera talent, and directs show programming and figure animation—and that's just a partial list of his responsibilities.

Not surprisingly, Rafferty's dream job at Disney didn't start out on this level. His career path actually started with a humble dishwashing job at Disneyland while he was still in college, where he was an art major. After college, he worked for a while as an advertising copywriter. When he heard that Disney was hiring people to work on the new Epcot theme park, he applied for a job as a writer, figuring he knew a little something about theme parks from his old dishwashing job. He succeeded in getting hired, but not as a writer. Instead, he found himself dusting show models and cutting mats for artwork. But still, he had his foot in the door at Epcot, and he made the most of the opportunity. Working on his own time after hours he created and developed some original ideas and ran them by a friendly vice president, and "after paying a lot of dues and trying to prove my creative worth," Rafferty told me, "I was finally and officially accepted into the creative division."

Thus, a path that began with dishwashing led to an exciting array of assignments at various Disney theme parks. Looking back on his experience, Rafferty quips in classic Disney fashion, "I guess it's true what they say: 'When you DISH upon a star, your dreams come true.'"

Rafferty's career path is typical of many others who have found their way into digital storytelling. A straight, clear-cut route is quite rare. It's not like deciding you want to go into dentistry and knowing that step number one is applying to dental school. In Rafferty's case, his career aspirations evolved over time, and once he knew what he wanted to do—to become a creative part of Disney Imagineering—he focused his efforts and sacrificed his free time to get where he wanted to be.

SOME KEYS TO SUCCESS

Although new media involves cutting-edge technology, two industry pros who were queried on advice for establishing a career in this field mentioned some tried and true old-fashioned values (*GlGnews*, March 2002). In fact, the answers they gave would have worked as well for a stone-age hatchet maker. For example, Stevie Case said the three keys to success were drive, dedication, and the desire to learn, while John Romero named passion, hard work, and an optimistic outlook. And both also stressed the importance of being a finisher—to complete any project you commit yourself to doing.

SELLING AN ORIGINAL IDEA

What if, unlike Rafferty, your dream is not to work within a particular company or hold a particular job but instead to sell your own original ideas for a game or other type of interactive entertainment? No question, this is an appealing goal, one shared by many hopeful individuals. Sad to say, however, it is not particularly realistic for several reasons.

For one thing, ideas are plentiful, to the point that most companies are flooded with their own internal ideas generated by employees of the company, and thus they are not looking for ideas from the outside. For another thing, as they say in Hollywood, ideas are cheap; execution is everything. Execution is where the real challenge lies, and execution takes experience, talent, time, and often an investment of money. To convince a company that your concept has merit, you'll need more than an idea. You'll want to have something to show them—a concept document, a design document, or, even better, a working prototype. And you'll also need to consider the pitching strategy for your project. Who is the target audience for this product, and why would they like it? What competing projects already exist, and how is yours different and better? And how would your project be a good fit with other offerings in the company's line?

But even if you've done all the necessary groundwork, the companies you are planning to approach are unlikely to give you a warm reception if you are an unknown quantity to them. Developing a game or other work of interactive entertainment is a risky proposition that can cost millions of dollars. If a company is interested at all in hearing pitches from outside vendors, they will be far more likely to be receptive to a known developer with a proven track record than they would be to a stranger.

HELPING HANDS

Despite these discouraging words, if you are convinced that you have a stellar idea and want to have a go at trying to sell it, you can obtain some excellent guidance from a document prepared by the International Game Developers Association (IGDA), the premiere organization of game developers. Called the *Game Submission Guide*, it offers information about the pitching process and includes a checklist of what you will need to include for a professional-looking submission. Although written with video games in mind, the information pertains equally well to other forms of interactive entertainment. Members can download the guide from the organization's website, www.igda.org. Although it was written a number of years ago, its points are as relevant as ever.

In addition, the IGDA site also contains a column written by game industry veteran Tom Sloper called *The Games Game* where you can find archived articles about submitting game ideas.

THE DIFFERENT EMPLOYMENT PATHS

If you are interested in finding full-time employment in interactive media, you will be happy to know that a surprisingly wide variety of businesses employ staff members who specialize in this field. The most obvious are the game publishers and game developers. The publishers have deeper pockets than the developers, and they may either develop projects in-house or farm them out to developers, who do the actual creative work, which the publishers then package and market. These publishers and developers do not necessarily restrict

themselves to video games. They may also make games for mobile devices and for the Web, including MMOGs.

In addition to game publishers and developers, another group of entities focuses on interactive media: the design firms that deal with interactive media. Some of them specialize in Web design work, while others pursue cutting-edge projects in iTV and DVDs. Some work in a wide sweep of interactive media. In addition to iTV projects, they do work in kiosks, wireless devices, the Web, and DVDs.

One entire industry that is becoming increasingly involved in interactive media is the Hollywood entertainment business, as we've seen throughout this book. Not only are movie studios making games based on their films, but they are also promoting their films on the Internet and on mobile devices, sometimes using highly creative approaches. Television networks also promote their shows via new media and in some cases enhance their offerings via iTV. Public broadcasters are particularly aggressive in using interactive media to maximize the content of their programming, developing projects for the Web, DVDs, and iTV. Thus, traditional entertainment studios and broadcasters are definitely worth investigating for employment opportunities.

In considering possible employers, do not by any means overlook major corporations. Most of today's large companies have internal divisions that produce content for the Web and other interactive media, work that is often done under the umbrella of the promotion or marketing departments. Other entities that do work in interactive media are toy companies, ad agencies, and PR companies, as well as companies that specialize in interactive training programs. Another group of organizations to consider are cultural institutions—museums, historic sites, aquariums, and so on-all of which may use interactive displays to make their exhibits come to life. And theme park companies employ individuals like Kevin Rafferty to create attractions that take advantage of the latest interactive technologies. In addition, government agencies sometimes produce interactive programming for educational, informational, or training purposes.

COMMON ENTRY POINTS

Although, as we've seen from Kevin Rafferty's story, the path to a great job in digital media is not necessarily a straight one, a couple of traditional routes do exist. One is by becoming a beta tester, which is particularly attractive to people who want to work in games. Beta testers are hired to look for bugs in games before they are released to the public, and this type of work is often a stepping stone to a higher level job within the same company. Another proven route is via student internships. Internships offer first-hand exposure to a professional new media work place. Not only are they educational, but such experiences are also good to have on a résumé. And, best of all, they can lead to full-time employment.

Aside from scoring an internship or a job as a beta tester, the pathway into digital storytelling is much like that for any other kind of work. You need to research the field to determine which segment of the industry would offer you the most potential, given your particular talents, interests, and skill set. It is also quite helpful to network and to attend industry events, which we will be discussing in more detail later in the chapter. And before setting out on a job search, you'll want to give serious consideration to creating a portfolio of sample work, which is discussed in detail in Chapter 26.

BREAKING IN: SOME HELPFUL INFORMATION

If you are seriously interested in getting a job in digital media, especially video games, and want to know how to get into the field, visit the section of the IGDA website called *Breaking In*: http://www.igda.org/breakingin. The site includes an excellent section on major career paths, interviews with professionals in games describing how they broke in, and a list of resources.

In addition, game designer Ernest Adams has a Web page devoted to breaking into the game business: *The Wanna-Be Page:* http://www.designersnotebook.com/Wanna-be/wanna-be.htm.

WORKING AS A FREELANCER

But what if you would prefer to be your own boss rather than to be a full-time employee of an organization—is this an option in new media? The answer is a tentative yes. It depends on your experience, on your specialty, and the tenor of the times. Back in the 1990s, it was quite customary to be hired to work on a specific project and then move on once the project had been completed. Currently, most companies work entirely with full-time staffers. One of the few professional areas that still offers opportunities to freelancers is in writing, my own specialty. The more credits you have and the more people you know in the industry, the more likely you are to find freelance writing work, though it is more difficult than it used to be.

The work one does as a freelance writer varies tremendously from project to project. Some of the assignments you snag are not much different from doing piece goods work in a factory. You may be expected to churn out hundreds of lines of dialogue, sometimes with little variation between the lines, and the work can be quite tedious. On the other hand, some writing jobs are highly creative. You may have a chance to collaborate on the overall design and content of a project and to develop original characters; you may also be able to help develop what the interactivity will be and how it will work. Each type of interactive medium poses its own challenges. Writing a script for a kiosk will be quite different from writing one for a smart toy, and both will be different again from writing an ARG or a serious game.

One of the most stimulating things about being a freelance writer is being able to take on projects that are quite different from each other; your work is always creatively challenging. However, being a freelancer also means dealing with issues

that one does not have to worry about as a full-time employee. For example, you might have to chase after a client to get paid or find yourself mired in an unpleasant situation called *project creep*, in which a project grows much bigger than it was originally understood to be. Project creep can cause you to spend many more weeks than you had planned on an assignment but without receiving additional compensation.

Fortunately, freelance writers do not have to go it entirely alone anymore. The IGDA has a SIG (special interest group) for writers, and the Writers Guild of America, West, recently formed the New Media Caucus, a support and advocacy group for writers in this field. The Writers Guild also offers two special contracts for interactive writing. The first, called the Interactive Program Contract, or IPC, covers writing for most types of interactive media, including video games and mobile entertainment, while the second, called the Made for Internet Contract, specifically covers original writing done for the Internet. Both contracts are available directly from the Guild's organizing department. Qualified new media writers can even obtain membership in the Guild, which once just included writers of motion pictures and television.

LEGAL CONSIDERATIONS

At some point or other, if you are working in new media, you are bound to run into legal situations. For example, you are quite likely to be faced with issues involving *intellectual property* (IP). Intellectual properties are unique works of human intelligence—images, writings, music, pieces of animation, even game engines or an invention for a toy—that are given certain legal protections, which include copyrights, patents, and trademarks. Intellectual properties can be extremely valuable, and they are fiercely guarded in interactive media with a zeal bordering on paranoia. You may become involved with IP questions when it comes to protecting your own creations; you may also run into IP issues when you want to use the creative work of others in a project.

IP issues can be highly complex, but one thing about them is quite simple: You don't want someone stealing your intellectual property and you don't want to be accused of stealing intellectual property that belongs to someone else. The first situation can result in your losing a significant amount of income; the second can result in a lawsuit. To prevent either situation from occurring, you need to familiarize yourself with the basics of intellectual property law. One place to start is with the archived website of entertainment and new media attorney and IP specialist Michael Leventhal (www.wiredlaw.com). The archived site contains a good primer on IP, called *Intellectual Property 101*, plus a number of links that will take you to more information on the subject.

Another legal matter you will need to be familiar with is a document called a *non-disclosure agreement*, or NDA, often used in high tech circles. You will no doubt become aware of NDAs if you are submitting a project to a company in the hopes of selling it or if a company is interested in hiring you for a project,

but first needs to share with you what has been done with the project to date. Both situations raise the risk of valuable information being seen by strangers who might possibly use it without authorization. To avert such a risk, it is customary for one party to request the other to sign an NDA. When someone signs such a document, he or she promises to keep the information they are receiving confidential. (See Figure 25.1.)

If you are working as a freelancer or are running your own development or design company, you will also need some legal protections in the form of a contract. You will definitely want a contract if you are entering into a new employment relationship; that is, if you or your firm is being hired to do some work for another entity. A contract should specify what your responsibilities will be and what you will be paid at each juncture, often tying payments to the completion of various *milestones* (points when particular parts of the project are due). It should spell out what happens if the work expands beyond what has been assigned, thus avoiding the problem of project creep, discussed earlier. The contract may also include language about the kind of credit you will receive and where the credit will appear, and may note who will hold the copyright to the completed work. If you are inexperienced in negotiating contracts, you would be well advised to seek the help of an attorney. Even if you think you are savvy in such matters, it is always a good idea to have a lawyer look things over before signing.

But even before you reach the contract stage, you need to take some steps to protect yourself against an unscrupulous or inept employer. (Working for a well-intentioned but inexperienced client can be as perilous as working for one who deliberately intends to take advantage of you.) Before going too far in any discussion with a new client, try to learn as much about the company as you can, either by doing some research or by asking the prospective employer a series of focused questions. Asking the right questions about the company and the project will help you determine whether this is something you'll want to pursue—or if it is something you should run from.

EDUCATING YOURSELF

In any case, concerns about contracts and protecting your intellectual property are matters to be dealt with once a career is established. Let's take a few steps back and discuss how one prepares for a career in new media. It usually begins, as you might expect, with the right education. In terms of a formal education, you have a choice of two different paths. Path number one is to get a good foundation in the liberal arts, and then pick up specialized training, if needed, after graduation. Path number two is a more focused route: to enroll in an undergraduate program in computer science or in digital arts. Digital arts programs are becoming increasingly common at institutions of higher learning all over the world, both as undergraduate programs and as master degree programs. Specialized programs can give you a good background on theory and invaluable hands-on experience in creating interactive projects; they sometimes offer internship programs and can serve as fairly smooth stepping-stones to a good job.

419

NON-DISCLOSURE AGREEMENT

This non-disclosure agreement	("Agreement") is entered into as of	
("Effective Date") by and between		
("Artist"), and	, located at	
("R	ecipient"). Artist and Recipient are engaged in discussions in	
contemplation of or in furtherance of a business relationship. In order to induce Artist to disclose		
its confidential information during such discussions, Recipient agrees to accept such information		
under the restrictions set forth in th		

- 1. <u>Disclosure of Confidential Information</u>. Artist may disclose, either orally or in writing, certain information which Recipient knows or has reason to know is considered confidential by Artist relating to the [NAME] Project ("Artist Confidential Information"). Artist Confidential Information shall include, but not be limited to, creative ideas, story-lines, characters, trade secrets, know-how, inventions, techniques, processes, algorithms, software programs, schematics, software source documents, contracts, customer lists, financial information, sales and marketing plans and business plans.
- 2. Confidentiality. Recipient agrees to maintain in confidence Artist Confidential Information. Recipient will use Artist Confidential Information solely to evaluate the commercial potential of a business relationship with Artist. Recipient will not disclose the Artist Confidential Information to any person except its employees or Artist's to whom it is necessary to disclose the Artist Confidential Information for such purposes. Recipient agrees that Artist Confidential Information will be disclosed or made available only to those of its employees or Artist's who have agreed in writing to receive it under terms at least as restrictive as those specified in this Agreement. Recipient will take reasonable measures to maintain the confidentiality of Artist Confidential Information, but not less than the measures it uses for its confidential information of similar type. Recipient will immediately give notice to Artist of any unauthorized use or disclosure of the Artist Confidential Information. Recipient agrees to assist Artist in remedying such unauthorized use or disclosure of the Artist Confidential Information. This obligation will not apply to the extent that Recipient can demonstrate that: (a) the Artist Confidential Information at the time of disclosure is part of the public domain; (b) the Artist Confidential Information became part of the public domain, by publication or otherwise, except by breach of the provisions of this Agreement; (c) the Artist Confidential Information can be established by written evidence to have been in the possession of Recipient at the time of disclosure; (d) the Artist Confidential Information is received from a third party without similar restrictions and without breach of this Agreement; or (e) the Artist Confidential Information is required to be disclosed by a government agency to further the objectives of this Agreement, or by a proper court of competent jurisdiction; provided, however, that Recipient will use its best efforts to minimize the disclosure of such information and will consult with and assist Artist in obtaining a protective order prior to such disclosure.
- 3. <u>Materials</u>. All materials including, without limitation, documents, drawings, models, apparatus, sketches, designs and lists furnished to Recipient by Artist and any tangible materials embodying Artist Confidential Information created by Recipient shall remain the property of Artist. Recipient shall return to Artist or destroy such materials and all copies thereof upon the termination of this Agreement or upon the written request of Artist.
- 4. No License. This Agreement does not grant Recipient any license to use Artist Confidential A model NDA (Non-Information except as provided in Article 2.

5. <u>Term</u>.

(a) This Agreement shall terminate three (3) years after the Effective Date unless terminated valuable information earlier by either party. Artist may extend the term of the Agreement by written notice to Recipient. Either party may terminate this Agreement, with or without cause, by giving notice of termination to the other party. The Agreement shall terminate immediately upon receipt of such notice. Valuable information will be kept confidential. Docum courtesy of Michael Leventhal.

Figure 25.1
A model NDA (Non-Disclosure Agreement), a document which guarantees that valuable information will be kept confidential. Document courtesy of Michael Leventhal.

- (b) Upon termination of this Agreement, Recipient shall cease to use Artist Confidential Information and shall comply with Paragraph 3 within twenty (20) days of the date of termination. Upon the request of Artist, an officer of Recipient shall certify that Recipient has complied with its obligations in this Section.
- (c) Notwithstanding the termination of this Agreement, Recipient's obligations in Paragraph 2 shall survive such termination.

6. General Provisions.

- (a) This Agreement shall be governed by and construed in accordance with the laws of the United States and of the State of California as applied to transactions entered into and to be performed wholly within California between California residents. In the event of any action, suit, or proceeding arising from or based upon this agreement brought by either party hereto against the other, the prevailing party shall be entitled to recover from the other its reasonable attorneys' fees in connection therewith in addition to the costs of such action, suit, or proceeding.
- (b) Any notice provided for or permitted under this Agreement will be treated as having been given when (a) delivered personally, (b) sent by confirmed telefacsimile or telecopy, (c) sent by commercial overnight courier with written verification of receipt, or (d) mailed postage prepaid by certified or registered mail, return receipt requested, to the party to be notified, at the address set forth above, or at such other place of which the other party has been notified in accordance with the provisions of this Section. Such notice will be treated as having been received upon the earlier of actual receipt or five (5) days after posting.
- (c) Recipient agrees that the breach of the provisions of this Agreement by Recipient will cause Artist irreparable damage for which recovery of money damages would be inadequate. Artist will, therefore, be entitled to obtain timely injunctive relief to protect Artist's rights under this Agreement in addition to any and all remedies available at law.
- (d) This Agreement constitutes the entire agreement between the parties relating to this subject matter and supersedes all prior or simultaneous representations, discussions, negotiations, and agreements, whether written or oral. This Agreement may be amended or supplemented only by a writing that is signed by duly authorized representatives of both parties. Recipient may not assign its rights under this Agreement. No term or provision hereof will be considered waived by either party, and no breach excused by either party, unless such waiver or consent is in writing signed on behalf of the party against whom the waiver is asserted. No consent by either party to, or waiver of, a breach by either party, whether express or implied, will constitute a consent to, waiver of, or excuse of any other, different, or subsequent breach by either party. If any part of this Agreement is found invalid or unenforceable, that part will be amended to achieve as nearly as possible the same economic effect as the original provision and the remainder of this Agreement will remain in full force.
- (e) This Agreement may be executed in counterparts and all counterparts so executed by all parties hereto and affixed to this Agreement shall constitute a valid and binding agreement, even though the all of the parties have not signed the same counterpart.

IN WITNESS WHEREOF, the parties have executed this Agreement as of the Effective Date.

RECIPIENT	ARTIST
Typed Name	Typed Name
Title	Title

BUT WHAT IF YOU ARE A LUDDITE?

Not everyone feels that it is good to focus on new media as an undergraduate. For example, designer Greg Roach, introduced in Chapter 4, strongly believes that no matter what position you are angling for in interactive media, you should first have a liberal arts education. He says "a grounding in the classical humanities is critical. Programmer, 3-D artist, designer, whatever . . . I'd much rather hire a traditional painter who's a Luddite [a person who rejects technology] but who understands color theory—and then train her in Maya—than hire a hot-shot 3-D modeler whose aesthetic has been shaped exclusively by console games."

If you are already out of college or if going to college is not an option for you, you might consider a certificate program in new media arts. Such programs are offered by many community colleges and by university extensions. Or your might select just a few courses that prepare you in the direction you wish to go in—classes in Flash animation, for example, or Web design. How much technical know-how you need varies from position to position. It is always helpful to have a general understanding of digital technology and a grasp of basic software programs, but if you want to be a digital storyteller, it is even more important to understand the fundamentals of drama and literature. You would be well advised to take a course that teaches narrative structure, or one in world mythology, and you should definitely take at least one course in dramatic writing.

Not all of your education has to take place in a classroom. If you don't already, spend some time playing games, trying out different genres and different platforms. Include MMOGs, ARGs, mobile, and casual games on your "to play" list so you can see how the experiences differ. Even if you aren't interested in working in games, they can teach you a great deal about design and interactivity. If a particular area of gaming is unfamiliar to you, find someone who plays this kind of game—a relative, a local student, a family friend—and ask them to give you a tour of one or two. Most people are happy to oblige, but you can always make it more attractive by treating your guide to a pizza.

Finally, you can get an excellent free education online by visiting websites devoted to various aspects of interactive media. You can also sign up to receive electronic and print trade publications. Each segment of the new media arena has several websites devoted to it and usually several electronic publications. Many have been mentioned in this book, and a diligent online search will turn up others.

INDUSTRY EVENTS

Another excellent way to educate yourself is by attending conferences, trade shows, and other industry events. Most of these gatherings are divided into two quite different parts: a conference and an exposition. By strolling around the expo floor, you get a chance to see demonstrations of the latest hardware and

software in the field, often given by some of the creators of these very products. And by attending the conference sessions, you will hear talks by industry leaders and learn about the latest developments in the field. Although these trade events can be expensive, many of them offer student discounts and many also have volunteer programs. By working as a volunteer, you can take in as much of the event as you want during your off hours.

Virtually every sector of the interactive arena holds at least one annual event. Two major international conferences are MIPTV featuring Milia, which is held in Cannes, France, and the Tokyo Game Show in Japan. In the United States, the Game Developers Conference (GDC) is well worth attending. It offers excellent presentations on every facet of game design and production, including mobile games, MMOGs, and serious games, and many of the topics are of particular interest to digital storytellers. The Austin Game Conference is another high quality event.

If you are interested in computer graphics, you will definitely want to attend the annual SIGGRAPH conference. It is also one of the few shows where significant attention is paid to VR. For those interested in iTV, the showcases held by AFI's Digital Content Lab offer an excellent opportunity to see demonstrations of cutting-edge iTV programming and other types of interactive media. The training field has its special gatherings, too, with *Training Magazine's* annual conference and expo being just one example. The events mentioned here are just a small sampling of trade shows, conferences, and conventions that involve interactive media; new ones are started every year, and a few older ones sometimes fall by the wayside. The best way to find out about the industry events in your particular area of interest is by subscribing to electronic and print publications that specialize in the field.

THE PEOPLE CONNECTION

Industry events, excellent as they are, only take place at infrequent intervals. To stay more closely involved, and to connect with others who work in new media, you would be well advised to join one of the many professional organizations in this field. Networking with others in the field is one of the best ways to find work and stay on top of developments in the industry, as virtually any career counselor will tell you. It is in even more important in a fast moving field like interactive media. Merely joining and attending an occasional meeting, however, brings limited benefits; you'll reap far greater rewards if you join a SIG (*special interest group*) or a committee within the organization and become an active, contributing member. By participating on a deeper level, you are more likely to form valuable connections that can lead to jobs. Two such organizations are the Academy of Interactive Arts and Sciences (AIAS) and the International Game Developers Association (IGDA).

A number of guilds and other organizations within the Hollywood system now welcome members who specialize in interactive media. Among these main-stream organizations are the Writers Guild, noted earlier, the Producers Guild,

Working as a Digital Storyteller CHAPTER 25

and the Academy of Television Arts and Sciences, generally known as the TV Academy. These organizations all have active committees or peer groups made up of new media members and put on special events focusing on interactive entertainment.

Unfortunately, many of the organizations mentioned here only hold meetings in certain geographical regions, and if you live outside these regions, it is difficult to become actively involved. However, you might also look into the possibility of forming a local branch, which can be a great way to meet other members in a less congested setting.

SOME POINTERS FOR A CAREER IN NEW MEDIA

Here are some helpful ideas for establishing and maintaining a career as a digital storyteller:

- Anticipate change. This field does not stay still, so you need to continually educate yourself on digital technologies and new forms of digital entertainment.
- Don't restrict your vision only to this field. Indulge your interests in the world beyond. Not only will this be of value to you in your professional work, but it will also help keep you balanced.
- Educate yourself on narrative techniques. All good storytelling relies on certain basic principles.
- Stay tuned to traditional popular culture—to television, film, and music.
 To a large extent, new media and traditional media intersect and influence each other.
- If you are angling for a first job or a better job, consider building your own showcase. Not only will it give you a way to display your talents, but you will also learn something in the process. For more on showcases, see the next chapter.
- As one of our experts said in Chapter 19, referring to smart toys, sometimes you have to dump all the pieces on the floor and play with them.
 Playing games and participating in interactive experiences is the single best way to keep your edges sharp.

Creating Your Own Showcase

Is it a good investment of your time to create an original piece of work or a portfolio of samples to show off your talents?

If you do decide to create your own showcase, what should it include, and what is the best way to highlight your strengths?

What sorts of things do not belong in a showcase and can make a negative impression?

SHOWCASING YOUR WORK: IS IT WORTHWHILE?

It is reasonable to wonder, given how much effort it takes to create an original piece of work, if it is ever worth the investment of your time and energy to put together your own showcase. I would answer this question with a resounding yes, based on my own observations of the interactive entertainment industry and also based on the interviews I've done for this book. A little later in this chapter, we will examine some actual situations in which people have successfully showcased their work. Creating your own showcase can benefit you if one of these scenarios fits your personal situation:

- **1.** You have not yet had any professional experience in interactive media but are interested in working in the field.
- **2.** You are already working in digital entertainment but are considering moving into a different area within it or would like to move to a higher level.
- **3.** You are working as an employee in the field but want to work as a freelancer.
- **4.** You are working as a freelancer and want to attract new clients.

Having an original piece of work to show, or a portfolio of work, is of particular importance if you have not yet had any experience in the field. How else will you be able to demonstrate to a prospective employer what you are capable of doing? A well thought out "calling card" of original work illustrates what your special talents are, where your creative leanings lie, and also reveals something about who you are as a person. A showcase of original work also bears a powerful subtext: You are serious enough about working in this field to spend your own time putting together a demonstration of your work. It carries the message that you are energetic, enterprising, and committed.

Producing a showcase project is a strategy used by small companies as well as by individuals. For example, Free Range Graphics undertook *The Meatrix* (described in Chapter 12) as a *pro bono* project in part to stimulate new business, a gamble that paid off handsomely.

However, the advice to build a promotional calling card must be given with a serious note of caution. If you do undertake such a significant self-assigned task, you need to go about it in a way that will set off your abilities in the most positive light possible and avoid doing things that can undermine your prospects.

CONSIDERATIONS IN CREATING A PROFESSIONAL SHOWCASE

For some people, putting together a showcase is a relatively easy task because they can use samples of student projects or volunteer work that they did, or even of professional assignments. But if you don't have any such samples, or the samples you have are not well suited to your current goal, you are faced

with the daunting job of creating something original from scratch. You will have a number of things to consider before you actually begin. The following sections will address many questions about making a showcase that will almost certainly cross your mind.

Portfolio or Single-Piece Approach?

A portfolio approach includes several brief examples of work, while a single-piece approach focuses on one well-developed project. Each tactic has its own pros and cons. With the portfolio approach, you can effectively demonstrate your ability to work in a range of styles and on different types of subject matter. However, the portfolio approach also means that you will have to undertake several different projects and build them out to the point that they are solid enough to serve as good samples.

By showcasing a single piece, on the other hand, you can present a more fleshed out and complete project than you'd have in a portfolio, where the samples tend to be short and fairly superficial. But having just one piece of work to showcase can be a little risky because the work you are exhibiting might not be what the prospective employer or client is looking for, and you will have nothing else to illustrate what you are capable of.

So where does this leave you? It's best to make the call based on your own individual situation. If you already have a couple of samples you can use and have some ideas about another one or two you could put together, then you are probably already well down the path toward the portfolio approach. On the other hand, if you feel confident you've got a great concept to showcase and that it would work well as a demo piece, than that's probably the best way for you to proceed. There's no right or wrong answer here.

Distribution Method?

You will need to determine what method you will use to make your showcase available to the people you want to see it. The three most obvious choices are the Internet, CD-ROMs, and DVDs. Virtually any prospective employer or client should be able to view your work on any one of these platforms, so ease of viewing is not a factor here. Your work itself, and your own leanings, is really your best guide. It makes sense to distribute your showcase on the medium in which you are most interested in working. But if you want to work in an area that falls outside of the three already mentioned avenues of distribution—if you are interested in iTV, say, or in VR, then pick the medium that you feel would display your material to the best advantage. One final consideration for a multiproject portfolio: It is advisable to package your showcase on a single platform rather than having a jumble of different works that cannot easily be viewed together. If you have both Web and CD-ROM samples, you might want to put your Web pages on the CD-ROM with the other examples, or vice versa. As another possibility, you could embed links to your Web pages in your CD-ROM.

Subject Matter and Approach?

One of the most important questions you will be faced with is what the content of your showcase will be. The honest answer is that no one can tell you what to do here. The best choices are the ones that most closely reflect your own personal interests, talents, and expertise. By picking a subject you really care about, you have the best chance of producing something that will be strong and will stand out from the crowd. The way you decide to construct your showcase should also reflect your personal taste and style—within limits, of course. Coarse humor and disparaging portrayals of any particular ethnic group are never appropriate. Also, you do yourself no favors by employing a sloppy, unprofessional-looking style.

But what if you have tried your best to think of some topics for your showcase and still come up blank? Then you might consider volunteering your services for a nonprofit institution in your community. Possible choices include your church, synagogue, or mosque; the local chamber of commerce or a community service group; or a school sports team or Brownie troop. Another alternative is to create a promotional piece for a business belonging to a friend or relative.

Although on the surface such projects seem to be creatively limiting, you may be inspired to create something quite clever. For instance, you could design an amusing advergame for your brother-in-law's landscaping business, or an interactive adventure tale about Brownies for your niece's Brownie troop. Volunteer projects for nonprofit organizations or for businesses have some solid advantages. They give you hands-on practical experience and also give you a professional sample to include in your showcase, even if the work was done without monetary compensation.

Gaps in Necessary Skills?

Lacking all the skills necessary to put together one's own showcase is a common problem because few people are equipped with the full range of talents necessary for building an effective sample piece. The problem can be solved in two ways: by teaching yourself what you don't already know or by teaming up with someone who is strong where you are weak. Teaching yourself a new skill like Flash animation may seem like an intimidating project, but as we will see from the *Odd Todd* case study later in this chapter, it is manageable. Software is becoming ever easier to use, and books are available that teach animation programs, image manipulation, Web page design, and media authoring. You might also take a community college course to fill in a particular gap.

But if you prefer to team up with a colleague instead, keep in mind you need not even be in the same community. Many collaborations take place in cyberspace, and sometimes they occur between people who have never met in person. Perhaps your strengths are in art, writing, and conceptualizing, while the other person excels at the more technical side of things. If you work together, you can create a project that is more effective than either of you could do alone and also demonstrates your special abilities. This can be a win-win solution for both parties. Of course, you will want to be sure that each person's contribution is made clear in the credits and that no one is claiming solo authorship for the entire project.

ODD TODD: A CASE STUDY

While it is important for a personal showcase to look professional, this does not necessarily mean it needs to follow a conservative, play-by-the-rules approach. If you take a look at the website *Odd Todd* (www.oddtodd.com), you will find an immensely quirky piece of work that breaks almost all the rules and yet has become a wildly successful endeavor. This is not to say that everyone should build a project as idiosyncratic as this one is, but it does effectively illustrate the power of being fresh and original and of having something meaningful to say. Essentially a one-person operation and done on a tiny budget, *Odd Todd* has thrust its creator, Todd Rosenberg, into the spotlight and changed his life.

The site is named for a fictitious character, Odd Todd, and is loosely based on the experiences of the site's creator, Todd Rosenberg, who lost his job with a dot com company during a radical downsizing. In a series of Flash-animated episodes, we watch Todd as he futilely searches for a new job and gives in to such distractions as fudge-striped cookies, long naps, and fantasies about large-breasted women. The artwork in the cartoons is rough and childlike, and the only human speaking character is Todd, who chronicles his hero's struggles in a voice-over narration. (See Figure 26.1.) The voice he uses is distinctive, marked by a puzzled kind of irony and bewilderment at his predicament, and further made unique by his urban drawl and a particular way of stretching out the end vowels in such words as money (mon-aaay) and cookie (cook-aaay). And though the site is extremely funny, it does have a serious side, touching on the painful issues of being unemployed and serving as a kind of a cyberspace support system for laid off white-collar workers. It even contains a special community feature called *Laidoffland*.

Beginning with just a single animated episode, the site has mushroomed into a full array of features. It includes dozens of cartoons, games, and interactive amusements, all relating to Odd Todd and his life and obsessions. It also includes a variety of daily and weekly specials such as a feature called "What's Happening," a diary-like log of Todd's life, and the Tuesday lunch special-recipe concoctions sent in by fans to nourish other laid-off stay-at-homes.

The Hows and Whys of Odd Todd

Why has a site featuring roughly drawn cartoons about an unshaven, unemployed guy in a blue bathrobe become such a hit? How did Todd Rosenberg set about making this site and how does he keep it going? And as a showcase,

430 Figure 26.1 Odd Todd is the fictional hero of the Odd Todd website, an endeavor that has turned its creator's life around.

> Image courtesy of Todd Rosenberg.

> > what has it done for his career? The real Todd shed some light on these questions during a phone interview and several follow-up emails.

> > First of all, let's address one burning question right away. No, the real Todd does not sound like the voice he uses on the website. That is a made-up voice, and many of the situations depicted in the cartoons are invented as well. But the core conceit—that an unemployed dot comer built the site—is totally true. The authenticity of the character's predicament, the real Todd believes, is an important reason why Odd Todd has become so immensely popular. People identify with it, Rosenberg explained. "They see it and say to themselves: 'It's so me!' or 'Someone else is doing exactly what I'm doing! '"

> > Rosenberg began the site after he was laid off from AtomFilms.com. Thinking he'd only be out of work for a few months, he decided to spend some of it doing something he'd always enjoyed—cartooning—and create something that

might possibly help him become employed again. The result was the first episode of Odd Todd. The debut episode was a humorous take on what it is like to be newly laid off, with too much time and too little money.

A DO-IT-YOURSELF APPROACH

Although Rosenberg had learned basic HTML at a prior job and had taught himself to draw (by using Mad Magazine as a model), he lacked training in almost every other skill he would need in order to build and maintain his new site. When asked what he'd studied in college, the University of Hartford, he confessed: "I never studied in college. I wasn't much of a student." He admitted to filling up his notebooks with cartoons instead of lecture notes. He had no training in screenwriting-he owned books on the subject, he said, but had never read them-and had never acquired experience in acting, either, because he had stage fright.

One of the first things he needed to learn, in order to bring Odd Todd to life, was Flash animation. He taught himself how with the help of a book called Flash 5 Cartooning. His "studio" was his apartment in New York, and he did everything from there. To lay down the sound track for the cartoons, he used the microphone that came with his computer and did all the voice work himself, including the strange chirps and other sound effects for the site's nonhuman characters. As a result, he managed to keep his start-up costs low, estimating that during his first year he spent under \$1000.

Keeping Things Going

Though Rosenberg's cartoons have an unpolished, homemade appearance, he can actually draw much better than the work on his website would suggest. In doing the animation for his first cartoon, he made a quick series of drawings, intending to use them as placeholders. But after he refined them, he discovered he much preferred the look of the rough first set and discarded the more polished ones. Even now, with multiple episodes behind him, he still makes five or six versions of each cartoon before he has one that he feels is right. Making the website look quickly dashed out and candid is totally in keeping with the fictional Odd Todd character, though accomplishing the right look actually takes a great deal of work.

In the beginning, however, Rosenberg's abilities in many areas truly were less than polished. His Odd Todd character would look different from picture to picture; he had trouble making him consistent. In addition, he didn't know how to synch the sound and the picture properly, or how to make a button to let users replay an episode or game. He kept going back to his books and asking more knowledgeable friends for help before he mastered what he felt he needed to know.

Now that the site has been up and running for a number of years, it still requires regular maintenance and new content. He continues to update it with new cartoons, games, and other features.

Since its launch late in 2001, Odd Todd has been visited by millions of unique users and has attracted major media attention. Dozens of articles have been

A CYBER SUPPORT SYSTEM

Rosenberg has managed to keep his expenses low in part by developing an informal exchange system. For instance, his site is hosted for free by Peak Webhosting, which saves him a great deal of money. In return, he promotes Peak Webhosting on his site, which has brought them business. He has also received significant volunteer assistance from one of his fans, Stacey Kamen, a website designer. Rosenberg reciprocates by prominently promoting her design skills and her website business on his site. (Kamen and her work will be discussed in more detail later in this chapter.)

Another fan, Geoffrey Noles, volunteers his services to the site by programming the *Odd Todd* games, such as the enormously amusing and popular *Cook-ay Slots*, a wacky slot machine game. Noles, too, receives credit on *Odd Todd*, as well as a link to his site. Rosenberg has never met either of these two important contributors face to face. They communicate by various electronic means, including, in the case of Noles and Rosenberg, by webcam.

written about the site, and Rosenberg has been featured on a great number of TV and radio shows. Loyal fans have contributed thousands of dollars to *Odd Todd*'s online tip jar, one dollar at a time, and they also support the site by buying a great variety of *Odd Todd* merchandise, from tee shirts to coffee mugs. The site has also spawned a book, *The Odd Todd Handbook: Hard Times, Soft Couch,* which, like the site, was created by Rosenberg.

Over time, however, the life of the fictitious Todd and the real Todd have diverged. While an episode might show a dejected Todd sending out résumés and trying to find work, in actuality Rosenberg is no longer dejected or looking for full-time employment. Instead, he makes enough money from the site and related merchandise, plus freelance work, to keep going. The success of the site, he said, and the creative satisfaction it has brought him, has caused him to lose interest in returning to the 9 to 5 corporate world. Ironically, he's actually making a living by being unemployed.

SOME OTHER APPROACHES TO SHOWCASING

The Internet, especially with the rapid spread of broadband, has proven to be an extremely effective platform for getting one's work seen. Some people, like Rosenberg, have created an entire website to promote their work, while others post their creations on sites like YouTube and MySpace. Still others, like Rosenberg's cyber support team, show off their work by collaborating with others.

A Two-Pronged Approach

Stacey Kamen, a Web and graphic designer with a specialty in business imaging (giving businesses a particular image via websites, brochures, and other materials), has taken two routes to making her work known. She contributes design work to the *Odd Todd* site and has built a site of her own (www.StaceyKamen. com), which is totally different from Rosenberg's.

Interestingly, when she first approached Rosenberg and volunteered her services, she wasn't thinking about how helping him out might boost her own

career. She first learned of Rosenberg's website when she was working at a dot com company, and it became clear that she was about to lose her job. A friend sent her a link to *Odd Todd*, and she visited it every day. "It made me laugh, and it took away that alone feeling, " she told me. "It had a big draw, apart from the humor. You felt you were in good company."

Still, she told me, the site was driving her nuts because the home page was so disorganized and the navigation was so clumsy. She contacted Rosenberg and offered to help, but he wasn't interested, maintaining that the unprofessional look was part of the *Odd Todd* mystique. She persisted anyway, and even sent him a plan of what she had in mind. Finally, the day before Rosenberg was due to make an appearance on CNN, he agreed to let her redesign the home page. She had just one day to do it but managed to tidy things up and add a smoothly functioning, jaunty new navigation bar on the left-hand side of the screen.

That was the beginning of their successful collaboration. Kamen continues to help him out with special tasks, like adding falling snowflakes to the site for Christmas and giving it an appropriate seasonal look for other holidays. In return for her help, Rosenberg makes a point of promoting Kamen throughout his site as "The Official Web Designer of *OddTodd.com!*" As a result, Kamen reports, 90% of the inquires she gets from prospective clients have come to her from the *Odd Todd* site. She's also getting more of her dream clients—companies and individuals from the arts and entertainment world, including musicians.

Looking back on how she first hooked up with Rosenberg and started working with him, Kamen said: "I was coming out of a corporate situation, always working with the same color palette. I was looking for more creative opportunities. It turned out to be the best business move I ever made."

Kamen's own website for her freelance design business, which she launched soon after she was laid off from her dot com job, is entirely different from the casual bachelor style of *Odd Todd*. It is crisp, polished, and elegant, laid out in a highly organized way. (See Figure 26.2.) Its design earned it a Golden Web Award from the International Association of Webmasters and Designers.

Figure 26.2
Stacey Kamen's
elegant style features
a bank of scrolling
images (far right) and
utilizes a quite different
approach from *Odd*Todd. Image courtesy
of Stacey Kamen.

"My website says a lot about me," Kamen said. "For instance, I love nature and earth tones, and I'm organized." She says the site also reflects her skills and style at a glance, without making the visitor sift through mountains of text. She wanted her site to show her creative side and eclectic nature. "A site like everyone else's—standard layout, standard buttons, standard navigation—wouldn't be 'me,'" she asserted. "I created my site with the idea of doing something different, not only its visual structure, but in navigation as well." The samples of her work that are included on the site reveal the diversity of her design approaches. "If you are going to be successful in the design business," she said, "you need to be flexible, and be able to shift gears easily."

Lonely No More

LonelyGirl15 is another self-made venture that, like *Odd Todd*, was produced on a shoestring budget and yet thrust its creators into the limelight. Unlike *Odd Todd*, however, this faux video blog, discussed in Chapter 15, was released at first as individual videos on YouTube. (The series now has its own website.) The project is the joint effort of Miles Beckett, a young doctor who dropped out of his residency program to do something more creative, and Ramesh Flinders, an aspiring screenwriter.

The two met at a karaoke bar birthday party and discovered they shared a vision of producing a new kind of entertainment specifically geared for the Internet, one that would use the kind of video blogging found on sites like YouTube, to tell a fictional story and that would seem so real that it would pull viewers into the lives of the characters. Together they created *LonelyGirl15*, shooting it in Flinders' bedroom with a cheap webcam, inexpensive props, and unpaid actors. They planned their strategy carefully, giving the episodes a rough-hewn look like other YouTube amateur videos and even having the main character, Bree, refer to recent videos posted on YouTube to make her seem all the more authentic.

STAKING OUT NEW TERRITORY

LonelyGirl15 has been a huge hit, and not even the discovery that Bree was not a real girl has managed to derail it. As of this writing 328 episodes have been released, and Beckett and Flinders are now represented by a major Hollywood talent agency. Interestingly, although they have had meetings with top TV producers, they steadfastly refuse to turn LonelyGirl15 into just another TV series, preferring instead to stake out uncharted creative territory. As Beckett told a writer from Wired Magazine (December, 2006): "The Web isn't just a support system for hit TV shows. It's a new medium. It requires new storytelling techniques. The way the networks look at the Internet now is like the early days of TV, when announcers would just read radio scripts on camera."

An Almighty Hit

Mr. Deity, which made its debut in 2006, is another Web-based video series made on a tiny budget that has given its creator enormous visibility. The Mr. Deity of this comedy series is God himself, and he is portrayed as a vision-

ary who is not especially good with the details. The videos are far too quirky to ever find a home on television but are a great fit for the Web, which loves edgy humor. Though they do not actually mock religion, they do pose some thorny theological questions in a humorous way. For example, why does God allow terrible things to happen to innocent people, and why do so many prayers seem to go unanswered? The series creator, Brian Keith Dalton, it should be noted, is not only an independent filmmaker, but was at one time training to be a missionary and asserts that he has great respect for religious people.

Like *LonelyGirl15*, the first episodes of *Mr. Deity* were released as individual videos on YouTube. They feature a revolving cast of four characters, including God, Jesus, Lucifer, and God's right-hand assistant, the highly efficient Larry. Dalton himself does almost everything: He writes, directs, edits, produces, and stars in the videos and even wrote the theme music. A one-person crew handles both the camera and sound. *Mr. Deity* has not only been a major hit on YouTube but also attracted the attention of Sony Pictures Entertainment, which now features two new episodes a month of Mr. Deity on its website, Crackle.

Mr. Deity is yet another example of how high originality is more important than a high budget when it comes to creating a showcase for your talent.

GETTING YOUR WORK SEEN

One excellent way to bring attention to your work is to enter it in contests and competitions. A number of new ones have gotten started in recent years, and we can expect to see more of them all the time. It's a good idea to keep your eyes open for them because winning one can bring your work tremendous exposure.

POINTERS FOR MAKING YOUR OWN SHOWCASE

If you are planning to create and build your own professional showcase, the following suggestions are helpful to keep in mind:

- 1. Don't imitate others; be an original. Let your showcase reflect what you really care about. This is the same advice offered by professionals in every creative field to anyone endeavoring to make something to show off their talents, be it a painting or a movie script or a novel or an interactive game.
- **2.** Define your ultimate objectives and mold your showcase accordingly. The material it contains should demonstrate your abilities in the type of work you want to do and be appropriate to the general arena where you hope to find employment.
- **3.** Don't confuse the making of a showcase with the making of a vanity piece. This isn't the place to display cute pet pictures or to brag about your snowboarding trophies. It is, however, appropriate to include your professional credits and contact information.

436

- **4.** Be sure your showcase actually works. Try to get a friend to beta test it for you. If the piece is for the Web, look at it on different browsers and on both Macs and PCs.
- **5.** If you are lacking in a particular skill, don't let that be a roadblock. Either teach yourself that skill or team up with more skilled colleagues.
- **6.** Humor can be an asset in a showcase, but inappropriate humor can backfire. If you think your piece is comic, run it by other people to see if they agree. Ideally, seek the opinions of people who are about the same age and at the same professional level as your target audience.
- **7.** If your work includes text, keep it concise and easy to read. Try whenever possible to find a way to do something visually rather than by printed words.
- **8.** Make sure that the interactive elements you include are well integrated into the overall concept, have a legitimate function, and demonstrate that you understand how to use interactivity effectively.
- **9.** If you are taking a portfolio approach instead of showcasing a single piece, select pieces that contain different types of subject matter and display different styles and approaches.
- **10.** Get feedback from others, and be open to what they say. Receiving feedback can be uncomfortable, but it is the only way you will find out how others see your work. Don't become so attached to any one feature that you are unable to discard it, even if it detracts from other aspects of your showcase. As a story editor once said to me: "Sometimes you have to kill your babies."

The process of creating an effective showcase will take time, but be patient. You will probably experience some frustrations and hit some walls. Such setbacks indicate you are stretching yourself, which is a positive thing. If you persist, you will end up knowing more than you did when you began the project, and you are likely to create something of which you can be proud.

Conclusion

We have now reached the end of the second edition of *Digital Storytelling*. I hope you have enjoyed reading about the exciting new developments in this field as much as I have enjoyed writing about them. The world of digital storytelling has burgeoned in ways impossible to predict while I was writing the first edition. I've done my best to cover the most significant new areas of digital storytelling and to include as many examples of groundbreaking work as possible. I hope that the innovative projects I've described here serve as a stimulus for your own creativity.

I encourage you, as you craft your own works in this field, to try to keep in mind that although digital storytelling is a newcomer to a very ancient craft, it is, like its predecessors, a powerful instrument. I hope that as you join the company of digital storytellers, you will use its power in a positive and creative way, and in doing so, you will help advance this evolving art a few more steps forward.

It has been an enormously challenging task to cover all that has been happening in a limited number of pages. Fortunately, however, there is a new Focal Press website for the material that could not be squeezed into this edition. It also contains convenient links to additional resources, as well as excellent online examples of digital storytelling. The URL is: http://:books.elsevier.com/companions/9780240809595, and I encourage you to visit it.

I also invite you to visit my own website, www.CarolynMiller.com. And please feel free to drop me a line at Carolyn@CarolynMiller.com if you have a question or have an interesting project you would like to bring to my attention.

And here's to storytelling, old and new!

Glossary

3G See third generation.

active learning See experiential learning.

- **Advanced TV Enhancement Forum (ATVEF)** Set of standards that allows Webbased content to be broadcast on TV.
- **advergaming** An entertainment that incorporates advertising into a game. Such games appear on the Web and on wireless devices. They are generally short, designed as a quick burst of fun.
- **agency** The user's ability to control aspects of an interactive narrative. Essentially, agency gives the user the ability to make choices and to experience the results of those choices. Agency also allows the user to navigate through the story space, create an avatar, change points of view, and enjoy many other kinds of interactive experiences.
- **agon** Greek for a contest for a prize at a public game; a contest or conflict. The words "antagonist" and "protagonist" are both formed around this root. The protagonist is the one who goes after the prize, and the antagonist is the one who tries to prevent this; their struggle is the core of dramatic narrative.

AI See artificial intelligence.

- **algorithm** A logical system that determines the triggering of events. In a game, an algorithm may determine such things as what the player needs to do before gaining access to "X" or what steps must be taken in order to trigger "Y." An algorithm is a little like a recipe, but instead of the ingredients being foods, they are events or actions.
- **alternate reality game (ARG)** An interactive game that blurs real life with fiction and that combines a rich narrative with puzzle solving. ARGs usually involve multiple media and incorporate types of communications not normally associated with games, such as telephone calls, ads in newspapers, and faxes.
- **analog** One of two ways of transmitting and storing information, including entertainment content, electronically; the other being digital. Analog information is continuous and unbroken. Film, video, LPs, and audiotape are all analog storage media.
- ancillary market The secondary use of an entertainment property. Typical ancillary markets for movies and TV shows are videos, DVDs, music CDs, and video games. Wireless games are also becoming part of the ancillary market.

- android A type of robot that is meant to look and act as much like a human being as possible, ideally to the point of passing as human. The word comes from the Greek, meaning "resembling man." Unlike mechanized robots, androids are capable of responding to visual and vocal stimuli, and some are capable of voice recognition and can converse in a fairly believable way.
- **animatronic character** A replica of a living creature that is computer operated but moves in a lifelike way and may also speak.
- **antagonist** In a drama, the adversary of the story's central character. Their opposition gives heat to the drama and provides the story with exciting conflict. The word is formed around the Greek root *agon*, meaning contest or prize. See *agon*.
- **arcade game** A game designed to be played on an arcade machine, generally having a great deal of fast action and designed for a short playing time, or a video game that is made in the style of an arcade game.
- **arcade machine** A coin-operated video game machine designed for play in public spaces.

ARG See alternate reality game.

- **artificial intelligence (AI)** Computer intelligence that simulates human intelligence. A digital character with artificial intelligence seems to understand what the player is doing or saying and acts appropriately in response.
- **assessment tool** A method of analyzing a learner's performance in an interactive project designed to teach or train.
- **attract mode** A visual tease on a kiosk screen that loops continuously until a user engages with the kiosk and triggers the program. It is also known as an attract routine.

ATVEF See Advanced TV Enhancement Forum.

- **augmented reality** A type of immersive environment in which digital technology is used in conjunction with physical props or in a real-life physical setting to create a unique experience. In such works, digitally created elements and physical objects (including people) are contained within the same space and may interact with each other.
- **automata** Self-operating mechanical figures that can move, and, in some cases, make lifelike sounds. Automata have been made since ancient times and are the forerunners of smart toys.
- **avatar** A graphic representation of the character controlled by the player. Players often have the opportunity to construct their own avatar from a selection of choices.
- **backstory** Background material relating to a drama that explains events that happened or relationships that were established before the current narrative begins.
- **bandwidth** The capacity of a communications channel to receive data, usually measured in bits or bytes per second. The higher the bandwidth connection,

the better able the user is to receive streaming video and to enjoy a high-quality Internet experience. High bandwidth connections are also called broadband and are available via DSL lines and cable and satellite services. Dial-up modems are only able to support low bandwidth; such connections are quite slow and do not support streaming video well. See also broadband.

- **beta tester** A person who looks for bugs in a software program or game before it is released to the public. This type of job is often a stepping stone to a higher level position in the software industry.
- **bible** A document that describes all the significant elements of a work that is in development. The term comes from television production and is used in the development of interactive content. The bible includes all the settings or worlds and what happens in them, as well as all the major characters. It may also give the backstories of these characters. Some bibles, called character bibles, only describe the characters.
- **binary choice** Having only two possible options for each decision or action offered to the user.
- **blog** A Web log. An online diary or journal that is accessible to anyone on the Web, or a site that expresses a personal opinion.
- **Bluetooth** A protocol that enables high-speed wireless connections to the Internet.
- **Boolean logic** Logic that uses only two variables, such as 0 and 1, or true and false. A string of such variables can determine a fairly complex sequence of events. Boolean logic can be regarded as a series of conditions that determine when a "gate" is opened—when something previously unavailable becomes available, or something previously undoable becomes doable. Boolean logic is also used to do searches on the Web.
- **BOOM** (**Binocular Omni Orientation Monitor**) A type of VR device that works like an HMD but is mounted on a rotating arm rather than on one's head. See also *head mounted display*.
- boss battle A fight between a boss monster and the player. See boss monster.
- **boss monster** In a video game, the most formidable opponent that the player encounters in a level or segment of the game. The boss monster will usually make an appearance right toward the end of the segment and must be defeated in order for the player to make further progress in the game.
- **bot** Short for robot; an artificial character. On the Internet, bots are programs that can access websites and gather information that is used by search engines.
- branching structure A classic structure in interactive works. It is a little like a pathway over which the user travels. Every so often, the user comes to a fork and will be presented with several different choices. Upon selecting one, the user will then travel a bit further until reaching another fork, with several more choices, and so on.

- **branded content** Programming that is funded by an advertiser and integrates promotional elements with the entertainment content. Unlike traditional advertising sponsorship, where the advertising is done through commercials, the entire program can be thought of as a "soft" commercial.
- **branding** A way of establishing a distinctive identity for a product or service; an image that makes it stand out from the crowd. By successful branding, the product is distinguished from its competitors and is made to seem alluring in a unique way.
- **broadband** A transmission medium capable of supporting a wide range of frequencies. Broadband can transmit more data and at a higher speed than narrowband, and it can support streaming audio and video. The term is often used to mean high-speed Internet access. See also *bandwidth*.
- **casual game** A game that can be easily learned and can be played in a brief period of time but is highly replayable. Such games are played online and on game consoles, PCs, cell phones, and other portable devices. They include a wide variety of genres, such as abstract puzzle games, shooters, racing games, and advergames.
- **CAVE (CAVE Automatic Virtual Environment)** An extremely immersive type of VR environment in which the user is surrounded by rear view projection screens and the 3-D images are seen through stereoscopic glasses.
- **CD-i** (**Compact Disc-interactive**) A multimedia system developed jointly by Philips and Sony and introduced in 1991. It was the first interactive technology geared for a mass audience. CD-i discs were played on special units designed for the purpose and were connected to a TV set or color monitor.
- CD-ROM (Compact Disc-Read Only Memory) A storage medium for digital data—text, audio, video, and animation—which can be read by a personal computer. The CD-ROM was introduced to the public in 1985 and could store a massive amount of digital data compared to the other storage media of the time.
- CGI See common gateway interface; computer generated image.
- **character arc** The transformation that a character, usually the protagonist, undergoes during the course of a story; the way a character evolves and changes. For example, a character might start off as cowardly but grow into a hero by the end of the narrative. The character arc is a staple element of linear drama, but it can also be found in works of digital storytelling.

chatterbot An artificial character, or bot, with whom users can chat.

cinematic A cut scene. See cut scene.

- **common gateway interface (CGI)** A Web term for a set of rules that governs how a Web server communicates with another piece of software.
- **computer generated image (CGI)** An image produced by a computer rather than being hand drawn, often used as shorthand for computer animation.

- **concatenation** The efficient reuse of spoken words and phrases to maximize space on a chip.
- console game A game played on a game console. See also game console.
- **convergence** A blending together of two or more entities into one seamless whole. In terms of interactive media, it may be used to mean the integration of telecommunications and broadcasting or the integration of the PC and the TV.
- **critical story path** The linear narrative line through an interactive work. This path contains all the sequences a user must experience, and all the information that must be acquired, for the user to achieve the full story experience and reach a meaningful ending point.
- **cross-media production** The merging of a single entertainment property over multiple platforms or venues. See also *transmedia entertainment*.
- **cut scene** A linear story segment in an interactive work; also called a cinematic. Cut scenes are used to establish the story or to serve as a transition between events; they are also shown at the culmination of a mission or at the end of a game.
- **cyberspace** A term used to refer to the nonphysical world created by computer communications. It was coined in 1984 by William Gibson in his sci-fi novel, *Neuromancer*.
- **database narrative** A type of interactive movie whose structure allows for both the selection and the combining of narrative elements from a number of categories drawn from a deep database.
- **design document** The written blueprint of an interactive work used as a guide during the development process and containing every detail of the project. It is a living document, begun during preproduction but never truly completed until the project itself is finished.
- **developer** A company that does the development work for a new software product, such as a game or smart toy.
- **dialogue tree** A form of interactive dialogue in which the player character or user is presented with several lines of dialogue to choose from. Each line will trigger a different response from the NPC being addressed and in some cases may even take the user or player character down different narrative paths.
- digital One of two ways of transmitting and storing information, including entertainment content, electronically, the other being analog. Digital information is made up of distinct, separate bits: the zeroes and ones that feed our computers. DVDs, CD-ROMs, CDs, and digital video are all digital storage media. Digital information can be stored easily, accessed quickly, and can be transferred among a great variety of devices.
- **digital video recorder (DVR)** One of several terms for devices that enable viewers to select and record television programs; the best-known device is the TiVo. Other generic terms for this type of device are *personal digital*

recorder and personal video recorder. These devices offer viewers more control than VCRs and include features like pausing live TV and the ability to skip commercials.

drill and kill game Educational games that drill children in particular skills.

- **dual-screen iTV** A form of iTV in which a television show and a website are synchronized and thus employ both a TV screen and a computer or mobile device screen. This form of iTV is available to anyone with a computer or mobile device, online access, and a TV set; it does not require any special equipment. It is also known as *synchronous interactivity*. See also *single-screen iTV*.
- **dungeon master** The person who, during the playing of an RPG or a real-time simulation, helps shape the action, serves as the game's referee, and manipulates the game's nonplayer characters. Dungeon masters were first introduced in LARPs and are a feature of MMOGs and other interactive experiences, including training simulations. See also *LARP* and *MMOG*.
- **DVD** An electronics platform that plays digitized programs, particularly movies and compilations of TV shows, on special discs, also called DVDs. The initials DVD once stood for "Digital Video Disc," but now the initials do not stand for any particular words; the initials themselves are the name of the technology.

DVR See digital video recorder.

- early adopter A person who is one of the first to use a new technology or device.
- **edutainment** An interactive program for children that combines entertainment and education; one of the most successful categories of children's software.
- **e-learning** Online education and training. College courses, university extension courses, and adult education courses are all offered as e-learning opportunities.
- electronic kiosk A booth or other small structure that offers the user an easy-to-operate computerized experience, often via a touch screen. Although usually used for pragmatic services like banking (ATM machines), they are also used for entertainment and informational purposes.
- **electronic literature** A form of literature that is not printed but instead makes use of the special capabilities of computer technology; also known as hyperliterature. See *hyperliterature*.
- email short for electronic mail, mail that is sent over the Internet.
- **emergent behavior** A computer-controlled character acting in ways that go beyond the things it has been specifically programmed to do; unpredictable behavior. When an NPC exhibits emergent behavior, it seems to have an inner life and almost be capable of human thought.
- emoticon Symbols used in text messages to express emotions.

- **engine** The computer programming that operates a game or other piece of software.
- **experiential learning** Learning by doing, acting and experiencing, as opposed to passive forms of learning, such as listening to lectures or reading books. Also known as *active learning*.
- **exposition** Information that is essential for the understanding of a story and must be incorporated into it for the story to make sense. It includes the background and relationships of the characters, their aspirations, and important events that took place in their past that relate to the story.
- **fan fiction (fanfic)** A type of narrative that is based on a printed or produced story or drama but is written by fans instead of by the original author.

fanfic See fan fiction.

- **first-person point of view** The perspective we have while participating in an interactive work in which we see the action as if we were in the middle of it and viewing it through our own eyes. We see the world around us, but we don't see ourselves, except for perhaps a hand or a foot. It is the "I" experience. See also *third-person point of view*.
- **first-person shooter (FPS)** A shooting game in which the player is given a first-person point of view of the action. The players control and play the protagonist, but they cannot see themselves, though they may be able to see a weapon they are holding. See also *first-person point of view*.
- **Flash animation** An animated film created with Adobe Flash animation software. It supports interactivity and is a common form of animation on the Internet.
- **flow chart** A visual expression of the through-line of an interactive project. Flow charts illustrate important aspects of the content and a project's interactive structure.

FMV See full motion video.

fourth wall The invisible boundary that, in the theatre, separates the audience from the characters on the stage, and in any dramatic work divides reality (the audience side) from fiction (the characters' side). Works of digital storytelling often break the fourth wall by bringing the participant into the fictional world or by the fictional world invading the real world.

FPS See first-person shooter.

fractal structure A structural model in which the essence of the story does not advance or change but instead grows in scope as the player interacts with it. The term is based on the mathematic concept of the fractal, a pattern that repeats itself endlessly in smaller and larger forms.

full motion video (FMV) Live action video seen on a computer.

fulldome A type of immersive environment in which images are projected onto the entire inner surface of a planetarium dome or a similarly shaped theatre. For audience members, it is somewhat like sitting inside a huge upside down bowl, surrounded on all sides by moving images.

- **functionality** How an interactive program works, particularly its interactive elements and its interface.
- game console A device made for playing video games. Some consoles plug into a TV set and use the TV as a monitor; others are self-contained hand-held devices. Most can support multiplayer games, and the majority of the current generation of consoles can connect to the Internet and can play DVDs.
- gameplay The elements that make a game fun; also, the way players play a game—how they control it and how the game responds. It consists of the specific challenges that are presented to the player and the actions the player can take in order to overcome them; it also includes victory and loss conditions and the rules of the game. In addition, it provides instantaneous feedback to the players' input and choices.
- **genre** A category of programming that contains certain characteristic elements. Major types of entertainment properties, like movies and video games, are broken into genres to distinguish them from each other.
- **global positioning system (GPS)** A satellite-based navigation system that allows individuals with receivers to pinpoint their geographic location.
- **GPS** See global positioning system.
- **grammar, artistic** The artistic principles or rules that can be employed in a creative field; a visual vocabulary. Every artistic medium requires its own specialized grammar; this is necessary for the artists who work in the field as well as the audiences who experience it. For example, jump cuts, dissolves, and montages are all part of the grammar of the cinema.
- **griefer** A player in a MMOG who enjoys killing off new players and otherwise making life miserable for them.
- **head mounted display (HMD)** A device worn on the head in a virtual reality simulation that enables the user to see the digital images.
- hero's journey, the Myths, and stories based on this type of myth, about the coming of age experience. Joseph Campbell analyzed this type of myth in his seminal work, *The Hero with a Thousand Faces*. Its core elements and recurring characters have been incorporated into many popular movies, and it has also served as a model for innumerable works of digital storytelling, particularly video games.
- **hidden story structure** A structural form that contains two layers of narrative. The top layer contains clues to a story that took place in the past. The user explores this top layer to uncover the second layer, the hidden story, and to assemble the pieces of the hidden story into a coherent and linear whole.

high bandwidth See bandwidth.

HMD See head mounted display.

hot spot An image or area on the screen that the user can click on to produce a reaction, such as a little piece of animation, a bit of audio, or a short video clip.

- **HTML** (**Hypertext Markup Language**) The software language used to create Web pages and hyperlinks.
- **HTTP** (**Hypertext Transfer Protocol**) Protocol used to transfer files, including text, sound, video, and graphics, on the Web.
- **hub and spoke structure** A modular structure for video games in which the player starts from a central location (the hub), and all the modules radiate out from there (the spokes). This structure is extremely clear and simple to navigate, making it especially suitable for children's projects. See also *module*.
- **hyperlink** A word or image that is linked to another word or image. See also *hypertext*.
- **hyperliterature** A catchall phrase for a number of forms of computer-based literature, including hypertext, digital poetry, nonlinear literature, electronic literature, and cyberliterature. Since it is computer-based, it is able to make use of elements that are not possible in printed literature, such as interactivity, animations, sound-effects, and hypertext (the ability to link various pieces of text together). See *hypertext*.
- **hyperstory** A form of iCinema in which one visual element is linked to another visual element, offering a different view of the same scene or story. It is similar to hypertext but uses visuals instead of text. See *hypertext*.
- **hypertext** A technique used in digital works that enables the linking of words or phrases to other related "assets," such as photographs, sounds, video, or other text. The user makes the connection to the linked asset by clicking on the hyperlinked word or phrase, which usually stands out by being underlined or by being in a different color. See also *hyperlink*.

hypertext markup language See HTML.

hypertext transfer protocol See HTTP.

- **iCinema** An interactive movie. Such works fall into two broad categories. One type is designed for a large theatre screen and is usually intended to be a group experience; the other type is for a small screen and is meant to be enjoyed by a solo viewer.
- **if/then construct** A fundamental way of expressing choice and consequence in an interactive work. In an if/then scenario, if the user does A, then B will happen. Or, to put it slightly differently, choosing or doing A will link you to B.

IF See interactive fiction.

IM or IMing (Instant Message or Instant Messaging) See instant messaging.

- **immersive environment** An artificially created environment or installation that seems real. Virtual reality is a type of immersive environment. See also *virtual reality*.
- incunabula The very first works produced for a new medium. The term comes from the Latin word for cradle or swaddling clothes, and thus means

something still in its infancy. The term was first applied to the earliest printed books, those made before 1501, but now the term is used more broadly to apply to the early forms of any new medium, including works made for various types of digital technology.

infotainment A presentation that combines information and entertainment.

instant messaging (IM or IMing) A method of chatting with another person while you are both online, much like a conversation. Although IMing began as a text-only medium, some service providers offer graphic and audio options as well.

intellectual property (IP) A unique work of human intelligence—such as a photograph, a script, a song, a piece of animation, or a game engine—that is given legal protection such as a copyright, patent, or trademark. Intellectual properties can be extremely valuable and are closely guarded.

interactive fiction (IF) A work of interactive narrative, usually text based, into which users input their commands via their computer keyboard. Works of IF are available on the Internet and as CD-ROMs and sometimes contain graphics and video. Works of IF resemble text-based adventure games (MUDs), but are engaged in by a solo user, not multiple players. They also lack a win/lose outcome. See also MUD.

interactive television (iTV) A form of television that gives the viewer some control over the content or way of interacting with it.

interactive voice response (IVR) Communications that take place on the telephone that facilitate the acquisition of information. The user is asked a series of questions by a recorded voice and responds by pressing the telephone's number keys or by speaking. Based on the caller's input, the system retrieves information from a database. IVR systems are commonly used by banks to provide account information to customers. They are also being called into play for various types of digital storytelling, such as ARGs. See also *ARGs*.

interface The elements of an interactive work that enable the users to communicate with the material, to make choices and navigate through it. Among the many visual devices used in interface design are menus, navigation bars, icons, buttons, and cursors.

Internet 2 A faster, more robust form of the Internet. It is used by government and academic organizations; it is not accessible to the general public.

IP See intellectual property.

iTV See interactive television.

IVR See interactive voice response.

kiosk See electronic kiosk.

landline telephones Telephones that are connected to wires and cables, as opposed to wireless phones.

440

lapwear Software products made for youngsters between nine months and two years of age. The term springs from the fact that children often sit on a parent's lap while playing with such products.

LARP See live action role-playing game.

laser disc A storage and playback format, also called a video disc, introduced in the late 1970s and used for watching movies and for educational and training purposes, as well as for arcade games. They have largely been replaced by DVDs, though a small number of devoted fans still use them.

latency The time it takes for a program to react.

LBE See Location Based Entertainment.

leaderboard A list of the top scorers in a game.

level A structural device in a game or other interactive work; it is a section of the work, akin to a chapter or an act. Each level has its own physical environment, characters, and challenges. Games may also be "leveled" in terms of degree of difficulty, with levels running from easy to difficult. Characters, too, can attain an increase in level in terms of their powers or skills; they are "leveled up."

licensed character See licensed property.

licensed property A piece of intellectual property, often a movie, a novel, or other work of entertainment, or even a fictional character, that is covered by a licensing agreement, allowing another entity to use it. Licensed properties and characters are generally highly recognizable and popular, and their use can add value to a new work. The Harry Potter novels are licensed properties, and Lara Croft is a licensed character.

linearity A state in which events are fixed in a set, unchangeable sequence, and one event follows another in a logical, fixed, and progressive sequence. Films and novels are linear, while interactive works are nonlinear.

live action role-playing game (LARP) Games that are played by participants in the real world as opposed to role-playing games played on computers or online. The earliest LARPs were war game simulations. Such games were the predecessors of the highly popular Dungeons and Dragons LARPs, which evolved into today's MMORPGs. See also *MMORPGs*.

Location Based Entertainment (LBE) Entertainment that takes place away from the home. Venues can include museums, theme parks, and retail malls. In many cases, LBE experiences involve immersive environments. See also *immersive environment*.

location-based gaming A type of game that is set and played out in real-world locations, usually in urban settings.

locomotion interface A type of immersive environment that employs a treadmill in a large screen environment. As the participant walks or runs on the treadmill, the images on the screen change.

log line A clear and vivid description of the premise of an entertainment property, usually no more than one sentence long. When used for an interactive project, it describes the concept in a way that indicates the nature of the interactivity, what the challenges might be, and what will hook the users. The term got its name from the concise descriptions of movies given in television logs and other entertainment guides.

low bandwidth See bandwidth.

- **ludology** One of two major and opposing ways of studying games, the other being narratology. Ludologists assert that even though games may have elements of narrative like characters and plot, this is incidental to the things that make them a distinct creative form, such as gameplay. Thus, they assert, games should be studied as unique constructs. The term "ludology" comes from the Latin word *ludus*, for game. See also *narratology*.
- **Machinima** A form of filmmaking that borrows scenery and characters from video games but creates original stories with them. The term combines the words "machine" and "cinema." Works of Machinima are often humorous, possibly because the characters, borrowed as they are from video games, are not capable of deep expression.
- **malleable linear path** A narrative through-line for a video game or other interactive work; similar to a *critical story path*. The malleable linear path includes the major actions the user must take or events the user must experience in order for the narrative to make sense and to reach a conclusion, but these actions or events do not need to occur in a specific order. See also *critical story path*.
- massively multiplayer online game (MMOG) An online game that is played simultaneously by tens of thousands of people and is typically set in a sprawling fictional landscape. MMOGs are persistent universes, meaning that the stories continue even after a player has logged off.
- massively multiplayer online role-playing game (MMORPG) An online role-playing game played simultaneously by thousands of participants, and one of the most popular forms of MMOGs. MMORPGs contain many of the elements of video game RPGs, in which the player controls one or more avatars and goes on quests. These avatars are defined by a set of attributes, such as species, occupation, skill, and special talents.
- **matrix** A table-like chart with rows and columns that is used to help assign and track the variables in an interactive project.
- **merchant-tainment** Physical items that can be purchased and that can contribute to an entertainment experience.
- **metatag** Information used by search engines, important for constructing indexes.
- **milestone** A project marker that specifies when the different elements of a project must be completed.

mission An assignment given to a player in a video game. Some video games are organized by missions rather than by levels, and the player must complete the missions one by one. See also *level*.

MMOG See massively multiplayer online game.

MMORPG See massively multiplayer online role-playing game.

MMS See multimedia service.

MOB (Mobile Object) An object in a game that moves.

mobisode A serialized story or multiepisode entertainment series made for mobile devices, similar to a webisode.

module A method of organizing or structuring an interactive work, often used in educational and training projects. Each module customarily focuses on one element in the curriculum or one learning objective.

MOO (**MUD**, **Object Oriented**) A text-based adventure game that is a close cousin to the MUD. See also *MUD*.

motion base chair A theatre-style seat used in ridefilms that moves in synchronization with the story's action. See also *ridefilm*.

motion capture An animation technique for producing lifelike movements and facial expressions in characters. This technique calls for attaching sensors to an individual (who might be an actor, dancer, or athlete) and digitally tracking this individual's movements and expressions. These movements and expressions are then "transferred" to an animated character.

MUD A text-based adventure game in which multiple players assume fictional personas, explore fantasy environments, and interact with each other. MUD stands for Multi-User Dungeon (or Multi-User Domain or Multi-User Dimension). Aside from being text based, MUDs are much like today's MMOGs.

multimedia service (MMS) A feature offered on wireless phones that enables users to send and receive more data than with SMS. It can support a variety of media, including photographs, long text messages, audio, and video, and different media can be combined in the same message. See also *short messaging service*.

multimodal The use of various methods of communication, such as spoken dialogue, text, animation, sound effects, and video, within the same work.

multiplatforming The development of an entertainment property for many different platforms, both traditional (theatrical motion pictures and television) and new (video games, the Internet, and so on).

multisensory A technique used in simulations, virtual reality, and other forms of immersive environments in which multiple senses are stimulated. While most forms of media only involve hearing and seeing, a multisensory approach might also include tactile sensations, smells, motion, and so on.

multitask To simultaneously perform several things at once, such as being online while also talking on the phone, listening to the radio, or watching TV.

- **narratology** One of two major and opposing ways of studying games, the other being ludology. Narratologists assert that games are a form of storytelling and they can be studied as narratives. See *ludology*.
- **natural language interface** A lifelike method of communication between a user and an artificial character in which the artificial character can "understand" the words the user types or says and is able to respond appropriately.
- **navigation** In interactive media, the method by which users move through a work. Navigational tools include menus, navigation bars, icons, buttons, cursors, rollovers, maps, and directional symbols.

NDA See nondisclosure agreement.

networked gaming environment The linking of computers together into a network that allows many users to participate in an interactive experience. Such networks may be used for educational and training purposes as well as for gaming.

newbie A new player or new user.

- **node** A design term sometimes used to indicate the largest organizational unit of a game (similar to a level or world) and sometimes used to indicate a point where a user can make a choice.
- **nondisclosure agreement (NDA)** A document used when potentially valuable information is about to be shared with another party. The party that is to receive the information, in signing the NDA, agrees to keep the information confidential.
- **nonlinearity** Not having a fixed sequence of events; not progressing in a preset, progressive manner. Nonlinearity is a characteristic of interactive works. Though the work may have a central storyline, players or users can weave a varied path through the material, interacting with it in a highly fluid manner.
- **nonplayer character (NPC)** A character controlled by the computer, not by the player.

NPC See nonplayer character.

parallel world A quasi-linear structure that contains several layers of story, each set in its own virtual world, and the user can jump between them. Often each world is a persistent universe, meaning that events continue to unfurl there even when the user is not present.

PC game A game that is played on a computer.

PDA See personal digital assistant.

PDR See personal digital recorder.

- **peer-to-peer learning** An educational environment that facilitates collaborative learning. Online peer-to-peer learning environments may include such features as instant messaging, message boards, and chat rooms.
- **persistent universe** A virtual environment that continues to exist and evolve after the user has logged off or gone away; a common feature of MMOGs.

- **personal digital assistant (PDA)** A wireless device that serves as an electronic Rolodex, calendar, and organizer. PDAs can download material from the Internet and from PCs.
- **personal digital recorder (PDR)** Same as a personal video recorder and digital video recorder. See *personal video recorder*.
- **personal video recorder (PVR)** One of several terms for devices that enable viewers to select and record television programs; the best-known of such devices is the TiVo. Two other generic terms for this type of device are *personal digital recorder* and *digital video recorder*. These devices offer viewers more control than VCRs and include features like pausing live TV and the ability to skip commercials.
- **pixel** Short for Picture Element. A pixel is a single tiny unit of a digital graphic image. Graphic images are made up of thousands of pixels in rows and columns, and they are so small that they are usually not visible to the naked eye. The smaller the pixels, the higher the quality of the graphic.
- **platform** A hardware/software system for running a program or a game.
- **platform game** A genre of game that is very fast paced and calls for players to make their characters jump, run, or climb through a challenging terrain, often while dodging falling objects or avoiding pitfalls. Such games require quick reflexes and manual dexterity.
- player character A character controlled by the player.
- **Player versus Player (PvP)** A competitive encounter between two players in a video game, as opposed to a competitive encounter between a player and an NPC. PvP combats can be quite violent and can result in the virtual death of one of the players.
- podcast A form of broadcasting distributed over the Internet and designed for playback on portable digital devices, though the audio or video material can also be enjoyed directly from the Internet. The term podcast combines the words "broadcast" and "iPod." The iPod (a portable MP3 player made by Apple) is one of the devices used to listen and watch such broadcasts, though Apple did not invent the term.
- **point of view (POV)** In interactive media, the way the user views the visual content. The two principle views are first person and third person. See *first-person point of view* and *third-person point of view*.
- POV See point of view; first-person point of view; and third-person point of view.
- **procedural animation** An animation technique for endowing characters with lifelike behavior and a wide range of actions. In procedural animation, characters are created in real time, rather than being prerendered. To make such a character, the animator provides a set of rules and initial conditions—in other words, a procedure.
- **product placement** An advertising technique in which advertisers pay a fee to a movie or television production company to have their product prominently

- displayed in a scene in a movie or television show. This practice is now becoming widespread in video games.
- **project creep** A situation in which a project grows much bigger than it was originally understood to be. Also called scope creep.
- **proprietary** The state of being owned or controlled by an individual or organization. In interactive entertainment, certain software is sometimes called proprietary, meaning that it is the exclusive property of that developer.
- **protagonist** The central figure of the drama, whose mission, goal, or objective provides the story with its forward momentum. The word is formed around the Greek root, *agon*, meaning contest or prize. See *agon*.
- **protocol** A set of instructions or rules for exchanging information between computer systems or networks.
- prototype A working model of a small part of an overall project.
- **publisher** A company that funds the development of a game or other software product and packages and markets it. A publisher may also develop projects in-house.

PvP See Player versus Player.

PVR See personal video recorder.

- **Rashomon structure** A structural form that contains several versions of the same story and users can experience each version from the POV of the different characters. The model resembles the Japanese movie, *Roshomon*, about a crime viewed by four people, each of whom saw it differently.
- **Really Simple Syndication (RSS)** RSS, which stands for both Really Simple Syndication and Rich Site Summary, is a family of formats for distributing content to websites; it is a form of syndication.
- **real-time 3-D graphic (RT3D)** Three-dimensional animation that is rendered in real time instead of being prerendered. In a game environment, the images respond to the players' actions.
- **real-time strategy game (RTS)** A genre of game that emphasizes the use of strategy and logic. In these games, the players manage resources, military units, or communities. In a real-time strategy game, the play is continuous, as opposed to a turn-based strategy game, where players take turns.
- **repeatability** A quality, also known as *replayability*, possessed by some video games and other interactive works that lends itself to more than one play, because each play offers a new experience, a new version of the narrative, or new challenges. Educational games that contain several layers of difficulty also possess this quality.

replayability See repeatability.

repurposing Taking content or programming models from older media and porting them over to a new medium, often with little or no change. For instance, the first movies were filmed stage plays, and the first CD-ROMs

were encyclopedias, and the first types of content available on Video iPods were reruns of TV shows.

rhizome structural model A structural form that takes its name from the field of botany, where it is used to describe an interconnecting root system. In interactive stories using this structure, each piece can be connected to every other piece. Thus, it is much like a maze.

Rich Site Summary (RSS) See Really Simple Syndication.

ridefilm An entertainment experience that takes place in a specially equipped theatre. The audience may sit in special seats (motion base chairs) that move in sync with the action taking place on the screen. This gives them the illusion that they are traveling, though they are not actually going anywhere. See also *motion base chair*.

robot A device that operates either by remote control or on its own and relates in some way to its surroundings. Some are designed to be playthings for children or adults; others are built to be part of entertainment or educational experiences. Many, however, are specifically built for highly pragmatic functions. The word "robot" is a variation of the Czech word, *robota*, which means slavelike labor or drudgery.

role-playing game (**RPG**) A genre of game in which the player controls one or more characters, or avatars, and vicariously goes on adventures. These games evolved from the precomputer version of *Dungeons and Dragons*. See also *avatar*.

RPG See role-playing game.

RSS See Really Simple Syndication.

RT3D See real-time 3-D graphic.

RTS See real-time strategy game.

rumble floor A device used to enhance the realism of an immersive environment. The rumble floor is built into the platform that participants move across, and it vibrates when cued by certain virtual events, such as an explosion or an earthquake.

sandbox structure A structural model that offers the user a great deal of freedom. Unlike a game, this type of structure does not set specific goals for the user to achieve and has no victory conditions. And unlike narrative-based works, it has no plot. However, such models do provide users with objects to manipulate and things to do, and they do have spatial boundaries.

scent necklace A device used to enhance the realism of an immersive environment. It is worn around the neck of the participant and gives off specific aromas at key points during the simulation, in keeping with the virtual landscape or action of the piece.

schematic An easy-to-understand diagram that illustrates how something works.

- **sequential linearity** An interactive structure that channels the user down a linear path and is quite restrictive in terms of the freedom of movement it offers to the user.
- **serious game** A game designed to teach a difficult subject, either to advanced students or to learners outside of academic settings. Because serious games are meant to be entertaining as well as teaching vehicles, they make intensive use of digital storytelling techniques.
- **short messaging service (SMS)** A feature offered on wireless phones that enables users to send and receive short text messages up to 160 characters in length.

SIG See special interest group.

- **simulation** A realistic and dramatic scenario in which users make choices that determine how things turn out. Simulations are featured in many types of interactive environments, including virtual reality and CD-ROM programs, and are used for entertainment and educational and training purposes.
- **single-screen interactivity** A form of iTV in which interactive programming is furnished via a digital set top box provided by a satellite or cable company and is viewed on one's television set. It thus requires just one screen, as opposed to dual-screen iTV. See also *dual-screen iTV*.
- smart toy Any type of plaything with a built-in microprocessing chip. Such toys can include educational games and lifelike dolls, animals, or fantasy creatures that seem intelligent and can interact with the child playing with it. They can also include playsets that tell a story as the child interacts with it.

SME See subject matter expert.

SMS See short messaging service.

- **social marketing** A specialized form of promotion that is designed to change the way people behave—to motivate them to break harmful habits, like smoking or overeating, and to encourage them to take up positive behaviors, like wearing seat belts or exercising.
- social networking site A website that contains content that is largely created by the users themselves and that facilitates communications between users. Such sites are virtual communities, and they may be populated by virtual inhabitants in the form of user-controlled avatars. See also *avatar*.
- **spatial narrative** An interactive drama in which the story elements are embedded in a three dimensional space, and the user discovers narrative fragments while exploring the fictional environment.
- **special interest group (SIG)** A group of individuals with similar interests formed within a larger organization.
- **state engine approach** An interactive mechanism that allows for a greater range of responses to stimuli than a simple if/then construct, which allows for only one possible outcome for every choice. See also *if/then construct*.

- **stereoscope** A device that enables people to see images in 3-D. Stereoscopic devices are used in VR installations.
- **stickiness** The ability to draw people to a particular website and entice them to linger for long periods of time; also the ability to draw visitors back repeatedly.
- **storyboard** A series of drawings that illustrate of the flow of action, the interactivity, and important pieces of the content of an interactive project, displayed sequentially, much like a comic book. Essentially, a storyboard is an illustrated flowchart. See also *flowchart*.
- storyline The way a narrative unfolds and is told, beat-by-beat. In traditional linear narratives, the storyline is all-important and very clear; it is "the bones" of a story. In interactive media, however, storylines tend to be less defined and apparent, because such works are nonlinear. In video games that contain a narrative, the storyline takes second place to gameplay, although the storyline serves to give context to the game.
- **streaming** Receiving video or audio in real time, without a delay, as it downloads from the Internet. Video received this way is called streaming video; audio received this way is called streaming audio.
- **string of pearls structure** A structural model for the linear story path in a video game or other interactive work. Each of the "pearls" is a world, and players are able to move freely inside each of them. But in order to progress in the story, the player must first successfully perform certain tasks in each pearl.
- **subject matter expert (SME)** An individual with special expertise who is consulted for a new media project, especially one designed for teaching or training. These specialists may offer advice about the target learners, the content of the project, or the teaching objectives.
- **synchronous interactivity** A form of interactive television in which the content of a television program and the content of a website are synchronized and designed for viewer interactivity; also known as *dual-screen iTV*. This type of interactivity calls for a secondary device like an Internet-connected computer or cell phone, as well as a television set.
- **synthetic character** A highly intelligent computer-controlled character. Such characters are capable of "understanding" the words typed or spoken by the user and are able to respond appropriately. Unlike a chatterbot, characters with this capacity are fully animated and highly lifelike. See also *chatterbot*.
- taxonomy In biology, the discipline of classifying and organizing plants and animals. In interactive media, a systematic organizing of content. As in biology, it is a hierarchical system, starting with the largest category at the top and then dividing the content into smaller and smaller categories, organized logically by commonalities. The word comes from Greek and is composed of two parts *taxis*, meaning order or arrangement, and *nomia*, meaning method or law.

- TCP/IP See Transmission Control Protocol/Internet Protocol.
- **third generation (3G)** A stage of development in wireless technology that enables wireless telephones to have high-speed access to the Internet.
- third screen A term that includes many forms of screen-based new media entertainment, including video games and content developed for the Internet and cell phones. While once there were only two types of entertainment screens—TV screens and movie screens—the third screen is a powerful newcomer to the entertainment world.
- third-person point of view The perspective we have in an interactive work in which we watch our character from a distance, much as we watch the protagonist in a movie. We can see the character in action and can also see their facial expressions. Cut scenes show characters from the third-person POV, and when we control an avatar, we are observing it from this POV as well. See also *first-person point of view*.
- three-act structure The classic structure of theatrical dramas and screenplays. This structural form was first articulated by Aristotle, who noted that effective dramas always contained a beginning (Act 1); a middle (Act 2); and an end (Act 3).
- **ticking clock** A dramatic device used to keep the audience glued to the story. It is found in both linear and nonlinear narrative works. With a ticking clock, the protagonist is given a specific and limited period of time to accomplish a goal. Otherwise there will be serious and perhaps even deadly consequences.
- **TiVo** The brand name for a device that allows TV viewers to select and record TV programs and play them back whenever they wish. Viewers also have the option of fast forwarding through the commercials. The generic terms for such devices are personal video recorder (PVR), personal digital recorder (PDR), and digital video recorder (DVR).
- **tragic flaw** A negative character trait possessed by the protagonist of a drama. Though this character may be noble in many ways, he or she also has a fatal weakness such as jealousy, self-doubt, or ambition, and this trait leads to the character's undoing.
- transmedia entertainment Entertainment properties that combine at least two media, one of which is interactive, to tell a single story. Possible linear components include movies, TV shows, and novels, while possible new media components include websites, video games, and mobile devices. In addition, these projects may also utilize everyday communications tools like faxes, voice mail, and instant messaging. This approach to entertainment goes by many different names, including multiplatforming, cross-media production, networked entertainment, and integrated media. Gaming projects that use the transmedia approach may be called alternative reality gaming. See also alternative reality gaming.
- **Transmission Control Protocol/Internet Protocol (TCP/IP)** A protocol developed for ARPANET, the forerunner of the Internet, by Vint Cerf and

- Bob Kahn. It is the basic communication language of the Internet, and it allowed the Internet to grow into the immense international mass-communication system that it has become.
- **treadmill** An internal structural system of a MMOG that keeps the user involved playing it, cycling repeatedly through the same types of beats in order to advance in the game.
- **Turing test** A rigorous set of standards to judge artificial intelligence (AI) in a computer program, set in 1950 by Alan Turing. In what is now known as the "Turing Test," both a human and a computer are asked a series of questions. If the computer's answers cannot be distinguished from the human's, the computer is regarded as having AI. See also *artificial intelligence*.
- **uncanny valley syndrome** A term coined by Japanese roboticist Masahiro Mori to describe the uncomfortable reaction people have to robots that seem too lifelike and human.
- URL (Uniform Resource Locator) A website address.
- **user-generated content** Content that is created by the users themselves. Such content includes everything from the avatars and objects found in virtual worlds to homemade videos and animations. It also includes Machinima, fan fiction, and the personal profiles and other content found on social networking sites.
- **verb set** The actions that can be performed in an interactive work. The verb set of a game consists of all the things that players can make their characters do. The most common verbs are walk, run, turn, jump, pick up, and shoot.
- video blog (vlog) A blog that contains video. See blog.
- **video on demand (VOD)** A system that lets viewers select video content to watch from the Internet or from digital cable or satellite systems.
- **viral marketing** A marketing strategy that encourages people to pass along a piece of information; originally used in Web marketing but now also used for wireless devices.
- **virtual channel** A designated channel where VOD videos are "parked." See also video on demand.
- **virtual reality (VR)** A 3-D artificial world generated by computers that seems believably real. Within such a space, one is able to move around and view the virtual structures and objects from any angle. A VR world requires special hardware to be perceived.
- virtual world An online environment where users control their own avatars and interact with each other. These worlds may have richly detailed land-scapes to explore, buildings that can be entered, and vehicles that can be operated, much like a Massively Multiplayer Online Game (MMOG). However, these virtual worlds are not really games, even though they may have some gamelike attributes. Instead, they serve as virtual community centers, where people can get together and socialize, and, if they wish, conduct business. See also MMOG.

Vlog See video blog.

VOD See video on demand.

VR See virtual reality.

walled garden An area of restricted access, generally relating to Internet content.

WAP See wireless application protocol.

- **webcam** A stationary digital video camera that captures images and broadcasts them on the Web. Webcams often run continually, and the footage is broadcast without being edited.
- **webinar** An educational or training session that takes place in a classroom and that combines Web-based and live instruction, with a live instructor acting as facilitator.
- webisode A story-based serial on the Web that is told in short installments using stills, text, animation, or video.
- **Wi-Fi** A protocol that enables a computer or mobile device to have a high-speed connection to the Internet and to connect with other devices, like game consoles and DVRs.
- wireless application protocol (WAP) A set of instructions that enables mobile devices to connect with the Internet and perform other functions.
- wireless telephony Communications systems that enable the transmission of sound, text, and images without the use of wires, unlike landline telephony.
- world structure A structural device used in interactive narratives. In such structures, the narrative is divided into different geographical spaces—the rooms of a house, different parts of a town, or different planets.

Additional Readings

- The following books offer additional information on various aspects of classic narrative, digital storytelling, design, and career issues:
- Adams, Ernest and Rollings, Andrew, Fundamentals of Game Design (Prentice Hall, 2006). An excellent, clear, and extremely thorough guide to game design.
- Adams, Ernest, *Break into the Game Industry: How to Get a Job Making Video Games* (Emeryville, CA, McGraw-Hill Osborne Media, 2003). A good guide to careers in the game industry.
- Aristotle, *The Poetics* (New York, Hill & Wang, 1961). The classic treatise on dramatic writing.
- Bonime, Andrew and Pohlmann, Ken, Writing for New Media: The Essential Guide to Writing Interactive Media, CD-ROMs and the Web (Hoboken, NJ, John Wiley & Sons, 1997). Written at the crest of the CD-ROM and Internet wave and thus not inclusive of more recent technologies, this book is addressed specifically to writers.
- Campbell, Joseph, *The Hero with a Thousand Faces*, Second Edition (Princeton, NJ, Princeton University Press, 1968). A classic study of mythology and particularly of the hero's journey, a universal myth that many dramatic works, including digital stories, are modeled on.
- Clark, Ruth and Kwinn, Ann, *The New Virtual Classroom: Evidence-based Guidelines for Synchronous e-Learning* (Pfeiffer, 2007). Written by two experts on e-learning, this book focuses on effective techniques for using digital media to teach and train.
- Crawford, Chris, *Chris Crawford on Game Design* (Indianapolis, IN, New Riders, 2003). A somewhat idiosyncratic but lively look at game design by a well-known game guru.
- Curran, Steve, Convergence Design: Creating the User Experience for Interactive Television, Wireless and Broadband (Gloucester, MA, Rockport Publishers, 2003). A handsomely illustrated work focusing primarily on design issues for iTV, wireless, and broadband.

Additional Readings

- Dodsworth, Clark, editor, *Digital Illusion: Entertaining the Future with High Technology* (Boston, MA, Addison-Wesley, 1997). A collection of articles primarily on theme park development and location based entertainment.
- Dombrower, Eddie, *Dombrower's Art of Interactive Entertainment Design* (McGraw Hill, 1998). Now out of print, this book was written by the game designer who once headed the interactive division of the Jim Hensen Studio (creators of the Muppets), and focuses primarily on game design.
- Garrand, Timothy Paul, *Writing for Multimedia and the Web, Third Edition* (Burlington, MA, Focal Press, 2006). A good general book about writing for interactive media, with a particular focus on the Internet.
- Gee, James Paul, What Video Games Have to Teach Us about Learning and Literacy (Palgrave Macmillan, 2003). An exploration of why video games are so effective as vehicles for learning.
- Herz, J., Joystick Nation: How Videogames Ate Our Quarters, Won Our Hearts, and Rewired Our Minds (New York, Little Brown-Warner Books, 1997). A provocative and interesting work on the cultural impact of video games.
- Iuppa, Nicholas V., *Designing Interactive Digital Media* (Burlington, MA, Focal Press, 1998). A very thorough and practical book that primarily addresses design issues.
- Iuppa, Nick and Borst, Terry, Story and Simulations for Serious Games: Tales from the Trenches (Burlington, MA and Oxford, England, Focal Press, 2007). An in-depth examination of the role of narrative in training simulations and games containing case studies of projects the authors have worked on.
- Johan H. Huizinga, *Homo Ludens* (Beacon Press, 1971). A study of the concept of human play, from an historical perspective.
- Maciuba-Koppel, Darlene, *The Web Writer's Guide: Tips and Tools* (Burlington, MA, Focal Press, 2002). This book focuses entirely on writing for the Web.
- Meadows, Mark Stephen, Pause and Effect: The Art of Interactive Narrative (Indianapolis, Indiana, New Riders, 2003). A beautifully illustrated and thoughtful examination of interactive narrative with an emphasis on design.
- Mencher, Marc, Get in the Game: Careers in the Game Industry (Indianapolis, IN, New Riders, 2002). A guide to careers in the game industry.
- Murray, Janet, *Hamlet on the Holodeck: The Future of Narrative in Cyberspace* (Cambridge, MA, MIT, 1998). A highly regarded and thoughtful book about the potential of digital storytelling. One of the first books written on the subject, the book is still extremely valuable for its ideas, even though some of the references are dated.
- Pearce, Celia, *The Interactive Book: A Guide to the Interactive Revolution* (Indianapolis, IN, Macmillan Technical Publishing, 1997). Now out of print, a collection of essays exploring the social, cultural, and psychological impact of interactive media.

- Rollings, Andrew and Ernest, Adams, Andrew Rollings and Ernest Adams on Game Design (Indianapolis, IN, New Riders, 2003). A solid book on game design.
- Ryan, Marie-Laure, *Narrative as Virtual Reality* (Baltimore and London, The Johns Hopkins University Press, 2001). A scholarly examination of the role of story in interactive narrative. The book contains some extremely interesting models of interactive structure.
- Szulborski, Dave, *This Is Not A Game: A Guide to Alternate Reality Gaming* (Lulu, 2005). A comprehensive study of alternate reality games, written by one of the field's leading writer/designers.
- Szulborski, Dave, *Through the Rabbit Hole: A Beginner's Guide to Playing Alternate Reality Games* (2006), an introduction to alternate reality games, from a player's point of view, written by one of the field's leading writer/designers.
- Tollet, John and Rohn, David, with Williams, Robin, Robin Williams DVD Design Workshop (Berkeley, CA, Peach Pit Press, 2003). A thorough explanation of DVD design.
- Vogler, Chris, *The Writers Journey: Mythic Structure for Writers, Third Edition* (Studio City, CA, Michael Wiese Productions, 2007). An examination of Joseph Campbell's theory of *The Hero with a Thousand Faces*, a mythic structure that is the basis of many games; this book is geared toward writers.
- Wardrip-Fruin, Noah and Harrigan, Pat, First Person: New Media as Story, Performance and Game (Cambridge, MA and London, England, MIT Press, 2004). A thought-provoking collection of readings about the role of story and game in interactive media.
- Wimberly, Darryl and Samsel, Jon, Writing for Interactive Media (New York, Allworth Press, 1998). One of the first books on writing and designing interactive media, it focuses primarily on CD-ROMs, the Internet, and video games but is still a good introduction to the subject.

Subject Index

A	in video games, 252	Antagonist(s)
Academy of Interactive Arts and	weak, 107, 119, 168, 351	comic, 96
Sciences, 422	Agon, 64, 90	creation of, 96-98
Academy of Television Arts and	Aldiss, Brian, 322	definition of, 90
Sciences, 423	Alexander, Jesse, 157	family friendly, 96
Action games, 246	Algorithm, 117	multiple number of, 97-98
Action points, 116	Allen, Woody, 16	succession of, 97-98
Active learning, 195	Alternate reality gamers, 289	Antiques Roadshow, 310
Adaptation	Alternate reality games	AOL
of book into movie, 48	agency in, 302	Kids Online, 137
of book into video game, 140	Art of the Heist, The, 299	Time Warner merger with, 44
of branded properties, 138–140	artifacts in, 297, 298f	Apple, 30
challenges associated with, 48	barriers to entry, 301	Aquarium model, 122
children's projects based on,	Beast, The, 289-291, 293-294	Archeological dig model, 125
138–140	Casablanca, 301	ARGers. See Alternate reality gamers
convergence and, 47–49	characteristics of, 288	ARGs. See Alternate reality games
definition of, 48	compelling nature of, 293–294	Aristotle, 70, 73-75, 105
description of, 29	creation of, 289–295	Arlen, Gary, 42
in interactive media, 48	description of, 35, 47, 153	Arli\$\$, 309
of Internet-based material into	digital media effects on, 294	ARPANET, 24, 29, 258
movies, 49	hidden story model used in, 125	Art, concept, 184
of video game into movie, 48	I Love Bees, 297, 299	Art of the Heist, The, 299
Adaptive training systems, 201	Internet involvement in, 288	Artifacts, 63-64
Advanced Research Project	Last Call Poker, 299	Artificial intelligence
Association Net. See ARPANET	live events, 289	description of, 17
Adventure games, 136, 247	Lost Experience, The, 159	development of, 23
Advergames, 213–215, 248	Majestic, 295–296	by digital characters, 81, 99
Advergaming, 34, 345	mobile devices and, 289	Athletic competitions, 11
Advertising	Perplex City, 299	Attitude selection, 107
branded content, 216–217	popularity of, 288–289	Audience. See also Target audience
digital media effects on, 33–34,	promotional uses of, 220–221	developmental considerations,
213–214	puzzles, 291–293	167, 171
genres for, 219–224	rabbit hole, 291, 292f	of interactive entertainment,
"hard sell" forms of, 212	resources, 302	55-56
on Internet, 30	Save My Husband, 263, 300	in large-screen interactive cinema,
need for, 212–213	tips for creating, 301	353-354
product placement as, 215–216	Who is Benjamin Stove?, 220-221,	of passive entertainment, 56
promotion vs., 213	297	Audio-Animatronic, 330
After action review, 203	Altman, Robert, 17, 311	Auditory interface, 251
After-game assessments, 202–203	American Film Institute, 308, 310	Augmented reality, 373-375
Age appropriateness, 133–135,	An American Family, 109	Automata, 322
146–147	Analog data, 4	Automated Teller Machine, 394
Agency, 56–57, 67, 172	Ancient games, 12, 70–71	Avatars
in ARGs, 302	Androids, 330–332	definition of, 92
in children's project, 147	Animatronic characters, 330	description of, 36, 60, 81
in iCinema, 389	Anstey, Josephine, 362	designing of, 276

Avatars (Contd)	CD-i	in children's projects, 141–142,
kiosk as, 406, 407f	history of, 27	144–146
in MMOGs, 92, 271–272, 276	Tamara influences on, 16	in linear narratives, 75
social networking sites, 271	CD-ROM, 27, 427	techniques for, 101–102
of user, 92	Cell phones	Character kiosks, 402
В	in Asia, 337	Chatterbots, 81, 99
В	in Europe, 337	Chichén Itzá, 11, 12f
Backstory, 80	popularity of, 336-337	Childhood, 132
Baer, Ralph, 25	3G technology used by, 337	Children
Balloon man model, 126	Cerf, Vint, 24	age classifications for, 132-133
Barriers, 119	Certificate programs, 421	aspirational desires of, 134
Bartle, Richard, 270, 273	Character(s). See also Avatars; Point	development of, 132-133
BBC, 310–312	of view	focus groups using, 133
BBCi, 310 Backett Miles 424	absence of, 90	gameplaying by, 14, 130
Beckett, Miles, 434 Bell, Ben, 122	animatronic, 330	gender differences, 134-135
Berners-Lee, Tim, 24	antagonists. See Antagonist(s)	multitasking by, 130
Besmehn, John C., 328–329	appearance of, 102	respect for, 147
Beta testers, 415	archetypes, 90	websites for, 137-138
Bible, 173–174	attaining of new strengths by,	Children's projects
Binary choice, 118	103	age appropriateness consider-
Blogs, faux, 32, 222, 262	biography of, 101	ations, 133-135, 146-147
Board games, 13–14	branded, 138	age group considerations in
Bonilla, Diego, 360	classic, 90-91	designing, 144
Boolean logic, 117–118	computer-controlled, 96–98	agency in, 147
Borst, Terry, 182, 272	developmental considerations,	boredom, 144
Boss battle, 98	172	branded properties as basis for,
Boss monster, 98	in digital storytelling, 88	138–140
Bowen, Hugh, 108	emergent behavior by, 103–104	character development in, 141-
Boys' Toys, 312-313	emotions by, 108–109	142, 144–146
Brainstorming, 168	evolving by, 102–103 flaws in, 91	content for, 131, 135–138, 145–146
Branching structure, 118-119, 119f	intelligent, 98–100	design considerations for, 131
Branded content, 216–217	in interactive storytelling, 88–90	experts involved in creating, 133
Branded properties, 138-140	in jeopardy, 76	gender considerations, 134–135
Broadband	learning by, 102–103	humor in, 142–143, 147
connectivity, 29–30	in linear storytelling, 88–91	interactivity in, 147
convergence and, 42–43	minor, 98	interface design for, 146
video on Internet viewed using,	in MMOGs, 276-277	"junk food" approach to, 144
305	name of, 102	"medicinal" approach to,
Broadcast television	new types of, 81	143-144
advertising on, 33–34	nonplayer, 66, 81, 89	original properties as basis for,
digital media effects on, 32 infomercials on, 34	player, 89	140-142
Buffy the Vampire Slayer, 49	protagonist, 90	overexplaining of, 144
Burroughs, William, 15	roles of, 88	parental considerations, 135
Bushiness, 119	stereotyping of, 101	"playing it safe" in, 144–145
Bushnell, Nolan, 25	summary of, 110-111	respectful of children in, 147
Businen, Holdin, 25	synthetic, 99–100	rewards in, 146
C	tension experienced by, 76	Seven Kisses of Death for,
Campbell, Joseph, 6–7, 10, 65, 72	in Toontown Online, 279–280	143–147
Can Video Games Make You Cry?, 108	vividness of, 101	sweetness in, 143
Career, 412–413, 423	voice-over by, 178	target audience, 133, 136
Case, Stevie, 413	Character arc	tension in, 145
Casual games, 77, 248–249	construction of, 102–103	Choose Your Own Adventure, 15, 118,
Catharsis, 6, 19, 65, 75, 110, 250	definition of, 48, 89, 101 Character development	216, 361, 389
	Character development	Classic dialogue, 105

Classroom learning, 190–191	intermedia influences as form of,	target audience considerations
CNN, 230	49-50	during, 167, 169–171
Coal mine model, 123	potential of, 43	tasks performed in, 166
Cohesion, 63–64	in television, 45–46	Developmental psychology, 132
Collaboration, 84	transmedia storytelling as form	Dialogue. See also Verbal
Collins-Ludwick, Anne, 78–80,	of, 47	communications
84-85, 120, 251	Core concept, 168–169	attitude selection with, 107
Comedy shorts, 263	Corporate training, 204	classic, 105
Comic antagonists, 96-97	Critical beats, 120	in digital storytelling, 105–107
Communications	Critical path document, 185	functions of, 104
oral, 104-105	Critical story path, 120–121	in interactive media, 105–107
verbal. See Verbal	Crucible experience, 202	for smart toys, 329
communications	Cruse, Carlton, 160	written, 106
written, 105, 108	CSI, 306–307	Dialogue script, 178–182
Community building, 232, 259	Cul-de-sacs, 119	Dialogue tree, 106–107
Complete graph structure, 123	Curriculum setting, for edutainment	Digital arts programs, 418
Computer	games, 194	Digital Content Lab, 308
digital storytelling affected by, 22	Cut scenes, 80	Digital data, 4
history of, 22-23, 23f		Digital entertainment
public access to, 23	D	changes in consumption of,
Computer games, 245	D 1 T-1 25	31–32
Computer-controlled characters,	Dabney, Ted, 25	popularity of, 31
96–98	Dalton, Brian Keith, 435	Digital hypertext, 15
Concatenation, 329	Database narratives, 236, 359–360,	Digital information, 4 Digital media. See also specific media
Concept art, 184	388 DeBerros Luiz 152 160 161	advertising and, 33–34,
Concept document, 173	DeBarros, Luiz, 152, 160–161	213–214
Conflict, 71	Decision points, 116	broadcast television affected by,
Console games, 245	Design document, 174–177, 175f–176f	32
"Construction kit" commercials,	Deus ex machina, 74	content development for, 28–29
221–222	Development process	convergence in, 42–43, 45–46
Content	audience not considered during,	economic effects of, 34–35
branded, 216–217	167	global perspectives on, 38–39
for children's games, 131, 135-138, 145-146	bible, 173–174	Hollywood affected by, 32–33
for digital media, 28–29	brainstorming involved in, 168	museums' use of, 236
digitizing of, 43	checklist, 171–173	news media affected by, 228-230
DVD, 385–386	concept art, 184	for older learners, 192-193
interactivity effects on, 61–63	concept document, 173	professionals' use of, 38
for kiosks, 395–396	core concept, 168–169	teaching uses of, 190, 206-208
mobile, 344–345	decision making during, 169-170	training uses of, 204
user-generated, 35–37	definition of, 166	in United States, 39
for young users, 131	design document, 174-177,	for young learners, 191-192
Contract, 418	175f-176f	Digital media integration, 43
Convergence	documentation in, 166	Digital storytellers
adaptation as form of, 47–49	duration of, 166	career as, 412-413, 423
broadband and, 42-43	errors in, 167-168	description of, 412
cell phones with, 44-45	flowcharts, 182-184, 183f	education of, 418, 421
components of, 43t	ideas, 168	employment of
corporate examples of, 44	importance of, 166	as beta tester, 415
definition of, 42	milestones in, 170	entry points for, 415–416
in devices, 44-46	preproduction phase, 170	opportunities for, 415
digital media and, 42-43	prototype, 170-171, 184-185	paths for, 414–415
digital storytelling affected by,	serious games, 201–203	learning from, 75–76
46-50	simplicity of product, 167-168	legal issues, 417–418
game consoles with, 44	stages of, 170-171	life of, 412–413

paths for (Contd)	description of, 384	techniques for creating, 193-19
selling of an original idea,	design challenges, 389-390	Eisner, Michael, 261
413-414	features of, 384-385	E-learning, 206
Digital storytelling	formats of, 384	Electronic Arts, 295, 338
business purposes, 224-225	guidelines for working with,	Electronic construction kit model,
challenges associated with, 85	389-390	125
characteristics of, 17-18	history of, 28	Electronic kiosks
classic storytelling vs., 5, 19t	interactive narratives for,	adjunctive uses of, 402
convergence effects on, 46-50	387-388	applications of, 405-406
in educational and training proj-	menu system, 388, 390	attract mode/routine for,
ects, 193, 197, 203-204, 208	music videos, 386	395–396
games as model for, 70–72	nonlinearity of, 391	as avatar, 406, 407f
interactivity of, 4	popular use of, 384-385	content development for,
popularity of, 39	story-based projects, 387-389	395–396
storyline in, 77	summary of, 390-391	creative possibilities of, 404-407
traditional narratives vs., 4	DVD-Audio, 384	definition of, 394
video game characteristics	DVD-ROM, 384	design of, 401-402
applied to, 255	DVD-Video, 384	entertainment with, 403-404
Digital video recorders, 30, 304	_	example of, 396–401
Digitizing of content, 43	E	history of, 394
Dimensional storytelling, 375 Dionysian rituals, 6, 7f, 73	Eastgate, 15	informational content delivery
Direct-to-DVD movie, 386	Ecological Synthesis: Something Old,	through, 235
Disney, 278	Something New, An, 5	Magic Moment Pins, 398
Distance learning, 206	Education	multiuser design of, 397–398
Distributed narrative, 151, 294	certificate programs, 421	playing of, 399
Dithyrambs, 7	description of, 190–191	resources, 406
Documentaries, 359	of digital storytellers, 418, 421	script used in, 400f-401f
Documents/documentation	digital technology use in, 190	storytelling uses of, 395
bible, 173–174	industry events as opportunities	summary of, 408
concept art, 184	for, 421–422	time-travel via, 404–405 uses of, 394
concept document, 173	opportunities for, 418, 421 self-education, 431	versatility of, 395
description of, 166	through play, 421	E-mail, 24
design document, 174-177,	Educational specialists, 133	Emergent behavior, 103–104
175f-176f	Edutainment games. See also	Emergent culture, 201
dialogue script, 178-182	Teaching	Emergent culture, 201 Emergent narrative, 341
flowcharts, 182-184, 183f	active learning, 195	Emoticon, 108
specialized, 185	for children, 191–192	Emotions
storyboards, 184	curriculum setting, 194	in digital storytelling, 108–109
Dogon people, 7-8, 9f	definition of, 191	from fulldome, 381
Domers, 380	description of, 27	Empathy, 108
Dormans, Joris, 125	educational goals as foundation	Employment
Drama	for, 194	as beta tester, 415
iTV applied to, 311-312, 314-317	effectiveness of, 195	entry points for, 415-416
nonlinear, 16–17	end goals, 195-197	as freelancer, 416-417
participatory, 6–7	levels of difficulty, 195	networking for, 422-423
structure in, 115–116	for older learners, 192-193	opportunities for, 415
"Drill and kill" games, 192	peer-to-peer learning, 198	paths for, 414-415
"Drill down," 123	premise, 195–197	ENIAC, 22-23, 23f
Driving games, 246–247	rewards system in, 197-198	Entertainment
Dual screen interactivity, 304	role of, 193	changes in consumption of,
Duvall, Shelly, 76 DVD	serious games as, 198-200	31–32
bonus features of, 386–387	settings, 197	in educational and teaching
content on, 385–386	simulation use, 198	projects, 190
Content on, 363-360	storyline in, 196	in informational projects, 231

spatial narrative, 360-361

Hamlet on the Holodeck: The Future of edutainment. See Edutainment in kiosks, 403-404 Narrative in Cyberspace, 103, games transmedia, 32 125, 244, 364 virtual reality in, 371-372 goals in, 70-71 Harmonic paths, 123 history of, 11-12 Ethnographic field research, 202 information delivery using, HD-DVD, 385 eTV, 304-305, 308 Herigstad, Dale, 306-307 232-233 Europe, 305 Hero with a Thousand Faces, 10 informational, 232-233 Events, 81 Hero's journey, 10, 123 learning from, 70-72 Experiential learning, 195, 198 Heyward, Julia, 361 mobile, 343-344 Extreme AI, Inc., 338 Hidden story model, 125 regulations used in, 72 Highfield, Ashley, 310, 312 serious. See Serious games F Higinbotham, Willy, 25t stories and, 64-67, 71 Fan fiction, 37 Holechek, Max, 116 structure and format of, 72 Fantasy games, 136 Hollerith, Herman, 22 tabletop war, 13 Fantasy role-playing, 14 Hollywood Game consoles Farbanish, Lori, 326 digital media effects on, 32-33 convergence in, 44 "Fast keys," 305 description of, 245 interactive media use in, 415 Faux blogs, 32, 222, 262 professionals in, 33 Game Developers Conference, 422 Feedback, 250 transmedia storytelling in, Gameplay Festival of Dionysus, 6, 7f 157-160 definition of, 82, 250 Fiction Hollywood Reporter, The, 32, 34 point of view based on, 95 fan, 37 Home console video games, 25 Gamers interactive, 65-67 Hub and spoke model, 124 definition of, 55-56 Fictional blogs, 222 Humor, 142-143, 147, 233 demographics of, 31, 249-250 Fictional world, 172 HyperBole Studios, 54 Gaming elements, 18 Fiddle play, 326 Gee, James Paul, 195 Hyperliterature, 38 Field, Svd, 74 Hyperstory, 356-359 Geffen, David, 44 Fincher, David, 289 Hypertext, 82 Gender differences, 134-135 Finnegan's Wake, 15 Genres. See also specific genre First-person point of view, 93 alternate reality games. See First-person shooters, 95 Alternate reality games I Love Bees, 297, 299 Fisher, Katie, 73, 121, 167 of children's games, 136 iCinema (interactive cinema) Fisher, William, 249 comedy shorts, 263 academia and, 361 Flowcharts, 182-184, 183f decisions about, 169 agency in, 389 Focus groups, 133, 170 definition of, 245 description of, 350 Fourth wall developmental considerations, large-screen breaking of, 16 audience involvement, 353 in interactive media, 16 direct-to-DVD movie, 386 challenges of, 355 Fractal structure, 125 Internet, 258, 261-263 description of, 235, 350-352 Free Range Graphics, 218, 426 video games, 245-248 history of, 351 Free-form structure, 123 webcam dramas, 262-263 interactivity in, 351-352 Freelancers webisodes. See Webisodes sample experience, 353-354 contract use by, 418 Gibson, William, 24, 216, 225 small screen interactive description of, 416-417 Google Mobile, 235 cinema and, 355 Fulldome, 379-381 Gosford Park, 17 venues for, 355-356 Funnel model, 123 Goslin, Mike, 278 small-screen Grammar, 362, 370-371, 373 database narratives, 359-360 Granularity, 64 description of, 235-236, 350 G Greek theatre, 73, 91 examples of, 356 Galatea, 66, 322 Griefers, 281 hyperstory, 356-359 Game(s). See also Video games Group-based interactivity, 352-353 interactive narratives in, adaptation of movies into, 48 Guilds, 422-423 356-361 ancient, 12 large screen interactive cinema board, 13-14 н and, 355 children's, 14

Halloween, 10

digital storytelling and, 70-72

iCinema (interactive cinema) (Contd)	CD-i's, 27	storyteller affected by, 67
in United States, 356	CD-ROMs, 27	synchronous, 304
user as fulcrum model of, 360	connecting story elements, 81-82	types of, 59–61
summary of, 361-362	dialogue in, 105-107	Interface
If/then construct, 117–118,	DVDs, 28	auditory, 251
178f-179f	employment opportunities in,	definition of, 251
Immersion Studios, 351	414-415	developmental considerations,
Immersive cinema, 351	Hollywood writer's view of,	172
Immersive environments	78–80	manual, 251
animatronic characters in, 330	laser discs, 26	natural language, 99–100, 106
characteristics of, 364-365	opponents in, 97	remote control, 305
definition of, 130, 364-365	platforms for, 82	visual, 251
fulldome, 379-381	structure in, 74	voice recognition, 100
interactive theme park rides, 376	Interactive movies, 350	Interface design
location based environment, 364	Interactive mysteries, 263	for children's projects, 146
mixed reality, 373-375	Interactive narratives	description of, 80–81
multisensory, 365	breaking of fourth wall in, 16	International Game Developers
ridefilm, 375-376	building blocks of, 116–117	Association, 422
virtual reality. See Virtual reality	characters in, 89	Internet
Immersiveness	database narratives, 359-360	adaptation of material on, 49
description of, 57-59	description of, 15	advertising on, 30, 213
large-screen, 375-378	for DVDs, 387–388	alternate reality games, 288
Incunabula, 28	hyperstory, 356–359	branded content on, 216
Industry events, 421–422	mythic journey used in, 73	children's websites on, 137–138
Infomercials, 34	in small-screen interactive cin-	evolution of, 258
Informal exchange systems, 432	ema, 356-361	faux blogs, 32, 222, 262
Informational content delivery	spatial narrative, 360-361	genres, 258, 261–263
digital storytelling techniques	storyline in, 77–78	girl-specific websites on, 138
application to, 231-233, 238	tension in, 76	growth of, 29–30
electronic kiosks for, 235	user's role in, 95	history of, 23–24, 258
games for, 232-233	world structure used by, 117	informational content delivery
humor used for, 233	Interactive scripts, 79, 178	through, 234
Internet for, 234	Interactive storybooks, 136	interactive mysteries and adven-
mobile devices for, 234-235	Interactive theme park rides, 376	tures, 263, 265–267
multiple points of view, 233	Interactive training, 205–206	interactivity with, 59
museum installations, 236	Interactivity	journalism sources on, 35
transmedia approach for,	as a conversation, 54–55	narrative form, 265–267
236-237	active learning through, 195	news media affected by, 228
virtual reality for, 235	audience affected by, 55-56	organic approach to, 263–265
Informational games, 232-233	benefits of, 54	parental concerns, 135
Informational projects, 237-238	in children's games, 147	social networking sites on, 36
Infotainment, 231, 238	cohesiveness affected by, 63-64	stickiness of, 258–259
Instant messaging, 31	content affected by, 61-63	television and, 259-260
Integrated Media Bible, 154	definition of, 54	video sharing sites on, 37
Intellectual properties, 417	description of, 4-6	virtual worlds, 36
Interactive adventures, 263, 265-267	dual screen, 304	webcam dramas, 262–263
Interactive entertainment	group-based, 352-353	Internships, 418
agency in, 56	with Internet, 59	iPhone, 44–45
passive entertainment vs., 56	in large-screen interactive cinema,	iPod, 30
summary of, 84–85	351-352	iTunes, 30
for young users, 130	learning benefits of, 191	iTV (interactive television)
Interactive fiction, 65–67	meaningfulness of, 56	advertising uses of, 214
Interactive learning, 191	in MMOGs, 352-353	audience of, 55
Interactive media	multiuser, 352	BBC approach to, 310–311
adaptation in, 48	navigation as form of, 60	challenges for, 305–306
assigning variables in, 81	single screen, 304	description of, 45–46
	- 10 common de manager nos 2000	

Loeser, Michael, 273-274 Klein, Bill, 338-339 Digital Content Lab, 308 Log line, 169 Knowledge Adventure, 78, 127, 142, drama application of, 311-312, Loop backs, 119 314-317 192, 198 Lost in a Forest, 125 Krizanc, John, 16 dual-screen experience, 312-314 Lowenstein, Douglas, 256 Krong, Sven, 387 future of, 306-308 Lucas, George, 73 Kurosawa, Akira, 17 gaming techniques used with, Luddite, 421 314 Ludology, 244 L history of, 304 lessons learned about, 307 L Word, The, 308-309 М news delivery through, 235 Labyrinth Project, 359-360, 388 Machinima, 37 prototypes, 308-309 Laidlaw, Marc, 252 Magnavox Odyssey, 25 resources for, 317 Lapwear, 130 Malleable linear path, 120 in United Kingdom, 305, 310, Large-screen immersiveness, Manual interface, 251 312 375 - 378Martinez-Jitner, Barbara, 314 Large-screen interactive cinema in United States, 305 Massively Multiplayer Online user testing of, 306 audience involvement, 353 Games. See MMOGs video experiences, 304-305 challenges of, 355 Massively Multiplayer Online Iuppa, Nick, 272 description of, 235, 350-352 Role-Playing Games. See history of, 351 **MMORPGs** interactivity in, 351-352 Matrix, 81, 185 sample experience, 353-354 Jackson, Peter, 48 small screen interactive cinema McCrel, 194 Jahnson, Randall, 254 McPherson, Stephen, 157 and, 355 Jenkins, Henry, 193 Mechner, Jordan, 254 venues for, 355-356 Journalism, 30, 35 Media art, 38 "Junk food" approach, 144 Las Posadas, 57-59 Melisinos, Chris, 225 Laser discs, 26 Mia titles, 91f Last Call Poker, 299 K Microchips, 324 Le Sacre du Printemps, 38 Kain, Jackie, 236, 387 Milia, 422 Lean back, 55 Kamen, Stacey, 432-434 Military, serious games used by, Lean forward, 55 Kiosks 200-203 Learning adjunctive uses of, 402 Minor characters, 98 active, 195 applications of, 405-406 MIPTV, 422 classroom, 190-191 attract mode/routine for, MIT, 345-346 distance, 206 395-396 Mixed reality, 373-375 E-, 206 as avatar, 406, 407f **MMOGs** experiential, 195, 198 content development for, addicting nature of, 272-273 interactive, 191 395-396 aquarium structure in, 122 peer-to-peer, 198 creative possibilities of, 404-407 avatars in, 92, 271-272, 276 virtual worlds used for, 206-207 definition of, 394 characteristics of, 270-271, 285 Legal issues, 417-418 design of, 401-402 characters in, 276-277 Level entertainment with, 403-404 community aspects of, 273 creation of, 251 example of, 396-401 creator's point of view, 275-277 definition of, 117 history of, 394 description of, 36, 270 difficulty associated with, 195 informational content delivery designing of, 276 Leventhal, Michael, 417 through, 235 Life and Opinions of Tristram Shandy, future of, 285 Magic Moment Pins, 398 interactivity in, 352-353 Gentleman, The, 15 multiuser design of, 397-398 MUDs and, 270 Linear narratives playing of, 399 narrative in, 271-272 antagonist in, 91 resources, 406 nonplayer characters in, 276 characters in, 88-91 script used in, 400f-401f Pirates of the Caribbean Online, description of, 64 storytelling uses of, 395 283-285 learning from, 75 summary of, 408 player's point of view, 273-275 protagonist in, 90 target audience, 403 precursors to, 24 storyline in, 77-78 time-travel via, 404-405 promotional, 223 Linear structure, of entertainment, 14 uses of, 394 qualities of, 273 Location based environment, 364

J

versatility of, 395

MMOGs (Contd) social networking and, 137, 271 storylines in, 272, 276–277, 282 subscriptions, 271 television shows adapted into, 49 Toontown Online, 138, 223, 270– 271, 275, 277–282 war game simulations as precursor to, 13f MMORPGs description of, 270–271 virtual worlds and, 207 MMS. See Multi-media service Mobile devices. See also Cell phones advertising on, 213 alternate reality games and, 289 challenges associated with, 338–341 considerations for, 346–347 entertainment content on, 337– 338, 342–345 games on, 343–344 informational content delivery using, 234–235 promotion uses of, 345–346 resources for, 347 teaching uses of, 345–346 technological variances in, 338 Mobisodes, 158–159, 213, 219, 337, 342–343, 346 Modular structure, 124 MOOs definition of, 270 stories vs., 67 Mori, Masahiro, 331 Morie, Jacquelyn Ford, 370 Movie adaptations books adapted into movies, 48 into games, 48	Murray, Janet H., 64–65, 103–104, 125, 244 Museums digital technology use by, 236 mixed reality in, 373–374 Music videos DVD, 386 news media use of, 230 promotional uses of, 221 My Fair Lady, 66 Mystery games, 136 Mystery-adventure games, 136 Mythic journey, 73 Mythological symbolism, 7–8 Myths, 72 MYTHWORKS, 13 N Napster, 32 Narrative as Virtual Reality, 123, 125 Narratives database, 236, 359–360, 388 definition of, 4 distributed, 294 emergent, 341 fan fiction, 37 interactive, 15 linear. See Linear narratives in MMOGs, 271–272 nonlinearity in, 15–16 spatial, 360–361 traditional, 4, 150 transmedia, 161–162 for virtual reality, 372–373 Narratology, 244 Narrator, unseen, 107 Nashville, 17 Natural language interface, 99–100, 106	Newspaper Association of America, 229 Nodes, 116, 121 Nokia N-Gage, 44, 45f Noles, Geoffrey, 432 Non-disclosure agreement, 417–418 419f–420f Nonfiction projects, 160–161 Nonlinear structure, of entertainment, 14 Nonlinearity before the computer, 14–16 in dramas, 16–17 of DVD, 391 in narratives, 15 in writings, 15 Nonplayer characters antagonists. See Antagonist(s) definition of, 89 description of, 66, 81 emergent behavior by, 103–104 functions of, 98 intelligence of, 98 mental abilities of, 98–99 in MMOGs, 276 in Toontown Online, 279 Nurturing play, 326 O Opponents, 97 Opposition, 65 Oral communications, 104–105 Organizations, 422 Origins of Intelligence in Children, The, 132 Ovaltine Moment, 300
video game into movie, 48 MSNBC, 230 MTV, 223 MUDs definition of, 270 stories vs., 67 Multicolumn format, for scripts, 180f–181f, 180–182 Multi-media service, 336 Multiplatforming, 32, 151 Multiple points of view, 16, 233 Multisensory experience, 57 Multisensory immersive environments, 365 Multi-User Dungeons. See MUDs Multiuser interactivity, 352	Navigation definition of, 251 description of, 80–81 devices used for, 81 as form of interactivity, 60 Networking, 422–423 New York Times, The, 32, 229 News digital storytelling techniques application to delivery of, 231–233 iTV for delivery of, 235 News media content development for, 28–29 definition of, 4 digital media effects on, 228–230	Parallel streaming, 123 Parallel universes, 83 Parallel world model, 123–124 Participant, 56 Participatory dramas, 6–7 Passenger train structure, 122 Passive entertainment audience of, 56 definition of, 55 interactive entertainment vs., 56 Passover, 8 PC games, 245 Peer-to-peer learning, 198 Penalties, 82–83 Perplex City, 299 Perry, David, 252

Persona method, 202	social marketing, 217-218	programming of, 321
Personal digital assistants, 336	video games used for, 222-223	resources about, 332
Personal video recorder, 30	virtual reality for, 372	uses of, 321
Pervasive gaming, 151	virtual worlds used for, 223	Role-playing games
Pfister, Robert, 122, 275	webcam peepshows, 223-224	description of, 136, 247
Piaget, Jean, 132	webisodes used for, 220	military use of, 201
Picot, Edward, 38	Promotional gaming, 214	Rosenberg, Todd, 429-432
Pirandello, Luigi, 16	Protagonist	Ryan, Marie-Laure, 123, 125
Platform games, 136, 248	attaining of new strengths by, 103	
Play	definition of, 71, 90	S
education through, 421	evolving nature of, 103	Sabrina the Teenage Witch, 49
fiddle, 326	qualities of, 92	Sandbox model, 123
gender differences, 134-135	user as, 91-95	Santa Fe New Mexican, 228-229, 337
nurturing, 326	Prototypes	Save My Husband, 263, 300
Piaget's theories on, 132-133	iTV, 308-309	Scenes, 83
Player characters, 89	in video game development pro-	Schematic LLC, 306
Playmate Toys, 326	cess, 170–171, 184–185	Schulte, John, 328-329
Plot, 114	Public advocacy campaigns, 218	Schwinges, Marc, 160
Podcasts, 30	Punch card machines, 22	Screenplay: The Foundations of
Poetics, The, 73-74, 105	Purple Rose of Cairo, The, 16	Screenwriting, 74
Pogue, David, 230	Pyramid model, 123	Screenwriters, 105
Point of view		Script
assigning of, 81	Q	dialogue, 178–182
first-person, 93	Quicksilver Software, 73, 121, 167,	kiosk use of, 400f–401f
gameplay as basis for, 95	249	"Scripts and screens," 180
multiple, 16	_	Second-person point of view, 94
second-person, 94	R	Seger, Linda, 115, 152
third-person, 93–94	Rabbit hole, 291, 292f	Sensors, 84
of user, 92–95	Racing games, 136, 246-247	Sentient characters, 96
Portfolio, 429	Rafferty, Kevin, 412-413	Serious games
Povinelli, Daniel, 5	Rashomon, 17, 124-125, 260, 388	growth of, 198–199
Powers, James, 22	Raybourn, Elaine M., 201–202	military use of, 200–203 popularity of, 199
Pray, Diana, 78, 127, 142, 192–193,	Redenbacher, Orville, 100	resources for, 203
198 Premise, 169, 195–197	Remote control, 305	training uses of, 201
Preproduction phase, 170	Repurposing, 29, 385–386	types of, 199–200
Procedural animation, 104	Rewards	Shackelford, Judy, 324–326
Product placement, 215–216	children's games' use of, 146	Shooters, 247
Project creep, 417	edutainment games' use of,	Short, Emily, 66
Promotion	197–198 modular structure use of, 124	Short films, 223
advertising vs., 213	storyline and, 197–198	Short messaging service, 336
alternate reality games used for,	types of, 82, 197	Showcase
220–221	Rhizome model, 125	collaborations to create, 428
"construction kit" commercials,	Riddle Productions, 268	content of, 430
221-222	Ridefilm, 375–376	creation of, 426-429
digital media venues for, 213-214	Rites of passage, 10	distribution methods, 429
faux blogs used for, 222	Rituals, 8–10, 65	lack of skills to complete,
fictional blogs used for, 222	Roach, Greg, 54, 63, 118, 121, 170,	428-429
MMOGs as, 223	404, 421	Odd Todd case study, 429–432
mobile devices used for, 345-346	Robots	pointers for creating, 435-436
music videos used for, 221	adult use of, 329–330	portfolio approach, 429
narrative content matched with,	characteristics of, 320-321,	of single pieces, 429
225	329-330	subject matter of, 430
public advocacy campaigns, 218	definition of, 321	two-pronged approach to,
short films used for, 223	history of, 322	432-434

Sigui dance, 8	Spielberg, Steven, 289	critical story path, 120–121
Simulation(s)	Spin-off, 29	decision making regarding,
for children, 136	Spirited Away, 73	126–127
description of, 247-248	Sports games, 136, 246-247	definition of, 250
military use of, 201–202	Spot, The, 260, 288	designing of, 114-115
teaching uses of, 198	Spreadsheets, 182	developmental considerations,
Simulation Experience Design	St. John, Stewart, 260	172
Method, 201–202	Star Wars, 73	in drama, 115–116
Single screen interactivity, 304	State engine approach, 118	electronic construction kit model,
Six Characters in Search of an Author,	Steinmetz, Robert, 180, 184, 204,	125
16 Skalaton logic short 196	206	fractal, 125
Skeleton logic chart, 186 Small-screen interactive cinema	Stereotypes, 101	free-form, 123
database narratives, 359–360	Sterne, Laurence, 15	funnel model, 123
description of, 235–236, 350	Stevens, Wallace, 38	hero's journey model, 123
examples of, 356	Stewart, Sean, 290, 293, 302 Stickiness, 258–259	hidden story model, 125
hyperstory, 356–359	Stimulus and response, 59–60	hub and spoke model, 124
interactive narratives in, 356–361	Stone Cold Creamery, 199	importance of, 114
large screen interactive cinema	Stories	in linear narratives, 75 modular, 124
and, 355	as artifacts, 63–64	parallel world model, 123–124
spatial narrative, 360-361	components of, 5	passenger train model, 122
in United States, 356	games and, 64–67, 71	plot vs., 114
user as fulcrum model of, 360	goals in, 71	pyramid model, 123
Smart dolls, 46, 83	structure and format of, 72	Rashomon, 124–125
Smart toys	Story and Simulations for Serious	rhizome model, 125
advertising uses of, 214	Games, 272	sandbox model, 123
challenges in creating, 323	Story construction, 75–76	specialists involved in creating,
characteristics of, 320-321	Storyboards, 184	114
description of, 320	Storyline	string of pearls model, 121, 121f
developer's perspective on,	in edutainment games, 196	three-act, 115–116
328-329	in interactive narratives, 77–78	in Toontown Online, 282
development of, 323–329	in linear narratives, 77–78	in traditional narratives, 115-116
dialogue for, 329 history of, 322–323	in MMOGs, 272, 276–277, 282	user experience affected by, 120
inventor's perspective on,	rewards system and, 197–198	world, 117
324–326	in Toontown Online, 282	Subject matter experts, 170, 194
manufacturer's perspective on,	Storytellers. <i>See</i> Digital storytellers Storytelling	Supertoys Last All Summer, 322
326–328	description of, 4	Suspense, 267
multisensory experiences offered	digital. See Digital storytelling	Sweetness, 143
by, 328	dimensional, 375	Synchronous interactivity, 304 Synthetic characters, 99–100
resources about, 332	history of, 5	Szperling, Margi, 356–358
"sensors" used in, 325	kiosks for, 395	Szulborski, Dave, 221, 297
skeleton logic chart for, 186	traditional, 75-76	52d15613KI, 15dVC, 221, 237
summary of, 332	transmedia approach to. See	Т
"talking" by, 322	Transmedia approach	Tabletop war games, 13
uses of, 321	virtual reality used for, 367-369	Tamara, 16
SMS. See Short messaging service	Stravinsky, Igor, 38	Tanz, Larry, 154–155
Snack-o-tainment, 259, 337	String of pearls structure, 121, 121f	Target audience, 77, 127
Snow White and the Seven Dwarfs, 98	Structure	in an original project, 414, 436
Social marketing, 217–218	aquarium model, 122	in children's projects, 133, 136
Social networking, 36, 137, 271 Solomon, Richie, 266	archeological dig model, 125	considerations for, during the
Sopranos, The, 91	balloon man model, 126	development process, 167,
Space, 83	branching, 118–119, 119f	169-171
Spatial narrative, 360–361	coal mine model, 123	in kiosk projects, 403
Spiegel, Stacey, 353, 355	complete graph, 123 creating of, 126	misjudging the, 167, 181
. 0	Centing OI, 120	in video games, 255

Taxonomy, 234	prime-time use of, 153-155	guidelines for, 107-108
TCP/IP, 24	principles of, 151	Vertov, Dziga, 357
Teaching. See also Edutainment	producers' use of, 157-158	Video games. See also Game(s)
games	terminology for, 151	action, 246
digital media used for, 190,	Transmedia entertainment, 32	adaptation of, into movies, 48
206–207	Transmedia gaming, 151	adventure, 247
digital storytelling techniques	Transmedia narratives, 161–162	advertising in, 34, 214
used for, 193-198	Transmedia productions	agency in, 252
mobile devices used for, 345-346	creative potential of, 152–153	characteristics of, 250–251, 255
peer-to-peer learning, 198	holistic approach to, 152	cinematic quality of, 252–254
virtual reality for, 372	media used in, 151	cut scenes in, 80
Telephone	motivation for creating, 152	driving, 246–247 economic effects of, 34–35
communications using, 107	Transmission control protocol/	effectiveness of, 255
technological advances in,	Internet protocol. See TCP/IP	feedback from, 250
336–337	Treadmill, 282	fighting, 247
Television	Trubshaw, Roy, 270	genres, 245–248
adaptation of, into video games,	Tuch, Larry, 367	history of, 24–26
49	Turing, Alan, 99 Turkle, Sherry, 320	home console, 25
convergence in, 45–46	TV411, 309	interface. See Interface
interactive, 45–46 Internet modeled on, 259–260	Tweens, 133	learning from, 254–255
Tension, 76, 145	Tyler, Chris, 268	platforms, 245, 248
Text messaging, 31	Tylei, Gillo, 200	product placement in, 215-216
Theme park rides	U	puzzle, 247
description of, 214		resources for, 255
interactive, 130, 376	Ulysses, 15 Uncanny Valley Syndrome, 331	role-playing, 247
Theme parks, 396–397	United Kingdom, 305, 310, 312	shooters, 247
"Third screen," 32	United Kingdolli, 303, 310, 312	simulations, 247–248
Third-person point of view, 93-94	digital media in, 39	sports, 246–247
Three-act structure, 74, 115-116	iTV in, 305	structure of, 250
Ticking clock, 77	U.S. Army	target audience, 255
Time, 83	androids used by, 331	television shows adapted into, 49
TiVo, 30, 304	serious games used by, 200-203	writers' perspective on, 251–252
Tokyo Game Show, 422	User-generated content, 35-37	Video Games: Serious Business for
Training	Users	America's Economy, 34
corporate, 204	agency given to, 56-57	Video iPod, 30 Video on demand, 33, 42, 45, 304
digital media for, 204	avatar of, 92	Video sharing sites, 37
digital storytelling and, 203-206,	developmental considerations,	Vidstone, 406
208	172	Vincent, Richard, 92, 140
importance of, 203	as fulcrum, 360	Viral marketing, 212
interactive, 205–206 serious games used for, 201	immersiveness, 57–59	Virtual objects, 60
virtual reality for, 372	interactivity effects on, 67	Virtual reality
Training Magazine, 422	point of view of, 81, 92–95	advertising uses of, 214
Training Systems Design, 204–205	as protagonist, 91–95	artistic expression using,
Transmedia approach	roles of, 81, 95	367-369
defining of, 151–152	in small-screen interactive cin-	description of, 365-366
description of, 47, 82, 150,	ema, 360 in virtual reality, 370	dramatic potential of, 369-370
236-237	young, 130–133	emotions in, 109
feature films and, 156	young, 190 199	in entertainment, 371–372
Hollywood's interest in, 157-160	W	examples of, 366–369
informational content delivery,	V	"grammar" for, 370–371
236–237	Variables, assigning of, 81	informational content delivery
nonfiction projects' use of,	Verbal communications. See also	through, 235
160–161	Dialogue functions of, 104	narratives for, 372–373
power of, 152	functions of, 104	pragmatic uses of, 372

Virtual reality (Contd) promotion uses of, 372 psychotherapy uses of, 372 storytelling using, 367-369 teaching uses of, 372 training uses of, 372 users in, 370 Virtual worlds description of, 36 learning uses of, 206-207 MMORPGs and, 207 promotional uses of, 223 social networking in, 137 Visual humor, 143 Visual interface, 251 VIVISYS, 354 Vogler, Christopher, 73 Voice recognition, 100 Voice-over, 178 Volunteer projects, 430

W

Wachowski, Andy, 156 Wachowski, Larry, 156

Waddington, Darlene, 250, 254 WAP. See Wireless application protocol Washington Post, The, 229 Waters, Rich, 275 Weak agency, 107, 119, 168, 351 Webcam dramas, 262-263 Webcam peepshows, 223-224 Webinar, 207 Webisodes advertising uses of, 219 definition of, 219, 261 description of, 29, 32, 158 examples of, 261 origins of, 261 Weisman, Jordan, 289 Weizenbaum, Joseph, 99 What Video Games Have to Teach us About Learning and Literacy, Who is Benjamin Stove?, 220-221, 297

Wireless application protocol, 336

Wii, 245

Wireless technology, 336 Wizard of Oz, The, 73 World structure, 117 Wright, Will, 104 Writers employment as, 416 freelance, 416-417 perspective on video games by, 251-252 Writers Guild of America, 33, 417 Writer's Journey, The, 73 Written communications, 105, 108 Written dialogue, 106 X

Xbox Communicator, 46

Z

Zellers, Marcia, 309 Zucker, Jeff, 157

Project Index

24: Conspiracy, 158, 342 24: Countdown, 158

A

Afterworld, 261–262
Aibo, 330
A.L.I.C.E., 99
Altima Island, 225
Amazon.com, 356
America on the Move, 217–218
America's Army, 222–223
Animatrix, The, 156
AOL Pointe, 216
AOL's KOL, 137
Arrow to the Sun, 379
Art of the Heist, The, 299
Ashes to Ashes, 366

В

Baby Bright Eyes, 325–325
BarbieGirls.com, 36, 138
Beast, The, 289–291, 293–296
Belle de Jour, 262
Belle doll, 326–328
Beyond Good and Evil, 247
Big Brother Africa, 151–152, 160–161
Blair Witch Project, The, 150–151, 153, 261, 288
Bleeding Through: Layers of Los
Angeles, 359–360, 388, 389f
Botfighters, 343–344

Bridget Jones' Diary, 342

Buzz Lightyear AstroBlaster, The, 378

C

Carmen Sandiego, 27, 75, 185, 191
Cartoon Doll Emporium, 138
Casablanca, 301
Castles, 116
Chevy Tahoe online commercial contest, 56–57, 222
Chinese Hero Registry, 131
Cisco's Journal, 109, 314
Club Penguin, 36, 137
Code Alert, 180f, 183, 183f, 205–206

Colossal Cave Adventure, 247 Command and Conquer, 247 Computer Space, 25 Conversations, 233, 235, 369–370 Crackle, 435 Cybelle, 99

D

Darfur is Dying, 200, 232 Dark Age of Camelot, 273, 274f DarkCon, 109, 110f, 366-367 Dawn at My Back, The, 359, 387 Defaker, 222 Defamer, 222 Deus Ex, 246 Deus Ex, Invisible War, 246 Dick and Jane, 178f-179f Didi and Ditto, 96 Digital Edge, The, 229 Diners, 310-311 Discover the Stories Behind the Magic, 396, 412 Disney Game Kingdom Online, 137 DisneyQuest, 371 Dog the Bounty Hunter, 345 Donkey Kong, 248 Dragon's Lair, 26, 250, 386 DRU, 374-375

E

Earthquake in Zipland, 200
E-daze, 152–153
El Camino Real de Tierra Adentro, 232
ELIZA, 99
Enter the Matrix, 156
Environmental Detectives, 346
EverQuest, 122, 247, 270, 272, 275f, 276

F

Façade, 360 Facebook, 35–36, 137, 158 Final Fantasy series, 73, 247 Finding Nemo, 343 Flat World, 373 Food Force, 200, 232 Food Import Folly, 229, 232 Freddie Fish, 27 Fully Involved, 200 Funny or Die, 263

G

Galatea, 66
Games-to-Teach Project, 192–193, 345
Ghost Town, 262
Grand Theft Auto, 91, 199, 246, 256
Green Tea Partay, 221
Grim Fandango, The, 247
Gronk's Brain Flame, 379
Gun, 252, 299

Н

Half-Life, 247
Half-Life 2, 252
Halo 2, 297
Harry Potter and the Chamber of Secrets DVD, 387
Haunted Carousel, The, 78, 79f
Hawai'i Nisei Story, 231
Hephaestus, 193
Hire, The, 223

I Love Bees, 297, 299
Icebox, 263
iGod, 99
Imagined Place, An, 404
Indy 500, 247
In-Store Interactive Fragrance Assistant, 405–406
Interactive dollhouse project, 323
Invictus, 73, 116
It's Tough to be a Bug, 376

JibJab, 263 Jumpstart Advanced First Grade, 124f, 141, 142f, 174, 191 JumpStart Artist, 194, 196 JumpStart titles, 27, 78, 124, 127, 194

PROJECT INDEX

K

Kidscom.com, 130 King Kong Jump, 215

L

La Jungla de Optica, 193
Lara Croft: Tomb Raider, 48, 89f, 94f
Last Call Poker, 299
Left Behind: Eternal Forces, 199–200,
222
Lineage, 275
Lineage II, 273
LonelyGirl15, 262–263, 434–435
Lost Experience, The, 159–160, 296
Lost Video Diaries, 159
Love and Hate, 343
Lovely By Surprise, 220

M

Magic Moment Pins, 396 Majestic, 295-296 Manuela's Children, 387-388 Mario Bros., 48 Master of Orion 3, 116 MathBlaster, 27, 191 Max Payne, 246 Meatrix, The, 218, 219f, 426 Memory Stairs, 109, 370 Meow Mix House, 217 MesoAmerican Ballgame, The, 232 Mia: Just in Time, 140, 196, 196f Mia: Romaine's New Hat, 192 Mia titles, 91-92, 140-141 Miracles in Reverse, 361 Mission Rehearsal, 377-378 Mogi, Item Hunt, 344 Mortal Kombat, 247 Mr. Diety, 434-435 MUD, 67, 270 MySpace, 35-36, 137, 158, 432 Myst, 247

N

Nancy Drew mystery adventure games, 120–121, 140, 185 Neverwinter Nights, 247 Neverything, The, 220 Nigelblog.com, 158–159, 262 Nighttime Classics, 219 Noelle, 331 Nokia 2003, 344 Nokia Game, The, 344

0

Odd Todd, 429–432 Office: The Accountants, The, 158, 261 Official Harry Potter Website, The, 139f Online Caroline, 263 Oregon Trail, The, 27

P

Participate, 232 PEBBLES, 406, 407f Perplex City, 299 Pirates of the Caribbean Multiplayer. Pirates of the Caribbean Online, 223, 271, 275, 283-285 Planet Jemma, 263 Playhouse Disney Preschool Time Online, 137 Pong, 25-26, 31, 90, 244 Pop Quiz, 182, 183f Prince of Persia, 254 Prom Queen, 261 PS I Luv U, 343 Push, Nevada, 153-156, 296 Putt-Putt, 27

Q

Q Game: City of Riddles, The, 339–341, 344 Quantum Gate, 54

R

Race to School Game, The, 215
Rachel's Room, 263–265
Reader Rabbit, 191
Red vs Blue, 37
Re-Mission, 200
Repliee Q1, 331–332
Revolutionary War Immersive
Experience, 376
Rising from Ruin, 230–232
Robosapien, 329–330
Rock, Paper, Kiss, 343, 345

S

Save My Husband, 263, 300 Save Your Co-Worker, 180f, 205 Scourges of the World, 389 Second Life, 36, 123, 206–207, 216, 224–225, 229, 271 Seventh Guest, The, 27, 247

Shanghai: Second Dynasty, 116 Shelly Duvall Presents Digby's Adventures, 76 Sims, The, 247 Sims Online, The, 49, 215 Smallville mobisode, 158 Snake, 90, 337-338, 347 Something to be Desired, 261 Sonic the Hedgehog, 248 Space of Time, A, 360-361 Spacewar, 25 Spore, 104 Star Trek: Starfleet Command, 116 Stardoll.com, 138 Strand, The, 261 Stranger Adventures, 263, 265-266 Subservient Chicken, 224 Sucks Less with Kevin Smith, 346 Sunset Hotel, The, 343 Super Mario Brothers, 48, 248 Surf the Seaweb, 402

T

Tea Partay, 221
Teddy Ruxpin, 322
Tennis for Two, 25
Tetris, 65, 90, 247
Thing Growing, A, 362, 370
Thirteen Ways of Looking at a
Blackbird, 38
ThisistheMatrix.com, 156
Thunder Road, 311, 314
Tomb Raider, 48, 89f, 94f, 95, 193, 253
Toontown Online, 138, 223, 270–271,

Toontown Online, 138, 223, 270–271 275, 277–282 TyGirls.com, 138

U

Ultima Online, 270 Uncompressed, 357–358 Undercover Brother, 49 Underground Bounty Hunter, 263

V

Virtual Hills, 216 Virtual Luxor, 404 Virtual Temple, The, 369 VirtualMTV, 137 Vital Space, 353–354 Voices of Oakland, The, 374 Voyeur, 16–17, 27

PROJECT INDEX

W

Way Beyond Trail, The, 216-217, 223 WeeWorld, 36 Whack-a-Roach, 233 Who is Benjamin Stove?, 220-221, 297 Whyville, 207 Wings of Memory, 379 Woodrow Wilson, 160, 236, 237f, 387 World of Warcraft, 247, 273 WoW, 273

Y

YouTube, 35, 37, 49, 60, 216, 221, 230, 262, 432, 434
Yucky.com, 233